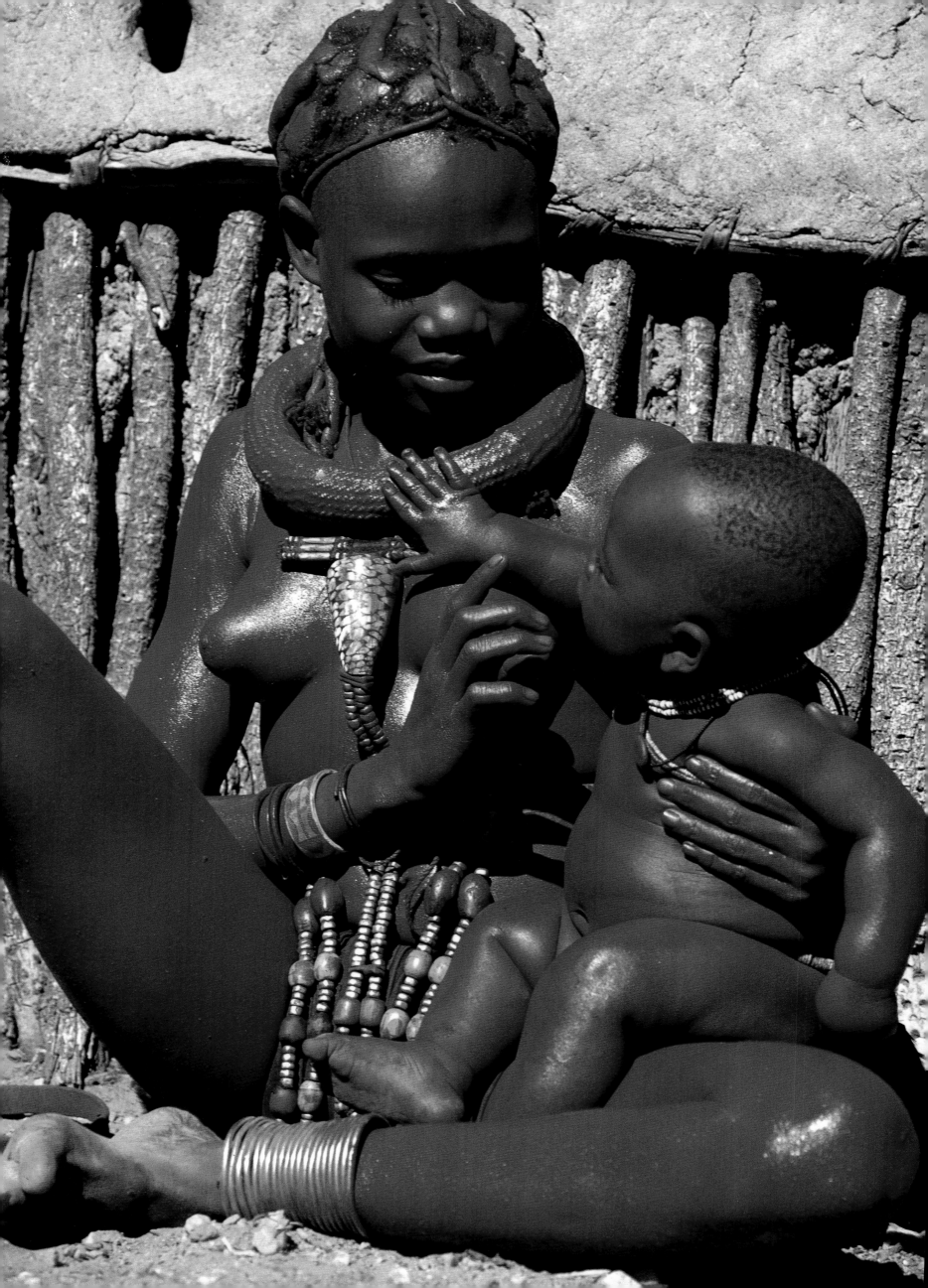

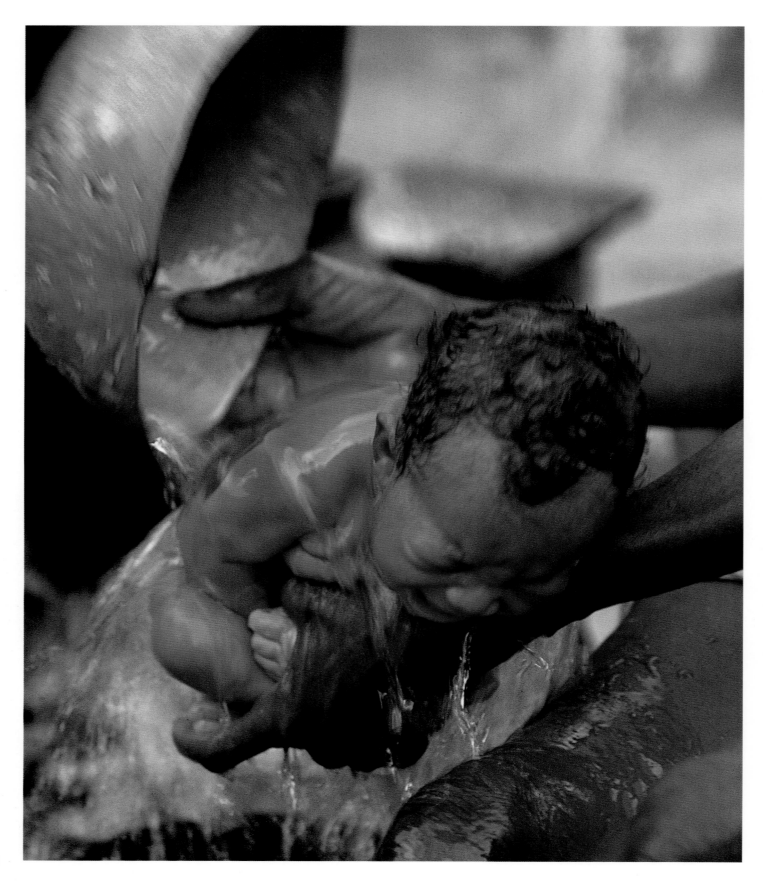

Birth Rituals

Minutes after birth, a Kassena baby from Ghana is ritually bathed with water from a calabash. During pregnancy, the mother will consult a soothsayer to learn the personality of her unborn child and the clothing and jewelry that must be acquired to welcome him or her to the world. She will then select a *wei*, which can be anything from a tree to a stone, to become the child's spiritual focus, a place for worship and sacrifice, throughout its early life.

Right: For the Maasai of Kenya, the most important childhood ritual is the Baby Naming Ceremony. Following the slaughter of a sacrificial goat, the heads of both mother and baby are shaved, signifying their shared journey into a new phase of life. On the evening of the ceremony the mother and baby join the father and three elders in the family hut, where the elders announce its new name and proclaim, "May that name dwell in you".

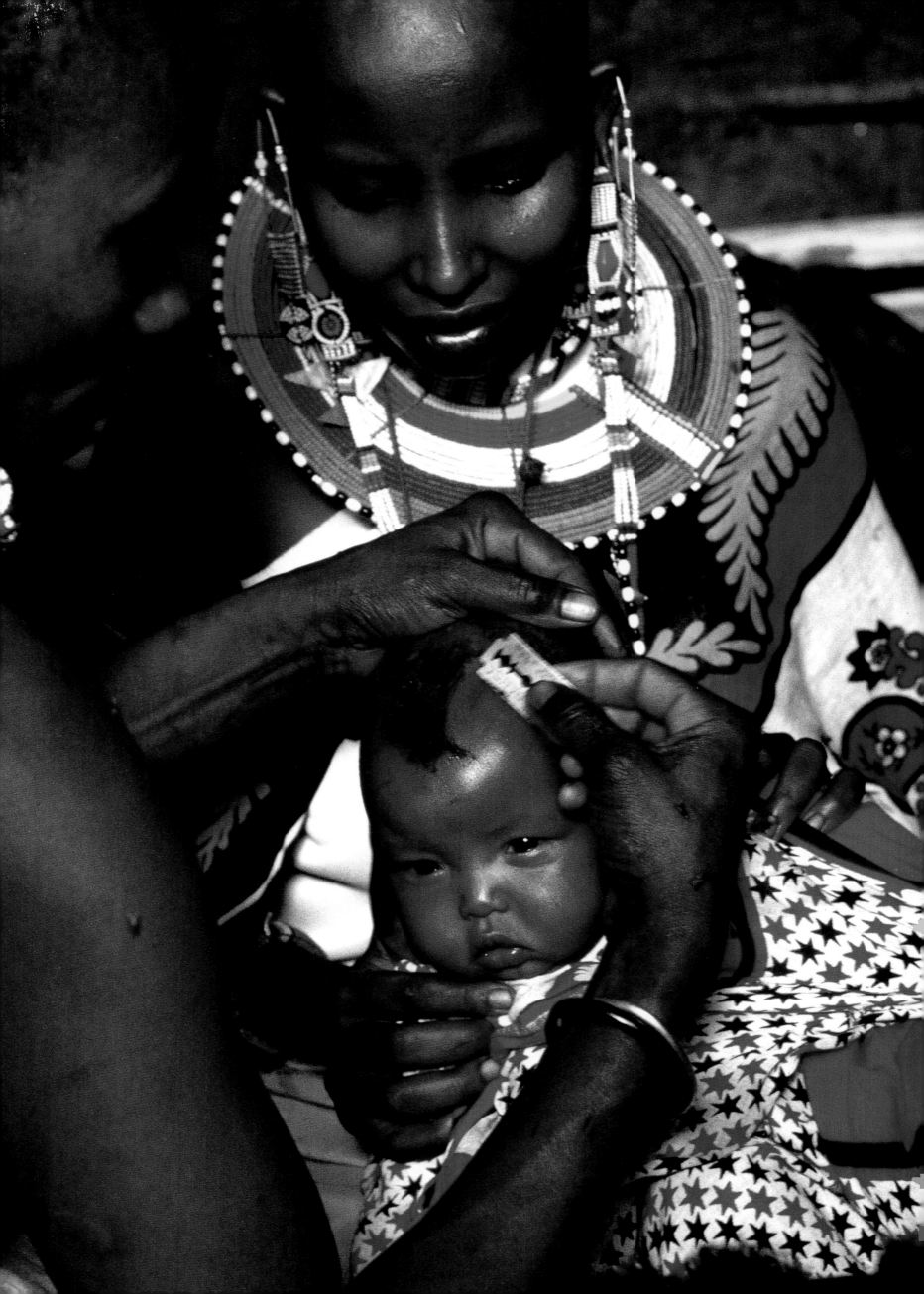

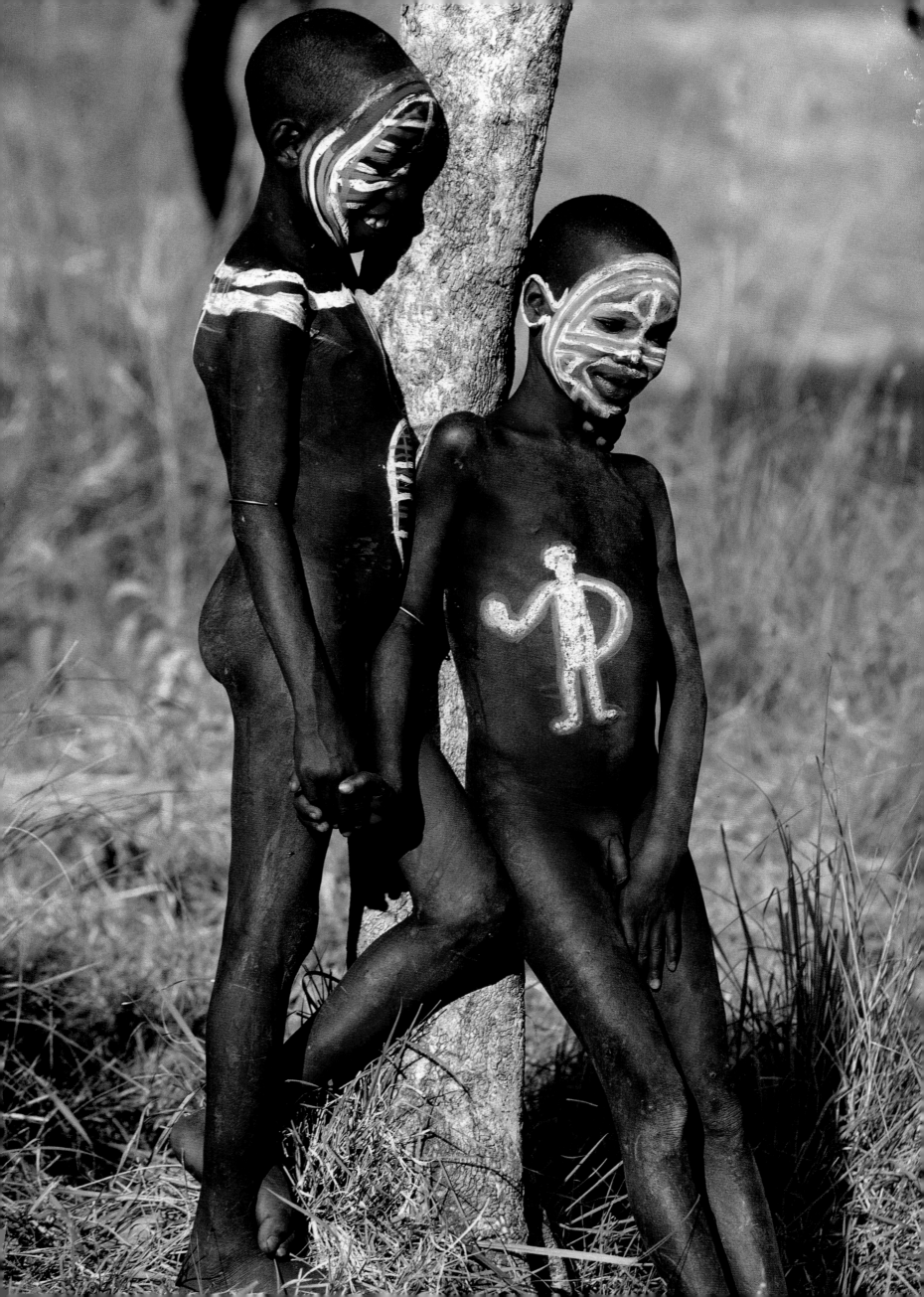

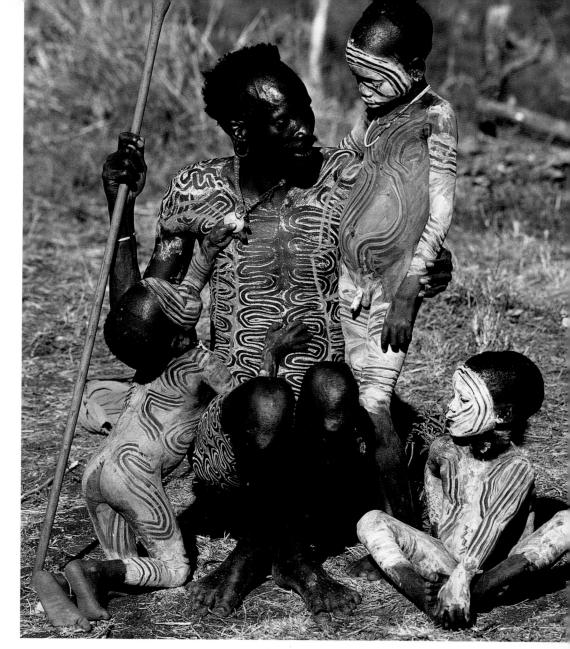

Creating Designs in Chalk

Surma children from Ethiopia decorate their bodies using chalk and earth pigments to create fanciful patterns. The youngsters begin learning the art of body painting at an early age by imitating their parents. Possessing little in the way of material culture, the Surma paint themselves as their prime means of artistic expression. Imaginations run wild as they turn their own bodies into works of art, incorporating the human figure (*left*) and, for young girls, the mature breasts of their older sisters (*below*). To reveal their close bonds to one another, best friends often paint their faces with identical chalk designs.

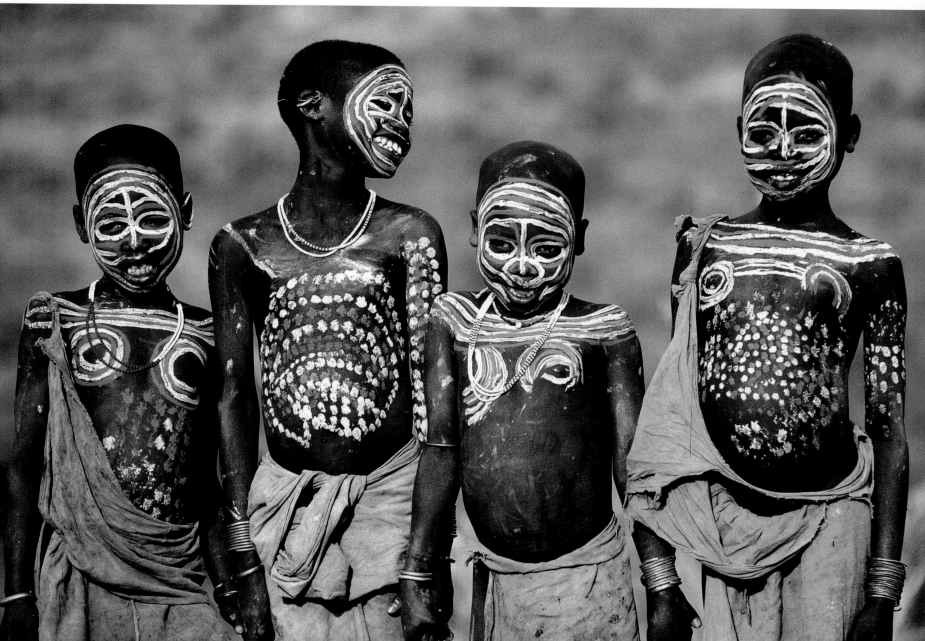

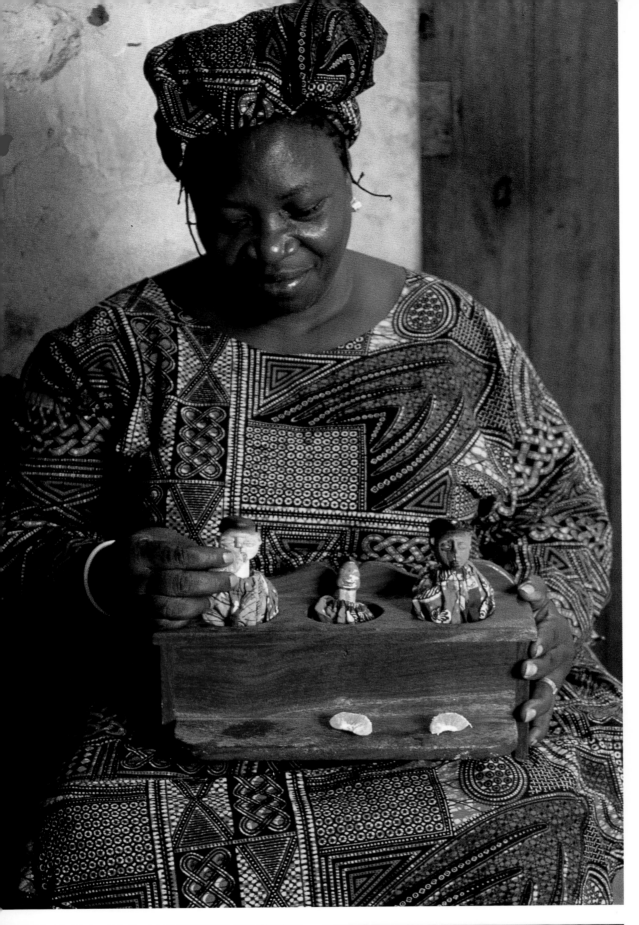

Sacred Twins

Twins, regarded as separate parts of the same being, are a blessing to the Fon people of Benin. They are treated more carefully than other children, must always be dressed alike, and are given the same gifts. When one twin dies, a small wooden image of the deceased is cared for by the mother as if it were a living child. After both have passed away, a pair of statues known as Hovi is carved and honored every year in a festival. A Fon woman (*left*) cares for three dolls: one for her father, one for his twin brother, and another that she found lying in the street, as though they are her own children.

Right: Krobo twins imitate their older sisters at an initiation ceremony. Their decorative cloth and beads are a vital part of female adornment reflecting the wealth of the extended family. At their naming ceremony, seven days after birth, they are given two to three beads on a cord to be tied onto their wrists for one week. Later they receive a strand of waist beads which, extended and replaced as they grow, will be called "a man's rosary" by their husbands.

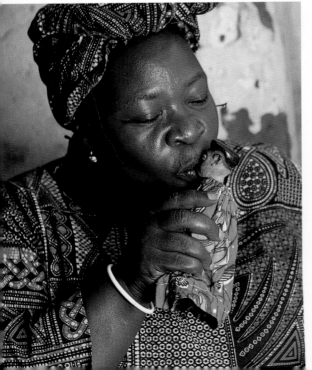

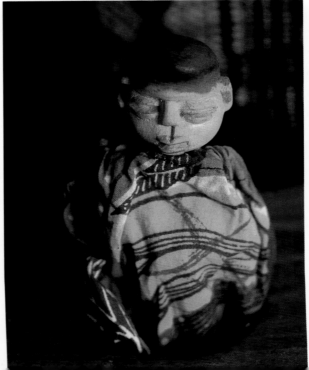

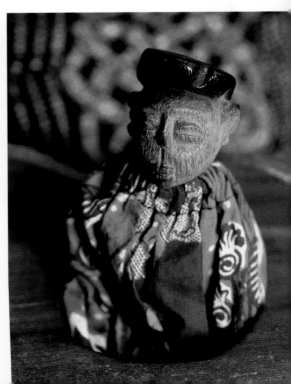

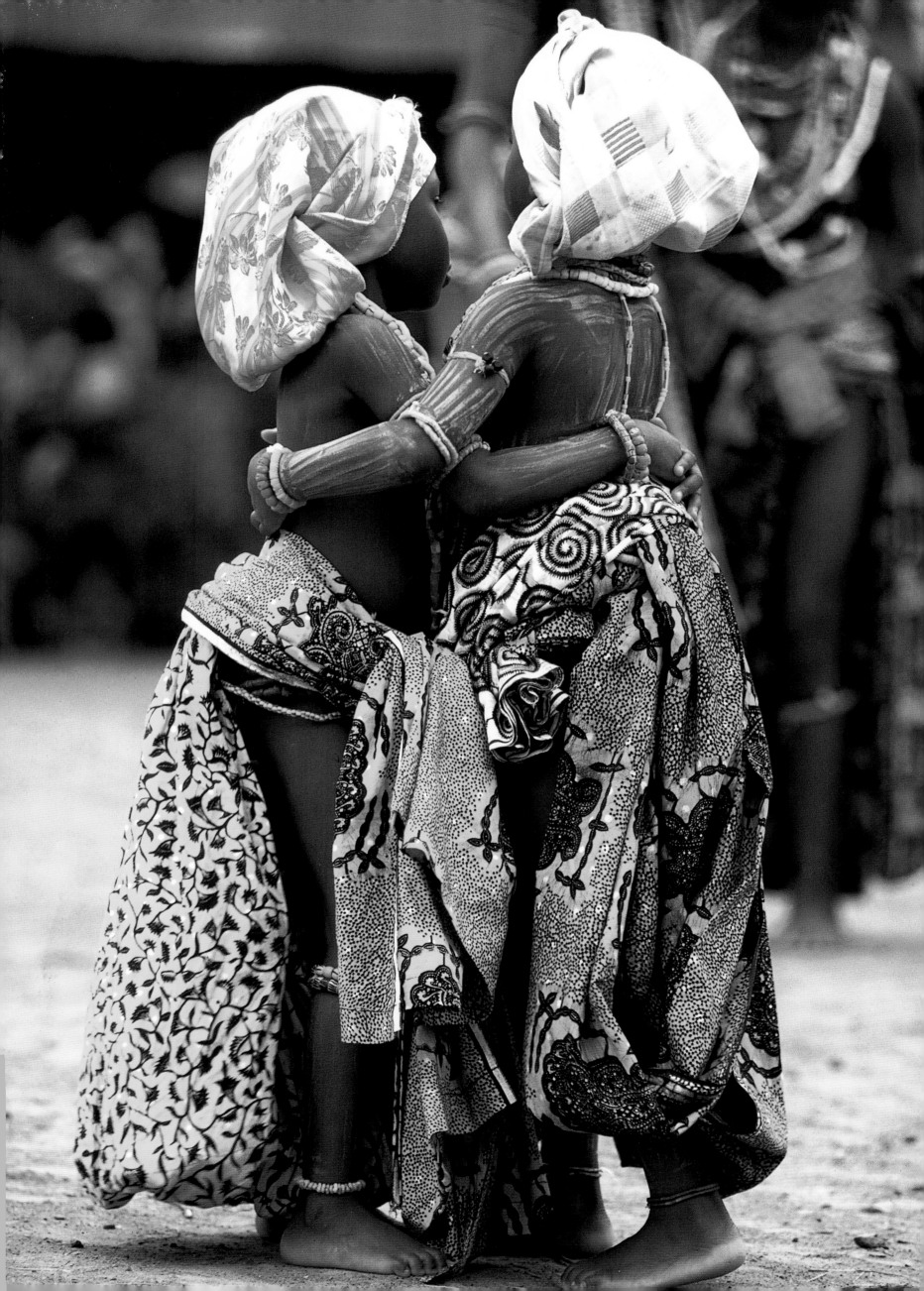

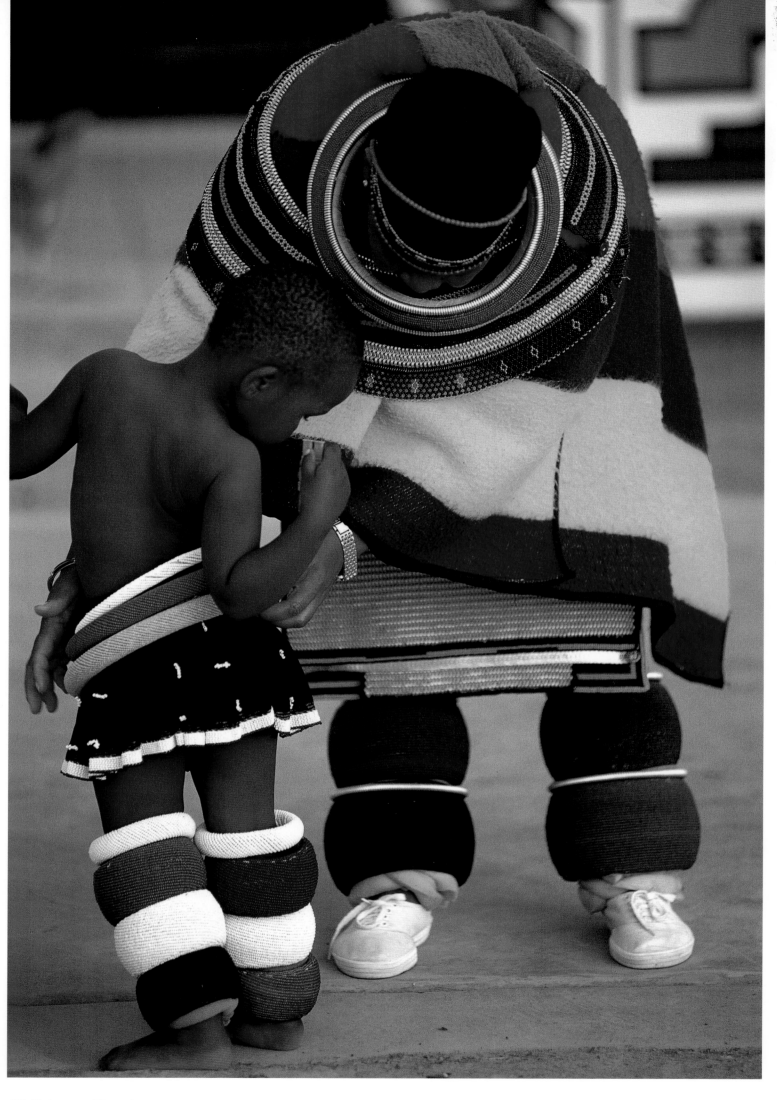

Childrens Beads

An Ndebele child from South Africa is dressed by her grandmother (*above*) in preparation for a family wedding. On her legs, the girl wears beaded hoops called *golwani*. Underneath her matching waist hoops is tied an apron of beaded tassels (*right*) known as *lighabi*, which although worn by both sexes, is more usually found on girls. As the child grows, the *lighabi* is replaced by larger versions, and is finally discarded after her initiation into womanhood.

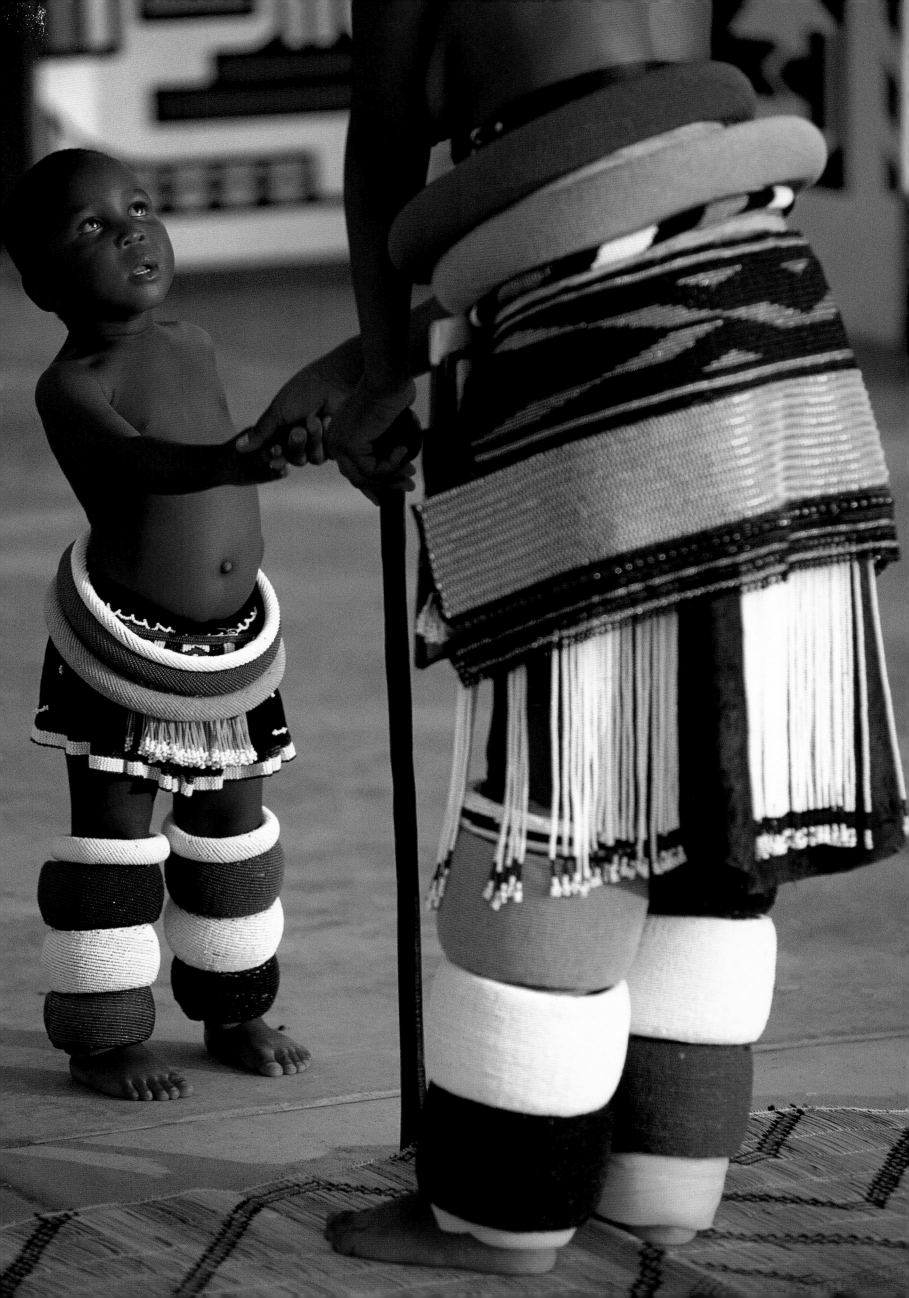

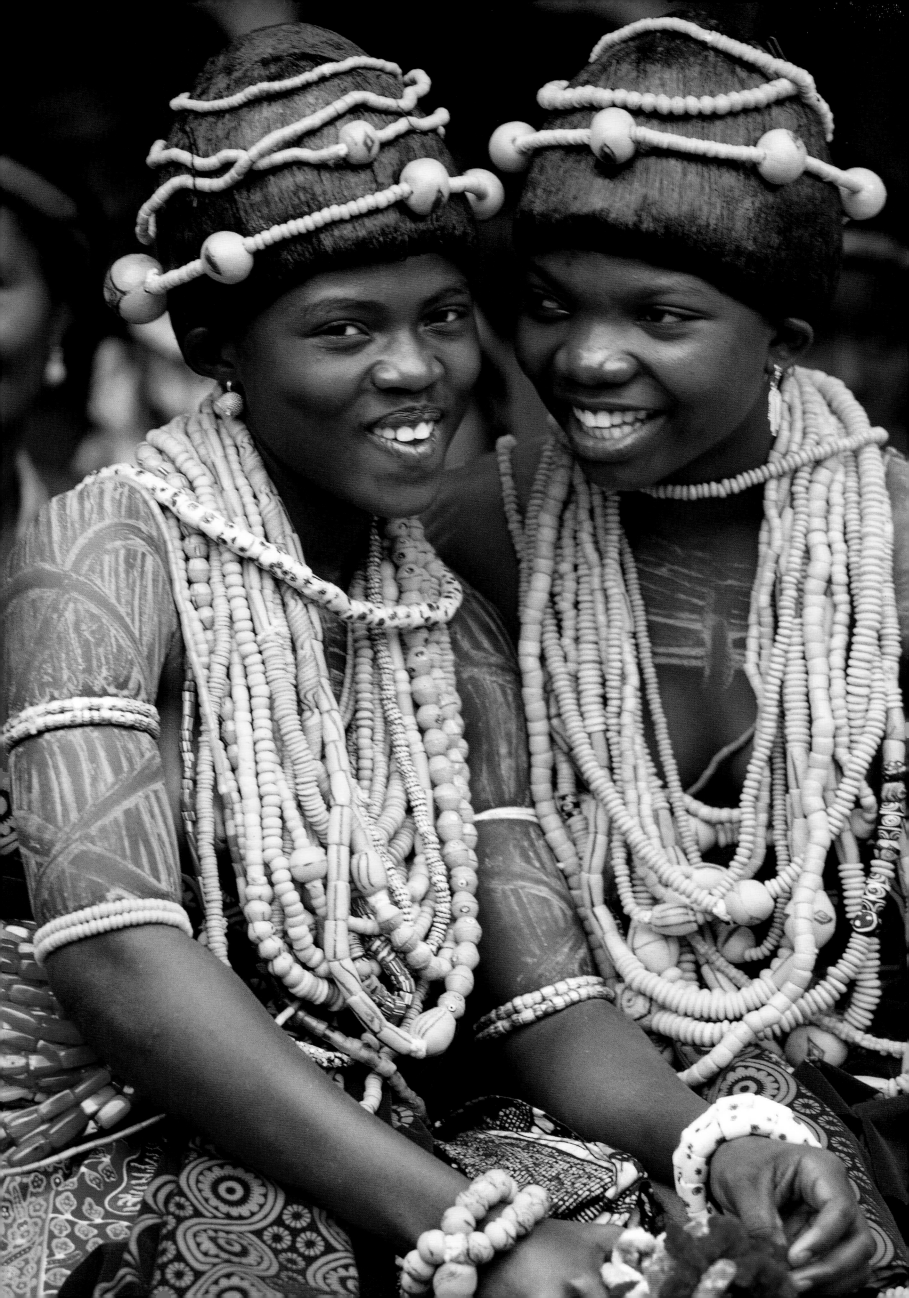

Krobo Coming of Age

The Krobo and their tribal cousins, the Shai, mark the passage of girls into womanhood by performing a series of rituals known as Dipo. Living in the fertile plains around the towns of Odumasi and Somanya in eastern Ghana, the Krobo celebrate femininity and fertility under the auspices of the earth goddess, Nene Kloweki. Dipo rites have been practiced since the eleventh century, and their popularity has not waned despite modern intrusions into traditional Ghanaian culture.

Beginning with a ritual that severs all ties with their childhoods, the initiates enter a three-week period of seclusion, during which they learn the ways of adult women. Taught the finer points of personal grooming, female conduct, domesticity, and, finally, the arts of dance and seduction, the girls undergo inner and outer transformation with the help of specially appointed Dipo guardians. When their tutoring is over, the initiates enter a sacred grove to pass a final test in a ritual encounter with Tekpete, the sacred stone. Held by priest-esses, they are lowered several times onto the stone in order to test their virginity. As each initiate leaves the grove, she is hoisted onto the back of a guardian mother and carried home with the greatest speed possible. This ritual reflects earlier times when young Krobo women were so prized for their beauty and reputation as good wives that they would often be kidnapped by men from other tribes.

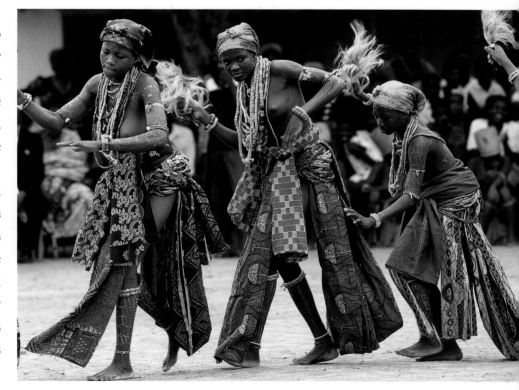

In celebration of the completion of Dipo training, the graduates adorn themselves for the Outdooring ceremony, when they publicly demonstrate their dancing skills for the chief, relatives, and, most importantly, prospective suitors who gather to admire the display of feminine grace and beauty.

Despite the influence of the Christian church in Ghana, which actively discourages the Dipo, and a modern world that deems the rite anachronistic, the Krobo people consider it their most sacred and beautiful ceremonial tradition. Performed exclusively by women over many generations, the rituals enhance female power and give special status to their roles in the community.

Left and right: Krobo initiates are presented to the community as women at the annual Outdooring ceremony.

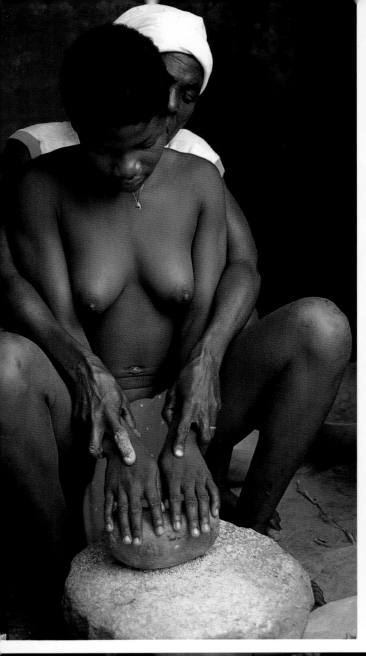

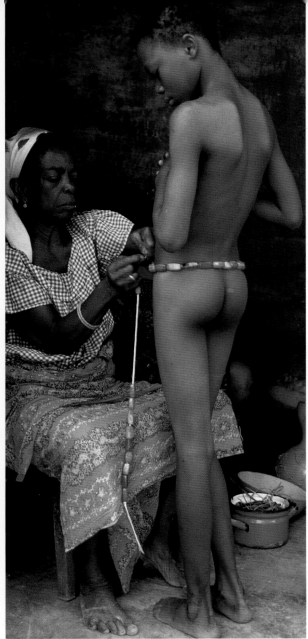

Becoming a Woman

At the beginning of the Dipo ceremony, each initiate enters a ritual house, sheds her clothing, symbolic of childhood, and is dressed anew by her ritual mother. Tied around her waist is a single strand of carnelian beads, over which is draped a long red cloth. The color of the beads and the cloth symbolize the blood of menstruation and offers protection from evil spirits.

During their three-week seclusion, the initiates are taught the traditional ways of preparing food by their ritual mothers.
Top left: A mother guides a girl's hands to demonstrate the proper rhythm of grinding millet, a staple of the Krobo diet.

The morning after the shaving of their heads, the initiates (*right*) carry their calabashes to the river to bathe. The washing ceremony is a purification rite to cleanse the body and spirit. Afterwards, they will be blessed by the village priest with the words, "Today you are a pure woman. Today you are holy. Bathe well before you go to Tekpete (the sacred stone)."
Left: After their ritual bathing, the girls are fed a special meal of water-yam porridge and palm-oil sauce prepared by their mothers.

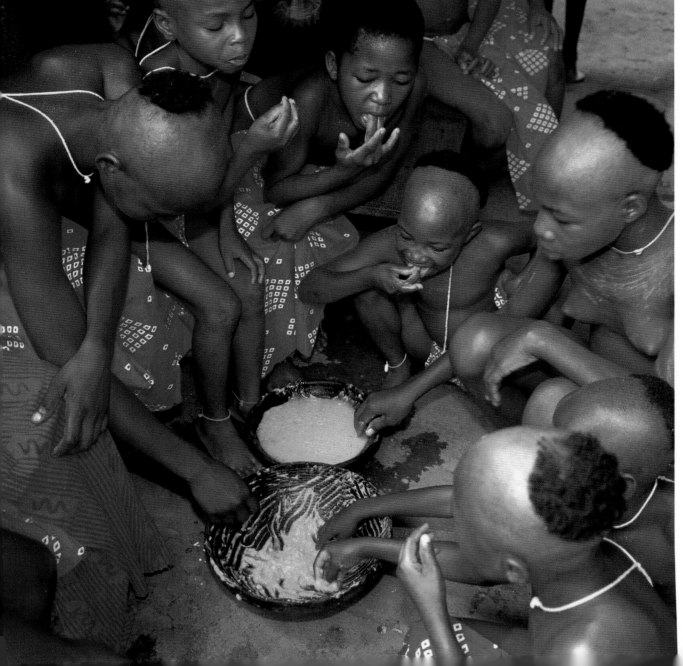

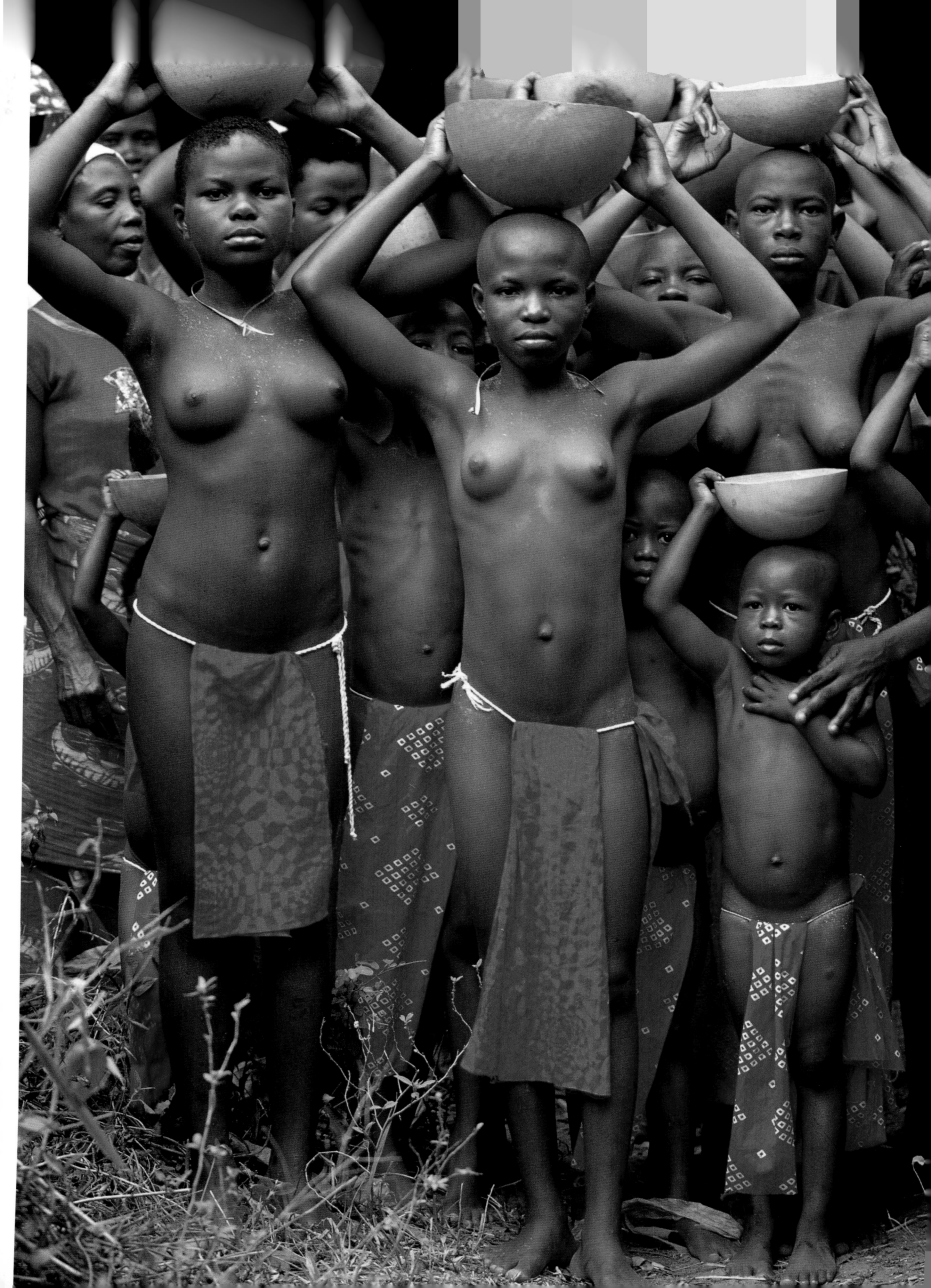

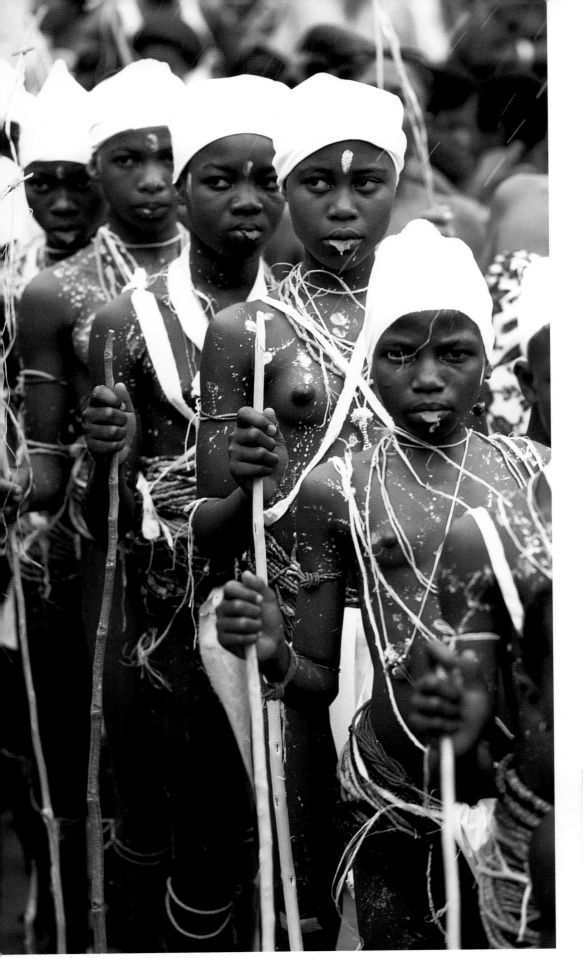

Sacred Stone of Virginity

The climax of the Dipo initiation ceremony is called the blessing of Tekpete, referring to a legendary sacred stone which the Krobo carried down from Krobo Mountain when the British evicted them from their place of origin in the nineteenth century. Wearing pure white strips of calico around their heads and chests, and maintaining a contemplative silence by pressing a single leaf between their lips, the initiates make their way to the sacred grove on the outskirts of the village. Each initiate has been splashed with chalky water to ward off any evil forces that might overcome her; she also carries a long stick called *dimanchu*, which literally means, "to make you a woman."

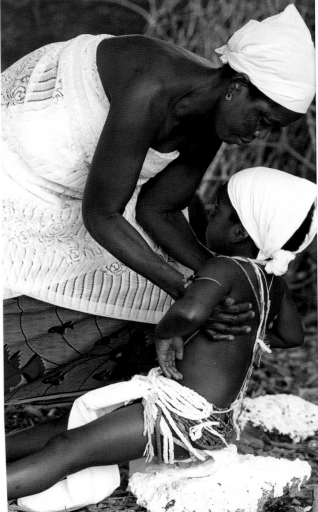

One by one, the girls are greeted by priestesses who will lower each in turn three times onto the sacred Tekpete stone (*right*). The priestesses study each girl as she touches the stone. Only when they are satisfied that the girl is a virgin will they pronouce her to be worthy of Dipo. The sanctity of the ritual depends on the initiate being pure of mind and body. If a girl is found not to be a virgin, or, worse still, if she is discovered to be pregnant, she risks being ostracized and will never attract a husband from her own tribe.

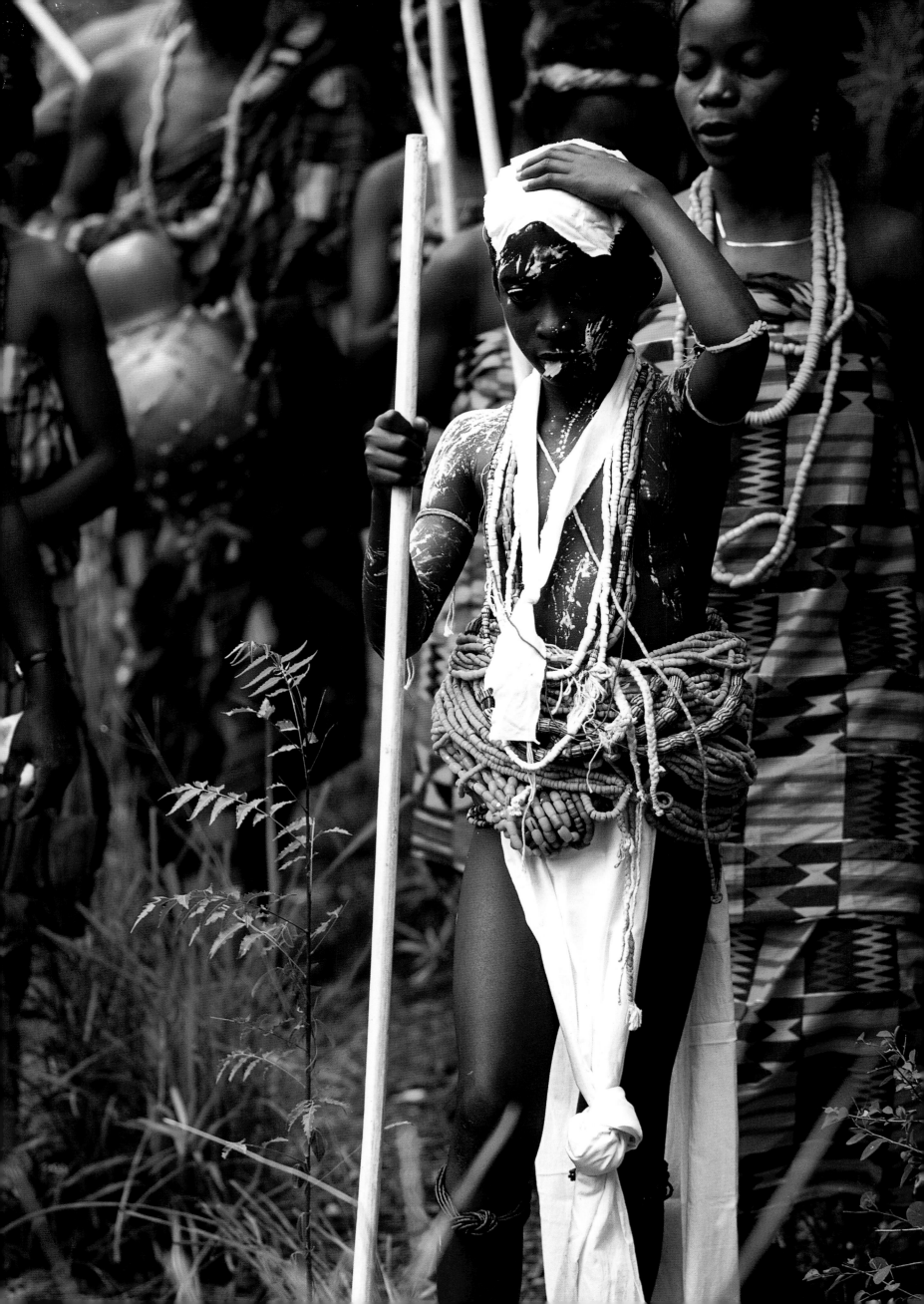

The Outdooring Ceremony

Two Shai girls relax together before the final stage of their initiation. Each girl wears an elaborate headdress called *cheia*, made of hoops of cane wrapped in blackened cord and taking six hours to complete. During the final week of Dipo instruction, the girls have studied the arts of dance and music and also learned about the subtleties of seduction, including special Shai techniques for making love. Men of other tribes consider Krobo and Shai women to be among the most desirable in West Africa. The initiates are now ready for their Outdooring Ceremony, during which they will be presented to the community of family, friends, and potential suitors. Tied around their necks and hips are beads that have often been passed down through a family for many generations and are of great value to the Krobo. Some of the girls will dance at the Outdooring Ceremony wearing a collection of beads worth as much as $5,000 and weighing up to 25 pounds.

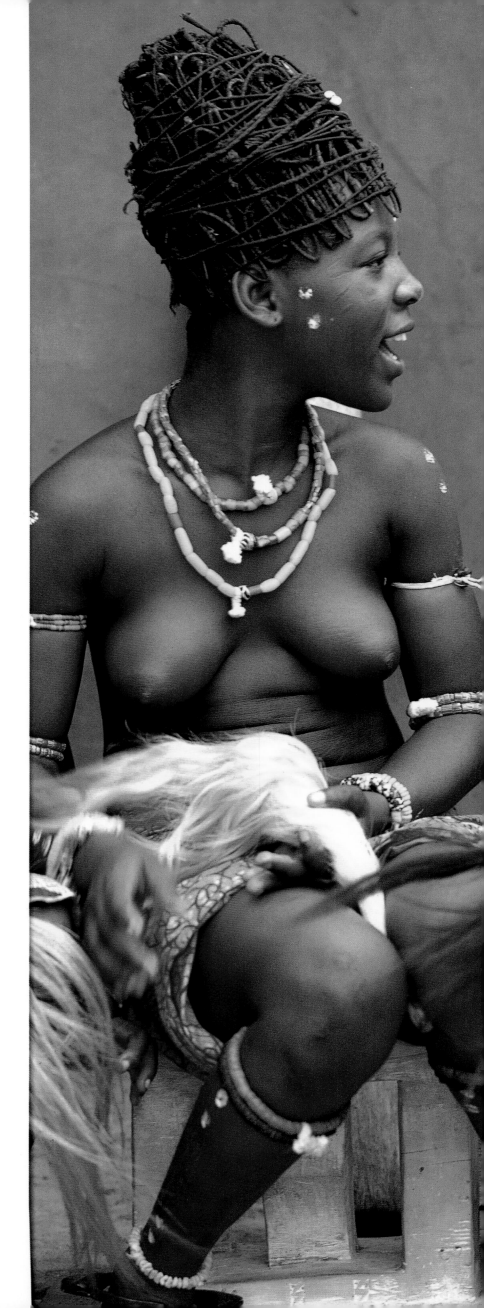

african ceremonies

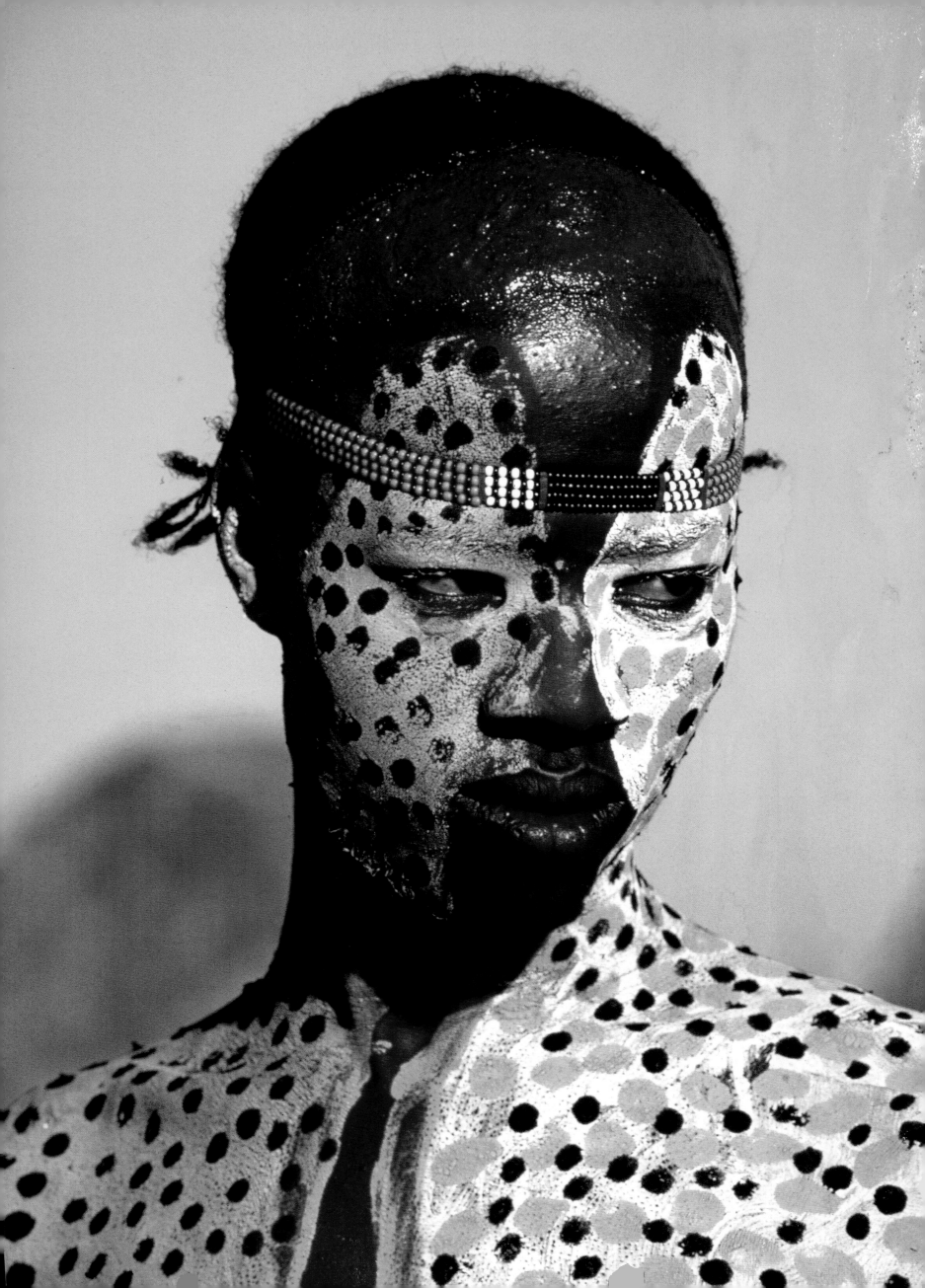

african ceremonies

the concise edition

carol beckwith & angela fisher

HARRY N. ABRAMS, INC., PUBLISHERS

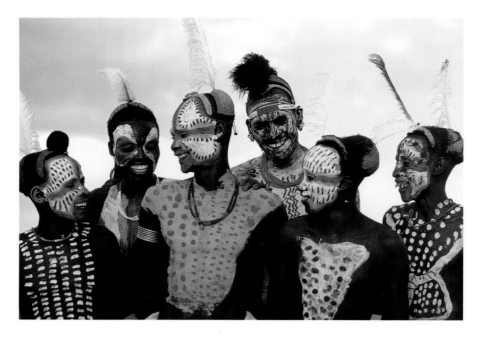

DESIGNERS: BARNEY WAN AND CAZ HILDEBRAND
RESEARCHER AND CO-WRITER: SHAUN FORD
COPY EDITOR: NICOLA GRAYDON
PRODUCTION DIRECTOR: HOPE KOTURO

**A portion of the royalties from the sale of this book will be used to assist
the peoples of Africa during times of need.**

LIBRARY OF CONGRESS CATALOGING-IN-PUBLICATION DATA
Beckwith, Carol, 1945-
African ceremonies / Carol Beckwith & Angela Fisher.-- Concise ed.
p. cm.
Includes bibliographical references and index.
ISBN 0-8109-3484-1
1. Rites and ceremonies--Africa. 2. Ritual--Africa. 3. Initiation
rites--Africa. 4. Marriage customs and rites--Africa. 5.
Africa--Religious life and customs. 6. Africa--Social life and
customs. I. Fisher, Angela. II. Title.
GN645 .B4 2002
306.4'096--dc 212002006143

FRONT COVER: Karo Man, Ethiopia. **BACK COVER:** Turkana Girl, Kenya
PAGE 1: Wodaabe Charm Dancers, Niger. **PAGE 2:** Karo Dancer, Ethiopia.
PAGE 4: Painted Karo Men, Ethiopia. **PAGE 7:** Ndebele Woman, South Africa.
PAGE 9: Profile of Karo Man, Ethiopia. **PAGE 13:** Zulu Woman, South Africa.

Printed and bound in Japan
10 9 8 7 6 5 4 3 2 1

Harry N. Abrams, Inc.
100 Fifth Avenue
New York, N.Y. 10011
www.abramsbooks.com

Abrams is a subsidiary of
LA MARTINIÈRE
GROUPE

Acknowledgments

AFRICAN CEREMONIES was made possible by the generosity of many individuals to whom we owe our deepest appreciation. We would like to thank David Koch for his outstanding support over the past 17 years. Without David's generous grant, this book would not exist. We acknowledge with gratitude three exceptional people who also contributed significantly: Jennifer Easton, Patricia Kluge, and Jennifer Small. In recognition of their special committment, we thank Roberto Edwards, Theodore Furst, The National Geographic Society, and Threshold Foundation.

From the start of our project, several dear friends, Bruce Ludwig, Joan & Arnold Travis, Tom Hill, and Josh Mailman, not only contributed generously, but gave incredible time and energy to involving others in our work. Among our dedicated supporters, we sincerely thank: Gregory Abbot, Leo Beckwith, Bowers Museum Council, Marion Greene, Patricia House, Richard Kaplan, Peter Keller, Lady Camilla Mackeson, and Bruce Schnitzer. Finally, thanks to those who enabled us to complete our fieldwork: Adele & Leonard Block, Franci Crane, Janet Ecker, Ivory Freidus, Ira Haupt III, William Kistler, Bo Legendre, Ginou McMillan, Joyce Reed, Alan Sieroty, Carol & Morty Simon, Joan & Roger Sonnabend, Bette Yozell, and Seymour Ziff. We thank Fuji Film UK for our initial film grant; Scott Andrews of Nikon USA for technical advice; Mike O'Keefe of Protocol London for film processing; Peter Rydon of Harlequin for duping & printing; and Robert Estall Photo Agency.

We are extremely grateful to Donald Johanson for friendship, belief in our work, and his introduction to the Institute of Human Origins, which has been so helpful and supportive throughout our project.

WEST AFRICA: In Ghana, we thank Ben Ephson for his friendship and expertise in the field; Chief Tetteh Odonkor Tuumeh I, for hospitality and guidance in the ways of the Krobo; and Dawn Liberi for sharing her Accra home. We thank Peter Billa and Chief Chiana Pe for helping with Kassena fieldwork. In recording ceremonies of priests and priestesses, we acknowledge Joyce Koranteng and Charles Konadu. In photographing fantasy coffins and funeral ceremonies, we thank our dear friend Paa Joe and the Kane Kwei workshop, and carver John Ayo Agbeve, who introduced us to the world of voodoo. We also extend our appreciation to Chief Addo Dankwa III, Chief Wereko Apem II, former US Ambassador Kenneth Brown and Bonnie Brown, Martina Odonkor, Kati Dagadu, Nii Korley, A.T.A Ofori, Gladys Sackitey, Christine Mullen Kreamer, and our "aunties": Comfort Dolf, Comfort Dawutey, and Madame Afi Dédé Sons of God.

In Togo, we are especially grateful to Alberto Nicheli of TransAfrica, who introduced us to remote corners of Togo, Benin, Nigeria, Burkina Faso, and Mali to witness ceremonies never before recorded. We also thank Soldja, Wali Bio, and Moussa Yao Bourdja.

In Benin, we thank Oba Adio Adetutu of Ketou, his son Marcel, and Chief Antoine Zéhé of Golin for enabling us to record a masquerade.

In the Ivory Coast, we express our gratitude to Tim Garrard and his remarkable assistant, the late Soro Foungnigue Idrissa, and to Sangaré Bakary for Senufo fieldwork. We also thank Joanie Lincoln for Adioukrou fieldwork, and Fritz & Jane Gilbert for hospitality.

In Senegal, we thank Amadou Coly Gomes, Urbain, Jules Camera, Charles Bubane, Mamadou Camara, and Wendy Wilson for guidance in the field, and Bruno & Elisabeth Brunetti for hospitality.

In Niger, Mokao bii Gao and our Kasawsawa family have given us generous access to Wodaabe ceremonies. The late Koffi Afagnibo of Nigercar Voyages provided transportation, and Garba Tawaye guided us for many years. Thank you to Annie & Pierre Colas of Les Roniers, Niamey, and to Ibrahim Gueye. In Agadez, we thank Richard Graille & Mohammed Ixa of Tidene Expeditions for friendship and Tuareg field organization, and Mohammed & Ayoo Zody for expert guidance.

In Mali, we acknowledge our exceptional guide and loyal friend Ibrahima Tapo of Mopti, who guided us by pirogue to record the Fulani cattle crossing and we thank Gogo, Maa, Aboudlaye Maiga, and Djaji bi Ada. In Dogon country, Apomi Saye, Chief Dogolou, Ali Saye, and Atimé Saye greatly assisted us during the Dama festival. We also thank Alberto Nicheli and Walter van Beek for making six weeks of Dogon fieldwork possible.

In Nigeria, our appreciation goes to the Emir of Katsina, Alhaji Muhammadu Kabir Usman, and Bala Katsina for help with the Sallah.

NORTH AFRICA: In Morocco, we thank Seyyed Sadrzadeh, Khalid Ariq, and Alan Keohane for guidance and interpreting; Bassou Chabou, Hassan Baamti, and Assou Fatima for assistance at the Imilchil Brides Fair; and Guedra dancer Sharaf Saadia and her troupe, Fadma, Fatna, Naima, and Samira.

EAST AFRICA: In Ethiopia, we acknowledge Worku Sharew for sharing his knowledge of Ethiopia, and for guiding with sensitivity in the field; Zewge Mariam Haile of Nile Tours, Addis Ababa, for expert field trips; and Stella & Alan Bromhead and Marie-France & Jean-Claude Vanson for generous hospitality. We thank Surma friends Kolaholi, Chinoi, and Muradit, and Karo hosts Amerikan and Chief Gelefo.

In Eritrea, we thank our guide Abraham Ghebre-Eghzi and our Rashaida hosts Hameida & Sheikh Seid Salleh Agil.

In Kenya, Terry Light of Africa Expeditions, Ltd, provided excellent transportation and camping. We thank our dedicated Maasai guide Bernard Ole Koikai and friends Chief Oltukai, Headman Najuri Topoti, Gideon Tate Ole Koyie, and Panin Parkisua. In Nairobi, Don Young, Alan Donovan, and Colin & Nicole Church offered great hospitality. Ahmed Sheikh Nabahany and Linda Donley-Reid gave invaluable guidance in Swahili traditions, as did Fatmah Ali, the late Bakari Mwalimu, and Mama Kate Baraka of Lamu.

In Uganda, we acknowledge H.M. Ronald Mutebi II for inviting us to record his coronation, and Wasswa Birigwa, Reverend Danny Kajumba, and John Nagenda for their assistance.

In Sudan, we thank Fabby Nielsen for his photographic contribution among the Dinka, and for his assistance in traversing the Congo.

SOUTHERN AFRICA: In Namibia, we give heartfelt thanks to our dear friend David Coulson for organizing fieldwork; Garth Owen-Smith and Maggie Jacobson for sharing expertise in Himba tradition; Chris Eyre for his hospitality and introduction to the renowned Himba healer Katjambia; and our friends Katjambia and Matjirwapi. To Bruce Ludwig, Tom Hill, and Bruce Schnitzer we extend thanks for their participation in our fieldwork in Namibia and Ethopia.

In South Africa, we thank the Nel family of Johannesburg for opening their home and hearts to us, and Karel Nel for assistance with Swazi and Ndebele fieldwork. In Swaziland, we acknowledge Ramila Patel, Princess Lavumisa, and Mike Staresinic for guidance and hospitality. **In Ndebeleland**, we thank Alex Zaloumis for introducing us to Margaret and Zanelle Shabangu, and Esther Mahlangu and Francine, Joyce & Daniel Ndimande for sharing expertise in traditional mural painting. **In Zululand**, we gratefully acknowledge Dione Thatcher, Juliet Leeb du Toit, and Robert Papini.

In London, our gratitude for many months of photographic editing goes to Maria Alexander and Shaun Ford, and to Eve Arnold for her unique professional eye. The vision of our inspired designers Barney Wan and Caz Hildebrand helped us to create this beautiful edition of *African Ceremonies*. We thank Runyon Hall for his contribution to original design. For research and writing, we thank Shaun Ford, who worked with tireless dedication. For meeting the challenge of combining two books into one, we thank our editor Nicola Graydon. For help with chapter construction we thank Mark Johnston. We thank Professor Herbert M. Cole and the following experts for generously reading and correcting the text: Dr. Frances Harding, Dr. Charles Gore, Dr. Walter van Beek, Dr. Hans Guggenheim, Dr. Riall Nolan, Dr. Monni Adams, Aicha Hall-Rahou, Karel Nel, Mike Staresinic, Dr. Linda Donley-Reid, Dr. Malami Buba, Baganda Minister Mustafa Mutyaba, Prof. Masagazi Masaazi, Alan Keohane, Ben Ephson, Nii Korley, Ablade Glover, Christopher Fyfe, Dr. Kwadwo Osei-Nyame, Bernard Ole Koikai, Resiato; Nick Martyn, Martina Odonkor, and Wonderboy Peters. For editing our text with a sensitive eye, we thank Simon Fisher, Deirdre Rochford, Tony Rennell, Yorick Blumenfeld, Noma Copley, Flory Barnett, and Andrea Belloli.

At Abrams, special thanks go to our publisher, Paul Gottlieb, for his inspired vision of the original *African Ceremonies* as a double volume; Hervé de La Martinière for his encouragement to make *African Ceremonies* a concise edition; Eric Himmel for his continual support as our editor; Shun Yamamoto for beautifully overseeing production; Harriet Blacker for originating excellent publicity; and Bob Morton for friendship and editing our original text. To Toby Eady, our agent, we offer thanks for all his efforts with our seventh book.

Most importantly, we thank Chad Hall, Maria Alexander and David Bradnum for sustaining us with love and support.

This book is dedicated to Leo & Marylyn Beckwith, and to Simon & the late Kate Fisher, who have traveled with us in our hearts throughout Africa.

C.B. & A.F.

Contents

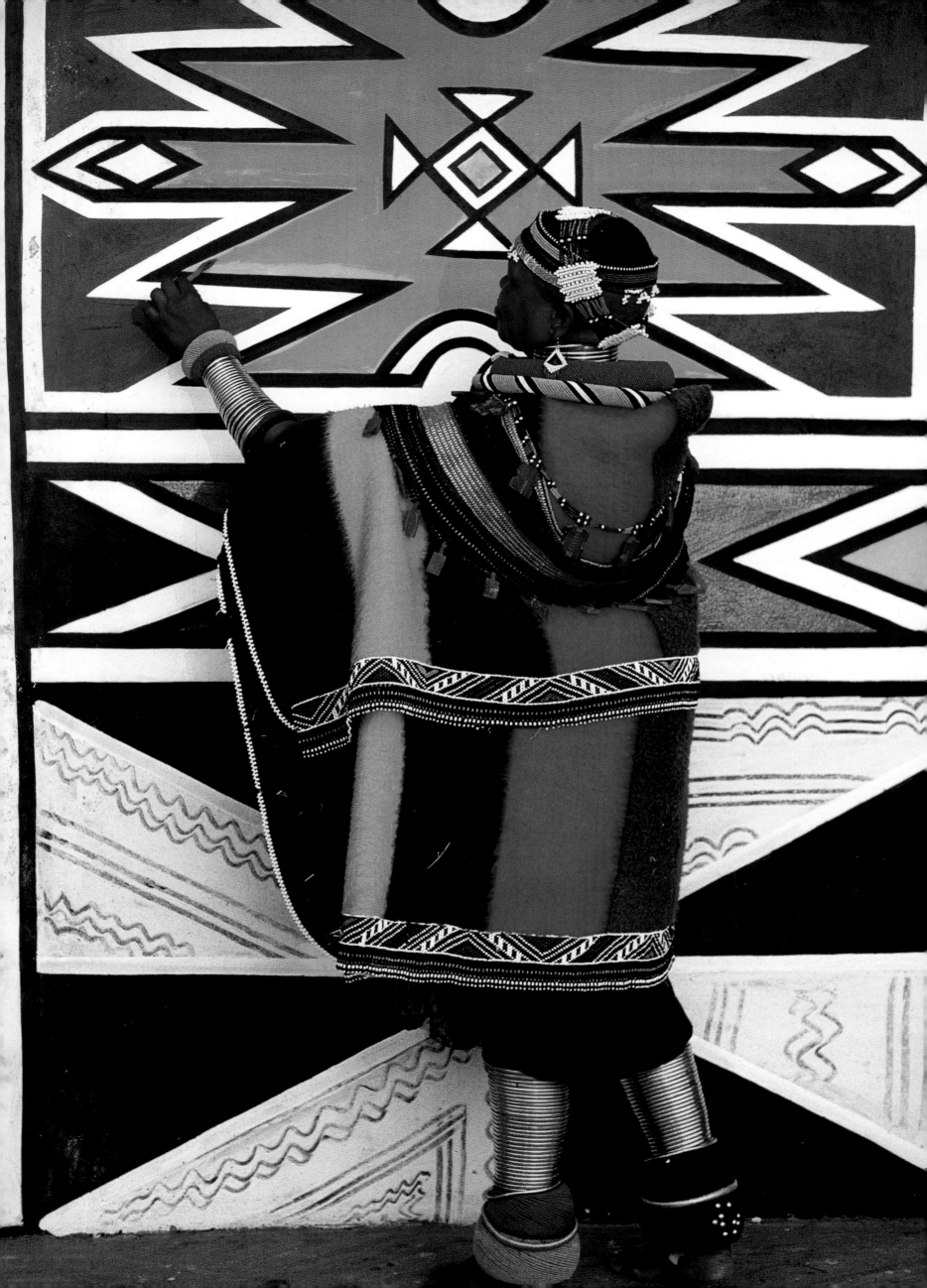

Foreword

I CONSIDER IT AN HONOR to be the first voice heard from this remarkable book. *African Ceremonies* successfully documents what many outsiders may consider unknowable—Africa's secret and profound bond with the sacred nature of ritual. I consider it a blessing to be a link between the continent's ancestral cultures and the expert and sensitive documenting of those cultures by Carol Beckwith and Angela Fisher.

My family from Burkina Faso named me Malidoma, which means "be friends with the enemy" in the Dagara language. This calling led me to local mission schools, where I was educated into the Western world view. My education, coupled with learning ancestral lore at home, gave me a clear understanding of the significance and value of my own indigenous culture. In addition, it gave me a new perspective on both cultures—a bifocal look at two worlds through the same eyes. At the heart of this knowledge is my belief that it takes extensive, uncritical exposure to an indigenous culture to see it clearly. One must be able to listen with new ears, see with new eyes, and be patient. Like me, Angela and Carol have developed this ability, and their book is a gift capable of bringing the Western and African worlds closer together. I have been able to reach out from Africa to embrace the modern world, and Carol and Angela have done the same. Together, we are forming a bridge—a way of understanding for others to follow.

Angela and Carol have worked in indigenous Africa for three decades, documenting and building a definitive archive of vanishing traditional ways. Driven by a love for the continent and its people, they have traveled to nearly every corner of Africa, living among its peoples and studying their ceremonies with professional exactitude and artistic compassion. This monumental book has been born from their dedication, and it stands as an enduring statement for future generations, as well as a call to preserve the priceless diversity of Africa's ceremonial life. *African Ceremonies* is an irreplaceable resource for researchers and scholars alike; more importantly, it will open the eyes and hearts of people interested in Africa, and it will also inspire those who seek to reconnect the beauty and sacredness of these ancient rituals with a culturally impoverished and spiritually distressed modern world.

I believe that Carol and Angela have responded to an urgent call from the continent's ancestors to record sacred ceremonies before it is too late. The Maasai Eunoto they recorded in Tanzania, in which warriors graduate to elderhood every seven years, will almost certainly not take place again on the scale that they observed. In fact, it may never happen again at all. The patience and diligence required by these dedicated women to obtain permission to record these sacred ceremonies, some of which are secret, required a level of dedication and loyalty to their subjects that is unmatched.

To understand why this work constitutes an academic and spiritual landmark, one must realize how sacred ceremonies form the heartbeat of nearly all 1,300 tribal communities. We listen to this ritual heart in order to gain deeper understanding of the identity, the spiritual philosophy, and the cosmology of traditional Africa. In making available to Africans and Westerners alike this wondrous book, Angela and Carol are offering both worlds a new wealth of cultural treasures—a legacy we are obligated to protect.

The modern world has too often stripped itself bare of meaningful rituals, and the psyches of modern men and women seek ways to reinvigorate their relationship with the sacred. The bridges between the traditional African world—calm, eternal, respectful of nature—and modern life need to be strengthened. If I can help as a Dagara shaman, I will have achieved my calling as a friend of the enemy. I now invite you to explore the magnificence of traditional African ritual through the pages of this book. At last, the rest of the world will know what it has been missing.

MALIDOMA PATRICE SOMÉ

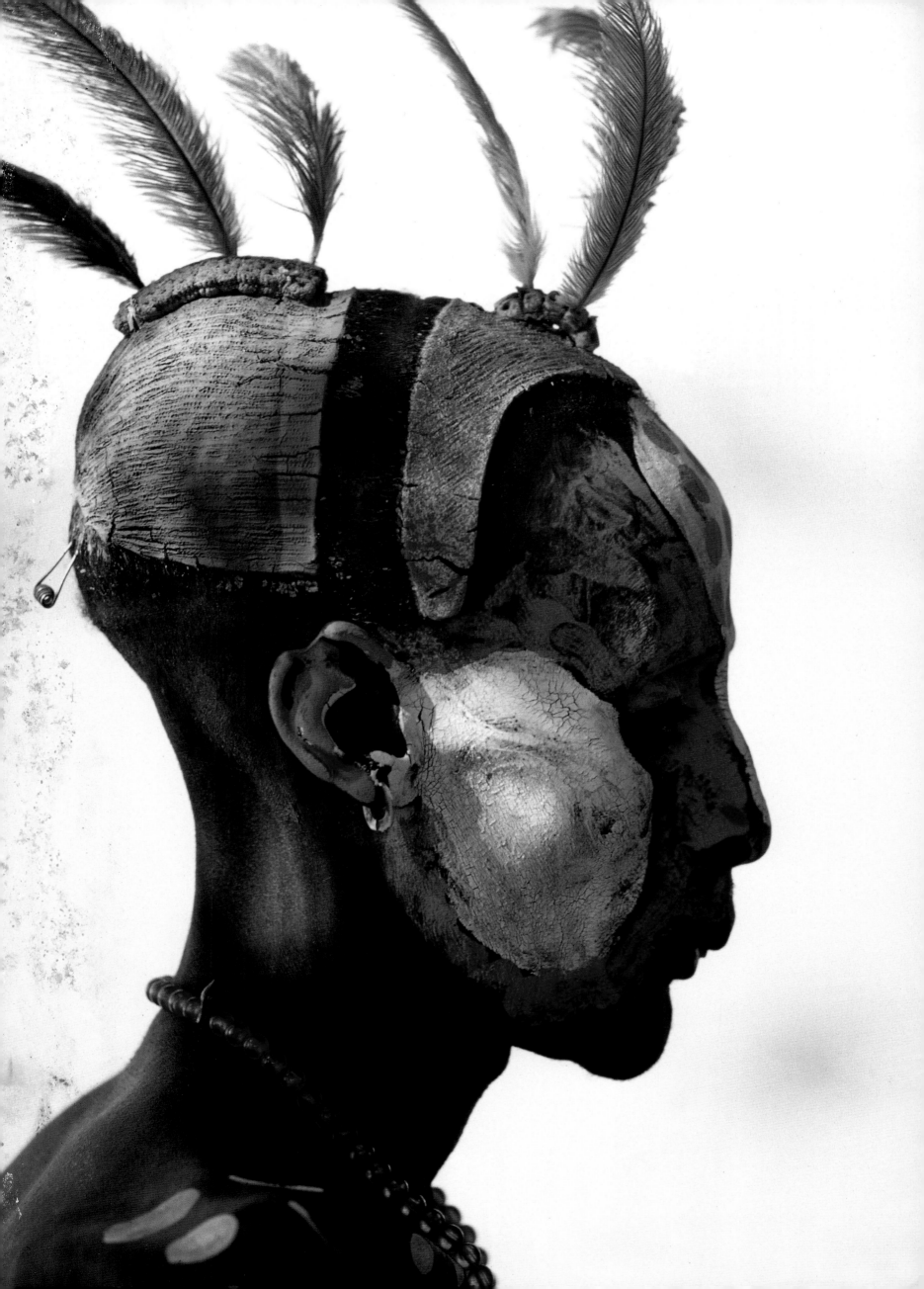

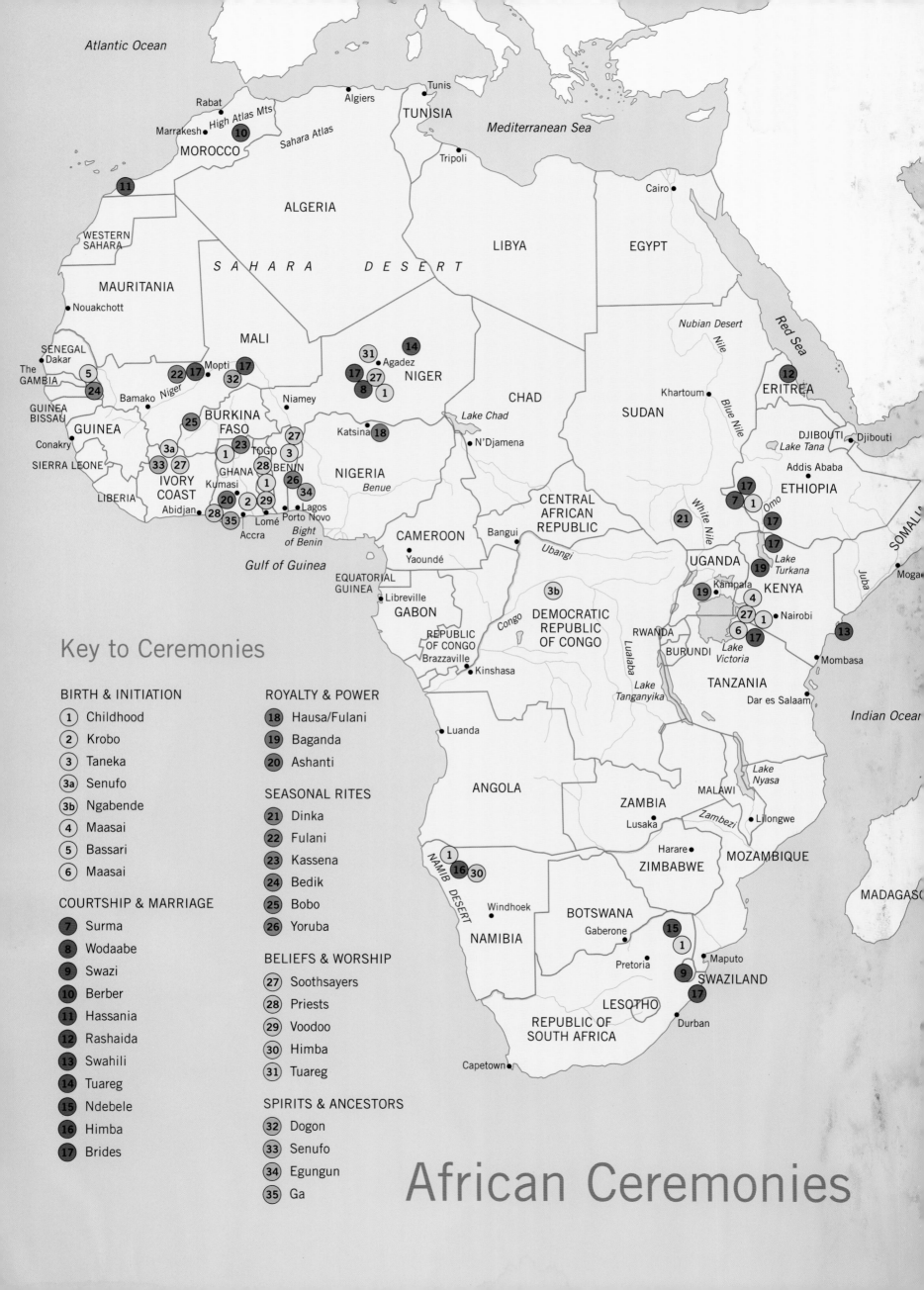

Atlantic Ocean

Rabat •
MOROCCO
Marrakesh • High Atlas Mts (10)
Sahara Atlas

Algiers •
TUNISIA
Tunis •

(11)

WESTERN
SAHARA

ALGERIA

Mediterranean Sea

Tripoli •

LIBYA

EGYPT
Cairo •

Red Sea

MAURITANIA

Nouakchott •

SENEGAL
The Dakar •
GAMBIA (5)
 (24)
GUINEA Bamako •
BISSAU
GUINEA

Conakry •

SIERRA LEONE

LIBERIA

MALI
(22)(17) Mopti • (17)
 (32)
Niger
(25)
BURKINA
FASO
(3a) (23)
(33)(27) (1) TOGO
IVORY GHANA (28)
COAST Kumasi • (1)
 (20) (2) (29)
(28) (35) Lomé •
 Accra •

Niamey •

(31)
(17) (27) (14) Agadez
 (8) (1)

NIGER

Katsina • (18)

(27)
(3)

NIGERIA
Benue

CHAD

Lake Chad

N'Djamena •

SUDAN

Khartoum •

Nubian Desert

Nile

Blue Nile

ERITREA (12)

DJIBOUTI
Lake Tana Djibouti •
Addis Ababa •
ETHIOPIA

Lagos •
Porto Novo •
Bight
of Benin

Gulf of Guinea

(26)
(34)

CAMEROON

Yaoundé •

Bangui •

CENTRAL
AFRICAN
REPUBLIC

Ubangi

(21)

White Nile

(17)
(7) (1) Omo
(17)
(17)
(19)

SOMALIA

Mogad

EQUATORIAL
GUINEA
Libreville •
GABON

REPUBLIC
OF CONGO
Brazzaville •

Congo

(3b)

DEMOCRATIC
REPUBLIC
OF CONGO

Kinshasa •

Lualaba

RWANDA

BURUNDI

Kampala •
(19)
UGANDA
(27)
(6)

KENYA
(4)
Nairobi •
(1)
(17)

Lake
Victoria

Lake Turkana

Juba

Indian Ocean

ANGOLA

Luanda •

Lake
Tanganyika

Lake
Nyasa

TANZANIA

Dar es Salaam •

(13)
Mombasa •

NAMIB DESERT

(1)
(16)(30)

Windhoek •

NAMIBIA

ZAMBIA
Lusaka •

ZIMBABWE
Harare •

Zambezi

MALAWI
Lilongwe •

MOZAMBIQUE

MADAGASC

Key to Ceremonies

BIRTH & INITIATION
- (1) Childhood
- (2) Krobo
- (3) Taneka
- (3a) Senufo
- (3b) Ngabende
- (4) Maasai
- (5) Bassari
- (6) Maasai

COURTSHIP & MARRIAGE
- (7) Surma
- (8) Wodaabe
- (9) Swazi
- (10) Berber
- (11) Hassania
- (12) Rashaida
- (13) Swahili
- (14) Tuareg
- (15) Ndebele
- (16) Himba
- (17) Brides

ROYALTY & POWER
- (18) Hausa/Fulani
- (19) Baganda
- (20) Ashanti

SEASONAL RITES
- (21) Dinka
- (22) Fulani
- (23) Kassena
- (24) Bedik
- (25) Bobo
- (26) Yoruba

BELIEFS & WORSHIP
- (27) Soothsayers
- (28) Priests
- (29) Voodoo
- (30) Himba
- (31) Tuareg

SPIRITS & ANCESTORS
- (32) Dogon
- (33) Senufo
- (34) Egungun
- (35) Ga

BOTSWANA
Gaberone •

(15)
(1)
Maputo •
(9) SWAZILAND
(17)

Pretoria •

LESOTHO

REPUBLIC OF
SOUTH AFRICA

Durban •

Capetown •

African Ceremonies

Introduction

IN 1991, WHILE CROSSING THE SAHELIAN STEPPE of Niger on camelback with our Wodaabe nomad friend Mokao, we found ourselves describing to him our desire to create a book of photographs covering the sacred ceremonies that we had witnessed in Africa. This book, we told him, would record those rituals that gave African life its special meaning. Never having seen a book, Mokao reflected on our words for a long time. He responded with unexpected understanding. The words he used to describe our dream were *maagani yegitata* – "medicine not to forget".

After ten years of field work, our dream has become a reality in *African Ceremonies*. With deep appreciation we present *maagani yegitata* to Mokao, to Africa, and to the rest of the world.

We first met as two young photographers in 1978 at a Maasai warrior ceremony in East Africa. Each of us was working on a first book, and we recognized in one another two kindred spirits who shared a deep love for and fascination with Africa. After completing our own books—Angela's *Africa Adorned* and Carol's *Maasai* and *Nomads of Niger*— we began to make plans together to record the peoples and cultures of the ancient Horn of Africa — Ethiopia, Djibouti, and Somalia. After five years of fieldwork, we successfully completed our book *African Ark*, which quickly became a testament to a vanishing world as famine took hold of Ethiopia and civil war raged in Somalia.

The experience of working together on *African Ark* fueled our desire to create a book that would visually explore the meaning and power of traditional rituals and ceremonies across the African continent before they disappeared forever. We took a year out to raise funds and secure the support of three foundations and twenty-seven individuals who made it possible for us to realize our dream. Little did we know the extent of our undertaking. It took us nearly a decade to produce our coverage of ninety-three ceremonies in twenty-six countries.

Photographing ceremonies throughout Africa requires immense dedication and an ability to cope with huge logistical challenges. Rituals do not conform to a calendar. Some ceremonies take place annually; others, such as the Dogon Dama festival, take place only once every twelve years. We needed to learn the timing of ritual cycles, to be constantly in touch with friends and informants across the continent, and to be able to leave our base in London on only a few hours notice. African rituals take place when the time is deemed to be auspicious according to phases of the moon or changing seasons. Some ceremonies wait for the rains so that the herds may be gathered from far afield; others rely on a bountiful harvest so that grain is available to brew the necessary quantities of millet beer.

Sometimes, one arrives to discover that a ritual has been postponed. On one occasion, we came to the West African Sahel to find that insufficient rain had delayed the annual gathering of the Wodaabe nomads. We bought a donkey to carry our equipment and walked with the nomads for five weeks while we all waited for the rains to fall. Whenever we showed signs of impatience, they would simply say, "She who can't bear the smoke will never get to the fire." We developed a patience and perseverance that we did not know we had.

Before photographing a group of people, we felt that it was important to develop friendship and trust. We spent all our waking hours with them, ate the same foods, slept on traditional mats, and took on the pace of their lives. We tried to learn at least fifty words of the language in each place we worked: Carol became fluent in Fulfulde, the tongue of the Wodaabe nomads, and Angela studied Swahili, the lingua franca of several countries in East Africa.

Where language failed, we found that by watching those around us with increased awareness and by using our intuition we were able to communicate in ways that did not require words. We

immersed ourselves in activities, experiencing the world we were photographing. In Maasailand we drank blood from the dewlap of a sacrificial bull along with the warriors at their Eunoto ceremony. In the Sahara Desert we traveled with Tuaregs on camelback disguised as nomadic women, migrating across the border to attend the wedding ceremony of a couple from two noble families.

As two women traveling alone, we were frequently adopted into extended families and given African names. Carol was variously called Nanyuki (The Red One) and Mokorol (She Who Wears Dangling Pendants on Her Long Black Braids); Angela was known as Dede Gaga (Firstborn Girl Tall) and Julama (after a particularly beautiful Wodaabe woman). We were fortunate to be able to form close contacts with both sexes. Women invited us into their personal lives, revealing to us the intimacies that they could never have shared with a man. Yet we were equally accepted by the men, who saw us simply as foreigners and thus treated us as honorary males. In this way we were privileged to photograph male rituals to which women were often denied access.

We traveled in many ways: on foot, by camel, horse, mule, sailing dhow, and four-wheel-drive vehicle, often finding ourselves in remote areas never before been visited by outsiders. To reach the Surma of southwest Ethiopia and photograph courtship rituals that culminate in dramatic Donga stick fights, we formed a mule train of fifteen animals loaded with all our food, camping gear, medical supplies, and photographic equipment for a six-week stay. We trekked for days through spectacular rain forests and over 8,000-foot mountains.

During our years in Africa, we have observed that life relies on a continuing cycle of giving and receiving. Each rite begins with a gift or an offering and nothing is taken from the land without giving something back to it. Survival depends on this basic principle. We have looked for appropriate ways to reciprocate the support and care given to us by the communities we lived among. For the Wodaabe we funded the digging of wells to bring water to their dry Sahelian home; in Kenya we helped to set up the first all-Maasai school. The Tuareg in Niger have eased their struggle for survival during the dry season through craft initiatives that we helped to establish. And in Ethiopia we set up a basketry and weaving project for women in relief camps, to help support their children and survive the worst of the famine. We have seen how much Africa has suffered in the past from people coming to extract resources without reciprocation. As a gesture of appreciation, a portion of the royalties from this book will go to assist communities we have photographed.

Living in traditional African societies has made us aware of the value that rites of passage have for the individual and the community. Ceremonies that mark the stages of life from birth to death provide clear definitions of what is expected of the individual and give a sense of identity and belonging. Ceremony is the structure for celebrating the passage from one stage of life to another, and ritual is the powerful mechanism for keeping in touch with one's own spirit and the spirit world.

As we have come to admire the beauty, strength, and vitality of Africa's peoples and their traditions, we have also realized how vulnerable many of these cultures have become. Famine, drought, and political upheaval are taking a toll. Some groups we visited a decade ago have now disappeared, and Western ways are eroding the belief systems of many cultures. Concerned that many of these traditions are in imminent danger of being lost, we embarked on this project to document these vanishing ways of life and create a visual record for future generations. We have approached this project not as anthropologists but as artists, following our passion to record the ancient traditions of Africa. It has been a rite of passage that has tested us, sometimes to the limit of our endurance, and changed us in ways that we never could have imagined.

Our friend, the Dagara shaman Malidoma Patrice Somé describes a rite of passage as a journey of the spirit. "Before you get started,' he says, "you own the journey, but after you begin, the journey owns you." Our journey now owns us.

CAROL BECKWITH & ANGELA FISHER

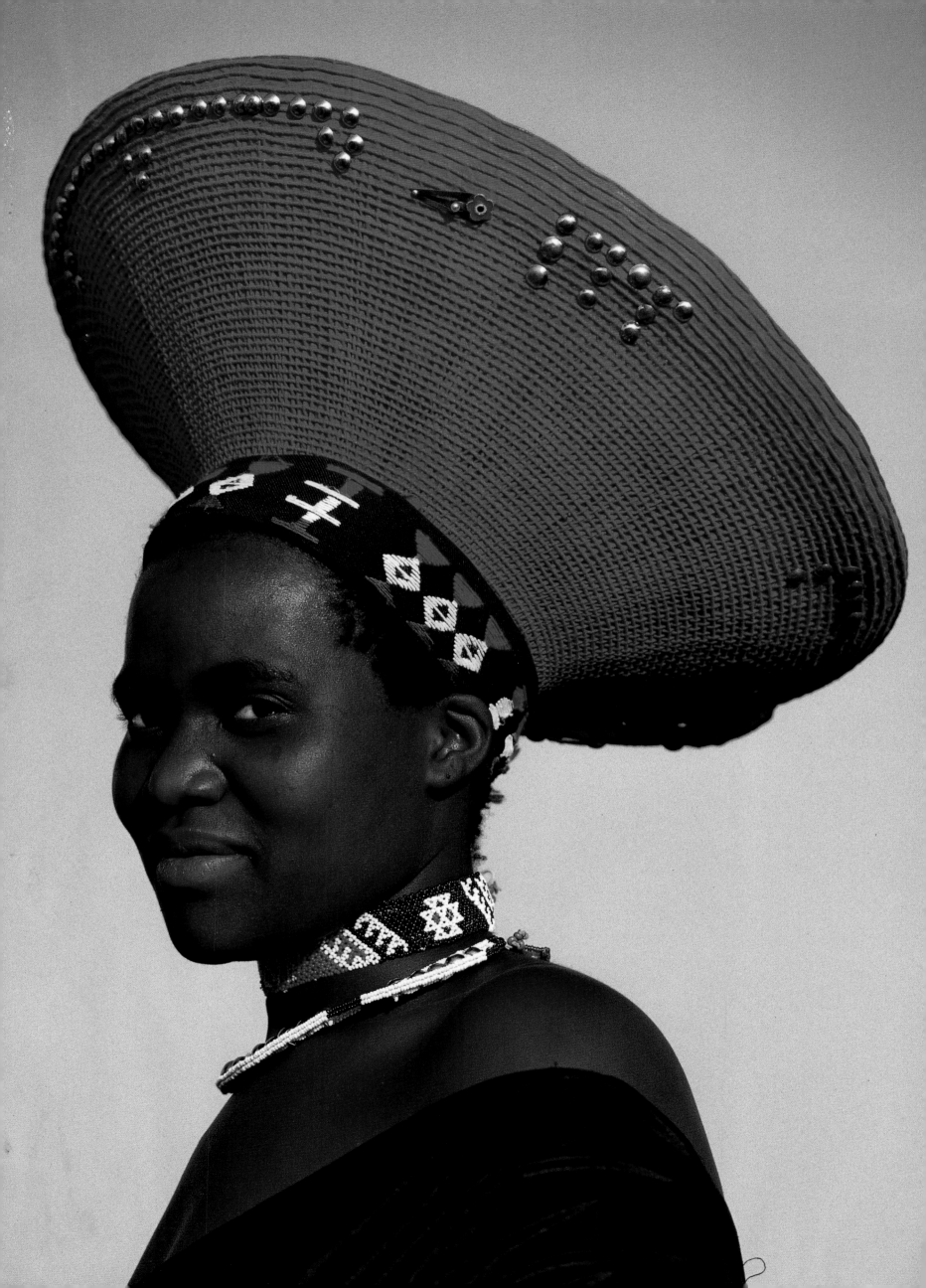

BIRTH & INITIATION

On a cool May morning in the south of Senegal, a single line of young Bassari men passed slowly by us in the midst of their initiation into elderhood. They were silent— apparently having lost their ability to speak. Some had forgotten how to walk and were leaning on the shoulders of elders. Several were being lowered onto the ground to sleep in a shady clearing by the sacred forest. These healthy adolescent initiates were undergoing a transition back to childhood, to a time before they could either speak or walk. Discreetly, we observed the helpless young men being cared for by their ritual guardians.

We approached one of the Bassari elders who was watching to see that the initiates did not harm themselves in their defenseless state, and we asked him how this had happened. "They have been eaten and returned by Numba," he said. We came to understand that Numba was the mysterious chameleonlike deity of initiation, believed first to devour and then to regurgitate initiates as fledgling adults. As a result, the young men would have to be taught once more how to walk, talk, and even eat. Although we understood the symbolic value of rebirth in initiation rituals, the transformation of the Bassari boys seemed extraordinary to us. For the Bassari, moving into adulthood is a profound process, and nothing less than total rebirth will enable them to reach the next stage in life. Dagara shaman Malidoma Patrice Somé explains the tribal imperative of these rituals:

"Many African people believe that a person cannot

mature without undergoing the process of initiation. Anatomic maturation is insufficient for adulthood. The breaking down of fundamental perceptions of the world experienced during initiation permits another self to grow and to be born."

FIRST STEPS

In traditional African societies, the passage from one stage of life to the next is marked with important rituals and ceremonies. From the moment of birth, an African is connected to family, to community, and to the ancestors. The arrival of a child is often seen as the reintroduction of the spirit of an honored ancestor back into the world. The first breath of life, however, is not always drawn without complication. The Fon people of Benin believe that some babies may refuse to be born. Just before birth, the eldest of a set of twins is said to peek out of the womb to survey the outside world. If it determines that the world is unsafe, it returns to the womb to report to its sibling. The twins may then refuse their delivery. The Fon, who experience high infant mortality, use this explanation of a stillbirth to soften the blow of losing a child.

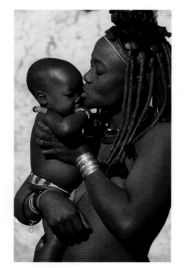

To ensure survival during their most fragile years, many African babies are protected by talismans. Whether they consist of a leather pouch filled with blessings or a collection of special beads, these talismans connect the child to ancestral powers as well as to the spirits of nature.

Among the nomadic Wodaabe of Niger, firstborn children are sometimes cared for by women who are not their mothers. The nomads consider firstborn children so sacred that a mother may not trust herself to nurse her child. Instead, other mothers will suckle the child for the first

few days of its life. Furthermore, a mother and father are not permitted to speak their firstborn's name throughout its life, because the Wodaabe believe that the spirits of death cannot see a child without a name.

For many Africans, the process of naming a baby is often too risky to be done at birth, when a child's life is still precarious. Babies are often named only when it is evident that they will survive. The Wodaabe give all their children a nickname seven days after birth and formally name them when they are twelve years old. The temporary name bestowed at birth is often associated with the conditions of the baby's arrival. For example, Bango, a Wodaabe boy, was named after the word *bangol*, which means long migration. He was born during an especially challenging journey through the desert. The Krobo in Ghana follow a similar custom, naming their children in relation to their position in the birth sequence in the family, the day of the week on which they were born, and any notable physical characteristics. Afi Dede, a Krobo name, means Friday Firstborn Girl; Dede Gaga means Firstborn Girl Tall. In African pastoralist societies such as the Surma of Ethiopia and the Dinka of southern Sudan, a boy is named at puberty when he receives his namesake ox. He is named after the color or markings of this favorite animal. This naming creates a simple and effective bond between the boy and the natural world, a vital link to the animals that are key to the survival of all nomadic pastoralists.

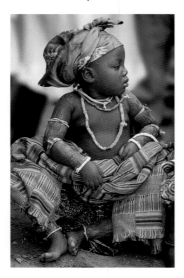

CHILDHOOD

African communities consist of single families, extended families, and lineages, all of which create a broad base of support for children. Kinship terms such as "uncle" or "auntie" are often used for a wide range of people—not only a parent's siblings. It is often these "uncles" and "aunties" who give the children a sound emotional foundation. Responsibility for raising a child is often shared between mother and grand-

mother or among a man's several wives. The emphasis is on providing loving support for all of the community's children. Among Wodaabe mothers, communal support of children extends also to the literal sharing of them: a mother with several offspring will often give a barren woman a child to call her own.

African children are instilled with an independent spirit at an early age. In nearly all of the cultures in our book, children play independently from dawn until late in the night, watching over each other and imitating their older siblings. Even with all their freedom, however, children are given responsibilities. A Maasai girl assists her mother in collecting "sausage" plants to make honey beer. A Himba boy will be given a small number of goats to look after for his family. In Maasailand a boy learns about herding animals by collecting different colored stones, which represent goats or cattle. He herds these stones in and out of

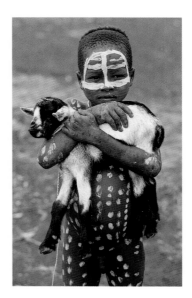

miniature kraals on the ground, taking the animals to pasture and protecting them from predators. This game has been passed down for generations, linking the boy to the survival strategies of his community. A Baoulé proverb states, "You don't have to show the sky to a child. It learns by observing and from other children."

INITIATION

In African societies there comes a time when a child moves to the next stage of life and assumes more adult responsibilities. This period of initiation provides the individual with instruction about what is expected in the next phase of life. It allows a child to develop with a sense of direction and meaning. There are many differences in initiation rites across the African continent, but the result is the same: a relatively innocent youth undergoes a series of rituals and emerges a man or woman, physically, emotionally, and mentally prepared for his or her new role.

In all initiation ceremonies, a select group of elders

knowledgeable in tradition takes charge of the sequence of ritual events. Deciding when and where initiation rites will take place is a profound and sacred activity. In Maasai society the elders monitor initiation rituals in a ceremonial cycle of approximately twenty-five years. The exact locale and time for major initiations is determined by a Maasai *laibon*, a diviner who consults an oracle for the most auspicious time for the ceremonies to take place. The initiates are then drawn together for their passage to the next stage of life.

Novices undergo their initiations either communally or individually. Even if they experience their initiations alone, they remain part of a group or generation of age mates undergoing an identical ordeal. A young Hamar man in Ethiopia undergoes a ritual called

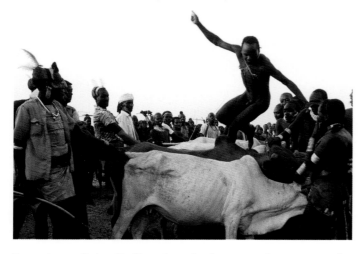

Jumping of the Bull, wherein he must leap over the backs of between twenty and forty bulls to prove his manhood. Once all of the initiates have emerged successfully from their tests, their generation is given a formal name by which they will be known for the rest of their lives.

TRANSFORMATION

Every initiation ceremony involves a ritual isolation of the male and female novices, separating them from the community to prepare for their transformation. To begin their compulsory period of training, they enter a sacred place, often a forest or a specially built ritual house. It is there that initiates lose their childhood identities and gain their adult selves. Krobo girls are sequestered in a ritual house for three weeks to learn what will be expected of them as wives and mothers. Maasai warriors move out of their communities into a ritual enclosure, where they live for a period of up to

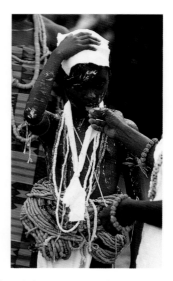

two years. Bassari initiates go into a sacred forest and lose their ability to speak and care for themselves.

Ritual isolation operates on a mental and emotional level as well as a physical one. It is a time for the initiate to turn inward and connect with the spirit of his culture, the forces of nature, and the ancestors that will guide him throughout his life. During this time, initiates must neither communicate with the outside world nor share the secret knowledge they are gaining. To do so would invite punishment from the gods. Once inside their sacred place, the novices go through powerful transformation rituals. It is often not possible to see the rituals that occur in the sacred forest, but we were told that the initiates lose their sense of personal identity and enter a liminal state where they are neither themselves nor yet a new person. Their new identity must be forged during this period so that they are ready for the next stage in their lives.

During their Eunoto ceremony, Maasai warriors go to a sacred chalk bank, where they paint their bodies in symbolic patterns. Disguised by these white chalk designs, the warriors return to their compound, where they believe that their mothers will not recognize them, since they have metaphorically moved into the next stage of life. At the end of their initiation, the warriors undergo another physical change: their beautiful long hair is cut, and their beads and colorful shields are replaced by more sober clothing. Observing the transformation, the Maasai say, "We replace the spear of warriorhood with the weapon of wisdom."

RITUAL GUARDIANS

In most cultures, each initiate is given a ritual guardian to protect and ensure his well-being. Among the Krobo of Ghana, ritual mothers guide young girls into womanhood. These women are not the actual mothers of the girls but serve as mentors to the initiates. The ritual mothers are empowered to teach the girls to become mothers in their own right. Another interesting group

are the guardians of the Taneka male initiates of Benin. Known as Kumpara, these guardians accompany their charges during an eight-month initiation period. Together, they roam the countryside, making appearances in local markets, where the Kumpara entertain villagers with erotic dances to raise money for the initiates' food. The social role of the Kumpara, in addition to protecting the initiates, is a subversive one. They are lawfully able to break taboos and are sanctioned by society to act outrageously. These highly skilled entertainers serve as an outlet for the socially unspeakable, but they are also dedicated to caring for the initiates until their initiation is complete.

Ritual guardianship also plays an important role in the initiation ceremonies of the Maasai. When a boy is circumcised, he is assisted by a man known as the back supporter, who sits behind him as a moral and physical support during this painful ritual.

CLIMACTIC ENCOUNTER
After having been isolated for a period of instruction, the initiates undergo a climactic encounter or ordeal that marks the climax of their initiation and the beginning of the new phase in their lives. Male initiations often involve confrontation in the form of a test of bravery. To prove their courage, Maasai warriors hunt lions armed only with a spear. Each Bassari

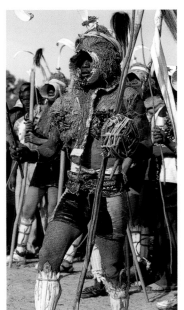

initiate must combat a fierce masked spirit that has come from the sacred forest to confront him. The initiate is not expected to win the battle, but must simply do his best. Survival is a victory—a sign that the initiate will be brave enough to face life.

For African girls, circumcision is one of the greatest challenges in their lives. A Maasai initiate undergoes this ancient ritual at puberty when she first menstruates. The circumcision validates her passage into adulthood and prepares her for marriage and for motherhood. Female

circumcision is a highly controversial subject. From the Maasai point of view, circumcision marks a girl's becoming a woman and legitimizes her marriage and children. In the view of the Western world, the ritual seems a cruel form of mutilation. We understand that it is important for the Maasai to maintain this age-old rite of passage into womanhood, but we would hope that the ritual could be modified so that it reflected the gentle nurturing nature of the Maasai people. The Krobo, for example, who do not practice female circumcision, scarify the back of the initiate's hand with a tattoo of fine blue marks to indicate that she has undergone the training of initiation and has passed into womanhood. The tattoo serves as a proud symbol of maturity.

EMERGING AS AN ADULT

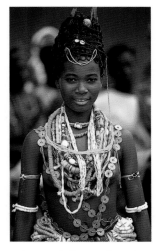

Once the ordeal or climactic encounter has been overcome, the initiate emerges into the world reborn into a new role in life. As if coming out of a cocoon, a Krobo girl puts on her most beautiful ornamentation to signify her new status. Now eligible for marriage, each girl wears a wealth of cloth and inherited beads. In full regalia, the initiates parade before the village and their families, attracting potential suitors. Maasai boys who have bravely endured circumcision wear headdresses of colorful, stuffed birds, symbolizing their successful passage through the test. The Taneka initiate has his circumcised penis wrapped in green leaves for display to the community—a clear indication of his entry into manhood.

Initiation ceremonies are social transformations whereby a society produces an adult prepared for greater responsibility. To achieve this, African cultures isolate and train individuals about their forthcoming responsibilities and privileges. In isolation, initiates have the time and space that allows for reflection, contemplation, and resolution. The process facilitates their graduation to the next part of their lives, creating a strong sense of personal and communal identity.

African Childhood

Across Africa, a child is not only a member of an ancestral bloodline but also a future custodian of the culture of its people. From the outset, many ceremonies are performed, which herald the entry of a human being into the first stage of life, and establish it as a new addition to the lineage.

Because infant mortality remains high in Africa, many cultures are extremely superstitious during the first few years of a child's life and carry out rituals to protect it from danger. The Himba of Namibia never leave a baby on its own or even put it down, lest the child be stolen away by some malevolent spirit. The Wodaabe of Niger do not name children before their twelfth birthdays, so that they cannot be identified by the spirit of death. Maasai babies, however, are named soon after birth, and a ritual shaving of the heads of both mother and child serves to bond the pair before a name is officially given. The Kassena of Ghana seek the help of soothsayers to divine the name of a child before it is born, and to choose a personal deity that will protect the infant throughout its childhood. Despite these precautions, deaths occur, and there are prescribed rituals for deceased children and their surviving families. The Fon people of Benin commemorate the death of a

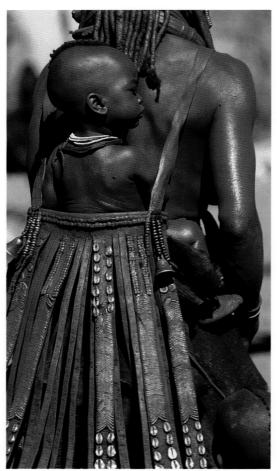

twin child (twin births being very common in that society) by carving a doll that is carried around by the mother and treated as the embodiment of the dead twin.

In all African societies, childhood is a time for learning responsibilities and skills that enable children to contribute to their communities. Under the instruction of their mothers, small girls help with domestic chores; boys often look after goats and sheep. Early training in work, however, is balanced with adequate time for children to develop creativity through imaginative play. Surma children from Ethiopia, find expression through the art of body painting and the imitation of animals in their games. African childhood has also traditionally been a time for encouraging children to take an active part in tribal ceremonies, their first steps on a journey that encompasses all the realms of human experience.

Above: The pastoral Himba of Namibia regard their offspring as a great blessing. Babies are never left alone and are carried everywhere in a hide back-sling. *Right:* Playing safely in her sister's arms, a baby is smeared with a mixture of red ocher and animal fat and wears the protective beads of childhood.

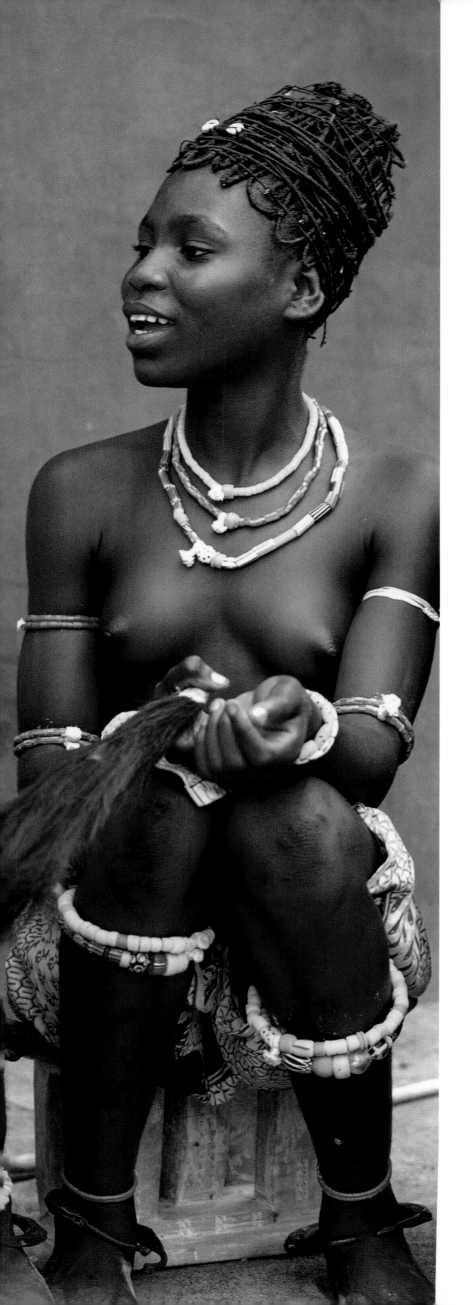

Wearing the Family Wealth

The Krobo are among the oldest and most famous makers of ground-glass beads in Africa. Many of the beads, known as *akori*, or *aggrey*, are made locally; others have been traded from Venice since the seventeenth century, as well as from Holland and Czechoslovakia. Denoting family wealth and social status, each type of bead an initiate wears has a name and significance. Blue beads, called *koli*, mean "something you love very much", and are associated with affection and tenderness. Yellow beads symbolize maturity and prosperity. White beads represent purity and virginity and can also signify respect for the gods and ancestors when worn by priestesses. The two large yellow beads (*below*) known as *bodum* beads are said to possess magical protective powers and according to legend, will bark like a dog should an intruder enter an initiate's bedroom.

Following pages: At their Outdooring Ceremony, Krobo initiates, wearing Dipo-pe straw hats, perform the *klama* dance which emphasises their graceful movements.

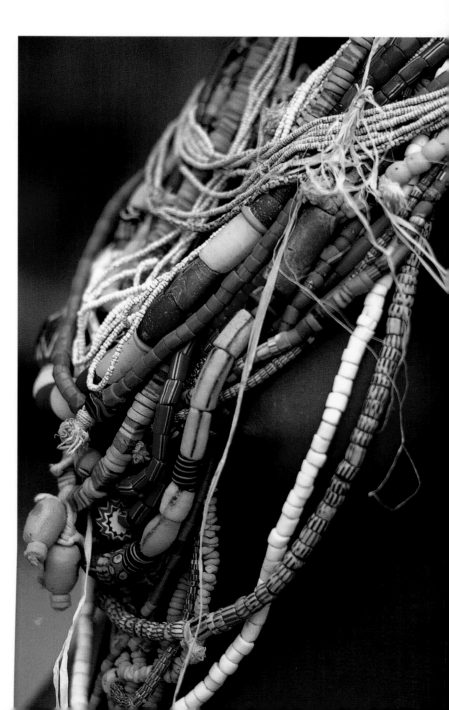

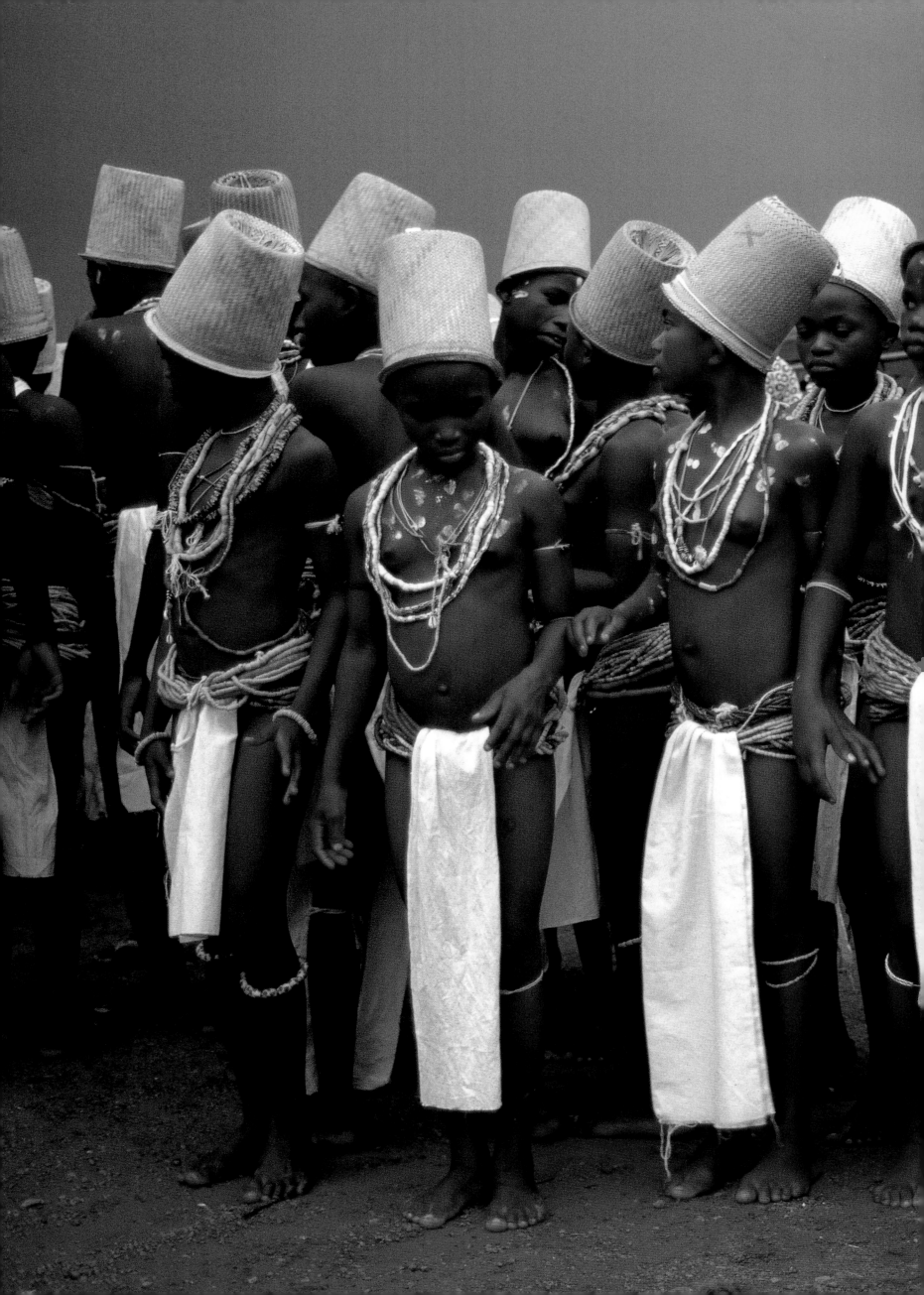

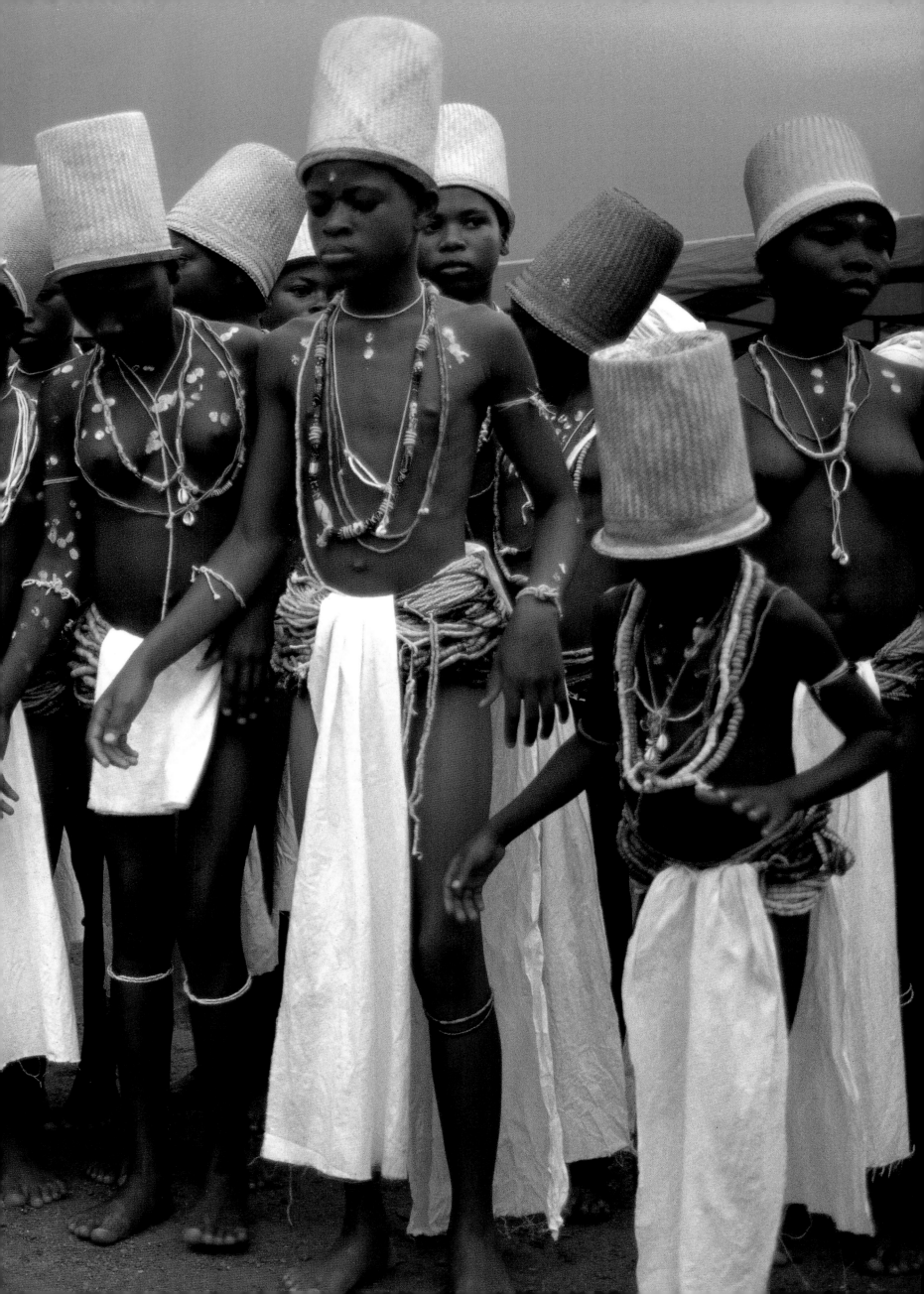

Taneka Initiation

For the Taneka of northern Benin, male initiation constitutes an eight-month period of rituals culminating in circumcision. Men are circumcised between their late teenage years and their early thirties, depending on when they and their families can afford the expense. The costs include feeding the guests and paying musicians, who play the gong-gong, talking drums, and flutes. The initiates themselves pay a fee to the village priest and to the circumcisors. During the ceremony, the initiate undergoes a ritual death, whereby the youth symbolically passes away and is reborn a mature man, who is initially regarded as a stranger by the community. Required by tradition to be the embodiment of masculine courage, he must also appear to be indifferent to the ordeal he is about to face. The Somba of Benin, one of the nine subgroups of the Taneka, also share an initiation period lasting eight months. Unlike other Taneka groups, however, they undergo fierce ritual whippings to test their manhood prior to their circumcisions.

For the Senufo women of Ivory Coast, after undergoing genital excision, initiation involves a training period of up to eight years during which they learn the basic principles of marriage and motherhood. Confined to secret societies, the Senufo women's initiation is more discreet than the men's, with overt ritual acts and public ceremonies sometimes completely absent.

Male and female initiation in each of these cultures tests the initiates' courage in the face of physical trauma, provides training for new roles in society, and bonds individuals to their peer groups. These rites powerfully mark transitions from one stage of life to another and give individuals a strong sense of social definition and personal pride.

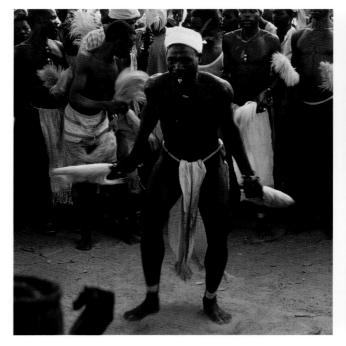
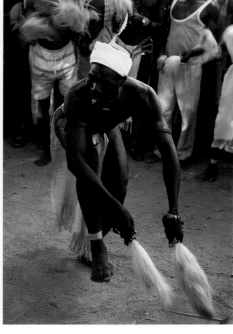

Above: A Taneka initiate, holding ritual flywhisks, presents himself to the village elders before circumcision. *Right:* An elder embraces the youth to test his ability to face his ordeal. If the boy's heart is beating too fast or his hands are shaking, the elder will discreetly administer a herbal sedative.

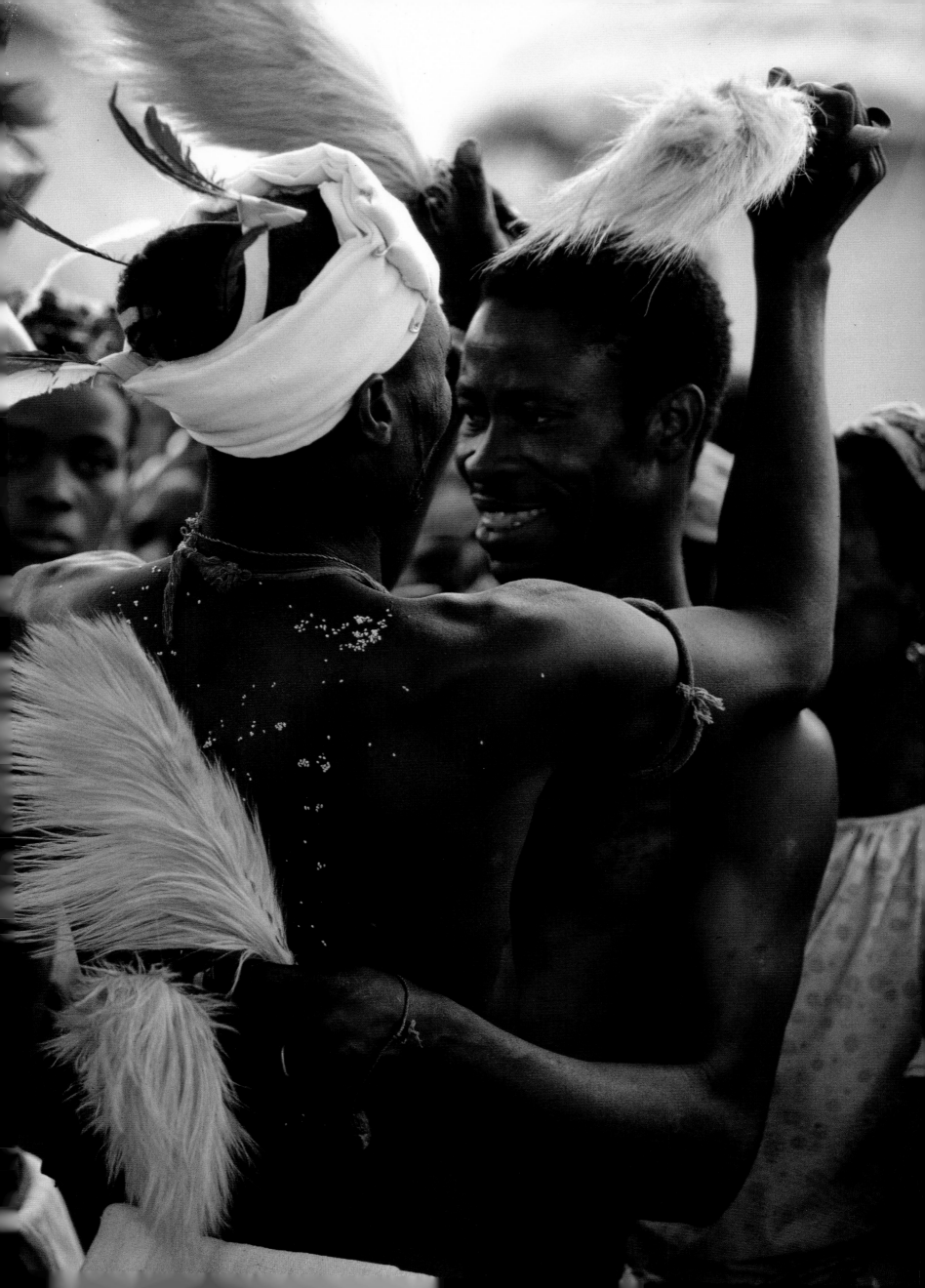

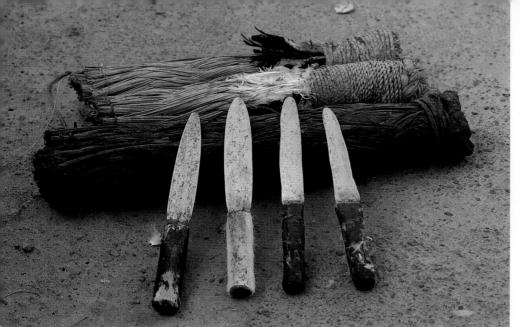

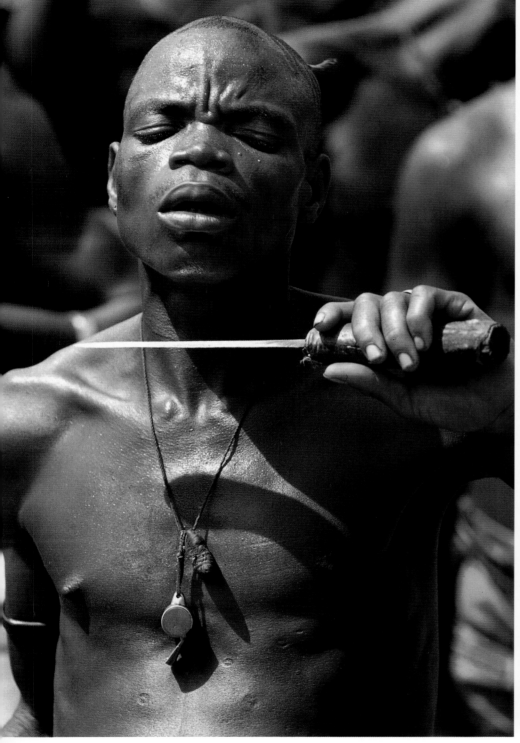

Confronting the Knife

On the morning of his day of circumcision, each initiate, known as Sana, selects one of four knives brought by village elders from the clan house, wrapped in a feather-lined sheath and honed to sharpness by the blacksmith. As he tests the knife against his neck, the initiate anticipates his proud deliverance into manhood, for, as the knife literally cuts into a Sana's flesh, it also metaphorically cuts his ties with his life as a boy.

Taunted by villagers to toughen him for the ordeal ahead, the youth climbs a sacred mountain and chooses a place where he will be circumcised. Lying in a shallow pit dug by his guardian, the initiate covers his face with the

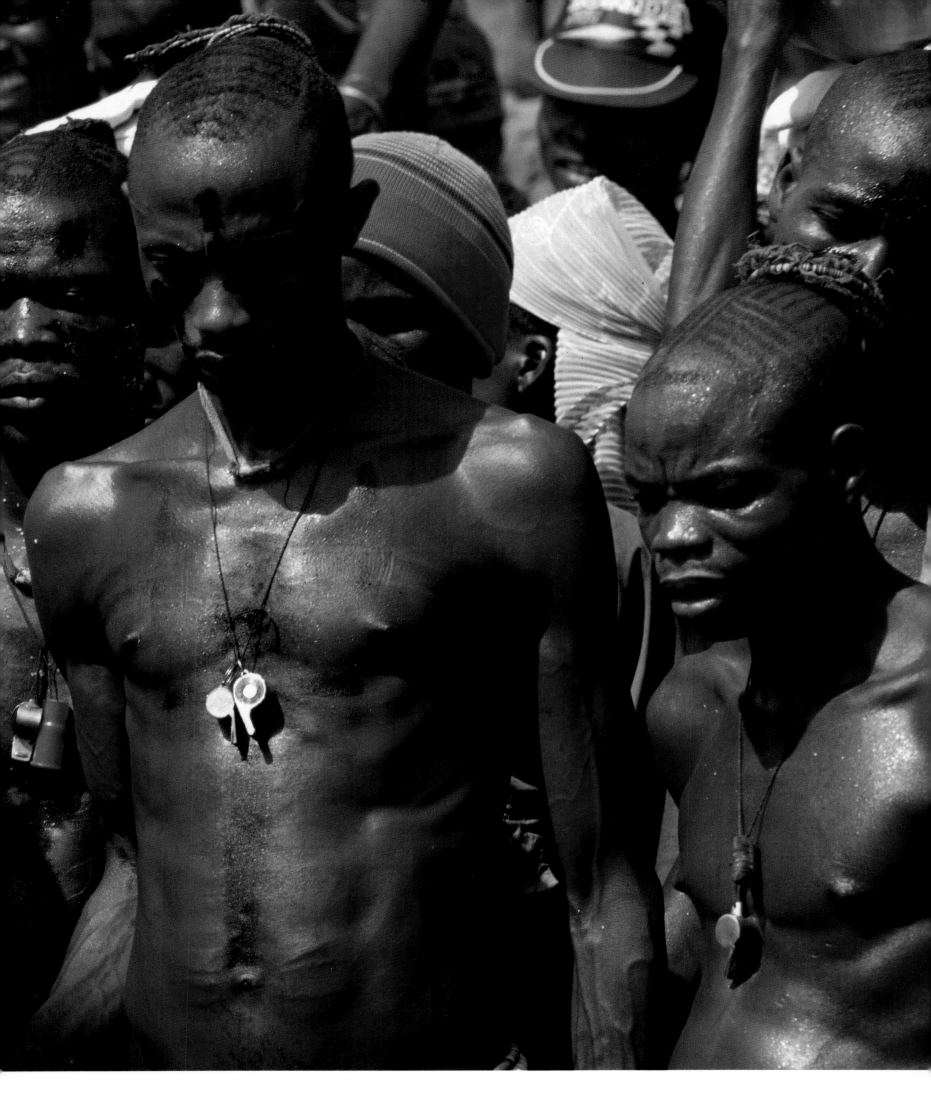

flywhisks. The circumcisor says to him, "If you do well it is an honor, if you do badly it is your shame." The Sana replies, "The hour has arrived and I am here for everyone to see." Standing lightly on the Sana's feet to secure his body, the circumcisor pulls on the penis three times and makes his first cut. Three cuts are made and the excised flesh is discarded. The Sana must not cry out, flinch, or grimace.

Following pages: After circumcision, each initiate is carried home, where a guardian wraps banana leaves secured with raffia cord around his penis to staunch the flow of blood. Still in great pain, the Sana sits stoically with a small fan to cool his burning wound. He will wear the wrapping for the next three months, during which he will not engage in sexual activity or cultivate crops.

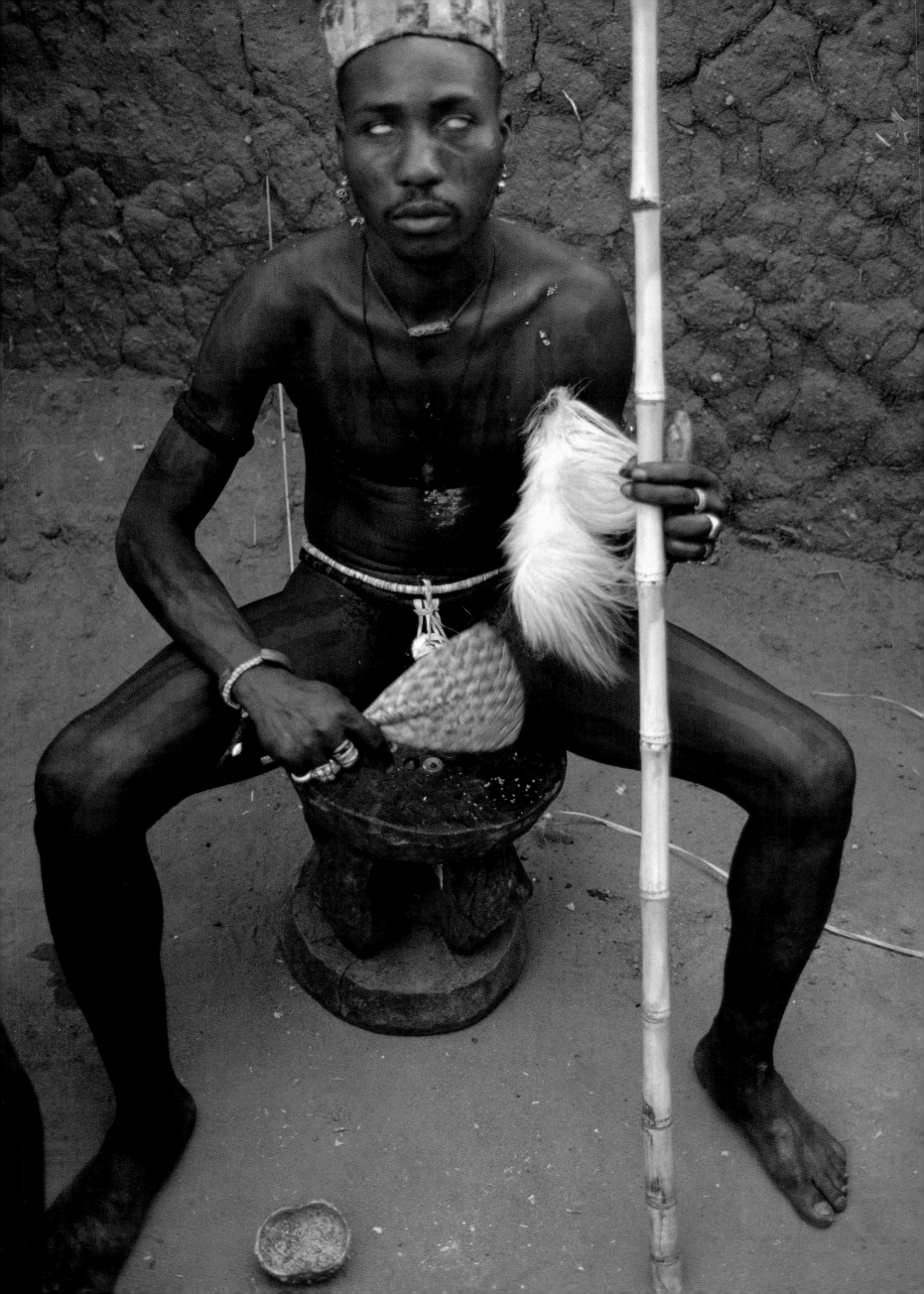

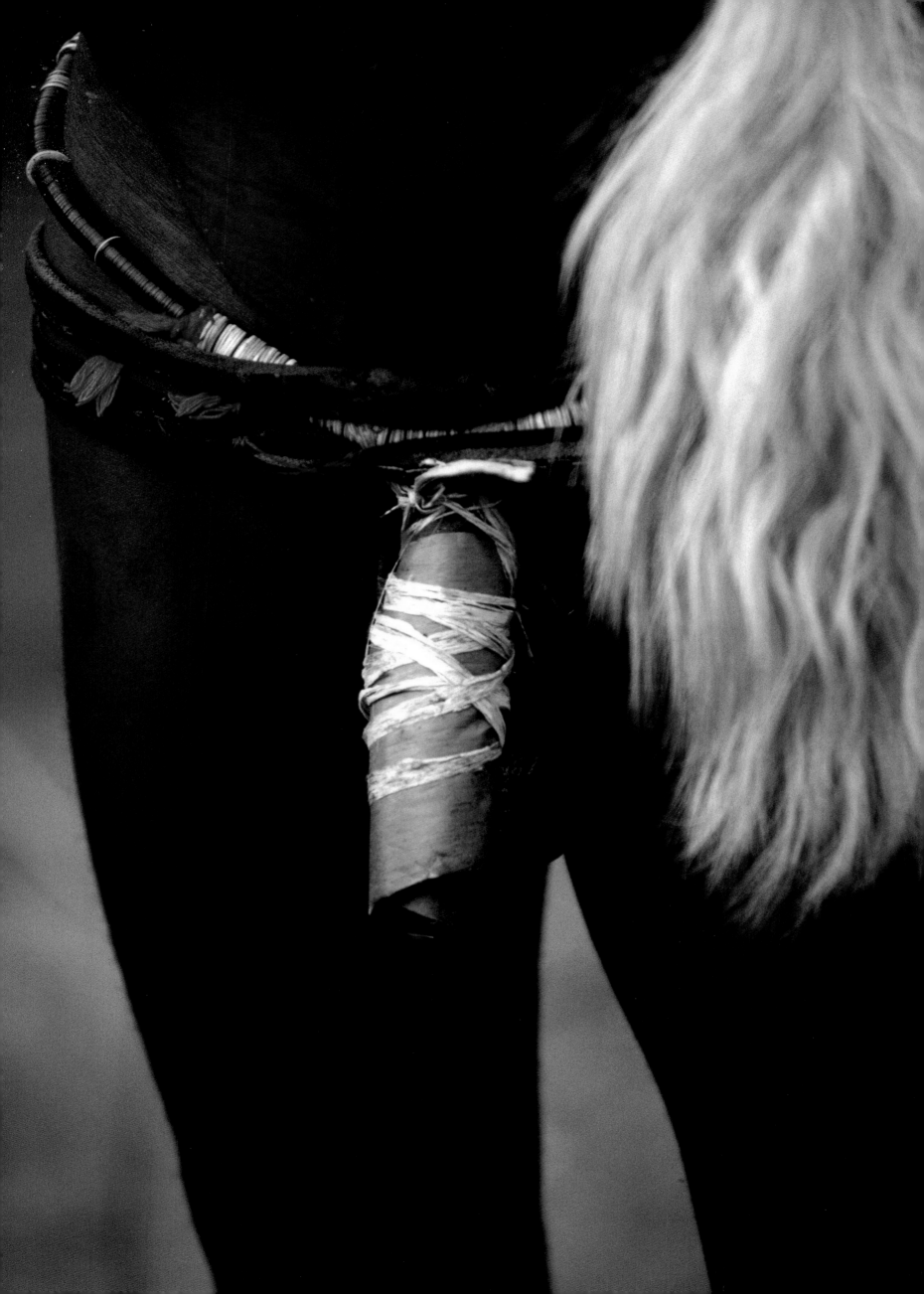

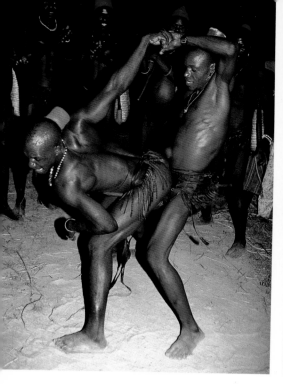
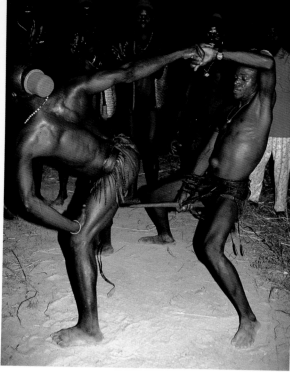

Father Spirits of the Penises

During the months preceding circumcision, the initiates are looked after by guardians called Kumpara. These guardians act as entertainers on market days to announce the forthcoming rituals and provide light relief for village families whose young men will undergo the most serious transition of their lives. Acting as lewd clowns, the guardians lampoon the crowd and engage in exaggerated sexual horseplay. Goaded by spectators, they imitate every imaginable sexual position using large wooden phalluses, known as "father spirits of the penises", that drive the audience wild.

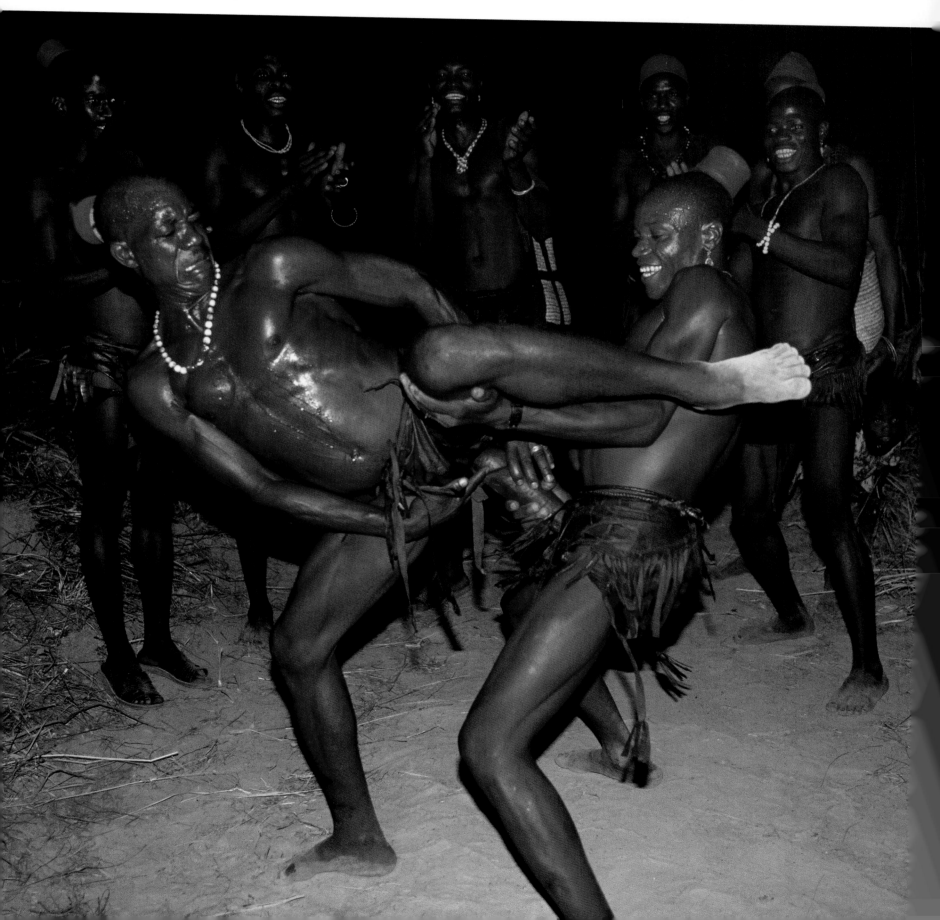

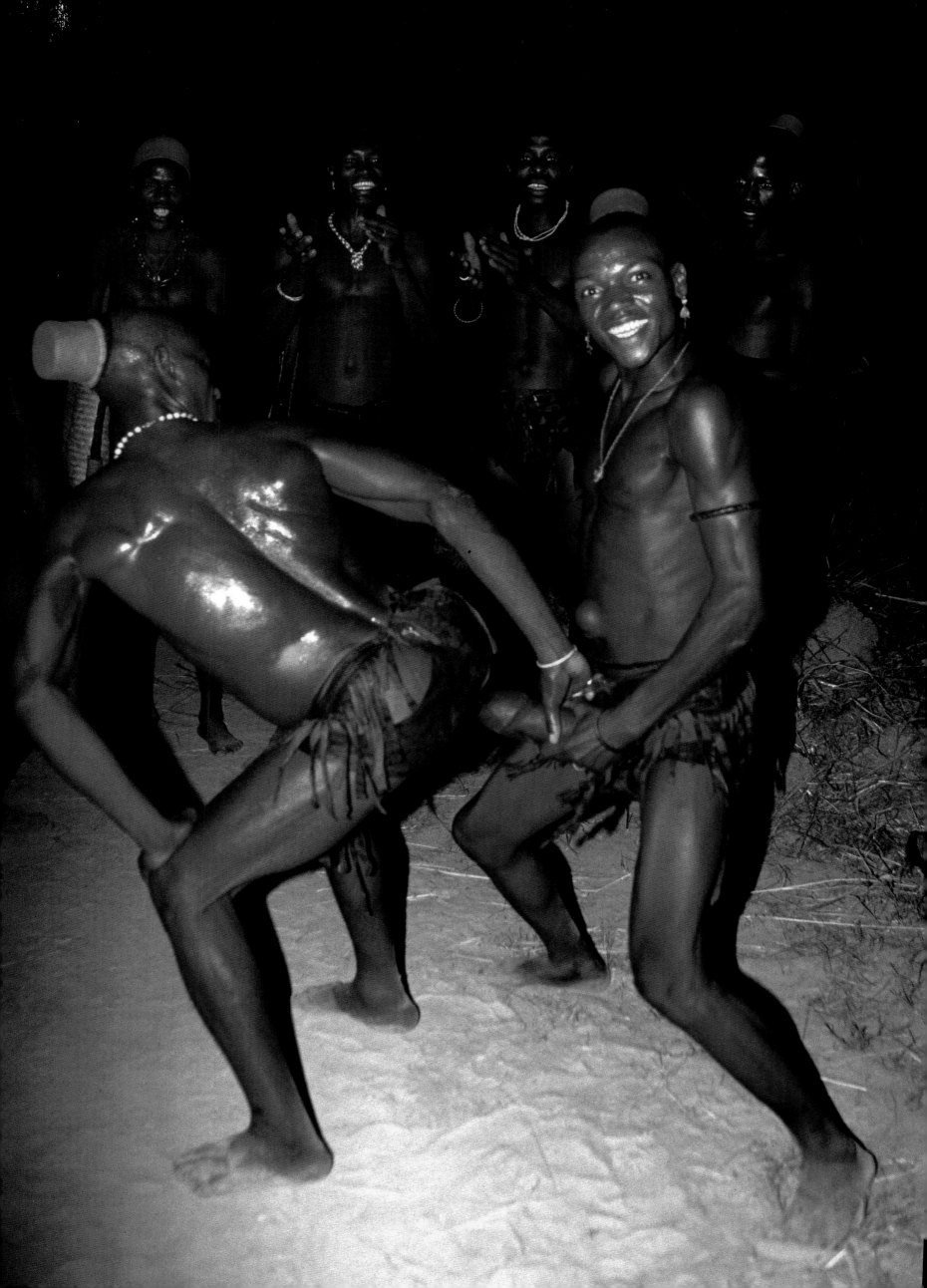

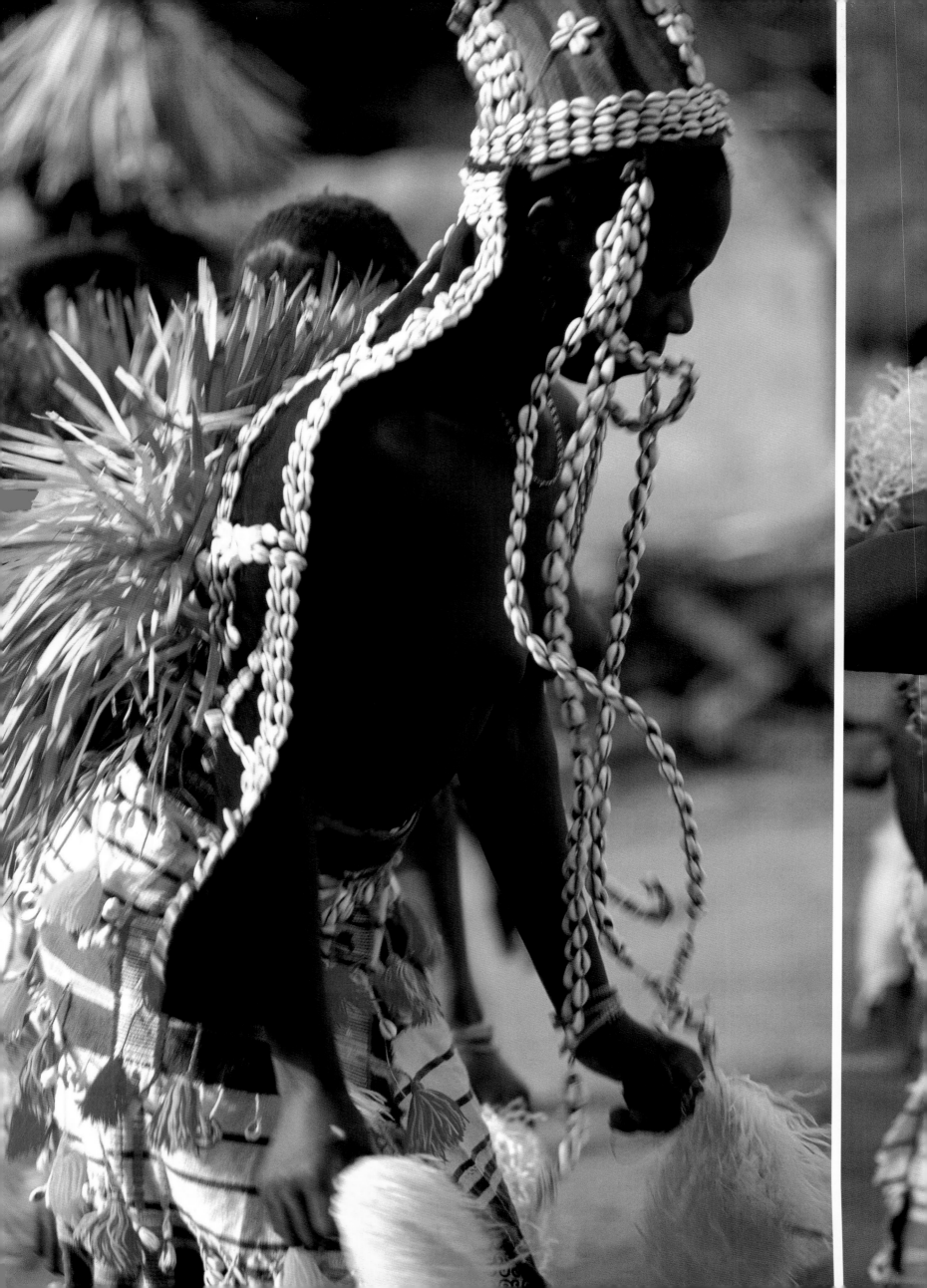

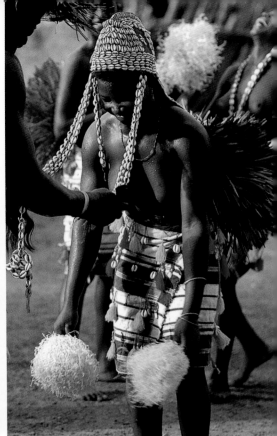

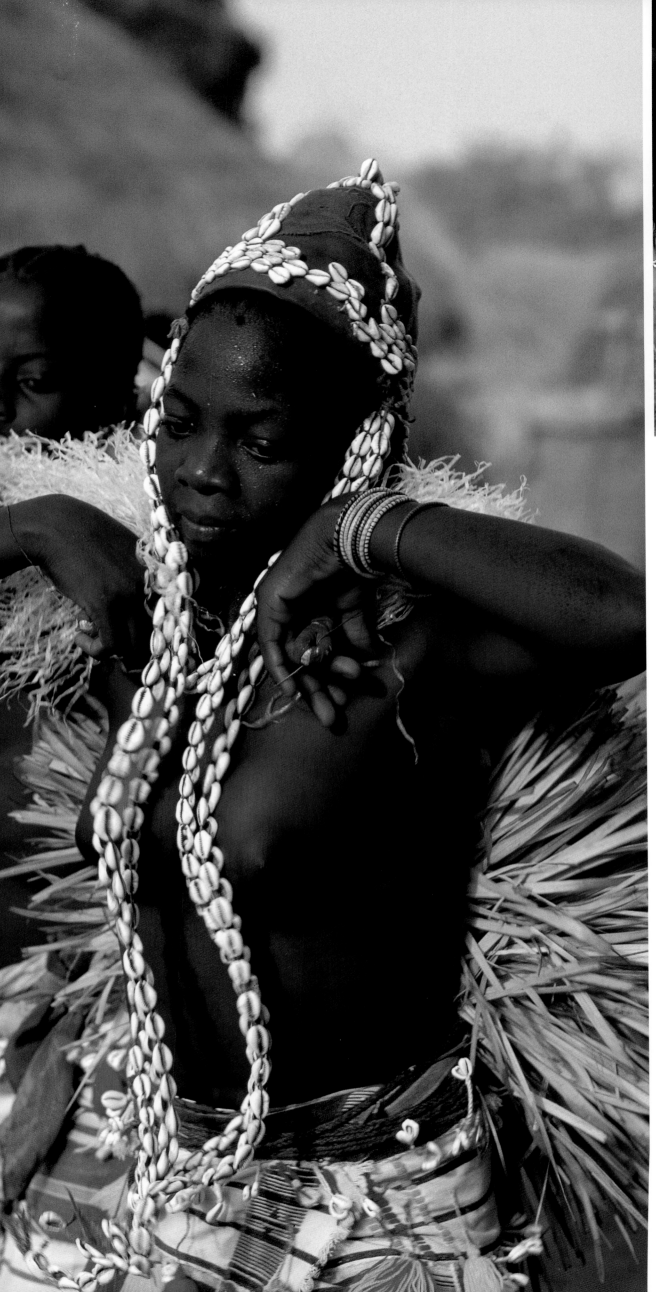

Dancing into Womanhood

For girls of the Senufo group from the Ivory Coast, initiation into adult life begins at the age of eight. Over the next seven years, initiates are schooled in the secret and complex arts of the Poro society of womanhood. At the end of this, they achieve initiation in a ceremonial dance called the Ngoron. Festooned with strings of cowrie shells symbolizing femininity, and wearing large grass pompoms on their backs, the girls celebrate their newfound maturity. A primary rite of passage for Senufo females, the dance is both subtle and complex. Its steps can take up to six months to master and are taught as the culmination of a girl's ritual instruction.

Following pages: Layers of raffia grass cascade from the waists of female Ngbende initiates from Northern Congo; across their chests are bandoliers of dried corncobs. The raffia-grass visors they wear conceal their juvenile identities until the ritual is complete and they are reborn as women.

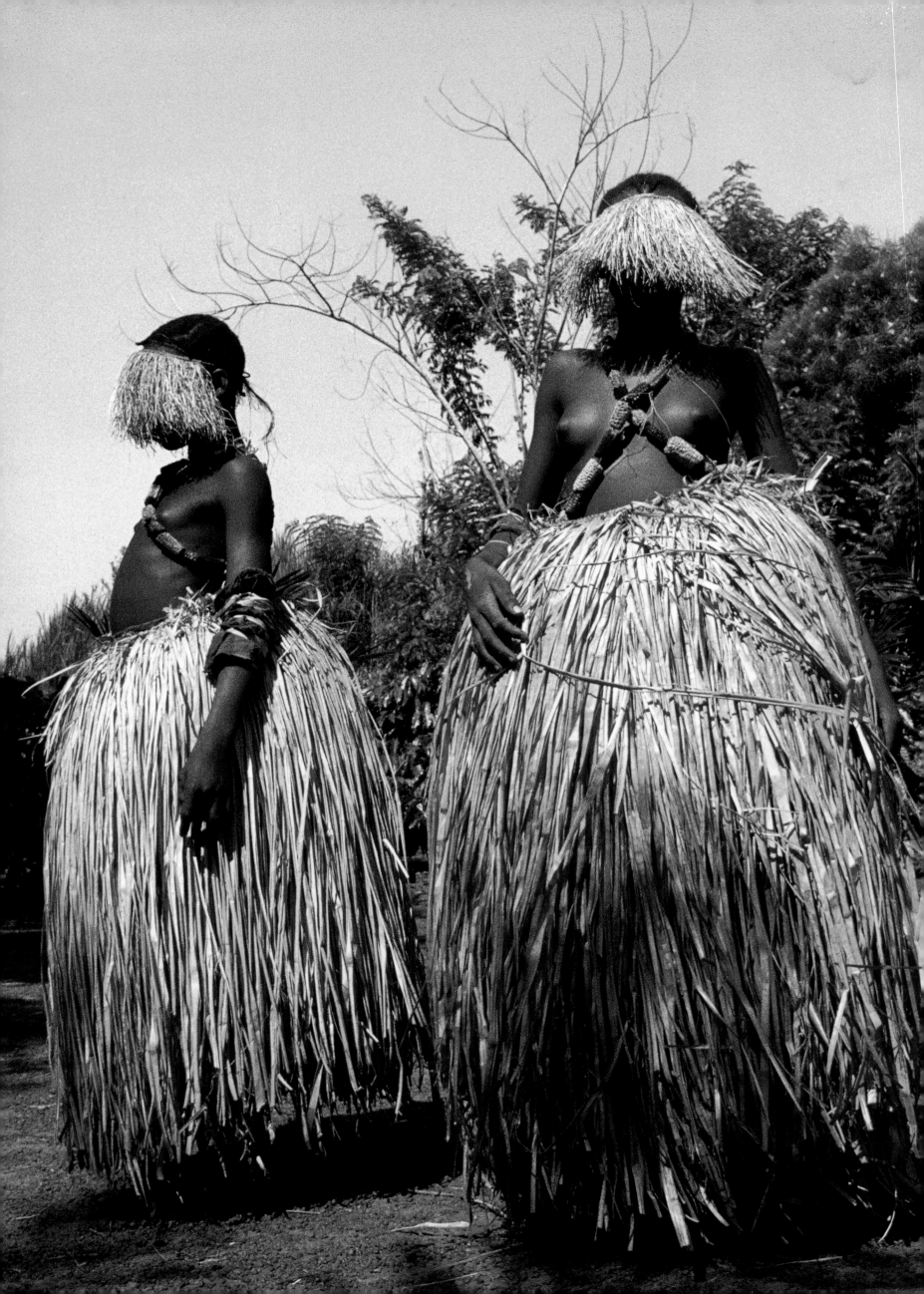

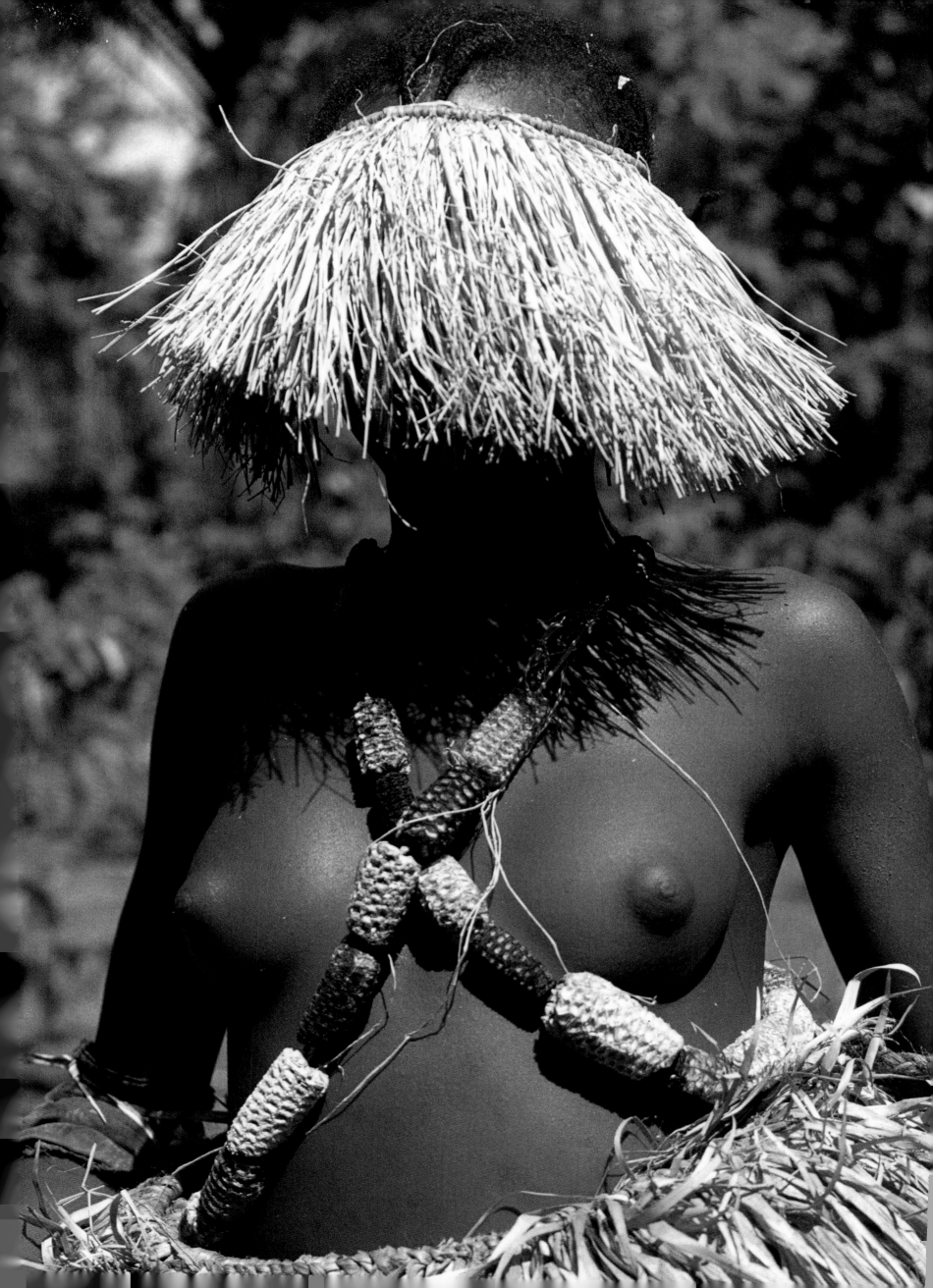

Maasai Circumcision

Heralding the beginning of adult life, circumcision is regarded by the Maasai of Kenya as a rebirth, a new road to the ways of maturity. They believe that the male or female youngster who undergoes the agony of such an ordeal with courage will be able to endure the challenges of life and uphold the proud reputation of the Maasai people.

For both male and female initiates, circumcision takes place at dawn. A boy, usually between fifteen and eighteen years old, undergoes the operation outside the main gate of his family's cattle enclosure. Taunted with insults by his friends to build up his resistance, he must endure the cutting without flinching to prove his bravery. If he cries out, he will bear the shame for the rest of his life. A girl, between the ages of twelve and fourteen, undergoes a clitorectomy inside her mother's home. Without anesthetic, her clitoris and labia minora are cut away by the female circumcisor, but, unlike a boy, she is permitted to express pain without dishonor. Both males and females go through a healing period of up to six months, a time that serves as a transition into adulthood. The girl remains in seclusion, and the boy joins the collective activities of his age mates. Following this period of recuperation, males become warriors and females enter married life.

A Maasai warrior may not marry until he graduates from warriorhood, in his late twenties or early thirties. Prior to this, he may only have sexual relations with uncircumcised girls between the ages of nine and thirteen, who cannot become pregnant. For the Maasai, pregnancy out of wedlock is strictly taboo. At the onset of menstruation, girls are circumcised and must leave their warrior boyfriends to prepare for marriage with older men who are selected by their parents and may be twice the girls' age.

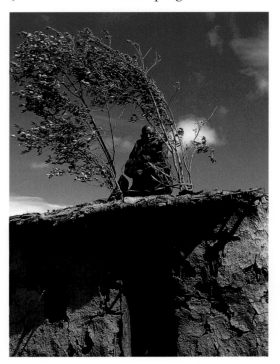

A highly controversial issue in contemporary Western society, female clitorectomy has been practiced by the Maasai for centuries. Without undergoing this painful ritual, a girl will not be considered a woman, will not be permitted to marry within Maasai society, and will not be able to bear legitimate offspring. A Maasai girl who refuses this rite of passage will be ostracized from her community and alienated from her cultural tradition.

Above: Outside a Maasai hut, the leafy branches of an olive sapling indicate the presence of a boy about to undergo circumcision. *Right:* An initiate awaits his ordeal.

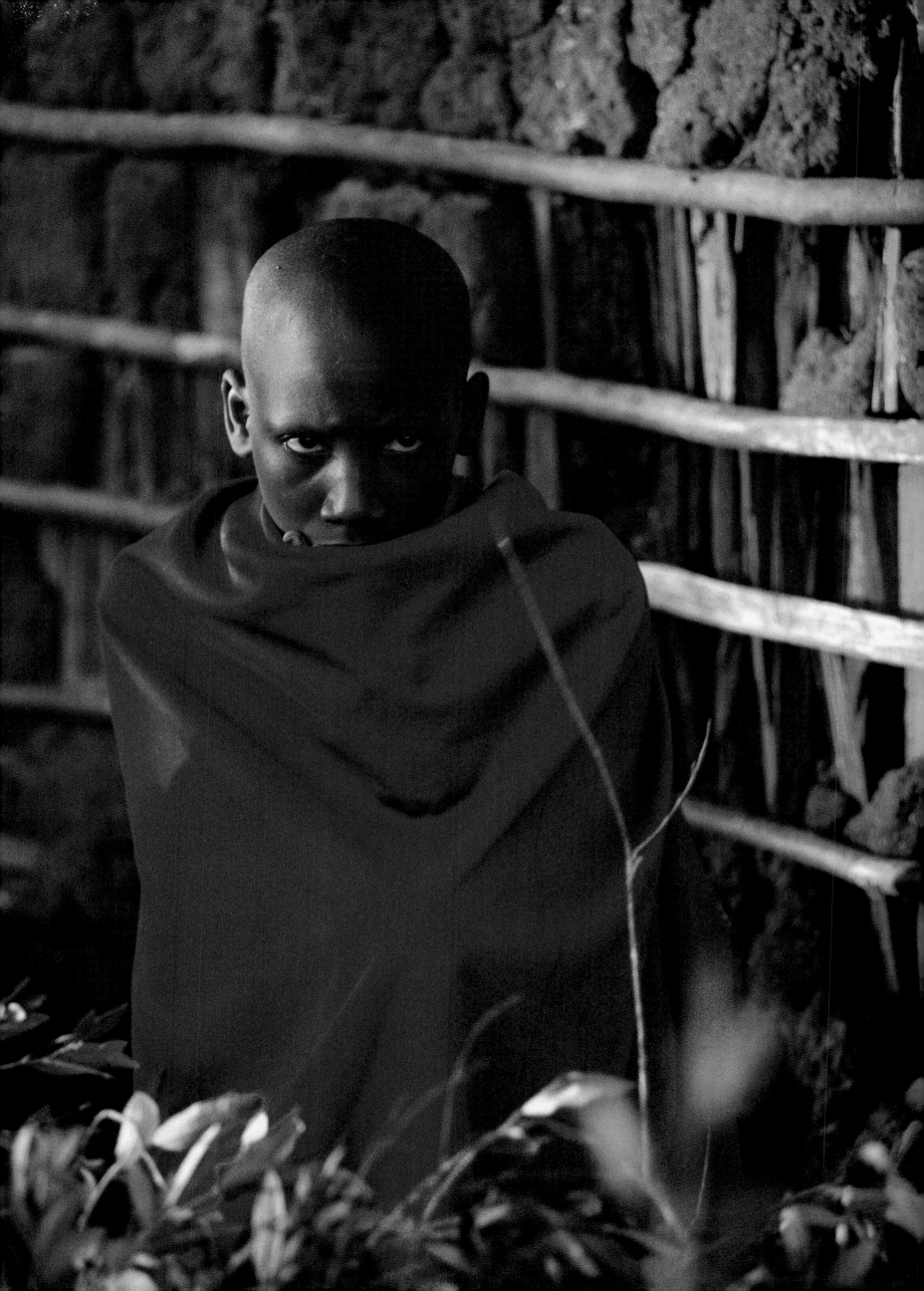

On the Threshhold of Manhood

The initiate rises just before dawn and bathes, using water that has been kept outside all night in a bucket containing an axe head to make the water colder. His body numbed, the boy is insulted relentlessly by his age mates to toughen him for the ordeal that lies ahead. As a parting gift from his mother, he has been given the hide of an unblemished ox, on which he will sit during the cutting. Accompanied by his father, the boy walks to the entrance of the family cattle kraal. Already in attendance are the initiate's close male relatives and the circumcisor, who has been brought in from the Ndorobo tribe especially for the occasion. He will be paid one goat for every operation he performs. Women are forbidden to come to the cattle kraal for the duration of the ritual.

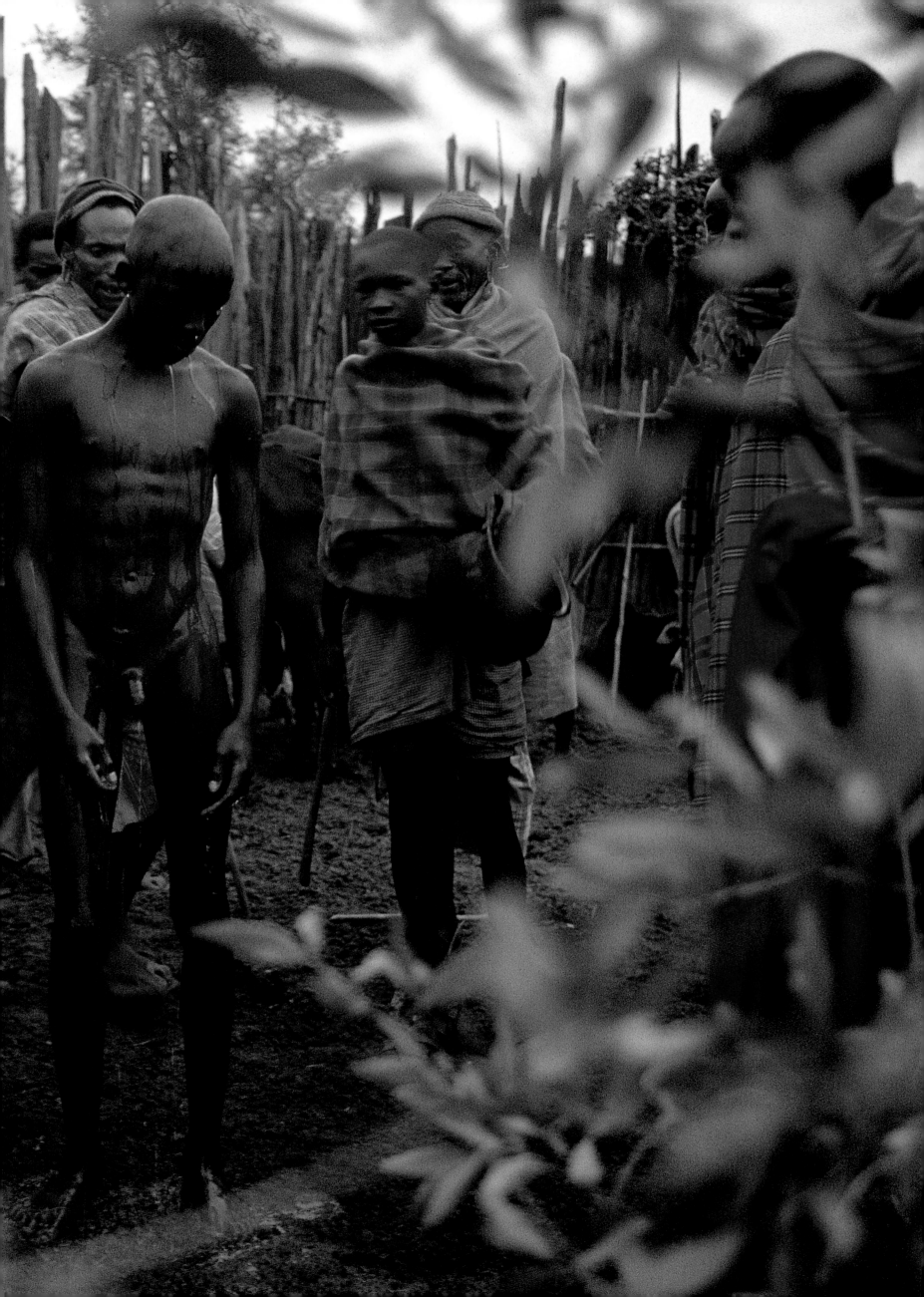

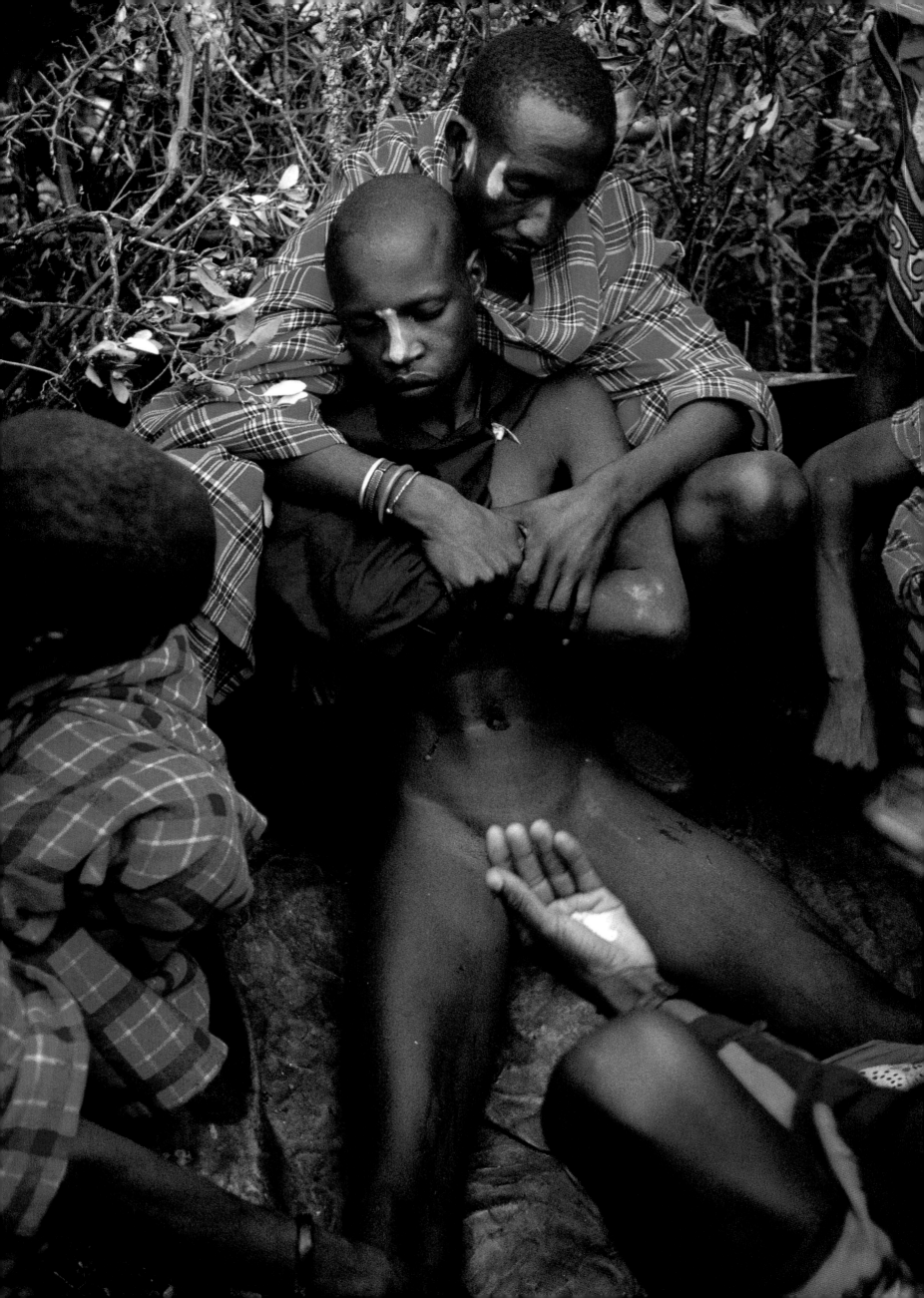

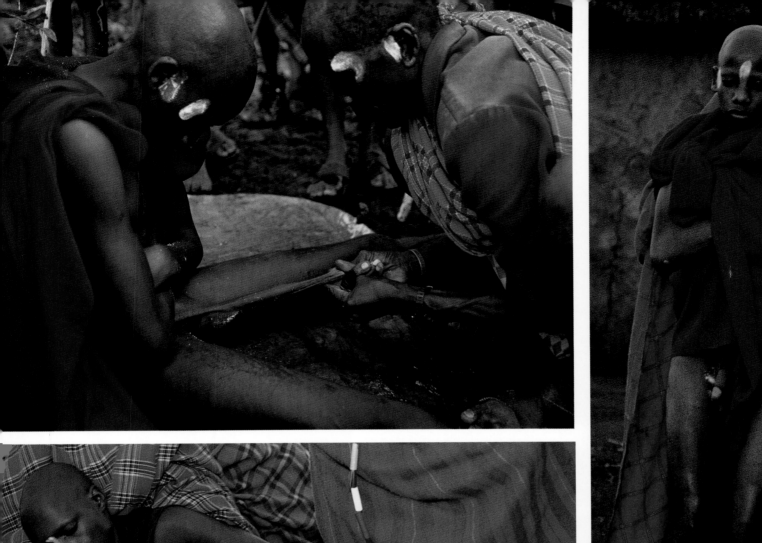

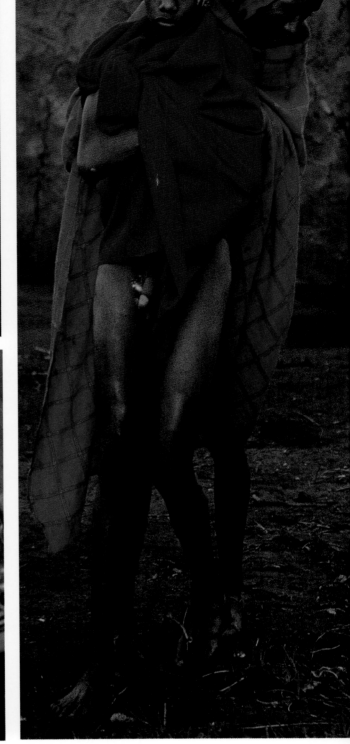

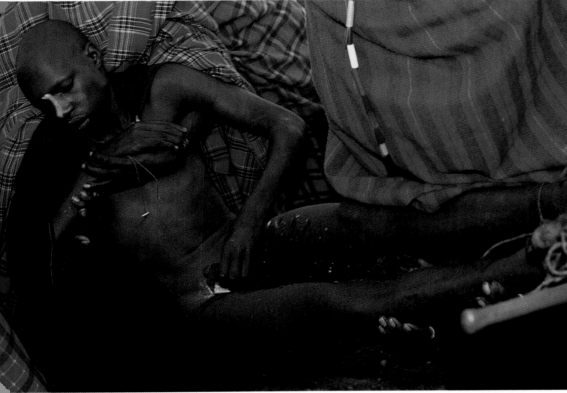

The First Cut

Seated securely between the legs of a back supporter (*left*) so that he is prevented from making even the slightest movement, the initiate prepares himself. The circumcisor throws a libation of chalk and milk over him and calls out, "One cut," so as not to take the boy by surprise. He then puts a knife through the boy's foreskin, and when the cutting is complete, a flap of skin is left beneath the head of the penis – a unique feature of Maasai circumcision. With the entreaty, "Wake up, you are now a man," the circumcisor indicates that the initiate is free to leave.

Still in great pain and weak from shock, the initiate is carried back to his mother's hut to nurse his wound and rest. He receives a ritual calabash of fresh cow's blood to restore his energy. Treated like a woman recovering from childbirth, he is carefully looked after by his family and restricted from performing certain tasks. As a reward for his bravery, his father may give a cow or a goat. This experience will serve to remind him of his youthful courage for the rest of his life. After healing, the initiate is allowed to have sexual relations for the first time.

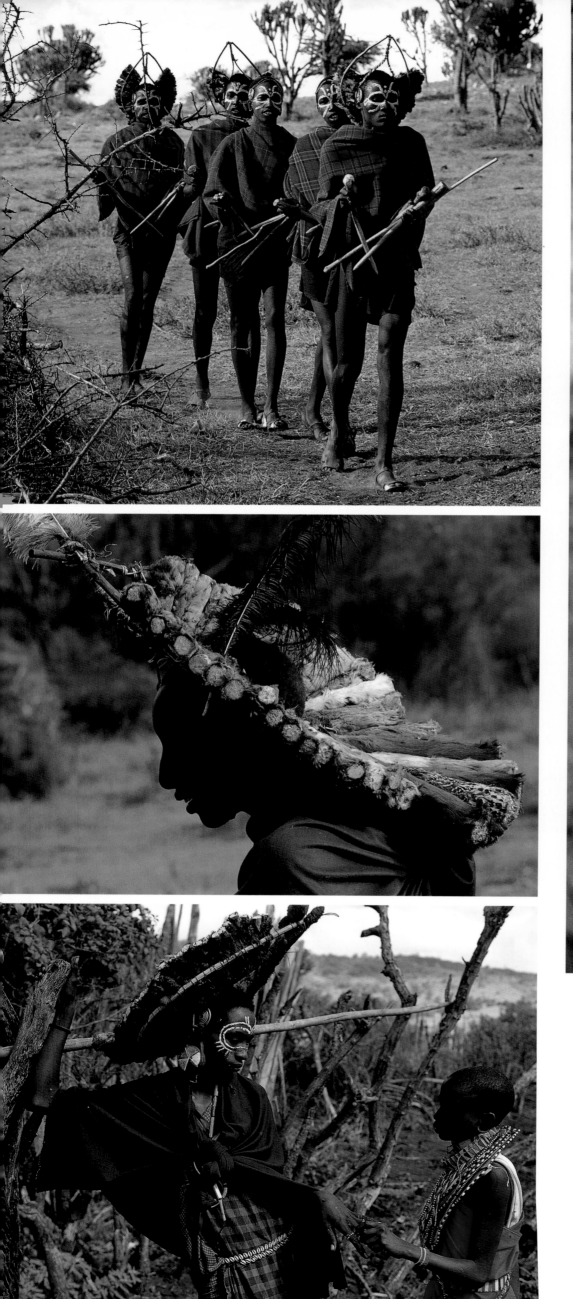
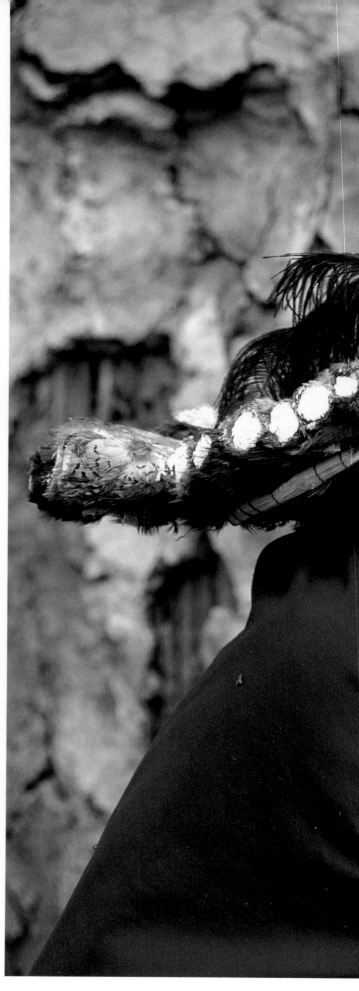

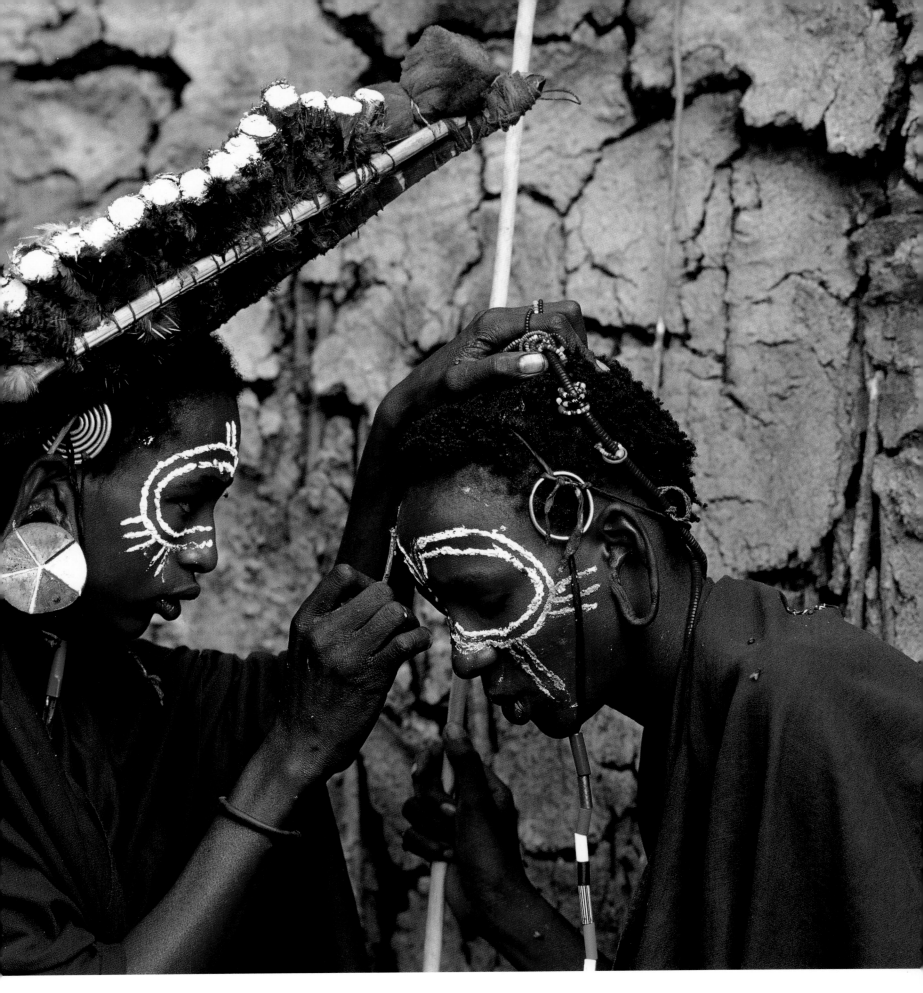

A Crown of Birds

From neighboring camps, the age mates of the initiate arrive to celebrate his entry into manhood. Each guest wears a headdress of colorful stuffed birds and has his face painted with white markings to indicate his intermediate status between adolescence and warriorhood. When the initiate has healed sufficiently to be able to walk, he goes out to hunt for small birds. Shooting them with a bow and blunt arrow, he eviscerates the carcasses, stuffs them with ashes and dried grass, and ties them to a

circular frame, which he wears as a ceremonial crown. If he has withstood circumcision unflinchingly, he may wear colorful birds, symbolic of courage, but if he has cried out, his crown will be drab. It may take up to forty birds to complete such a headdress.

Above: Dressed in dark blue, an initiate paints white chalk designs on the face of a recently circumcised age mate. For protection during this vulnerable period of transition into warriorhood, both young men wear

their mothers' coiled brass pendants against their temples.

Below left: During the healing period, the newly circumcised boys roam Maasailand, chasing young girls and shooting them with blunted arrows. Each time an initiate hits a girl, she must give him one of her beaded finger rings to wear on a band around his head or on a finger. The greater his collection of rings, the more admired he is as he enters the most exciting period of his life—being a Maasai warrior.

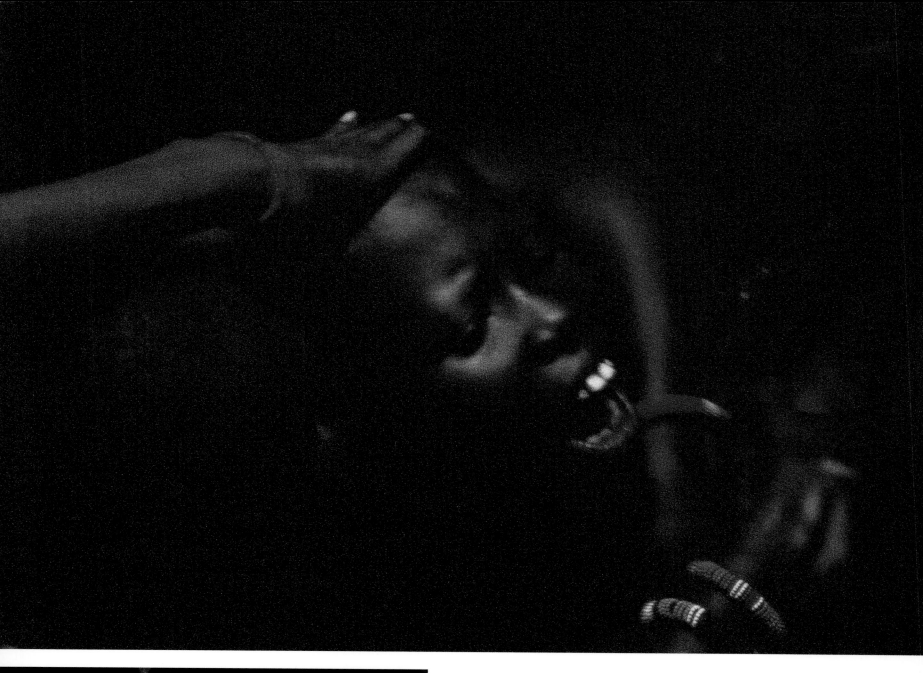

The Cry of Pain

Ritually shaved and washed, a young girl sits in the darkness of a hut before a female circumcisor, surrounded by her family. A special curved blade is used to cut away her clitoris and labia minora. No anesthetic is given; the only concession to the girl's pain is that, unlike her male counterpart, she may cry out without disgracing herself.

During the cutting, she screams in pain and appeals to her relatives to let her go (*above and left*), but they continue to hold her down, believing the procedure to be in her best interests. The excision completed, the girl rests in her family hut. At the end of the day, she is inspected by a female elder. If the circumcisor's work has been carried out satisfactorily, the girl is free to resume her recuperation; if not, she faces a repeat of her earlier ordeal. During her weeks of recovery, she is secluded with her family and other initiates. Dressed in dark blue and wearing a beaded band around her head (*right*) she is not allowed to be seen or spoken to by men, other than immediate relatives. She receives gifts of livestock to honor her new status and can now look forward to marriage and children of her own.

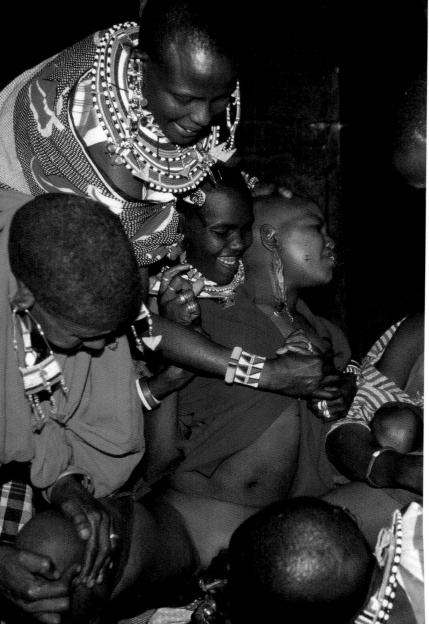

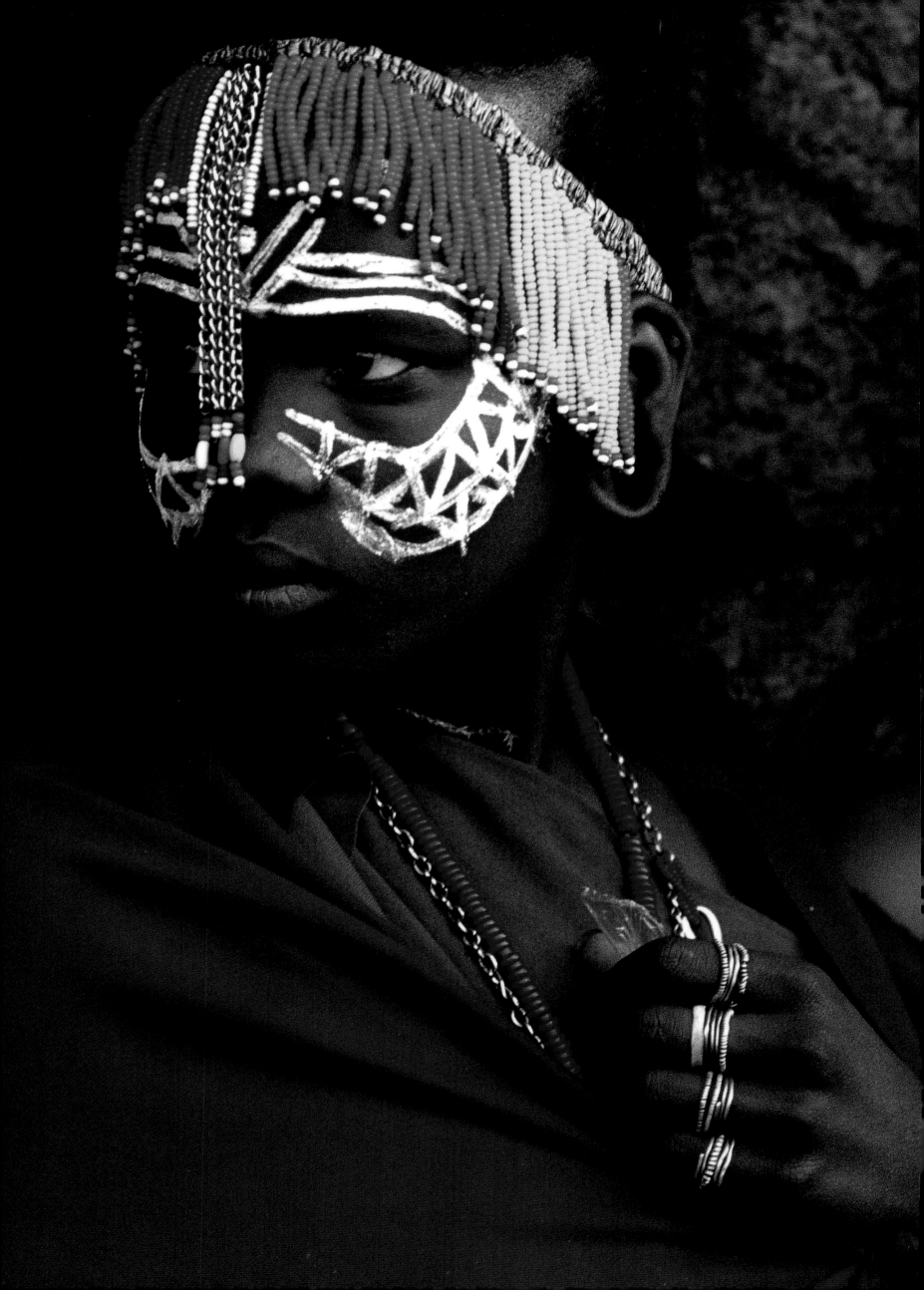

Bassari Age Passages

Living as hunters and agriculturists, the Bassari inhabit the northwest foothills of Fouta Djalon in southern Senegal. In Bassari society, roles and responsibilities are defined by a person's place in a strict chronological hierarchy. The age-grade system is the central social institution, and specific roles of behavior within the community are clearly defined for each age level. Order is enforced by each older grade. In recent times, punishment for transgressions against the code of behavior have usually taken the form of a fine: previously the penalties were severe—sometimes even resulting in death.

The Bassari have a more comprehensive age-grade system than most other traditional societies, with major ceremonies marking the transition from one age grade to another. Men pass through seven stages, beginning at ten years of age. The most important ceremony of the male cycle is initiation into adulthood, which occurs when men are between fifteen and twenty years old. Women pass through eight stages, starting at the age of twelve: their major ceremony occurs at thirty-five years of age, when they enter a period of communal leadership. Whereas Bassari men celebrate their entry into adult life, the women celebrate the life they have already experienced.

The initiation of young men, called Koré, takes several months to complete. During this time, the boys, who normally live in a communal house with other unmarried males, are removed from the village. They are supervised by a group of older initiates who act as their guardians. Living in a ritual house, the boys are completely separated from their own families, and have no contact with the opposite sex. As the initiation process begins, the guardians take the boys into the nearby sacred forest. Legend has it that in the forest the boys meet their deaths at the hands of Numba, the mysterious chameleon deity of initiation, who devours them and then regurgitates them as fledgling adults.

The most important female ceremony, the Ohamana, lasts for a day and a half, during

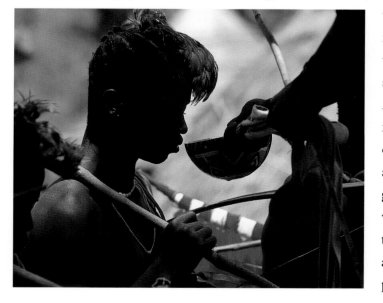

which the women dance all night in a trancelike state, wearing beaded regalia that symbolizes their new status. After graduation, the women's responsibilities will include organizing communal labor and overseeing female age-grade rituals. For Bassari women at this stage of life, their tradition dictates that they be as wise as their male counterparts are strong.

Above and right: Bassari initiates at their ritual entry into manhood. *Following pages*: Silently, the male initiates leave the sacred forest in a transformed state.

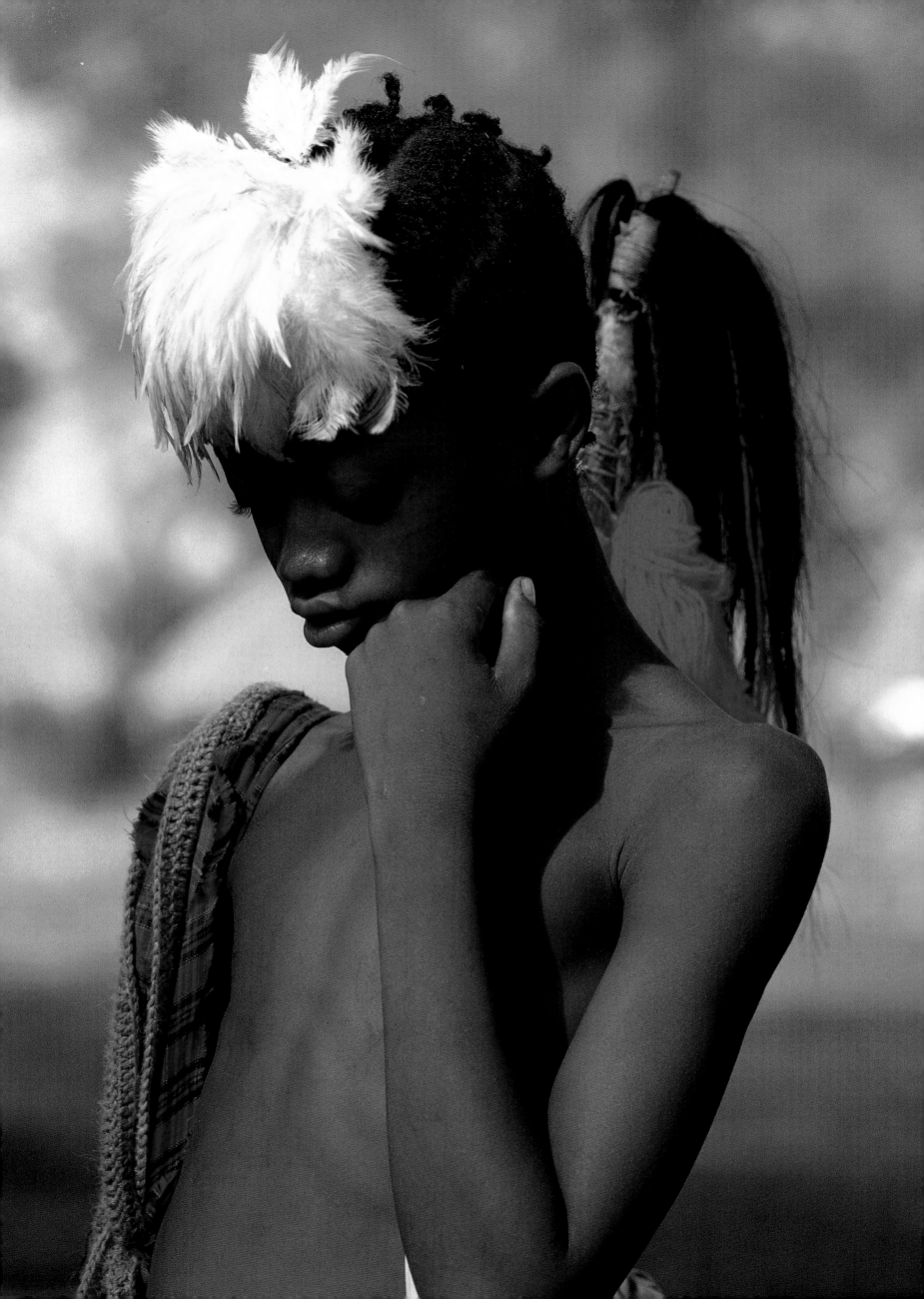

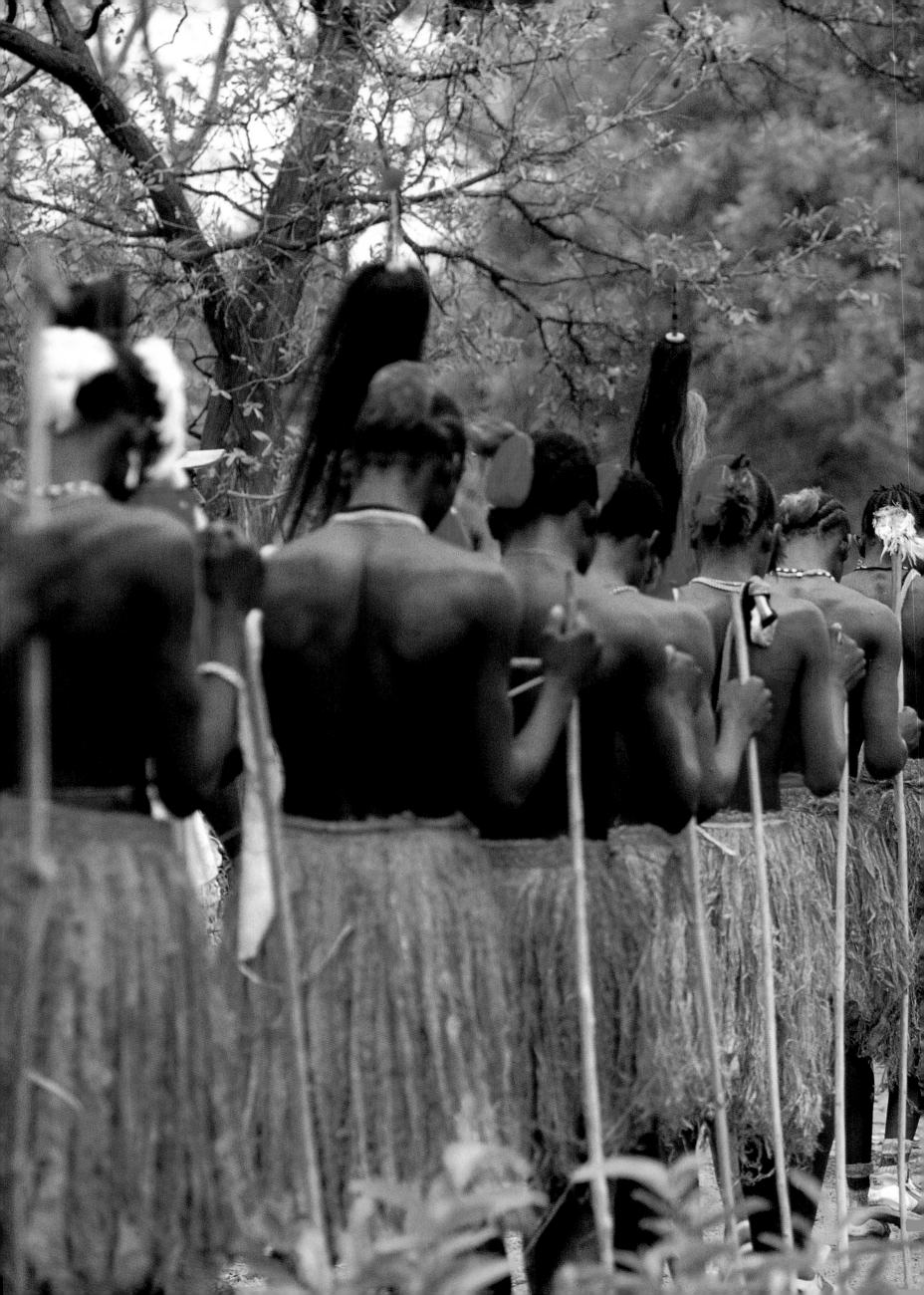

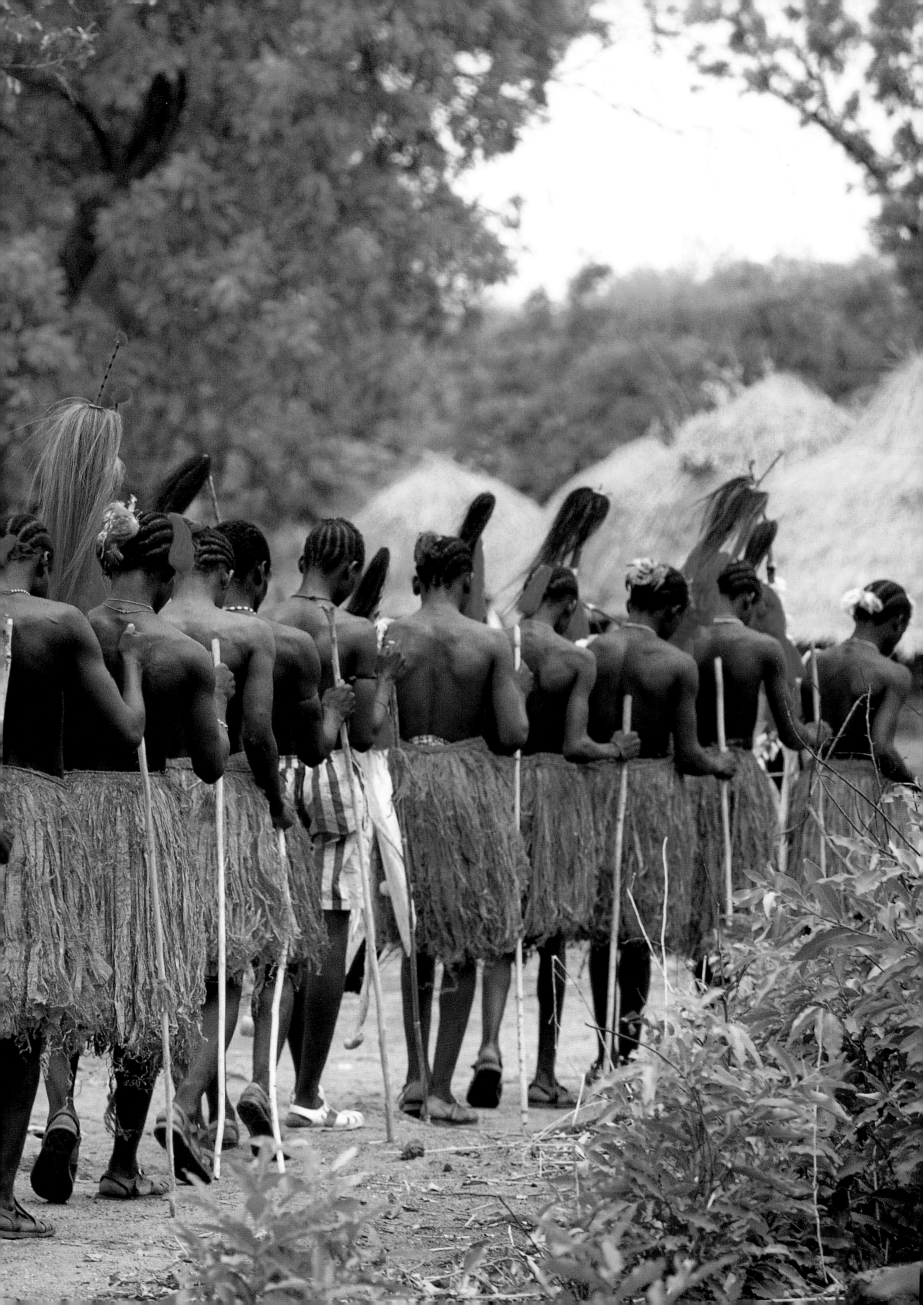

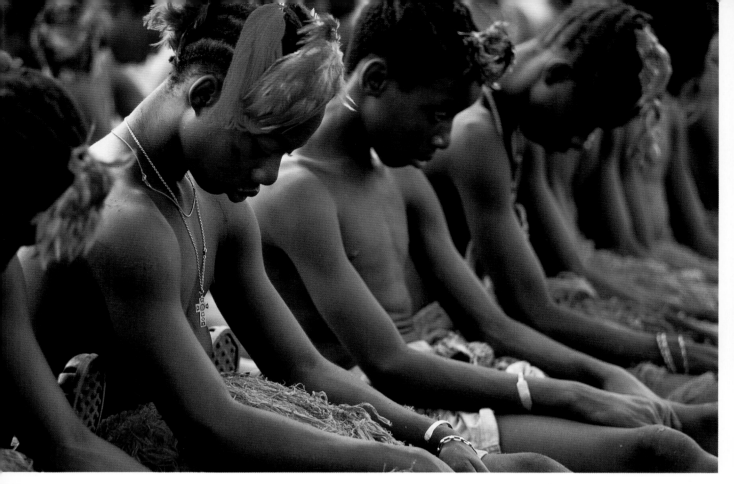

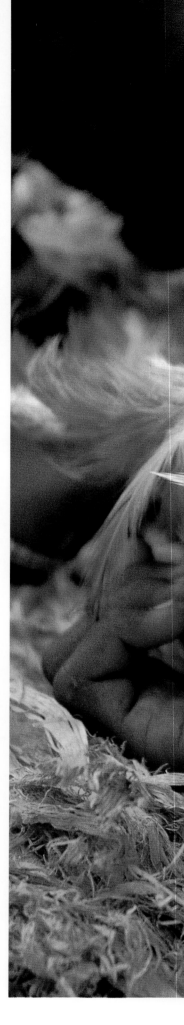

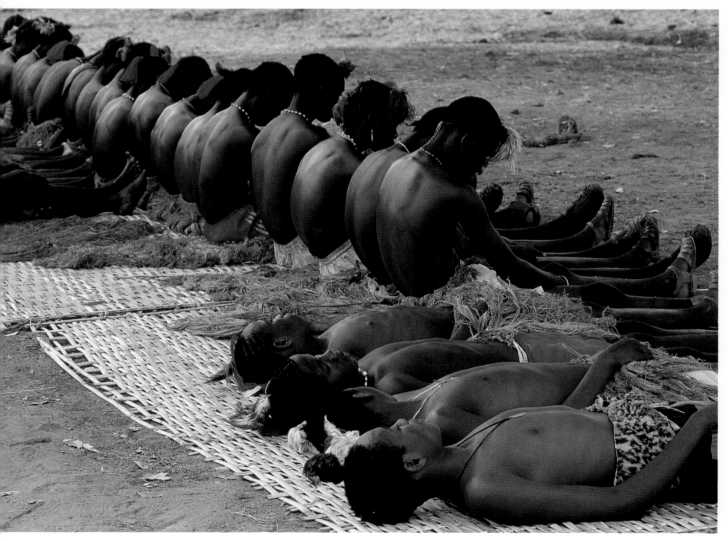

Symbolic Rebirth

Before their entry into the sacred forest, the male initiates are washed by women serving as ritual aunts who also rub them with palm oil and braid their hair with feathers from sacrificed chickens. Once the feathers are put in place, the boys behave as if they recognize no one. In the sacred forest, they undergo the death of their childhood identities through a series of harsh rituals and emerge behaving like infants. During this limbo period, lasting one week, they are cared for by guardians who carry them, feed them, clean them, and put them to sleep. This simulated regression recreates a state of purity from which they emerge as adults, ready to assume mature roles in the community. During their retreats into the forest the boys cannot talk, laugh, smile, or even look from side to side.

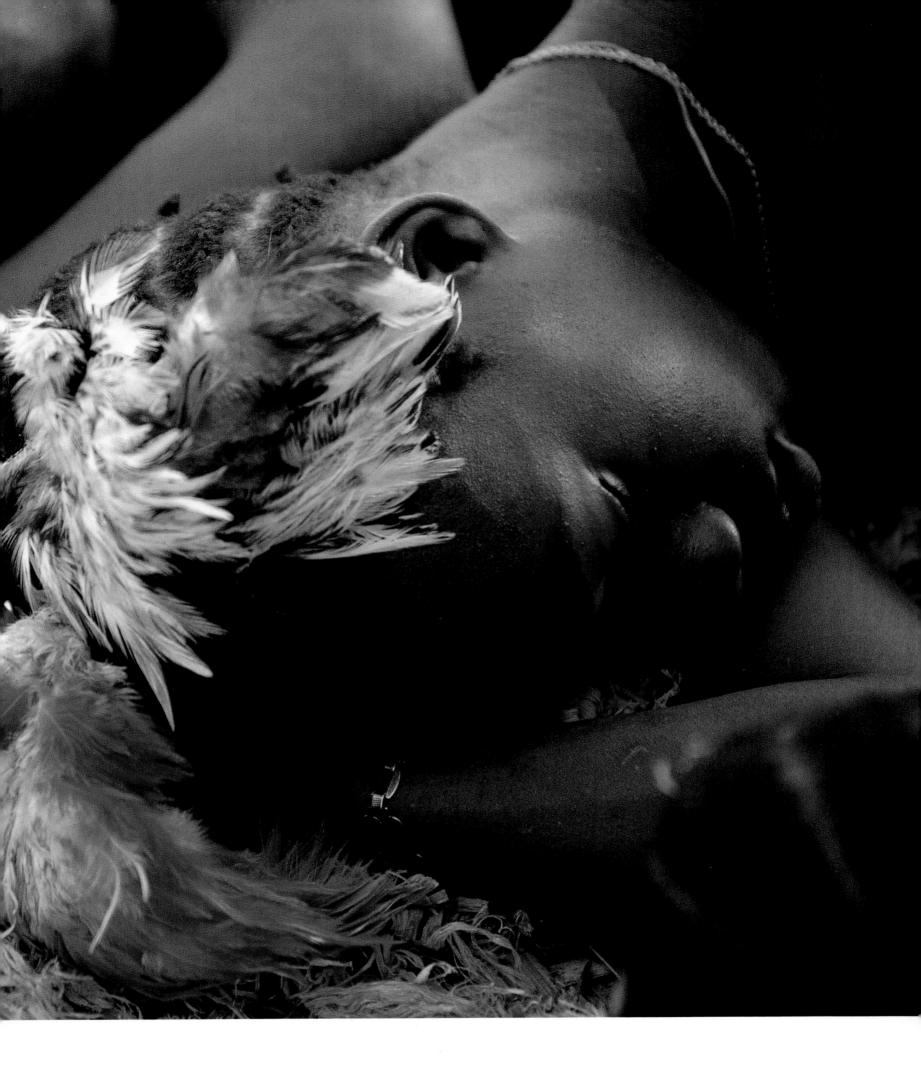

They remain impassive and focused on their goal. These constraints aim to teach the initiates obedience and self control. Sequestered together, they develop bonds that last for the rest of their lives.

Following pages: A gunshot fired by a village elder signals the arrival of a long line of masked dancers, called Odo-Kuta, or Lukuta in the singular, who emerge from the sacred forest to join the celebration. Embodying the spirit of nature, they descend from the mountains to oversee festivities and insure that tribal traditions are maintained. The Odo-Kuta evolved from the Bassari's animistic origins and act as a link between them and their environment. The power of the dancers' masks is considered absolute, since its wisdom comes from beyond the human realm.

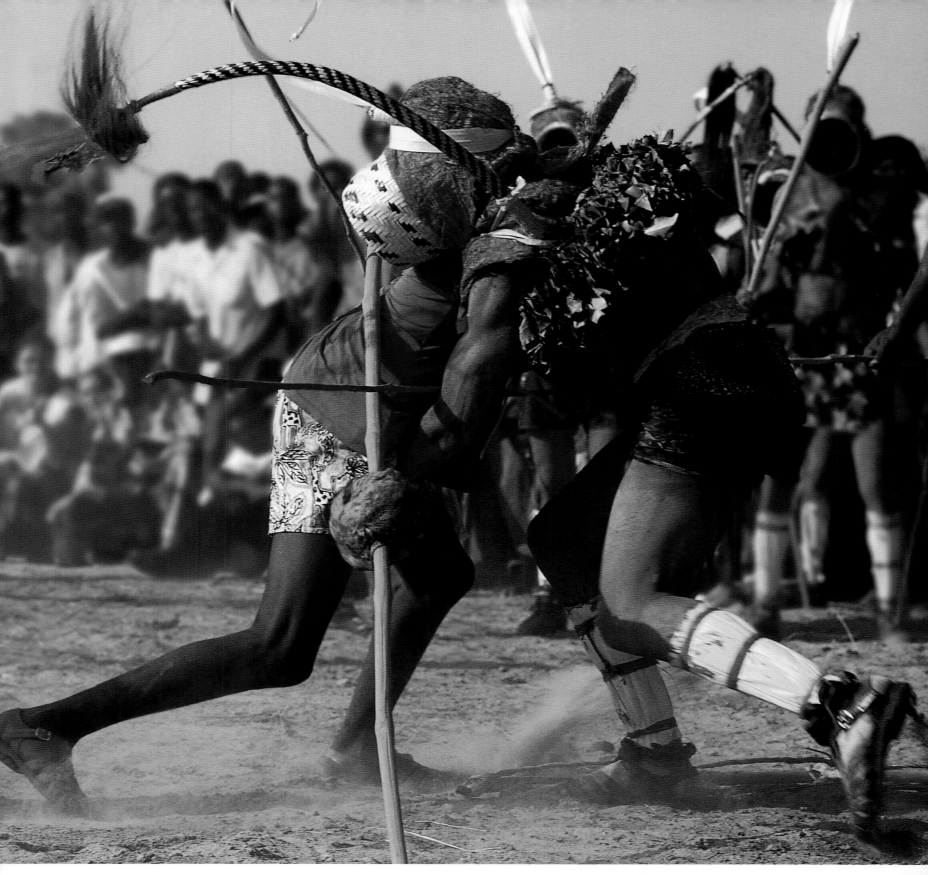

The Confrontation

The climax of the Bassari male initiation is a duel between each new initiate and a Lukuta mask, a combat viewed as the final measure of virility and courage. During this demanding ordeal, each initiate must battle ferociously with his formidable opponent, using every technique he knows to defend himself. For the fight, the Lukuta removes his cartwheel mask to reveal a protective hood and visor and a heavily padded chest protector. He also wears a gauntlet and holds a long switch to beat the initiate.

Right: Whether or not an initiate wins the fight, that he has challenged the mask and fought like a man is considered proof that he has left childhood. He is given a new name, develops a new personality, and assumes a new status. So marked is the transformation that the initiate is presented to his parents as a stranger who has appeared to replace the son they have lost.

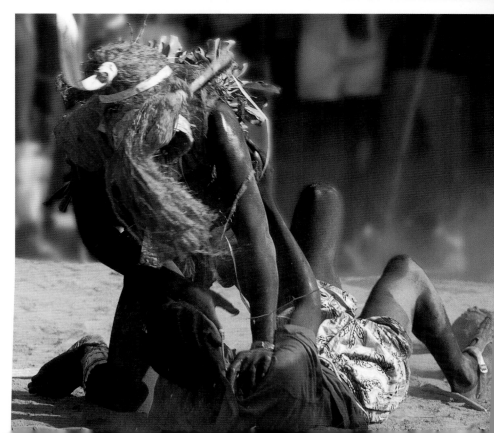

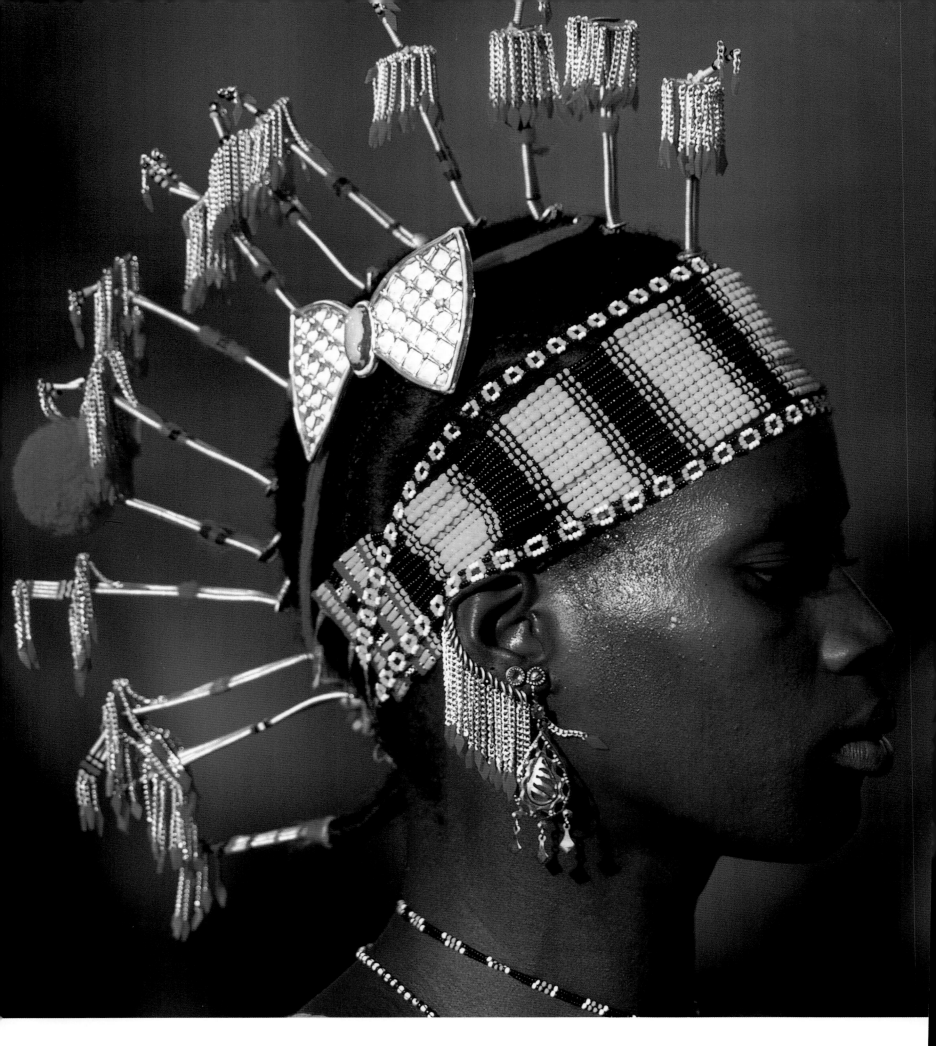

Beads of Passage

Bassari women, like the men, live within the rigid domains of ritual secrecy and have their own spheres of social and economic activity. Also subject to the age-grade system, Bassari women undergo initiation ceremonies that define transitions to new stages of life every six years. These female initiates are celebrating the graduation that marks the passage from the Odoyil, thirty to thirty-five-year age group, to the next group, Odepeka. As they enter this new stage, the initiates wear distinctive ritual attire comprised of aluminum belts and beaded bandoliers, as well as intricate headdresses styled to resemble the crests of birds. Their dance, Ohamana, is named for the iron bells they wear on their ankles to enhance the rhythm

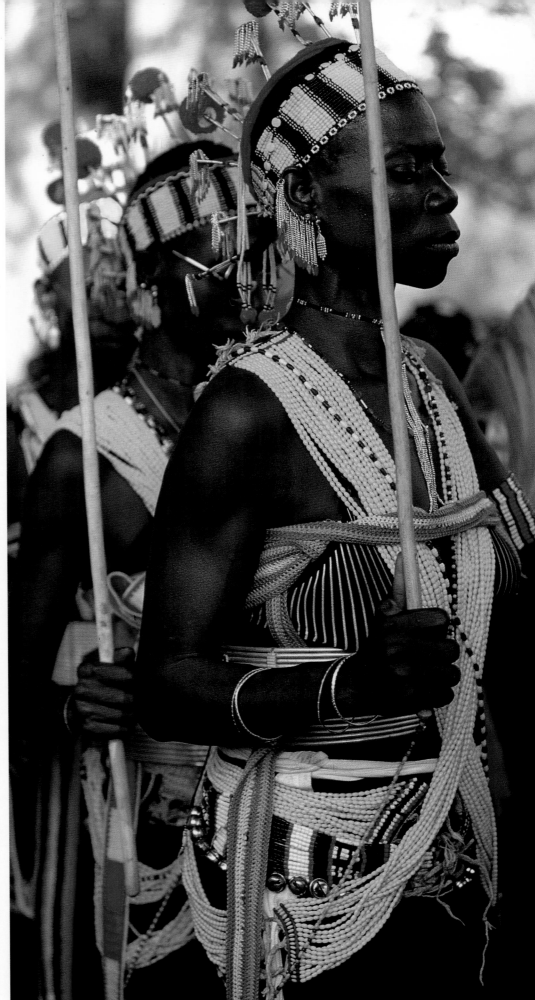

of their movements. In a seemingly mesmerized state, the women advance in single file, taking tiny steps that give the impression that they are dancing on the spot. They move slowly in a large circle, carrying dance sticks topped with stylized beaded dolls in one hand, and horsetail flywhisks in the other. The initiates' beadwork indicates their enhanced status as they move into a phase of life when they will be responsible for organizing communal labor in the village and presiding over important female rituals.

Following pages: Male Bassari dancers wear finely crafted aluminum belts and beaded girdles.

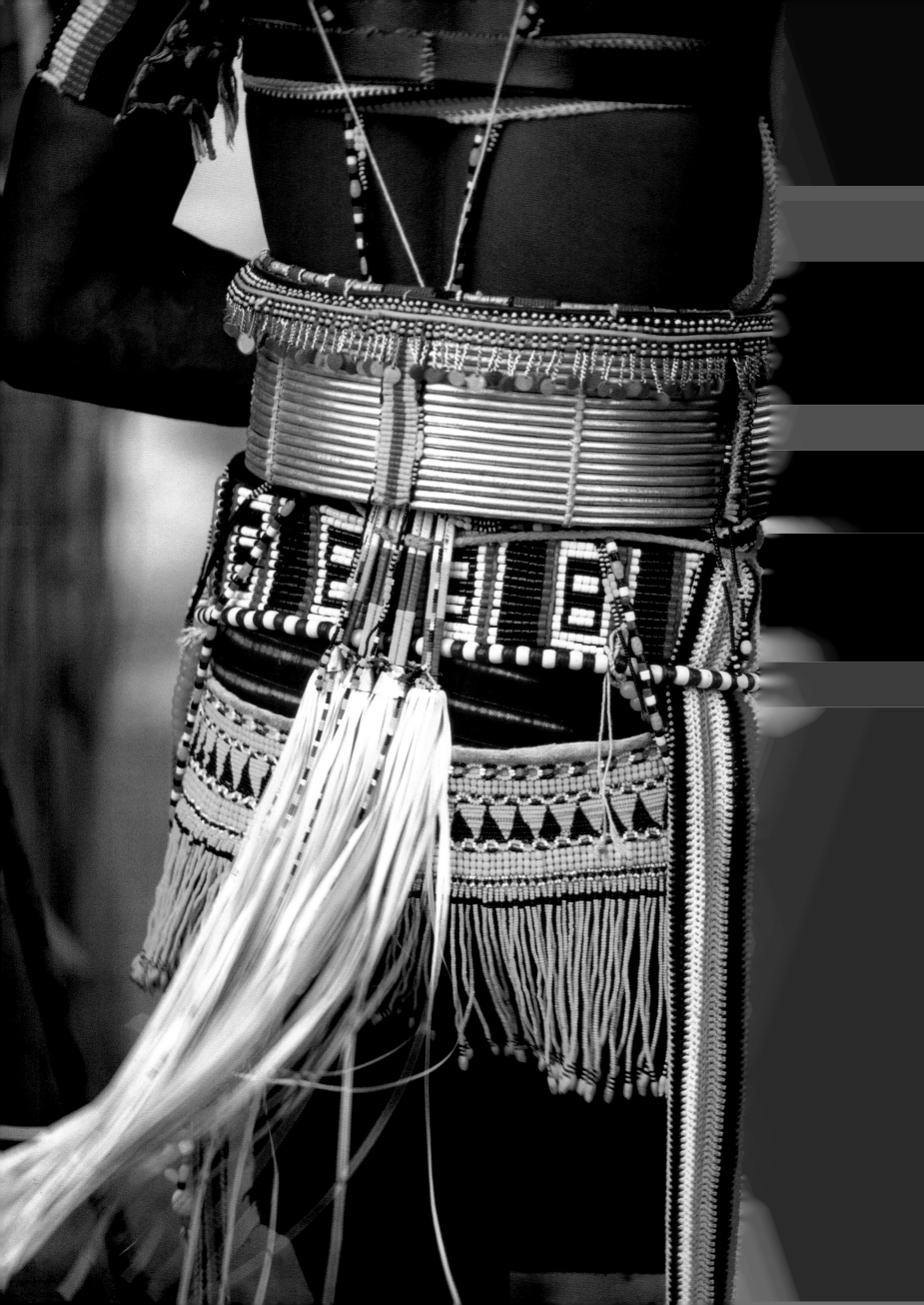

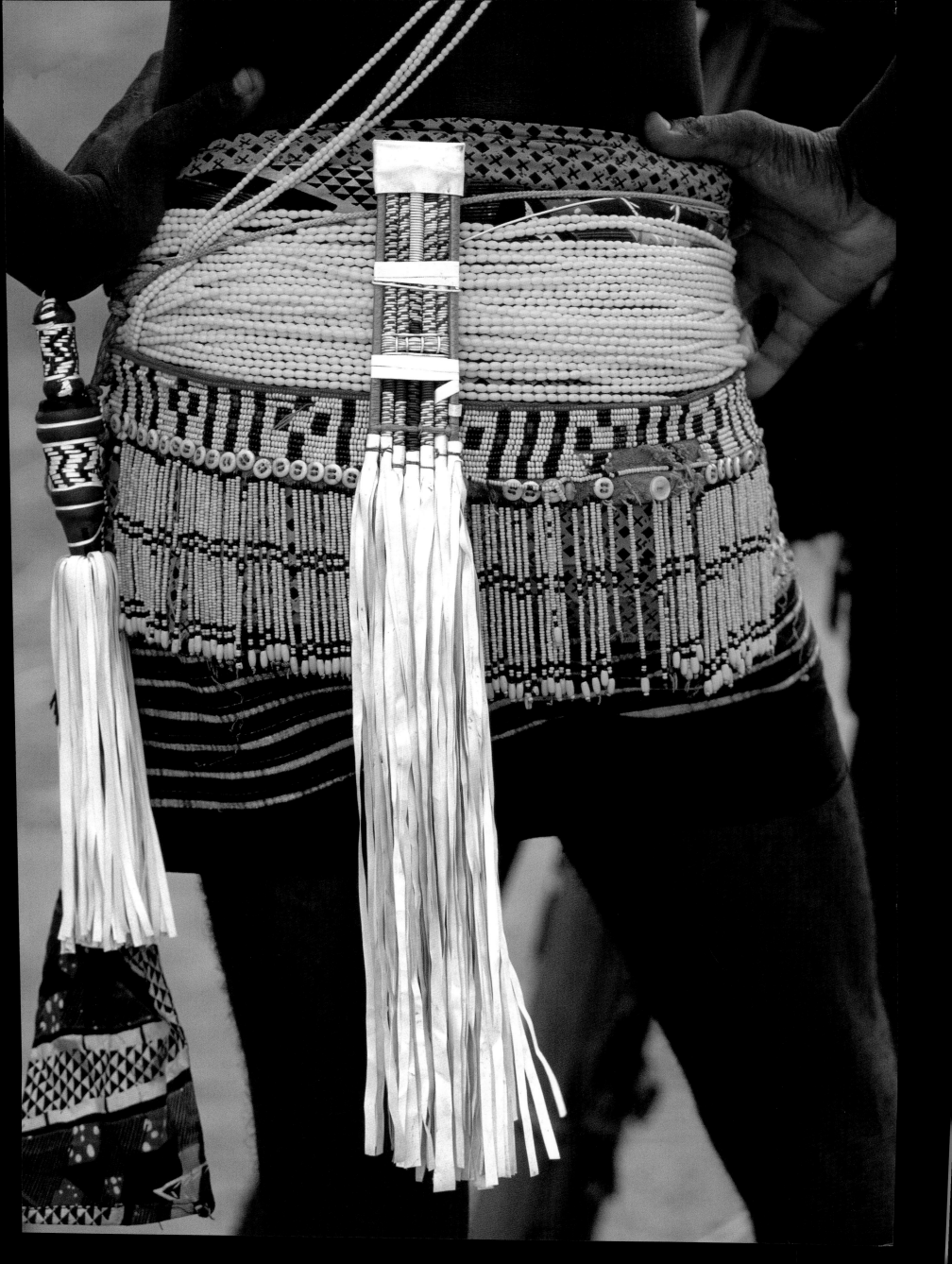

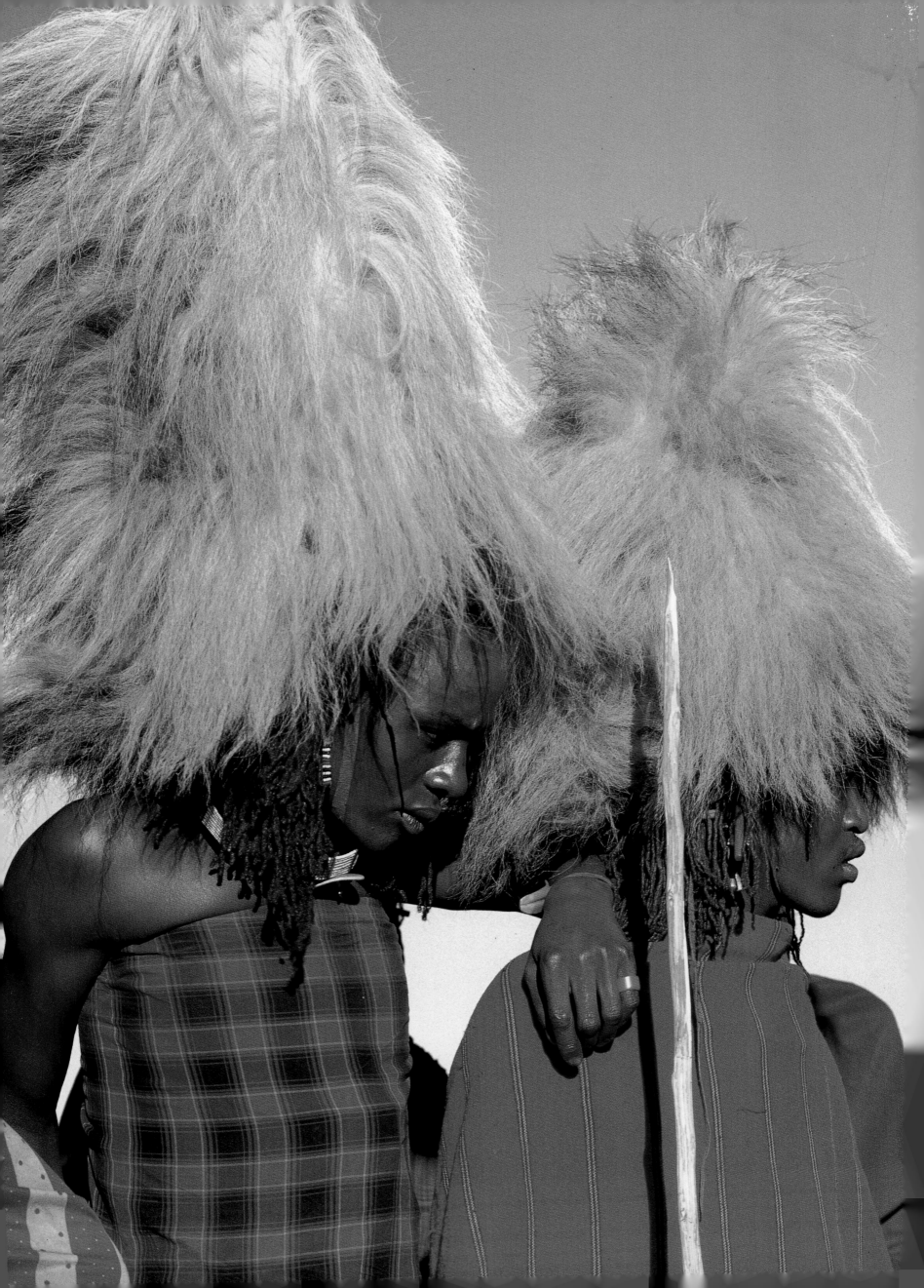

Maasai Warriorhood

Living in the Great Rift Valley of Kenya and Tanzania, the Maasai are believed to have originated along the Nile in North Africa and then migrated southward into East Africa during the fifteenth century. Renowned as great warriors, the Maasai believe that all the cattle on earth once belonged to them, and they still occasionally go on raids to retrieve their stolen herds.

Maasai men move from one stage of life to another with elaborate ceremonies marking each passage. The ritual cycle extends over more than twenty-five years, beginning with circumcision. By far the largest and most spectacular ceremony, occurring midway through the cycle, is the graduation of warriors into elderhood—the Eunoto, a word that literally means "the planting", and is symbolized by the piercing of a hide. After Eunoto, an entire age grade moves from the freedom of youth to the responsibilities of adulthood.

Preceded by many months of preparation, the Eunoto occurs only once every seven years and lasts for four days at a location selected by a *laibon*, a Maasai diviner. At the chosen place, the mothers of the warriors build a ceremonial circle of huts, a *manyatta*, surrounding a large ritual house called *osingira*. There, and at sacred chalk banks nearby, the most important rituals take place. The warriors travel vast distances on foot across Kenya and Tanzania to honor their heritage and affirm their solidarity. When they return home, they face the responsibilities of elderhood—marriage and the acquisition of wealth in the form of children and cattle. Because of the rapidly changing social and political conditions in East Africa, it is believed that the Eunoto pictured here, when 104 warriors passed into elderhood, may have been the last Maasai celebration on such a large scale.

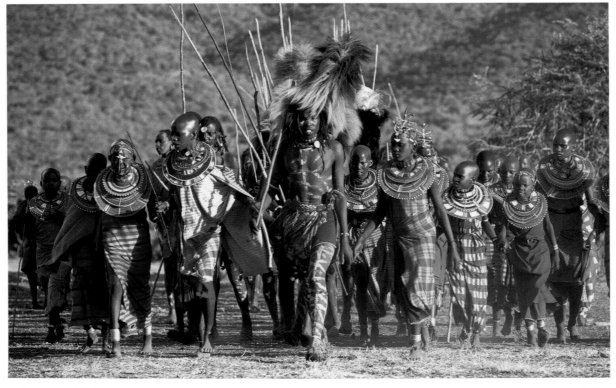

Above and left: The sound of kudu horns echoes across the Loita plains as warriors arrive in full regalia for their ritual passage into elderhood. Accompanied by their girlfriends, they have exchanged their spears for the wooden staffs of elderhood and wear headdresses made from the manes of lions they have killed during warriorhood.

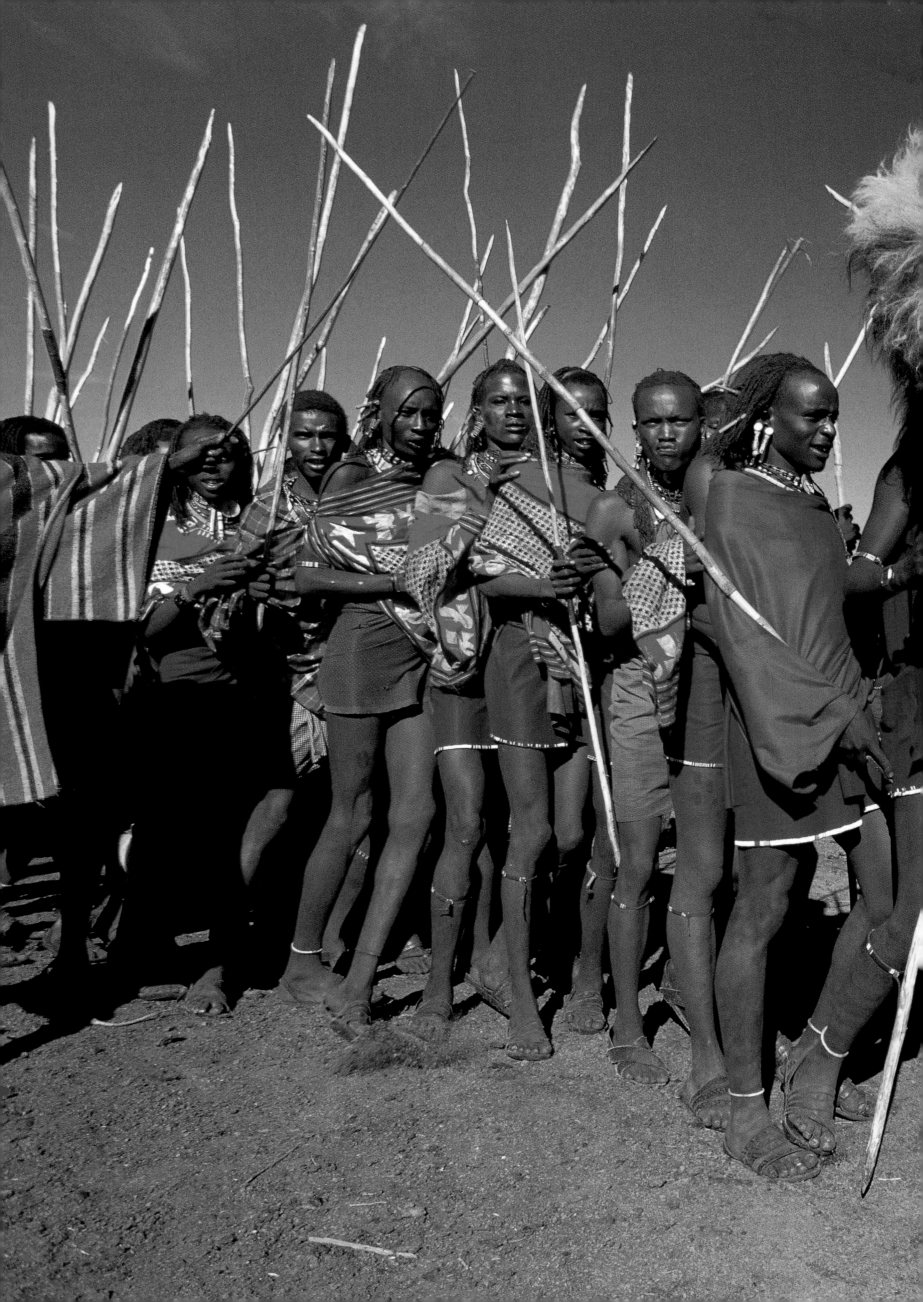

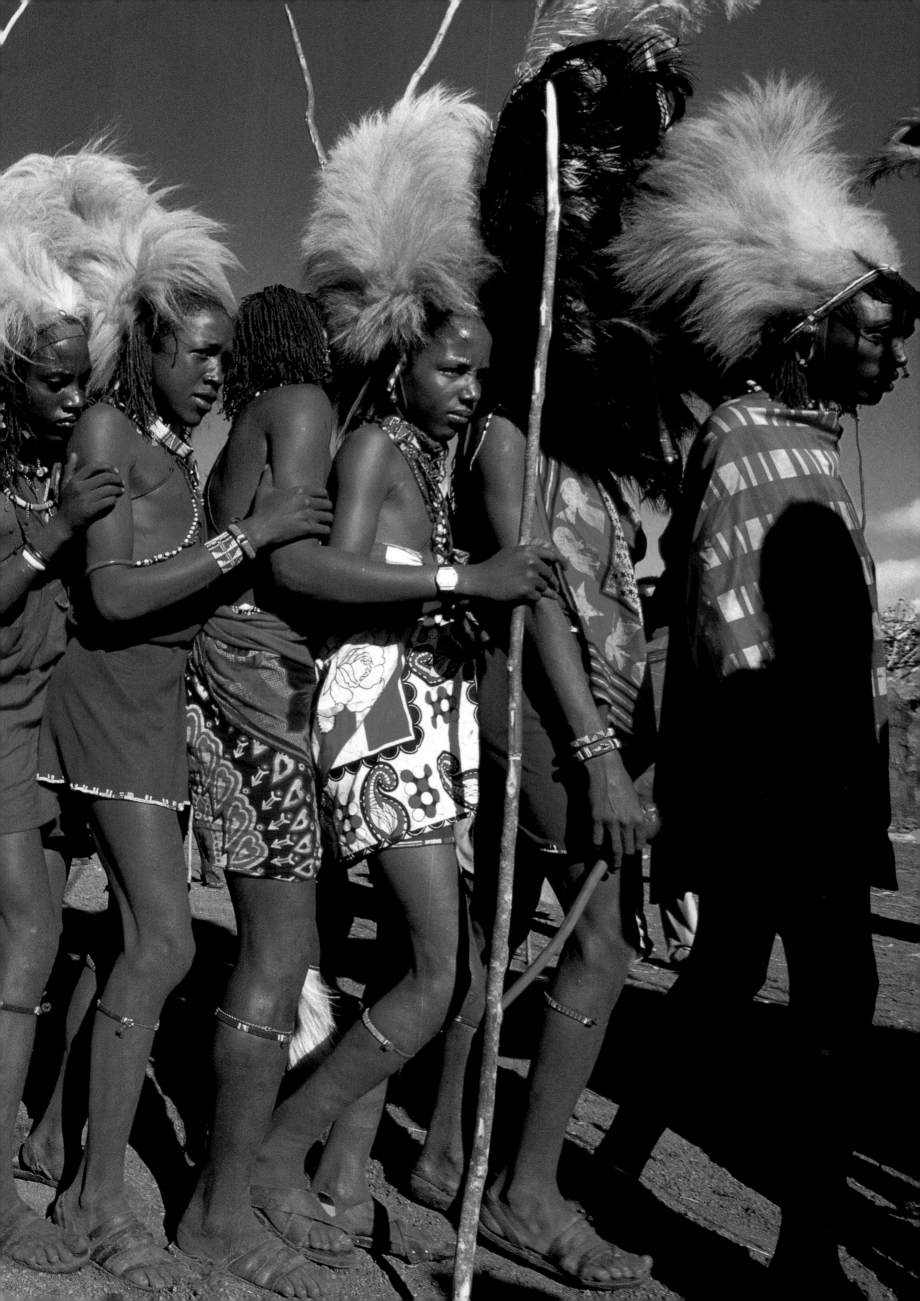

Power of Warriorhood

Preceding pages: Glistening with red ocher, warriors gather for the Red Dance which is dedicated to the hot, fiery aspect of warrior temperament. In song and dance they celebrate those who have distinguished themselves by successfully killing a lion armed only their wits, their courage, and their spears.

Right: In celebration of their impending graduation, the warriors launch themselves into a leaping dance known as *empatia*. With natural grace and ability, they seem to defy gravity. At the height of each leap, the warriors shimmy their shoulders to the accompaniment of the rhythmic, guttural chanting of their age mates. On landing, a warrior often flings his long ochered hair against the cheek of his special girlfriend standing nearby.

Following pages: Throughout the ceremony, young Maasai girls adoringly accompany their warrior boyfriends as they charge about the *manyatta* blowing long horns and carrying buffalo-hide shields decorated with the symbols of their achievement. To carry such a shield, a warrior must have either killed a buffalo – an extremely dangerous feat – or received the shield as a gift from an older brother.

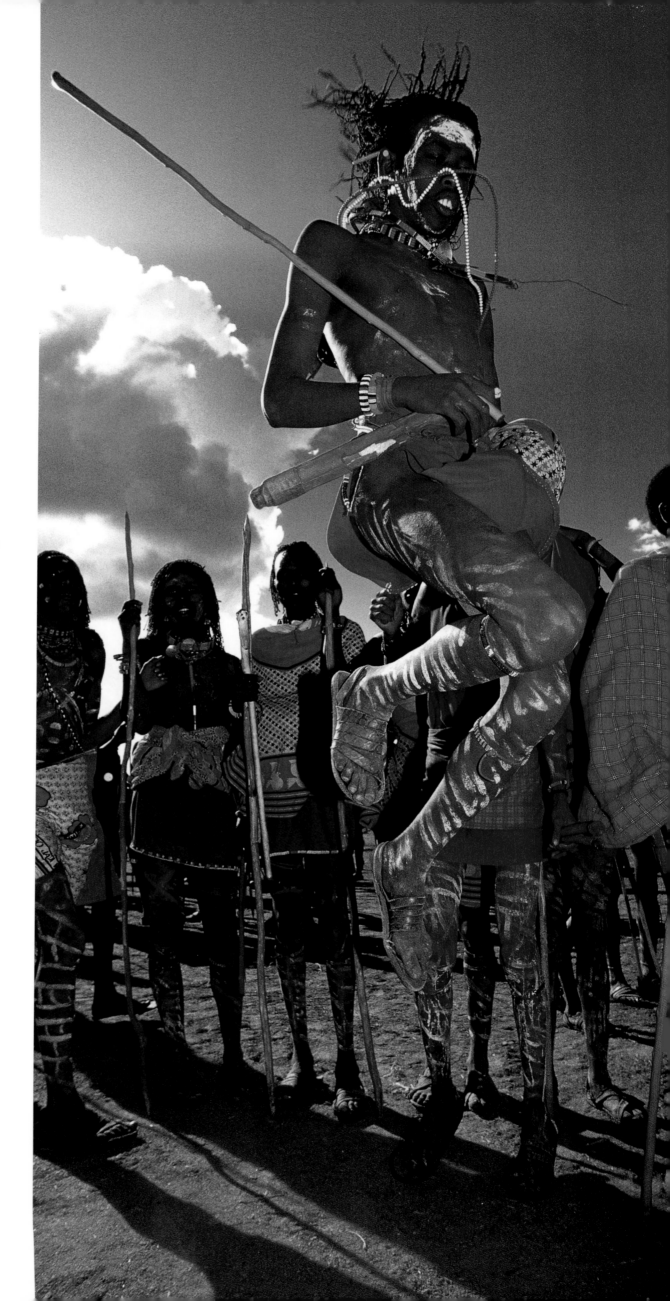

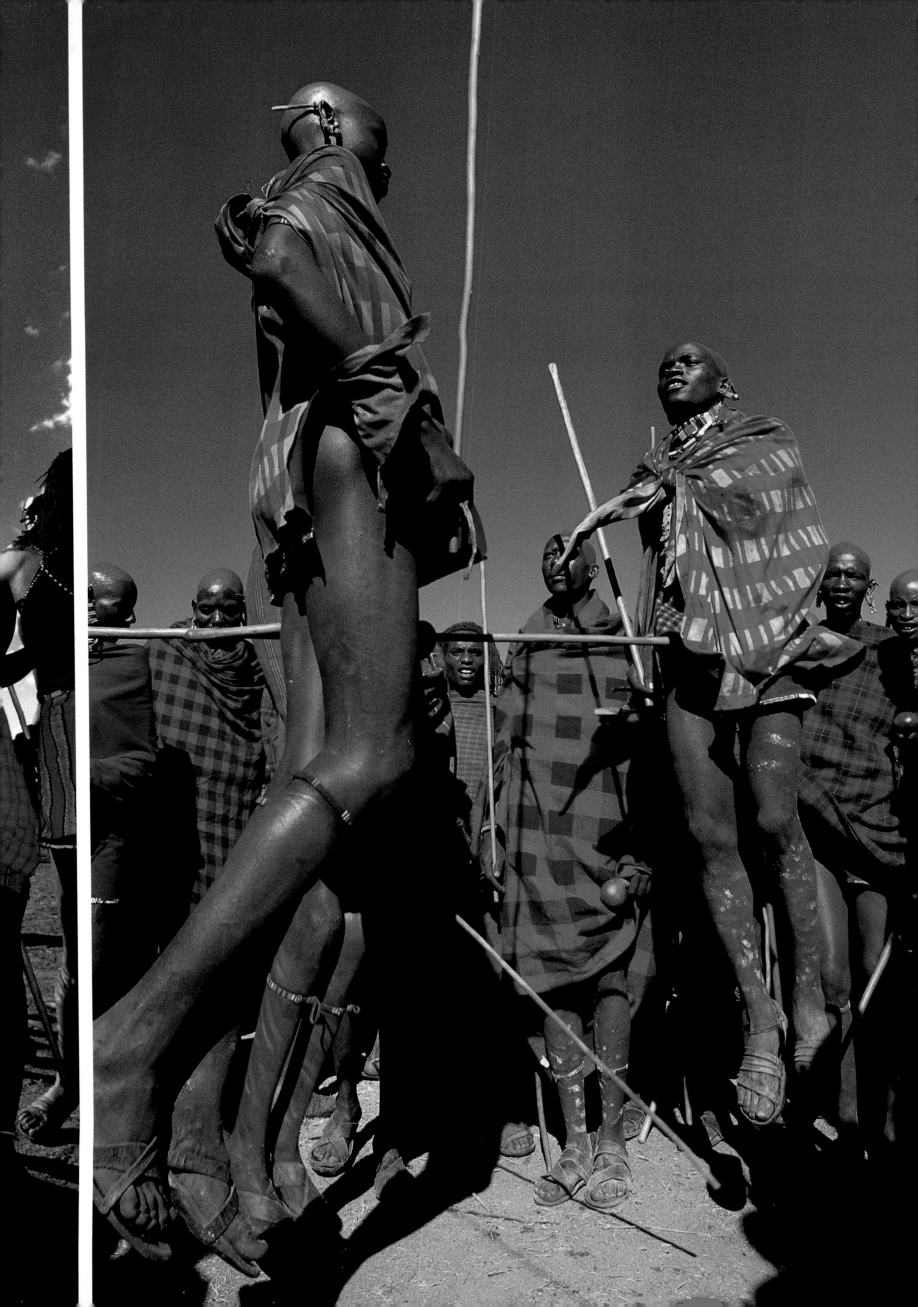

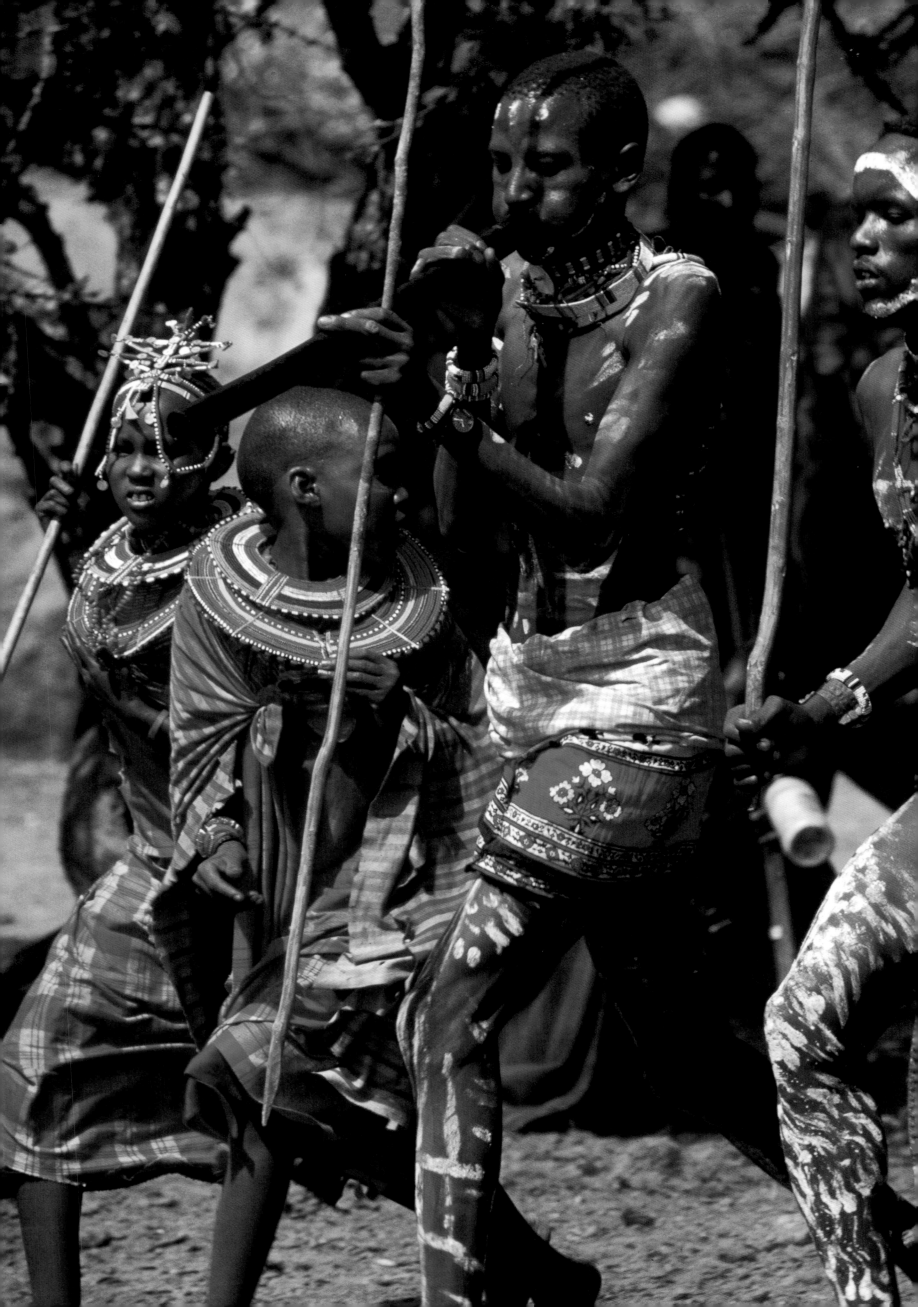

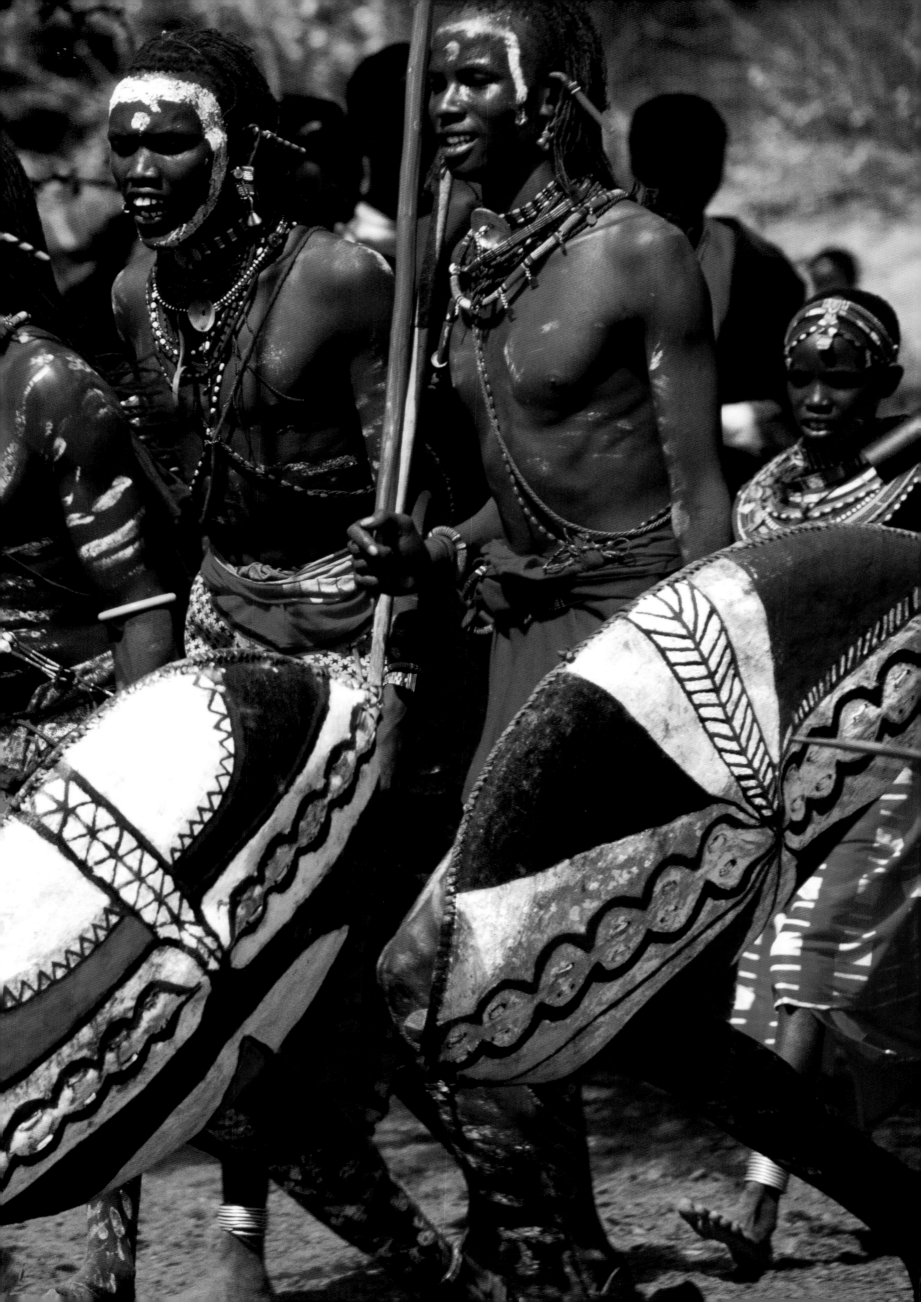

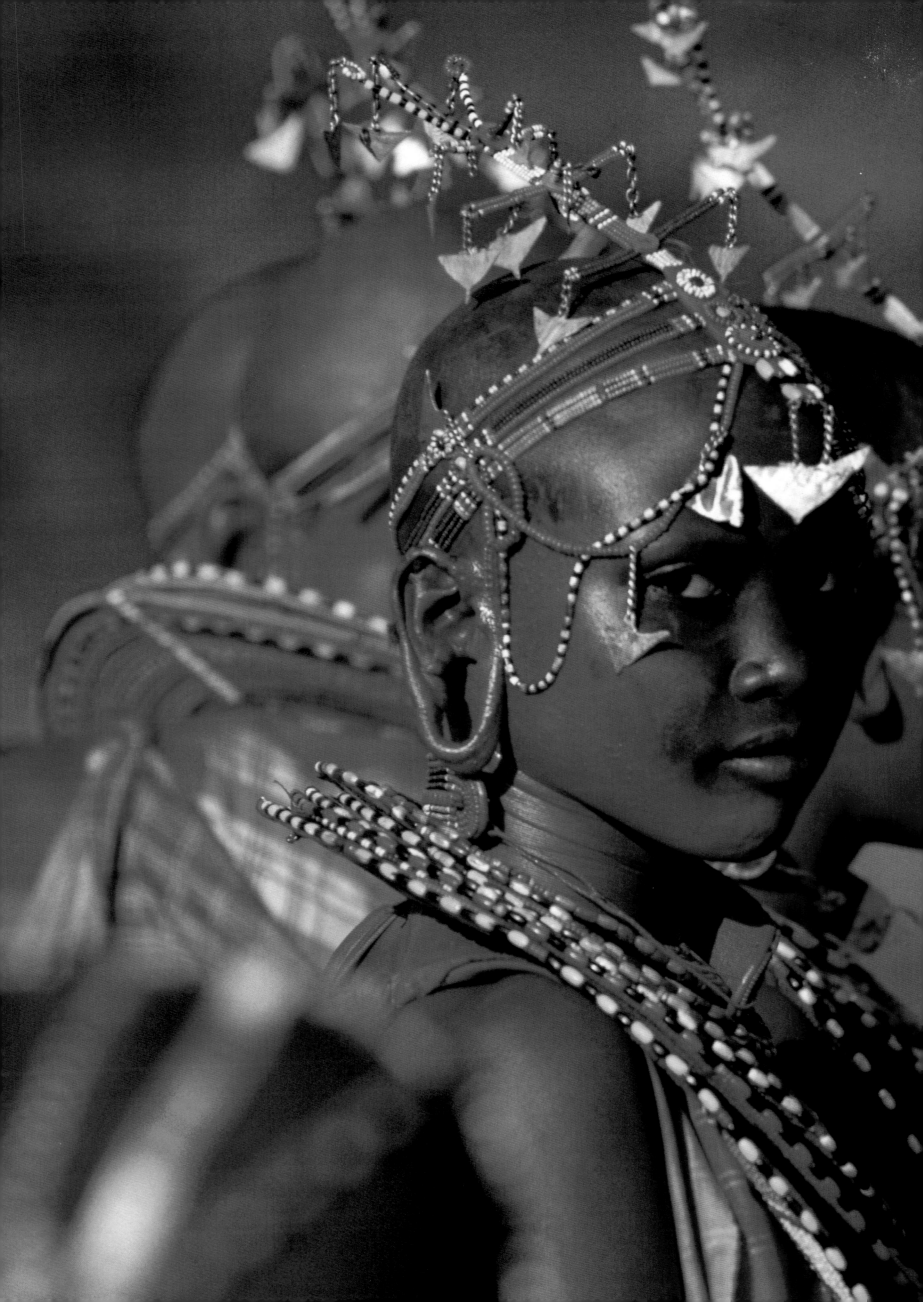

Warriors' Sweethearts

Maasai girls wear beaded collars and headbands designed to enhance their movements as they dance for their warrior boyfriends. The warriors may enjoy intimacy with the young, uncircumsized females. Many of the girls are too young for sexual relationships, but, should sex occur, they do not risk disapproval as they are pre-pubescent, unlikely to fall pregnant and therefore safe from dishonor. This is the one time in their lives when girls are able to enjoy freely chosen relationships. Traditionally, a girl selects three lovers from among the warriors. The first, called "the sweetheart", is the one for whom she prepares milk; the second, known as "the skewer", takes over when the first is not present; the third referred to as "the one who crosses over", may court the girl's favors when the first and second are absent. There is no jealousy among the three lovers, and they respect each other's status in relation to the girl.

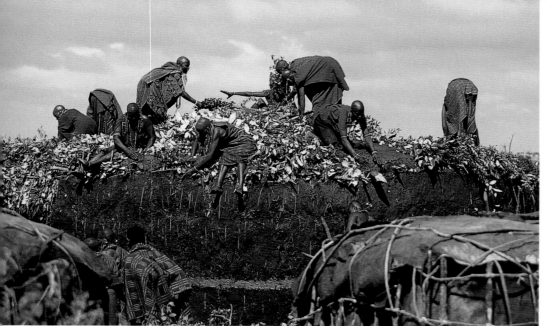

Overcome with Emotion

On the third day of the ceremony, the warriors – who have retreated to the forest – rush back to the *manyatta* calling out the names of their ancestors. They head straight for the *osingira*, a ritual hut built by the forty-nine mothers whose sons are thought to be the most distinguished. The *osingira* is supported by a massive center post "planted" by the warrior singled out as the ritual leader of his generation.

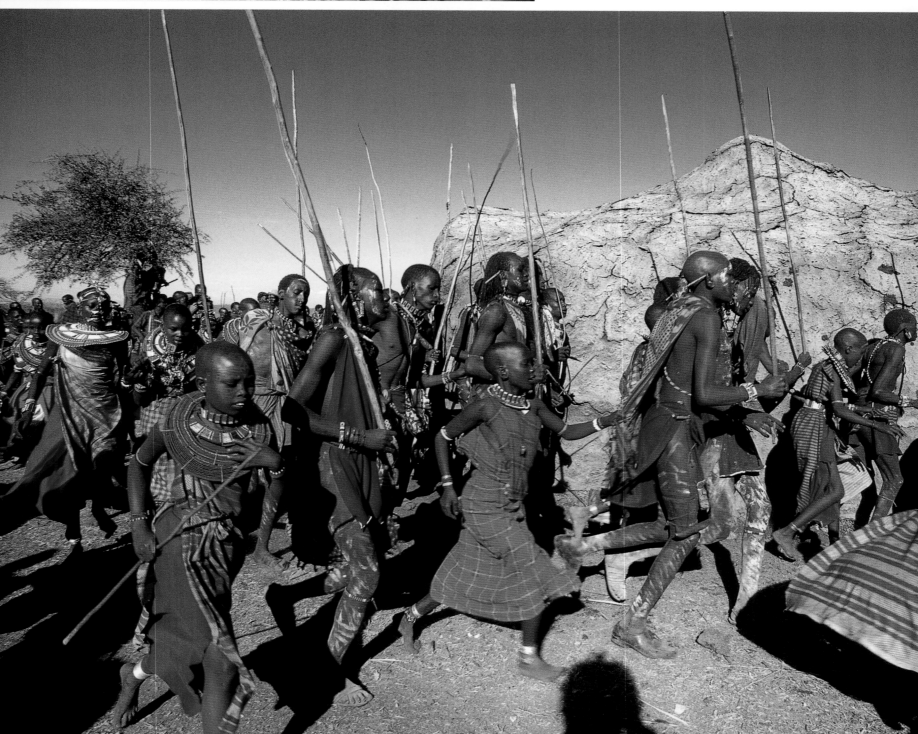

The warriors are distraught to be leaving warriorhood, and some are highly nervous, especially those who have slept with circumcised women and may be refused entry to the sacred house. As they circle the *osingira* with increasing speed, they become consumed with emotion. *Right*: Writhing and foaming at the mouth, a warrior falls into a rigid trance-like state called *emboshona*. He is completely unaware of his actions. His ostrich headdress is removed for safekeeping, and he is forced to the ground and held by his mother until he recovers. Later, the most sacred part of the initiation takes place as the warriors, deemed to be pure and moral, enter the *osingira* to spend the night drinking milk, eating special food, and performing secret rituals.

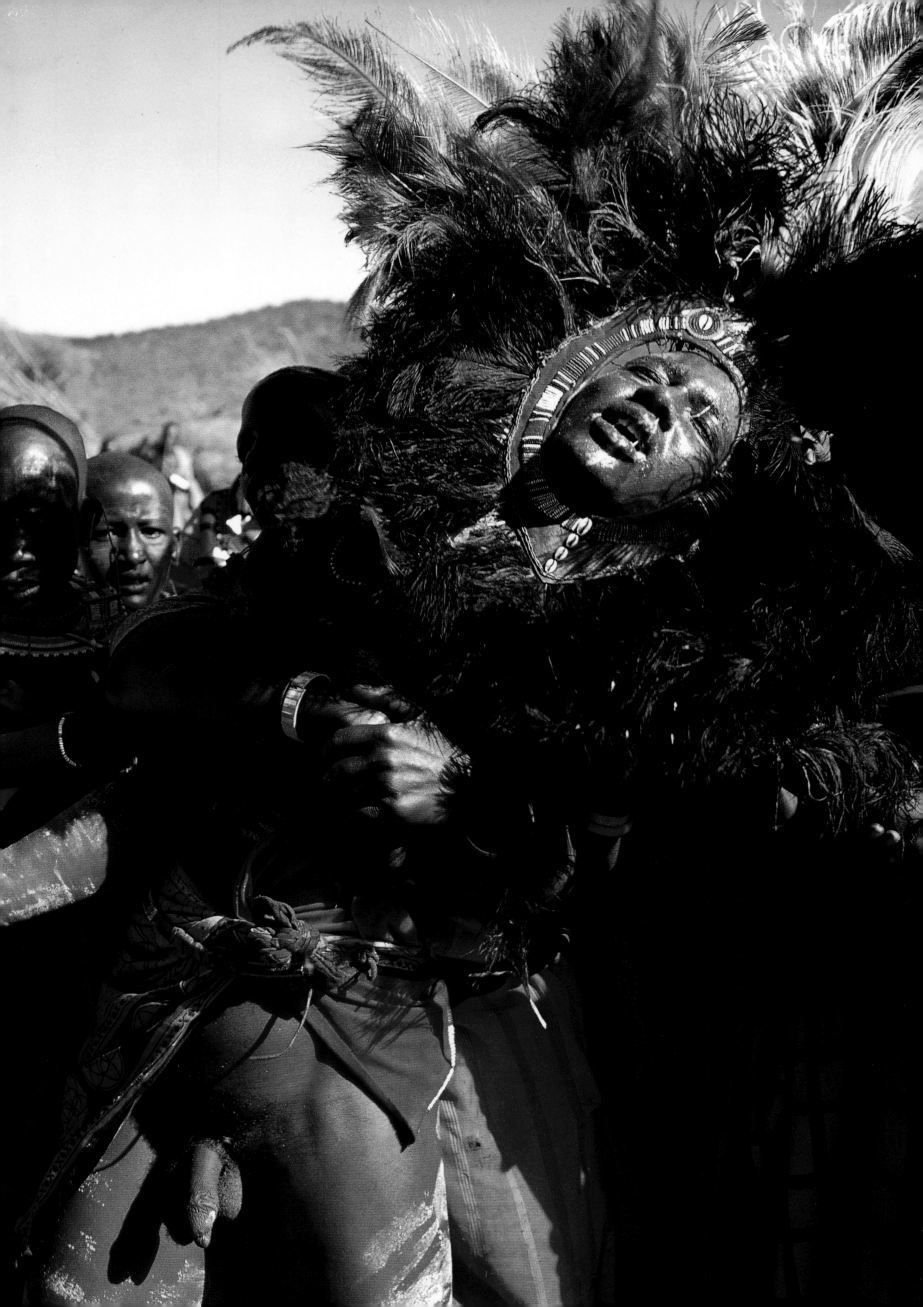

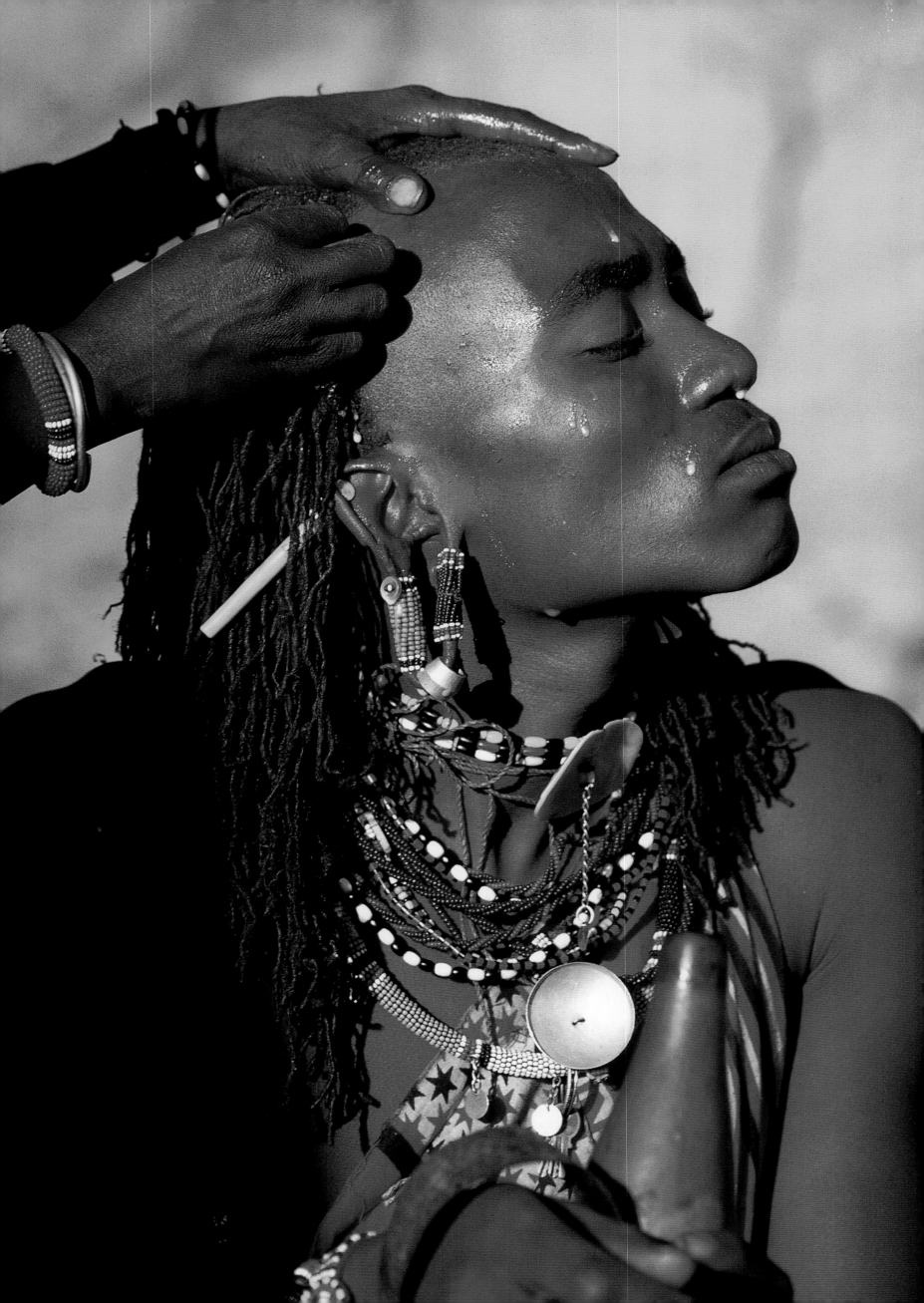

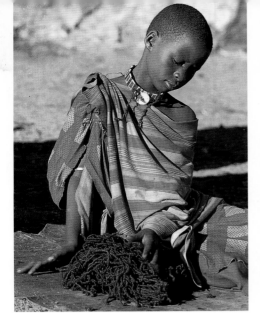

The Final Blessing

At sunrise on the final day of the Eunoto, the mothers and their sons prepare for the most poignant ritual of the ceremony. Using a sharp blade and a balm of milk and water, each mother shaves off the long locks of hair that have identified her son as a warrior for the past ten or more years. A Maasai taboo rules that a mother who has had sexual intercourse with a man of her son's generation will be denied this privilege, but if she is morally unblemished she will play the most important role in her son's life since she gave birth to him. *Above:* A warrior's young girlfriend caresses his fallen locks, knowing that her special relationship with him will soon end. Following his graduation, he will leave her to marry a circumcised woman.

Following pages: After the heads of the newly shaven initiates have been rubbed with glistening red ocher, the young men gather to receive the final blessings of the elders. The initiates sit in quiet reflection as the elders walk among them, chanting prayers and spraying them with mouthfuls of milk and honey beer. The elders bless the men with the words, "May Enkai give you a long and healthy life, may Enkai give you many children and cattle, and may you enjoy true *arkasis* (wealth)." The ceremony over, a new generation of elders returns home to face the challenges and responsibilities of the next stage of their lives.

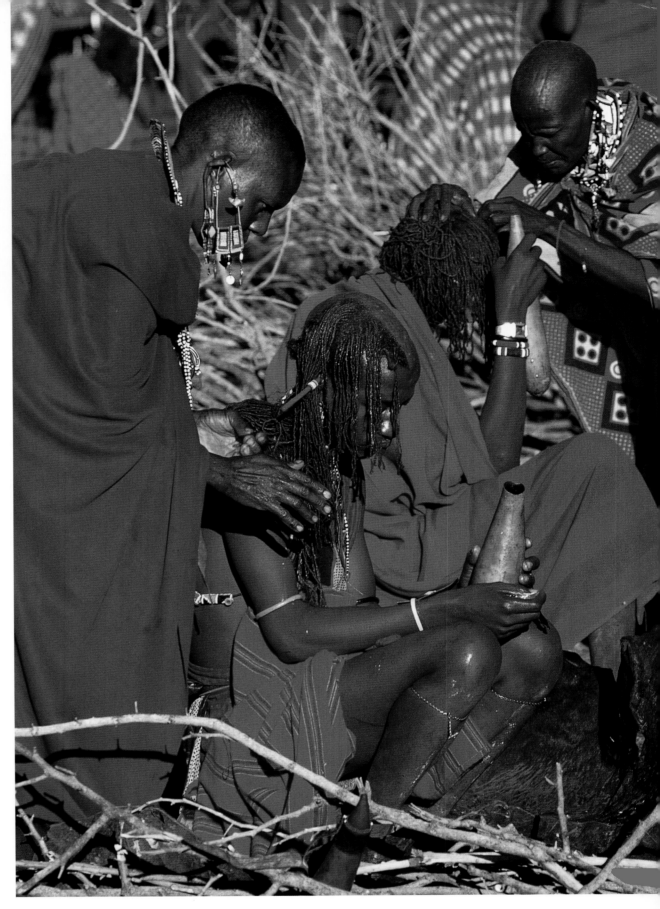

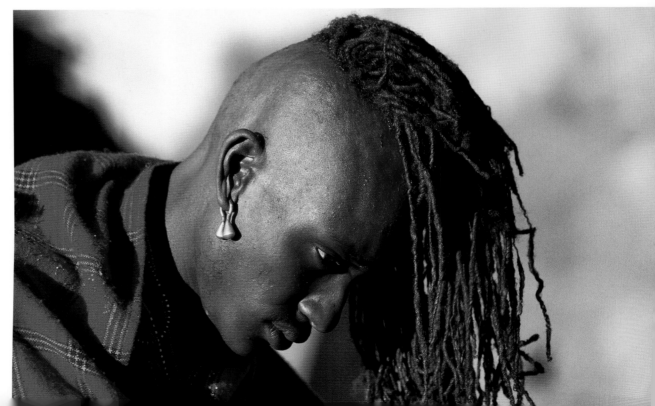

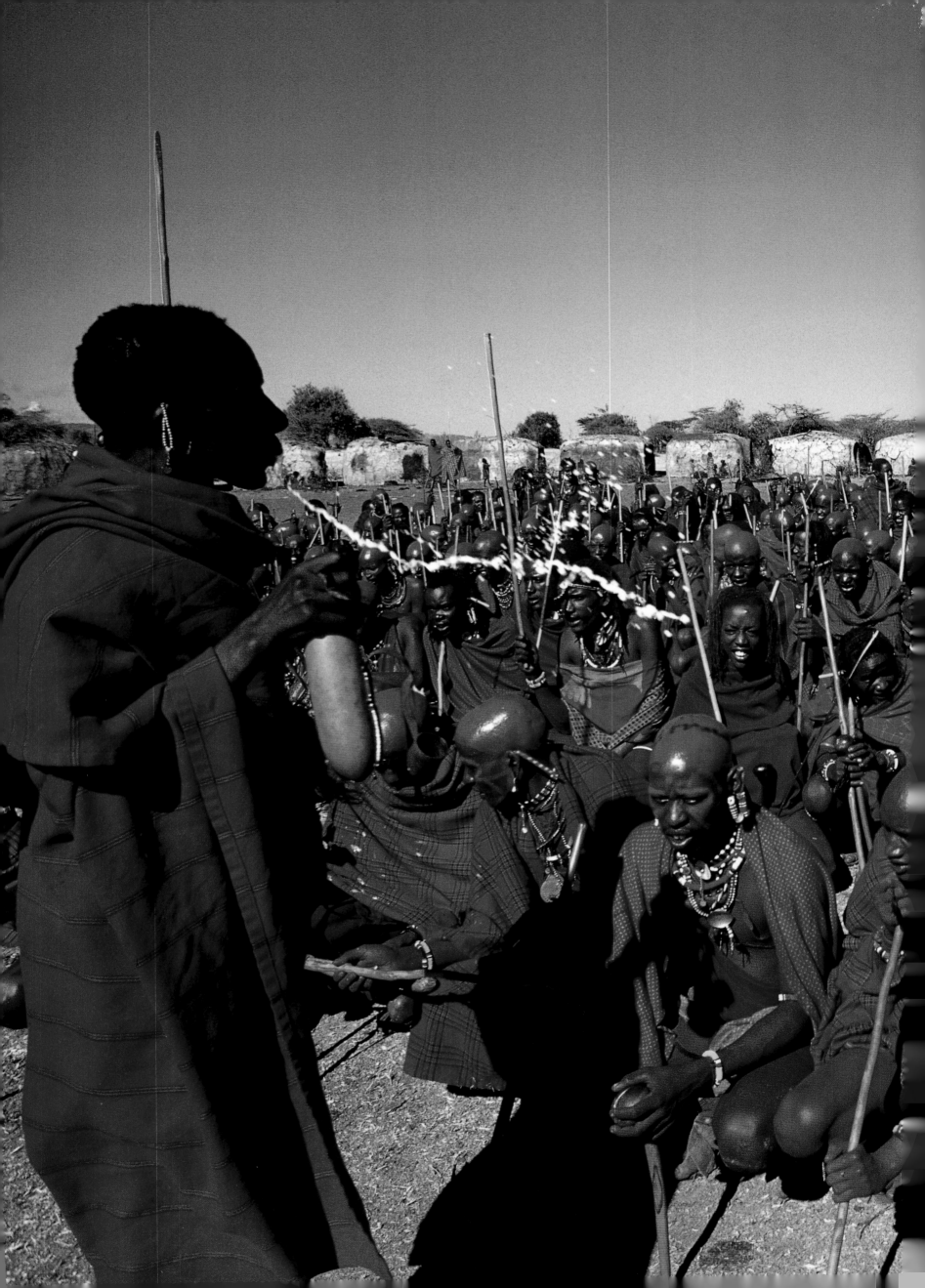

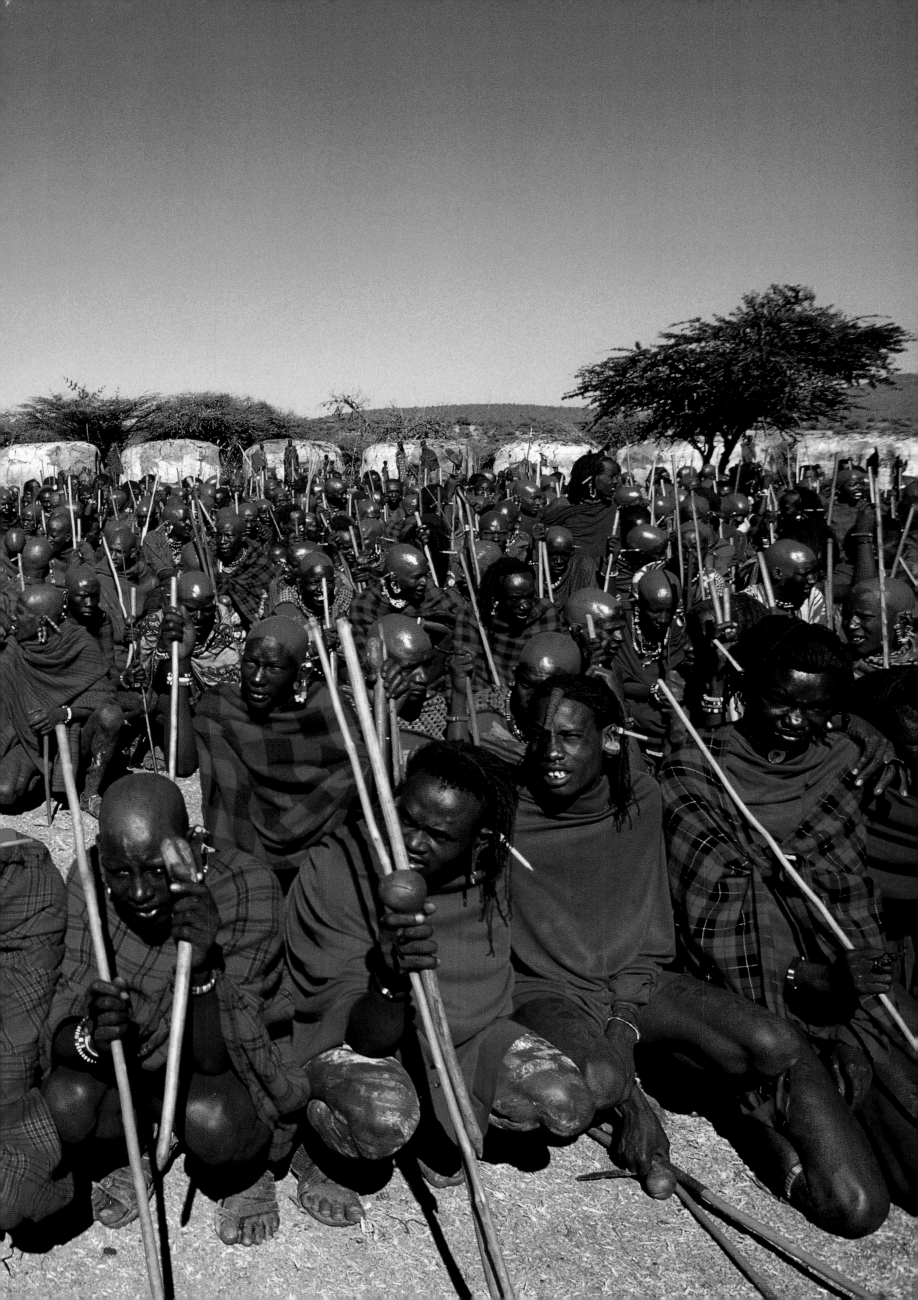

COURTSHIP & MARRIAGE

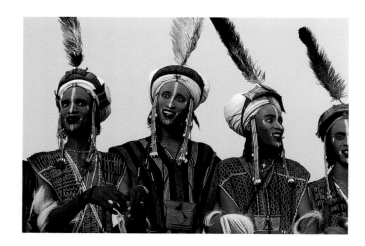

Nebi, the graceful young Wodaabe girl, took us aside and whispered, "When the dancers pass by, run your fingers along the back of the man of your choice. He will pretend not to notice, but if he desires you, he will meet you afterward in the bush." Intrigued, we watched Nebi study each dancer by the light of the moon. When she saw Bango, she moved discreetly around the circle of dancers and placed herself directly behind him. The men were trembling from the hypnotic effect of their chant and the slow movement of the circle. Bango's face was painted yellow and white, his lips were blackened, and the long line of his profile was accentuated by an ostrich plume on his head. Nebi lifted her hand and ran her fingertips along Bango's back, barely grazing his smooth, copper-colored skin. He pretended not to notice. Minutes later Bango caught Nebi's furtive glance and winked at her several times. She lowered her eyes, as required of Wodaabe women engaged in the act of seduction. Bango twitched the corner of his mouth, indicating the place he had chosen for their meeting.

Nebi slipped away from the dance circle and followed Bango into the open plains of the West African Sahel. The desert offers no privacy; we wondered where Nebi would go. At that moment we saw Bango unfold a large colorful blanket. Nebi squatted on the ground, and Bango covered them both. As our eyes adjusted to the darkness, we glimpsed several colorful mounds of blankets scattered about the plain, all in motion. We could recognize the owners by the familiar designs on their blankets, but the Wodaabe have a saying "What the eyes do not see does not happen." Nebi was safe and invisible under Bango's blanket as she began what would become a permanent relationship.

Nebi's story is a part of a complex set of fascinating behavior patterns that the Wodaabe of Niger have developed to handle the pressures of courtship, seduction, and marriage in a challenging desert environment. Through their unusual marriage practices, the Wodaabe have tried to find a balance between the age-old tensions of romantic passion and family stability. Their broadly accepting view of human nature has helped them survive as a nomadic people in the inhospitable Sahel of Niger.

COURTSHIP

Across Africa, the seductive signals that people transmit to members of the opposite sex are complex and ancient. The many ways of attracting romantic partners range from flirtatious gestures to gifts that carry coded messages. The signals also include a wide variety of

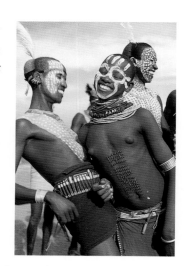

bodily adornments designed to enhance attraction and indicate availability.

At their annual dances, Wodaabe men preen and paint themselves to attract wives and lovers. Performing dances to exhibit their great physical beauty and charm, they express the legacy of their ancestors, Adam and Adama. It is often the women who select their husbands and lovers. Although the Wodaabe place great emphasis on physical beauty, they say that an individual's personal charm (togu) will always attract the opposite sex even if he or she is not beautiful: "A person with togu will never be alone."

Among the Surma of Ethiopia, attraction to

women is based more on practical qualities and less on physical beauty. Our friend Kolaholi explained that Surma men are instinctively drawn to a girl who is a hard worker and has a cheerful nature. His wife, Natero, added that Surma women are attracted to masculine strength, as demonstrated by powerful Donga stick fighters whose many scars are a testament to their conquests in battle.

In some African cultures, nonverbal signals communicate romantic intentions. A Wodaabe man lays one finger on top of the other to indicate that he wants to sleep with a woman. She places one finger beside another to indicate her agreement. When a nomadic Tuareg woman of the Sahara admires a man, she will approach him after a camel race, rubbing the loose dye from her indigo veil onto the nose of his camel to indicate her interest. In response, he will force the camel onto bent knees and walk the animal alongside his female admirer.

In South Africa, Zulu girls bestow beaded necklaces on young men they admire. These necklaces are called love letters and are encoded with colored messages. White means, "My heart is pure and white in the long lonely days." Black means "Darkness prevents my coming to you," and is given to a man when a girl is longing to meet him but is unable to do so.

ADORNMENT

Clothing and jewelry play an important role in seduction; they are used to reveal as well as conceal. Tuareg women in Mali use their long tressed hair to communicate a message: one braid drawn across the forehead indicates that a girl is single and available for courtship; two braids signify that she is married. An unmarried woman wears a single tunic and as many as two skirts; a married woman wears two or three tunics and up to four skirts. In some cultures, puberty aprons are worn to reflect the stage of a woman's life. An unmarried Surma girl wears a burdensome ten-pound chastity belt made of iron beads to help protect her virginity. This will be exchanged for a soft hide skirt on the day of her marriage. One of our Surma female friends privately confided that when she was a girl she was not allowed to remove her chastity apron, but she occasionally slid it around to her back in moments of passion.

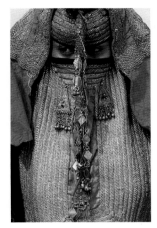

In Muslim societies, concealment is often woven into the art of seduction. A Rashaida groom in Eritrea cannot see the object of his affection behind her mask and must choose her for the beauty of her eyes, voice, maturity, and personality. One Rashaida man told us that if he ever dared to look beneath her veil, he would be put to death by the sword. Even having premarital sex with his beloved would not be considered as serious a social transgression as seeing her mouth. In Berber society, Ait Hadiddou women wear coded head coverings when they attend the annual Brides Fair at Imilchil. A girl wearing a rounded hood displays her status as a virgin. The man who courts her must be prepared to spend as long as one year negotiating with her family for her hand in marriage. A woman who wears a pointed hood identifies herself as a widow or divorcée and announces her availability for an instant marriage at the Brides Fair.

BRIDE WEALTH

Bride wealth is established by the father of the bride and indicated in a number of different ways. Once a Surma girl is betrothed, a circular clay plate is inserted into her lower lip. Over a period of six months, her lip is successively stretched, and increasingly larger plates are fitted. The final plate indicates the size of the bride wealth that will be expected by her family. A large plate may command as many as seventy-five cattle. Among pastoral people, it is usual for bride wealth to call for twenty-five to thirty animals. This represents a substantial sum, since a cow in Africa may be worth as much as $100 and a camel as much as $500.

Among the sedentary Berber, a groom and his family make the nuptial payments for a virgin bride in installments. First, a large payment of cattle and money is made. Next, the groom pays the girl's family a quantity of sugar, dates, henna, and tea. Third, he sends a donkey laden with gifts, including clothing and jewelry, to the bride's house. Finally, he dispatches to the bride's family a three-foot-wide pancake that can feed as many as forty people.

Wodaabe brides are given a special collection of calabashes (hollowed-out gourds) by their husbands, families, and friends. These calabashes have no practical use. They are treasures representing bridal wealth and are displayed at an annual three-day collective celebration of births and marriages called the Worso. Our Wodaabe friend, Magogo, received more than three hundred calabashes, which she now transports through the desert on a special pack ox, displaying them only at the Worso. During the drought in 1984, her pack ox died, and she and her friends were forced to tie their calabashes to the branches of acacia trees, hanging talismans around them for protection from theft. Magogo returned a year later, with a new pack ox to collect her calabashes, and, true to her belief, she found that the bundles had remained undisturbed.

PREPARING THE BRIDE

In many African societies, the bride enters a period of preparation for marriage, during which she is isolated from the community to undergo rituals that will prepare her for a new role as wife and mother. A Swahili bride receives beauty treatments while secluded for several days behind a curtain in a special chamber. Her hair is ceremonially washed, her body is massaged with coconut oil and perfumed with sandalwood, and her hands and feet are decorated with henna. A wise older

woman called a *somo* teaches her traditional ways to please a man. Outside her family, the only men she is allowed to see during this period are homosexual males, who are not considered a threat to her maidenhood. These young men often train her in the domestic arts of married life. They also give the groom sexual counseling, performing an erotic dance to the accompaniment of Tarabu music. Occasionally, these homosexual men, known as *shoga*, convey secret messages between the prospective bride and groom, who are forbidden to meet before marriage.

Among Islamic societies such as the Hassania and

Berber, bridal body decoration involves the application of intricate patterns in henna to the hands and feet. A Himba bride ochers her entire body, which both beautifies and perfumes her, since the ocher includes aromatic ingredients. Both of these body applications also play a protective role: henna guards against djinns and evil spirits, and ocher screens the skin from the harsh sun. Animist peoples such as the Karo and Geleb use chalk body painting to enhance the bride's beauty.

Concealing the bride in elaborate veils and wedding masks plays an important part in Islamic weddings in Swahili and Rashaida cultures. Except in the presence of her family, a Swahili bride will be hidden by a body veil until the night on which she consummates her marriage. Less strict in their observance of Islam, Berber brides wear veils only at the time of their marriage, while Wodaabe brides are covered with blankets and concealed in the bush throughout their entire wedding ceremony.

A woman's most exotic and valuable jewelry is brought out at the time of her wedding. Songhai brides of Mali encrust an elaborate cone-shaped hairstyle with silver, gold, and ancient glass beads in a style of decoration that has been worn since the sixteenth century, the height of the Songhai Empire. The magnificent gold earrings and amber beads woven into the hair of a Fulani bride represent family wealth. Ndebele brides wear immense beaded hoops around their legs and hips to accentuate the voluptuous weight that their men so admire.

THE WEDDING CEREMONY

Traditional African marriages comprise a series of ceremonies that range in length from one day to a week. These frequently involve separate events for the bride and groom and their respective guests. Some weddings may even exclude the bride and groom, who may be in ritual isolation during this time. In strict Islamic societies, many brides and grooms are not allowed to see each other until they consummate their

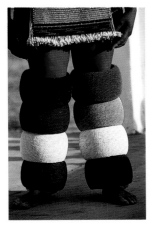

marriage. Even in animist societies, the bride may be kept in seclusion for most of the nuptial events. A Surma bride makes only a brief appearance during her wedding, wearing her newly fashioned lip plate and dressed in new hides. She is accompanied by an older woman, who holds a large wooden spoon and ritually mixes an invisible pot of porridge—a symbol of the bride's new domestic life. As she stirs the imaginary porridge, she sings "You are no longer a girl, but a woman, no longer free to roam the forest."

Feasting, dancing, animal sacrifice, and blessings are consistent elements that ensure the community's participation in marriage rituals. These social threads of the wedding fabric are designed to bond the two families and their larger world. Some of the most dramatic wedding dances are performed by the Zulu, who stage mock conflicts between the families of the bride and groom. The bride's family ritually resists her removal and demands proper compensation from the groom's family, who bid to take her away. This wild and aggressive dance finishes only when a sacrificial bull is driven between the two parties.

LEAVING HOME

At a designated point during a wedding, the bride leaves her home to move to the household of her husband's family. This process may be highly emotional, particularly if the girl is quite young and inexperienced

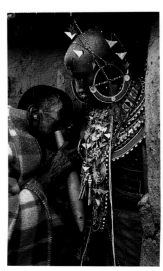

in the ways of the world. When a Maasai bride leaves her father's kraal, she is told that she cannot look back or she will turn to stone. The Maasai groom's best man clears all obstacles from the bride's path, but there is one impediment he cannot clear. Waiting for the young girl at her husband's compound is an aggressive gaggle of his female relatives—all hurling insults and cow dung at the girl. This is a test to see if she will be able to handle the difficulties that life may throw at her. Some of the epithets flying her way include "You're as ugly as a donkey with crooked legs!" "You're as short as a pygmy!" This last insult is especially harsh for the Maasai, who pride themselves on their long legs and statuesque bodies. In contrast

to this treatment, the Zulu of South Africa often send a bridesmaid to accompany the bride during her first month in the home of the groom—a sympathetic way of gently easing the bride into her new life.

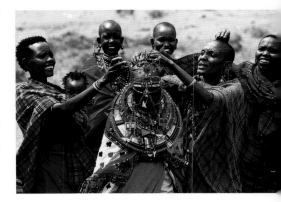

DIVORCE

In societies where marriages are arranged and women marry at a young age, social customs have developed to allow for escape from an unhappy marriage. In most cases, if the girl repays her bride price, she is immediately released from the marriage. Most women, however, cannot muster sufficient wealth.

Barrenness is one of the most pressing causes for divorce. A woman without children has no place in society and may even be viewed as a cursed being. Maasai women continually pray for children. When they pass a holy tree, they place green grass or a beaded necklace or anklet on its branches to ask for fertility. The following personal prayer-song of a barren Maasai woman, translated by Tepilit Ole Saitoti, illustrates how sad and lonely life can be for a woman without a child:

I cross savannas unescorted
And the lion roars at me
The black-maned lion roars at me
And the one without a mane.
The black-maned lion alongside the zebra
I pray to the One with many colors
So he will give me a child.
Then I can stay home like a
Real woman and stop wandering.

Surma Courtship

The Surma people live in the remote wilderness of southwestern Ethiopia, near the border of Sudan. In past times, the Surma lived as pastoralists, but over the decades they have been subject to relentless armed cattle raids by their neighbors, the Bumi, who have also stolen the best grazing areas, pushing the Surma north from their original homelands. Today, they supplement their livelihood with agriculture, growing crops of sorghum and maize, which have become part of their staple diet.

Celebrations of courtship and marriage take place after harvest season, when food is plentiful. During this time, young Surma men and women spend considerable time painting their bodies and adorning themselves to attract the opposite sex. Marriage proposals are traditionally made by a man selecting a bride and then negotiating a bride-price of cattle to be paid to her father. There is a dramatic alternative, however, in which young women choose a husband. This happens after an extraordinary competition among the men, called the Donga stick fight.

The Donga tournament begins in November at the end of the rainy season and continues weekly over a three-month period. Competitors often walk up to thirty miles to reach the fighting venue, where top fighters from each village challenge one another to duels. The stick fight, considered the most vicious of all sports across the African continent, has no rules except that a competitor must not kill his opponent. The winner of the tournament not only earns the esteem of his peers but also becomes the first choice of one of the most desirable girls, who is singled out by her peers to select the victor as her husband.

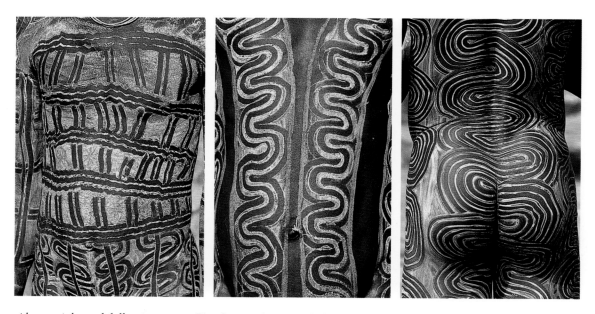

Above, right and following pages: The Surma decorate their bodies with chalk paint and ocher pigments in a variety of designs to beautify themselves and attract the opposite sex.

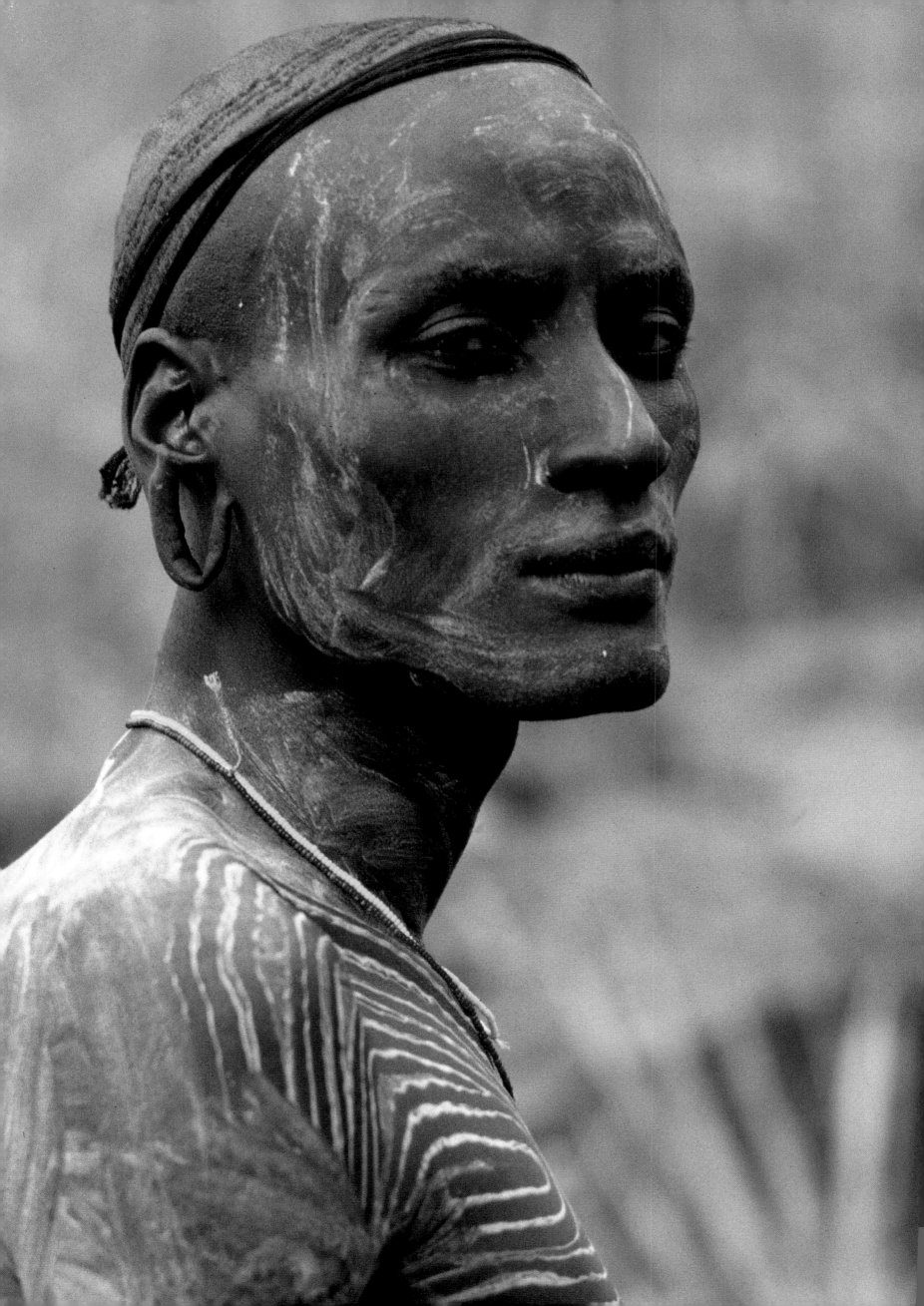

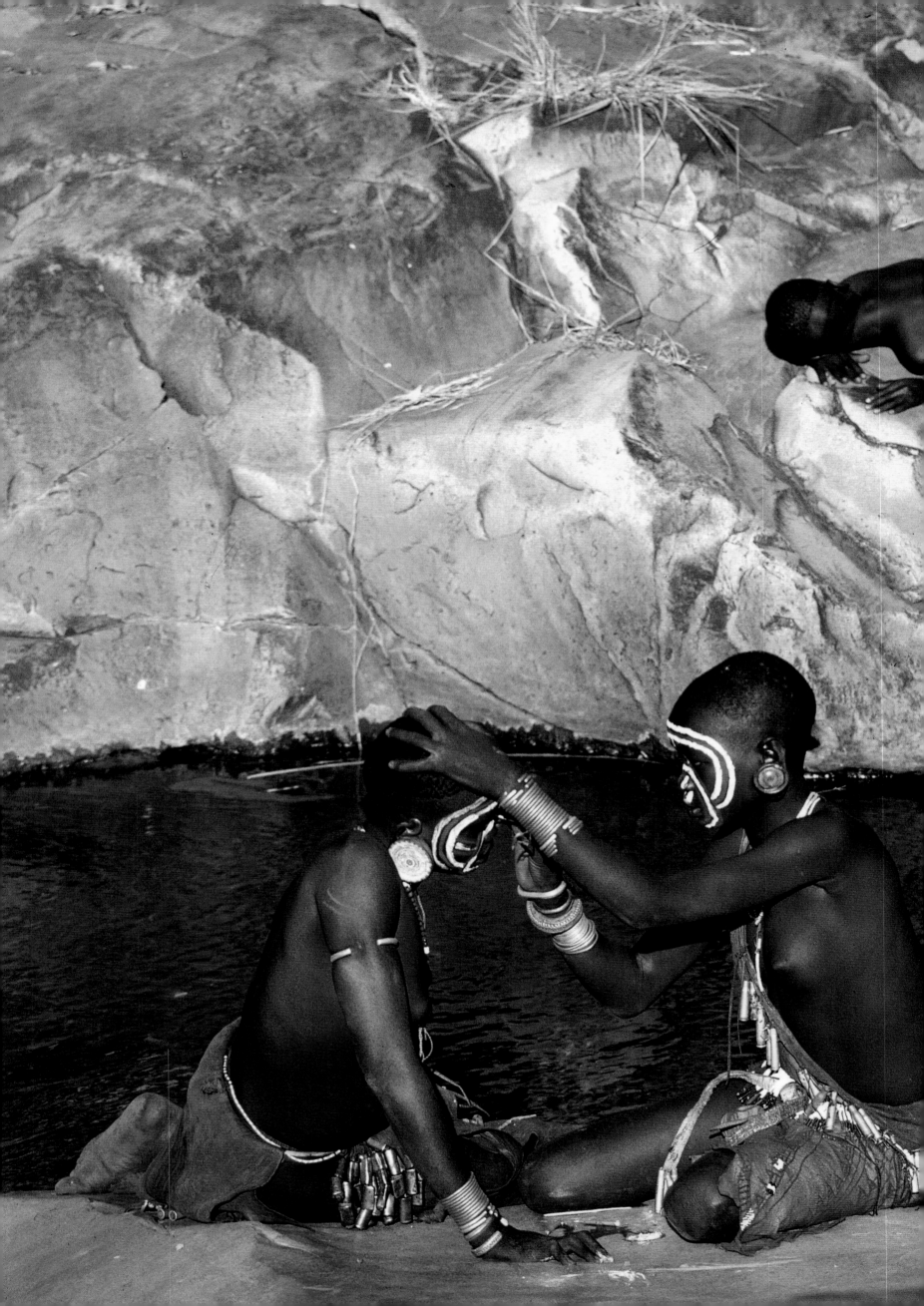

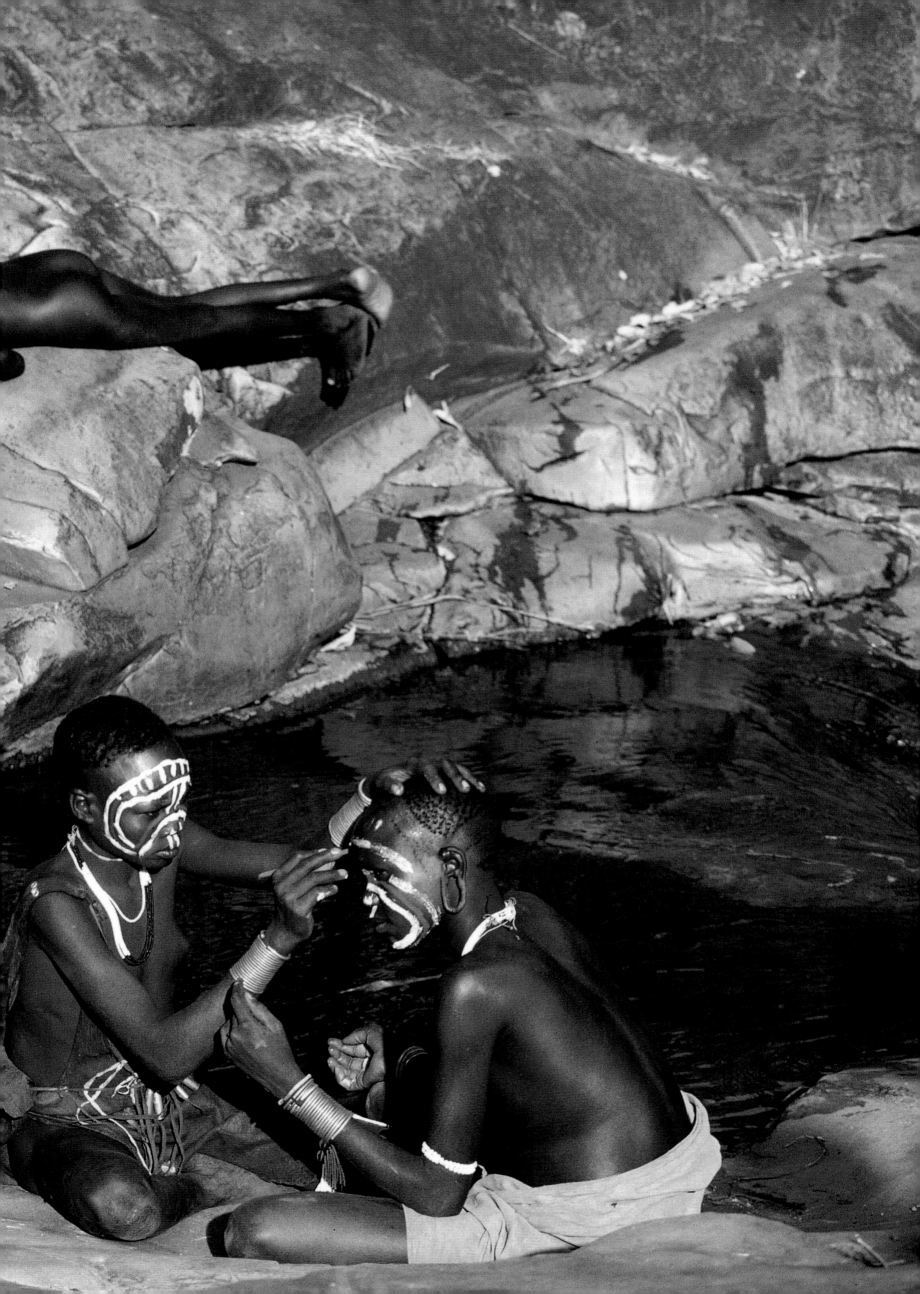

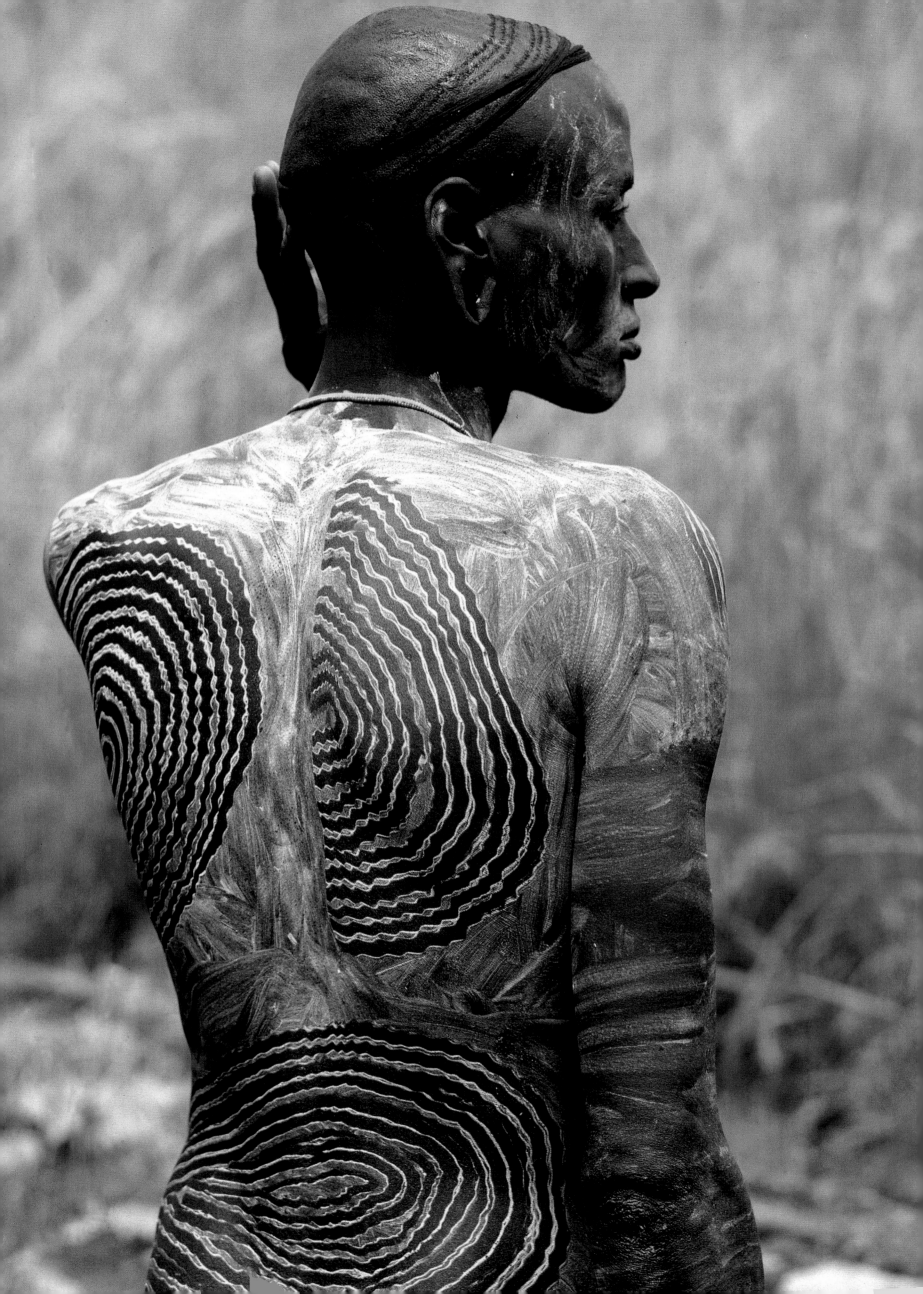

Attracting the Opposite Sex

Preceding pages: Surma girls express their affection for one another by painting their faces with identical designs. After the harvest, when marriage proposals are likely to be made, the girls also decorate their bodies to make them even more alluring to men. Each day, they go to the chalk banks by the river to create new designs that may enhance their desirability.

Left: Surma men spend hours perfecting their appearance during the courtship season. They create their principal body decoration by smearing the skin with a mixture of chalk and water and drawing intricate designs with their wet fingertips to expose the dark skin underneath. The pattern of concentric circles on this man's back matches the delicate design of his newly shaven head.

Right: Unmarried Surma girls wear a traditional *cache sexe* of iron beads, called *siriga*, weighing up to ten pounds, which symbolically protects their maidenhood. This puberty apron has a curious ambiguity: it both conceals a girl's sexuality and attracts the eye. Given to a girl by her family while she is still a child, the iron apron is worn until she marries and replaces it with a hide apron.

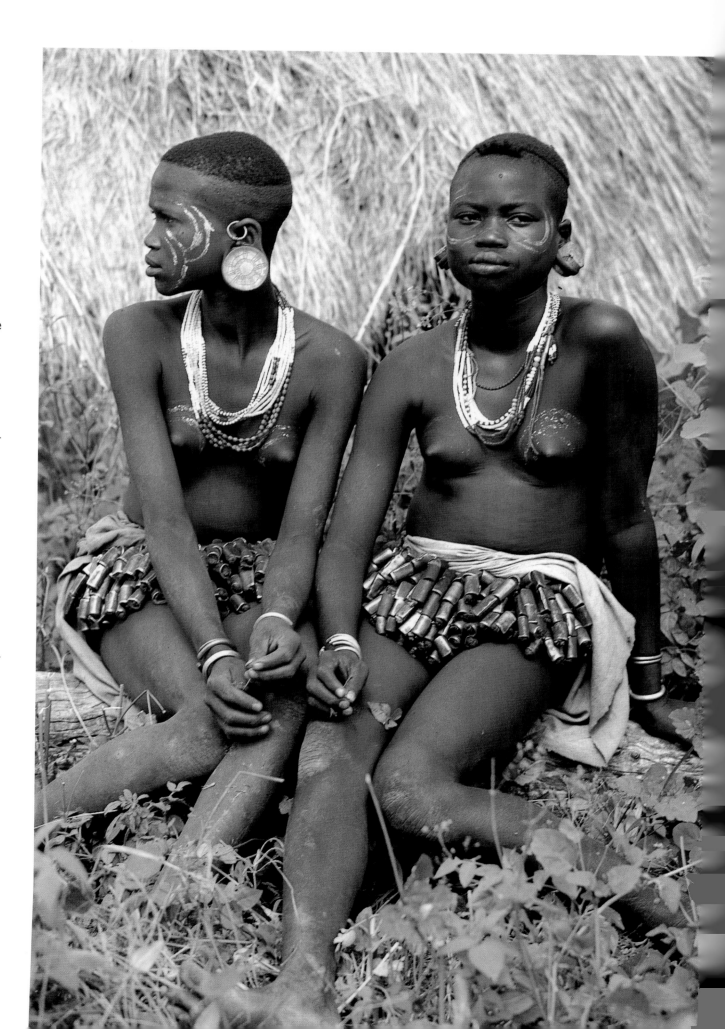

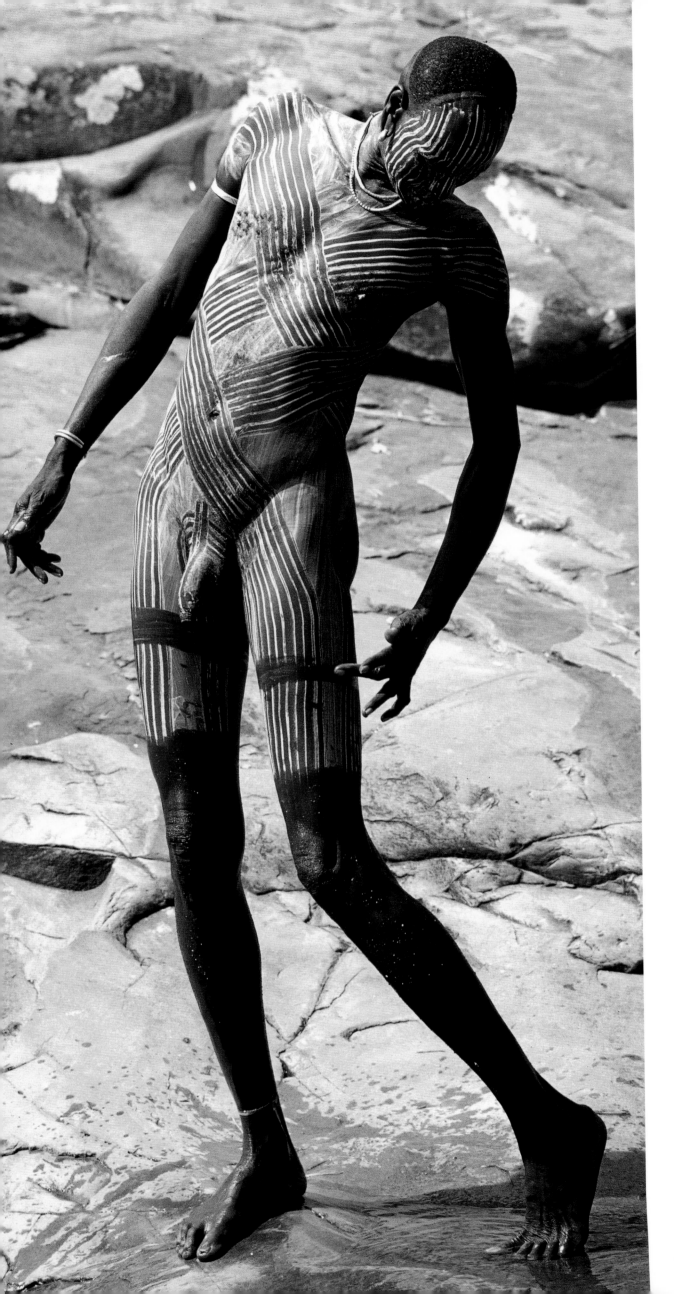

Enhancing Masculinity

In a society where adornment and clothing are minimal, the Surma see the body as a canvas on which they can express themselves. The best artists are generally male, painting young women and children as well as each other. In addition to decorating their bodies to attract the opposite sex, Surma men use body painting to intimidate their opponents and increase their power at the time of the Donga stick fights

The Donga Stick Fight

Following pages: After the harvest, Surma men assemble for a series of wild and violent stick fights called the Donga. A test of nerves and brute strength, the Donga is fought to prove masculinity, settle personal vendettas, and, most importantly, win wives. The fifty or so men who participate in each tournament represent different villages. The contestants, armed with six-foot-long wooden poles, fight in heats, with the winners going on to the next round until the competition narrows to two finalists. Each fighter's goal is to knock his opponent down, eliminating him from the game. Severe injuries are often inflicted but rarely prove fatal. If a fighter should kill his opponent, he and his family are banished from the village. Prior to each bout, the spectators, some of whom have fought in previous contests, become so frenzied that they break into spontaneous dueling.

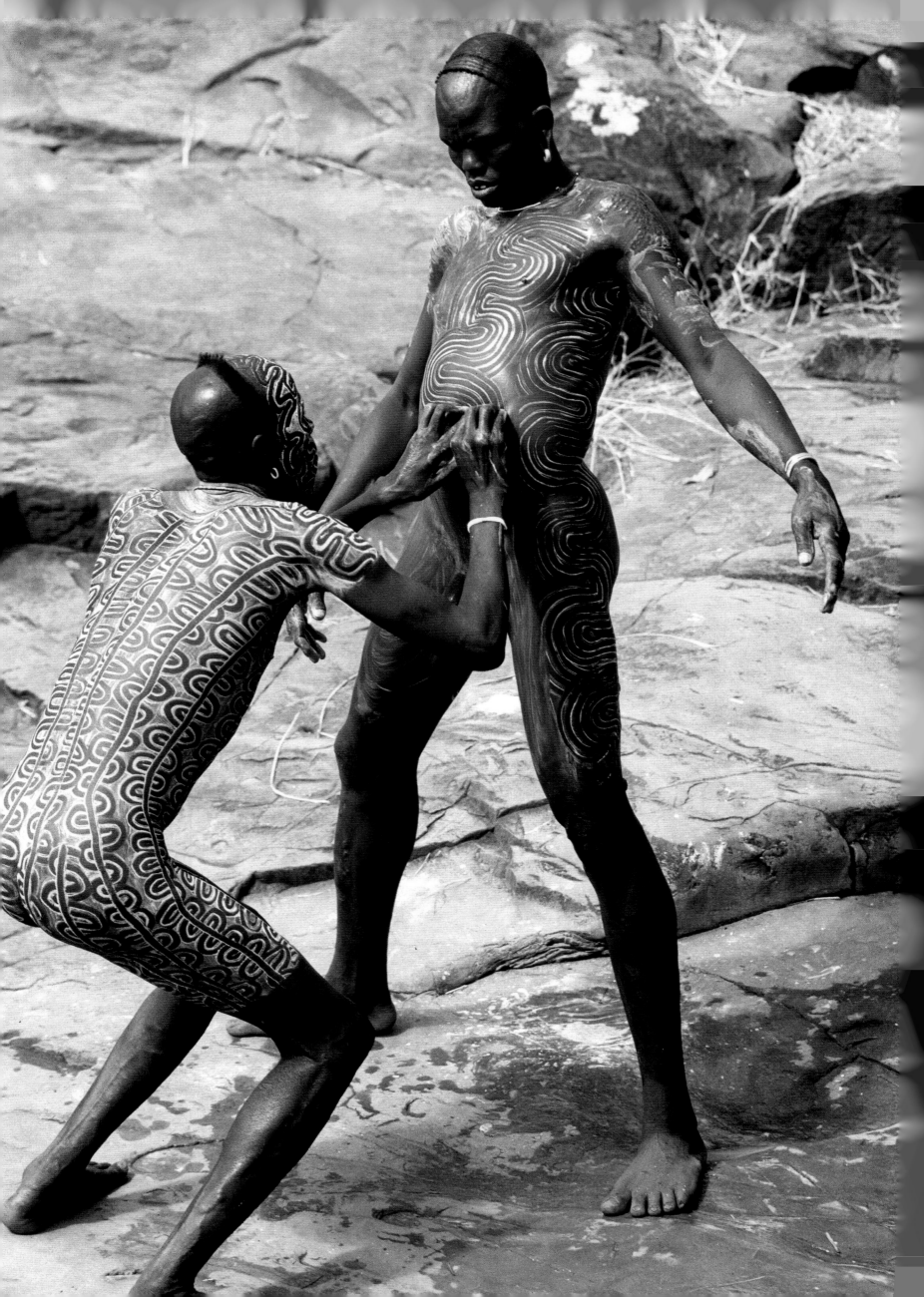

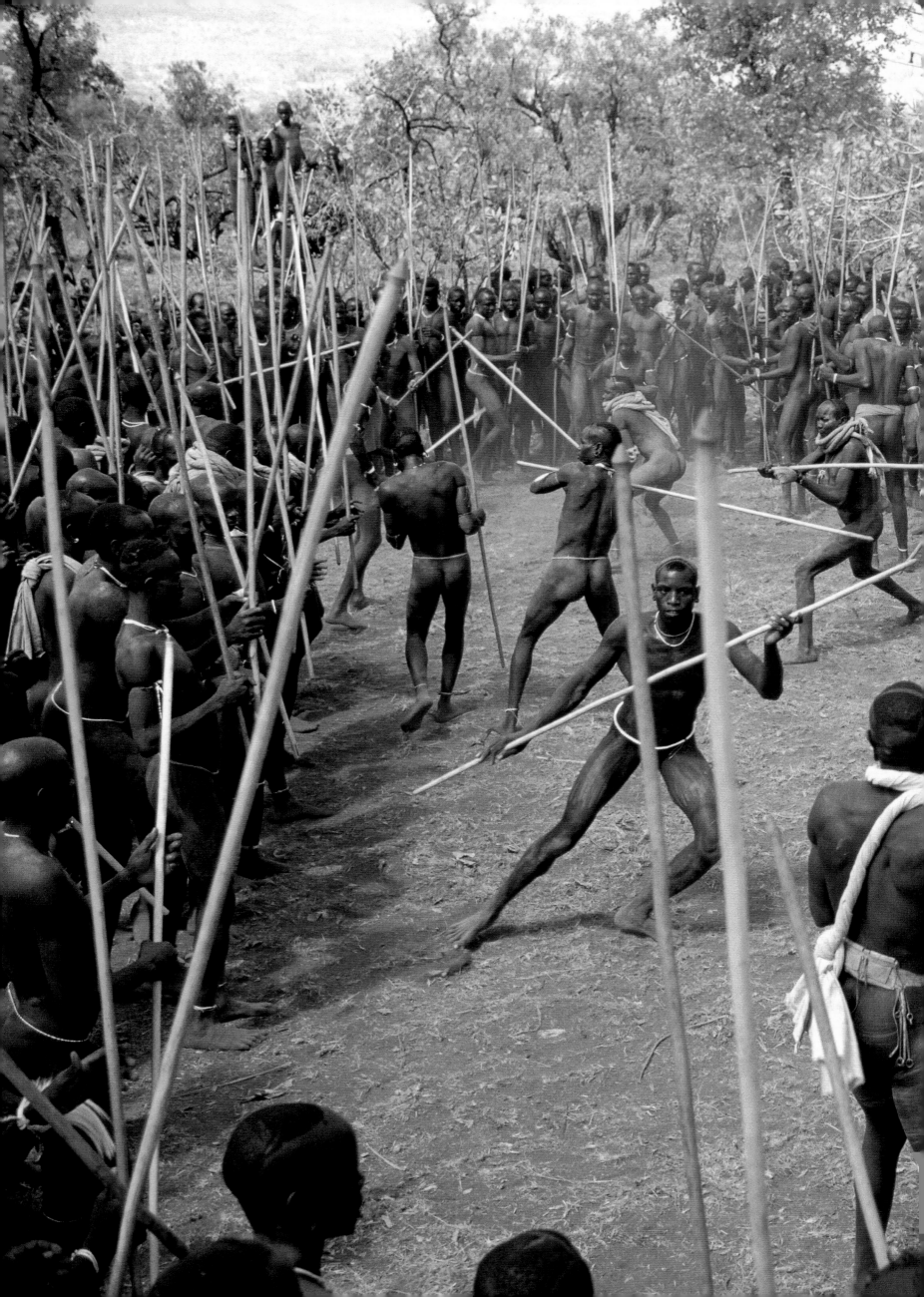

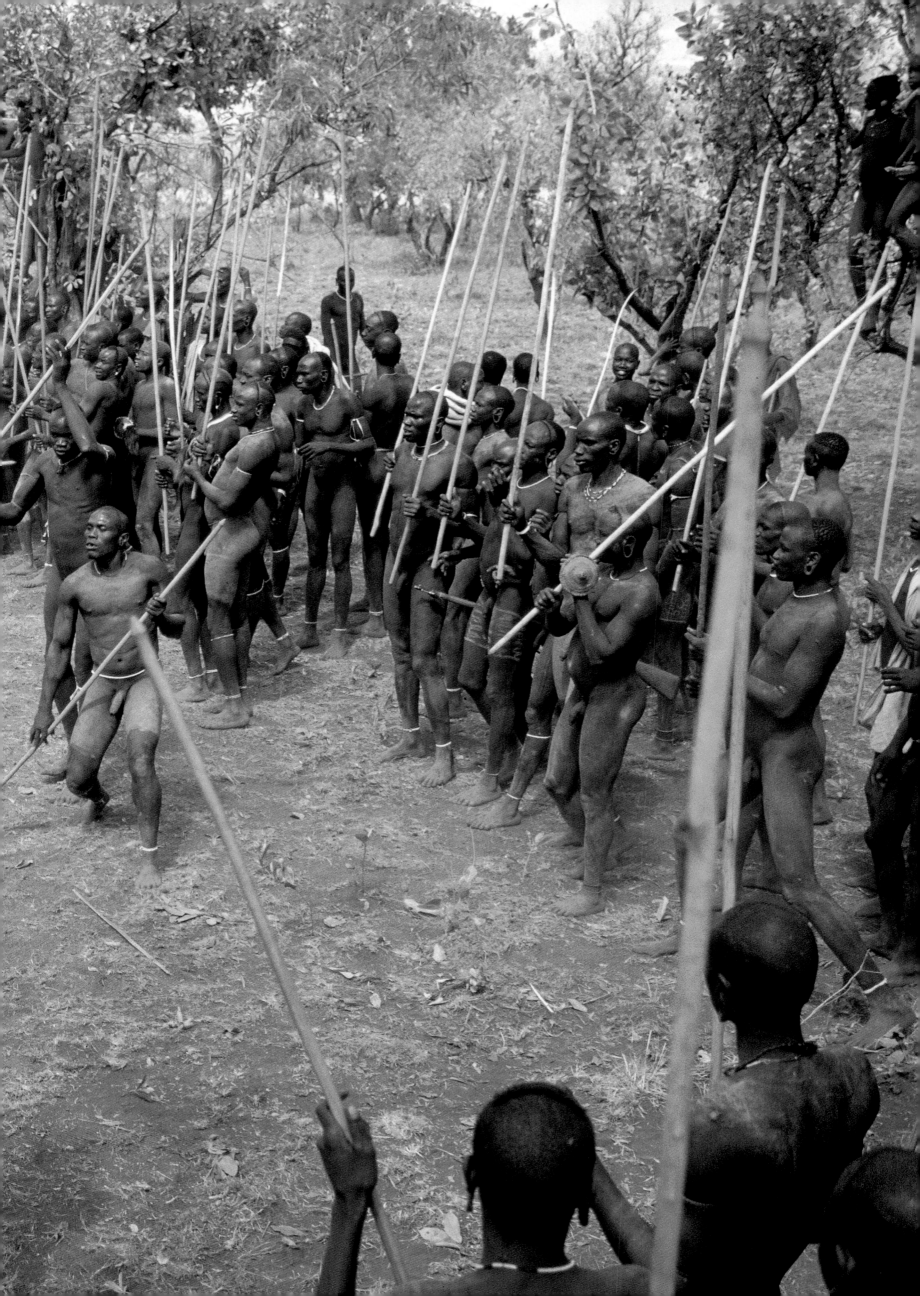

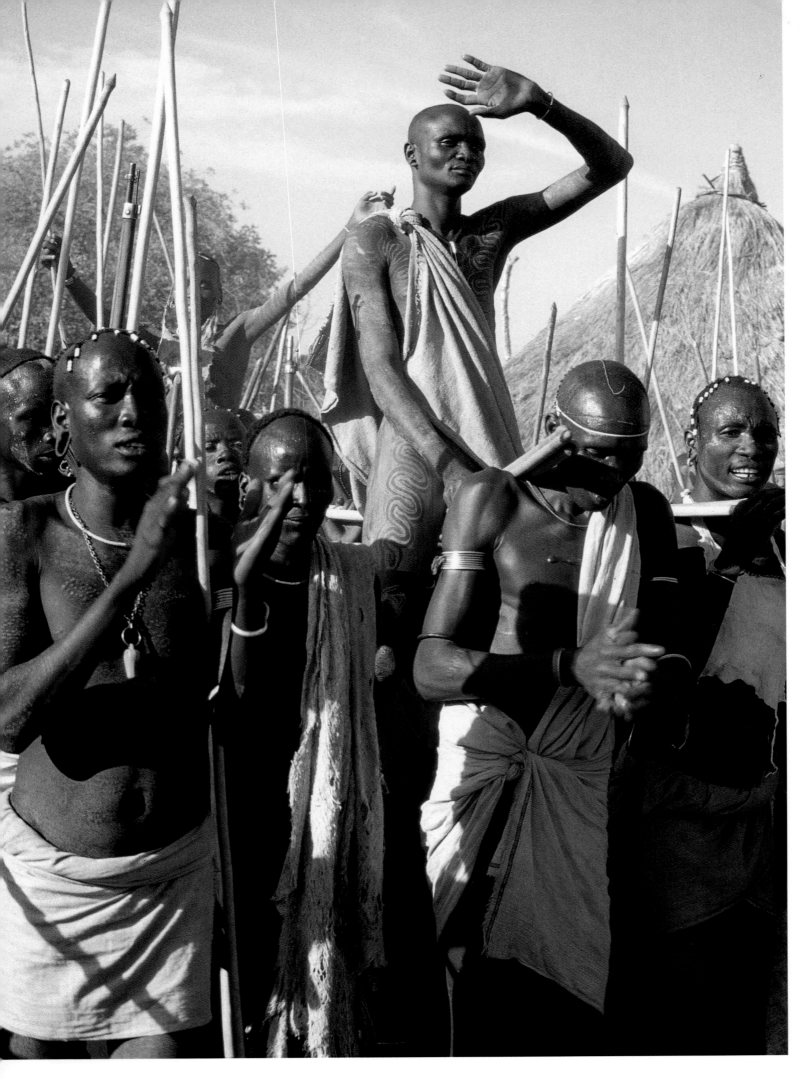

The Champion

At the tournament's end, the winner is ceremonially lifted onto a platform of fighting sticks and presented to the young girls watching from the sidelines. They decide among themselves who will choose the champion as her husband. The winner must then offer the girl's parents a bride-price of cattle, the number of which is determined by the size of a lip plate that is inserted into the lower lip of the betrothed girl. When the groom has assembled the required cattle, the marriage is formalized. The groom also gives a beautiful ox to the bride's parents, and the bride is renamed after the beast's color: Mistress of the Red or Mistress of the Black being among the names she may receive.

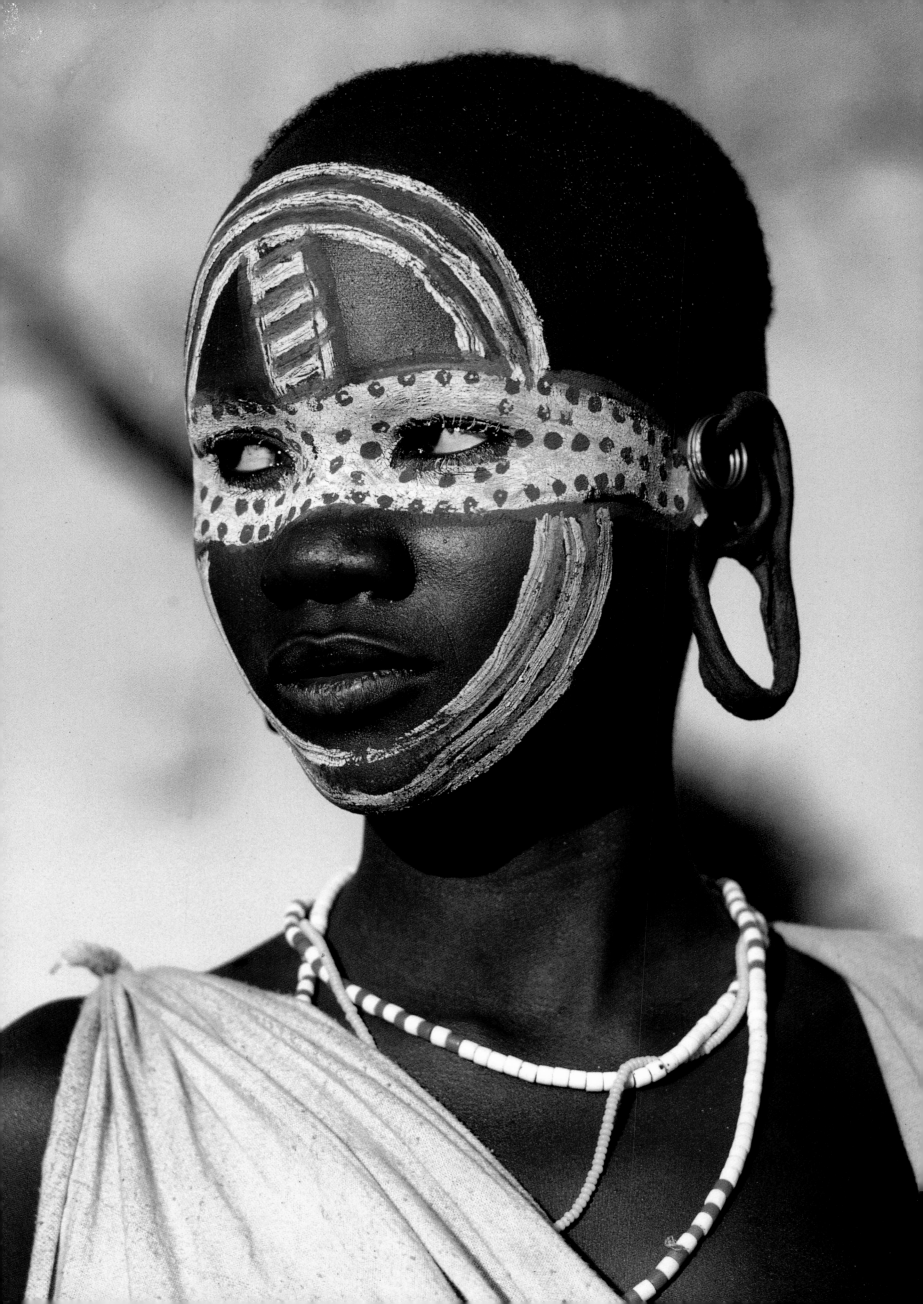

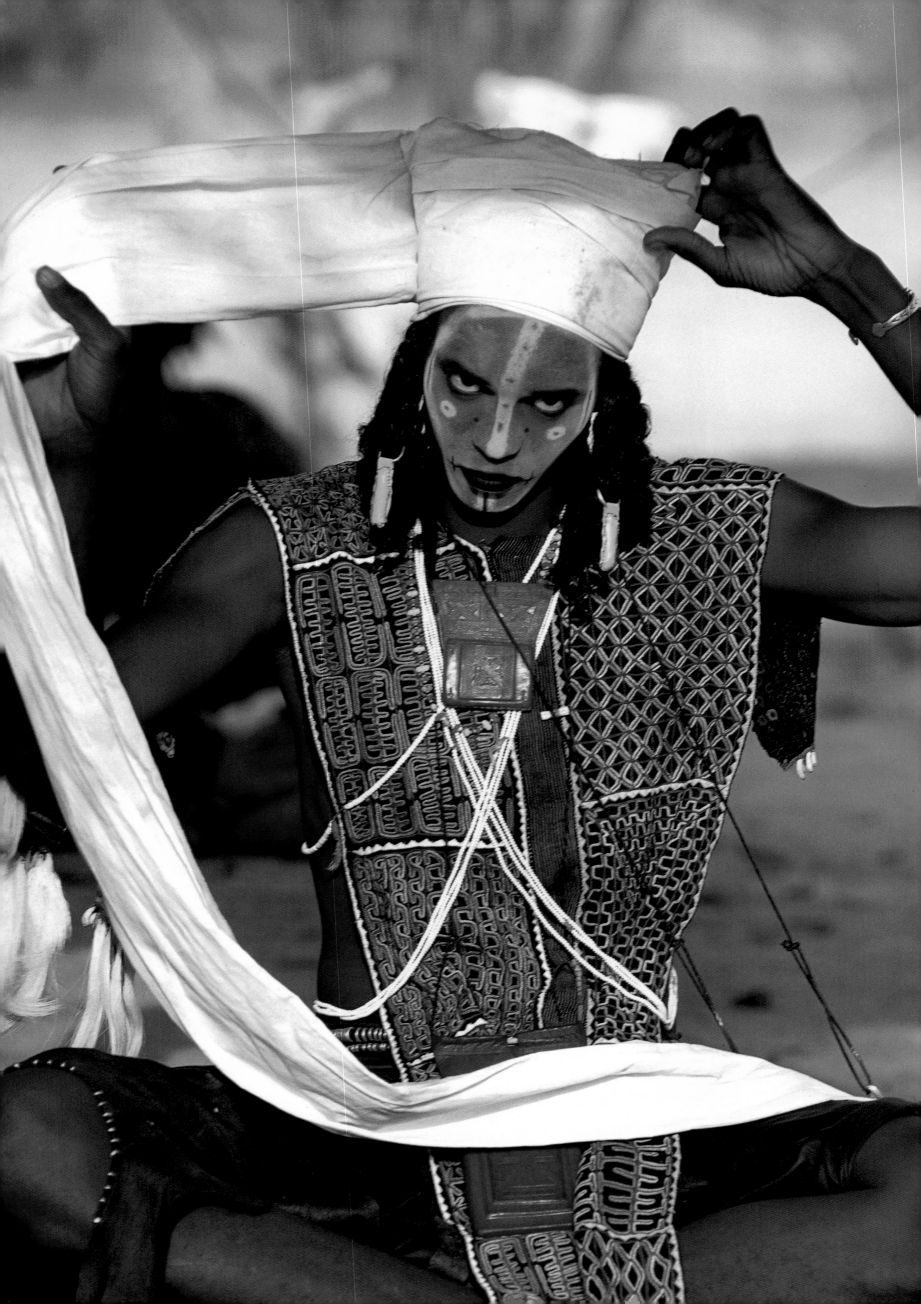

Wodaabe Charm Dances

In Central Niger, between the great Sahara Desert and the grasslands, lies an immense steppe called the Sahel, scattered with thorny bushes and skeletal trees and seared by an implacable sun. For nine months of the year, hardly a drop of rain falls; for the remaining three, rain returns and life is reborn. In this inhospitable terrain live the Wodaabe nomads, a resilient tribe of about 45,000 pastoralists, who are among the last in Africa to maintain a fully nomadic existence. Belonging to the Fulani ethnic group, whose six million members are now mostly semi-sedentary, the Wodaabe migrate throughout the year with their zebu cattle, camels, goats, and sheep in search of pastures and water. They believe that the nomadic life they lead is the only one for them because it is the way of tradition—a sacred birthright to be treasured until death.

The word *Wodaabe* means People of the Taboo, referring to those rules of social conduct handed down by their ancestors. As one elder explains, "We have a code of behavior that emphasizes *semteende* (reserve and modesty), *munyal* (patience and fortitude), *hakkilo* (care and forethought), and *amana* (loyalty). This way of life, along with our many taboos, was given to us by our ancestors." Along with this code, the Wodaabe place great emphasis on beauty and charm, which form the basis of one of the most unique and unusual courtship rituals in Africa.

At the end of the rainy season, a magnificent celebration called the Geerewol takes place, marking the climax of the year. For seven days, up to 1,000 men participate in a series of dance competitions judged solely by women. During this week, women single out the most desirable men, choosing husbands and lovers: many romantic alliances flourish.

A Wodaabe man may take as many as four wives. The first must be a cousin, selected by his parents at his birth. The others are chosen for love. Meetings that lead to love marriages often take place at the Geerewol.

The celebration is dominated by three dances: the Ruume, a daytime dance of welcome and a nighttime dance of seduction; the Yaake, a competition for charm and personality; and the Geerewol (after which the festival takes its name), in which young men vie to be judged the most beautiful. Wodaabe believe that the Geerewol best expresses the birthright of beauty handed down by their ancestors, and this legacy and their ability to express it distinguishes them among African societies.

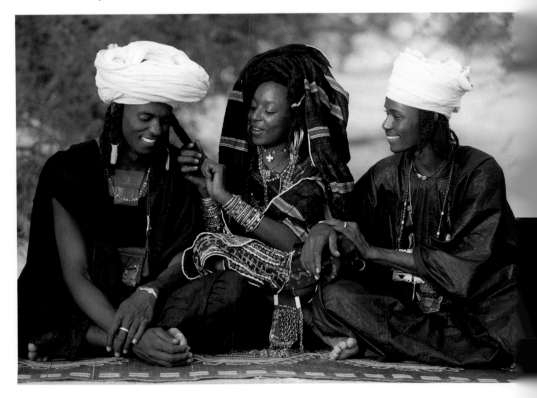

Left: A Wodaabe man wraps a twelve-foot turban in preparation for the Yaake charm dance. *Above*: A young woman tresses the hair of a dancer during the courtship season.

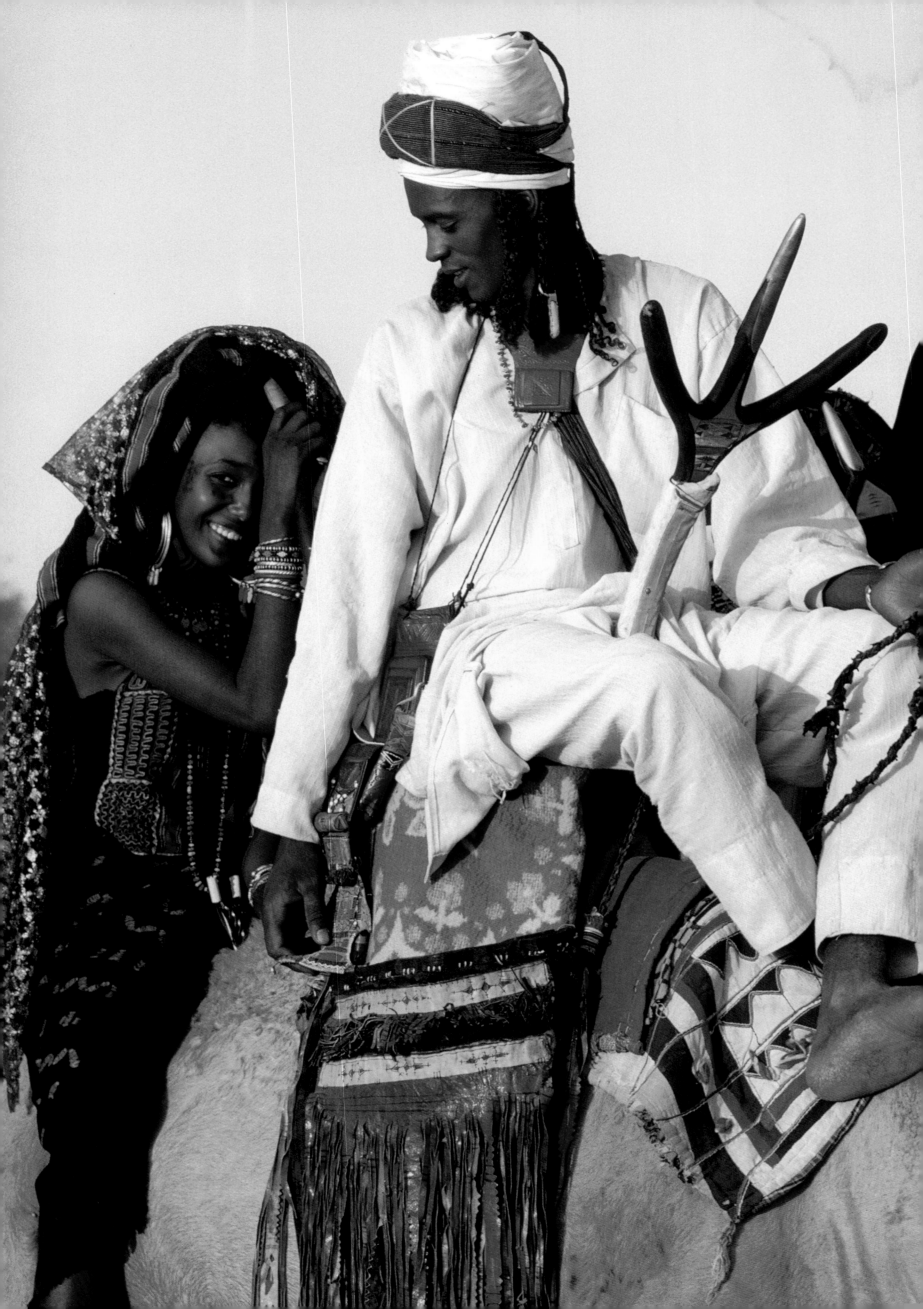

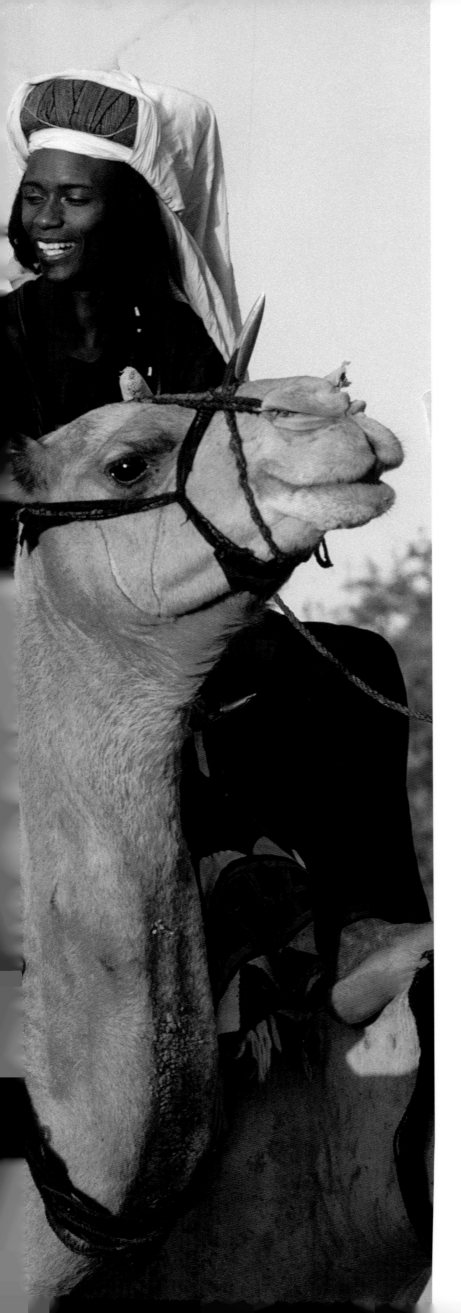

Flirting with Two Lovers

During the courtship season, a Wodaabe girl flirts with two men who may both become her lovers. Among male cousins of the same age, called *waldeebe*, the tradition of reserve that normally governs Wodaabe behavior is lifted. These two *waldeebe*, who openly display affection toward one another, may court and seduce the same girl. Should she decide to marry one of them, the other will always be welcome in the camp of her husband, who will generously offer her for the night—but only with her consent. Although Wodaabe men and women often experience jealousy, this emotion is absent among the *waldeebe*—the emphasis being on sharing and generosity. *Below*: Two women prepare each other for their role as judges in the Yaake male charm dance.

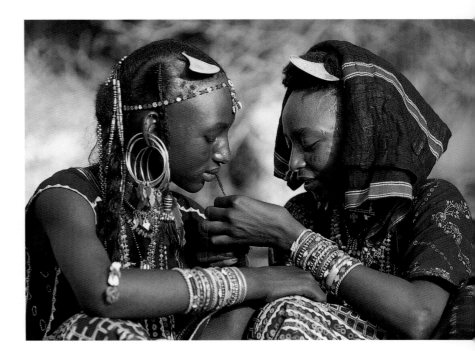

Following pages 108-109: Men perform the Ruume circle dance to welcome guests. The rhythmic repetition creates a hypnotic effect as the men sing paeans to female grace and beauty.

Following pages 110-111: Male dancers perform the Yaake charm dance while an elder woman alternately praises and mocks the dancers. If a dancer's performance is exceptional, the woman dashes toward him yelling "Yeeee hoo!" and gently butts him on the torso on the head.

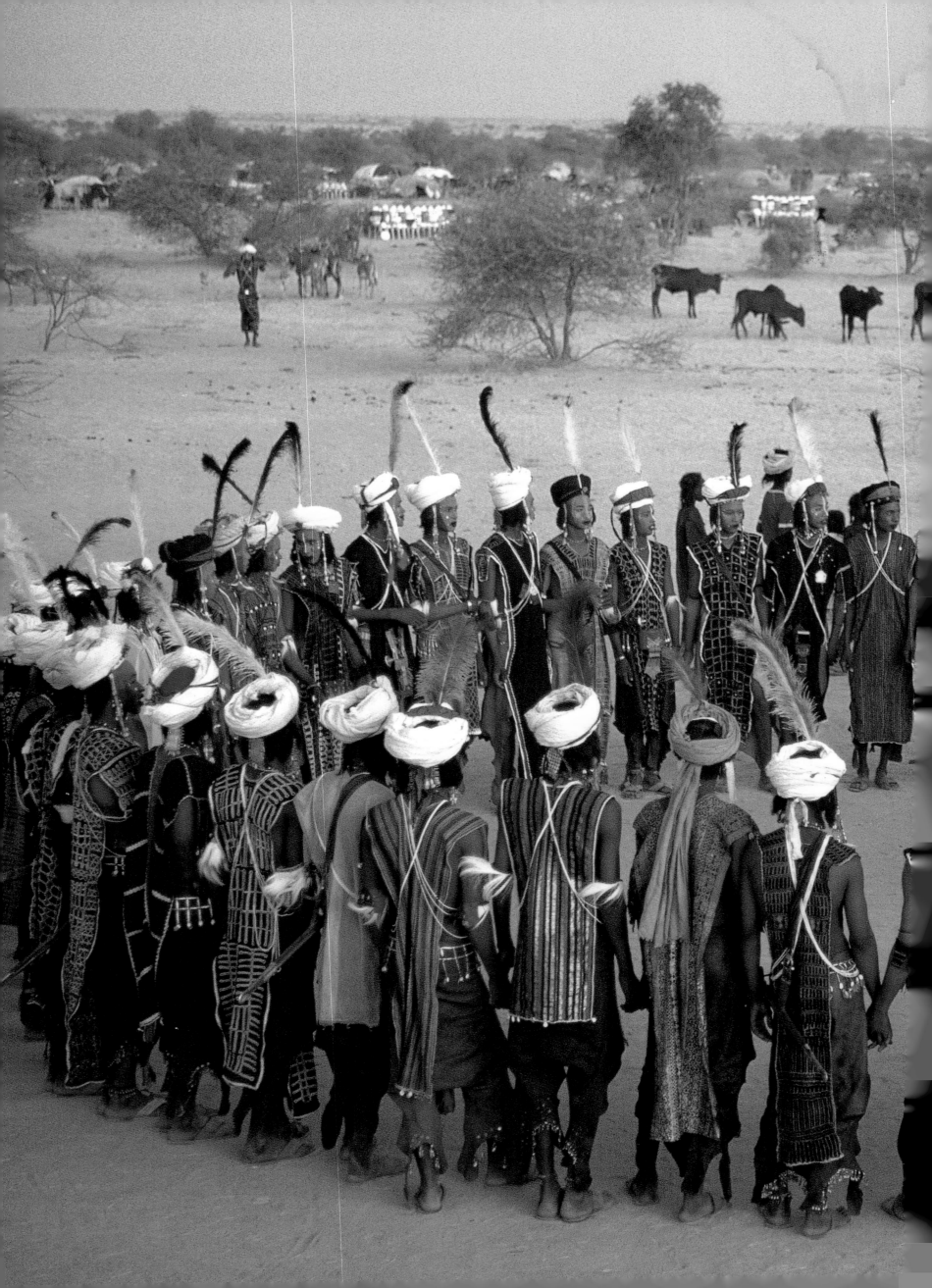

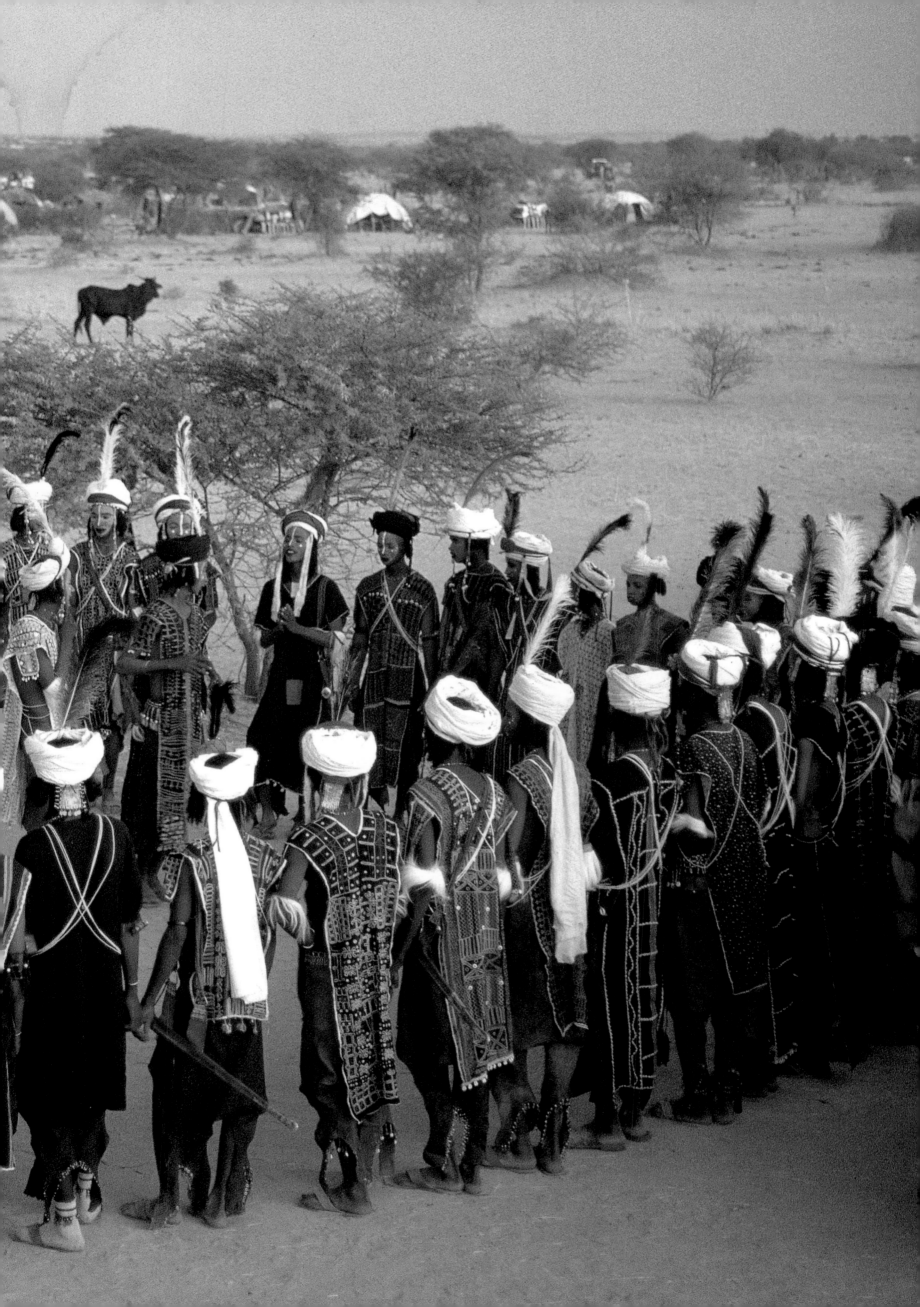

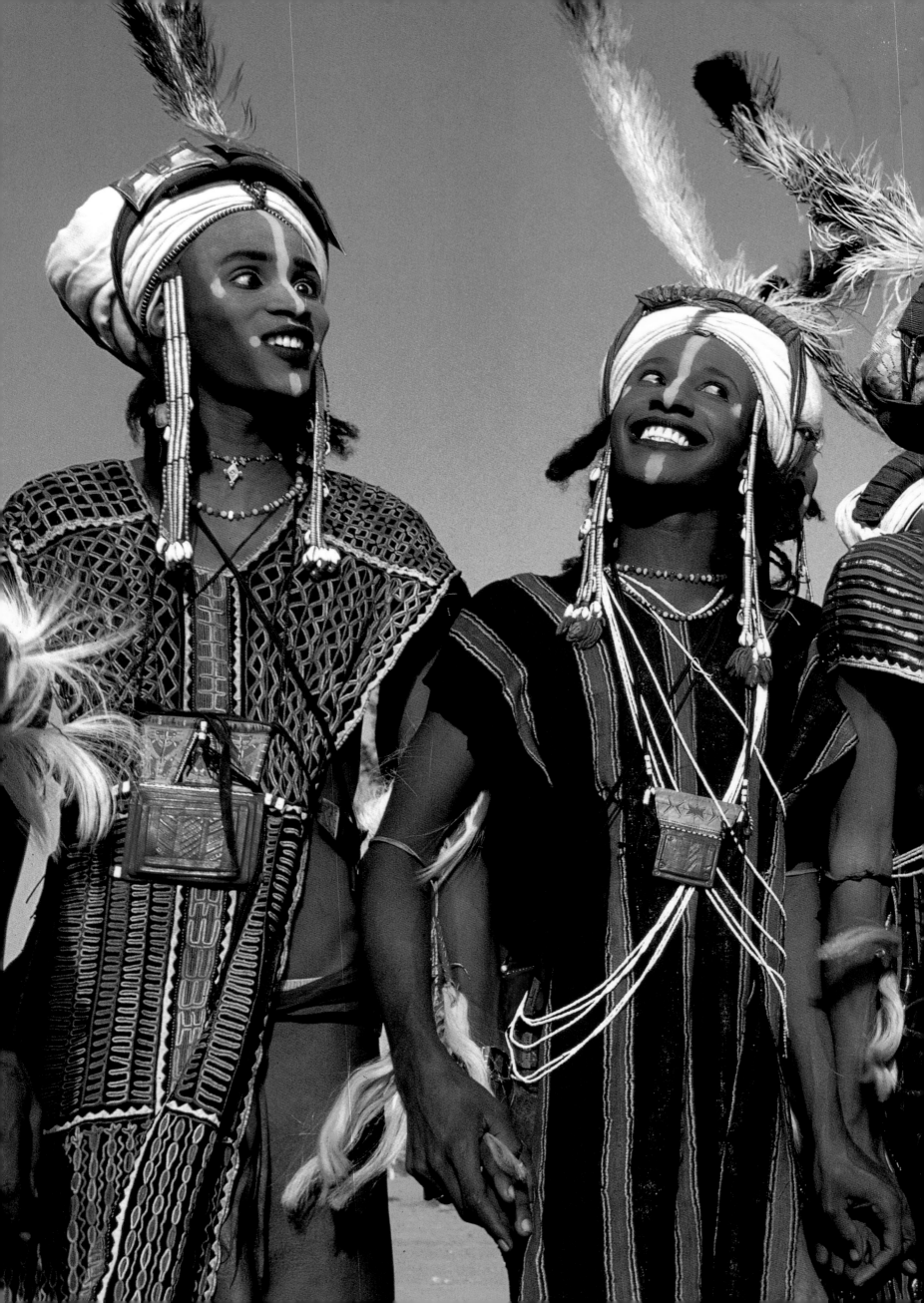

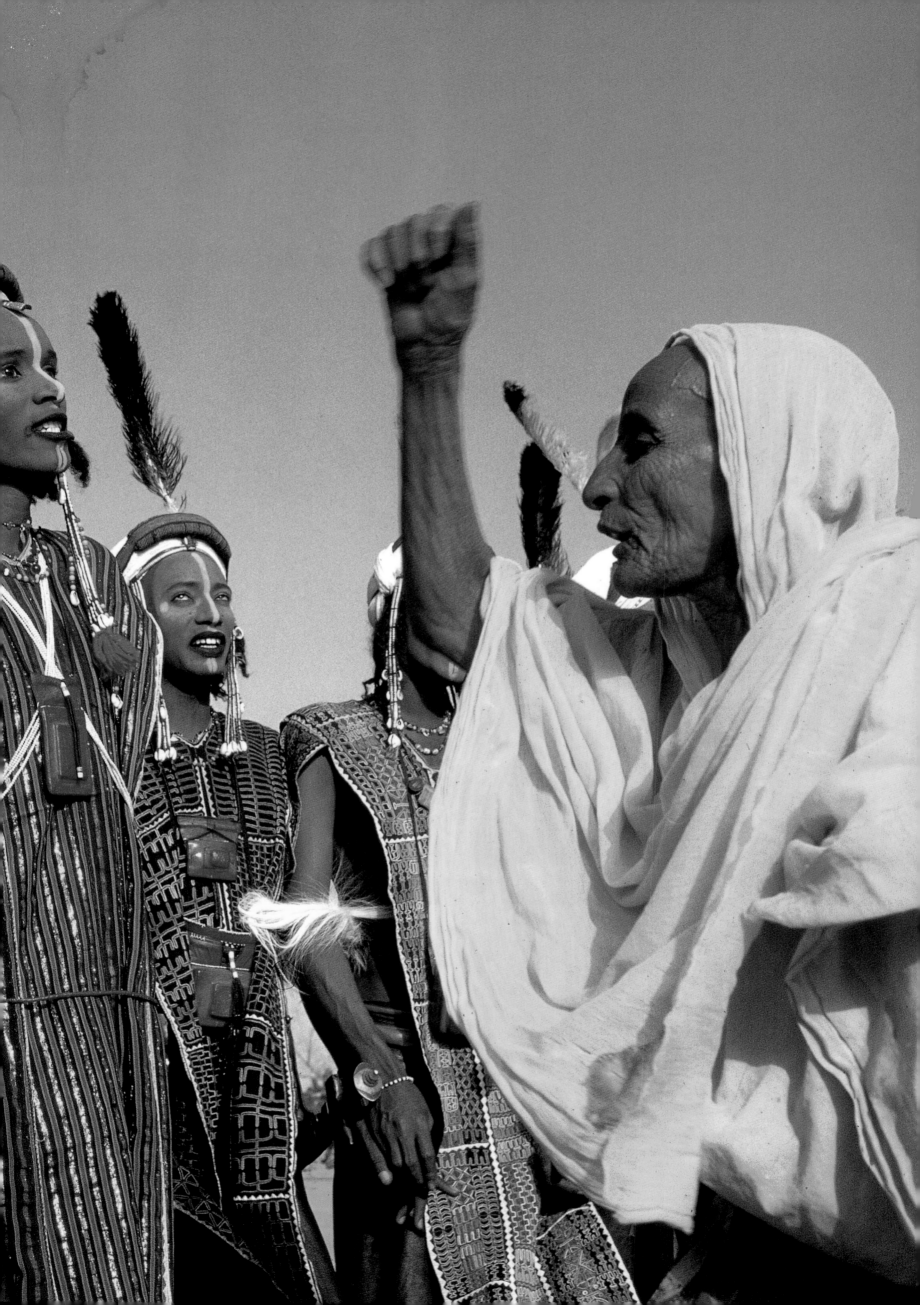

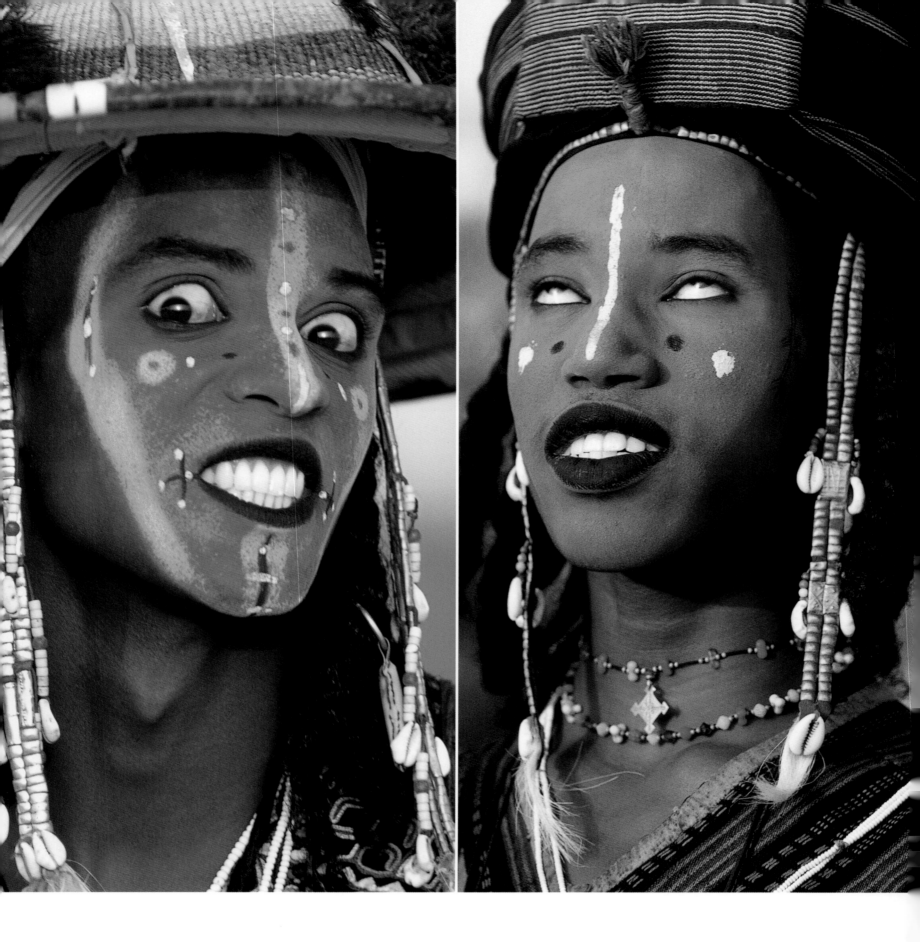

Wodaabe Charm Dancers

In the golden light of late afternoon, Wodaabe men perform the Yaake, a competition of charm and personality judged by young women. Each dancer applies pale yellow powder to lighten his face, borders of black kohl to highlight the whiteness of teeth and eyes, and a painted line from forehead to chin to elongate the nose. He also shaves his hairline to heighten his forehead. Shoulder to shoulder, the dancers quiver forward on tiptoe to accentuate their height, and launch into a series of wildly exaggerated facial expressions upon which their charm, magnetism, and personality will be judged. Eyes roll, teeth flash, lips purse, part, and tremble, and cheeks pout in short puffs of breath. A man who can hold one eye still and roll the other is considered particularly alluring by the female judges. The Wodaabe say that the strength of the eyes makes marriages.

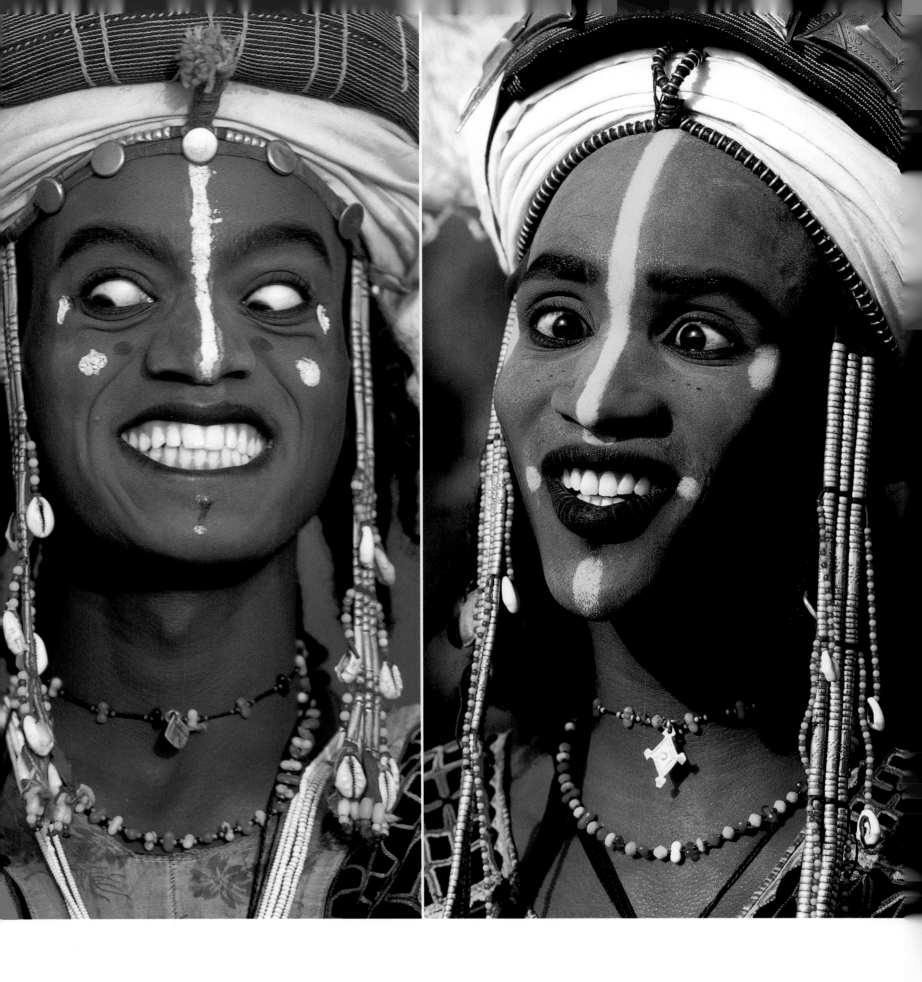

The talismans the dancers wear protect them from jealousy, make them desirable to women, and may even make a man invisible at night when he slips off to steal a woman. A small vial of perfume also hangs hidden inside each dancer's tunic. Sensitive to fragrance, the Wodaabe believe that by wearing a perfume infused with secret potions they will become irresistible to their female judges. The long, narrrow tunics worn by the dancers have been elaborately embroidered by female relatives; each design has a name and tells a story. *Following pages*: After the Yaake charm dance, Wodaabe men perform the Geerewol, a dance of male beauty from which the most handsome men are selected. Elder men and women dash up and down the line of dancers, mocking and criticizing them to inspire greater performances.

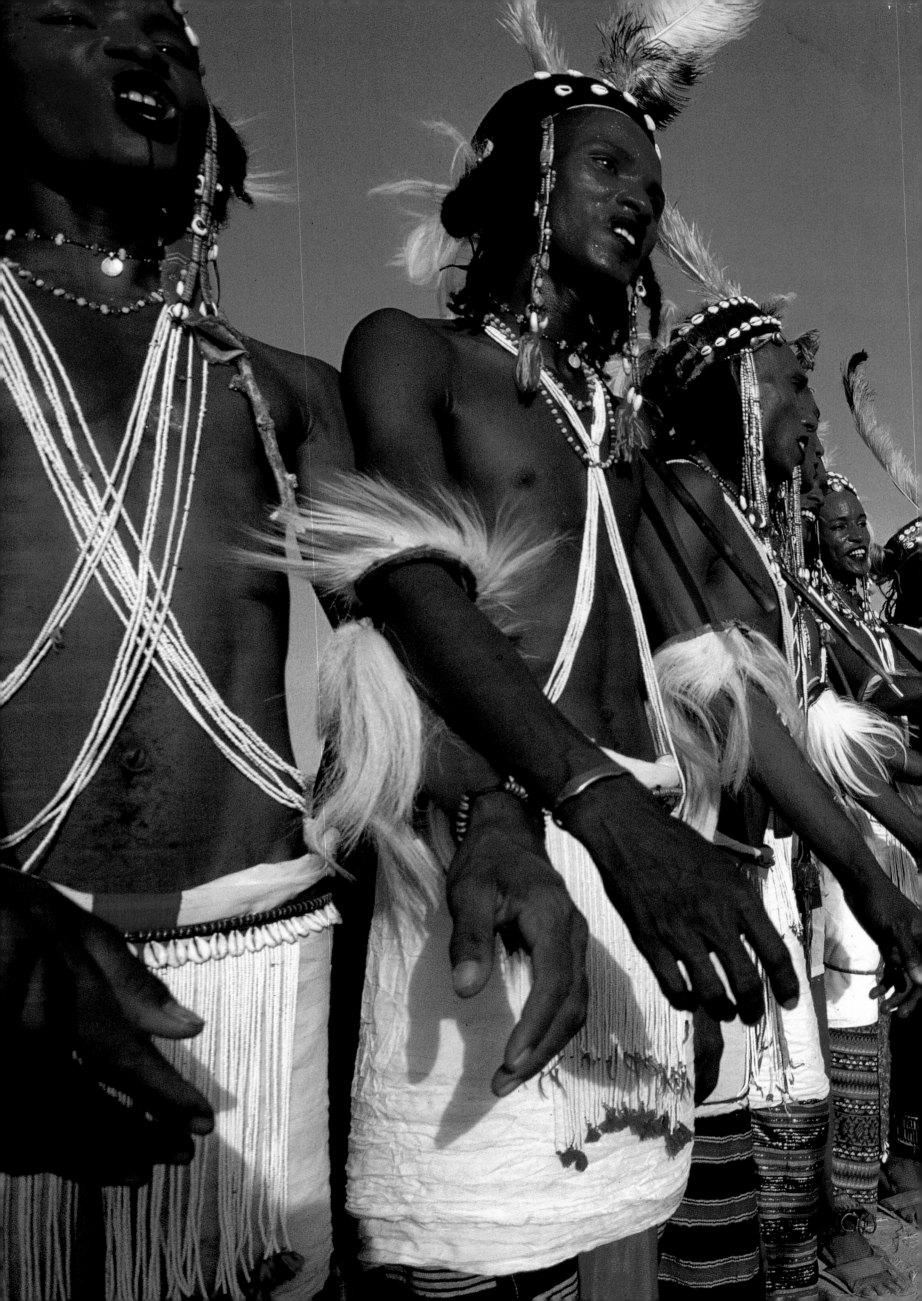

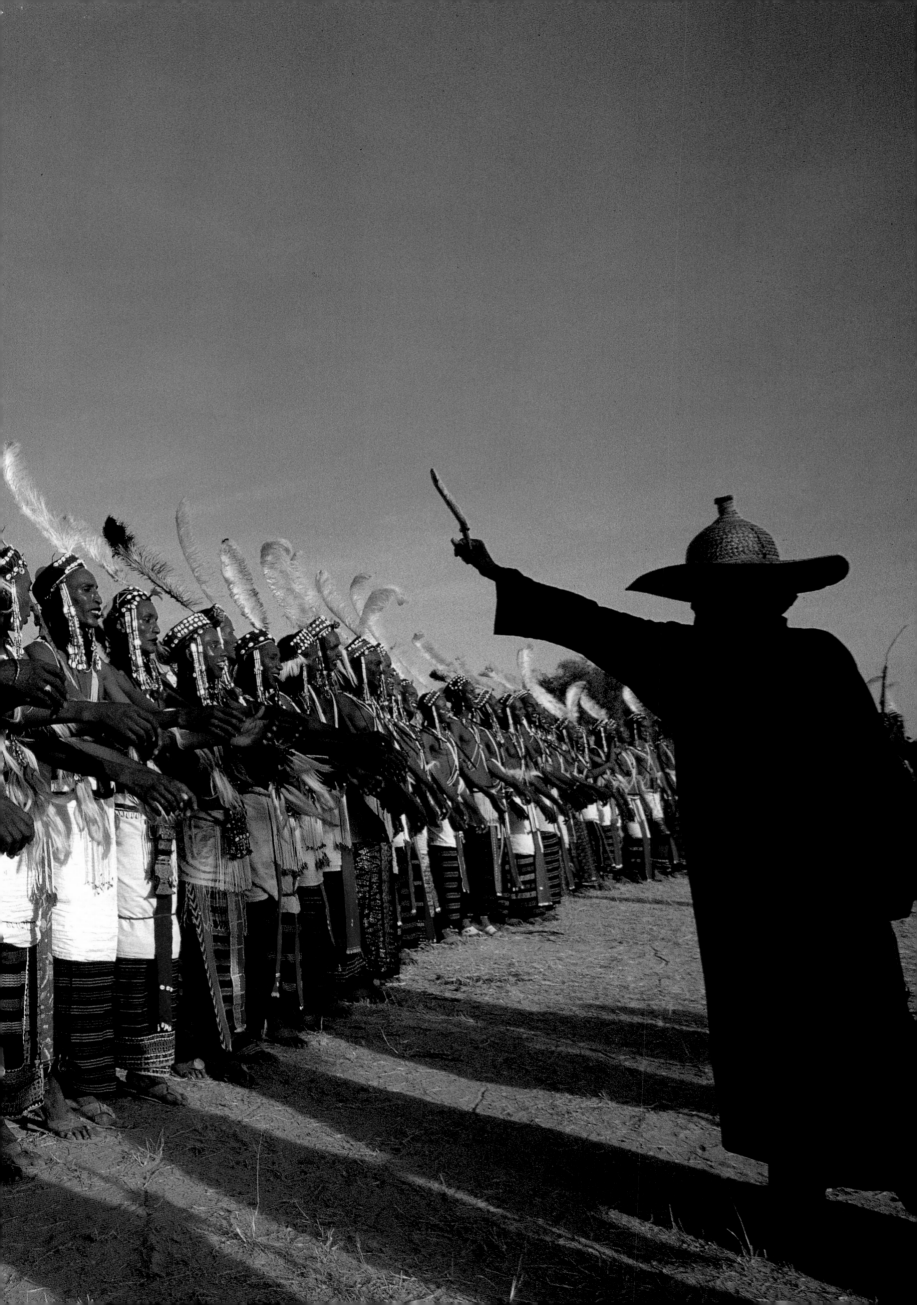

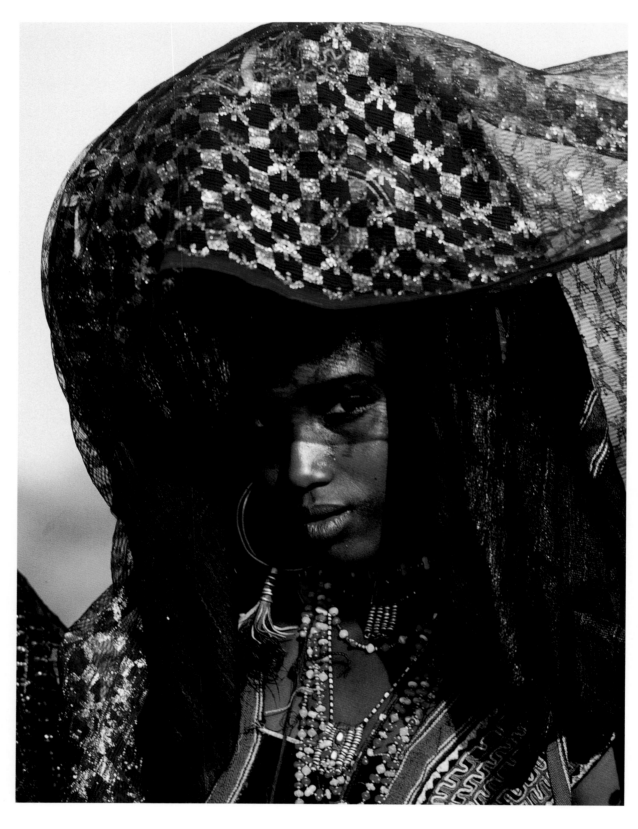

The Dance of Male Beauty

Resplendent in red ocher face makeup, a contestant takes his place in a line of fifty or more dancers for the grand finale of the Geerewol dance of beauty (*preceeding pages*). For two hours the dancers chant in hypnotic harmony, gracefully swinging their arms forward and turning their heads to display their broad smiles and the whiteness of their eyes and teeth. Three unmarried girls chosen for their beauty are brought out one by one by the elders to serve as judges. Shielding her glance under a veil so as not to look directly at the object of her desire the young woman (*above*) indicates her choice. The winners reap the most valued rewards: increased pride, the admiration of other men, and the ardor of women.

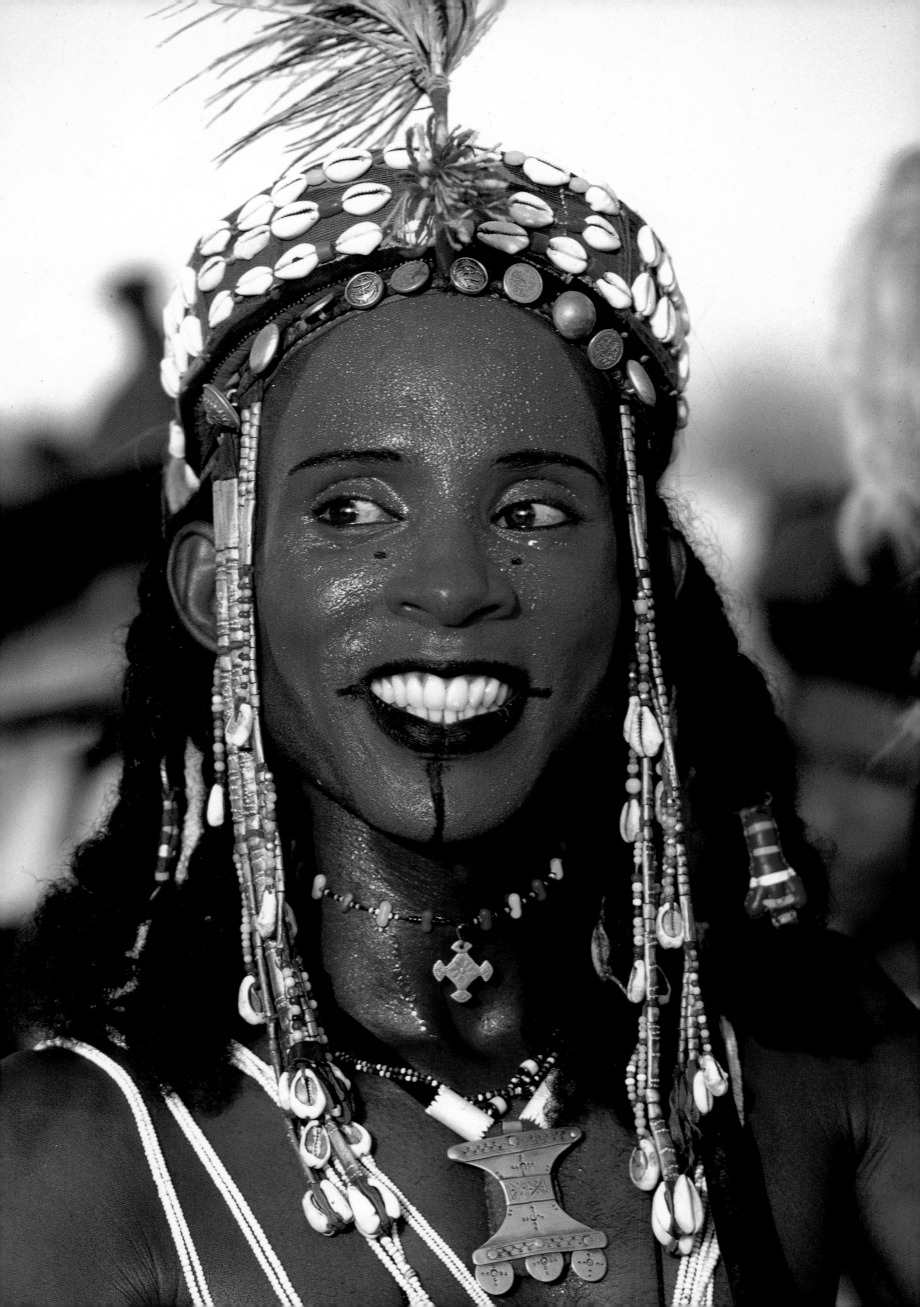

Swazi Reed Dance

Swaziland, a small kingdom in southern Africa, occupies the southeastern corner of Gauteng province, formerly Transvaal. Its capital, Mbabane, lies in the Mdzimba Mountains near the royal village of Lobamba, where the country is governed by the Swazi monarchy and its parliament. At the head of traditional Swazi society is King Mswati III, called The Lion, and Queen Mother Ntombi, known as The She-elephant. They are considered the embodiment of the nation; their health and prosperity relate directly to the nation's well-being and the fertility of the soil. Members of the Dlamini clan, the two rulers have distinct religious and political responsibilities in cultural affairs, in government, and at traditional celebrations such as the Umhlanga, or Reed Dance ceremony. This spectacular event occurs once a year and affirms the strength of the Swazi nation.

The most important myth in Swazi culture, which details the story of creation, tells that the first human beings emerged from a primordial reed, split lengthwise. Thus, the Reed Dance (the word *umhlanga* means reed) serves as an annual reminder to the Swazi nation that its people all come from the same root, the ancient stock of their ancestors. The Reed Dance

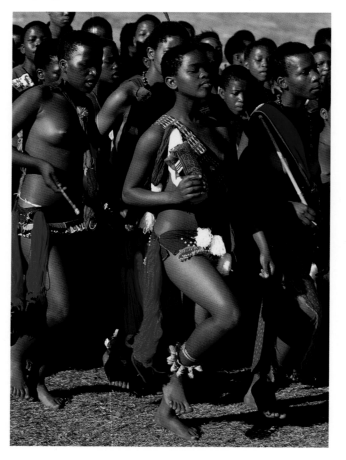

ceremony occurs over a seven-day period in late August or early September. It is a rite of passage into womanhood, and it provides an opportunity for young unmarried women to express their allegiance to the Queen Mother, as mother of the nation and the custodian of rain-making medicine.

The ceremony also allows the king to survey his female subjects with a particular view to finding wives among them, for the Swazi believe that it is the king's duty to support as many wives and raise as many children as possible. Over the course of his long reign, the present monarch's father, King Sobhuza II, had sixty-five wives and more than a hundred children.

Above: Swazi girls from ten to eighteen years old come from all parts of the country to perform the Reed Dance for the royal court. *Right*: A princess carries the ritual knife she has used for reed-cutting.

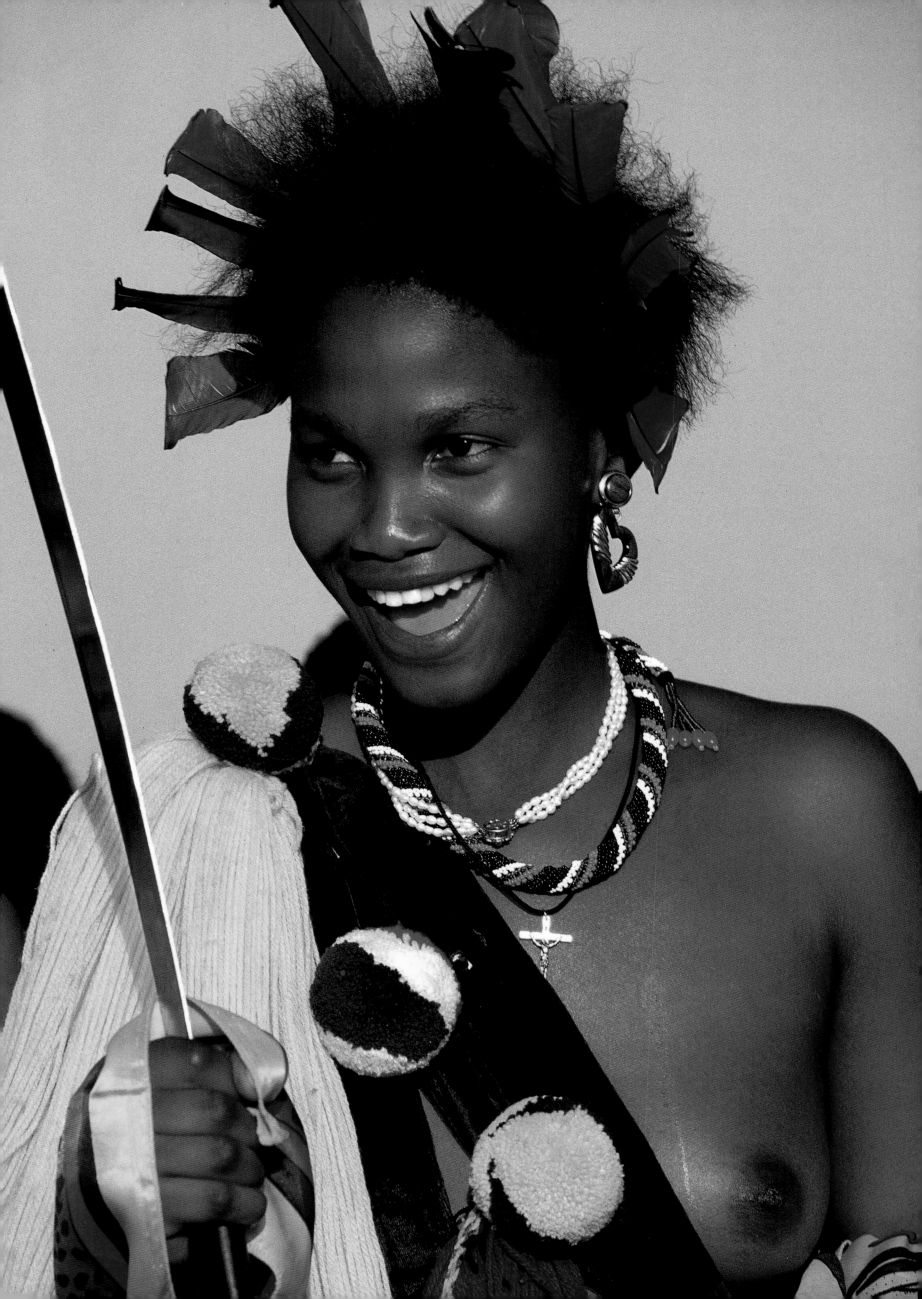

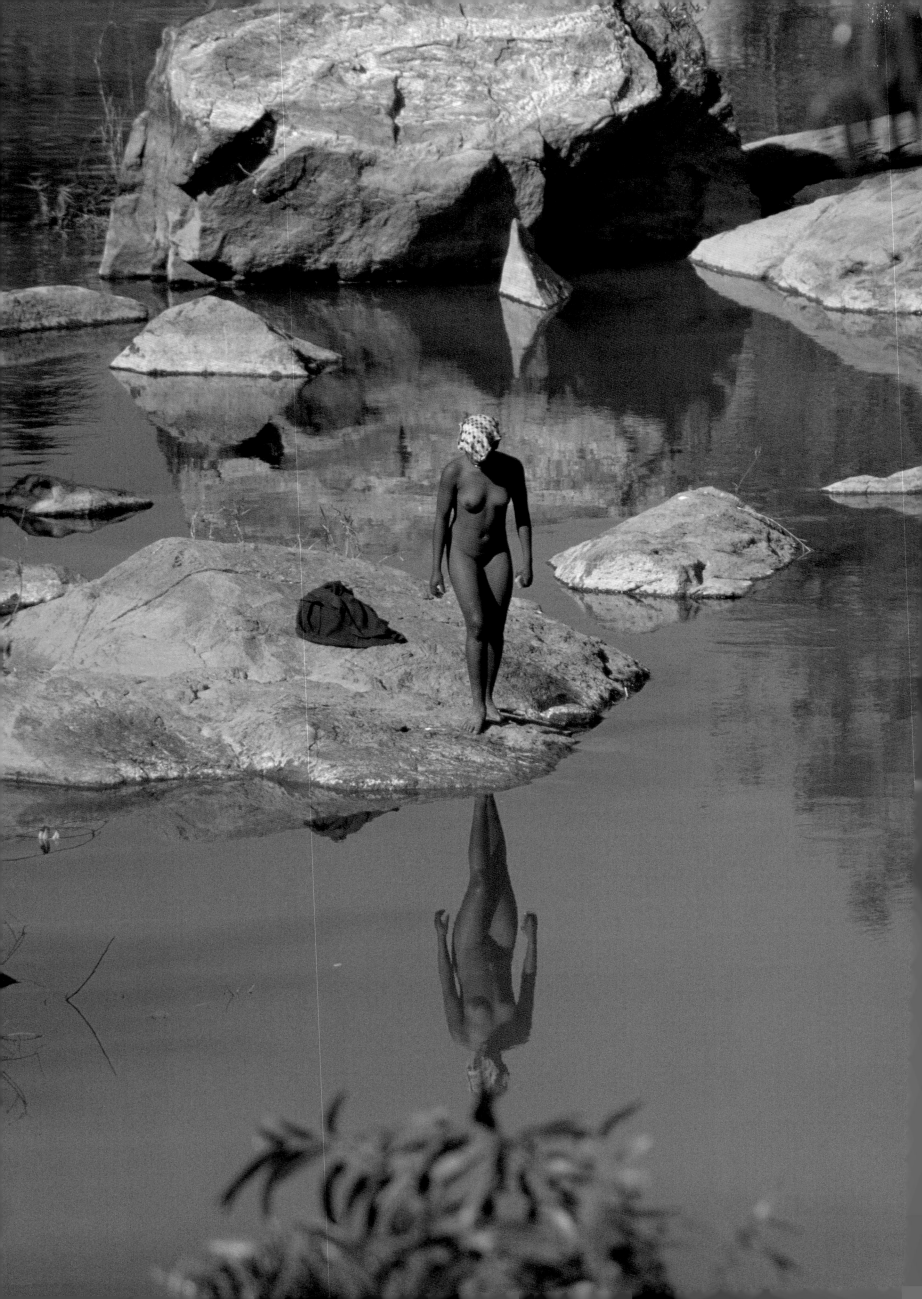

Ritual Bathing

Following their arrival in Lobamba, the royal capital, girls from throughout Swaziland ritually bathe in the river and hot spring near the royal palace to cleanse themselves for the ceremony. They have been collecting reeds from the two most prolific reed-growing areas, the Bham'sakha and Sidvokodvo rivers. The girls cut the reeds with large knives, often working through the night to gather a sufficient quantity, before carrying them as far as forty miles to Lobamba, where they rest before the start of the celebrations.

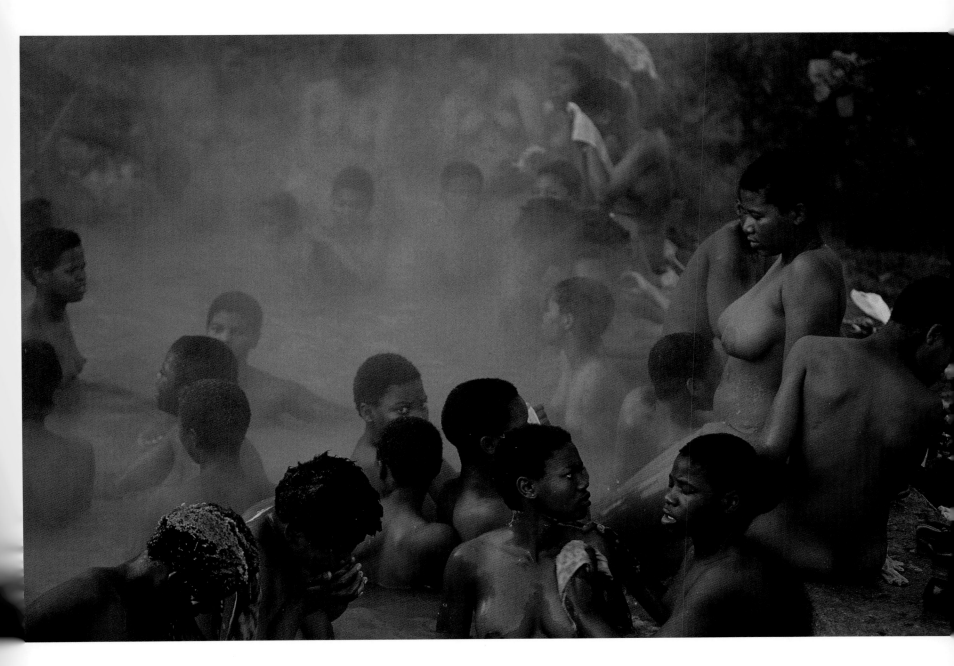

The Reed Offering

Following pages: Marching in unison, the girls carry their offerings of reeds to the palace of the Queen Mother. These reeds will reinforce the wind-breaking fence that surrounds her royal home. The act of encircling the Queen Mother's compound symbolizes the strengthening and affirmation of womanhood throughout the Swazi kingdom.

The girls wear short, beaded puberty aprons, decorated with fringing and metal studs. The colors of the apron beads convey different messages: a red bead suggests fertility; white stands for transition or purity; and black represents marriage and wealth. Hoping to catch the eyes of suitors, if not of the king himself, the girls also adorn themselves with vibrantly colored woolen sashes with color-coded yarn tassels, denoting whether or not the wearer is betrothed to be married.

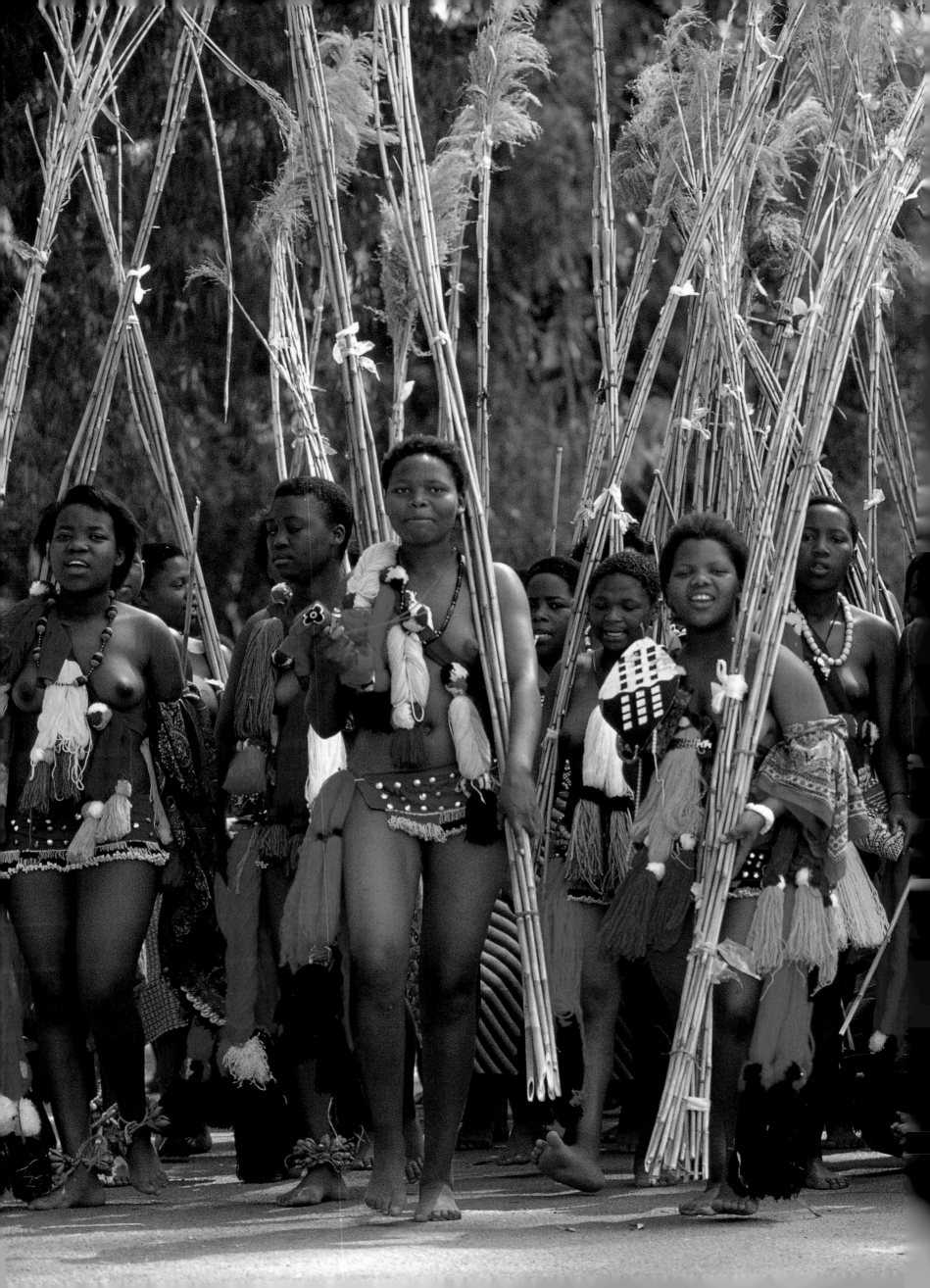

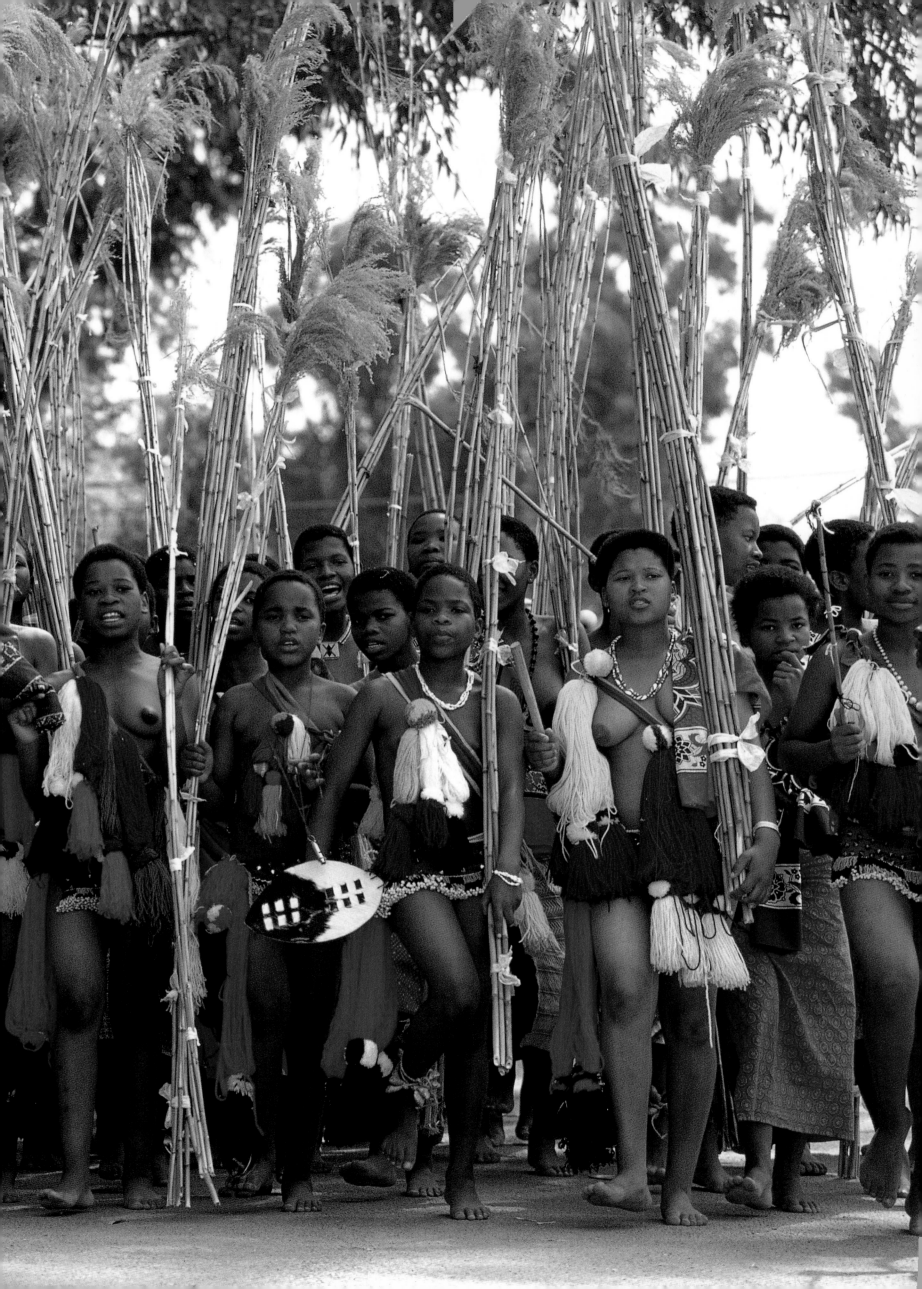

Catching the King's Eye

King Mswati III leads his royal warriors around the main parade ground to appraise the maidens. The Swazi believe their king to be spiritually endowed with the characteristics of animals, and this is expressed in his ceremonial regalia (*left*). His apron of leopard skin denotes royal status and power, the red lourie plumes in his hair represent beauty, while his club, made from the emandla tree, has magical masculine powers. Whenever the beauty or dancing ability of a girl catches his eye, he bends down and drops his shield in front of her to indicate his pleasure. In this way, the king surveys potential new wives from among the many maidens attending the ceremony. His final choice, based on clan diplomacy, is announced later in the same year.

Right: A princess, wearing red lourie feathers in her hair to indicate royal status, leads the maidens. She carries the long knife with which the reeds were cut, reminding the audience of the Swazi creation myth of the original reed, split lengthwise, out of which the first human beings emerged.

Below and following pages: As many as twenty-five thousand girls from throughout the Swazi kingdom participate in the Reed Dance celebration which is also regarded as a female rite of passage into womanhood. Festooned with colorful woolen tassels, the girls parade around the ritual arena, singing and blowing metal whistles to set the rhythm of their marching dance.

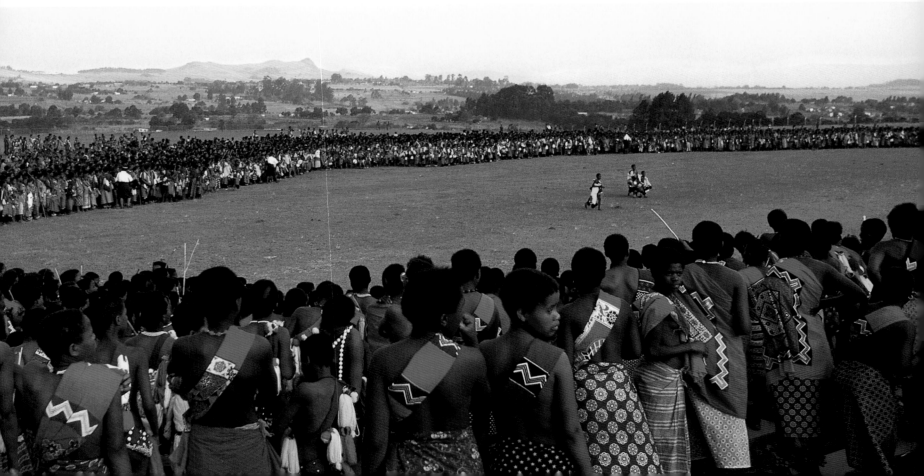

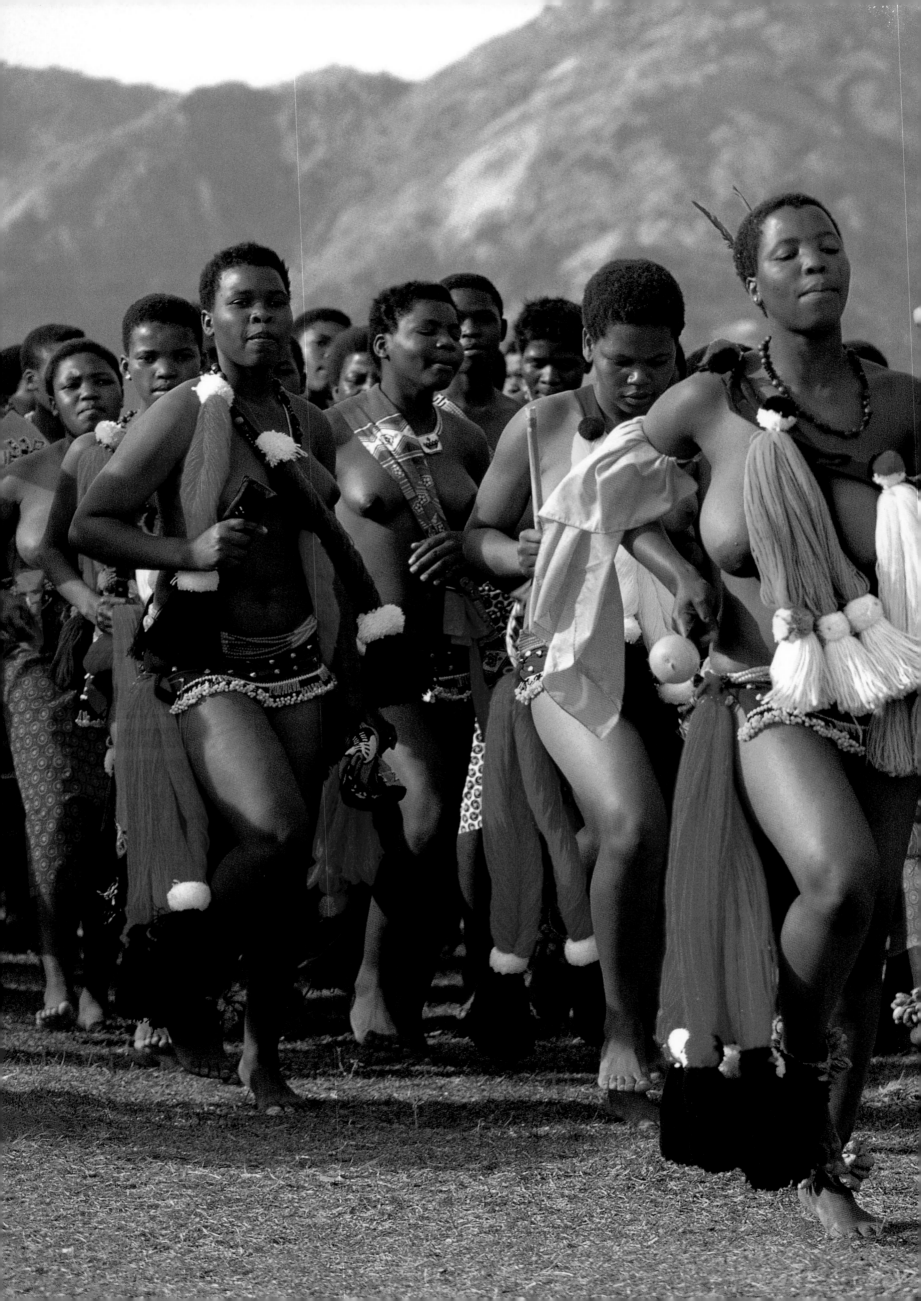

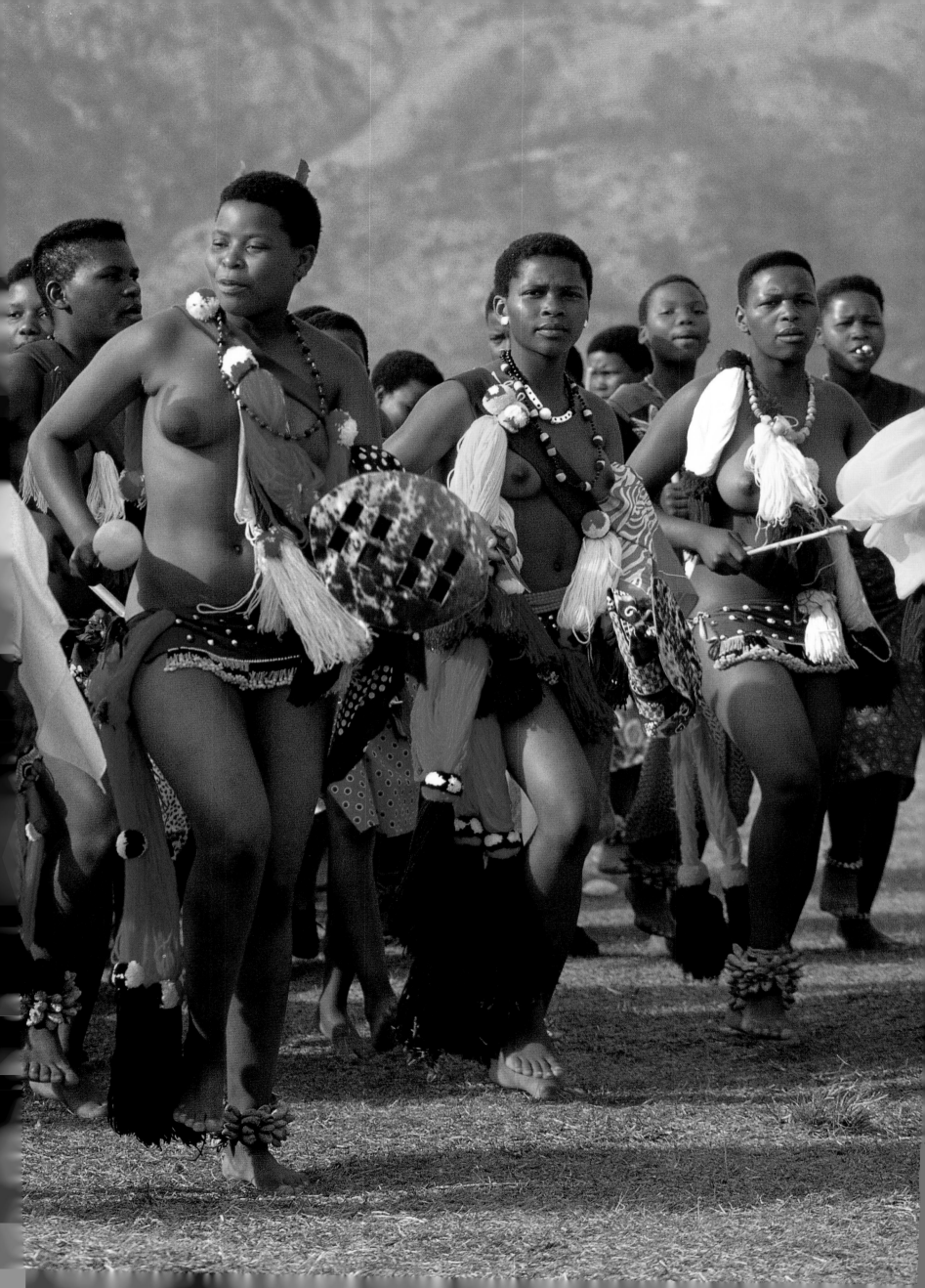

Berber Brides

The Ait Hadiddou group of the Berber people occupies the rugged region of the High Atlas Mountains of southern Morocco and live as independent farmers and herdsmen. Exposed to Islam in the eighth century, they adopted the new religion but retained their original language, character, and many traditional beliefs, including monogamy and marriage customs not associated with Muslims elsewhere. Berber women often choose their own husbands, a rarity in the Muslim world, where marriages are strictly arranged, and, unlike most Arab women, they never veil their faces, except at marriage.

The unique style of Ait Hadiddou marriage can be seen at the annual Berber Brides' Fair in Imilchil, where virgin girls, divorcées, and widows come to find partners. A divorcée or widow may make an instant marriage and go home with her husband that night. For a virgin girl, the marriage will follow a year-long courtship. The wedding itself begins with an initial payment by the groom's father, which includes sugar, dates, henna, and tea. The celebrations start with dancing in the late afternoon and continue throughout the night. Later, the groom sends a mule bearing gifts of clothing and jewelry to the bride's home, and on the evening of the third day, he joins his new wife to consummate the marriage. Sometimes this takes place in a communal wedding chamber, where several young couples live together for five days, learning to make love and growing accustomed to each other. After the consummation, the bridal bed sheets are paraded before the guests as evidence of virginity. On the final night, all the newlyweds are presented to the village; the grooms lift their brides' veils in public for the first time to show off their beauty to the community.

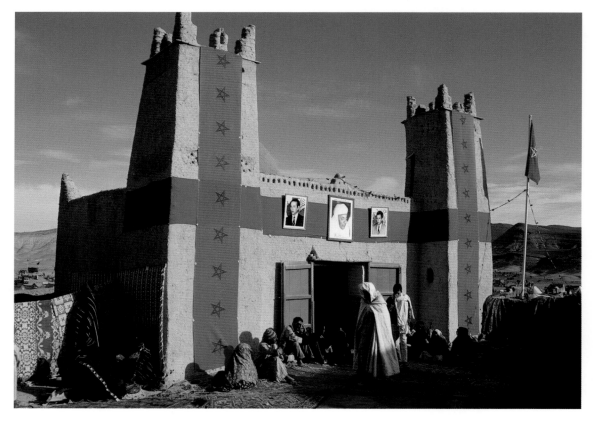

Above: At the Imilchil Brides Fair, marriages are blessed at the shrine of Sidi Mohammed el Merheni.
Right: A virgin bride wears a traditional silk veil, with silver and amber jewelry. *Following pages*: In plain view, a couple court in the fields outside their *casbah*, so as not to compromise the girl's status as a virgin.

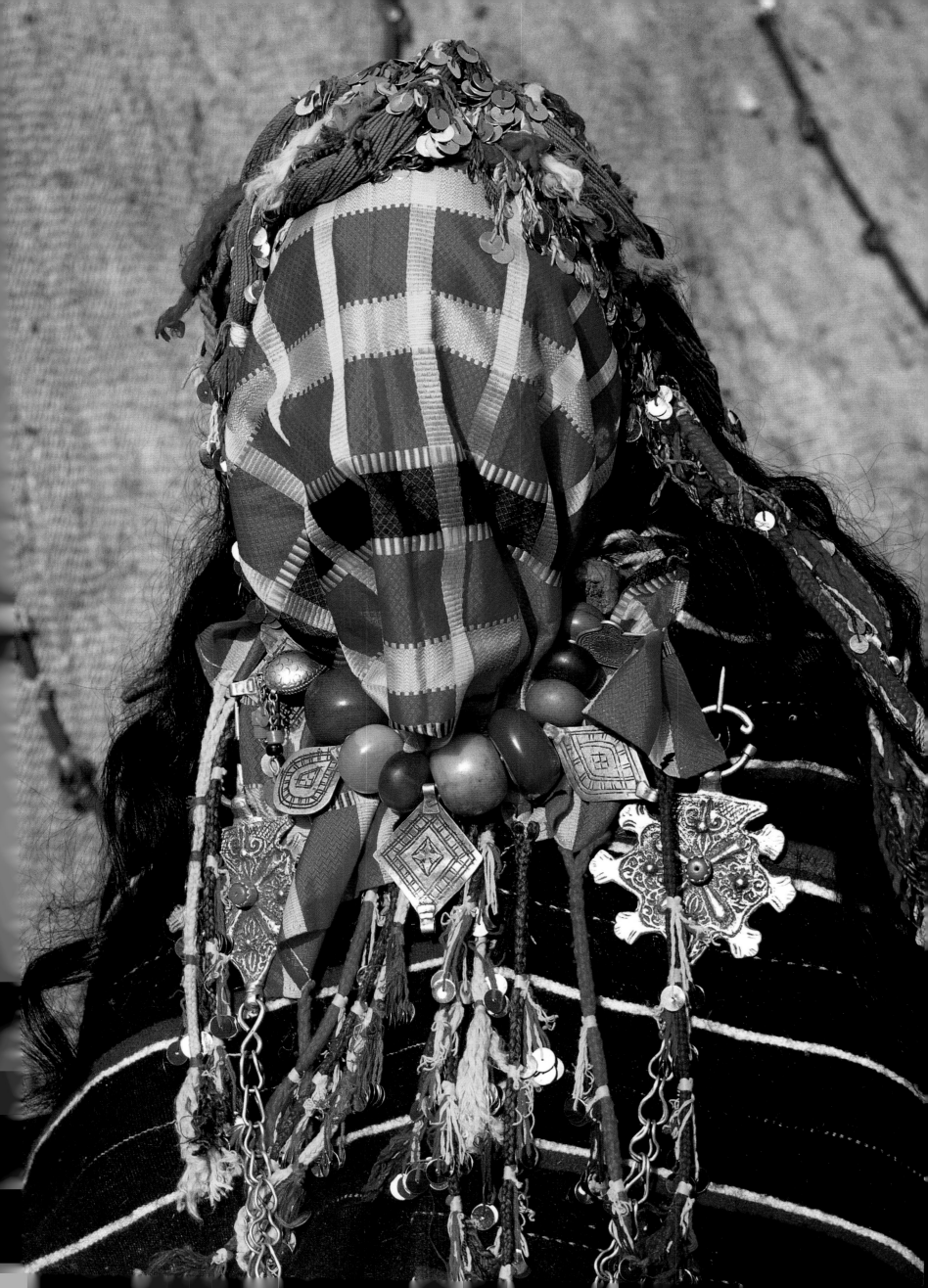

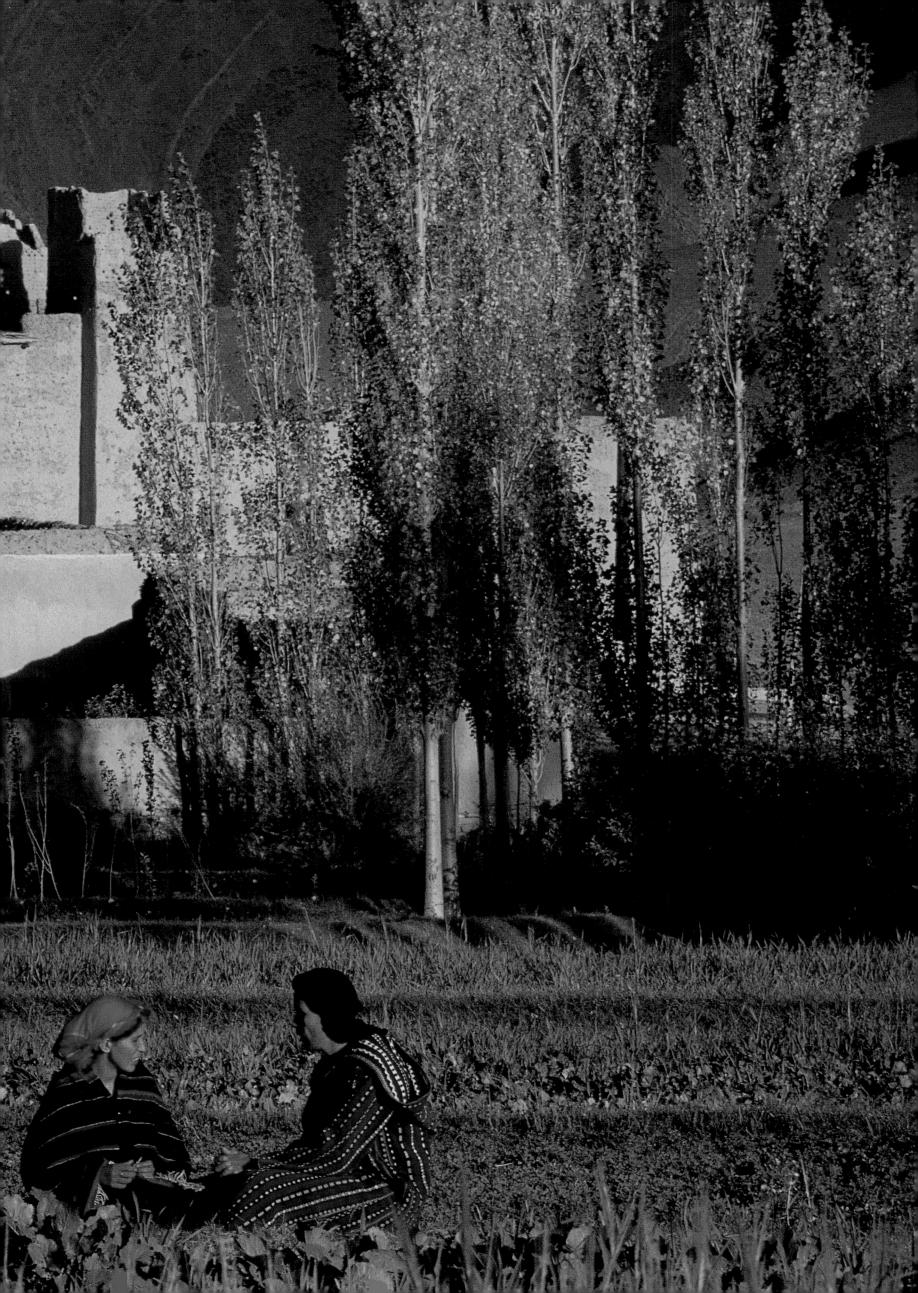

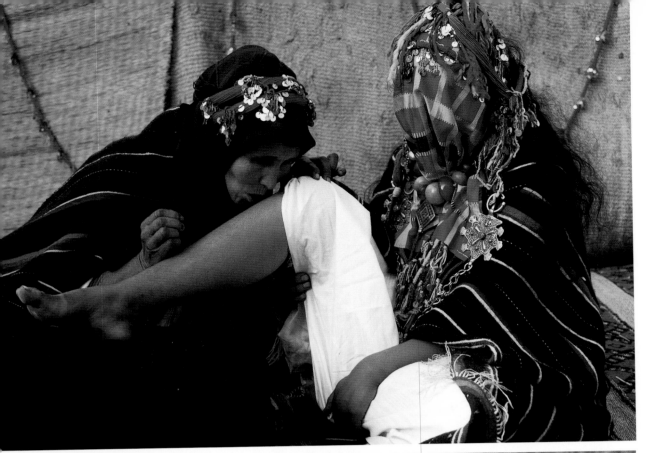

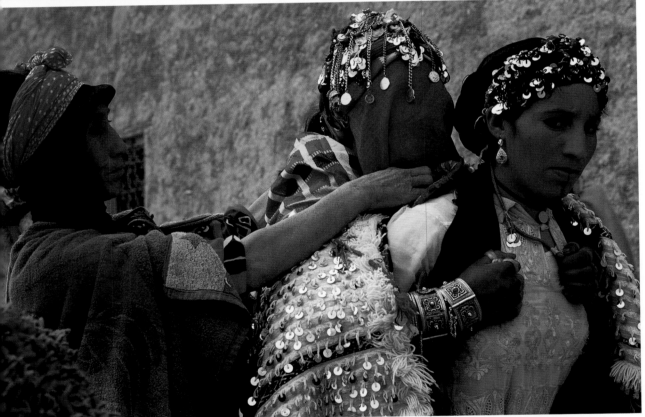

A Virgin Marriage

A mother prepares her virgin daughter for marriage. She tenderly kisses the girl's limbs before massaging them with henna, symbolizing cleanliness and offering protection in married life. Tucked beneath her heavy amber and silver necklace, a colorful silk cloth conceals the girl's face until the nuptial rites are concluded. A pair of silver fibula connected by a chain secures her hand-woven woolen cloak.

The veiled bride travels on muleback to the village of her husband's family. On arrival, the bridal procession circles the groom's village three times, exhorting the local saints to bestow blessings on the new bride. When she arrives at her new home, the girl is lifted off her mount by a female relative and carried into the house. Berber tradition requires that a bride's feet do not touch the ground. Inside the groom's house, female relatives prepare the bride for her marriage ceremony by applying henna to her hands and feet. They also pin money to her veil as a symbol of prosperity, and serve dates, almonds, cakes, and tea (*below left*). As the women guests sing and clap in celebration of the bride's arrival, the girl's mother lifts the veil and offers her a ritual glass of milk, symbolizing peace and fertility.

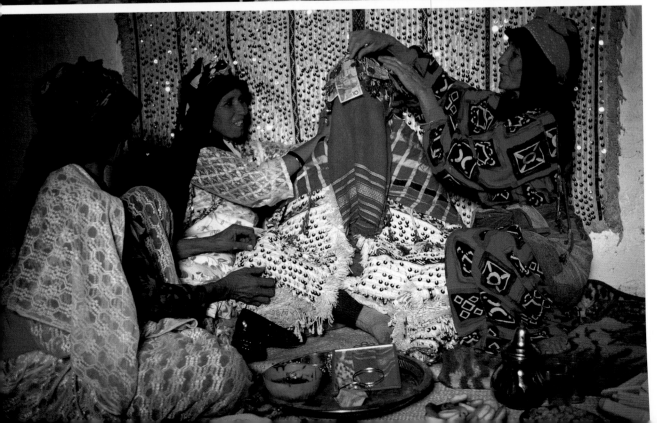

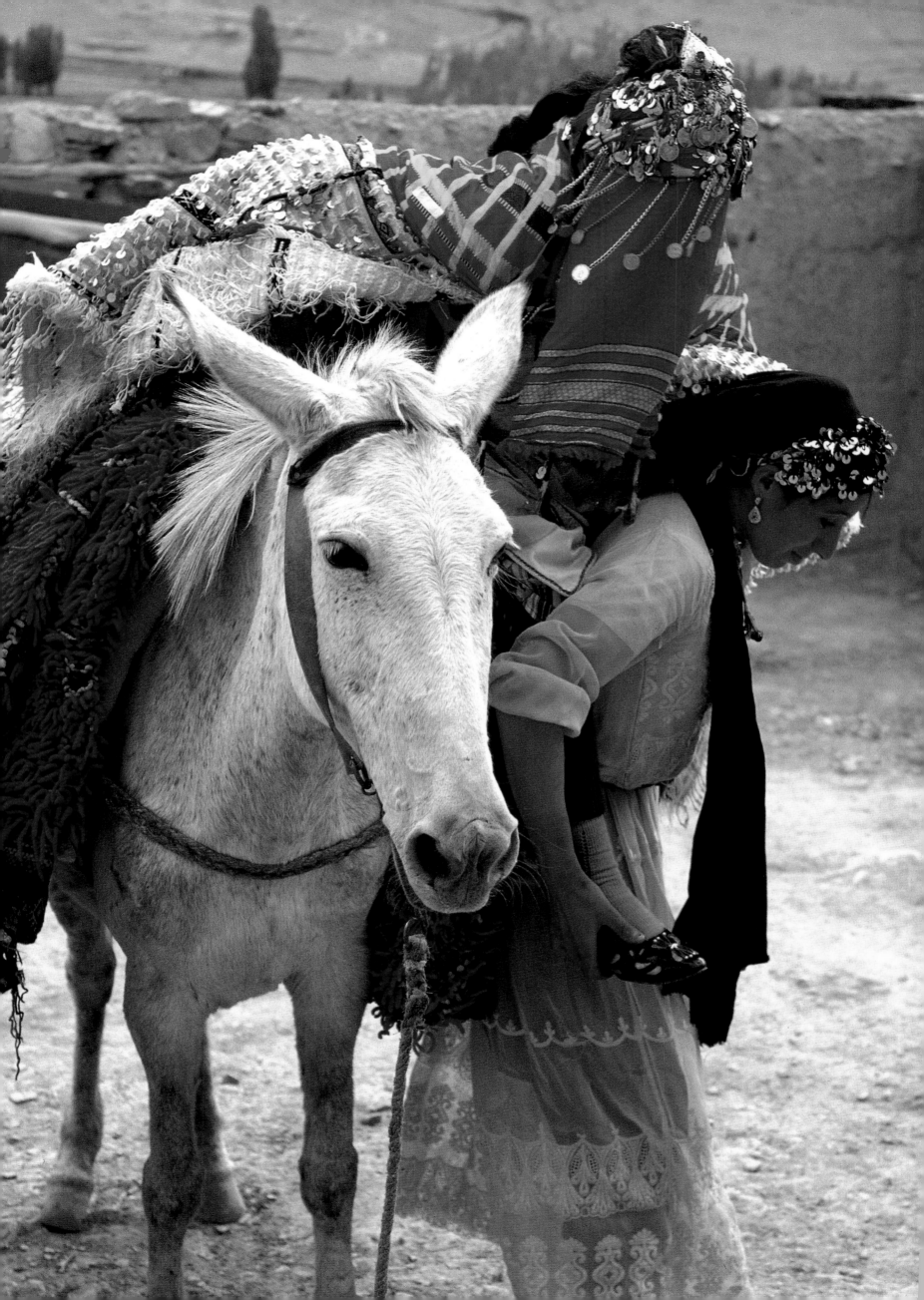

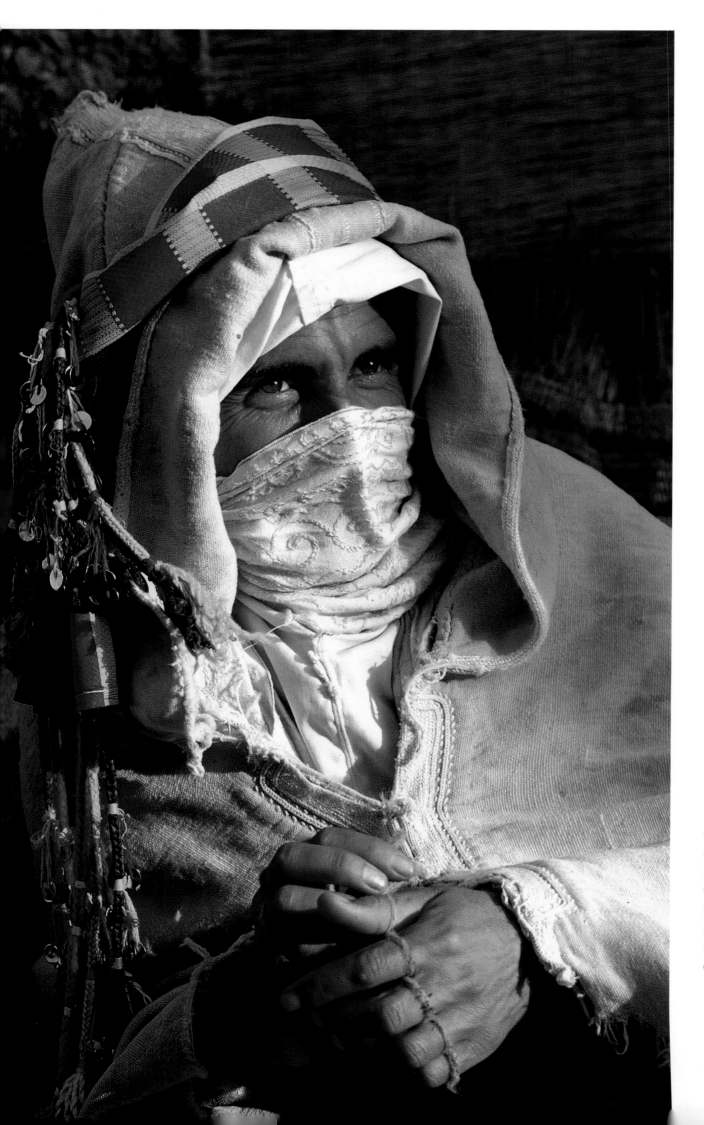

The Bride and Groom

The groom, traditionally dressed for marriage, wears two wedding robes and a silk veil over his nose and mouth. Twice the bride's age, he will be expected to provide for her every need once they are married. In preparation for the wedding, his fingers are ritually bound with string, and for a five-day period he is rendered helpless. During this time, he is fed and cared for exclusively by his fiancée so that the couple can get to know one another better before the marriage begins. After the wedding rituals are concluded, the bride is permitted to remove her veil, revealing, in this instance, the child-like beauty of a twelve-year-old. Reflecting the ideal of Berber beauty, the bride's lips are colored with crushed walnut root to plump them, her eyes are outlined with antimony to whiten them, and her complexion is brightened with saffron and ocher painted in a traditional pattern on her cheeks. Her two silver cloak clasps symbolize purity and honesty.

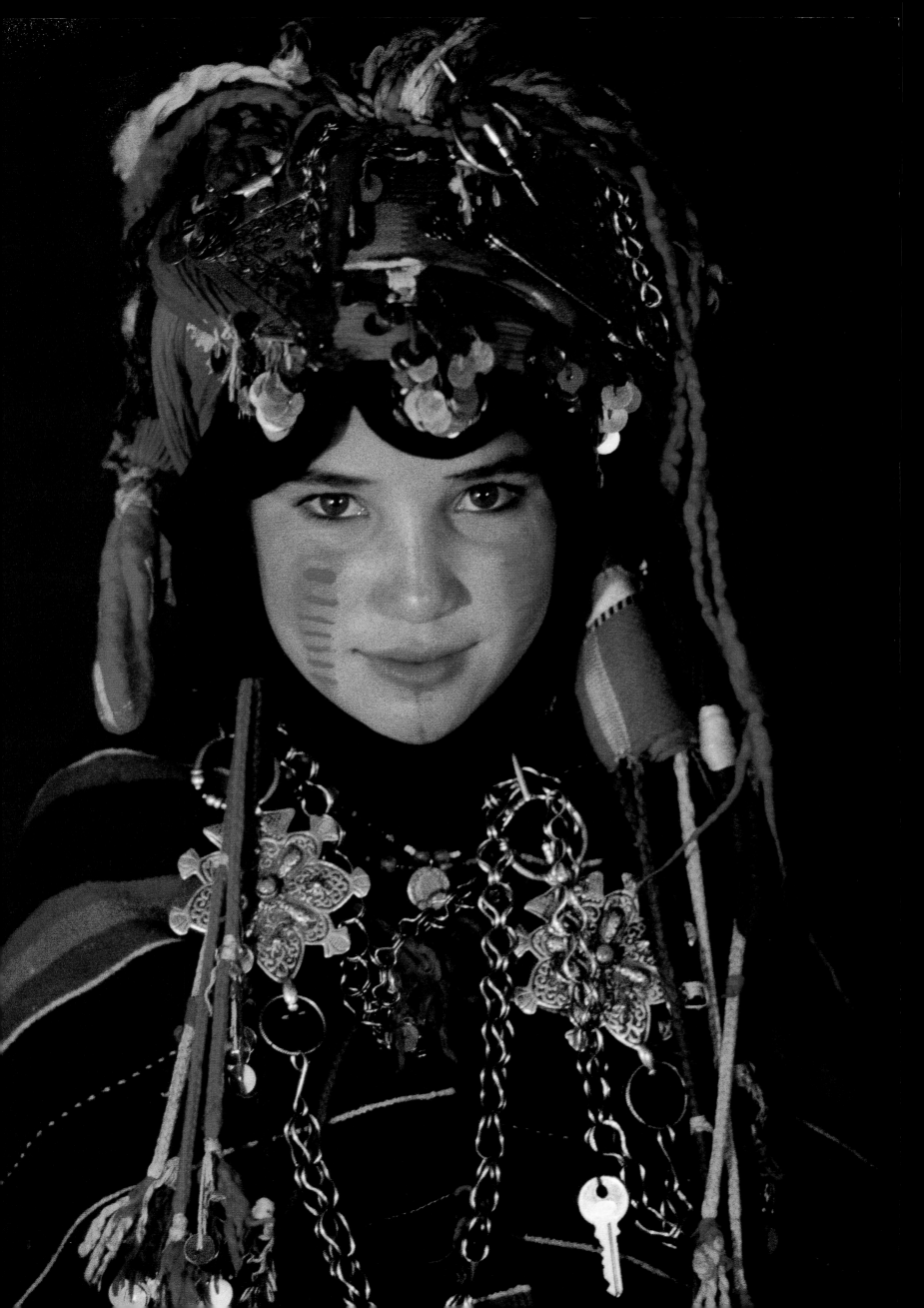

Hassania Veil Dance

The Hassania people trace their descent from the ancient race of Berbers. Nomadic pastoralists, they were driven out of their fertile lands in North Africa by invading Arabs and traveled across a vast region of the Mauritanian desert in search of a new homeland. Reaching the desert fringes of the south near the Senegal River, they intermarried, first with the local indigenous people from the western savannah and later with the Arabs. The traditional Moorish lifestyle of the Hassania was influenced by both cultures, but in particular by the flamboyant heritage of Arabia. Today they are settled in Mauritania, southern Morocco, and the Sahara Desert areas of Algeria and Mali.

Hassanian folk songs tell of the terrible hardship suffered by their migrant ancestors as a result of their travels through the harsh desert terrain. These songs often form a poignant accompaniment to the Guedra, the traditional dance of love, which is performed in ancient Moorish style as an expression of feminine grace and seduction. The songs of the Guedra, influenced by Gnaoua spirit music, are sung in Hassani, an Arabic dialect of the thirteenth century. The Guedra is traditionally performed from May to August as the opening ritual at weddings and at Berber festivals called *moussems*. It is danced by up to seventeen women at a time, accompanied by musicians who chant the dancers' praises and provide rhythmic accompaniment. The dance is considered by the Hassania to be one of the strongest expressions of their culture, but today, sadly, there are only about sixty women who can perform it to perfection.

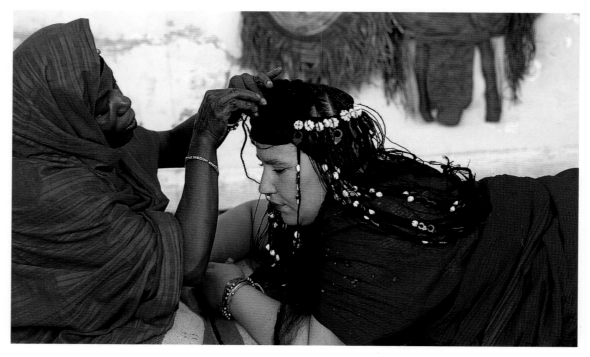

Above: A Guedra dancer's hair is embellished with precious beads and shells. *Right*: The Guedra begins with the dancer completely cocooned in indigo-dyed cloth, revealing only her hands.

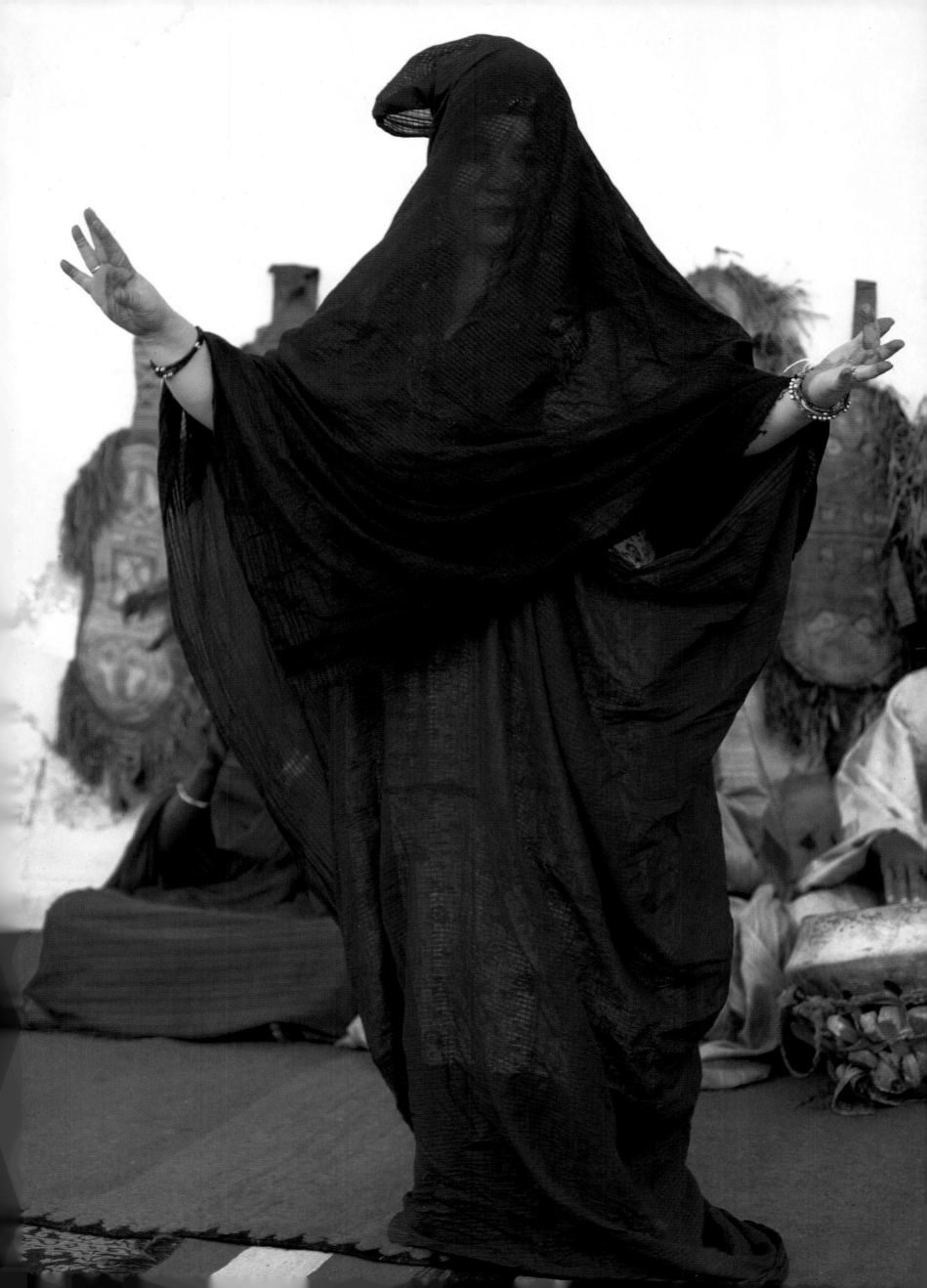

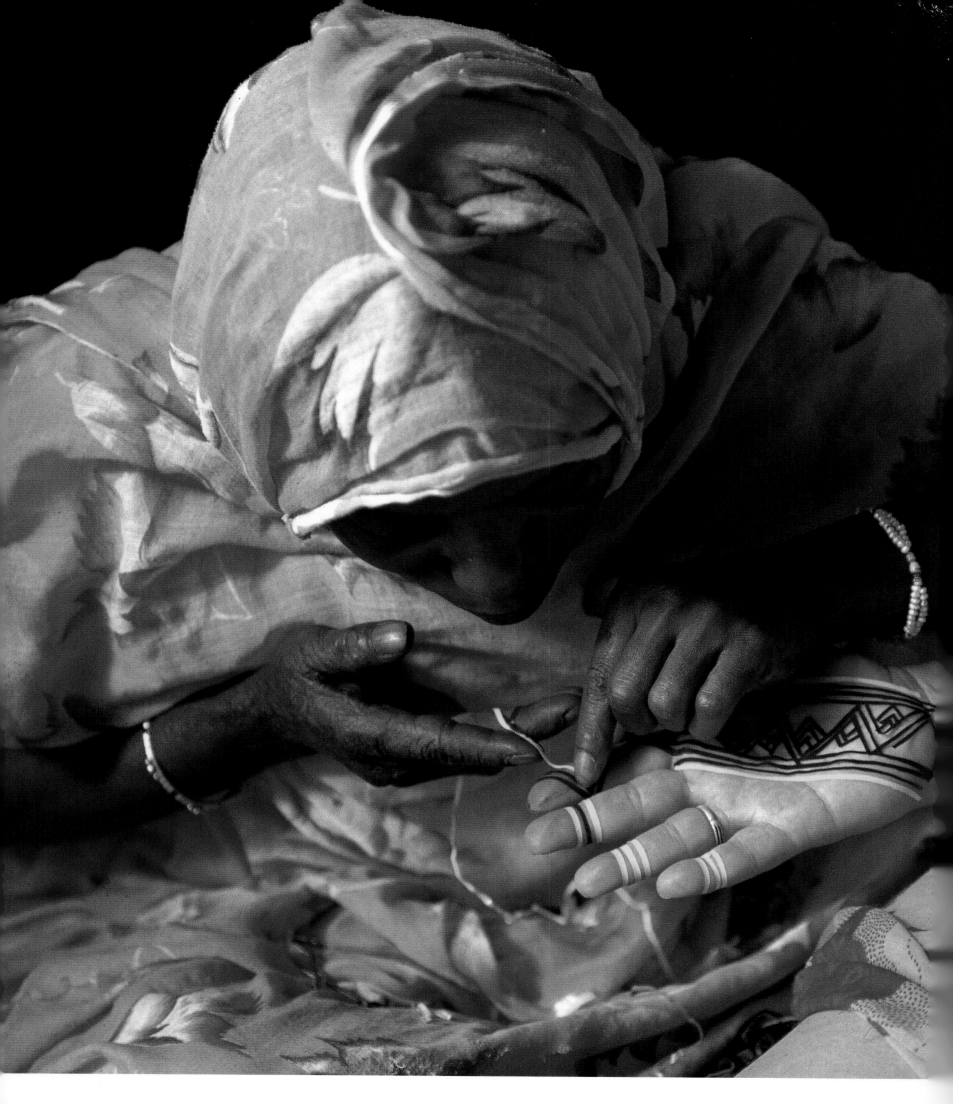

Embellishing Hands and Hair

Hidden by her robes for most of her performance, a Guedra dancer reveals only her beautifully decorated hands and feet. A specialist in the ancient art of henna painting masks off areas of the dancer's skin to create geometric motifs. When the masking is complete, the hands and feet are painted with henna paste. After some hours, the stencil tapes are removed to reveal an intricate pattern. The ornate silver jewelry, acquired as part of a dowry or passed from mother to daughter, is typical of the fine workmanship of smiths from oasis towns in the south of Mauritania. In preparation for the Guedra, a dancer's hair is braided and adorned with glass talismans, shell disks, amber beads, and gold pendants. The triangular shapes of the

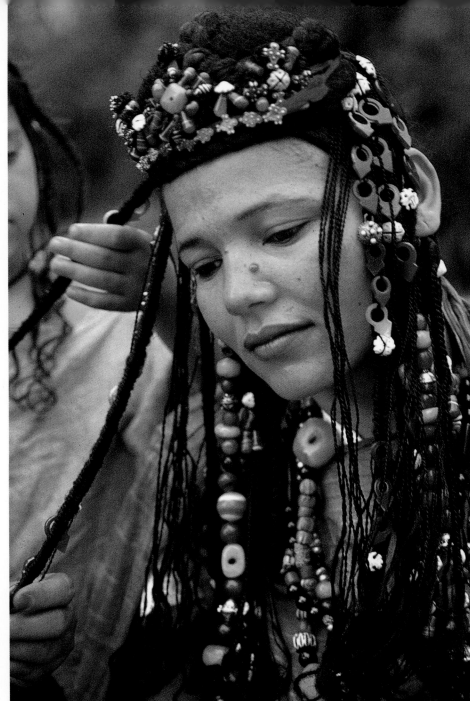

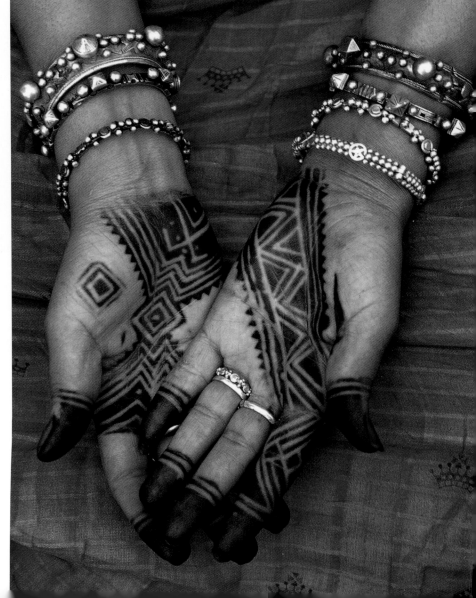

beads symbolize fertility and protection, while their colors represent virtues: blue, the purity of the sky; white, the health of Hassania servants; and violet, the dove, a symbol of love and gentleness. The large frontal bun made of false hair and studded with jewelry is favored by brides from wealthy families.

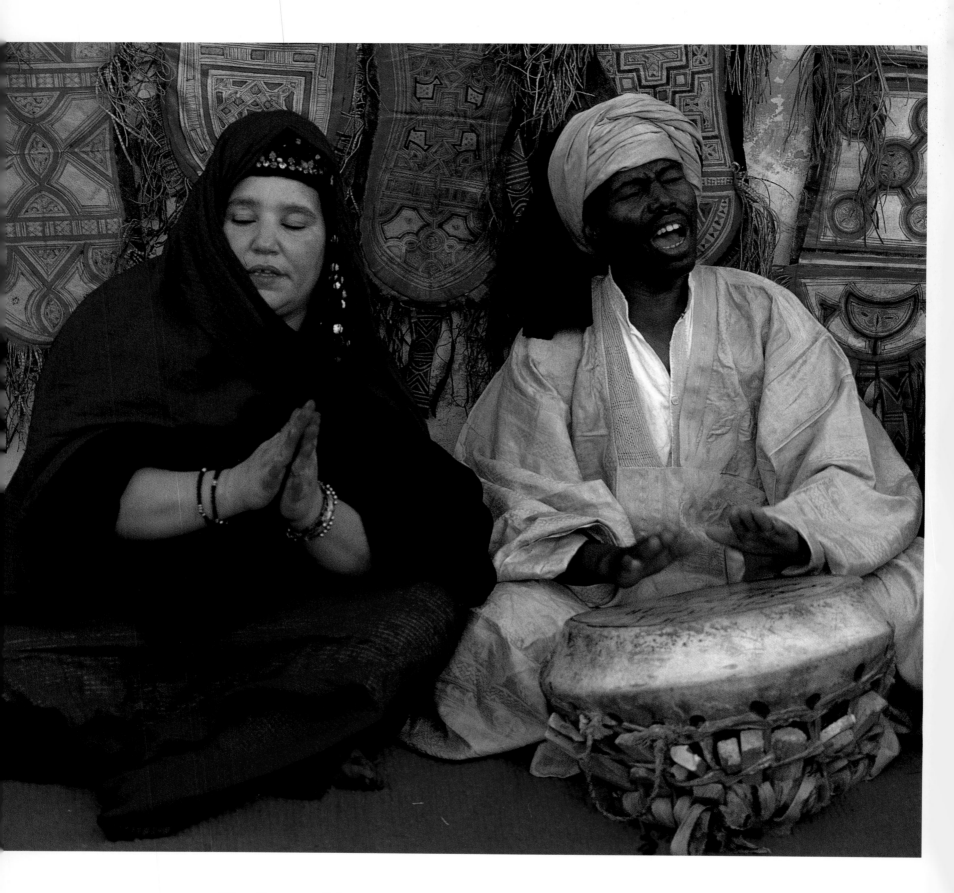

The Dance of Love

Hassania musicians and dancers from the border of Mauritania and Morocco celebrate the Guedra in the courtyard of their home. A ritual dance of love performed by women for the benefit of men, the Guedra is a ballet of the hands and feet. Sometimes the dancer stands, but more often she kneels, swaying back and forth to the accompaniment of drummers, while women clap and ululate to the mesmerizing beat. At the climax of the dance, she removes her veil so that her long strands of beautifully decorated hair swing wildly from side to side, emphasizing the sinuous movement of her body. Alluring in its femininity and often highly emotional, the Guedra is danced to traditional songs about the loves and lives of the Hassania people.

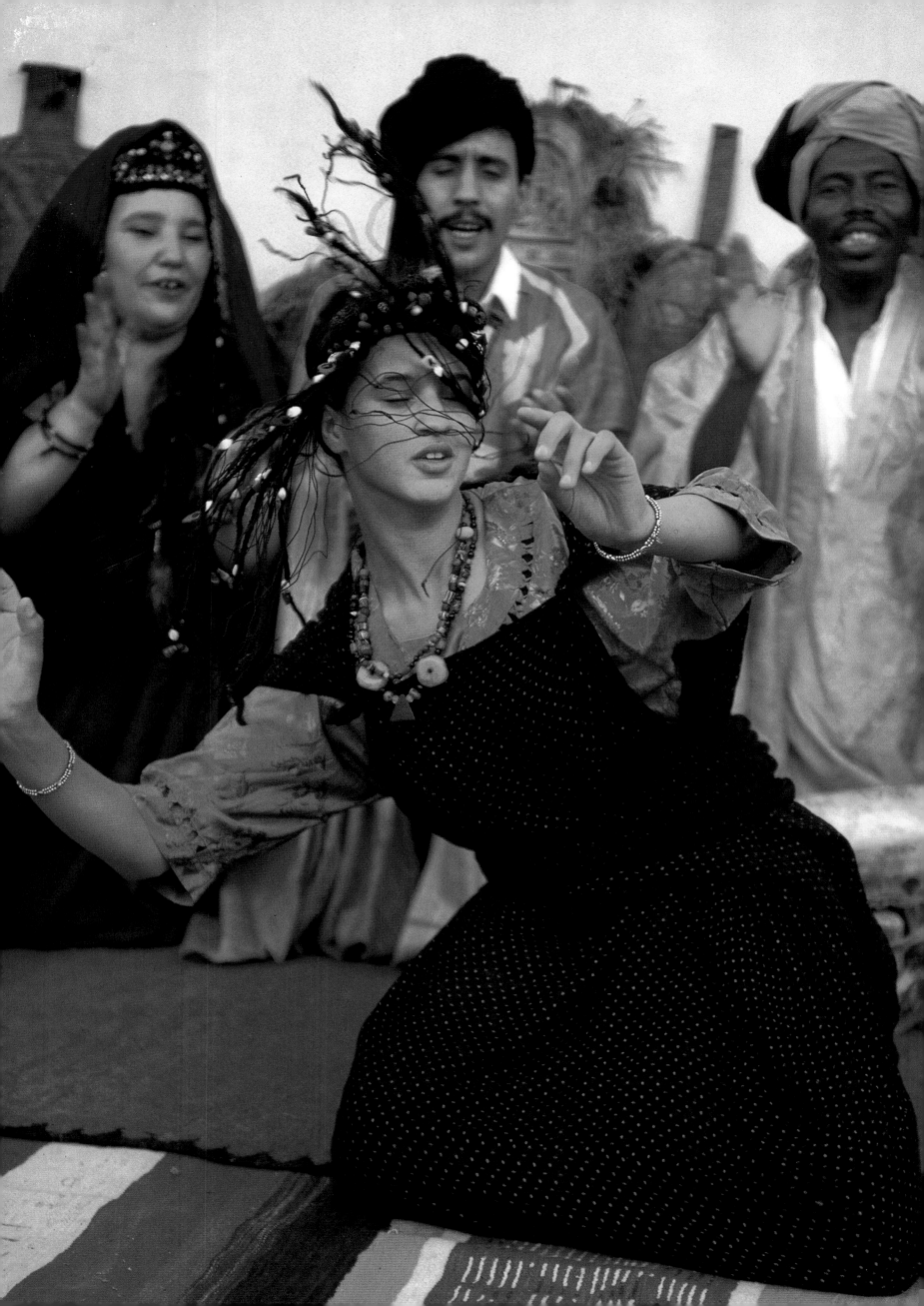

Rashaida Wedding

The Rashaida nomads, a Bedouin tribe from Saudi Arabia, crossed the Red Sea more than a hundred and fifty years ago and entered Eritrea and Sudan. A tough race of desert dwellers who lay no claim to owning land, they have survived by carrying out a lucrative camel trade with Egypt along the coastal desert of Sudan.

To protect their traditions the Rashaida marry exclusively within their own community. The most popular time of year for marriages is April and May. No weddings may take place during the holy days of Ramadan and Eid. As the sexes do not mix freely in Rashaida culture, young men and women have few chances to meet of their own accord. Marriages are usually arranged by families, and brides as young as sixteen may be married to men of fifty years or more, who can afford the large dowry of jewelry, camels, cloth, and cash. Should a woman not find a match to her liking, she may divorce after seven years, but her family is obliged to

return the dowry. Traditionally, a man may marry as many as four women, but today, because of the tremendous cost, men are taking fewer wives, and are forbidden to marry more than once a year, regardless of their wealth.

Rashaida wedding rites take place over a period of up to seven days in a large tent decorated by the bride in the days before the wedding. Festivities begin with the slaughter of a camel by the groom, and continue with feasting, dancing, and camel racing to entertain the guests. The marriage ceremony itself is performed on the first day, when the girl is asked by holy men if she is being forced to marry against her will. If so, the proceedings end immediately. If not, the marriage is blessed with a benediction. Special prayers for children, camels, health, long life, and water are added to the usual daily morning and evening prayers.

Above: Guests of the groom share a moment of relaxation while traveling to the wedding.
Right: Accompanied by his three wives, a wedding guest arrives on camelback.

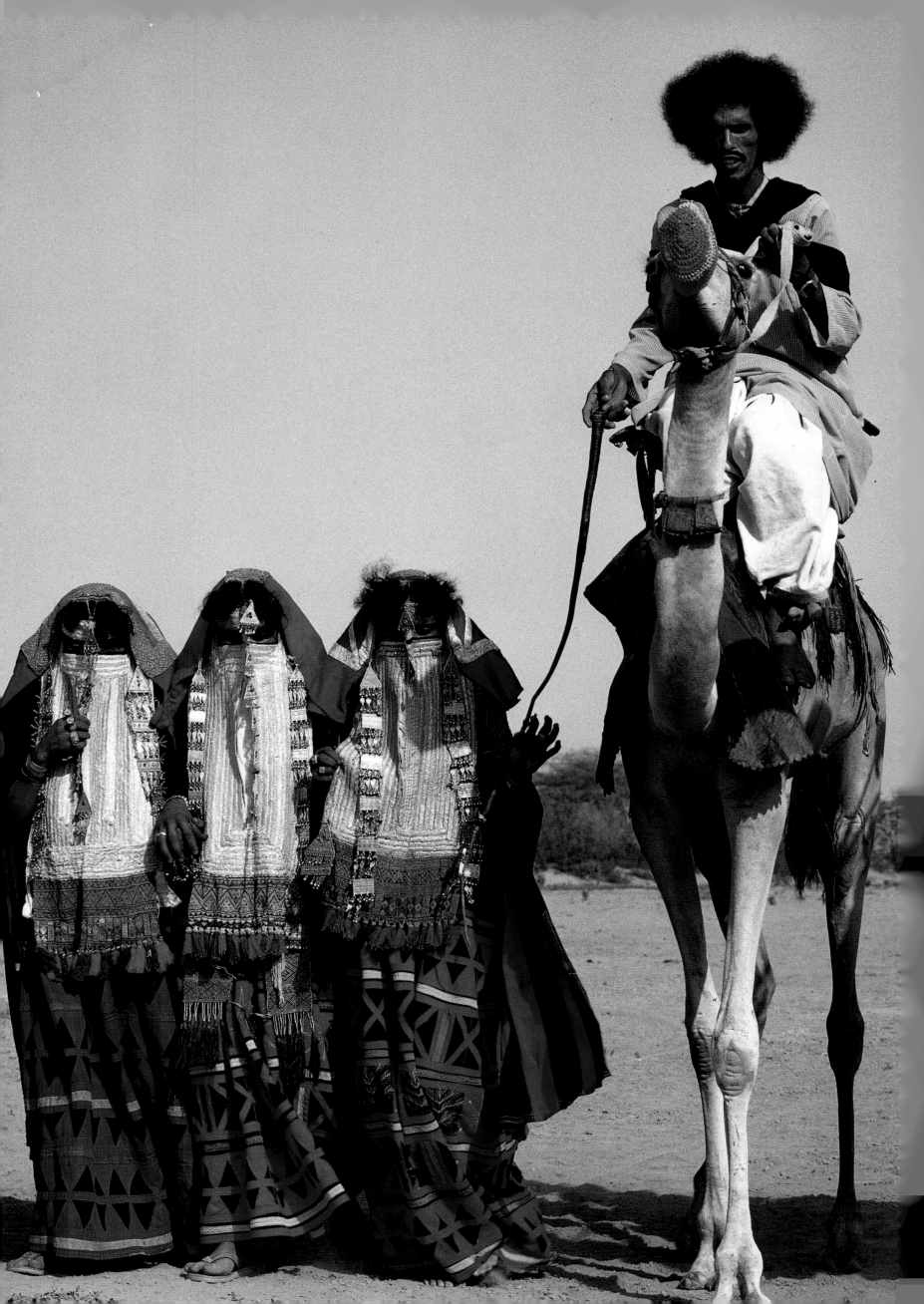

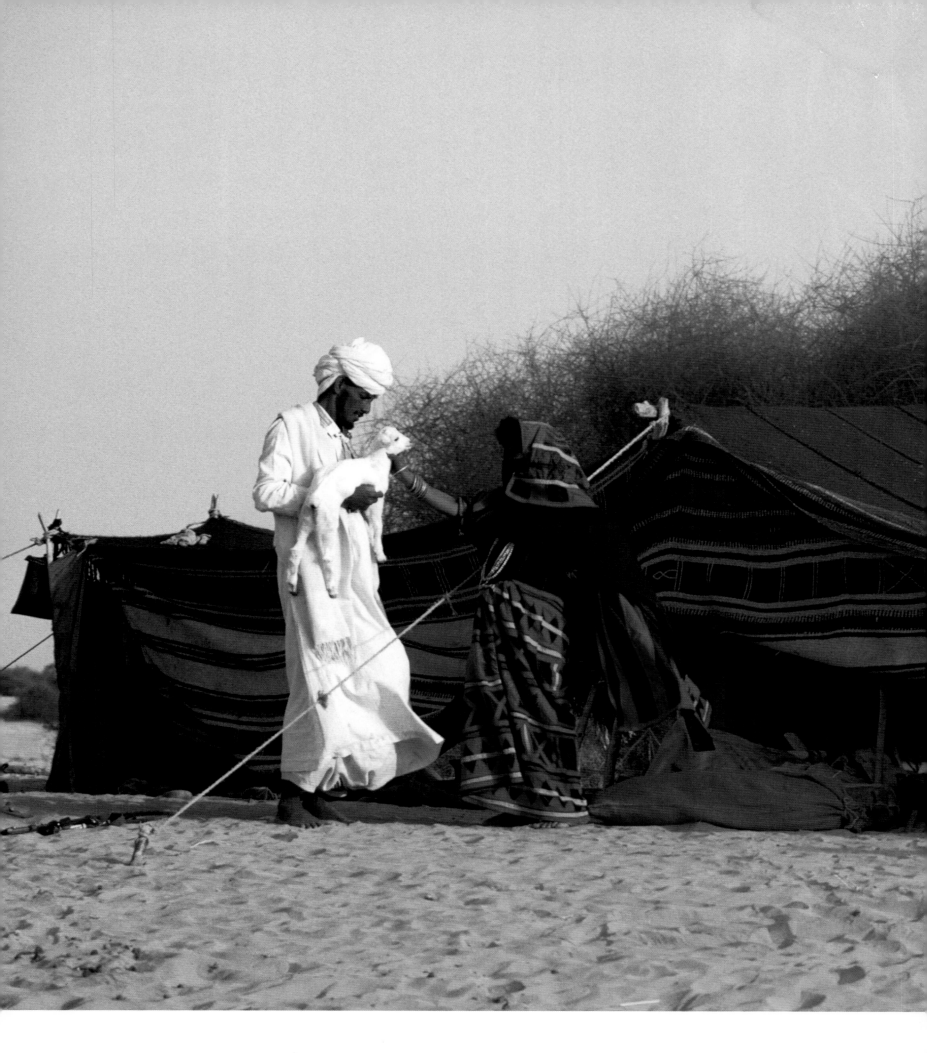

A Desert Wedding

A married couple converse outside their traditional tent covered with woven goat hair. Around them, festivities have already begun. On the first evening of the wedding, male guests of the groom arrive from neighboring villages to attend an exclusively male gathering. Gathered in the shade of a large tent, the men present the groom with gifts of money, which they tuck into his turban and waistcoat

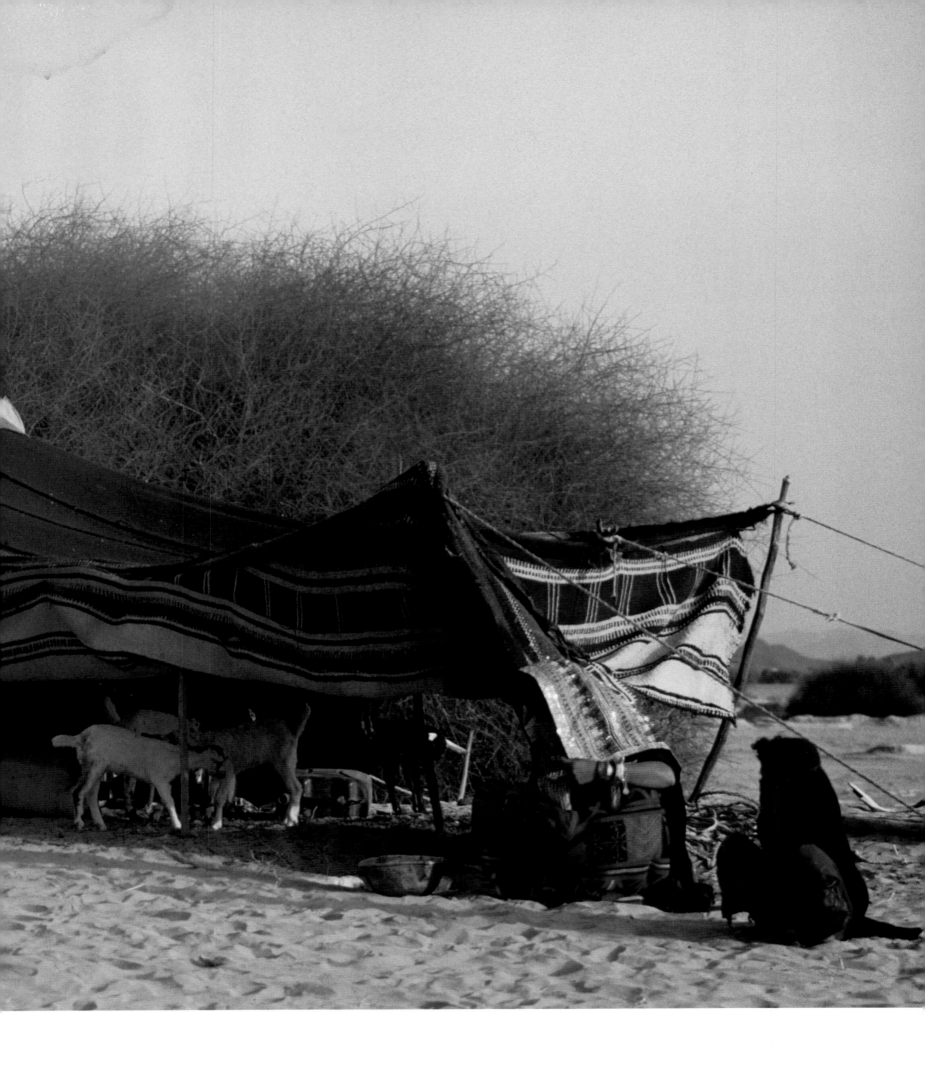

pockets while onlookers shout their wishes for success. The men enjoy an evening of revelry, joking, and dancing, which culminates in a feast of goat meat, wheat porridge, sand-baked bread, and sweet tea. As the men celebrate, the bride remains secluded in her tent. She is not permitted to be seen by anyone except her mother and sisters.

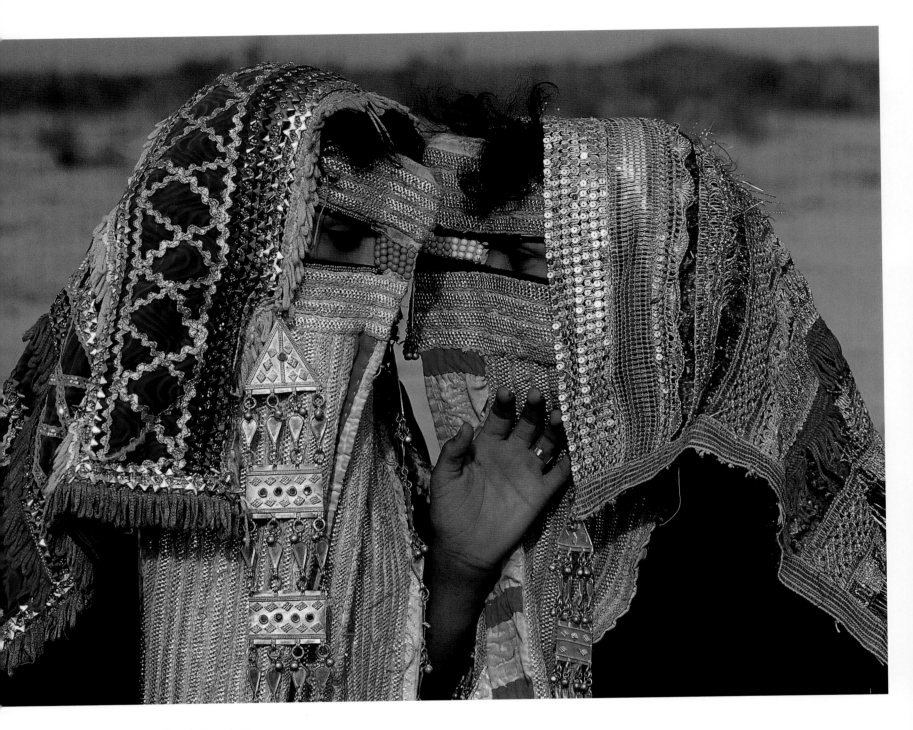

Veiled for Life

From the age of five, Rashaida women are required by the law of purdah to cover their faces when they are in public. When they eat, they pass food beneath the mask, and when they sleep, they must remain lightly covered. The mask, considered an expression of beauty, is only removed when they are alone with their husbands. The Rashaida believe that showing a smile, a sign of happiness, would be disrespectful to the Prophet Mohammed. At this Rashaida wedding, two women converse while another dances in celebration of her friend's marriage. The many layers of colorful fabrics she wears, including her richly appliquéd skirt, enhance her movements.

Following pages: At her marriage, a Rashaida bride replaces the veil she wore as a child with a more elaborate wedding mask, called *burqa*, which she will wear for a year. This mask was made by her mother and decorated with silver thread and pendants given by her husband. Also dressed traditionally, the groom wears a cotton tunic, an embroidered waistcoat, and a turban. He holds a ceremonial sword given to him by his parents and used in dances performed at the wedding.

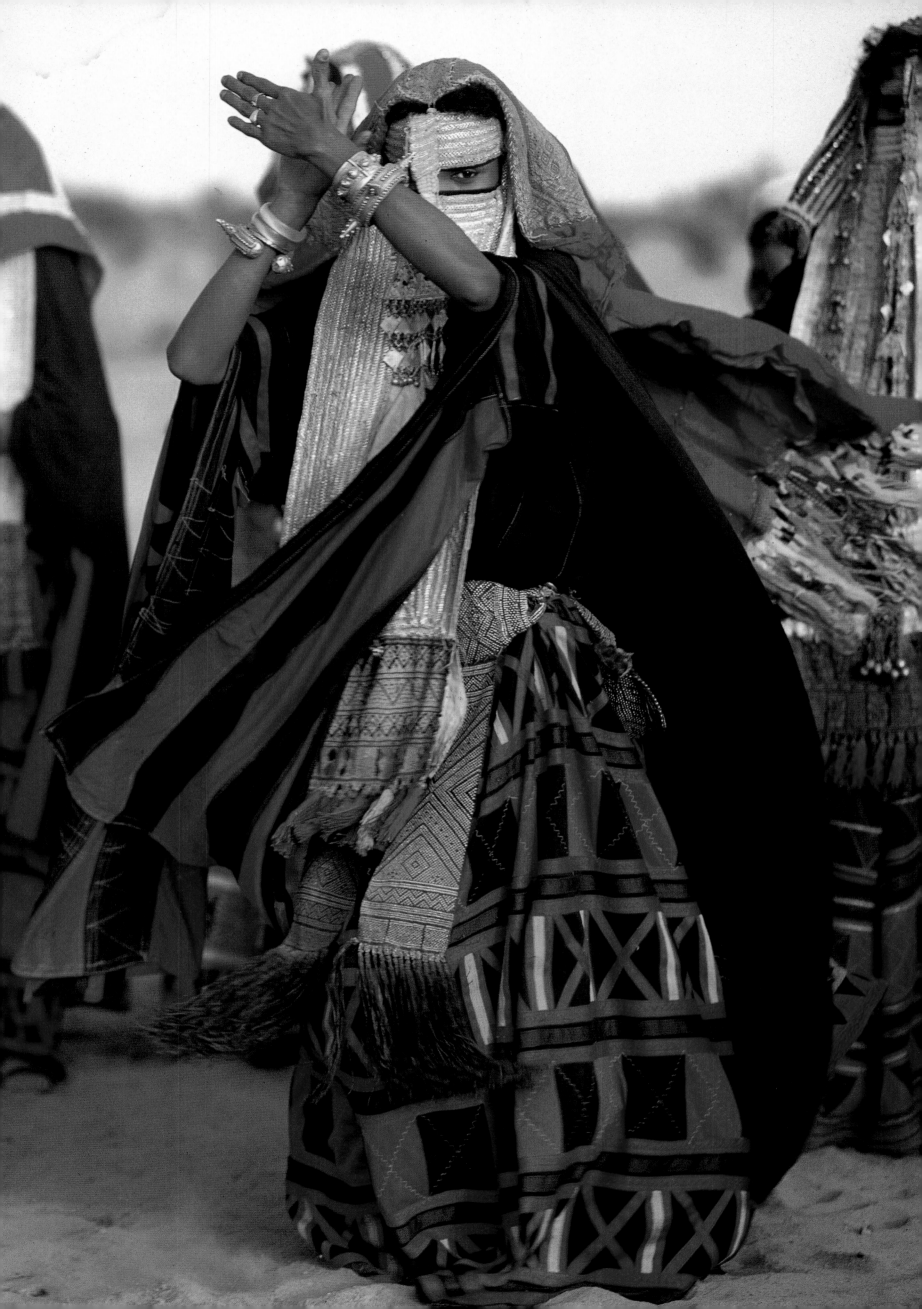

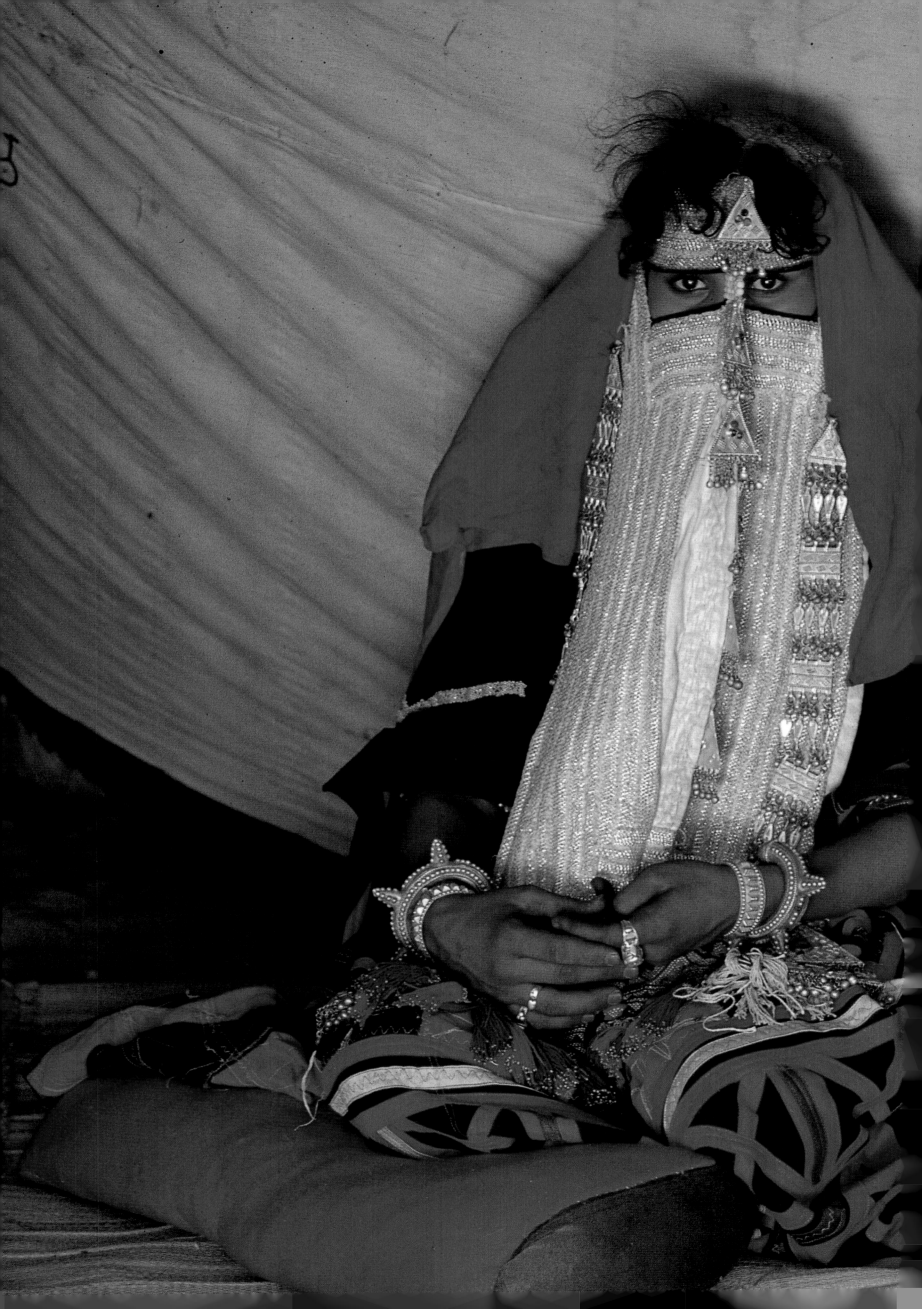

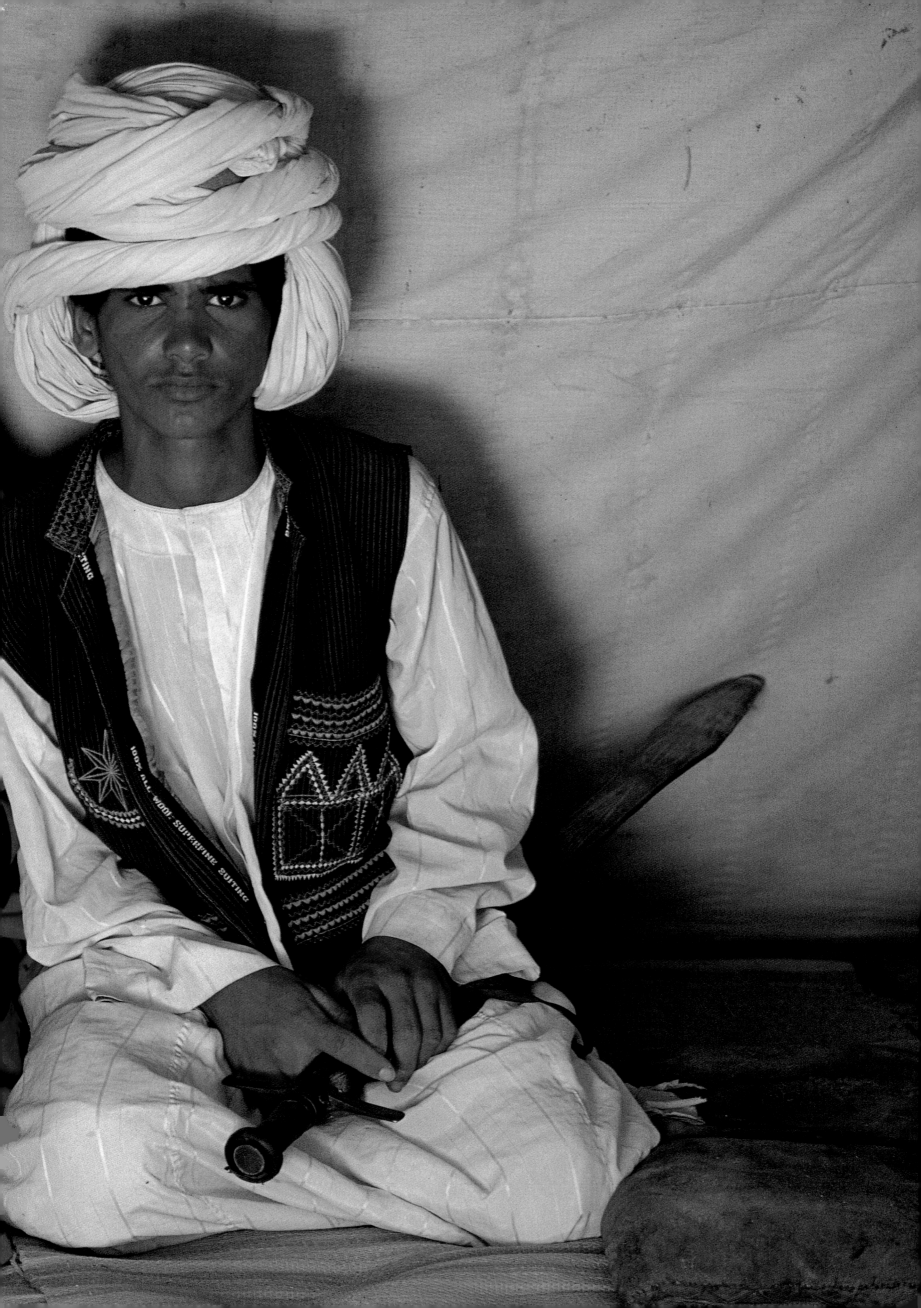

Swahili Brides

Swahili is the name given to East Africa's most widespread language and to the ancient culture of many of the people who inhabit the fertile strip of land on the coasts of Kenya and Tanzania and nearby islands in the Indian Ocean. In Swahili society, as in all Islamic cultures, the sexes are strictly segregated and the participation of women in public life is limited. Swahili marriages are arranged by families, based on the clan status, integrity, and financial position of the suitor. Once agreement has been reached, the groom must pay a dowry before marriage and a gift after marriage, the size of which depends on his family's financial situation.

The Swahili bride, who has often never seen her fiancé, enters a period of isolation to prepare for leaving her life as a girl behind. Accompanying her at all times is an experienced woman, called *somo,* usually a close friend of the bride's mother, who instructs the bride in the ways to please a husband. The wedding, supervised by the mother of the bride and usually held in the month preceding Ramadan, follows a traditional sequence of events. Special beauty treatments are given to the bride: her body is massaged with coconut oil and perfumed with sandalwood. Female relatives of the groom perform a ritual called Kupeka Begi (Send a Bag) in which they bring the bride gifts from her husband. In response, the bride's female relations perform Kupeka Msuaki (Bring the Toothbrush), wherein they deliver a tray of toiletries to the groom. Finally, before the wedding itself, all the women of the wedding party gather in a private courtyard to perform the *chakacha* dance, rolling their hips in unison to music, ululating, and singing songs filled with sexual overtones. Swahili weddings offer a unique opportunity for women to display the richness of their attire to the female community and to make their social positions known.

Above: The Swahili town of Lamu lies on Lamu Island off the coast of Kenya. *Right*: An elder blows the ivory *siwa* horn traditionally used to announce marriages, circumcisions, and religious events.

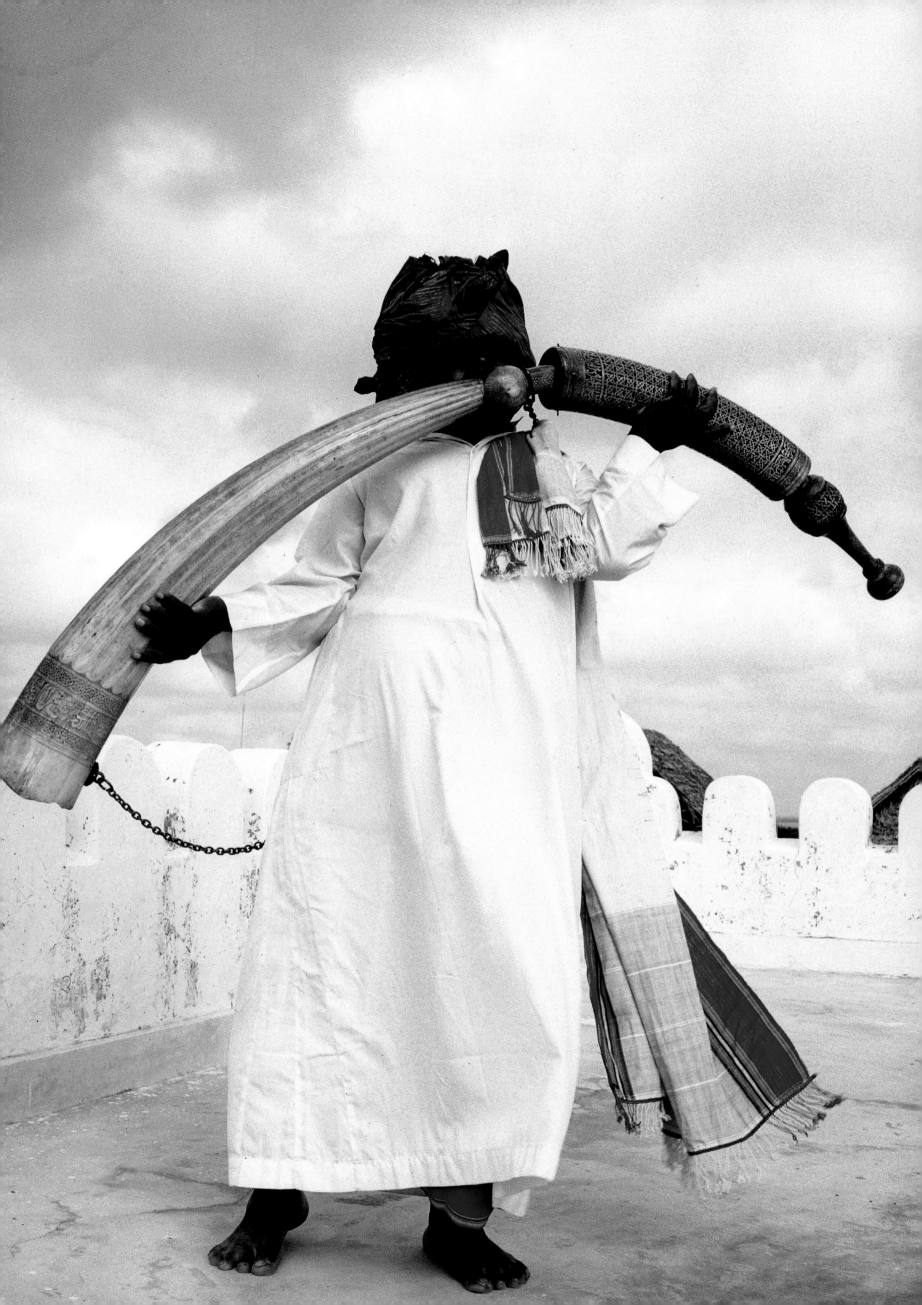

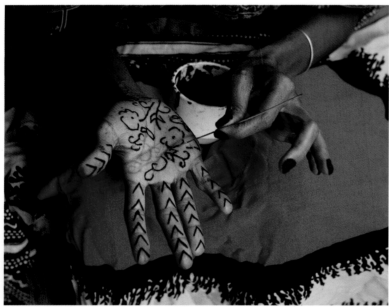

Lifting the Veil

A Swahili groom may not see his bride's face until their wedding night.
For two or three days beforehand, she remains in her room while her
hands, arms, and feet are decorated with a dye made of powdered
henna, water, and the juice of unripe limes. Her jewelry chest (*above*)
includes finely worked gold and coral necklaces, buffalo-horn disks once
used to stretch the ears, and gold filigree plugs.

The groom enters the bedroom, lifts the curtain surrounding the bed,
which is strewn with jasmine flowers, and places a necklace made of
gold or coral in the bride's hand. A playful hand tussle occurs, and who-
ever ends up holding the necklace is believed to have the upper hand in
the marriage. For seven days, the bride and groom remain in isolation,
enjoying each other's company. In former days, the bride would have
been accompanied by her *somo*, who slept under the bed to assist the
husband if the girl resisted consummating the marriage, and to witness
the girl's loss of virginity. A cloth displaying the virgin blood would be
displayed to the women waiting outside, while the bride's mother sang,
"You have broken into the fortress, my lion of duty."

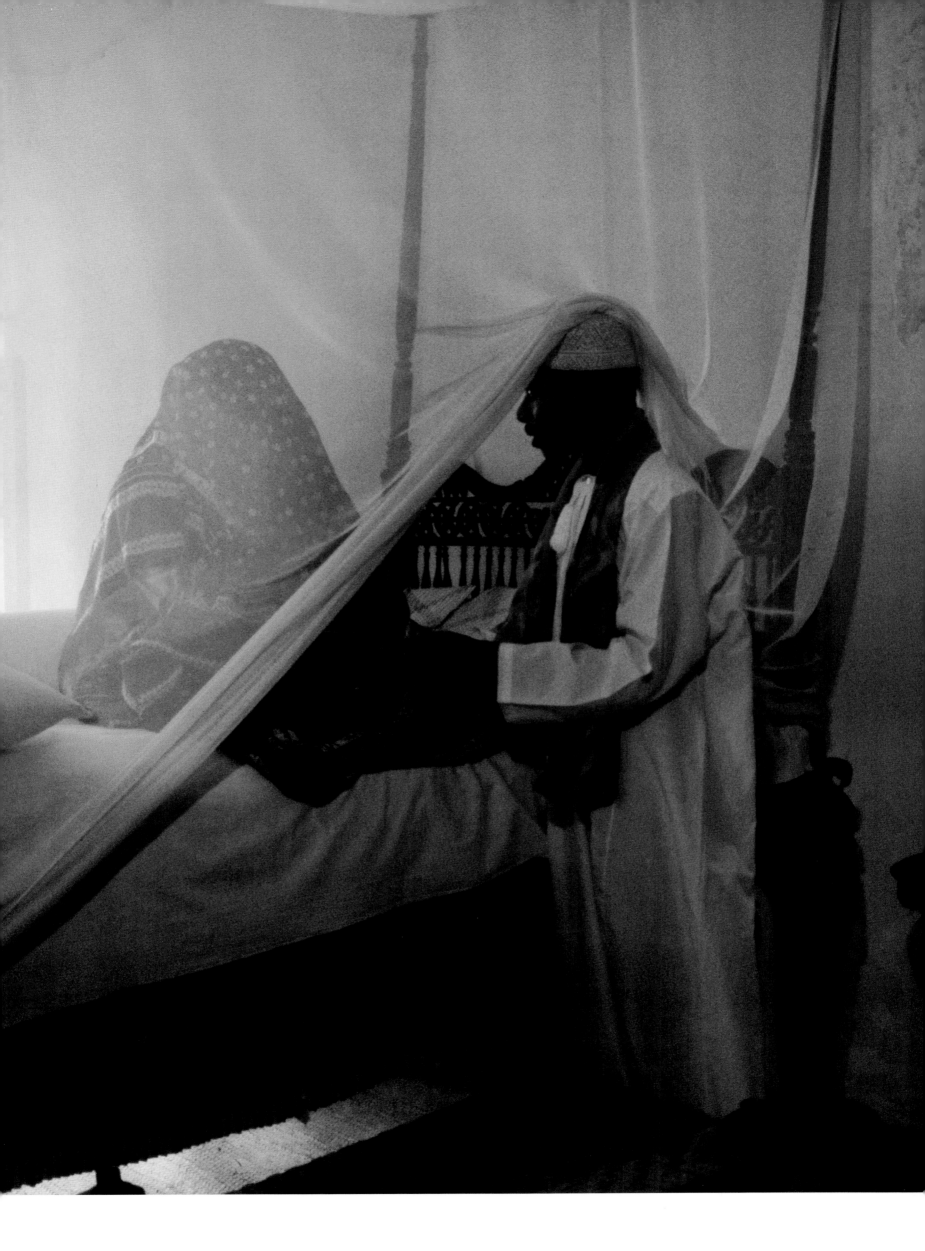

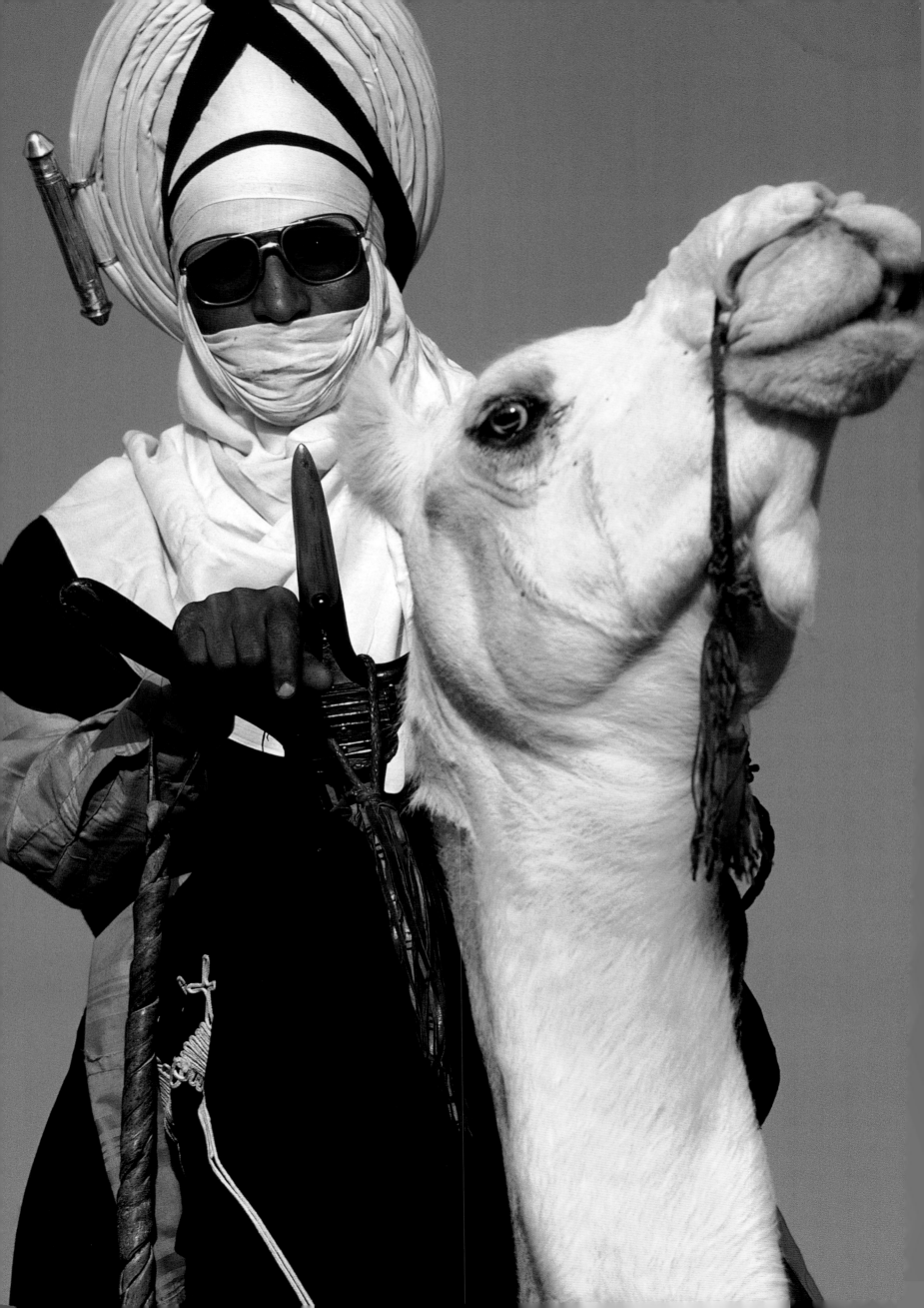

Tuareg Marriage

Descended from the ancient race of Berbers in North Africa, the Tuareg nomads make their home in the Sahara Desert, the largest desert in the world. A thousand years ago, when the Arabs invaded the Tuareg's fertile land in North Africa, some of them trekked southward into the desert to escape. They entered what is today Mali and Niger. To provide transport, they took up camel breeding, producing magnificent beasts perfectly adapted to great trans-Sahara caravans. Today, the majority of Tuareg live in the inhospitable lands of the Sahel, "the shore of the desert", and only a small number inhabit the true desert to the north. Tuareg society is Muslim and matriarchal, but – unlike most other Islamic societies – women are unveiled and free to choose husbands and divorce them. Tuareg men, however, are not permitted to divorce their wives.

Traditional Tuareg weddings begin with the announcement of marriage by a black-smith, who is believed to possess special powers of sorcery. Feared by the Tuareg, blacksmiths are thought to have inherited special skills, and both they and their wives play an important ritual role in marriage ceremonies. Throughout a Tuareg wedding, the bride

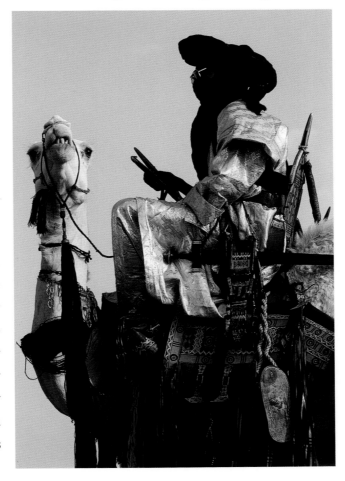

remains in seclusion, but is never left alone. She is attended at all times by friends and female relatives who prepare her for each stage of the ceremony. The women from her family build a special nuptial hut, in which the couple will consummate their marriage. They will move into a larger home when the bride conceives her first child.

When the groom arrives at the bride's camp with his family and friends, the festive part of the celebration begins. The ceremony affords a time for Tuareg men to show off the magnificence of their camels, and for women to display their exquisitely crafted silver jewelry and fine indigo attire. Seated in a circle women chant songs of love as men race their camels around them.

Left: A Tuareg groom will never be seen as more handsome or virile than he is on his wedding day.
Right: Proud of his fierce warrior heritage, a wedding guest shows off his aristocratic bearing. Tuareg men like nothing more than to parade and race their camels before admiring women.

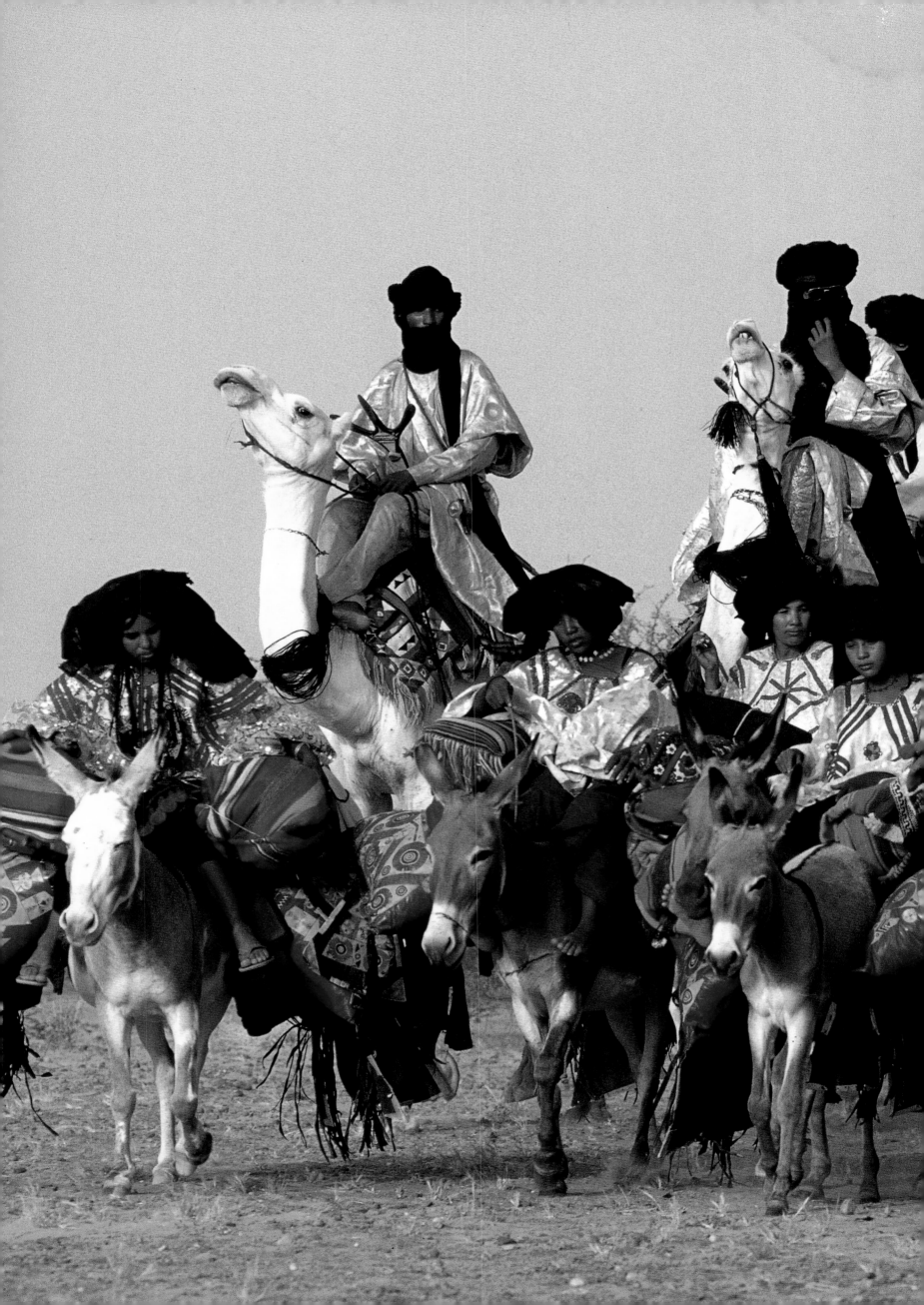

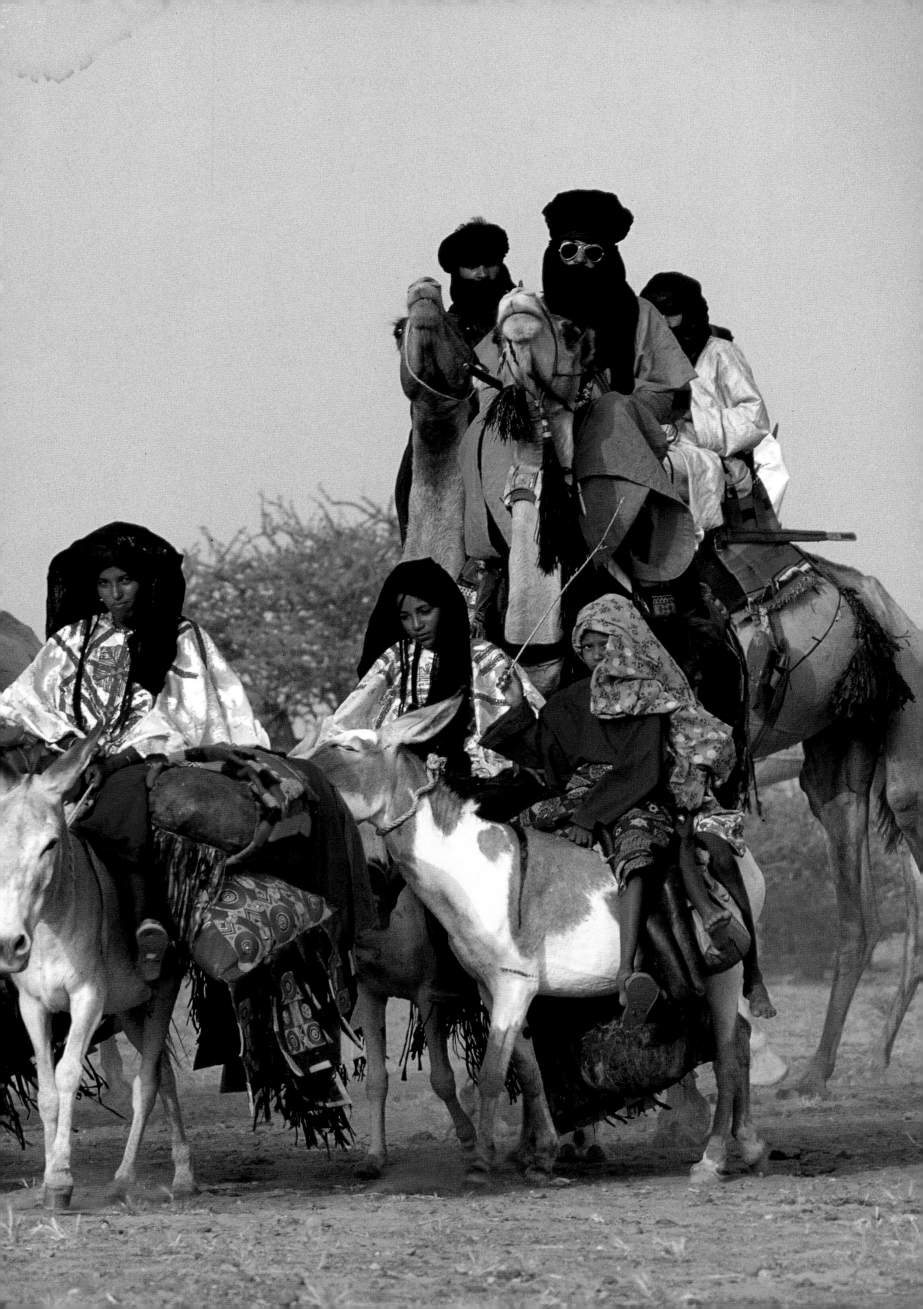

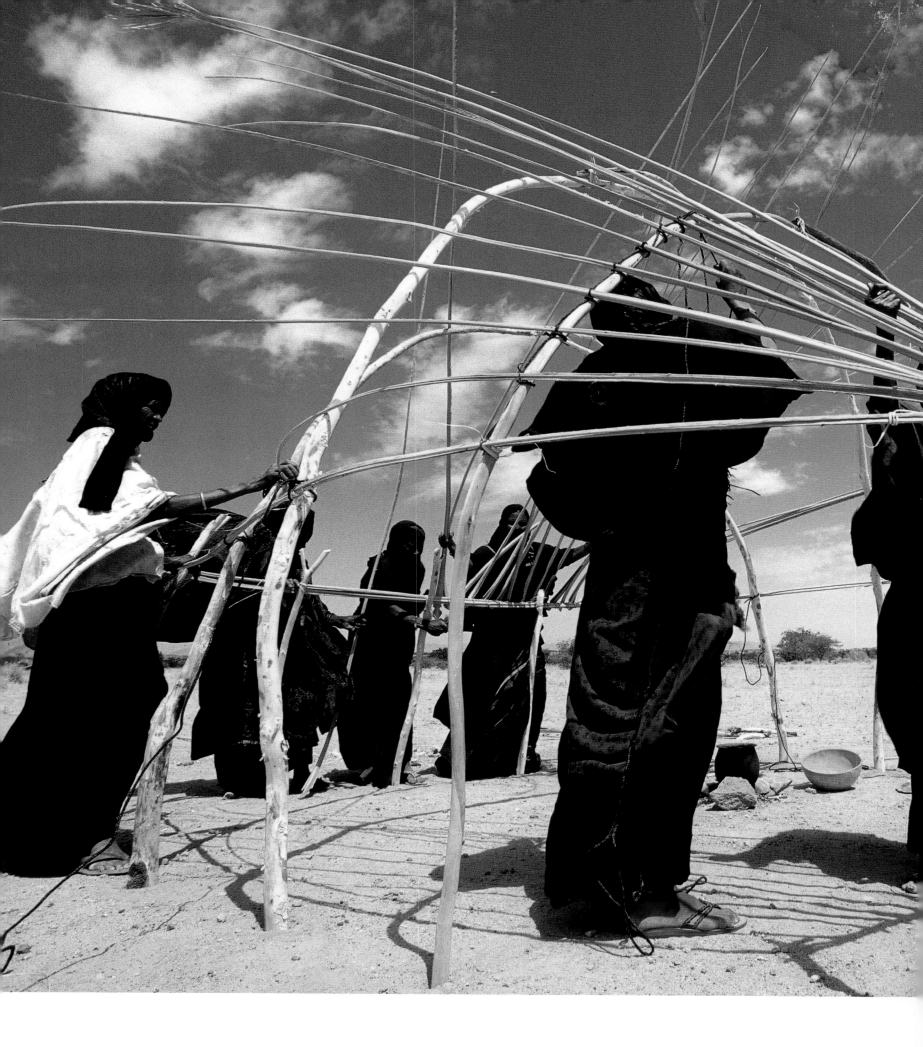

Arrival of the Guests

Preceding pages: Dressed in their nuptial finery, women arrive on donkeys heavily laden with colorful striped blankets and intricately patterned cushions, the men towering above them on camels. It is traditional for Tuareg women to walk or ride donkeys and for men to ride camels. Occasionally, a woman will accompany a man on a camel, especially when the distance traveled is far, but there is a strict code regarding this custom: a Tuareg man would never carry another man on his camel, or worse still, ride on a donkey.

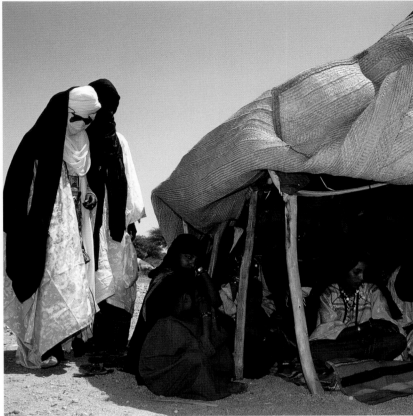

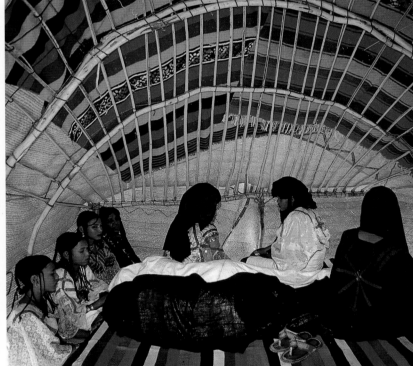

The Nuptial Tent

Using pliable tree roots, women from the bride's camp build the nuptial tent. Every day, for the first week of
marriage, they dismantle and expand the tent to symbolize the growing bond of the couple. During the day,
the groom visits his bride (*above right*), who is secluded in her family's tent and prevented from speaking to
anyone but her husband and relatives as protection from jealous spirits, or djinns. At night she goes to the
nuptial hut, where, surrounded by relatives (*below right*), she awaits her husband on their wedding bed.

159

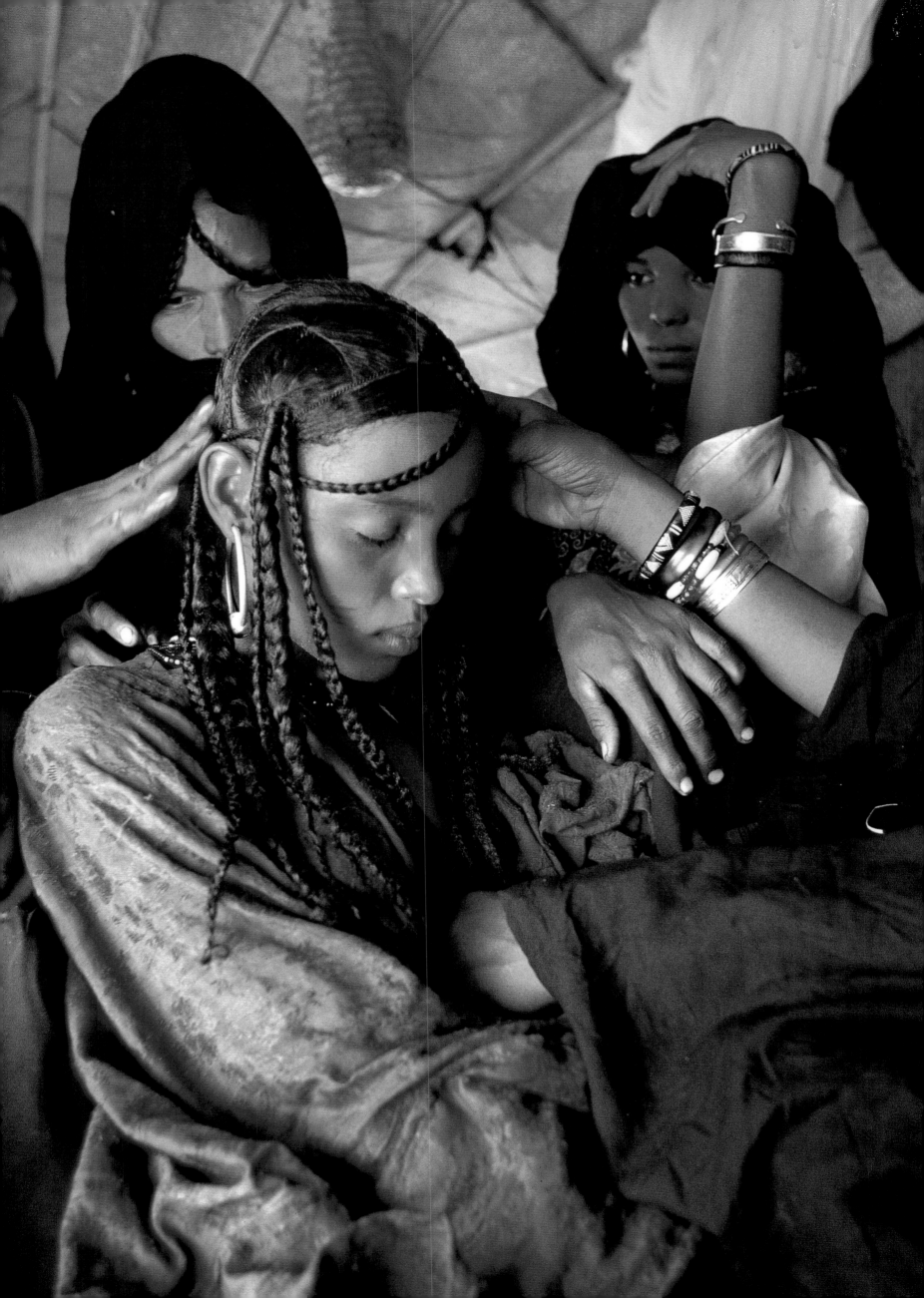

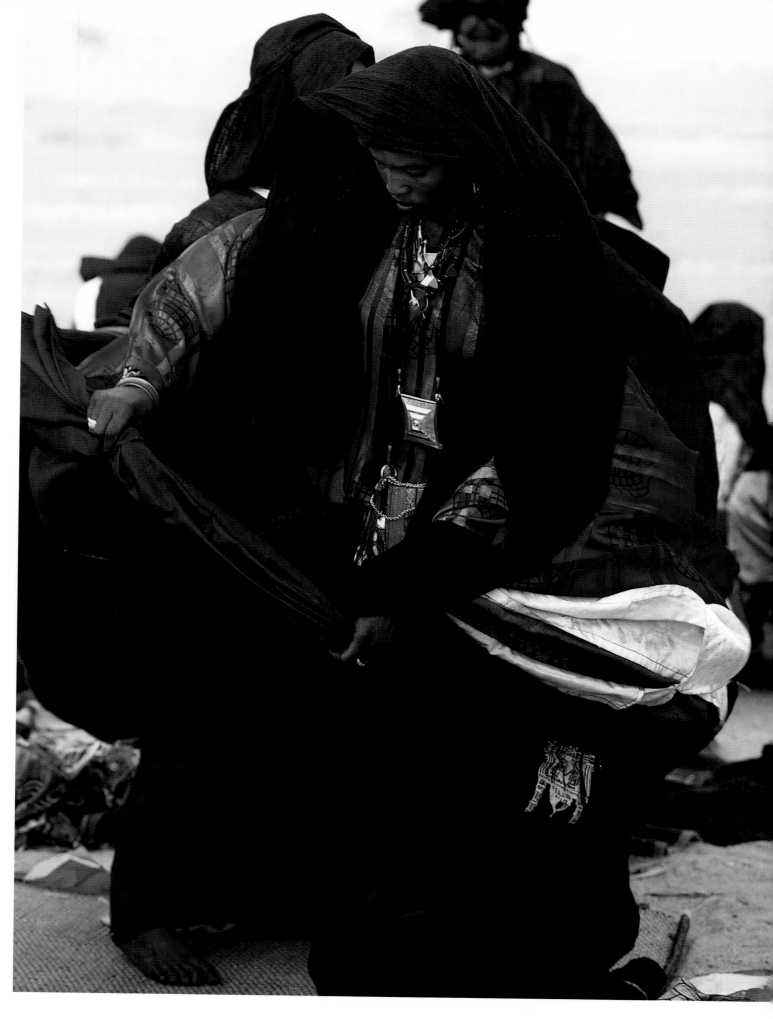

Preparations for the Wedding

The bride's hair, rubbed with pomade and fine black sand to enhance its luster, is braided by the blacksmith's wife, who is believed to possess special powers of sorcery. The bride's complexion is beautified with fragrant yellow herbal paste and ground red pigment. *Above*: A wedding guest, wearing a silver talisman, puts on a finely woven indigo cloth, beloved by the Tuareg for the unfixed blue dye that stains the skin. *Following pages*: During the Tendi ritual, women sit in a small circle beating a goat-hide drum. They sing love songs, ululate, and clap, while men mounted on their camels circle them. As the songs grow more passionate, the riders increase their speed until the women become a blur between galloping legs. Tuareg men dressed in ceremonial robes, like to display their camels decorated with fringed leather bags.

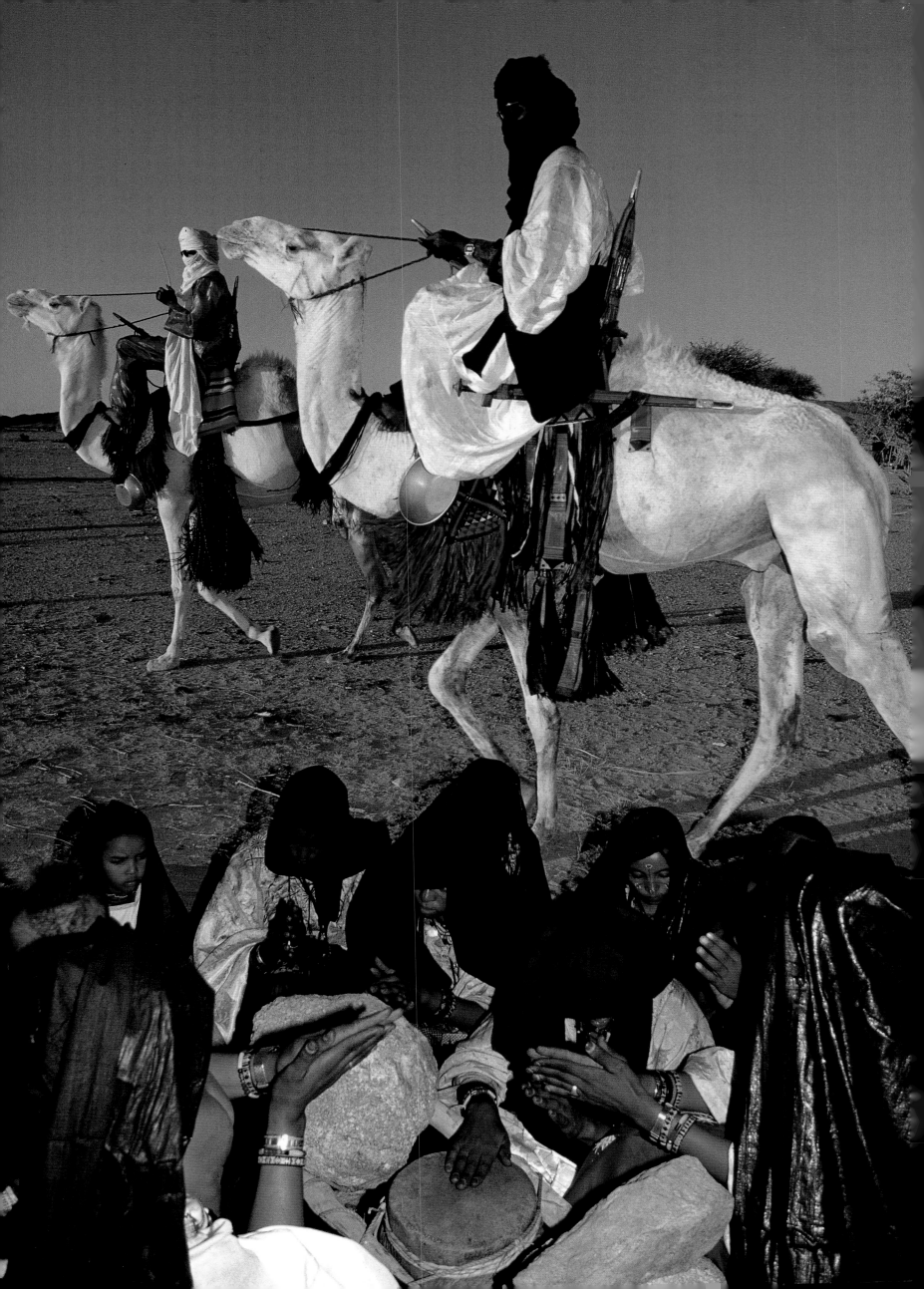

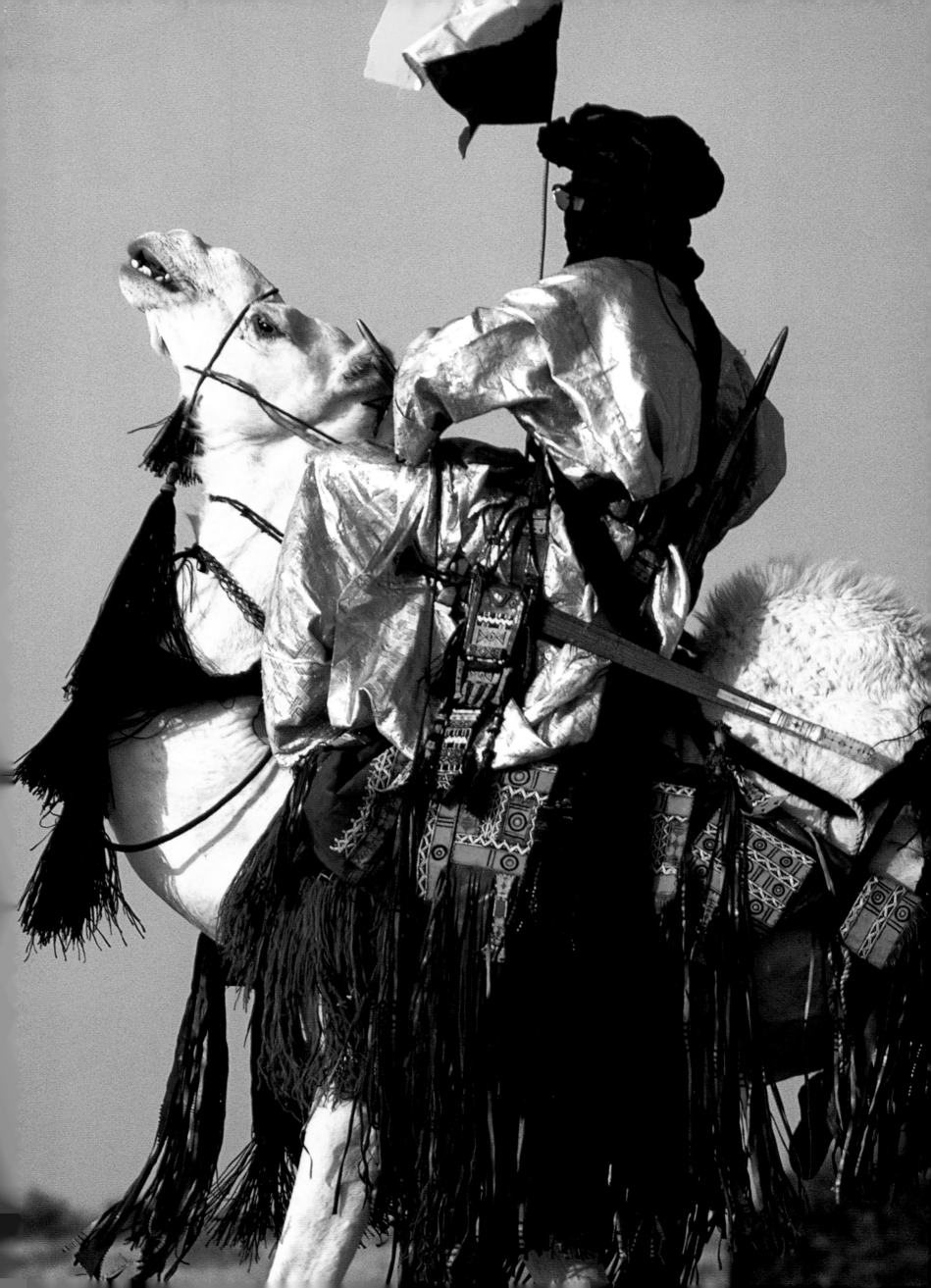

Ndebele Nuptials

One of two major groups of southern Ndebele peoples, the Ndzundza Ndebele live north of Pretoria, the capital of South Africa. Despite feudal wars, colonization, and relocation due to apartheid, they have managed to retain their language and distinctive cultural identity. For the Ndzundza Ndebele, traditional ceremonies, and marriages in particular, are important occasions to assert tribal solidarity.

Today, most Ndzundza Ndebele girls marry in traditional style. The marriage ritual itself divides into three stages, each accompanied by its own ceremony. The first stage (featured on the following pages) involves the bride leaving her family home. As in many African societies, a bride-price must be given by the groom's family before a marriage is approved. This payment is traditionally made in livestock and can be paid in installments. The wedding commences after the first payment, and the last occurs with the birth of the first child. If the bride fails to produce any children, all or part of the dowry may be retrieved by the groom's father. When the wedding date is set, the bride withdraws for two weeks of ritual seclusion in her parents' home. During this time she may only be visited by her female relatives, and must not be seen by any men outside her immediate family. At this stage, she wears a bridal apron called *liphotu*, distinguishable by two side flaps, which are said to represent the marriage partners, and a fringe of small beaded tassels symbolizing the expectation of children.

The second stage of marriage occurs with the birth of a first child and is considered the culmination of the marriage process. Following the birth, the bride earns the right to wear the most valued beaded apron, called *ijogolo*, whose distinctive five-paneled design represents a mother surrounded by children. The extraordinary beadwork worn by Ndebele brides has been inspired by their neighbors, the Pedi, a Sotho group of people to whom they are related through intermarriage. The third and final phase is a ritual solemnization, at which the husband honors his wife for all that she has brought him during their time together.

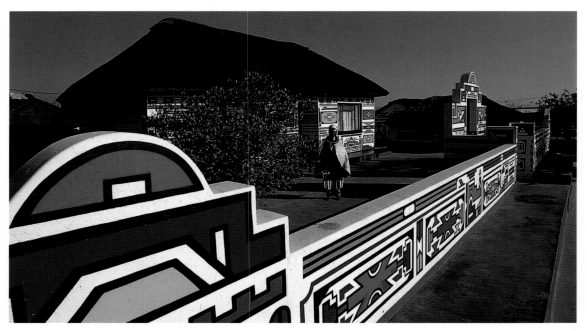

Above: At the the time of marriage, the walls of an Ndebele compound are freshly painted. *Right*: Female guests gather at the entrance to the bride's house to call her out of seclusion.

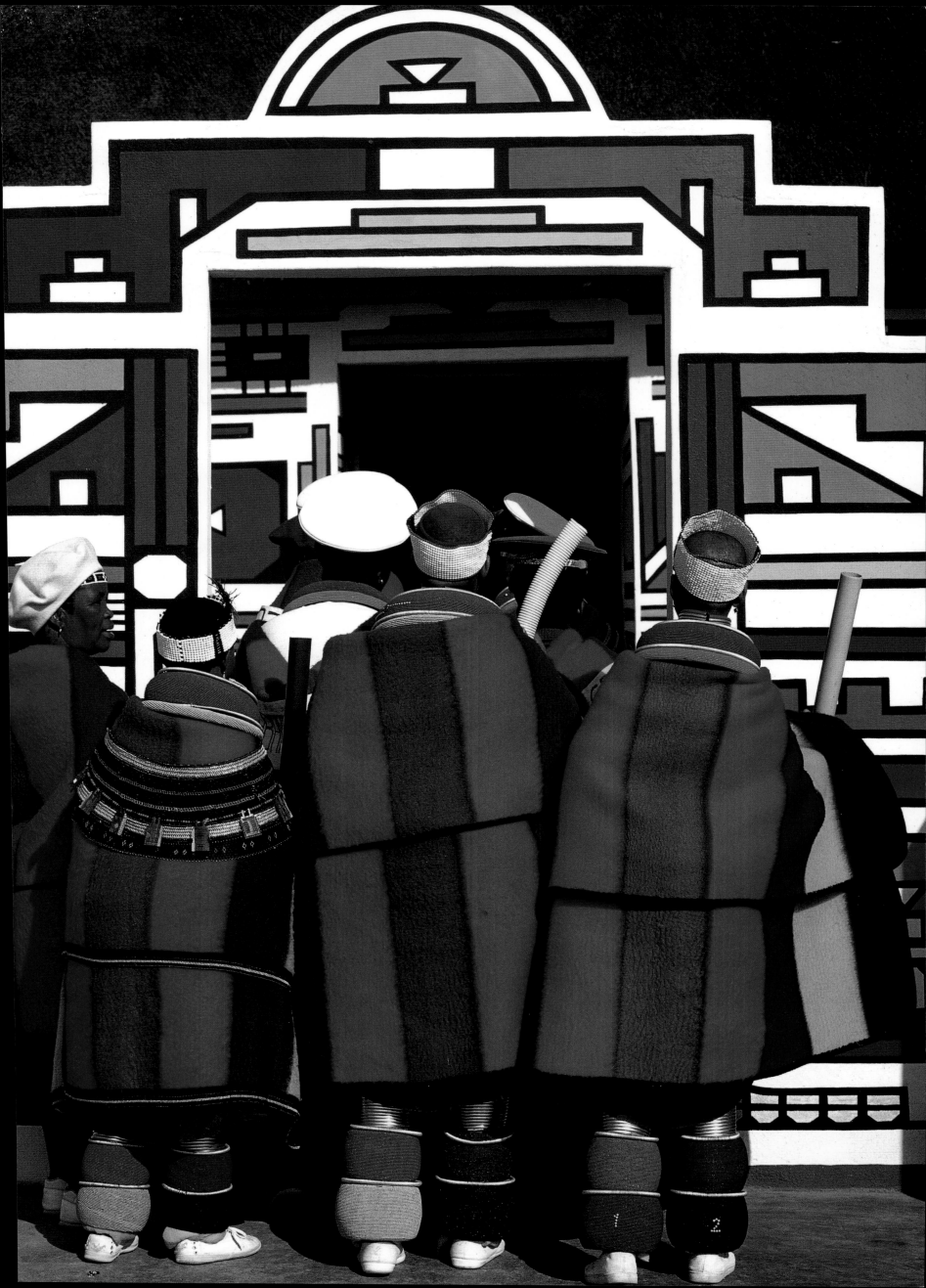

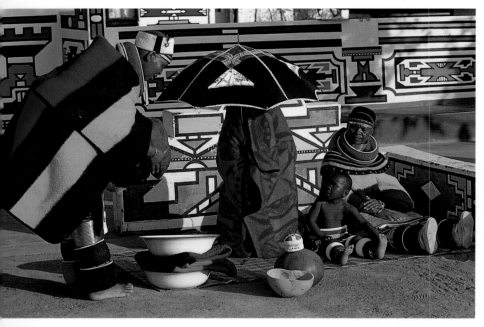

Preparing the Bride

Concealed under a ritual parasol (*left*), an Ndebele bride receives gifts from relatives and friends on her wedding day. Prior to marriage, she is dressed in beaded leg and waist hoops and a stiff maiden's apron indicating her availability (*below*). These hoops, called *golwani*, are made from hanks of twisted grass wrapped with strands of glass beads. They are worn by girls of marriageable age who have completed their initiation into womanhood. The leg hoops make movement difficult, so a girl must be assisted when putting them on and when she attempts to stand. Covering her lap, a square apron, called *ipepetu*, is reputed to insure chastity. After the wedding, the bride will exchange it for a nuptial apron, *liphotu*, and eventually for the five-paneled apron, *ijogolo*, reserved for women who have completed the marriage cycle by bearing children.

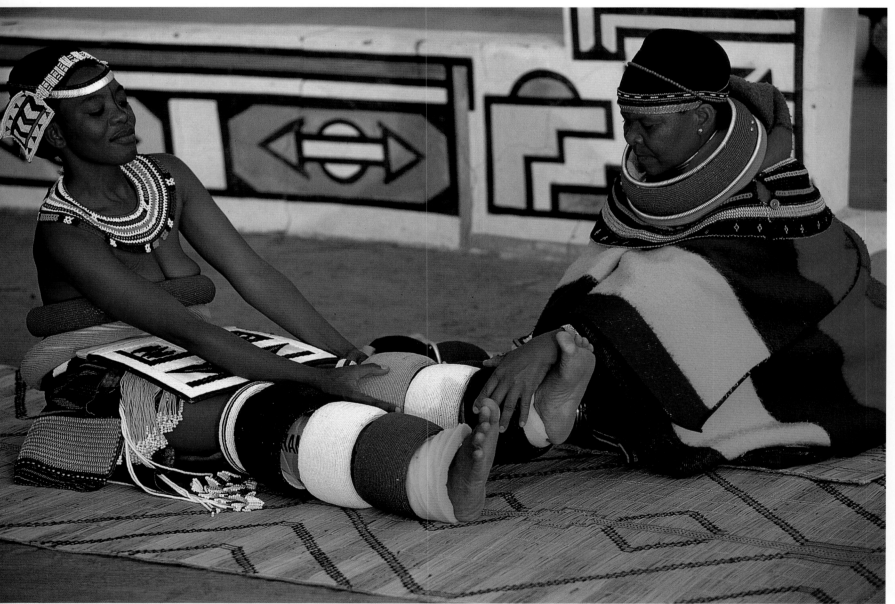

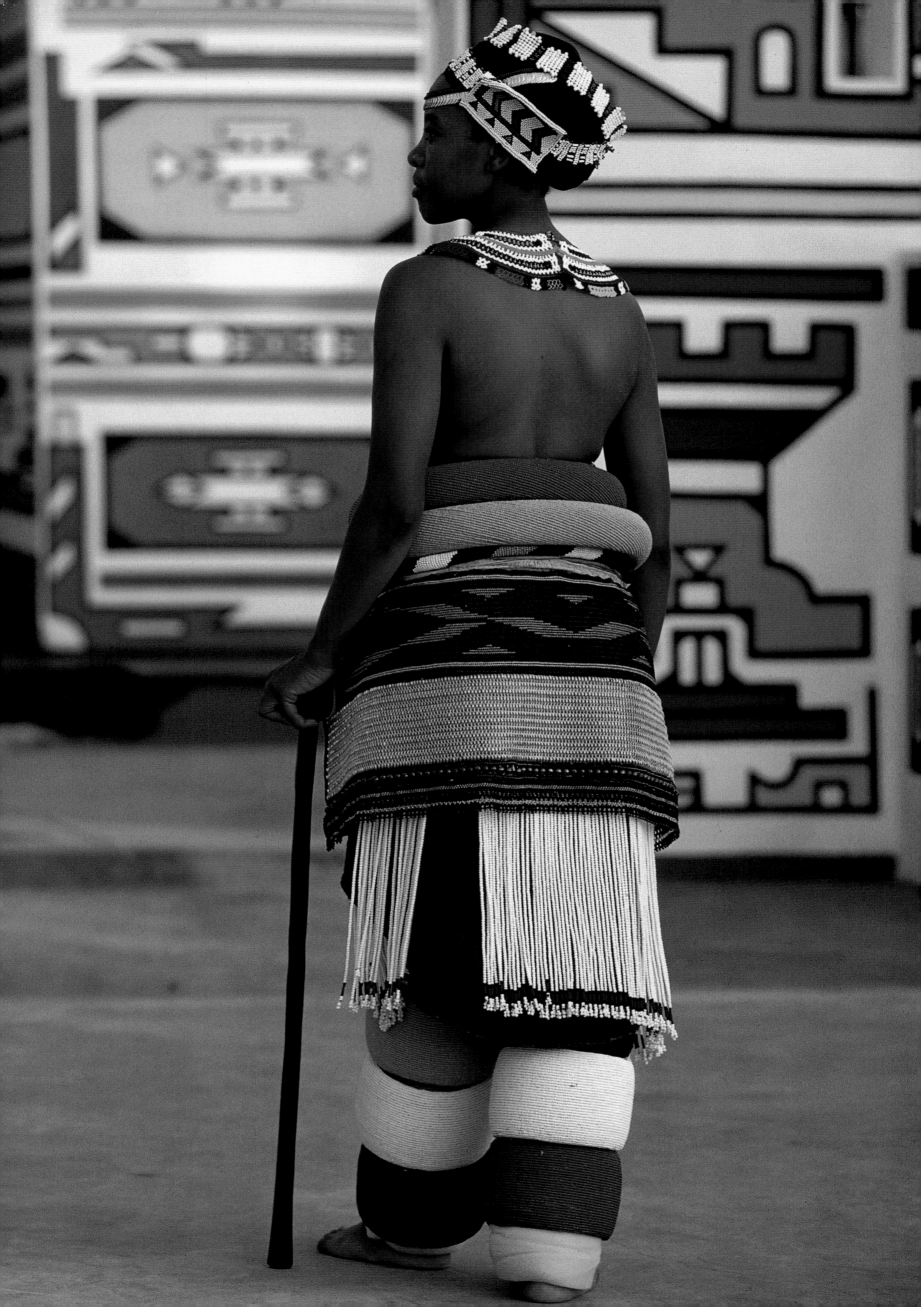

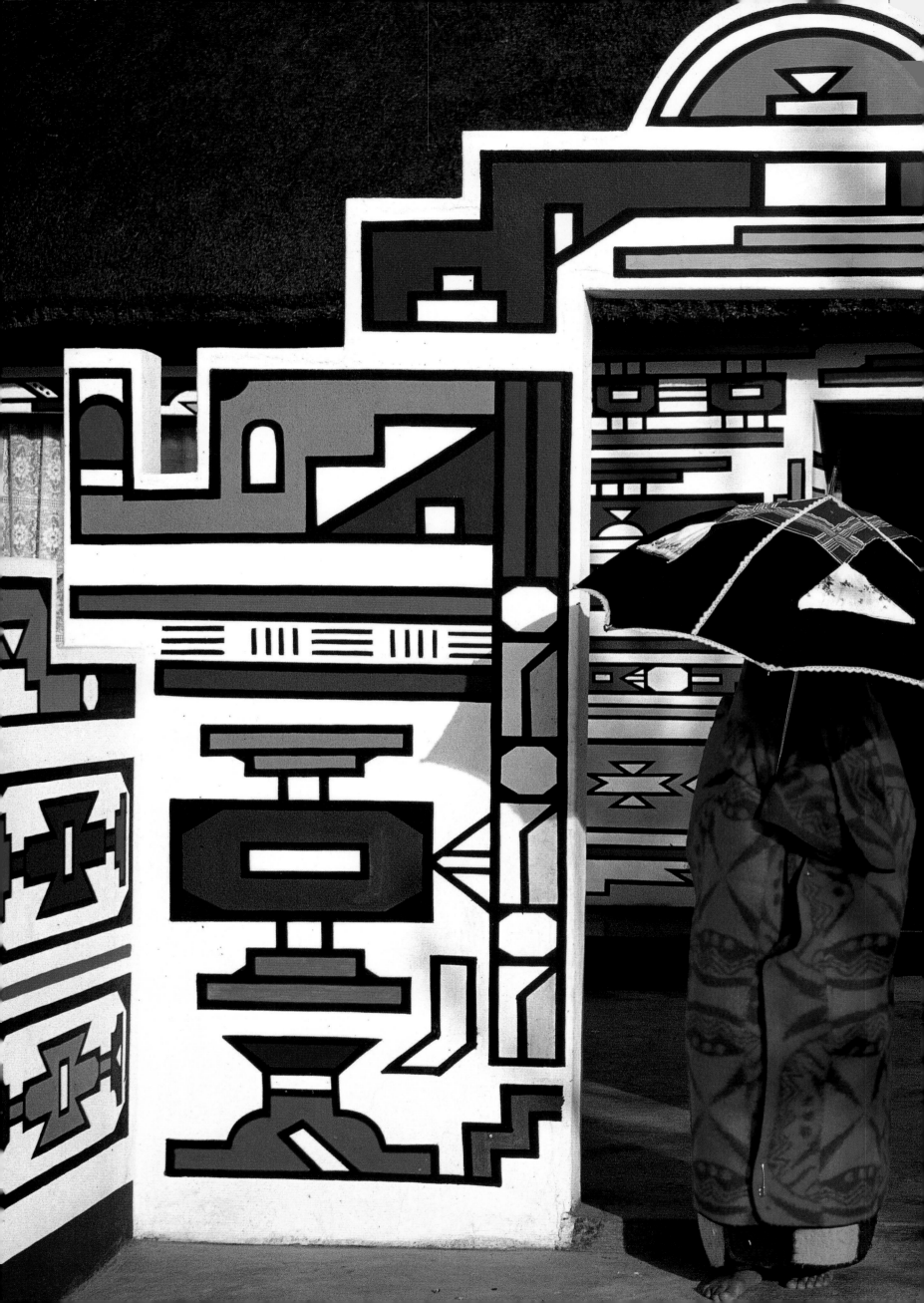

Leaving Home

Carrying a ritual parasol, the bride leaves the family compound bound for her husband's home. She will remain cocooned in a red ceremonial blanket until the nuptial rites are underway. Her blanket, called *nguba*, is a symbol of her married status, and she will add a strip of beading to the border with each year of marriage. The Ndebele believe that ancestors prescribe in dreams how much beading an *nguba* should carry.

Preceding the wedding, Ndebele houses are freshly painted by women who have been taught the techniques during womanhood initiations. Originally, the houses were painted in muted mud designs, but today the women use intensely colored commercial paints that do not deteriorate from the effects of weather. In addition to modern paints, new motifs such as airplanes, staircases, lightbulbs, and razor blades have been incorporated into Ndebele art.

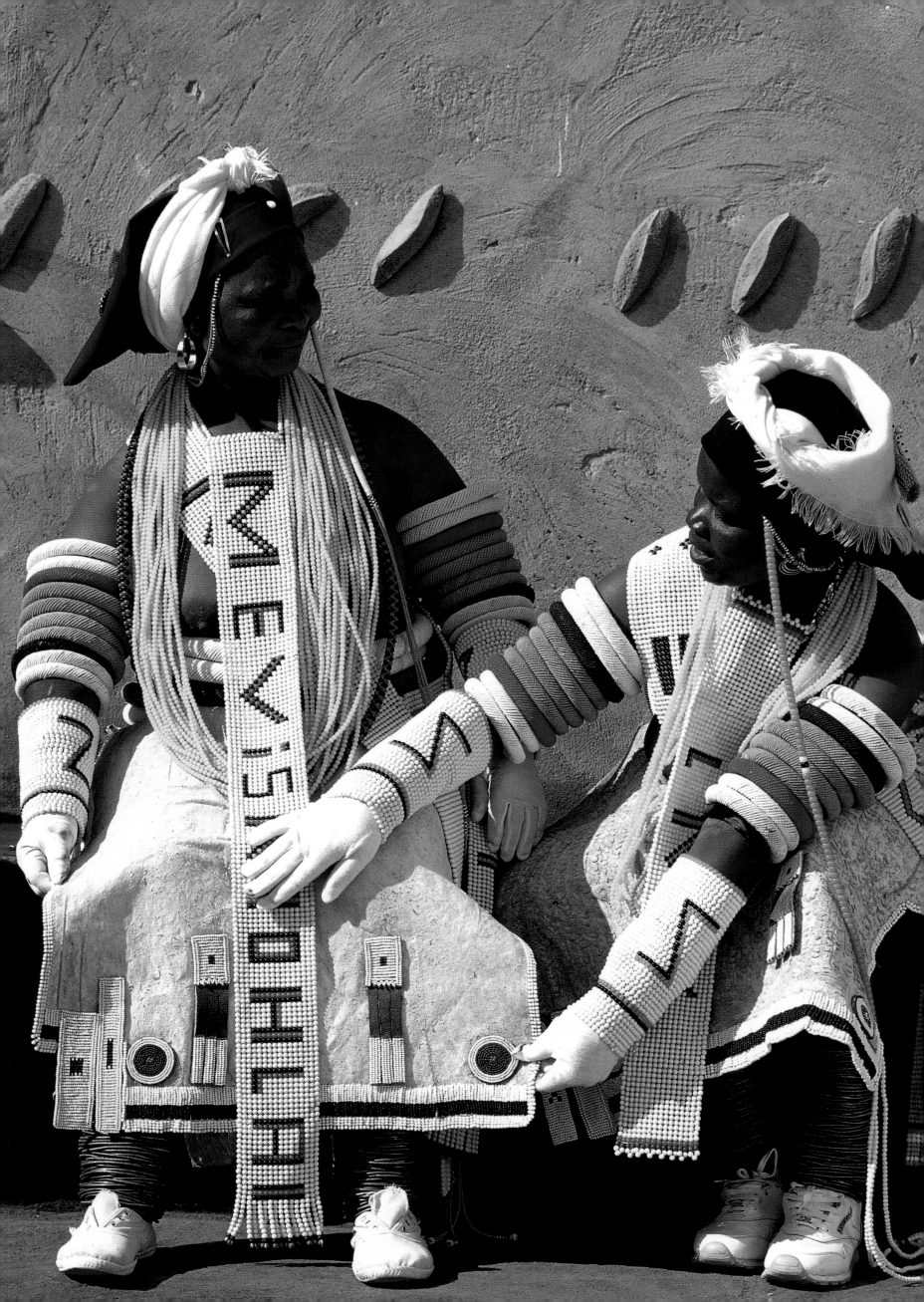

Pedi Queens

Neighbors of the Ndebele, and relatives through intermarriage, the Pedi people are renowned for their beadwork. Maintaining a strong matrilineal tradition, distinguished elder women, known as Pedi Queens, act as figureheads for their communities at ceremonial occasions. Adorned with an array of intricately beaded regalia, Mevis Mohlai (*left*) wears a long neck sash that bears her name.

Below: Beaded dolls, made by Pedi girls during their initiations, are paraded by the Pedi Queens during ceremonies as invocations to fertility—to assist women who have not yet conceived and to celebrate those who have. It is said the dolls can act as surrogates for deceased children, protect a family from harm, and encourage a bereaved mother to try for another child. If a Pedi girl continually plays with dolls, it is believed she will have many children. If she mistreats a doll, her parents reprimand her for not being a good future mother. During her wedding, a Pedi bride may carry a doll to signify her desire to bear children; she will look after it until the birth of her first child, whom she will name after the doll.

Following pages: Mevis Mohlai displays her splendid beaded outfit.

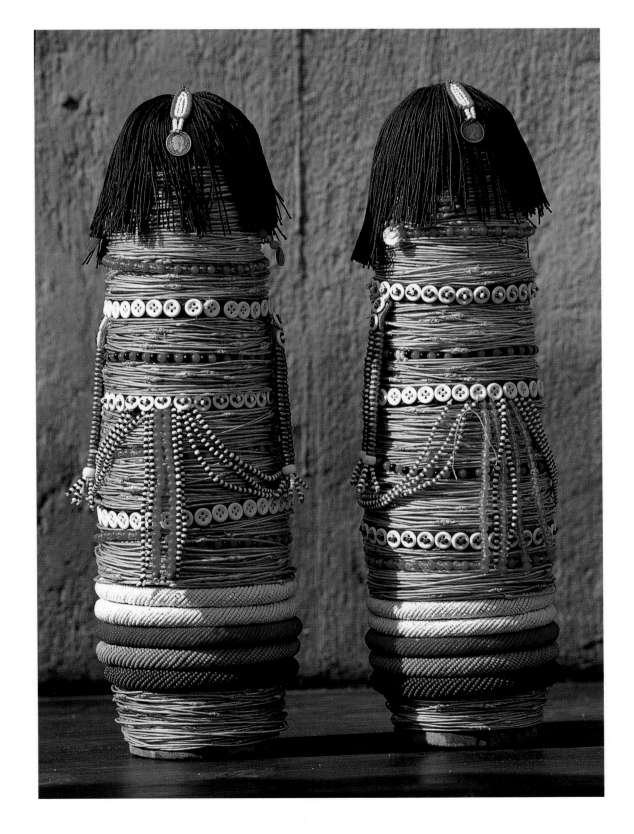

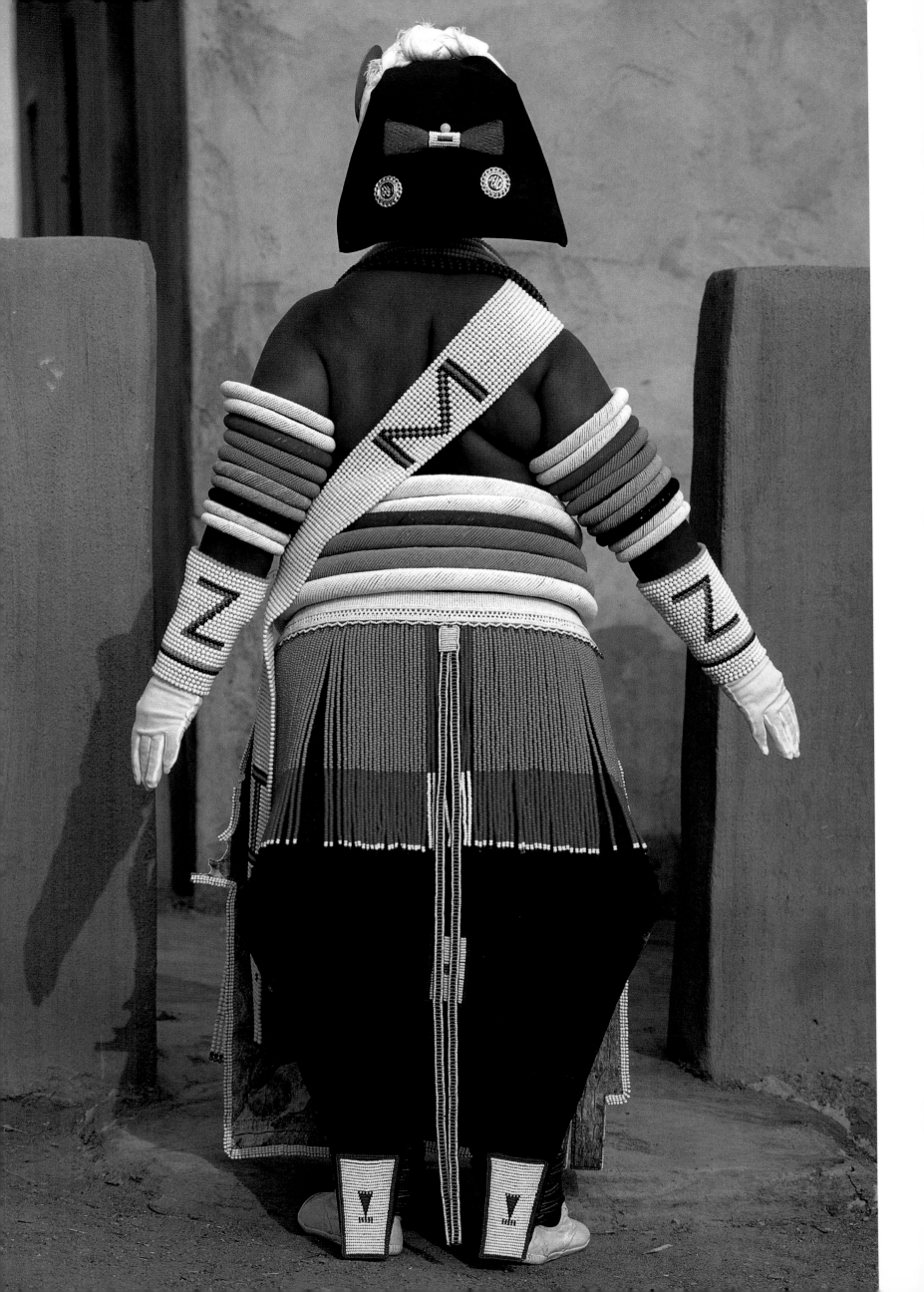

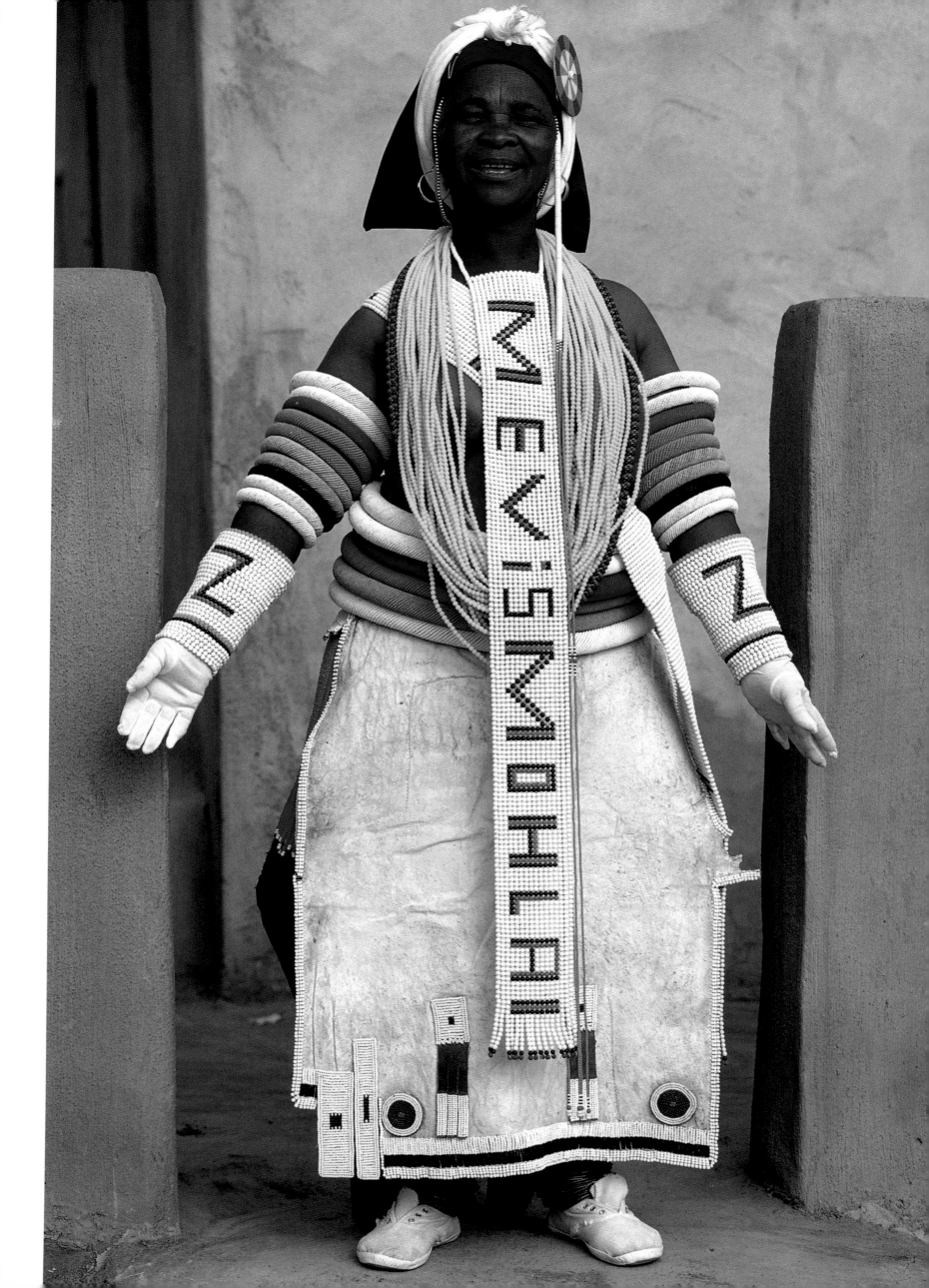

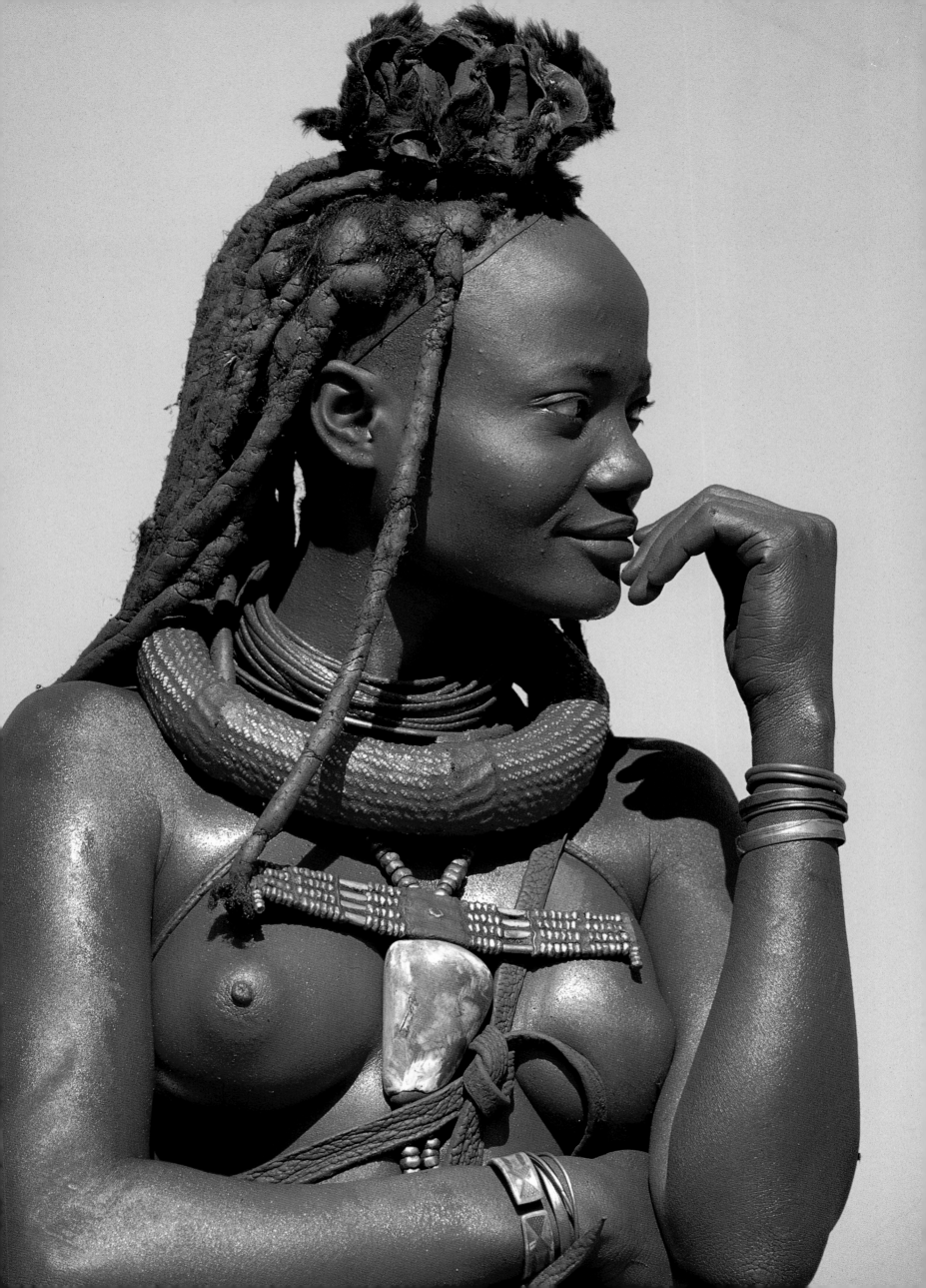

Himba Marriage

The Himba people live in the remote northwest corner of Namibia, in Kaokoland, along the edge of the Namib, one of the oldest deserts in the world. The Himba trace their origins to a single female ancestor, whose daughters and granddaughters founded the most powerful matrilineal clan in Himba society. They say: "If you meet a man and he tells you he is of your father's clan, you may greet him, hear his news, and walk on. But if he is of your mother's clan, then you will take him home and tell your wife to offer him milk and meat." Once among the wealthiest cattle breeders in Africa, the Himba have seen their herds diminished by recent droughts and guerrilla warfare. Despite this, they continue to follow a traditional nomadic lifestyle, herding cattle, sheep, and goats.

Himba marriages are usually arranged by parents, and even in the case of a love match the couple must have the agreement of their parents regarding the number of cattle to be given as bride-price. On the first morning of a Himba wedding, the father of the bride ritually slaughters a goat by kneeling on its windpipe: it is considered inauspicious that any blood should be spilled on this day. Distributing the meat among the community, he gives the fatty white stomach membrane to his daughter and to other women of child-bearing age, who wear it on their heads as a sign of his high esteem. Meanwhile, the groom, who stays at the bride's village in ritual seclusion, cleans and tans the goat's hide, which he presents to his mother-in-law and the bride for making backskirts.

Following an evening of feasting and ritual dancing, the bride is heavily ochered and perfumed as she prepares to leave her family compound for a new home with her husband. Before departing, her mother gives the bride one of her most treasured possessions, her *ekori* head-dress, which will be worn by the bride during her first month of marriage. On the bride's arrival at her new home, another meat feast is given in the couple's honor. This extends into the night, until the bridal pair leaves for a special ceremonial hut where they will consummate the marriage.

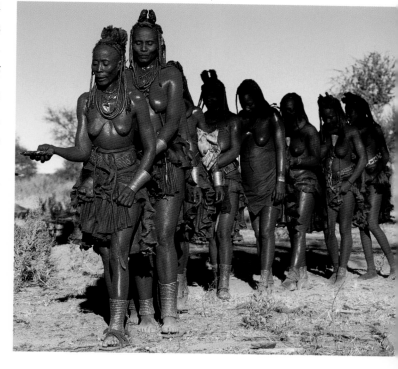

In the months following the wedding, the bride spends most of her time inside her mother-in-law's hut, only coming out to perform chores for her husband's family. Still considered an outsider, she does not become a full member of her husband's clan until she undergoes a ritual scraping of old ocher from her face and body, representing the end of her former life. She is then smeared with butterfat from the family's cows to announce her formal acceptance into her husband's community.

Left: Her body beautified with ocher and butterfat, a young Himba woman awaits wedding festivities. *Above*: On the morning of the marriage, women parade around the family compound asking for blessings and gifts for the couple. *Following pages*: A Himba family at their semi-permanent dwelling.

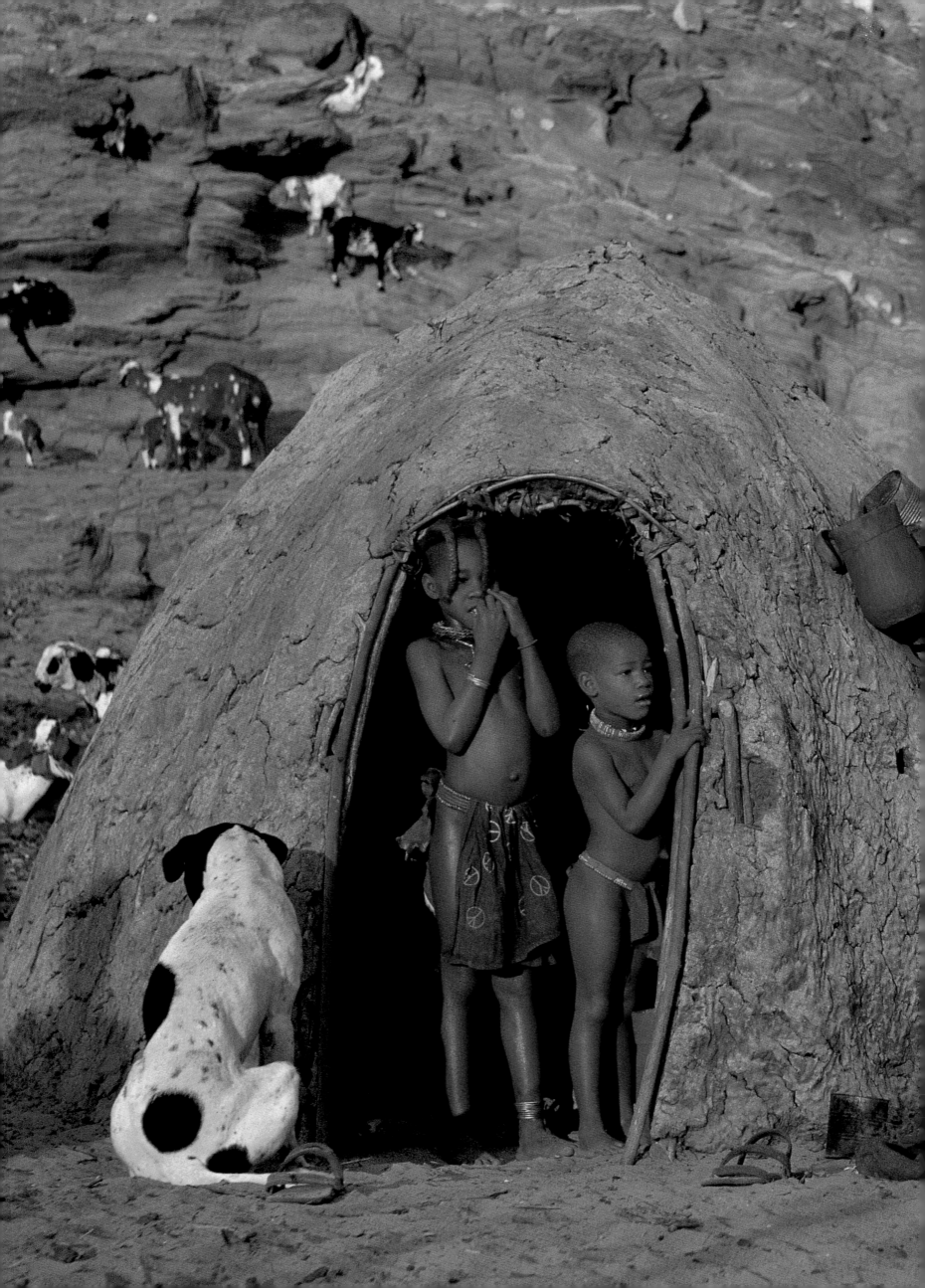

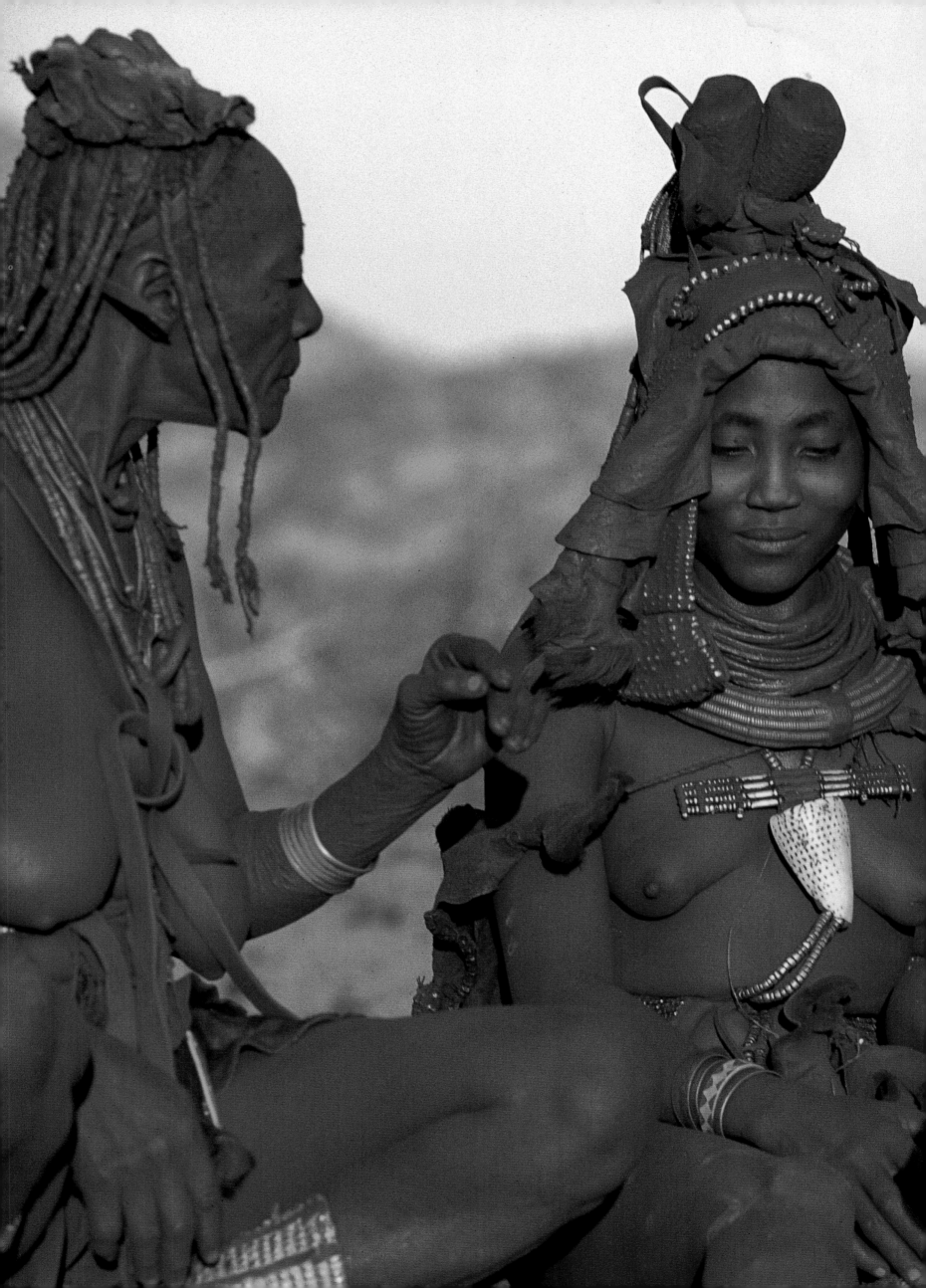

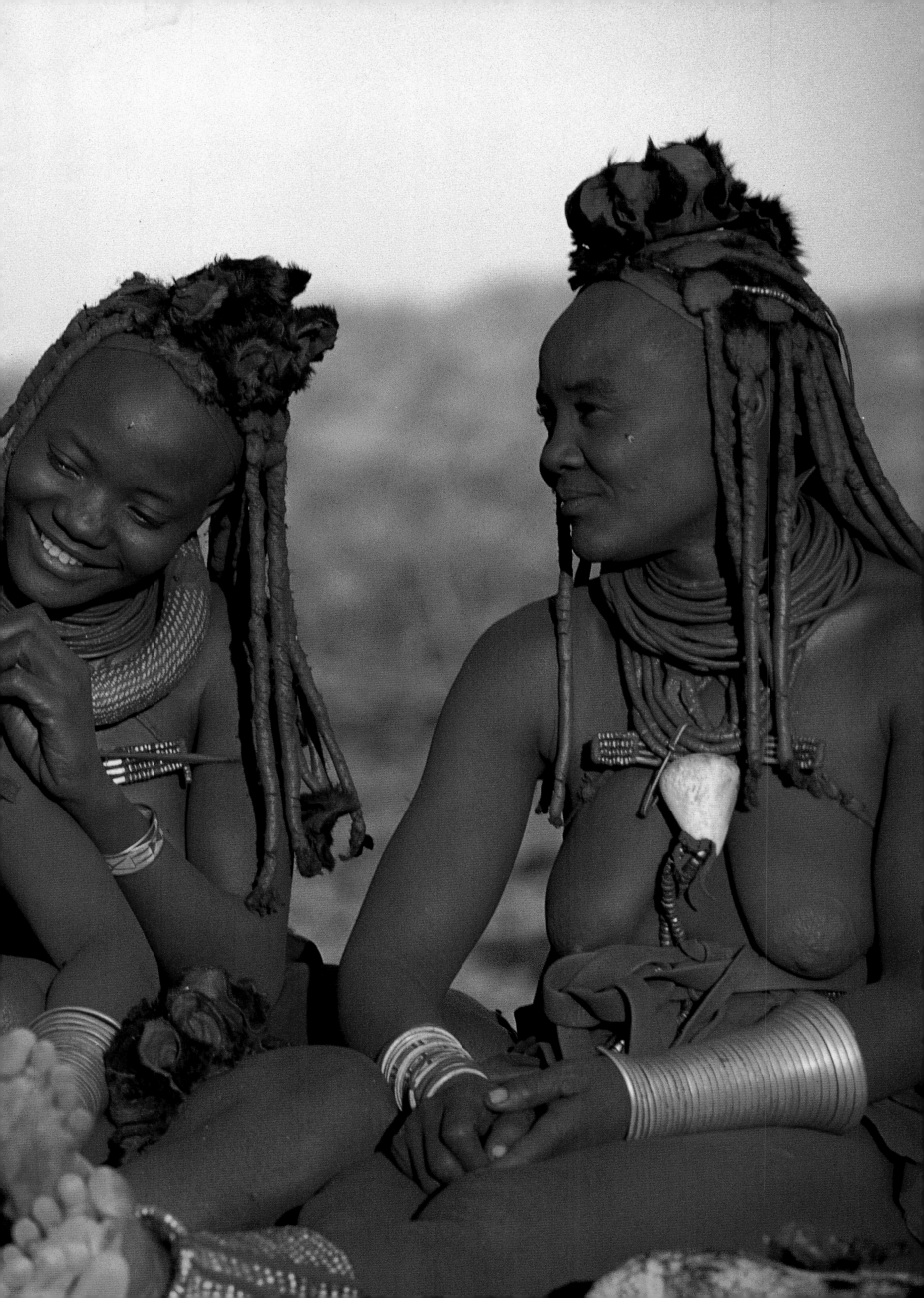

The Path of Marriage

Preceding Pages: On the morning of the marriage, female friends apply ocher and perfumed butterfat to the bride. A staple Himba cosmetic, this rich mixture provides protection from the sun, as well as beautifying the skin. The married women attending the bride wear the small, leather-rosette headdresses known as *erembe*, which replace the *ekori* after the first month of married life.

Right: The groom, secluded in a specially built nuptial hut, is blessed by a female in-law who covers his talisman belt, shell pendant, and copper necklace with a mixture of charcoal and animal fat. Showing himself in daylight would be viewed as the height of disrespect, providing possible grounds for cancellation of the marriage. This ritual courtesy provides insurance for the bridegroom should the marriage run into problems later on. If there are difficulties, he will be able to say to his in-laws, "Remember how I hid away in a dark hut; how I covered my form with a hide so you would not see me. Have I not proved my good faith already?"

Following pages 183-184: In the tranquility of her family hut, the young bride is lovingly prepared by her mother. Her skin is smeared with ocher and butterfat, and she wears jewelry made from beaten iron beads. Her mother gives her a ceremonial headdress called *ekori*, made from the finest hide. As she leaves the parental home, the front of her *ekori* is rolled forward so that she can only see straight ahead and is thus protected from the emotions of leaving home.

Following pages 185-186: A Himba bride wears a white conch shell pendant, traditionally passed from mother to daughter. These shells are highly valued, each being worth as much as a young goat. Around her neck the bride wears a torque of copper wire bound by leather and packed with ocher and mud. To the joyous sound of chanting, an exuberant girl leaps and twirls in honor of the bride.

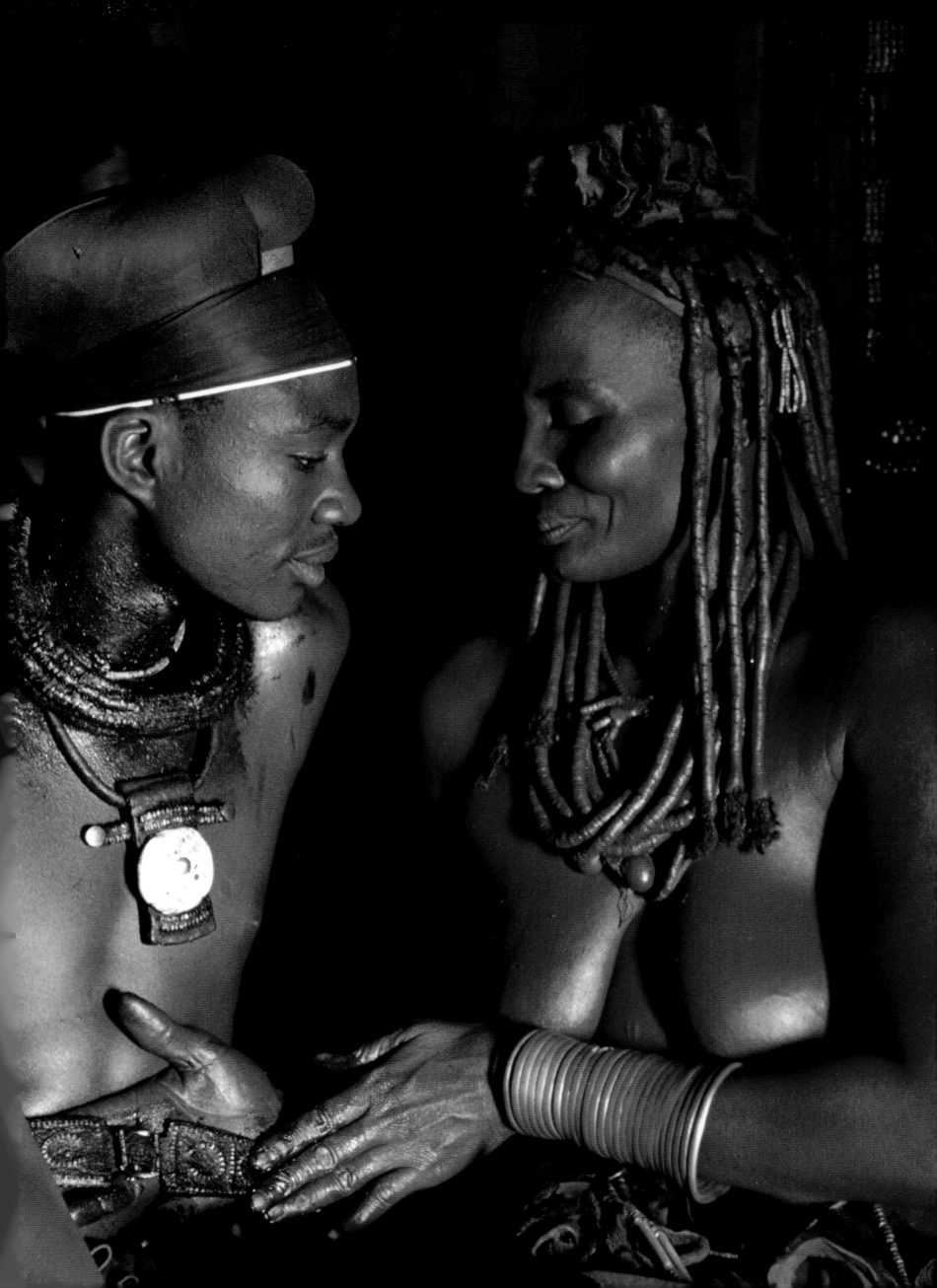

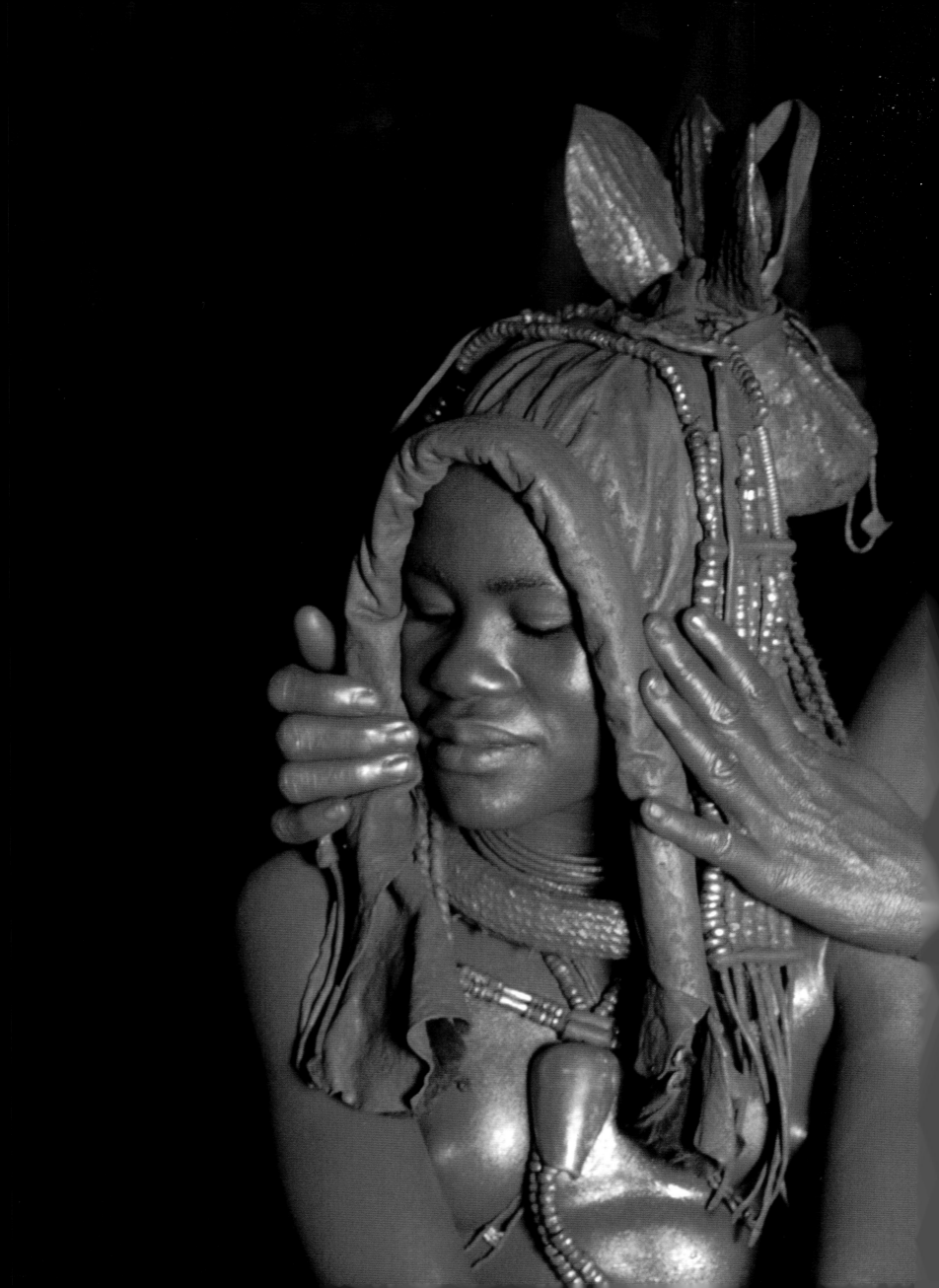

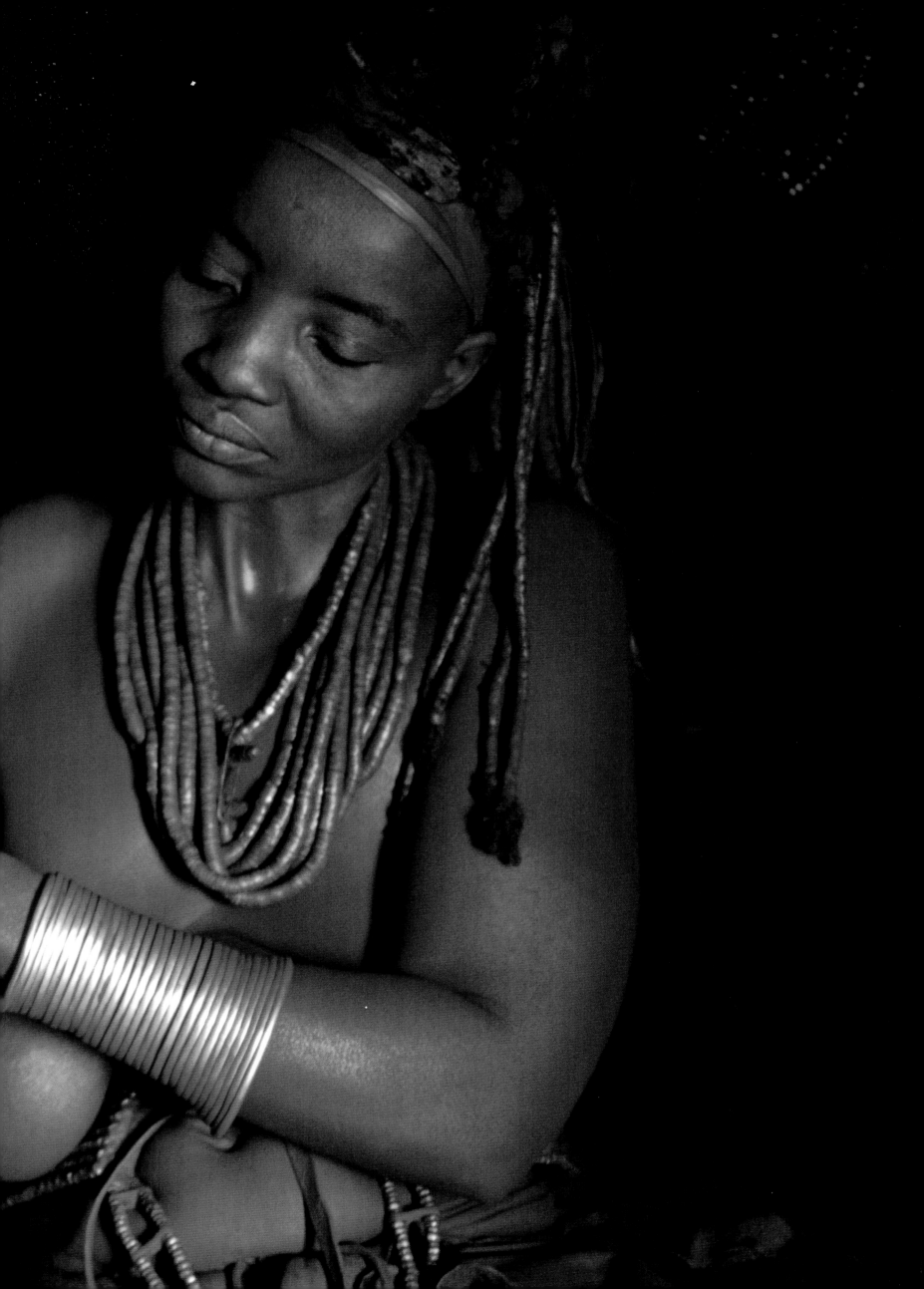

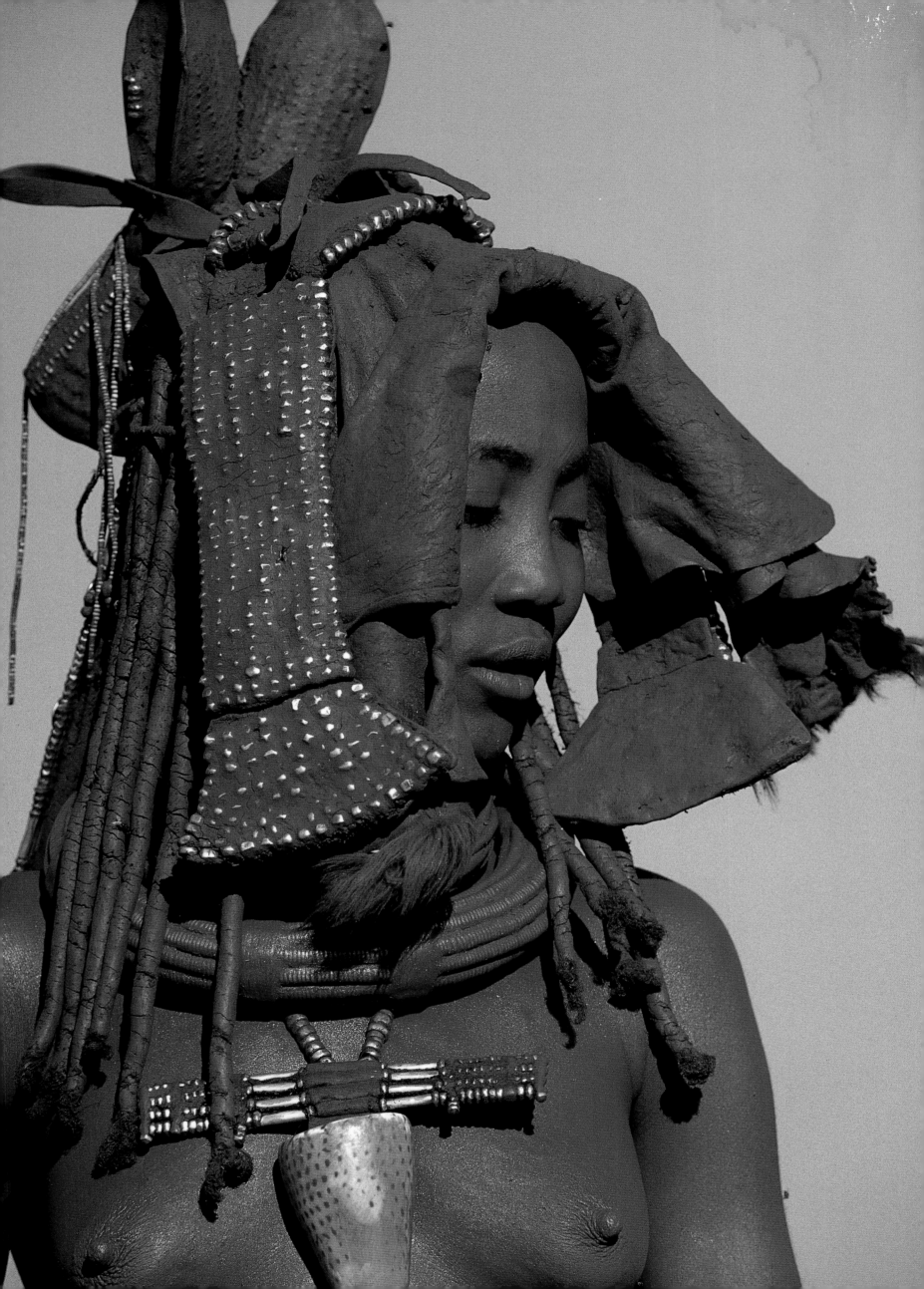

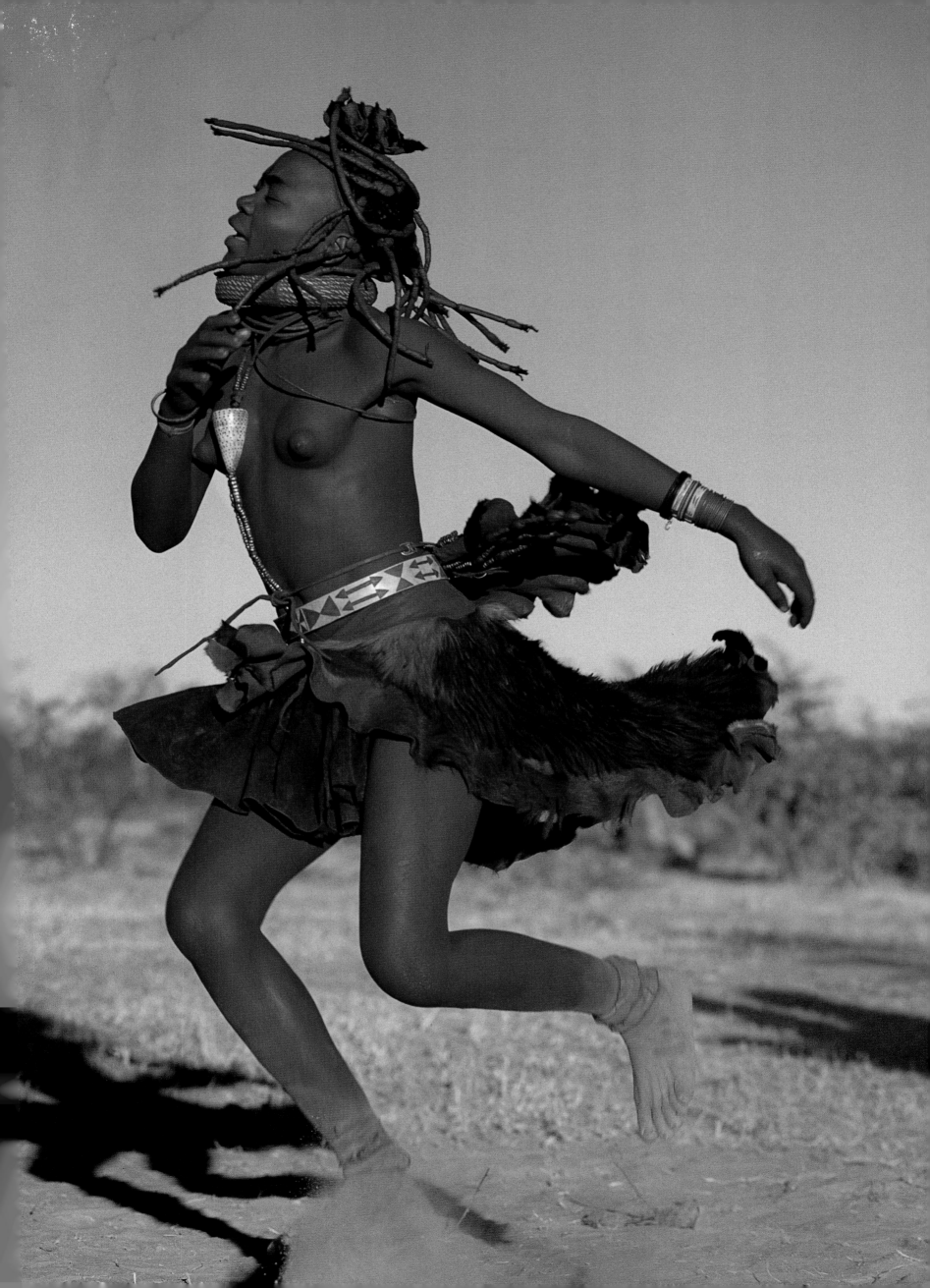

Brides and Grooms

Across Africa, marriage is one of the most significant events in an individual's life. The elaborate body decorations and jewelry worn at wedding ceremonies reflect the importance of the occasion. From the simple clay hair buns of the Turkana to the lavish gold earrings of the Fulani, wedding adornment reflects the range of lifestyles and beliefs of more than a thousand African groups. The following portraits of men and women at various stages of preparation for marriage reveal the extraordinary diversity of creative design throughout the continent.

Turkana of Kenya

A Turkana man says of a bride, "It's the things a woman wears that make her beautiful." A multi-layered beaded necklace with three back pendants indicates a girl's availability for marriage. A man's beaded headband and painted clay hair bun reveal his status as an elder and his eligibility for marriage.

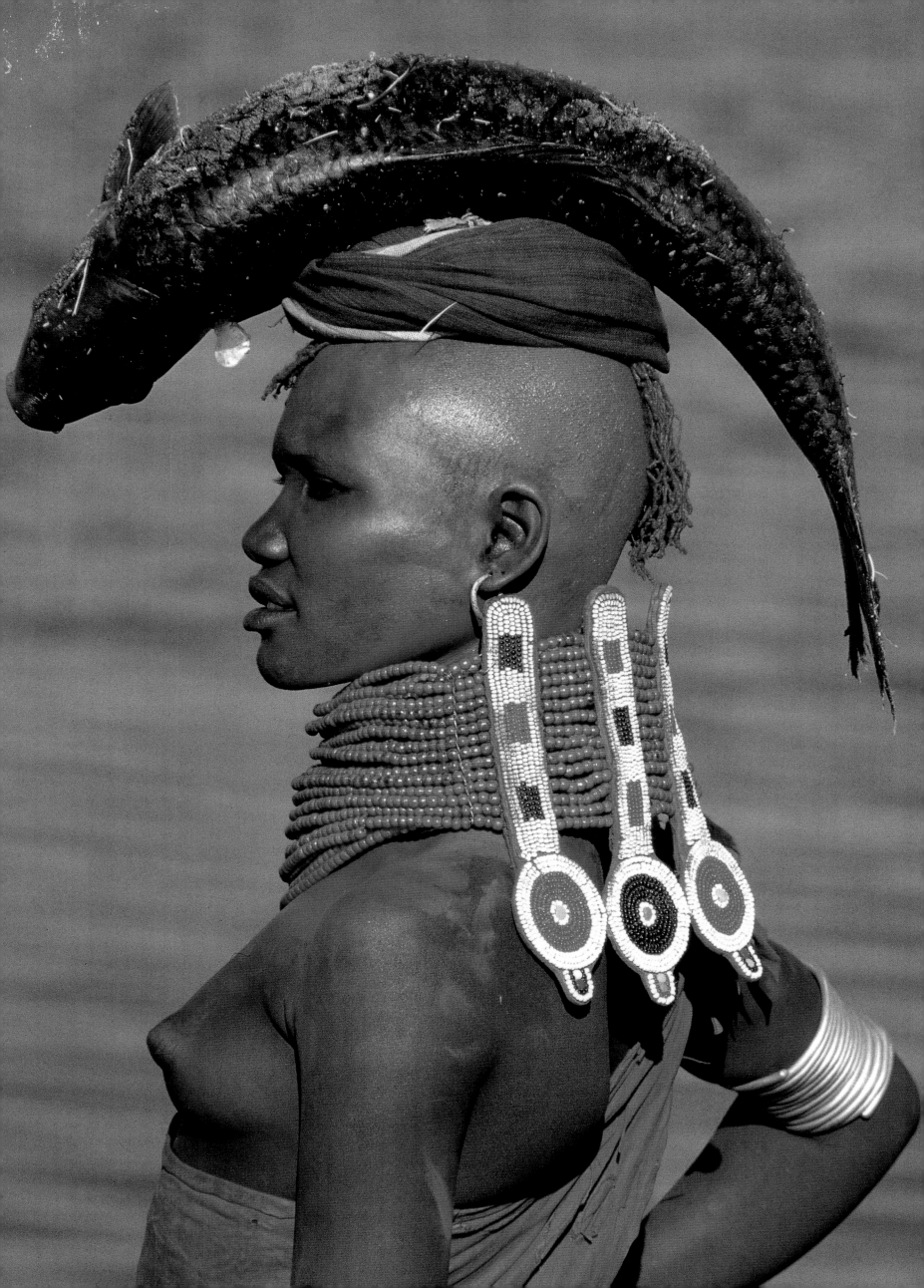

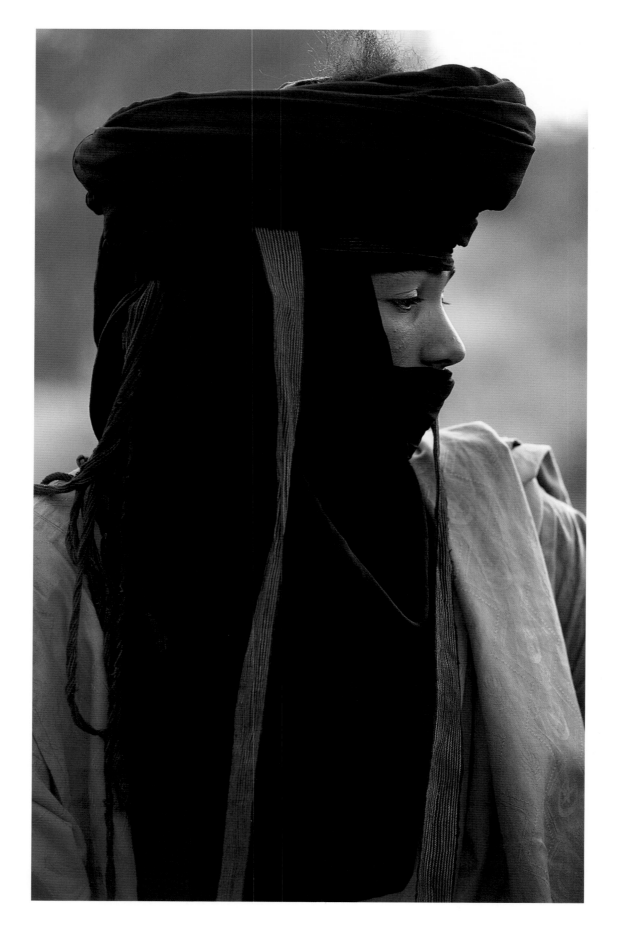

Fulani of Mali

A Fulani woman displays her bridal wealth in the form of large gold earrings and amber beads adorning her hair. A Tuareg man, from a group living close to the Fulani, indicates his wealth and marital status by the indigo color and sheen of his turban.

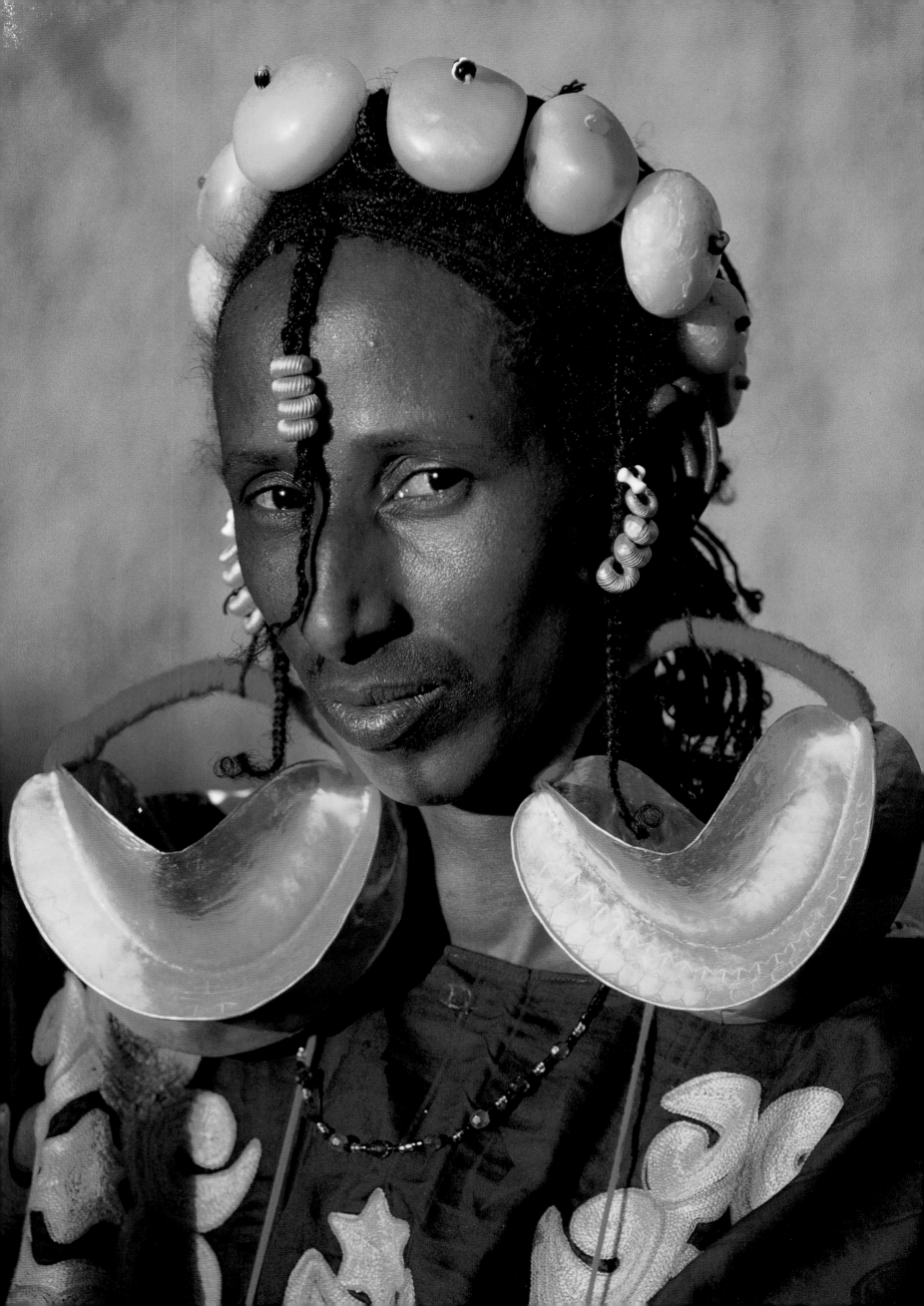

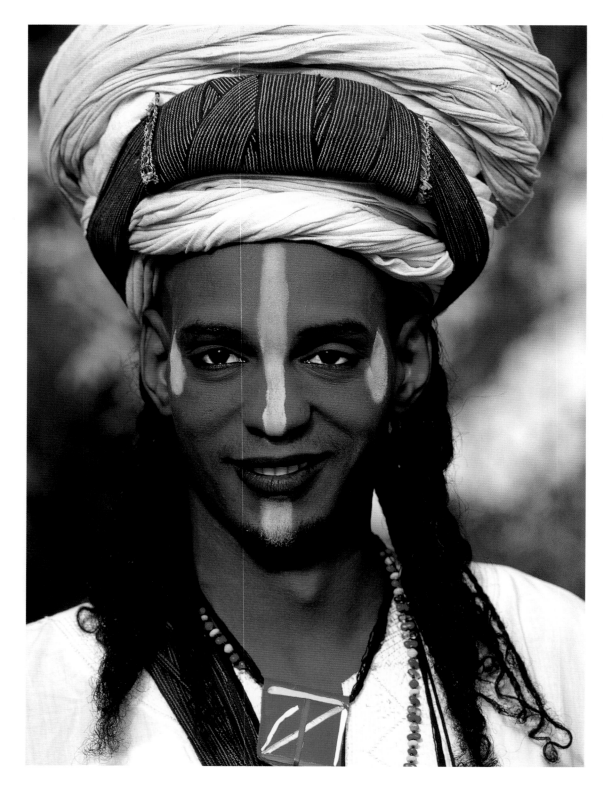

Wodaabe of Niger

Wodaabe nomads believe that their birthright of beauty comes from their ancestors, Adam and Adama. A Wodaabe male may take up to four wives; his first marriage is formally arranged by his parents at the time of his birth. His second, third, and fourth liaisons are freely chosen marriages based on love.

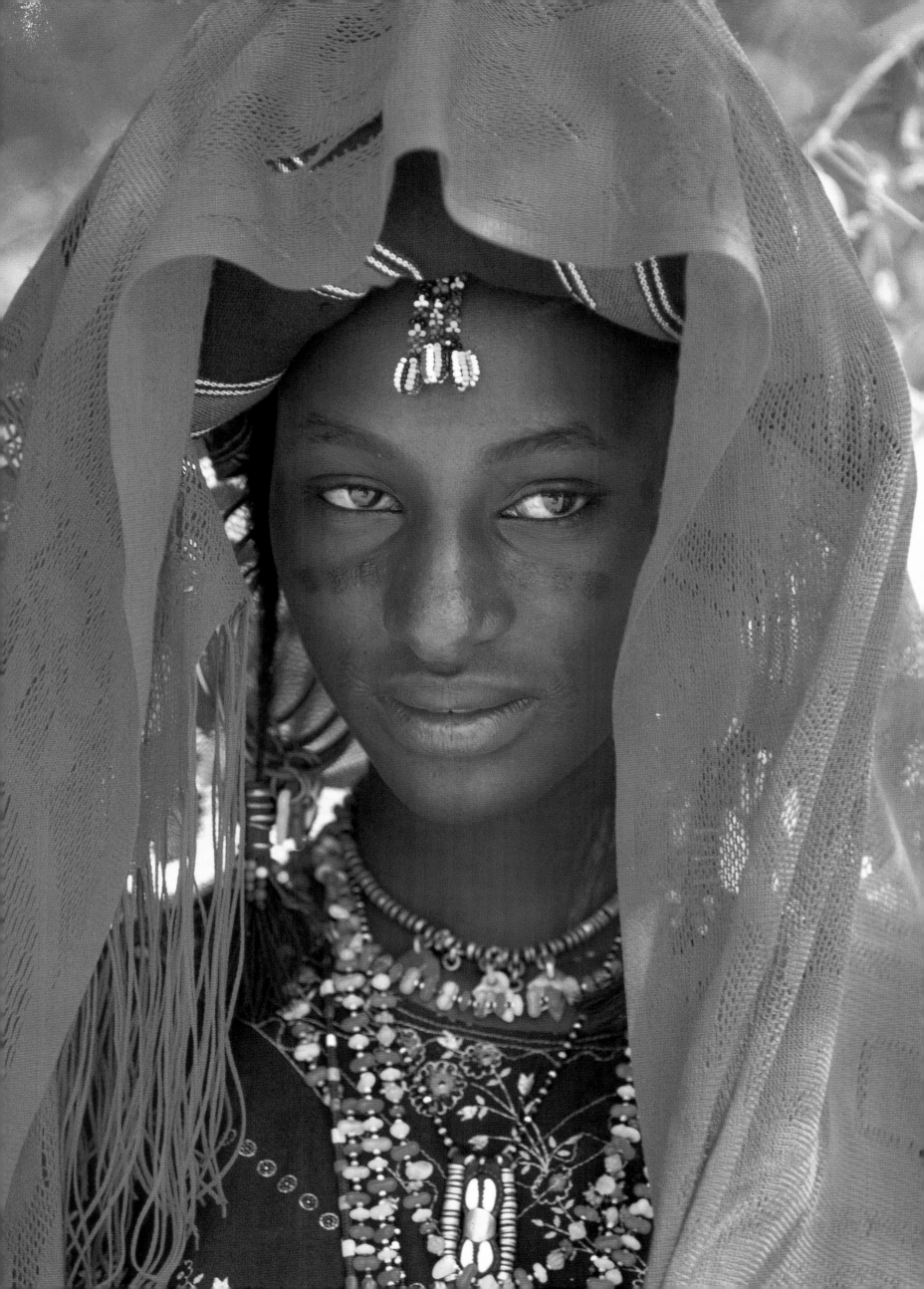

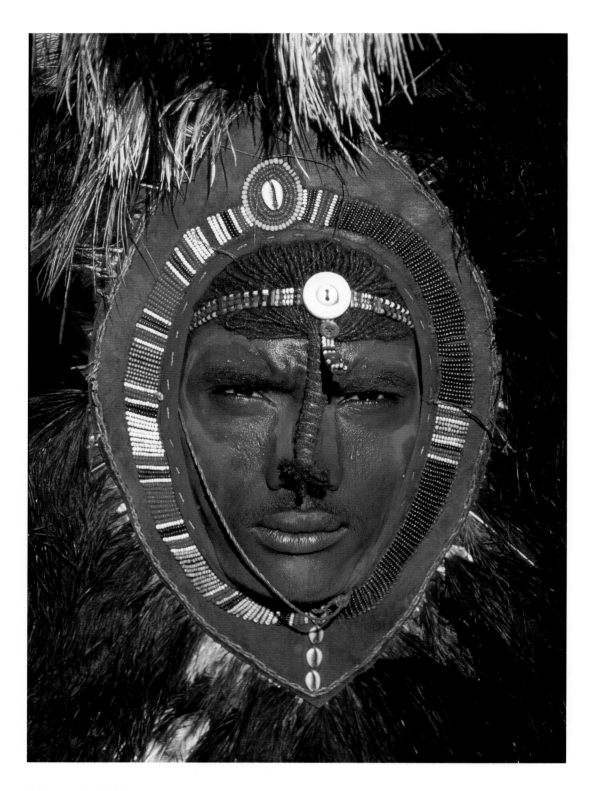

Maasai of Kenya

A Maasai bride is decorated with flat beaded-collar necklaces and an elaborate headdress. Traditionally she shows great sorrow on leaving her home and is forbidden to look back lest she turn to stone from grief. A Maasai warrior sheds his ostrich-feather headdress when he enters adulthood and becomes ready for marriage.

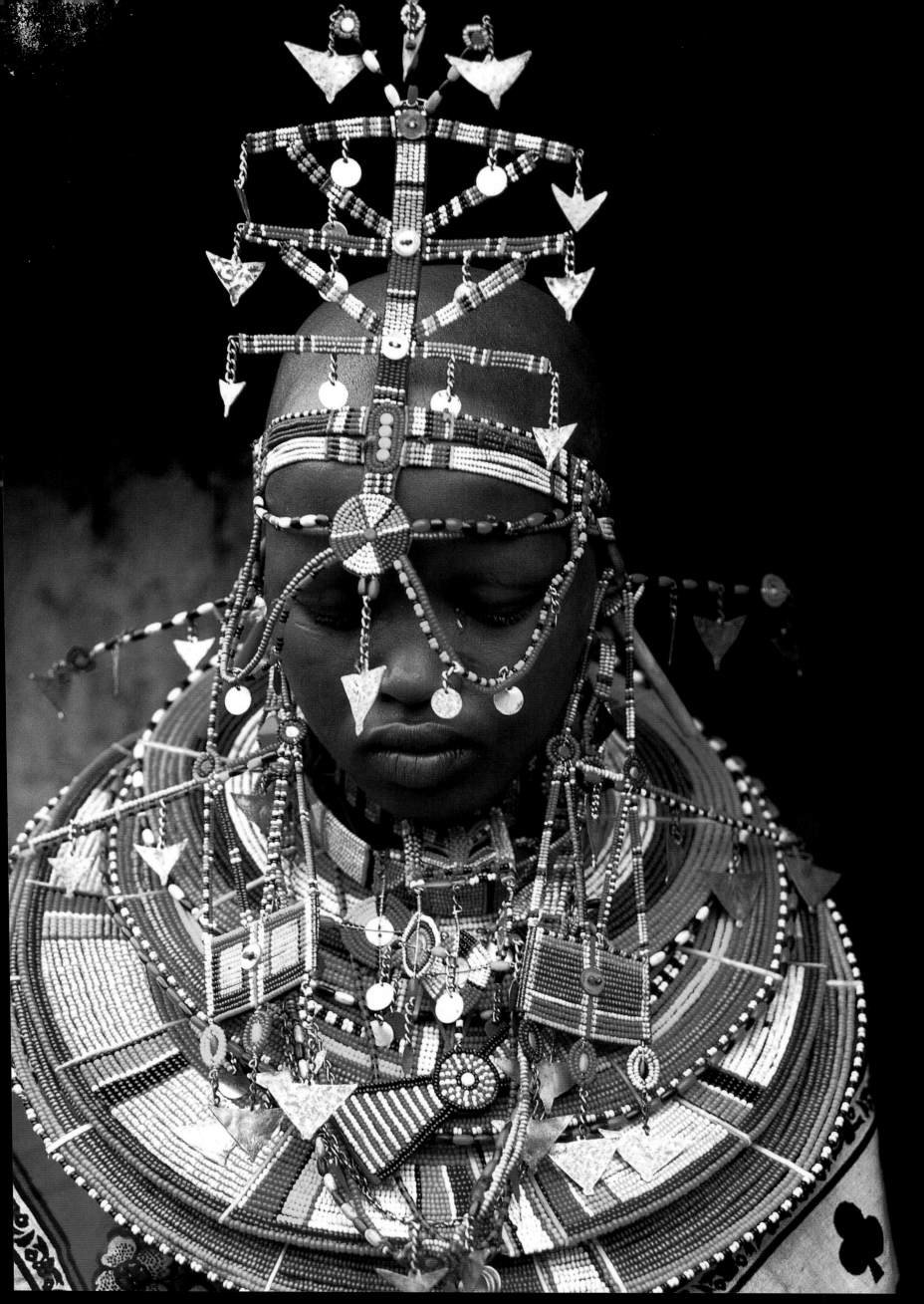

Surma of Ethiopia

A Surma man paints his body and performs in stick fights in order to win wives. A Surma bride wears a clay lip plate inserted into her lower lip six months before marriage. The size of the plate indicates the number of cattle the groom must pay her family for her hand in marriage. This lip plate is worth seventy-five head of cattle.

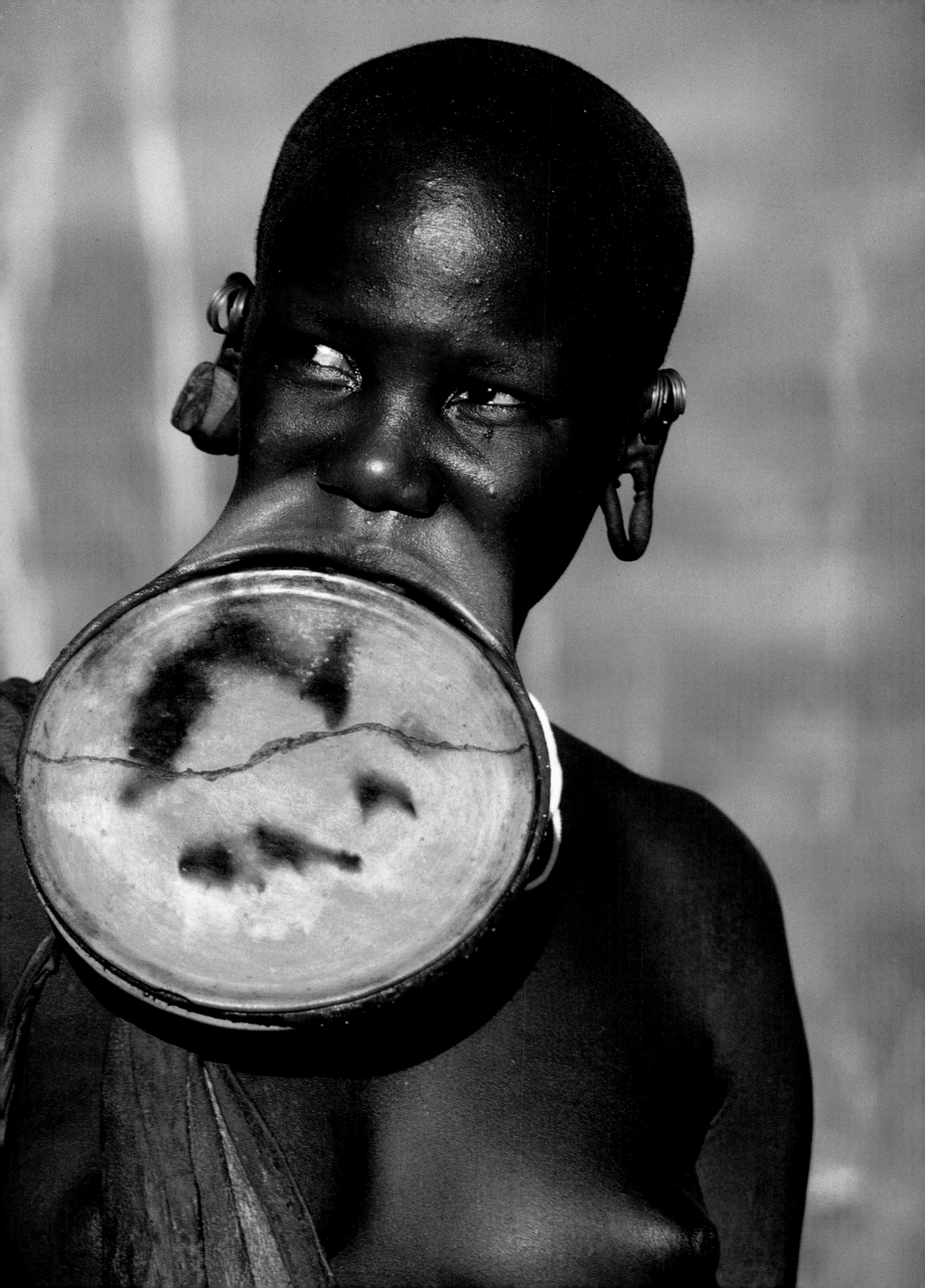

ROYALTY & POWER

The old woman fell to her knees before the majestic figure clad in leopard skins and bark cloth. Seated on the ancient throne of gnarled tree roots was H.R.H. Ronald Mutebi II, the newly crowned Baganda king of Uganda. As she chanted "Wangala Kabaka!, Wangala Kabaka!" (Long Live the King!), thousands of Baganda echoed her cry. Tears welled up in the eyes of those that watched the installation of their king, following twenty-seven years of political upheaval that disrupted the Baganda royal line. This momentous event of July 31, 1993 poignantly reconnected the Baganda people to their thousand-year history and re-established their wholeness and well-being as a kingdom.

All fifty-two clans of the Baganda were present on Buddo Hill, the sacred coronation site outside Kampala, showering their king with praise names— Ssaabsajja (Greatest of Men), Bbaffe (Master of Men and Husband of all Women), and Mpologoma (The Great Lion). Tied around his shoulders were four robes of office—a leopard skin, a calfskin, and two bark cloths. On his head was the traditional crown, beaded by the Leopard Clan. We were moved by his dignified composure, powerful presence, and great serenity. A clan elder closed the investiture with the cry, "Go and conquer your enemies!" The king responded with the vow, "I am the king to survive my ancestors, to put down rebellion, to protect the kingdom and rule the nation."

As we knelt to photograph the king, we were awed by the reverence of his subjects and could not help but see him through their eyes. He had become their divine ruler and a direct link to the powerful spirit world of royal ancestors.

SACRED BEINGS

Since the beginning of recorded time, kings have been closely associated with gods, often revered not merely as intermediaries between man and god but as gods themselves. They were believed to be able to bestow blessings on their subjects that were beyond the reach of mortal beings and were offered the kinds of prayer and sacrifice usually reserved for deities. As we saw in Buganda, the king is regarded with religious wonder. He forms a vital link to ancestors, to gods, and even to the supreme God Almighty. The Ashanti king of Ghana is also regarded as sacred. He is believed to be the terrestrial representative of the sun, and his soul, which is filled with the sun's power, is seen as the source of all life and blessings within the state. His royal person is symbolized by the Ashanti sign of the sun, the equal-limbed cross. Gold, his sacred metal, is used profusely in regalia; gold dust is sprinkled lavishly on the royal body at important ceremonies.

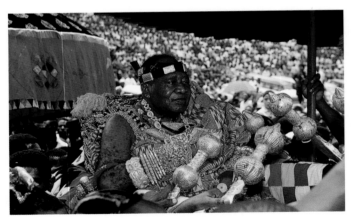

Traditionally, African rulers are symbols of the welfare of the state and are responsible for the security and prosperity of their people. In many societies, a king's role in maintaining social order is considered so important that when he dies it is believed that the realm temporarily falls into a state of anarchy. In ancient Buganda, to be without a king was regarded as disastrous, and for that reason the death of the ruler was not announced until his successor had been appointed. Ritual human sacrifices were offered to protect the new king from harm and to "set the land in order".

The subjects of a king are extremely sensitive about his destiny, because what befalls him will ultimately befall them. In Swaziland the king is obliged to avoid any contact with death. Forbidden to live in the same palace as his predecessor, he must build a new home in order to start his reign afresh. He must never touch a corpse, come close to a grave, or mourn for more than a few days. It is said by the Swazi people that "when the king is in darkness, the whole nation is without strength." When a Swazi king dies, to avoid upheaval in the realm his subjects are simply told, "The king is busy." Anyone who dared to announce untimely that the king was dead would be accused of "wishing to kill the country".

The sacred character of an African king is distinguished in many ways from the mortal nature of his subjects. In past times, to indicate that the Kabaka of Buganda was not a mere mortal, although he was human, he never walked on the ground in public and was always carried. His bearers traditionally came from the Buffalo Clan, and today they drive the limousines that carry him to his engagements. At major royal processions known as durbars, the Ashanti king of Ghana does not walk but arrives in a palanquin, lest he stumble and bring misfortune to the nation. When he is seated in state, his feet are placed on a stool to prevent evil spirits from entering his body. When he speaks, his linguist, a counselor known as *okyeame*, interprets his words, which are considered sacrosanct, to enhance his dignity and stature. In the Nigerian kingdom of Benin, we were told that the Oba (the king) required neither food nor sleep. Further, it was believed that he would only die in physical form, for his spirit was immortal, and that he would reappear on earth, linking the realms of the living and the dead. A ruler's well-nourished, often corpulent physique indicates to his subjects both his own good health and his ability to convey prosperity to others. He must, therefore, keep himself in a state of physical perfection as an outward sign of his moral perfection. He represents the harmonious blending of the spiritu-

al and mundane worlds in one body. The touch of the Ashanti king is reputed to be so powerful that in past times even his used bathwater had to be disposed of carefully, since anyone else who bathed in it would become too strong to control.

African rulers frequently control wealth—land, cattle, or gold—in their communities, whether it has been amassed personally or inherited. In the past, the Ashanti king of Ghana owned all of his country's land and gold mines, making him the custodian of great wealth and power. The greatest of Dahomey kings from the Fon kingdom of Benin was Roi Glelé, the ninth king, who ruled during the late nineteenth century. He was reputed to have 800 wives, 1,000 women slaves, an army of 10,000 soldiers, and 6,000 female bodyguards, whom he called Amazons. The king owned everything and granted land, wives, and favors to subjects who earned his approval.

SYMBOLS OF POWER

The Golden Stool of the Ashanti kingdom is a repository of ancestral forces, serving as both a shrine and a sacred symbol. Believed to have descended from heaven in a peal of thunder in the eighteenth century, it replaced the stools of the many previously independent city-states and sealed the union of the entire Ashanti nation. To sanctify the stool, the legendary chief priest Okomfo Anokye smeared it with a paste made from the hair and forefinger nails of the king, queen mother, and primary chiefs. In doing this, he infused the stool with the spirits of all notable persons from throughout the nation.

The Golden Stool is so exalted that to this day no one may sit on it, not even the Asantehene (paramount ruler) himself. It must never touch the ground and must be "fed" at regular intervals, for if it should become hungry, it might sicken and die, and with it the Ashanti nation would perish. Two wars have been fought with the British over their defiling of this precious object. When one official went so far as to try and sit on the stool, war broke out immediately.

While no other piece of regalia is as powerful as the Golden Stool, special Black Stools are also considered conduits for ancestral power. Even though an Ashanti chief may have been selected by a regional court, it is not until he is "enstooled" that he gains his royal per-

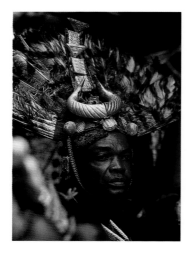

sona. He is brought naked to the black stool to signify that he is temporarily without social status. The moment his buttocks touch the stool, he is transformed into the ruler, the ultimate expression of human and ancestral power. The new chief is now considered to be transformed both physically and morally—"made complete".

Other royal symbols are imbued with ancestral power. In Nigeria, the Oba of Benin has nine kilograms of finely netted coral regalia that must be washed in blood once a year to protect the fertility of the land. At one time, in outlying areas of Benin, the king gave swords to chiefs to indicate that they had the power of life and death over their subjects. Ashanti kings of the past would make the final decision about whether or not to go to war by touching either the sword of peace or the sword of war. Thousands of lives depended on their choices. As the Ashanti still say about their king, "He is the one holding the knife."

REGAL DISPLAYS

Regal displays enable a king to promote his image as an extraordinary being. Kingly qualities are often revealed in iconic form through a breathtaking display of royal possessions. On August 13, 1995, we were invited to Ghana to attend the silver jubilee of the Ashanti king Otumfuo Opoku Ware II, honoring the twenty-fifth anniversary of his succession to the throne. Only six photographers were permitted to record this eight-hour ceremony. Held in the cultural capital of Kumasi, before seventy-five thousand guests, it was an awesome display of the wealth and power of the Ashanti nation, and one of the most spectacular events we had witnessed in thirty years of work in Africa. To the accompaniment of drums and ivory horns and the deafening cheers of the crowds, the king arrived in a palanquin, shaded by twirling velvet umbrellas. The gold jewelry on his arms was so heavy that bearers had to run alongside to support them as he

waved to the crowds. He was accompanied by a retinue of a hundred and fifty drummers, horn blowers, umbrella twirlers, Chief Soul Washers, elephant-tail switchers, fan and sword bearers, minstrels, counselors, executioners, key bearers to the king's treasury, and warrior guards. Also with him was the Golden Stool, the "soul" of the nation. This was the first time in twenty-five years that the stool had been seen in public. As the stool entered the arena on the shoulders of a special bearer, shaded by an enormous umbrella and accompanied by its own special throne, a hush fell over the spectators. The crowd around the stool was so densely packed that our Ashanti assistants had to lift us above it, giving us only seconds to photograph this unique sacred object.

The queen mother followed in her own palanquin, surrounded by attendants waving four-foot fans to keep her cool. Ceremonial umbrellas extended as far as the eye could see, shielding the paramount chiefs and their courts, who installed themselves in a grand circle around the king, now seated in state. The wealth and opulence of the durbar amazed us, all the more so when we considered that the entire spectacle centered around one person and one object, the Ashanti king and the Golden Stool.

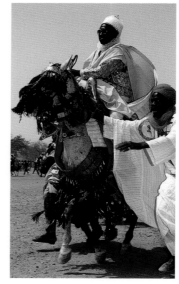

As the Ashanti king promotes his superiority through the lavish use of gold, the emir of Katsina in Nigeria exhibits his royal persona in a spectacular cavalry display. Every year he leads a religious festival called the Sallah to celebrate the completion of Ramadan, the Muslim month of fasting. Riding richly decorated horses, the emir's court, his aristocratic Hausa–Fulani chiefs, and his cavaliers and bodyguards clad in chain mail proceed through throngs of supporters in front of his palace—a show of authority dating back six hundred years. Towering over the throng, the emir and his court in their spectacular livery affirm themselves as being above and beyond the reach of ordinary men.

ART OF THE ROYAL COURT

Kings traditionally commissioned art that expressed the throne's vigor and uniqueness. When the empire of Mali reached its height in the fifteenth century, Timbuktu became one of the largest imperial courts in the world—a renowned center of Islamic learning. Its outstanding mosques and palaces were profound ex-

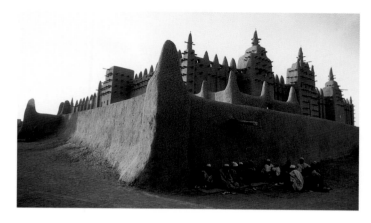

pressions of imperial power. In the kingdom of Benin, bronze casting learned in the thirteenth century was used at the king's command to create magnificent sculptures and bas-reliefs for the royal palace. These artworks are among the finest artistic achievements of their kind in the world.

In the equatorial forests of the Congo, the nineteenth-century Mangbetu ruler, King Mbunza, kept a huge retinue of craftsmen, who carved furniture, produced weapons, and created superb ornaments in ivory and copper. On important state occasions, the royal court assembled inside the king's legendary reception hall, a vast structure built from palm fiber and large enough for his several thousand wives and courtiers. Explorer George Schweinfurth described how "trumpeters played ivory horns too large to lift—as delicately as flutes, saluting the king as he danced, weighed down by all his finery."

The wealth supporting the kingdoms often came from natural resources such as gold and ivory, which were owned by the king. The Oba of Benin laid claim to one tusk from every elephant that was killed (the other went to the hunter), while in Ghana every nugget of gold over a certain size belonged to the Ashanti king. Funding for royal art also came from trade. The predecessors of the emir of Katsina taxed the Saharan caravans that linked the West African forest region to North African towns in Egypt and the Maghreb. This

trade originally involved the exchange of gold, ivory, and slaves for goods brought by the Arabs. Although the Ashanti kings were also peripherally engaged in this trade, gold remained their primary source of their wealth. Every year they would order all gold belonging to their chiefs to be melted down and recast, so that a tax could be levied. The gold jewelry and royal paraphernalia created by goldsmiths for the Ashanti court stand as powerful symbols of the Asantehene and his state, as well as being significant artworks in their own right. Each new Ashanti king or chief brings more wealth to the treasury: sandals, staffs, and gold ornaments made specifically to express his character or position in society. The Asantehene often wears a gold ring on every finger, each one referring to his exalted personality traits. His dress is a symbolic language in itself, and he can indicate his attitude simply by changing his costume. The *kente* cloth he wears is woven with motifs that refer to traditional proverbs concerning kingship and culture. Every new pattern that is designed must be submitted to the king, and if he selects the cloth for his own use, it may not be used by anyone else from that time on. The designs of the staffs carried by the royal linguists, who communicate messages between the king and his subjects, depict ancient proverbs. The final of a gold-leafed staff featuring a hand holding an egg, for example, signifies that "power is like an egg—held too tightly it breaks, held too loosely it falls," meaning that a successful ruler must be firm as well as sympathetic to the needs of his people.

In Africa today, royal kingdoms with large populations of loyal subjects exist primarily within larger modern nations. A small number of these kingdoms have managed to maintain their autonomy, but the majority no longer hold political power. They continue, however, to play an important role in preserving valuable cultural and ceremonial traditions. In this way, the age-old hierarchy of the king, his chiefs, and his subjects helps to maintain unity and promote stability.

The Emir's Court

Descended from the seven ancient warrior kingdoms of northern and central Nigeria, the Hausa are the most numerous peoples living in that region today. Vowing never to fight among themselves but only against invaders, they have kept their own language and way of life alive for many centuries despite the integration of various immigrant peoples into their community. In the nineteenth century, however, the resident Fulani population initiated a religious war, or jihad, led by the reformer Shehu Usman Dan Fodio. A strict Islamic order was consequently imposed on the region, and the Habe (Hausa) lineage of kings that had ruled for many centuries was replaced with a dynasty of Fulani chiefs, known as emirs.

In the large town of Katsina, Emir Alhaji Muhummadu Kabir Usman and members of his court regularly appear in ritual shows of leadership, where they express their authority on both secular and religious levels. Richly decorated horses play a major part in these events, acting as status symbols and reflecting the ancient equestrian tradition of the Hausa. The most

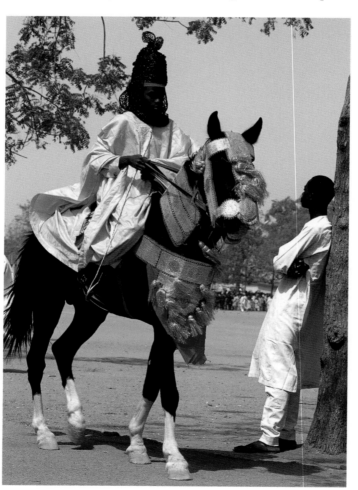

spectacular of these ceremonies are the two Sallah Festivals that follow Ramadan. The Eid-el-Fitr Sallah is held on the first day after the communal prayers that break the Ramadan fast. The Eid-el-Kabir Sallah (also known as Babbar Sallah, or Big Prayer) occurs before the start of the pilgrimage season to Mecca. Commencing the Sallah, the Emir and his retinue ride out before the town's inhabitants in their most extravagant robes along a historic route that links the sacred space of the mosque's communal prayer ground to the secular space of the palace. This route reflects the emir's dual role as the religious and political leader of the emirate. Many hundreds of horsemen join the

emir's procession, which culminates in an equestrian display outside the palace. The Sallah shown on the following pages celebrates Eid-el-Fitr, when one hundred thousand Hausa and Fulani subjects paid homage to the emir of Katsina.

Above and right: The elaborate livery of the horses and ceremonial finery of the riders reflect their social importance at the Sallah ceremony. *Following pages:* The Emir and his entourage parade through the town of Katsina, greeting the crowds.

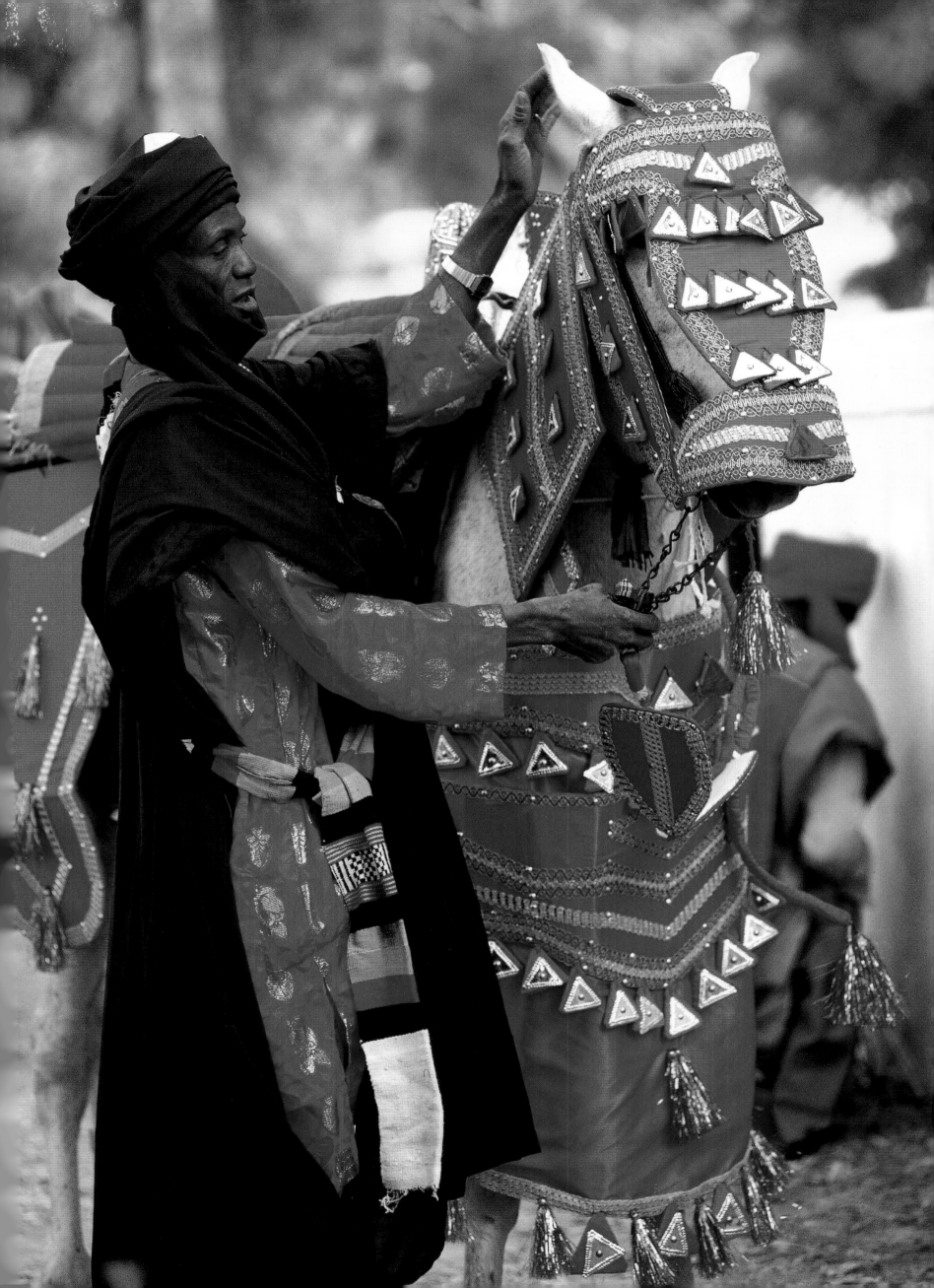

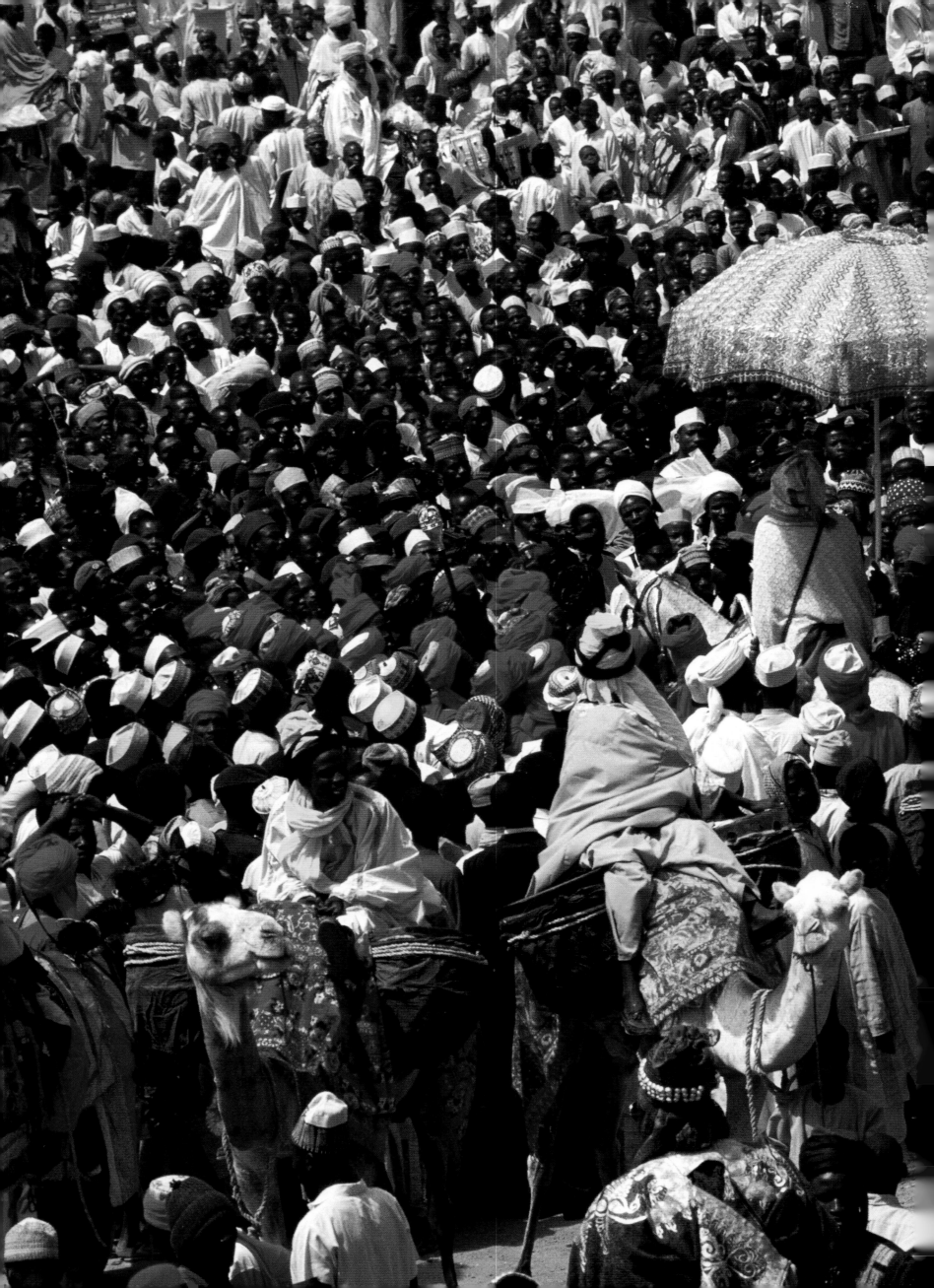

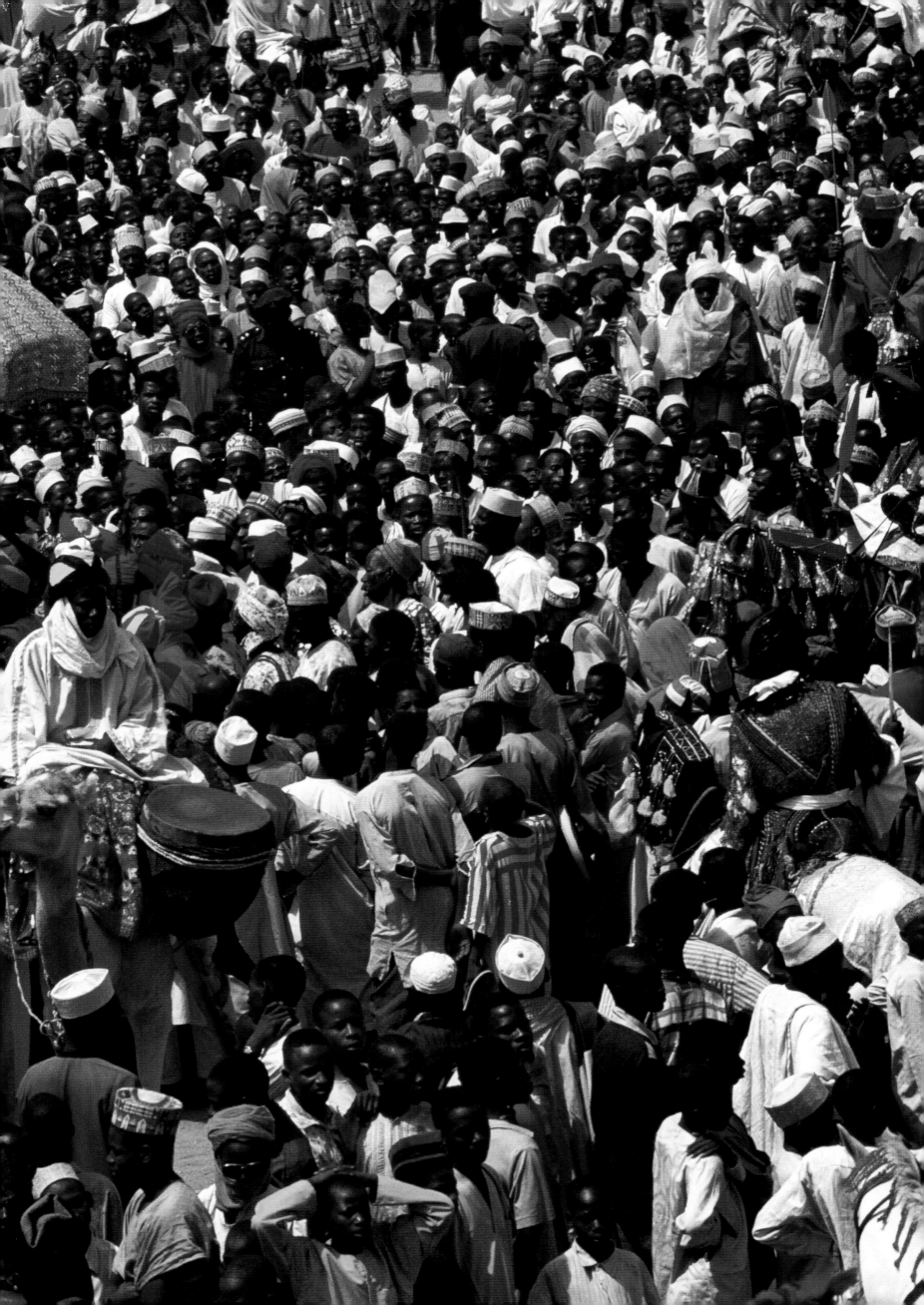

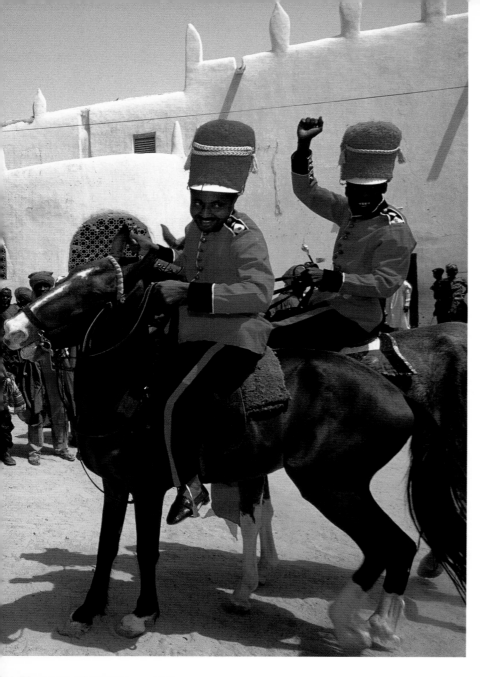

The Emir and His Court

Preceding pages: On the first morning of the Sallah cele-
brations, the emir, shaded by a pink umbrella, greets
the populace of Katsina. As the royal entourage moves
through the town, heralded by large *tamboura* drums
borne on camels, the emir's horse serves as a moving
throne, elevating him above the heads of his subjects.
The emir, His Royal Highness Alhaji Muhummadu Kabir
Usman, is the supreme head of the ruling dynasty,
holding the highest position of traditional power for
both the Hausa and the Fulani communities of the
Katsina emirate. Wearing a gold cloak over a white robe
and turban that signal religious piety, he is surrounded
by palace attendants. Two of his many sons, dressed in
British-style uniforms *(left)*, accompany him. As the
emir enters his palace, one son raises his arm with a
closed fist in the traditional show of appreciation.
Below: Court musicians play long, brass *kakaki* horns
announcing the Sallah celebration.

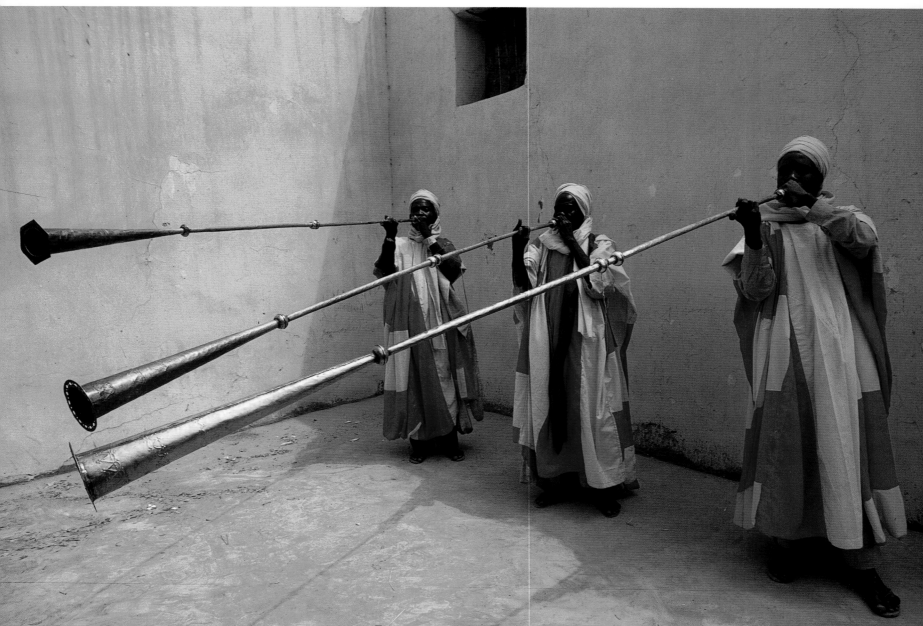

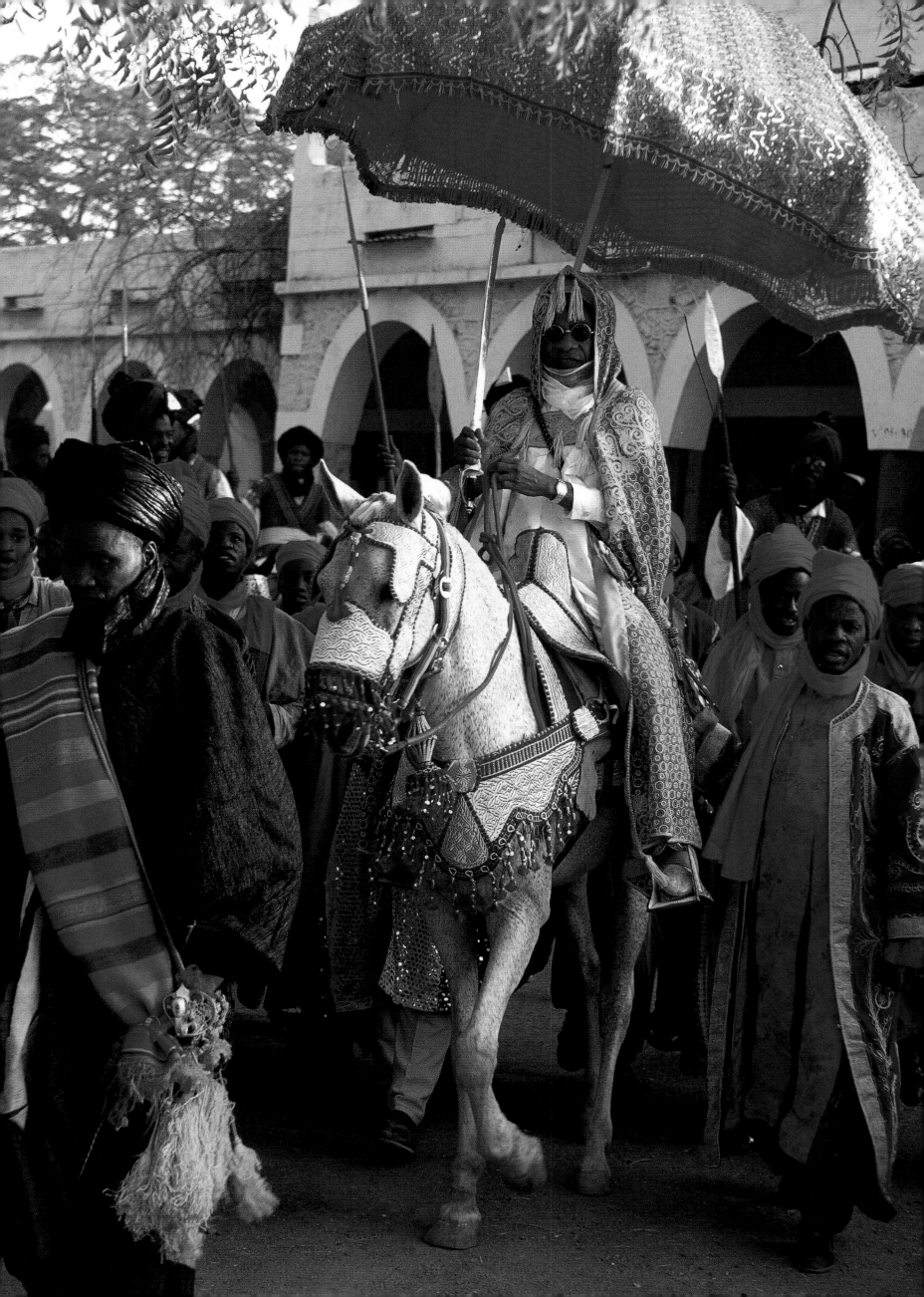

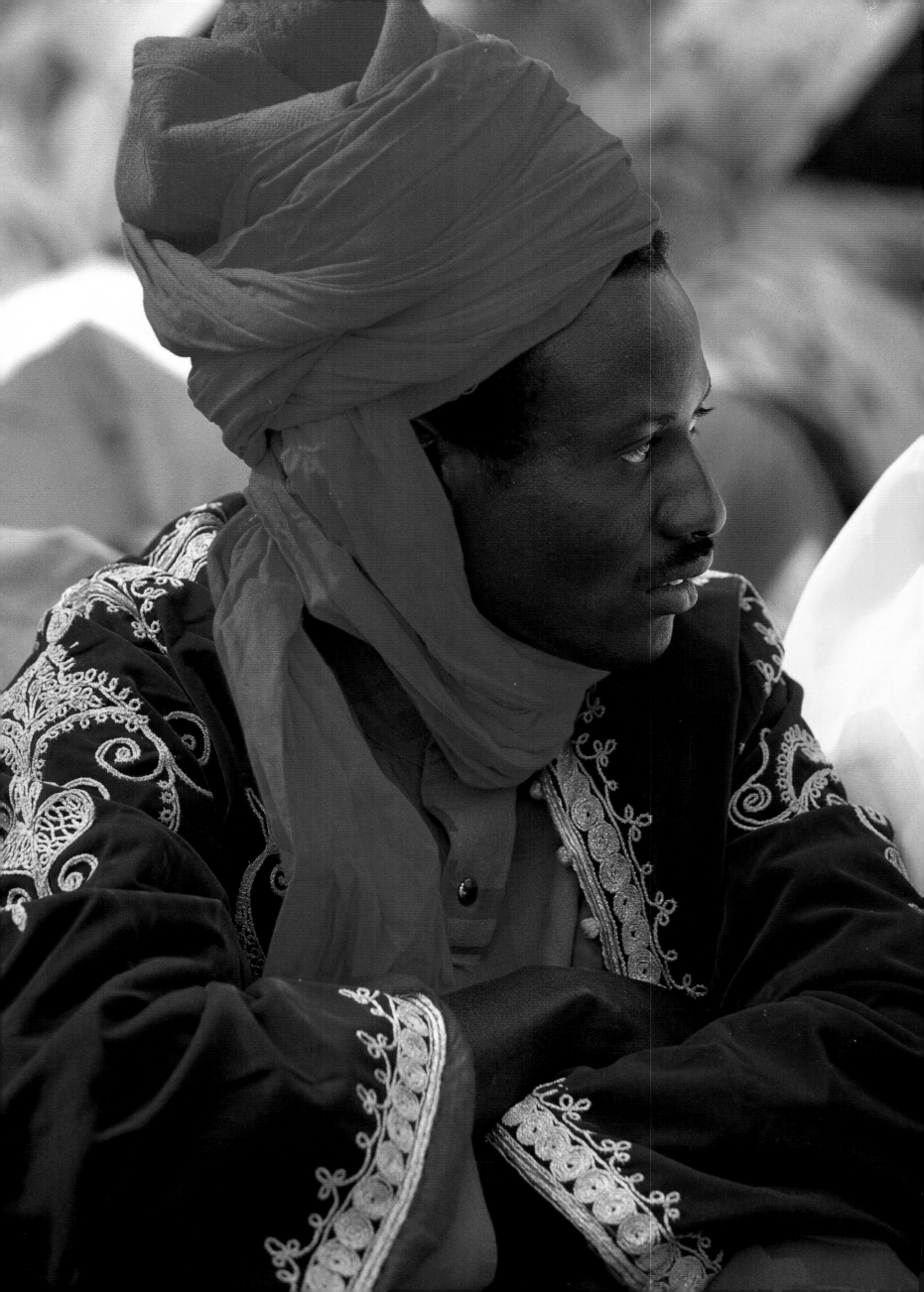

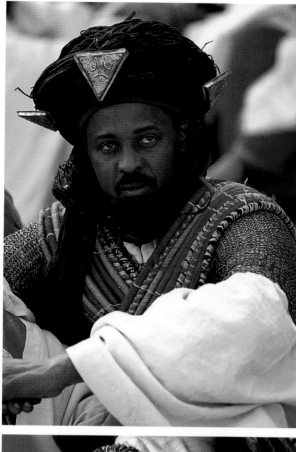

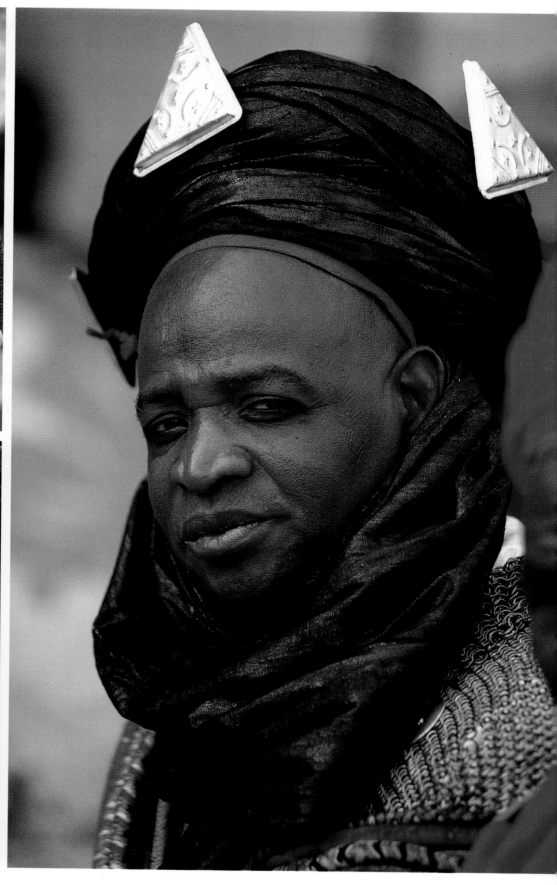

Royal Guards and Cavaliers

Clad in richly embroidered fabrics denoting the power and wealth of his master, a royal bodyguard (*left*) sits at the emir's side watching the procession pass by. The vibrant scarlet of his turban is traditionally associated by the Hausa with strength, vigor, and severity in action. The robes he wears are called *babbar riga* and are often presented by the aristocracy to their servants as tokens of appreciation for years of devotion and faithful service. Members of the emir's cavalry (*above*), known as *yansilki*, wear chain-mail tunics reminiscent of the Kanem-Bornu Empire; thick silken lanyards are draped over them. Their turbans, called *turkudi*, are fashioned from yards of strip-woven cotton, dyed with indigo to a dark hue, and beaten with additional indigo powder to produce a high sheen. The lustrous fabric is adorned with silver talismans intended to guard the wearers against injury in battle.

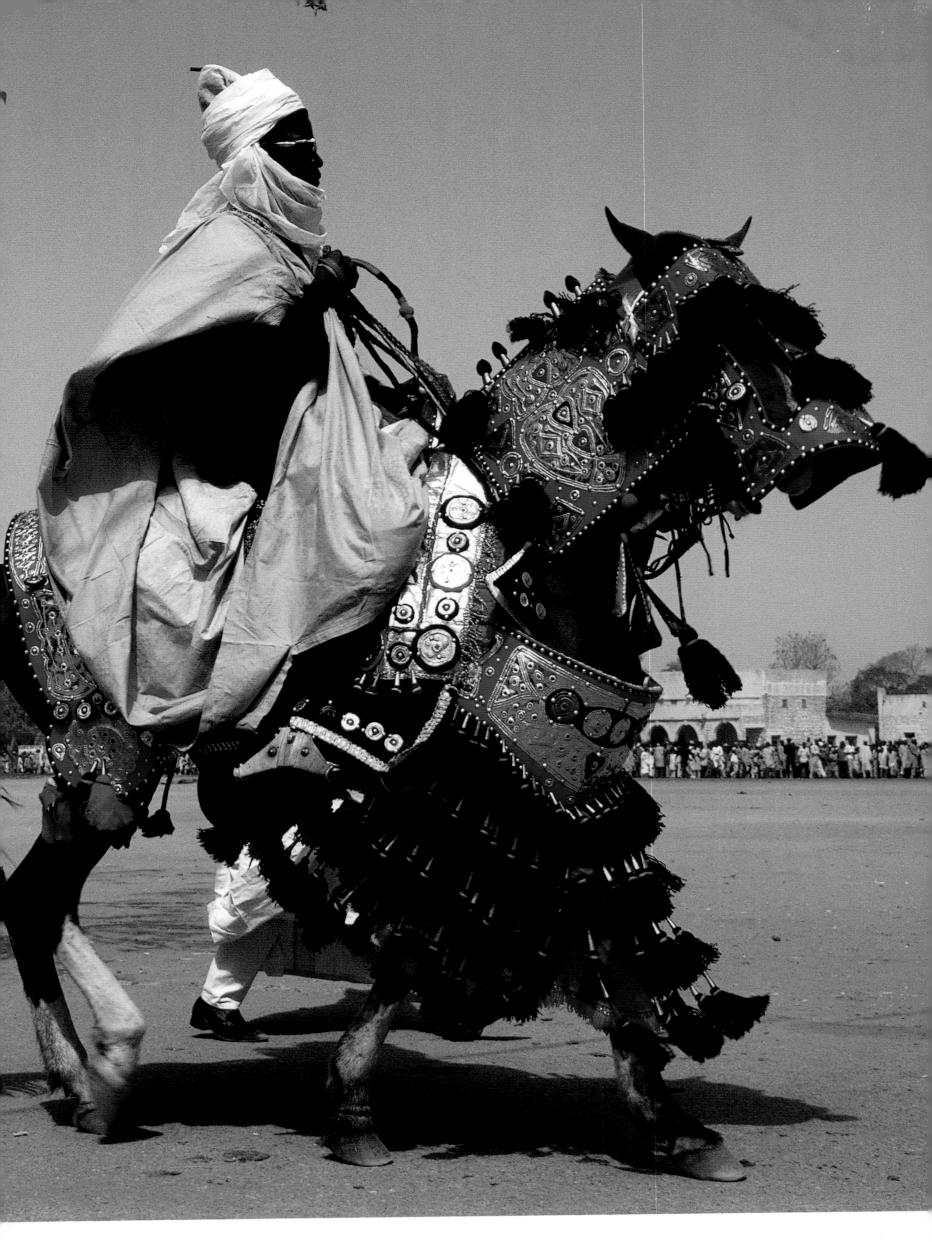

Ceremonial Horse Regalia

The regalia of the royal cavaliers and their horses is reminiscent of protective clothing worn by their warrior ancestors. Ceremonial harnesses are lavishly decorated with metallic tinsel, colorful embroidery, and leather appliqué. Small silver or gold balls containing medicinal packets ward off danger, and the leather pendants suspended from the reins are reminiscent of magical amulets known as *laya*, used to protect warriors against sword wounds. At festivals such as the Sallah, the main form of male clothing is the Big Gown Ensemble, consisting of a gown (*riga*), a distinctive turban (*rawani*), and a hooded cloak (*alkyaba*). The different qualities of cloth, tailoring, and embroidery and the number of gowns worn indicate the wearers status.

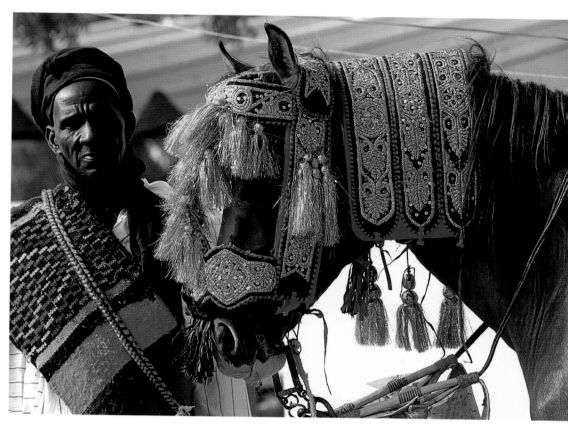

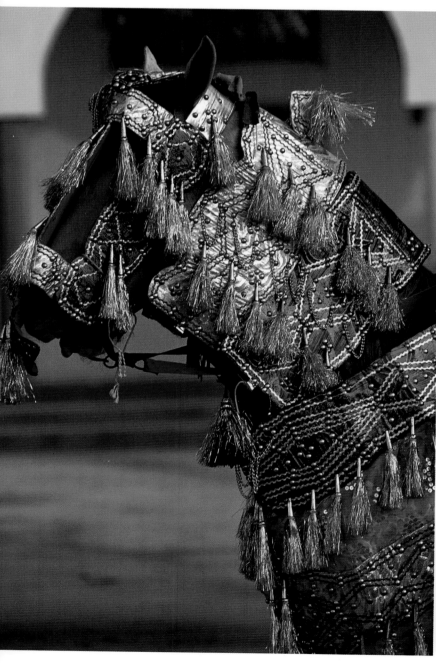

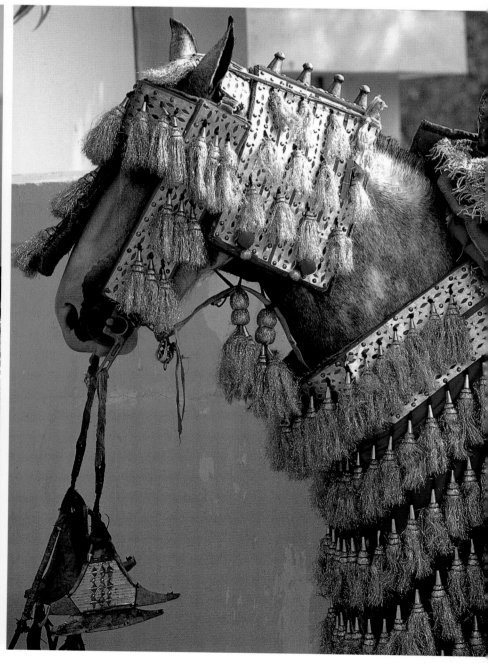

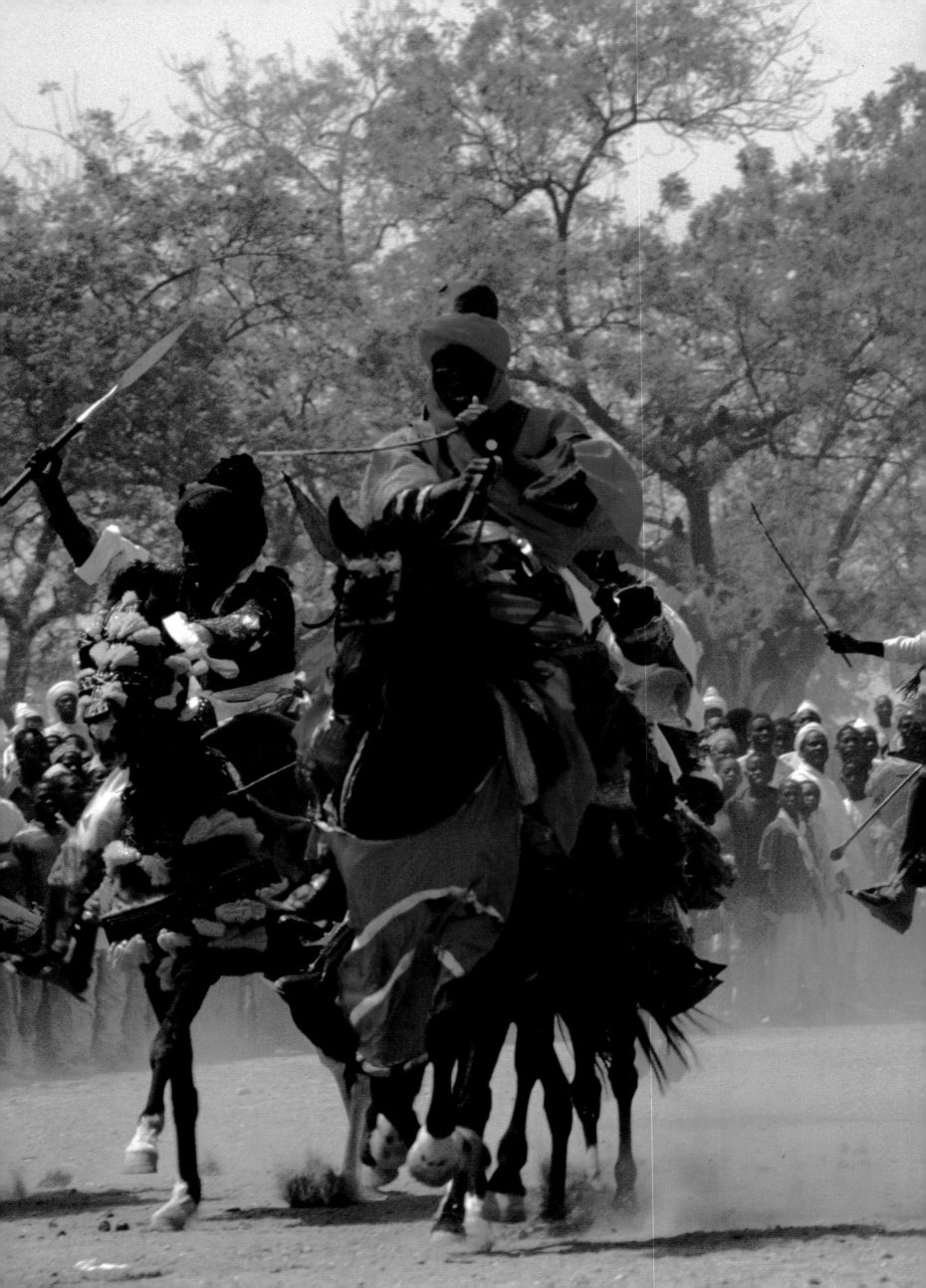

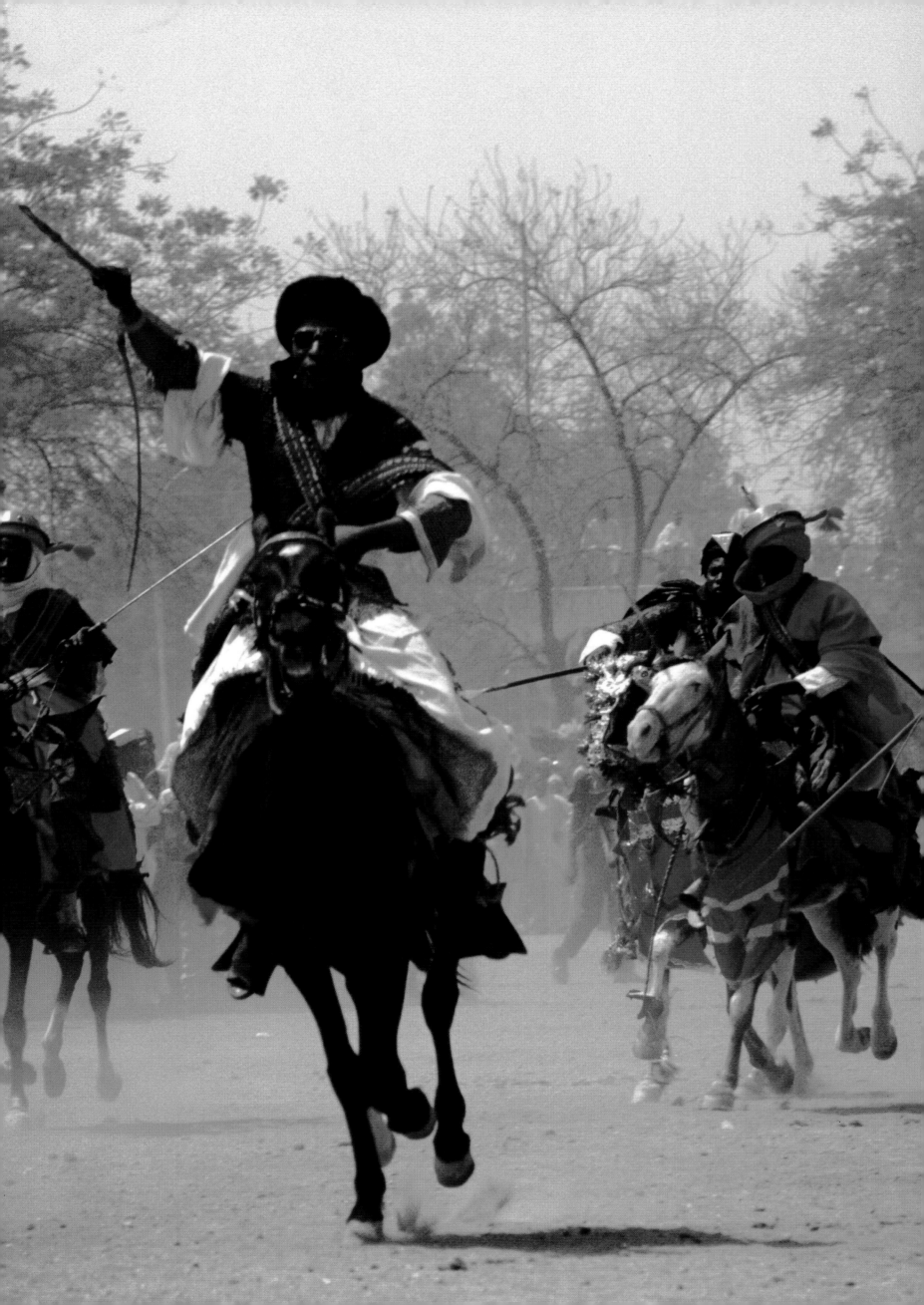

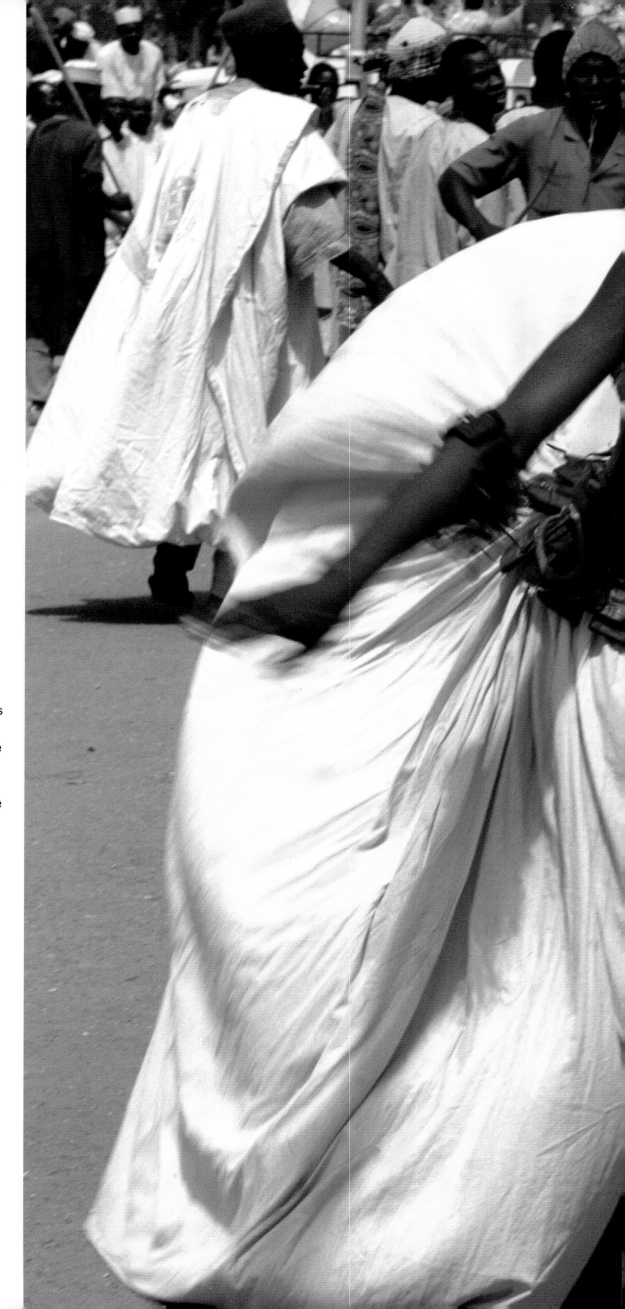

In Honor of the Emir

Preceding pages: Thundering past the cheering crowds, hundreds of horse-men race toward the emir to show their allegiance. This display, known as Hawan Daushe is traditionally staged on the esplanade in front of the palace following the Sallah procession. An exhibition of equestrian skill and prowess, the event is a reminder of the former brilliance of Katsina's cavalry. Consisting of a series of lightning-fast charges by the royal bodyguards and titled officials, who rein their mounts to a sudden halt, the Hawan Daushe simulates the traditional military maneuver of charging the enemy.

Right: Wearing billowing pantaloons and covered with leather talismans, a Hausa dancer called *Gardi* from the nearby town of Kankia whirls along the processional route of the Sallah ceremony to clear a path for the emir. As he performs, his voluminous pants fill with air and puff out like balloons. Resembling a small hurricane, the dancer leaps and spins, gathering speed as he careers past the crowds.

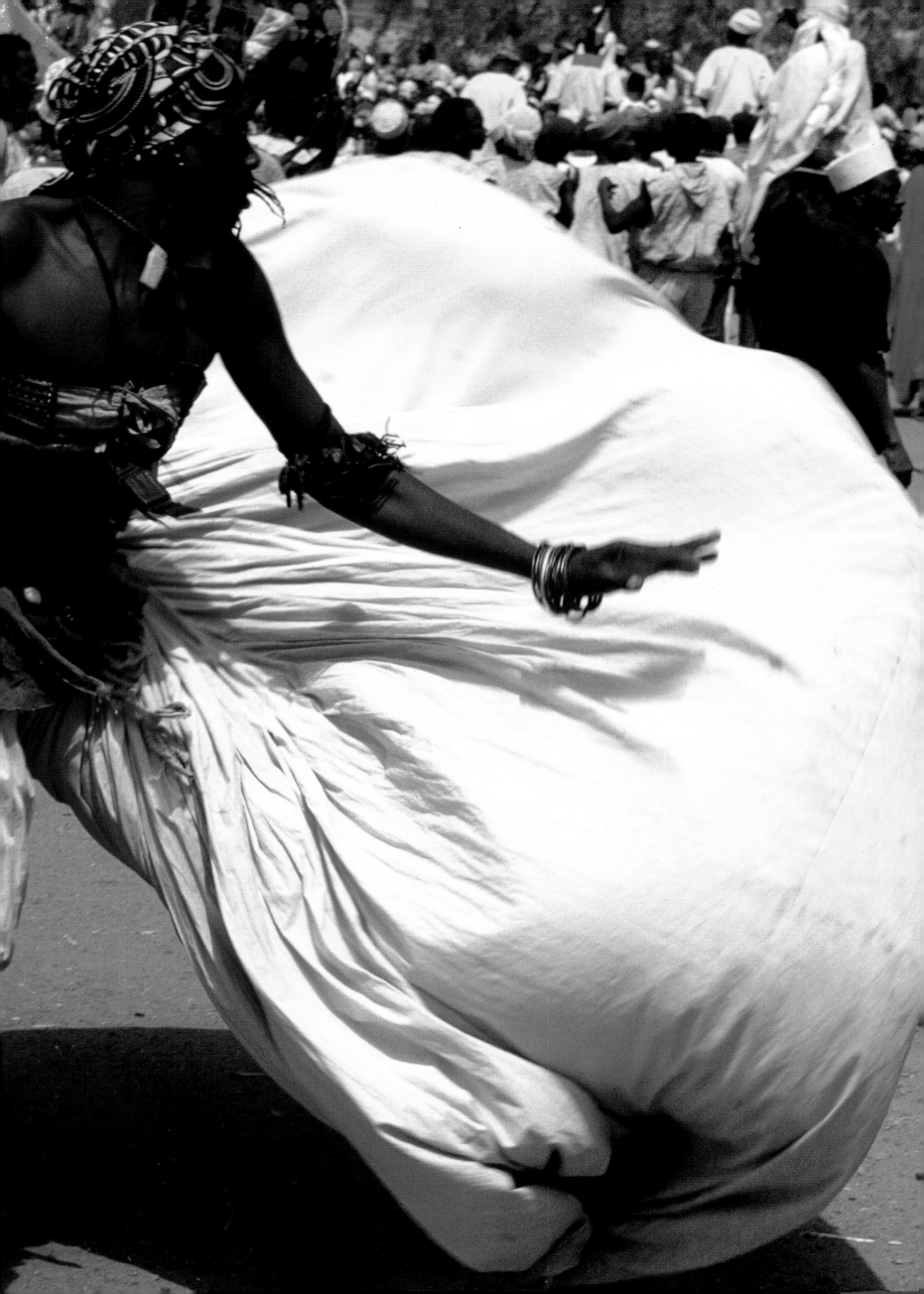

Baganda Coronation

The Baganda people, living in the central region of Uganda, are the largest and most politically powerful ethnic group of the country, numbering four million and representing one quarter of the population. The Baganda pledge loyalty to the kingdom of Buganda, which originated in the fourteenth century with the unification of many clans. Kintu, the first king, or Kabaka, who unified the clans, was honored with the title Ssaabataka, Head of Clan Heads. The unique nature of this kingdom is the equality of all classes and the absence of a single royal clan. Although Baganda society has a patrilineal tradition, the kingship arises matrilineally. A king is chosen from his mother's clan, and therefore every clan has the potential to produce a king.

In 1966, the Baganda kingship came to an abrupt halt, when the royal palace at Mengo was destroyed by the Ugandan army and the late King Mutesa II was sent into exile by Uganda's president, Milton Obote. Uganda fell into a state of anarchy, lasting nearly three decades. In 1993, the current president, Yoweri Museveni, decided to reinstate four of his country's tribal kingdoms, including Buganda. Putting a monarch back on the throne served as a reconciliation with a large part of the population as well as a means of reconnecting the Baganda people to their seven-hundred-year history. Ronald Mutebi II, who was living in Britain at the time, became the new king of Buganda. In keeping with modern government, however, President Museveni instructed the king to establish a monarchy that was cultural and ceremonial, not actively political.

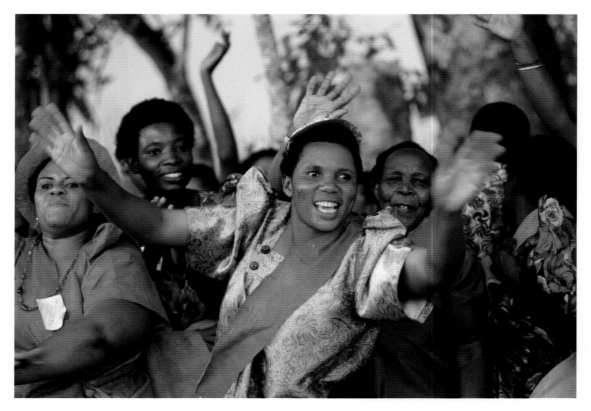

Above: A Baganda woman, proudly wearing a bark-cloth sash, is among 20,000 subjects celebrating the crowning of their new king. *Right*: Wearing leopard skin and bark cloth robes, Ronald Mutebi II is installed as Kabaka.

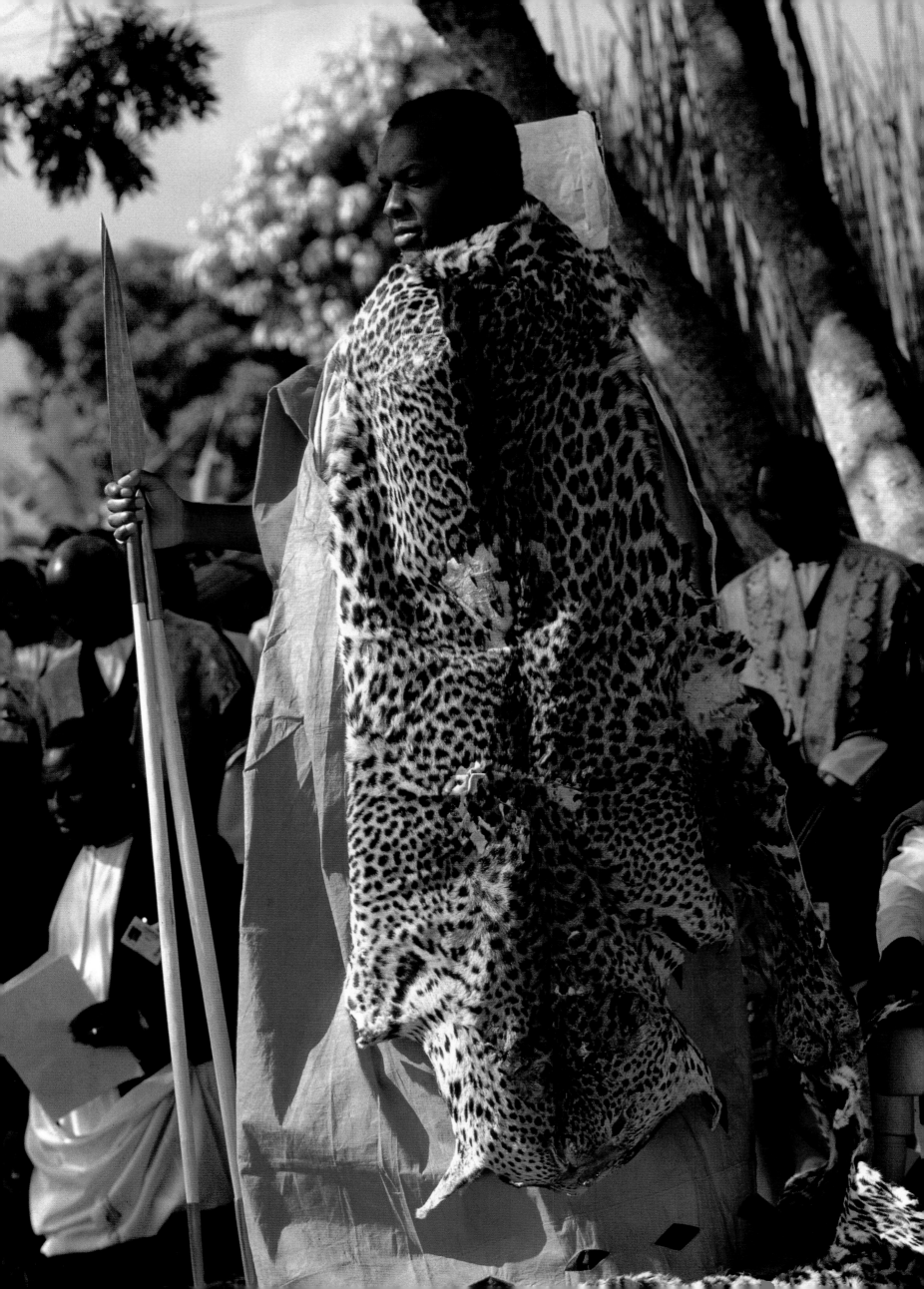

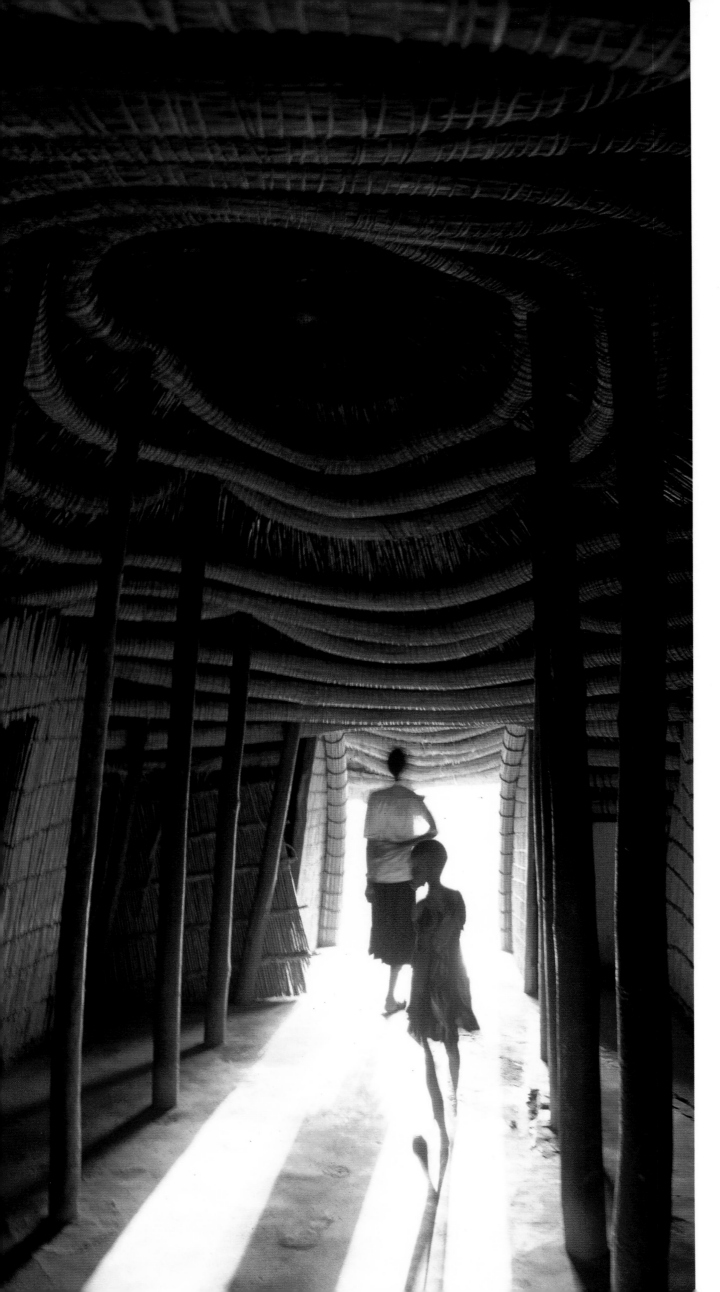

The Royal Shrine

The Royal Kasubi Shrine occupies the site of the palace of King Mutesa I in the central region of Uganda. When the king died in 1884, the palace became a mausoleum, and his three successors were buried there. The main entrance to the Kasubi Shrine (*left*) is constructed of reeds, grass, and sturdy saplings, and features a remarkable ceiling of large concentric rings made from the fronds of palm leaves. Both the entrance building and the main shrine (*right*) were constructed by clans, each of which had a special task. The interior was decorated by the Leopard Clan, and thatching was undertaken by the Colobus Monkey Clan. During construction, the thatchers had to abstain from sexual activity, and no women were allowed to enter the building. If the prohibitions were violated, it was believed that the roof would leak.

The Kasubi Shrine is the largest grass hut in Uganda, and one of the finest examples of traditional architecture. The interior, divided by a large bark-cloth curtain, houses the inner sanctuary, known as the *akabira*, or forest, where the spirit of the king resides. Kintu, founder of the kingdom, is said to have disappeared into the forest near his palace, and when his descendants die they also disappear into the forest sanctuaries of the shrine. The front half of the shrine features portraits of the last four kings, before which a dividing line of spears separates the worlds of the living and the dead. During ceremonies, the bark-cloth curtain is parted to allow the two worlds to meet.

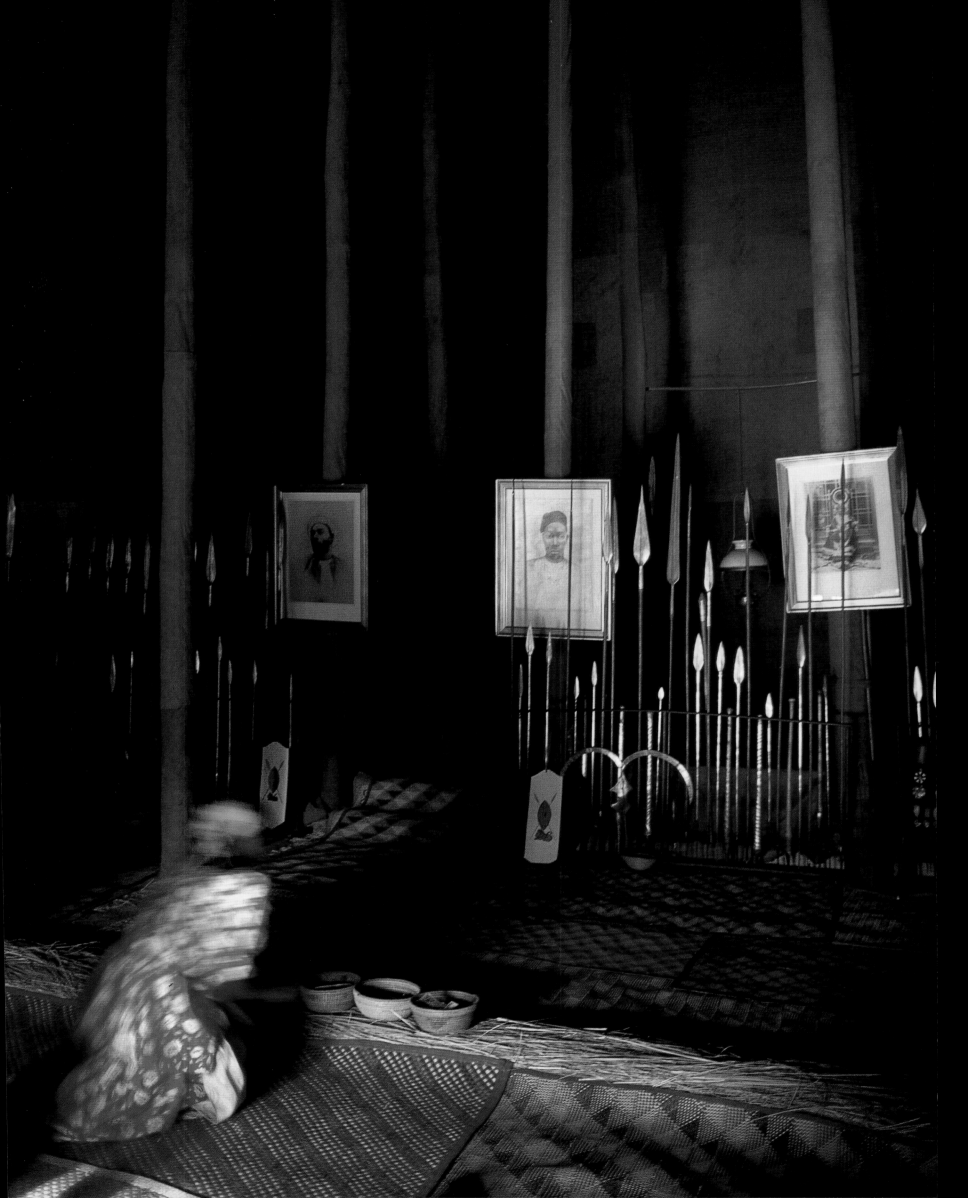

The Coronation of the King

The installation of Ronald Mutebi II took place in 1993 on Buddo Hill, near Uganda's capital, Kampala, at the site of the ancestral throne, an old, gnarled tree root draped with bark cloth and skins. The king wore four robes of office—a leopard skin, a calfskin, and two bark cloths. On his head was a traditional crown beaded by the Leopard Clan. One by one the elders of the fifty-two Baganda clans prostrated themselves before the king.

Left: An elder chief presented the king with two spears and a shield saying, "Go and conquer your enemies." Holding the spears and shield like a warrior, the king vowed to defend Buganda to the death.

Below: Buffalo Clan members flanked the aisle lined with bark cloth leading to the throne. In Buganda, bark cloths symbolize land ownership. According to legend, Kabaka Kintu, the founder of kingship, divided his lands among his subjects by planting bark-cloth trees, a type of fig tree.

Right: The king is lifted onto the shoulders of men from the Buffalo Clan and shown to his people. The Buffalo Clan are the traditional bearers of the king. In the past, they carried the king on their shoulders; nowadays, many are chauffeurs who transport the king in limousines.

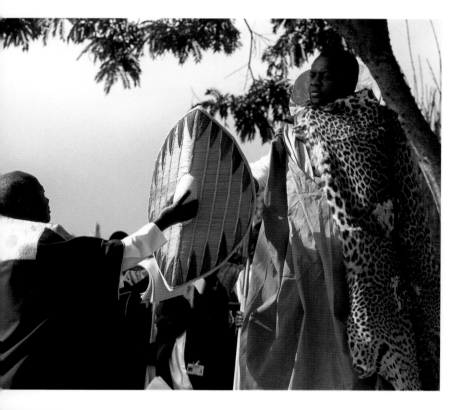

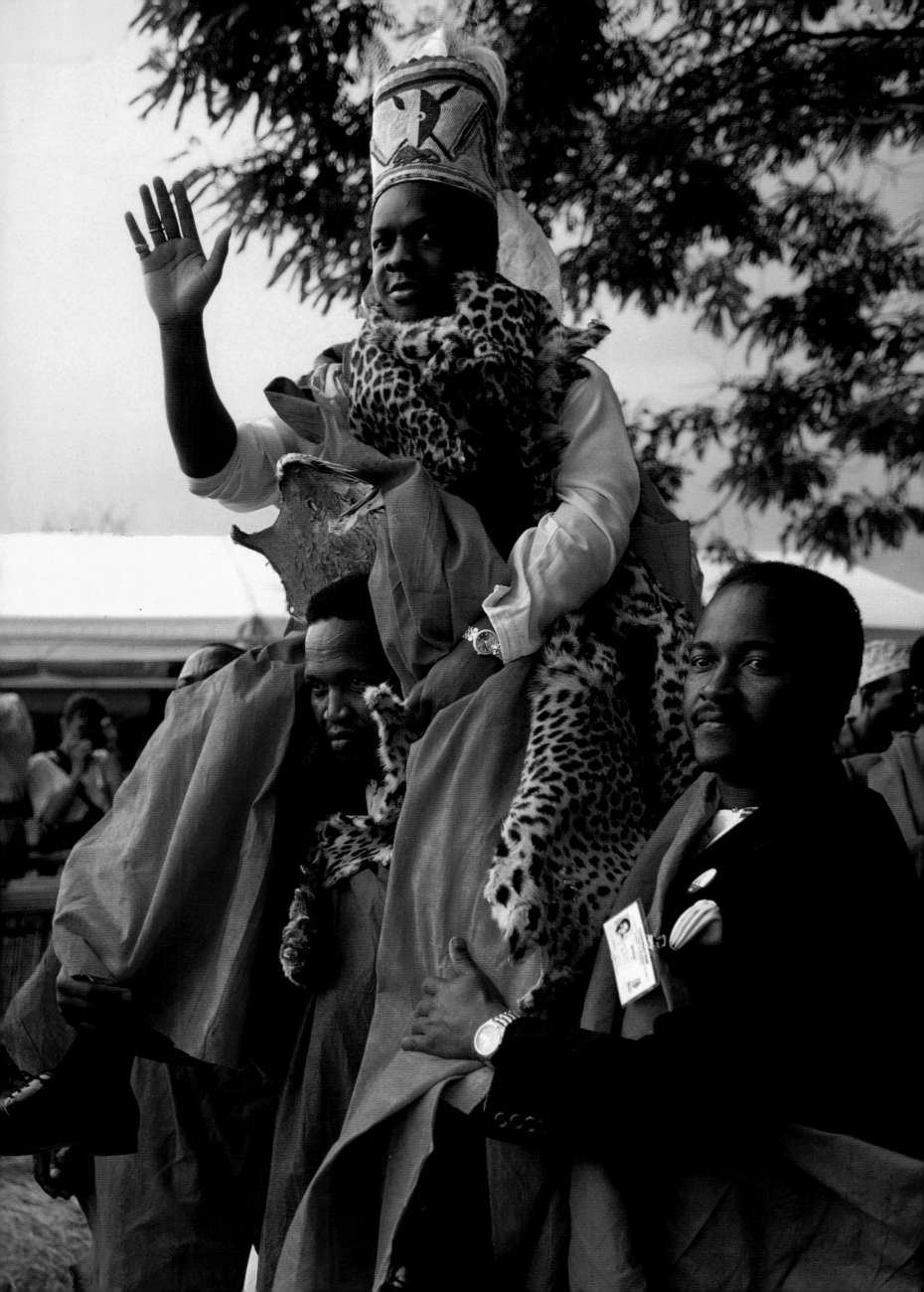

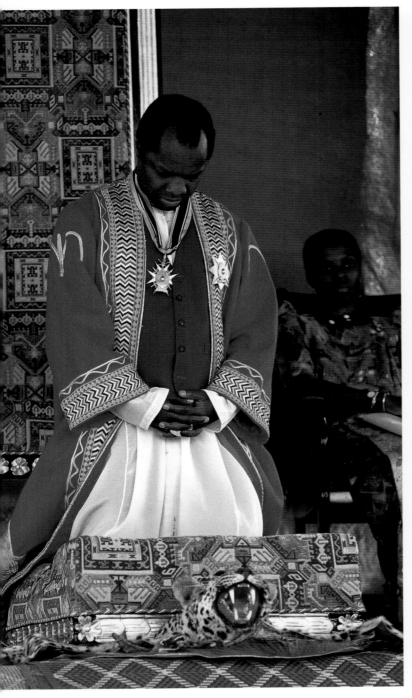
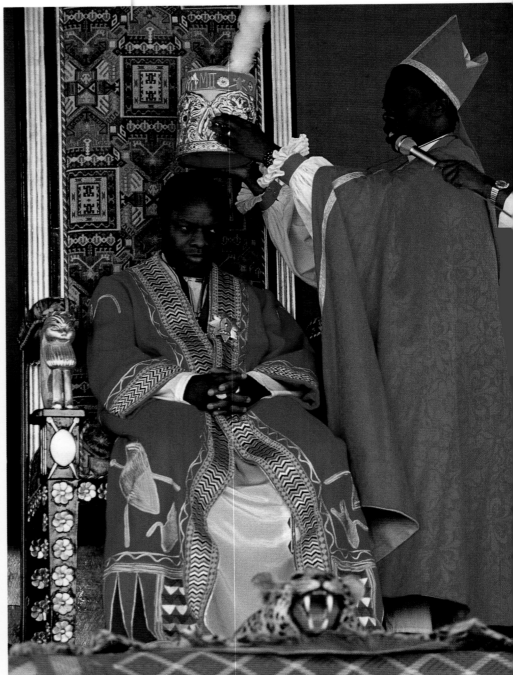

The Crowning Ritual

The coronation ceremony of the king included a modern as well as a traditional investiture. With the coming of British rule to Uganda, certain aspects of the ceremony became both Christianized and Anglicized. Thus, following the traditional coronation a full interdenominational religious service was held, during which the Kabaka was crowned by the Protestant bishop, who placed an elaborate golden crown made in Saudi Arabia on the king's head. The king wore a richly embroidered robe made in India and knelt in prayer in front of an ornate throne crafted in Egypt. He was blessed by the leaders of many faiths.

Behind the king throughout both ceremonies stood the Lubuga, his clan sister, who symbolizes his queen-wife and comes from his own Monkey Clan. In recognition of her symbolic role as food provider and housekeeper of the king's estate, she carried a knife and basket. If the king is not married, the Lubuga must live in the palace for a time to show his subjects that the king will always welcome people to his home because he has a wife who will never leave him. In former times, the Kabaka was revered as the all-powerful ruler of Buganda. Today, although his role is somewhat restricted, he is nevertheless responsible for the preservation of cultural and ceremonial traditions, the development of traditional agriculture, the maintenance of ancestral shrines, and the mobilization of Baganda self-help projects.

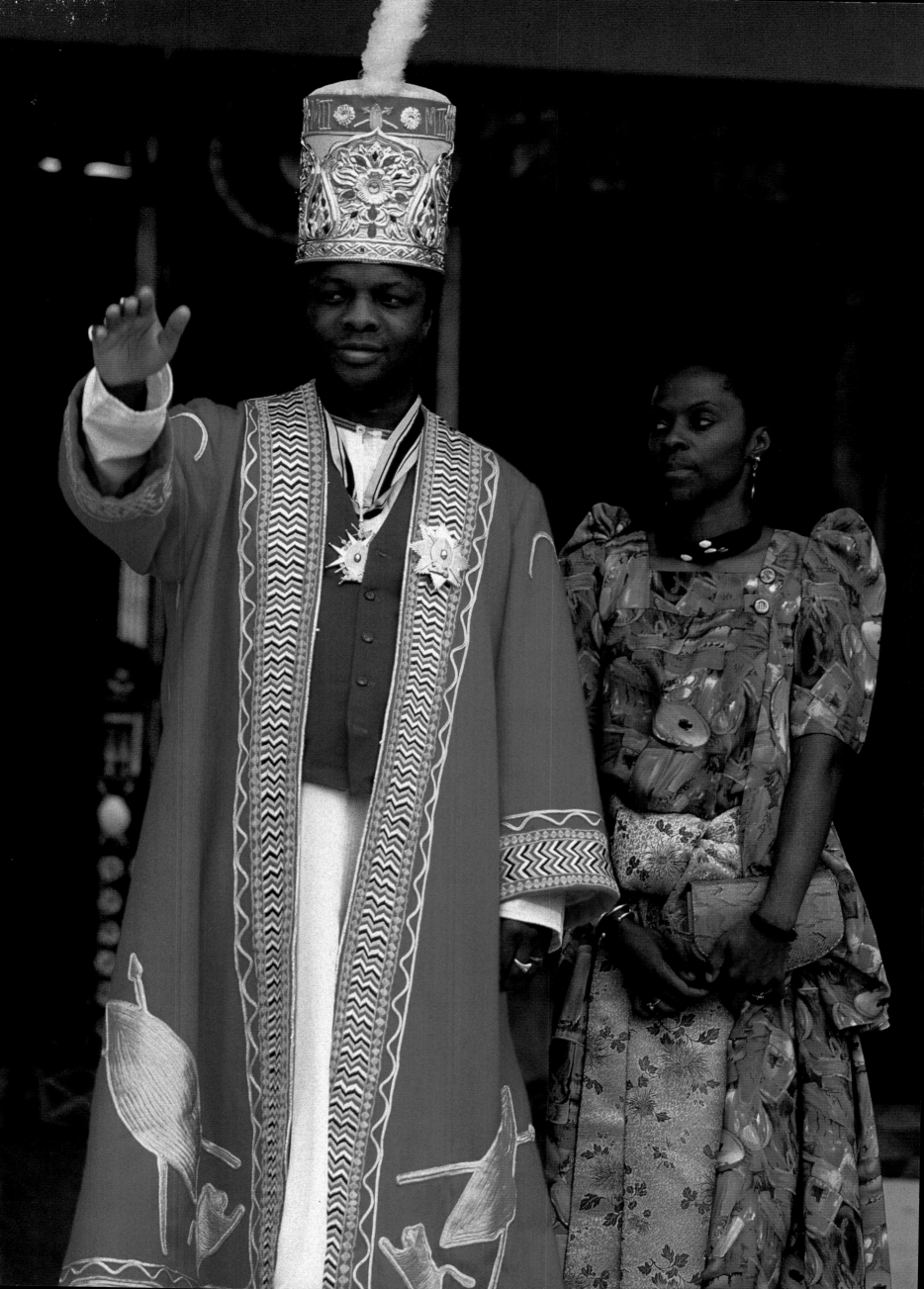

Ashanti Royal Gold

The Ashanti of Ghana, the largest group of Akan-speaking peoples, are believed to have come from the north in the fifteenth century, and by the early eighteenth century had become the most powerful of all the Akan groups, uniting a confederacy of feudal states under one ruler. Since that time, the Ashanti king, known as Asantehene, has ruled from the royal capital of Kumasi together with the Queen Mother, who traditionally participates in the sovereignty with her son.

Throughout its history, the Ashanti nation has gathered enormous wealth through the control of many gold mines, the majority of which belong to the crown. Over generations, the Ashanti developed a thriving economy based on agriculture and the prolific production of gold. Trading with many countries all over the world who had been drawn by tales of the Akan golden riches, Ashanti royalty exported an average of one ton of pure gold every year for almost three centuries. Under the patronage of the Asantehene, Ashanti goldsmiths became famous for their skill in designing exquisite artifacts and jewelry. Among the most precious of these is the celebrated Golden Stool, symbolic of the king's power and of the unity of his people. It is an object so sacred that it can be seen in public only four times in each century.

The golden heritage of the Ashanti kingdom was never more magnificently displayed than at the Silver Jubilee of King Otumfuo Opoku Ware II, in August 1995 in Kumasi. In the presence of some 75,000 loyal subjects and international guests, the Asantehene, his royal court, including his Chief Sword Bearer, and numerous paramount chiefs of Ghana displayed the most extravagant collection of golden regalia to be seen anywhere in the world. Culminating a year-long celebration in honor of the monarch's twenty-five-year reign, the royal procession lasted for more than eight hours as hundreds of dignitaries filed into a huge arena, symbolically reaffirming the wealth, power and solidarity of the Ashanti nation.

Above: The Golden Stool, said to have been "brought from the sky" by the legendary priest, Okomfo Anokye, in the eighteenth century, is the most precious icon of the Ashanti royal court. It is believed to represent the soul of the Ashanti nation. It is so precious that not even the monarch may sit on it.
Right: A paramount chief wears gold jewelry decorated with a stylized moon and star motif reflecting a proverb, "The evening star, desirous to being married, always stays close to the moon" – that signifies fidelity to the king. *Following pages*: King Otumfuo Opoku Ware II arrives at his jubilee celebration in a sumptuous palanquin under twirling umbrellas, surrounded by 150 chiefs and bearers.

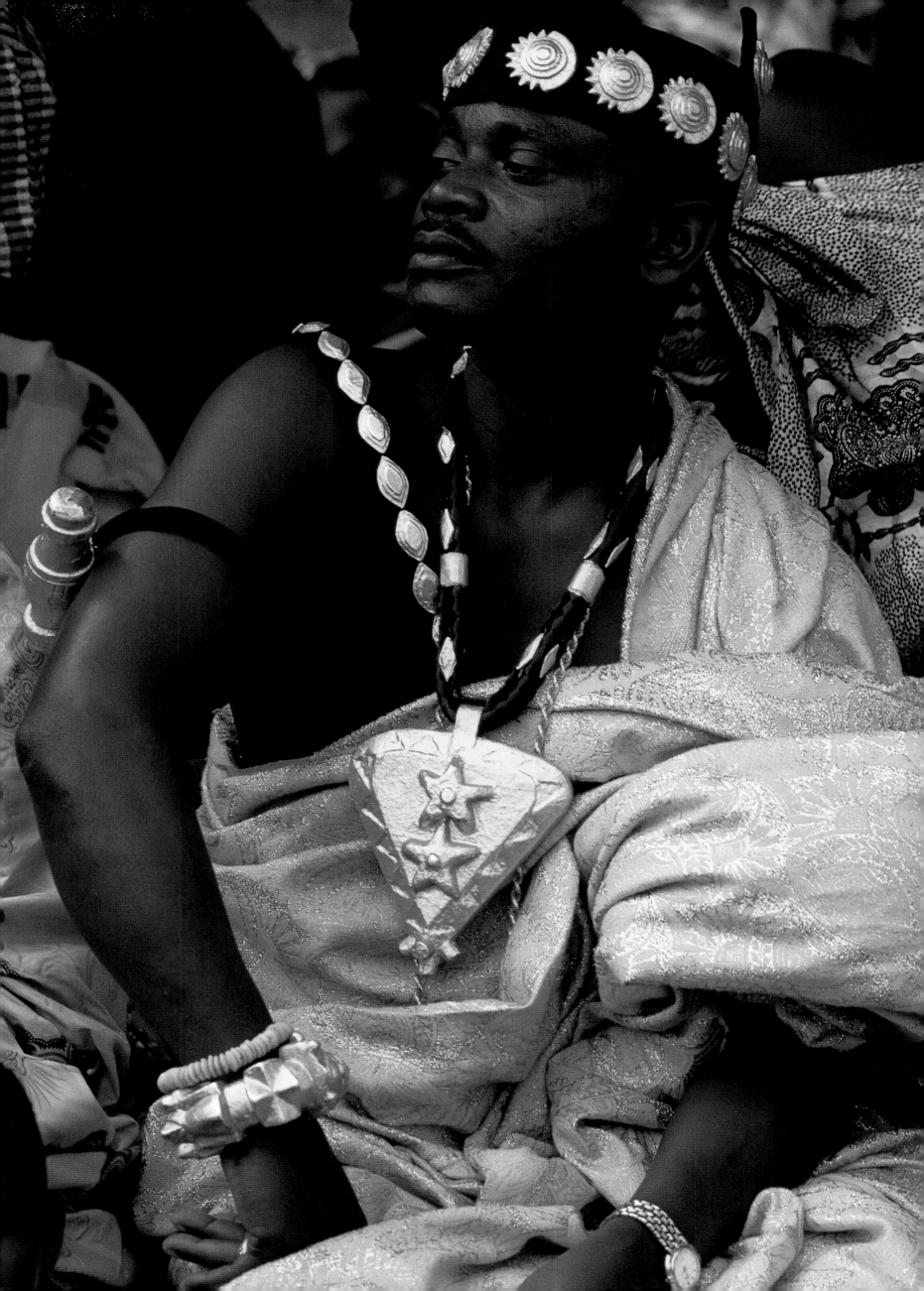

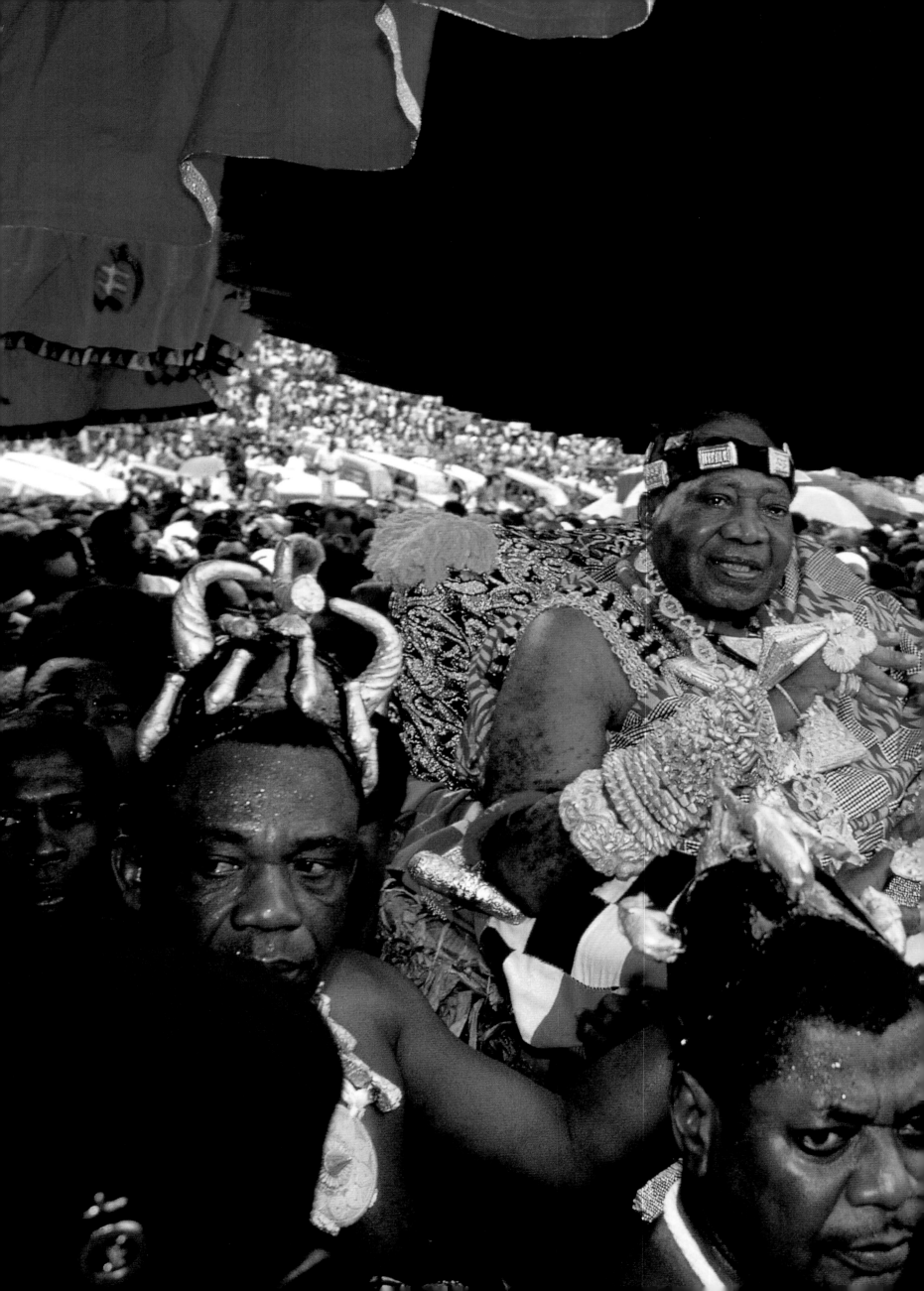

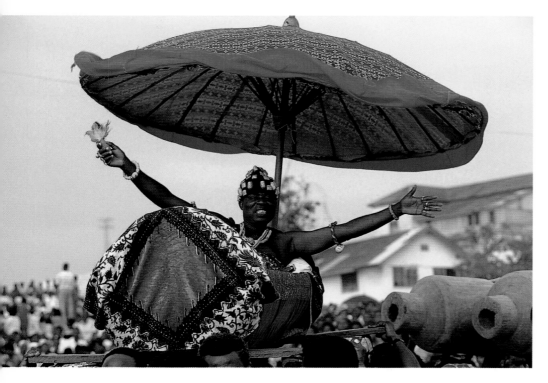

The Royal Procession

The most honored guest at the jubilee is the Queen Mother, Nana Afua Kobi (*below*), who arrives surrounded by fan bearers. Known as Asantehemaa, she is regarded as the true mother of the nation, the most powerful woman in its matrilineal society, and the one who is responsible for the selection of the king.

Right: Safeguarding his chief, a young boy, known as the Soul Bearer, sits in front of the palanquin wearing a gilded ram's-horn headdress and golden amulets. These talismans protect the chief from danger. *Upper left*: A paramount chief greets his subjects from his palanquin. Following him are large wooden *fontomfrom* drums which "speak" of the king's ancestry.

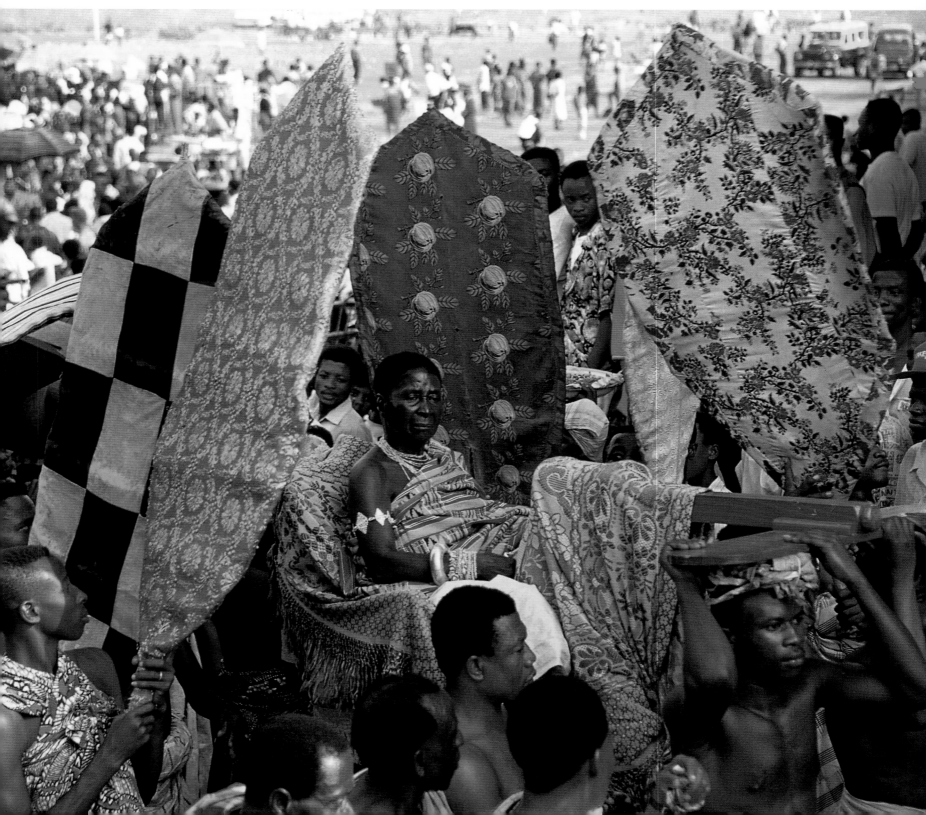

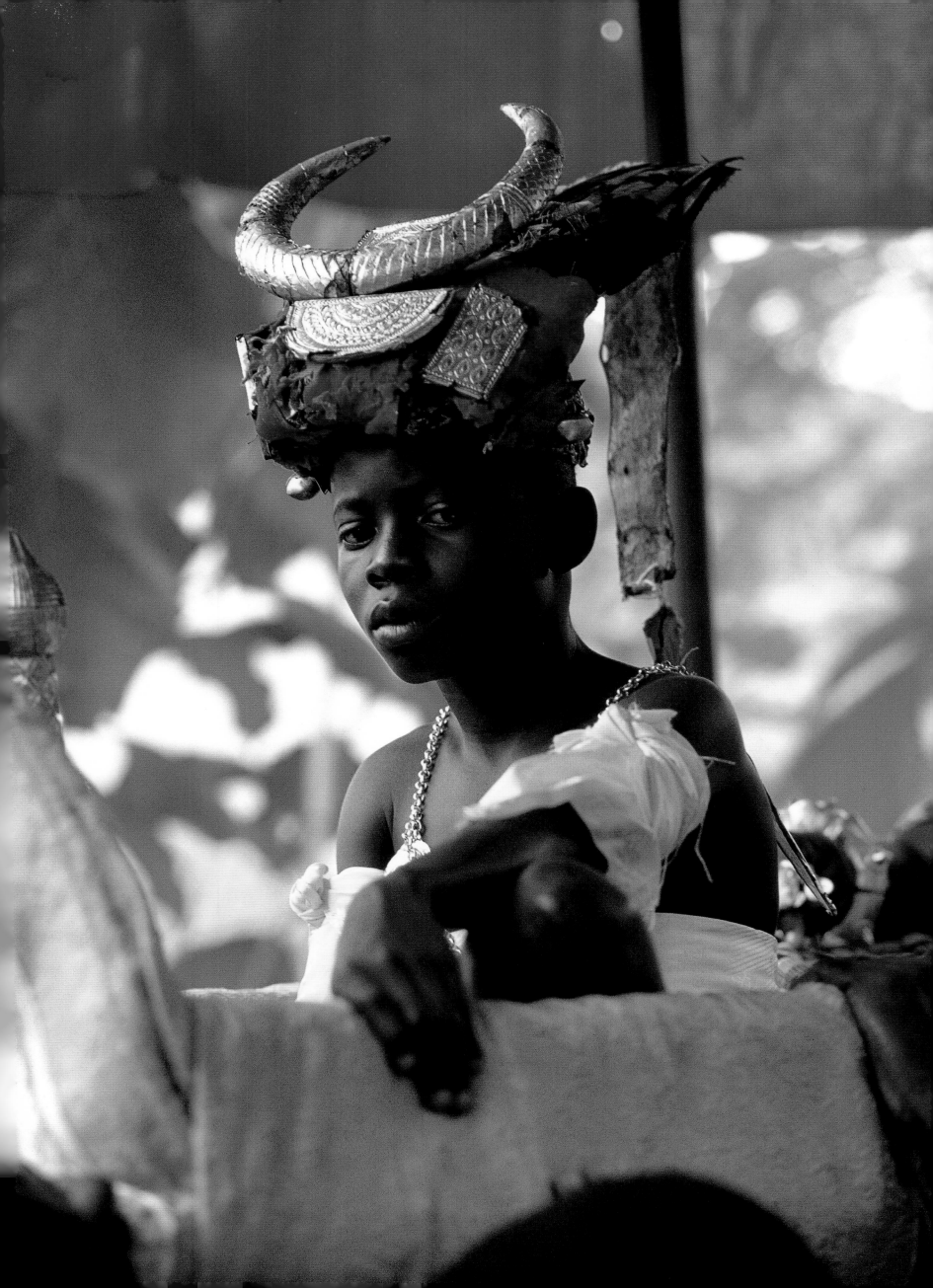

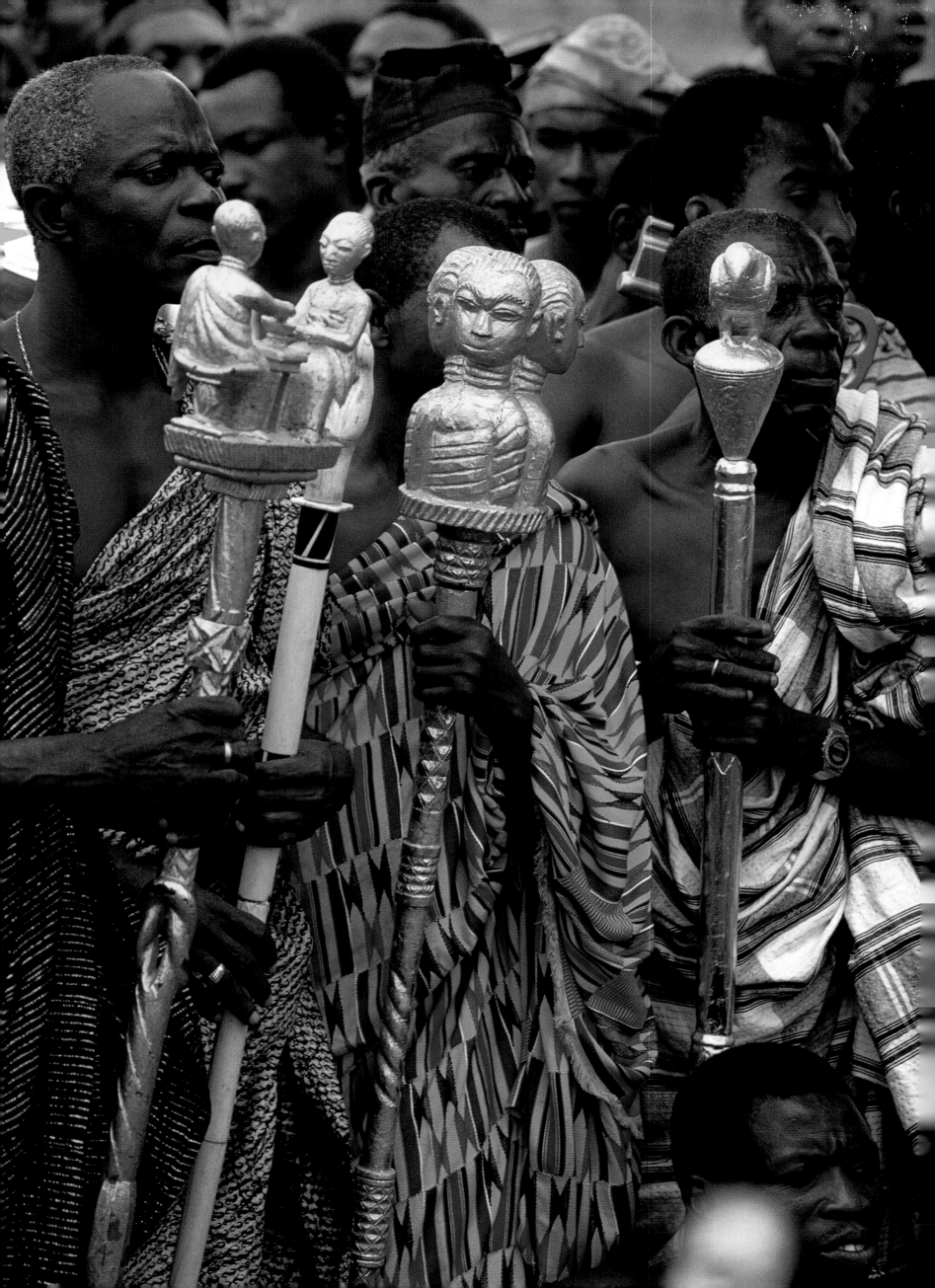

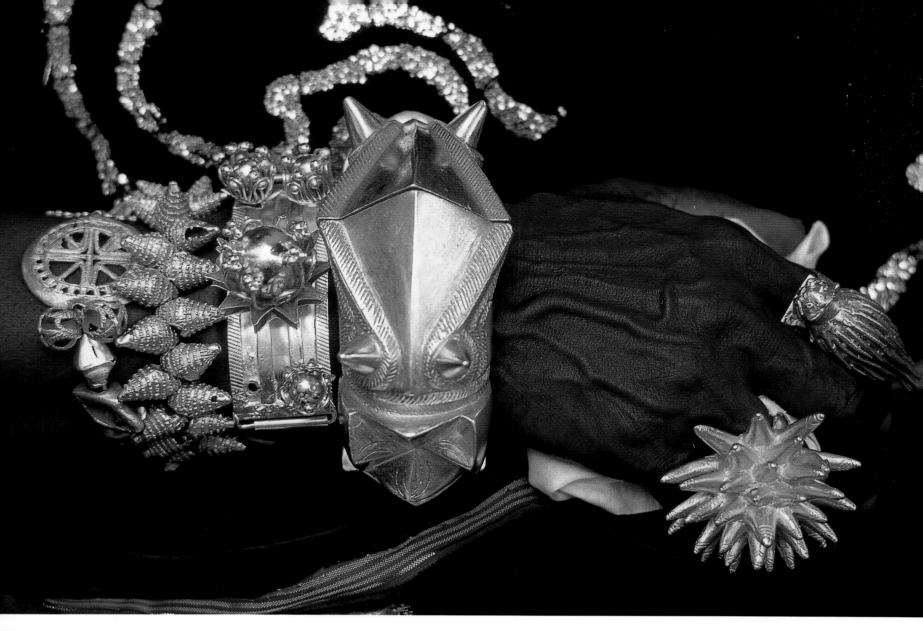

The Splendor of Gold

The display of gold at the Asantehene's jubilee in 1995 was unsurpassed in splendor. The arms of the Asantehene were so heavily laden with gold (*above right*), that when he moved, they had to be supported by a special attendant. Each chief wore gold regalia according to his status. The most senior chief present is always the most sumptuously attired, and it is considered im-proper for a lesser chief to surpass him. Discreet enquiries before the jubilee enabled chiefs to dress appropriately.

Gold is both the sacred and the material heritage of the Ashanti nation and is therefore rich in symbolism. The starburst ring, for example, seen on the hand of a chief (*above*), is named after a delicious fruit and reflects the proverb, "It may not speak, but it breathes," suggesting a leader who is calm but able to exert authority when opposed. The smaller ring features a palm-beetle, a great delicacy that refers to the proverb, "If you don't like the taste of the palm-beetle, console yourself with the thought of its grub" – in other words, patience is a virtue. The large hollow-cast bracelet on the chief's arm features a clasp with two heads, signifying the importance of seeing in more than one direction at once. The mudfish

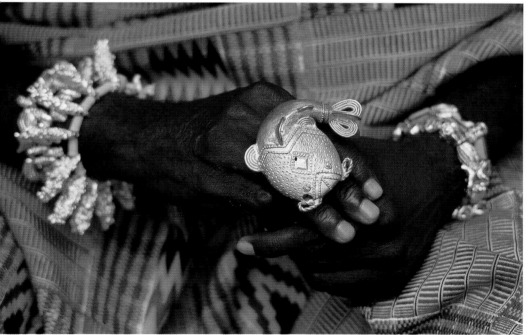

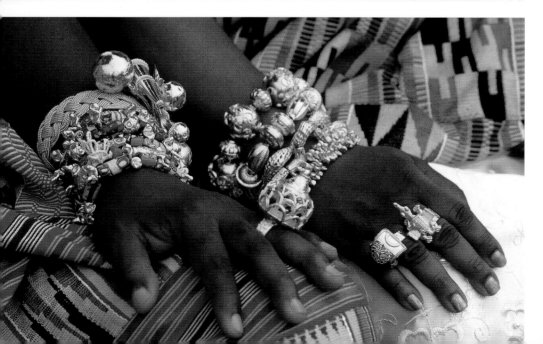

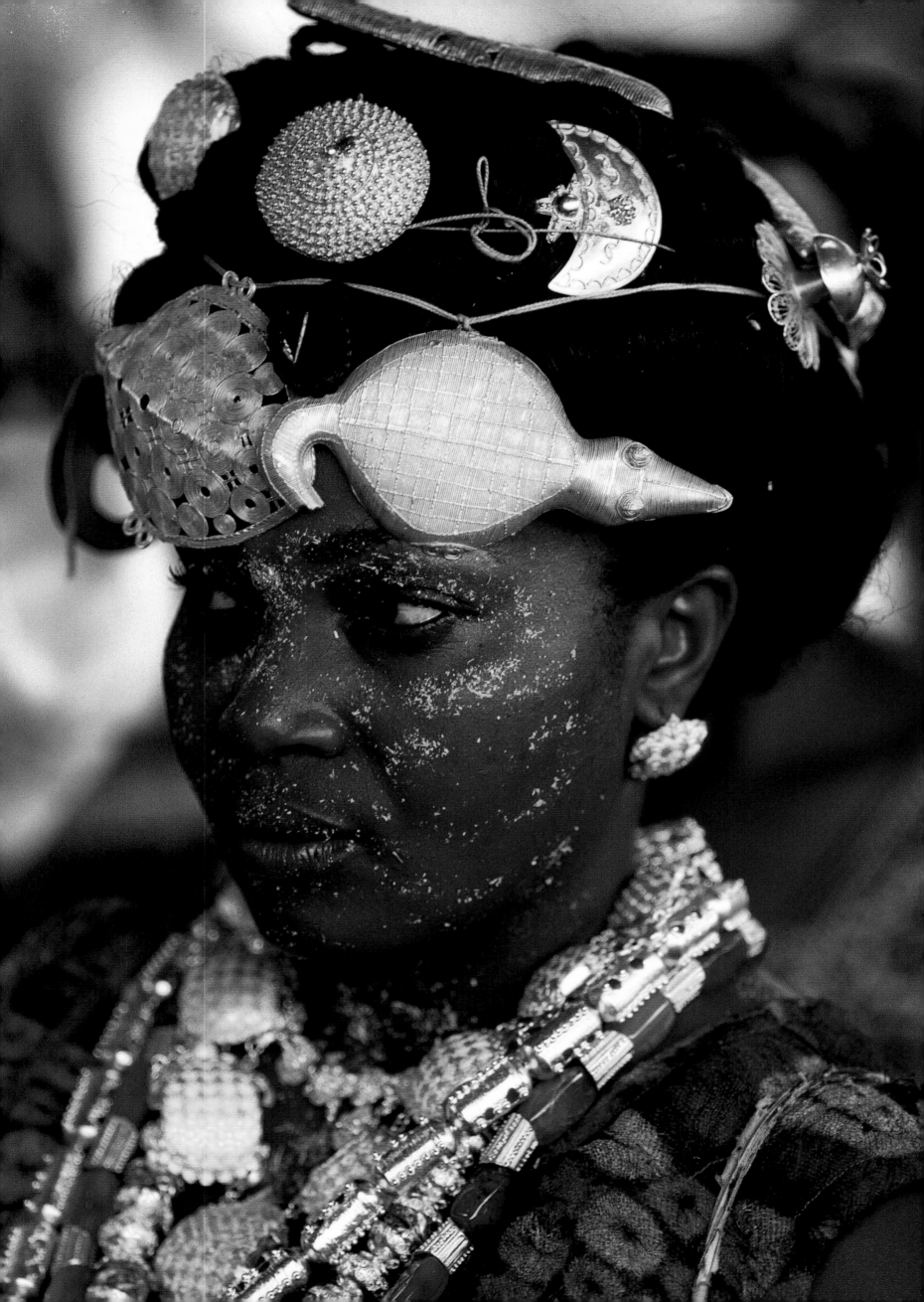

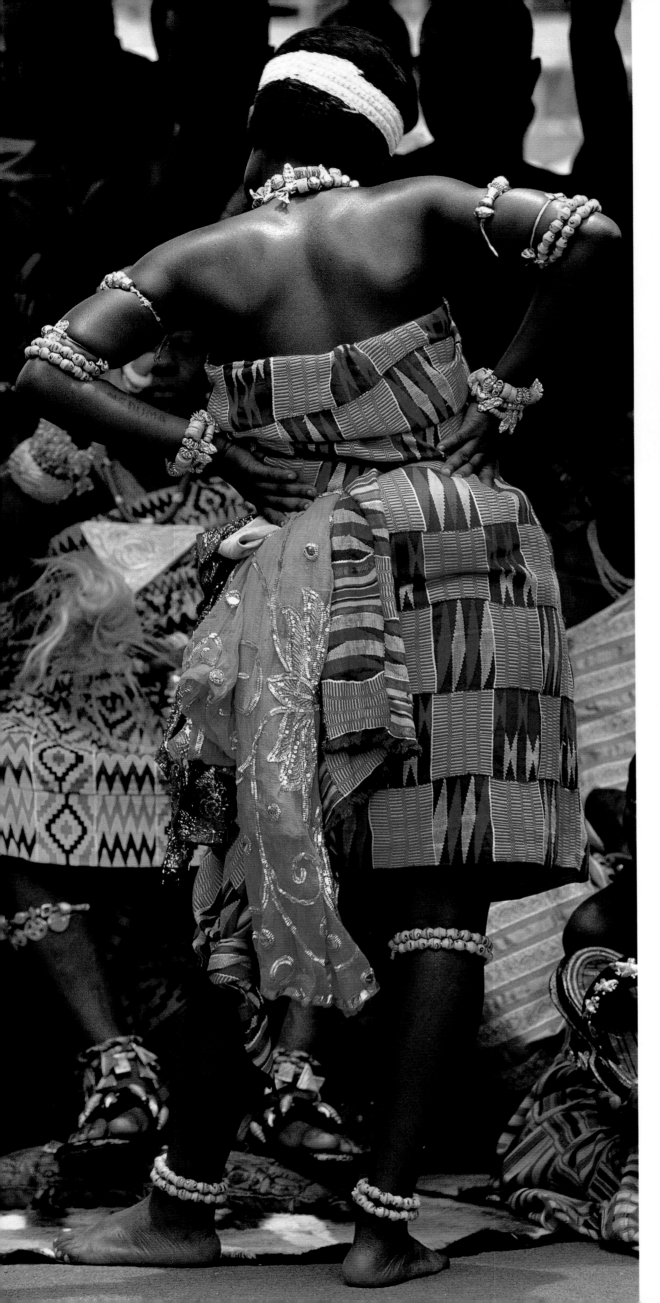

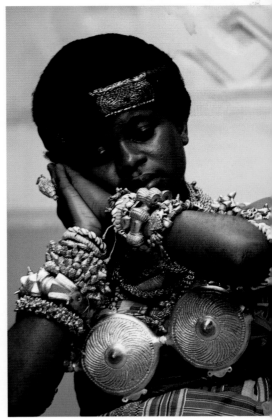

Women of Power

An Adioukrou Queen Mother (*right*) indicates her status by wearing gold turtle and crocodile talismans in her hair. Her jewelry symbolizes her husband's substantial authority and worth. This ostentatious display is known as the "coming of wealth" ritual, and publicly declares that a man has reached an impressive stage in the accumulation of riches. Sprinkled on her face is gold dust, once the main currency of all Akan peoples. *Left and above*: At the king's Silver Jubilee, female court dancers perform the Adowa, a traditional Ashanti dance that delights the royal assembly with provocative movements and complex footwork. Their choreographic vocabulary is used like a spoken language to convey desired messages. Dancers often employ double entendres in which they refer to one thing but really mean another, contributing to the skill and wit of their performance. The young dancer (*above*) is adorned with gold belonging to the royal treasury, among which are large breast-shaped plaques brought out at state ceremonies. Her bracelets are made from hollow-cast gold beads threaded together with ancient glass beads, which are even more valuable than the gold.

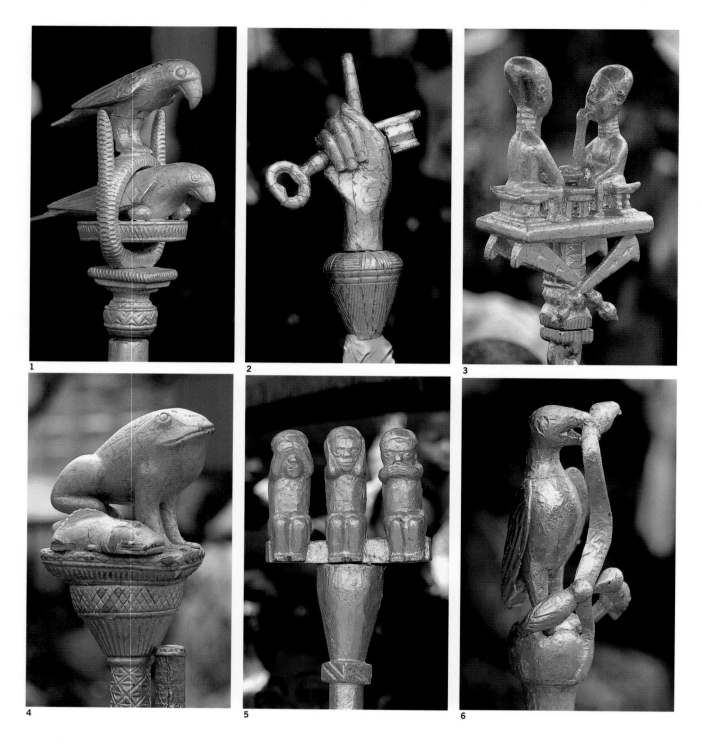

The Linguists' Golden Staffs

Above: Proverbs illustrated on the staffs:

1. "When the kite's away, the hawk sits on its eggs." (In the king's absence the throne is guarded by his kin).
2. "The chief holds the key to the treasury."
3. "Food is for the man who owns it, not for the hungry man." (Work before enjoyment.)
4. "No matter how fat the frog grows, it can never surpass the mudfish." (A chief rules, despite the power of his peers.)
5. "See no evil, hear no evil, speak no evil."
6. "The power of the eagle shows not only in the air, but on land."

Linguists, or Okyeame, act as intermediaries between the leaders and those who wish to address them. They repeat the words of both speakers in highly poetic language, and a chief's fame can depend on their eloquence. The Asantehene has thirteen senior and three junior linguists: most paramount chiefs have between four and eight. The linguists carry a distinctive staff, a symbol of authority, called *okyeame poma*, with carved and gilded finials representing proverbs. Nuggets of traditional wisdom, these proverbs address subjects and situations with cautionary wit.

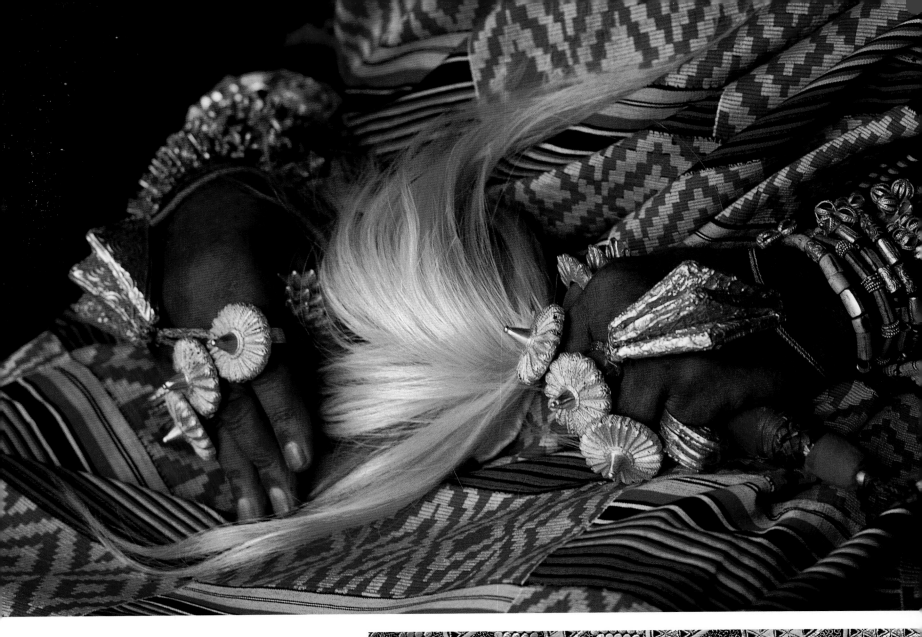

ring (*middle left*) refers to the nourishment and protection offered by a chief to his subjects. The sandals of Akan chiefs (*right*) are covered with protective gold-leaf talismans. Stools beneath the feet protect the chiefs from evil spirits entering their bodies from the ground. Of all the decorations worn, none are so finely made or so beautiful as those of the Asantehene himself (*above*). Every finger of the king is adorned with exquisitely cast gold rings. Over his hands, triangular gilt amulets, containing blessings from the Koran, protect him from harm. The horsetail fly-whisk he holds on his lap has been treated with medicine and charms to guard him from evil.

Following pages: Sitting in state at the jubilee, the Asantehene wears robes made from traditional *kente* cloth. Known as "the cloth that befits kings", *kente* denotes prestige and elicits both respect and humility from all those who understand its symbolism. Accompanying him is the Chief Sword Bearer whose duty is to absorb evil intent directed toward the monarch. The sword Bearer carries a legendary ceremonial sword called Mponponsuo and wears an eagle-feather headdress featuring a pair of gilt ram's horns.

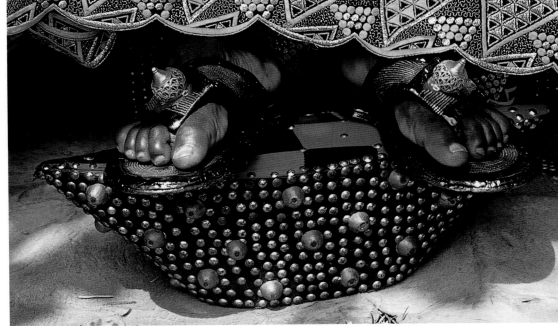

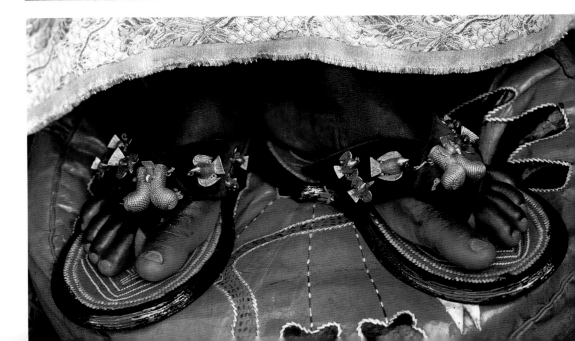

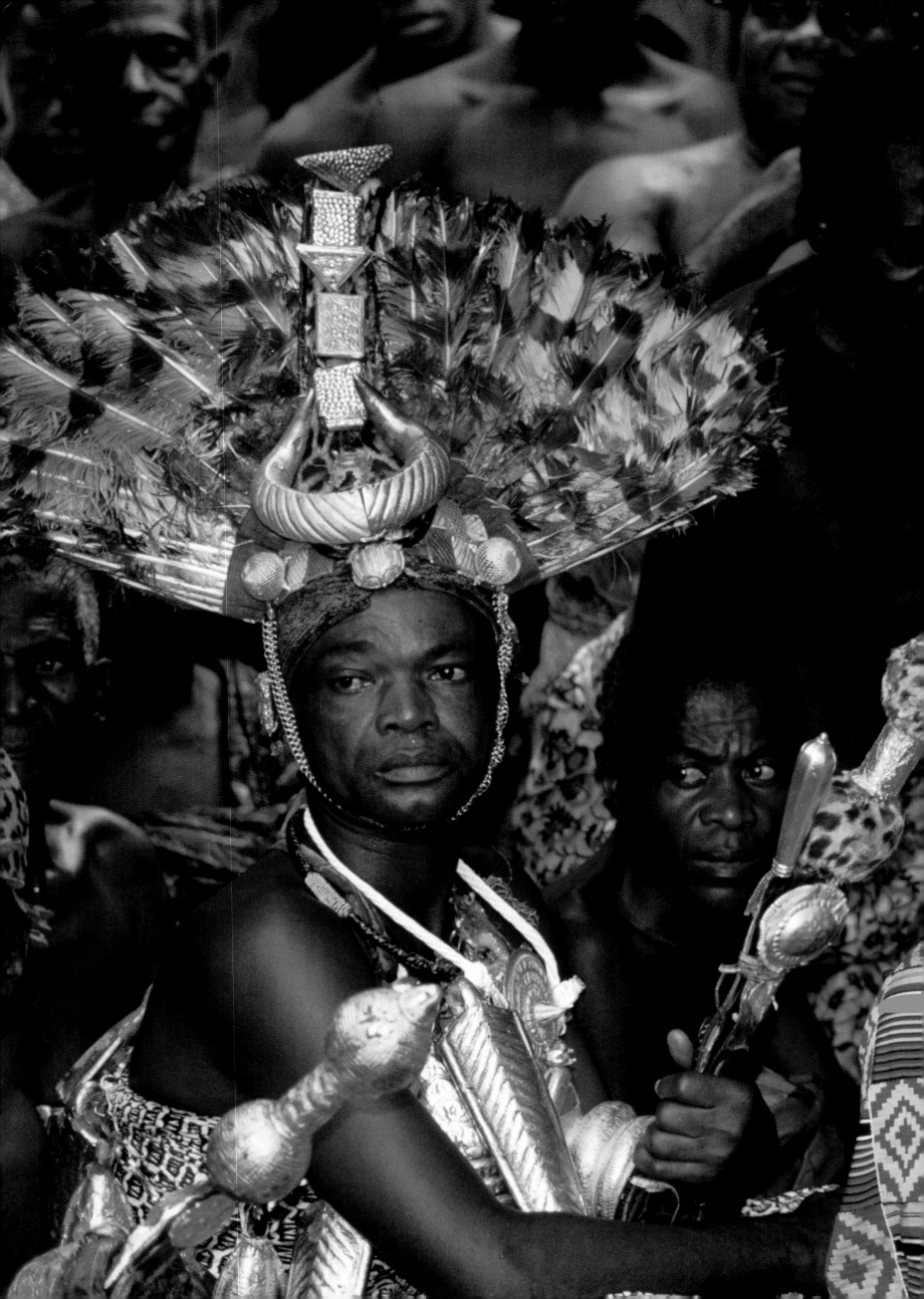

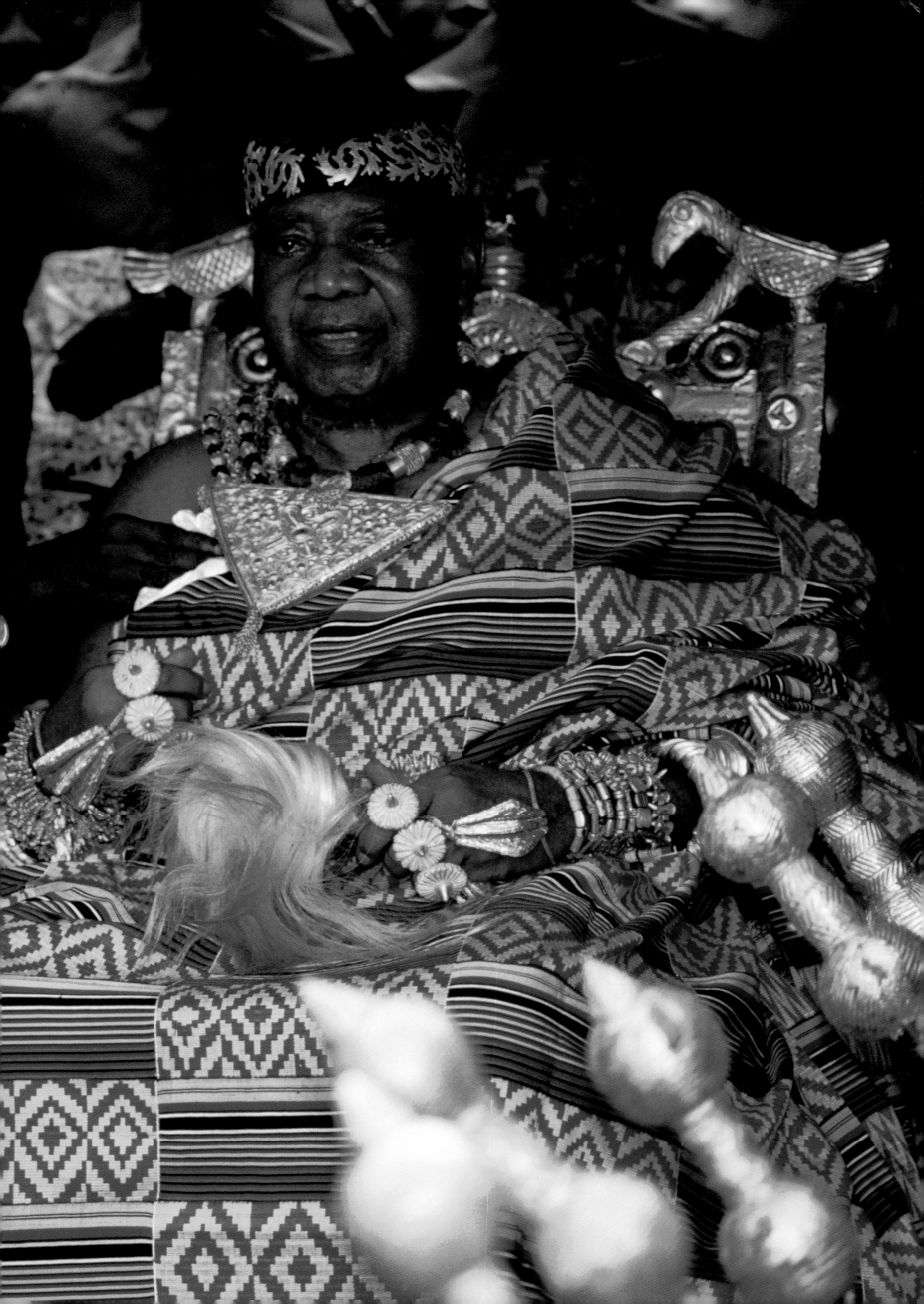

SEASONAL RITES

Peering through the dark desert night in Mali, we could barely make out the shadowy form stumbling toward us. As it drew nearer, we saw a Fulani man, slowly and hesitantly making his way back to camp. Seated around us were several other Fulani herders, reluctant to go out into the night. They were busily stitching medicinal potions into leather talismans with the intensity that marks a ritual practice. These intrepid cattle herders, normally confident to move about on the darkest night, complained that they were now unable to see.

"It's the special grass," said one elder "We are no longer able to find it." He went on to explain that the grass allowed his cattle to see at night, preventing them from stumbling into gullies and ravines as they grazed. "Without this grass, our people also stumble about in the darkness," he said, "so now we must gather sacred ingredients for the talisman, and put them around the necks of the animals to restore our vision."

A few weeks later in Bamako, the capital of Mali, we learned from a veterinarian friend, that the elder had been speaking about djenne grass, which is high in vitamin A and quickly becomes scarce in the long dry season. When the cattle cannot find the grass containing this nutrient, the resulting deficiency causes temporary night blindness—not only in the herds, but also in the herders, whose diet consists mainly of milk. The leather talismans the Fulani men had been stitching together served as supplications to the nature spirits and ancestors, asking for the rains that would produce the grasses so essential to their survival. Through centuries of desert living, the Fulani have understood the delicate balance of the seasons and the necessity to follow rituals that maintain the natural equilibrium.

MAN AND NATURE

Traditional African societies rely on an intimate understanding of the seasonal cycle for their survival. How people handle the passing seasons in savanna, desert, equatorial forest, and mountainous terrain can spell the difference between life and death. This is true for both agricultural people and nomadic pastoralists. Occasionally, droughts, floods, and other natural cataclysms completely destroy the balance between humans and their environment. However, it is widely believed that disaster can be avoided through the application of traditional knowledge and the practice of seasonal ritual.

Across Africa, seasonal rites are a time-honored means by which people seek the protection of the spirit world. These rituals solicit the blessings of nature, ancestor spirits, and the creator god in preparation for planting, harvest, pastoral migrations, and the hunt. In many cultures, it is believed that the spirits of nature—storm gods, water gods, and Mother Earth—must be appeased before any of these activities can successfully take place. Seasonal ceremonies not only help to ensure man's survival in the face of natural adversity but express his joy in the successful passing of each phase of the year.

RECIPROCITY

Whether an African is digging yams out of the ground or hunting an animal, he believes in reciprocity between himself and the natural world: whatever is taken must be accounted for, and something must be offered in return. Most African peoples experience a profound interdependency between their lives and the forces of nature and believe that the natural world merges inextricably with their own. They perceive a twinned uni-

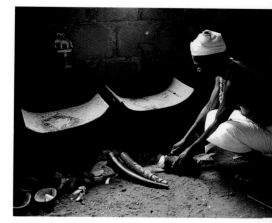

verse filled with mysterious and powerful spirits, where the trees, earth, and rivers must be respected at all times. In many societies, it is believed that man actually originated from the land itself—that the common mother or father of the clan or lineage rose out of the earth and went on to give birth to the people. Others believe that they sprang from animal ancestors and that all the animals and their affiliated spirits in the forest are related in some way and must be respect-

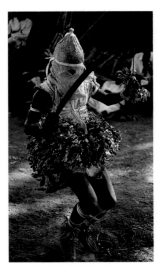

ed as equals (or even superiors). Africans recognize that through civilization human beings have lost touch with their innate wisdom of their natural origins. As a result, they often act blindly, upsetting the cosmic equilibrium through misdeeds that are sometimes unintentional.

At designated times of the year across Africa, a variety of rites are held to ensure the continuing reproduction of animals, the discovery of abundant hunting and fishing grounds, and the successful planting and harvesting of crops. These rites are offered to obtain blessings for fertility, multiplication, and growth. The Bedik of Senegal hold an annual festival in May during which they summon masked nature spirits from the sacred forest to determine when it will be auspicious to begin the year's cultivation. During their visit, the spirits also resolve problems within the community, and when all is at peace, they depart, bestowing their blessings on the land and signaling that planting may begin.

Rituals are particularly necessary when a taboo has been broken. The Fante people of Ghana, for example, never till the soil on a Friday, because to do so would bring great misfortune on the community. The Ewe people of Togo share with many other agricultural peoples a taboo concerning "first fruits". They consider it highly disrespectful to the gods that anyone should taste a yam from a current harvest before it is ritually offered at the village shrine. In South Africa, the Basuto say that the chief should eat the first ripe gourd. Tasting it as the representative of the ancestors, he proclaims, "I offer you the first grains of

the New Year that you may eat and be happy. Eat all of you, I deprive none among you. What remains on the ground belongs to me and your little ones." In the kingdom of Swaziland, the highlight of the Incwala First Fruit ceremony is the "throwing of the gourd" ritual. At its climax, the king, empowered by medicines, is the only person considered strong enough to sample the new crop; he tosses a green gourd to his warriors, who catch it with a shield before it touches the ground. This indicates that any taboo concerning a first eating of the crop has been lifted.

SEASONAL MIGRATION

The seasonal rituals practiced by pastoralist societies like the Dinka of Sudan, the Hamar and Geleb of Ethiopia, and the Fulani of Mali focus on the survival of their herds of cattle. For these cultures, animals represent not only currency, wealth, and bride-price but also a people's vital link to the spirit world. Animals provide milk as daily sustenance, hides for clothing and meat for sacrifice and feasting at ceremonial times. With sufficient pasture and water, a herd can furnish the essentials of life. Providing these resources, however, is not an easy task in the hostile environ-

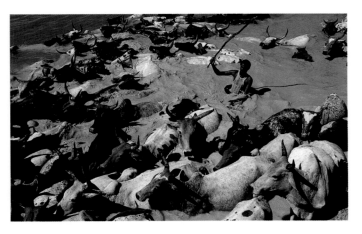

ments that pastoral peoples often inhabit. Moving the locations of their camps in response to the changing seasons is crucial to a community's survival, and numerous rituals and celebrations attend these periodic migrations.

Between November and April every year, the Dinka in southern Sudan move their vast herds to dry-season cattle camps to take advantage of the rich grasslands on either side of the river Nile—an area of impassable swamp during the rest of the year. At these camps, where countless herds of cattle with majestic lyre-shaped horns stretch as far as the eye can see,

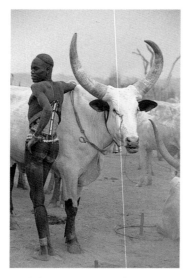

young Dinka men and women spend their time surrounded by their beasts, living in perfect communion with them. The Dinka believe that, in addition to providing their prime sustenance, cattle are their only access to the spirit world. This powerful connection between the Dinka and their animals finds explanation in one of their origin myths. Long ago, according to legend, the first warriors went hunting and killed the mother of both the first buffalo and the first cow. The animals vowed to take revenge on their murderers, but they chose to fight back in different ways. The buffalo decided to roam the forest and the plain and attack people whenever he saw them. The cow, however, acted more subtly. She allowed herself to be caught and domesticated and in time made humans dependent on her. Thus, the Dinka became obliged to satisfy her needs and even to give their lives for her.

During one dry season in 1981, in southern Sudan, we traveled for miles through twelve-foot-high elephant grass to visit a Dinka seasonal cattle camp. We watched Akol, a young herder, groom his prize bull, composing poetry and singing to it as a mark of affection. Akol was named after this dark brown ox which he had received at puberty and which he considered his twin. To show his devotion, he had decorated his own temples with ritual scars in the shape of the horns of his namesake ox. While courting young girls, he always took his ox with him and sang tenderly about his animal to the girl he loved in the manner of this classical poem (translated by Francis Mading Deng):

> Rising Beauty, Rising Beauty,
> Born by the king of the wilds. . . .
> I sing of an ox with a dark brown body,
> His horns have grown as long as the thorn of
> a peth [thorn tree]. . .
> Gingerly, he places his feet like a girl wearing
> coils on her legs.

We were moved by the poignant rituals between the Dinka and their animals in the cattle camps and appreciated that these practices had been at the heart of their survival for thousands of years.

CELEBRATING THE SEASONS

In 1994 we had the good fortune to experience one of the largest and most joyous annual celebrations in West Africa—the Fulani cattle crossings of the Niger River. Traveling in a pirogue along the river and its tributaries, we observed the Fulani gathering their vast herds from their dry-season camps in preparation for making the dramatic and dangerous crossing of the river. Over the course of ten days, we watched thousands of animals swim across the mile-wide river, driven and prodded by the herders, returning to their homes in the swampy grasslands of the interior Niger delta. Reunited with their families and girlfriends after a six-month separation, the herders celebrated the survival of their animals following the long and arduous dry-season search for pasture. Masked dancers and singers from local fishing communities gathered on the shore to entertain the herders. Family members and elders showered the successful herdsmen with gifts and praise. Adorned with gold earrings and amber beads, young Fulani girls enticed the young men to join them in courtship dances that continued late into the night.

Similarly joyful celebrations occur among the Omo River peoples at the end of the dry season, marking a more relaxed time when pasturelands nearer home turn green again. The Hamar and their neighbors, the Geleb and Karo, hold seasonal dances during which the men court the young girls. While dancing, the men hold their arms aloft in the shape of cattle horns and wear tassels on their elbows to imitate those worn by their animals. In addition, the Karo men paint themselves in a variety of imaginative designs, some

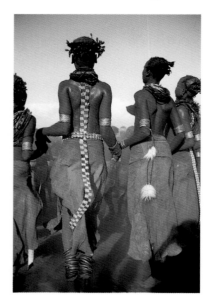

inspired by the spotted plumage of the guinea fowl—a striking and effective way of attracting the female eye.

Among settled peoples who farm the land, the Kassena of Ghana celebrate the end of the harvest by painting their houses with imaginative designs—a way of giving thanks to the nature spirits and ancestors for their success. The designs used in the house paintings are inspired by the natural world; the long horizontal band along the top of a wall echoes the rows in a cultivated field and symbolizes fruitfulness and continuity. With sufficient food in hand, the Kassena can now make preparations for the seasonal ceremonies of initi-

ation and marriage. The Ndebele of South Africa also paint their houses prior to the ceremonial season. Some of their designs are inspired by natural themes such as trees, plants, and flowers. Others depict modern motifs—razor blades, light bulbs, and airplanes, to which the Ndebele have been exposed in the cities and which they have inventively incorporated into their traditional mural paintings.

HONORING THE SPIRITS OF NATURE

In many African cultures, the use of masks and masquerades dramatizes the ways in which the seasons and the natural order are honored. During these vibrant rituals, spirits representing the forces of nature enter the masks to bring them to life. Crafted largely from wood, leafy branches, and raffia fiber, these nature masks were originally used in early agricultural purification rituals. They evolved from the belief that nature is essentially benevolent and that farming is an offense against this goodness. Despite their efforts to atone for this transgression, early agriculturists believed that on their own they could not be saved from punishment, so they created the first society of masks, whose task was to purify the earth and all those who had defiled it. With time, the masks assumed a broader role and introduced the power of the spirit world into other aspects of life, including initiations, funerals, and other community rituals.

The Zangbeto masks of the Fon people of Benin,

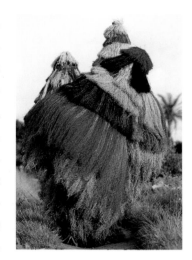

for example, appear in the villages to chase all menacing beings from the night. The Fon believe that masks are a symbol of protection, balance, and justice. When they appear in the community, their explosive character reminds the villagers of the power that inhabited the earth before human beings and which remains the source of wisdom and continuity.

Another agricultural group, the Bobo of Burkina Faso, holds dramatic masquerade rituals to ask permission from the nature spirits to plant and harvest their crops. The Bobo believe that every act that takes something from nature, whether it is the cutting of a tree or the gathering of fruit, has an negative impact. Permission for these acts must therefore, be gained through ritual. The Bobo masks bring bush spirits such as the owl, chameleon, bush cow, and serpent to help chase evil from the community, thus purifying it for a successful planting or harvesting season. The Bobo believe that if they did not hold these ceremonies, drought would strike their crops or a terrible plague would descend on their communities.

Among the Yoruba of Benin and Nigeria, it is believed that women have a dual spiritual force, or *ase* that can make them either mothers or sorcerers. During the masquerade of the Gelede society, held every year before the rains, this force is transmuted into its positive form. Through a series of ritual activities, both entertaining and educational, Gelede masks evoke the beneficent image of the role of women.

Linked closely to the earth for their survival, whether as herders or farmers, rural African communities keep vividly alive the age-old rituals that mediate between themselves and the forces of nature. Although they clearly understand that the elements cannot be fully controlled, they exert devoted energy to the ceremonies and rites that pay respect to higher powers and the spirit world. Conducted wholeheartedly, with joy and reverence, these seasonal rituals illuminate the African year.

Dinka Cattle Camp

The Dinka live on the vast plains of southern Sudan, around the perimeter of the world's largest area of swampland, known as the Sudd. They are isolated not only from the Western world but also from the rest of Africa. Composed of twenty or more tribal groups with a population of three to four million, they share a common language and a culture built around cattle herding. During the dry season, from November to April, the Dinka take their herds from permanent settlements on the higher savanna down to the swamplands. There they set up cattle camps called *wut* next to the tributaries of the River Nile, an area that continues to support grazing when all other pasture is parched. Today, the lives of the Dinka have been devastated by wars between southern Sudan and the Islamic north of the country.

Of all African tribes, the Dinka are the most devoted to their cattle—living, eating, and sleeping with their large herds. Dinka herdsmen lavish endless care and attention on their animals, which they consider part of the family: male youths are even named after favored oxen, in the hope that they will mature with the same strength and beauty. Source of their wealth, dowries, and food, cattle are their inspiration for living, and also provide the Dinka with a link to the spiritual world.

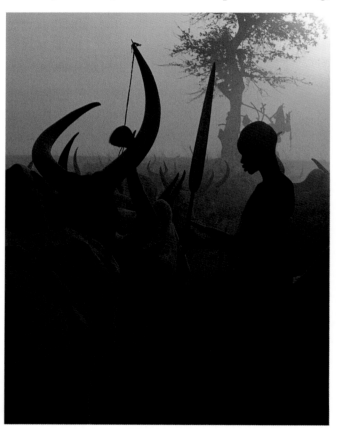

Dinka dry-season cattle camps are run mainly by the young men and girls, older people having been left behind in the highlands. During this favorite, leisurely time of the year, young people are surrounded by their animals and enjoy a convivial social life. A young man makes a special point of visiting his girlfriend accompanied by his namesake ox, and he will sing songs extolling the virtues both of the magnificent beast and the beautiful girl he is courting. Traditionally, dry-season cattle camps not only provide essential grazing for the animals but also many opportunities for the making of marriages.

Right: Dinka herders in traditional beaded corsets walk among their cattle in a dry-season camp.
Above: In the golden light of early evening, a herdsman stands proudly by his namesake ox.
Following pages: The distinctive long horns of Dinka cattle are trimmed by herdsmen and trained to curve in different ways, making it easier to identify them.

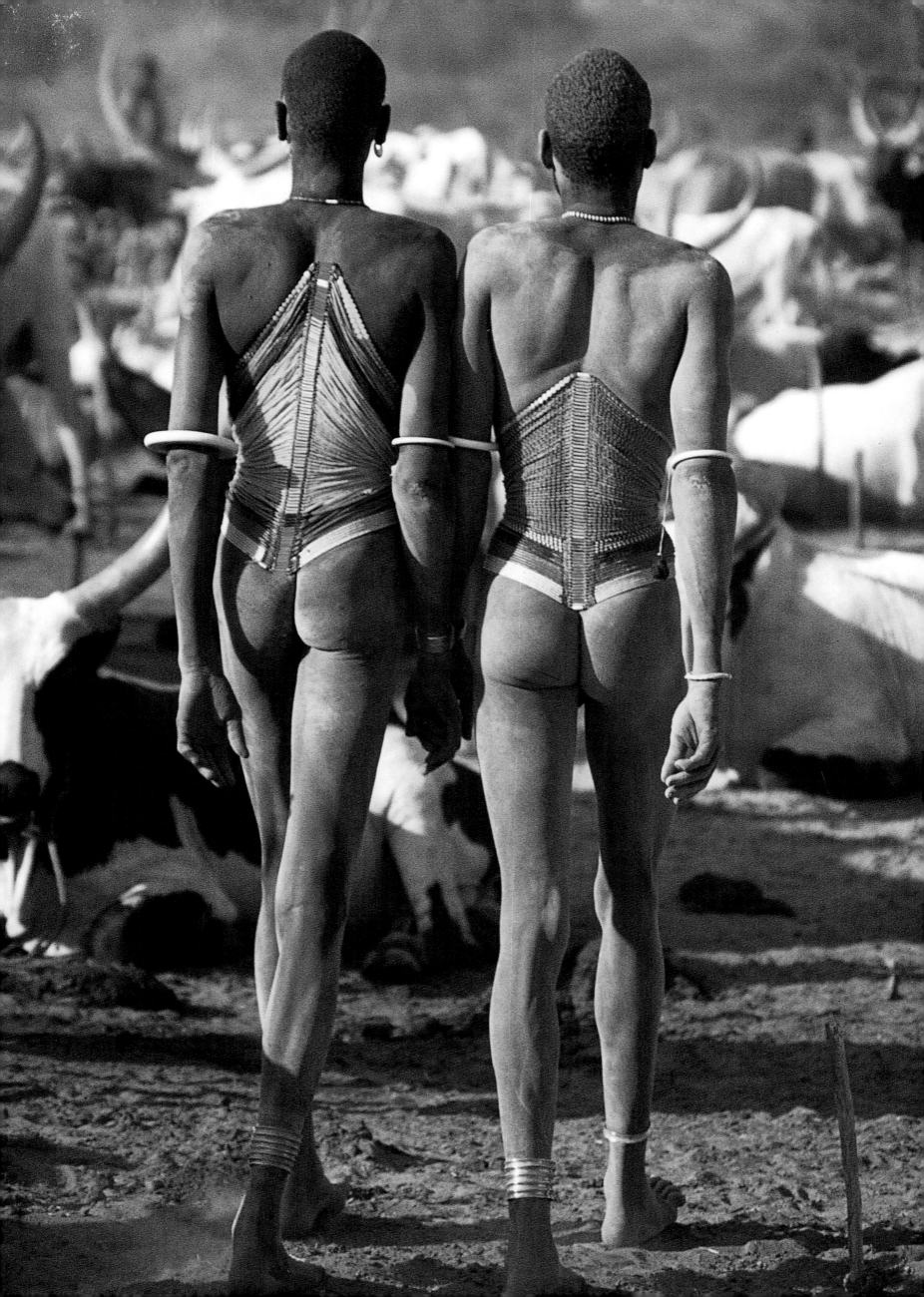

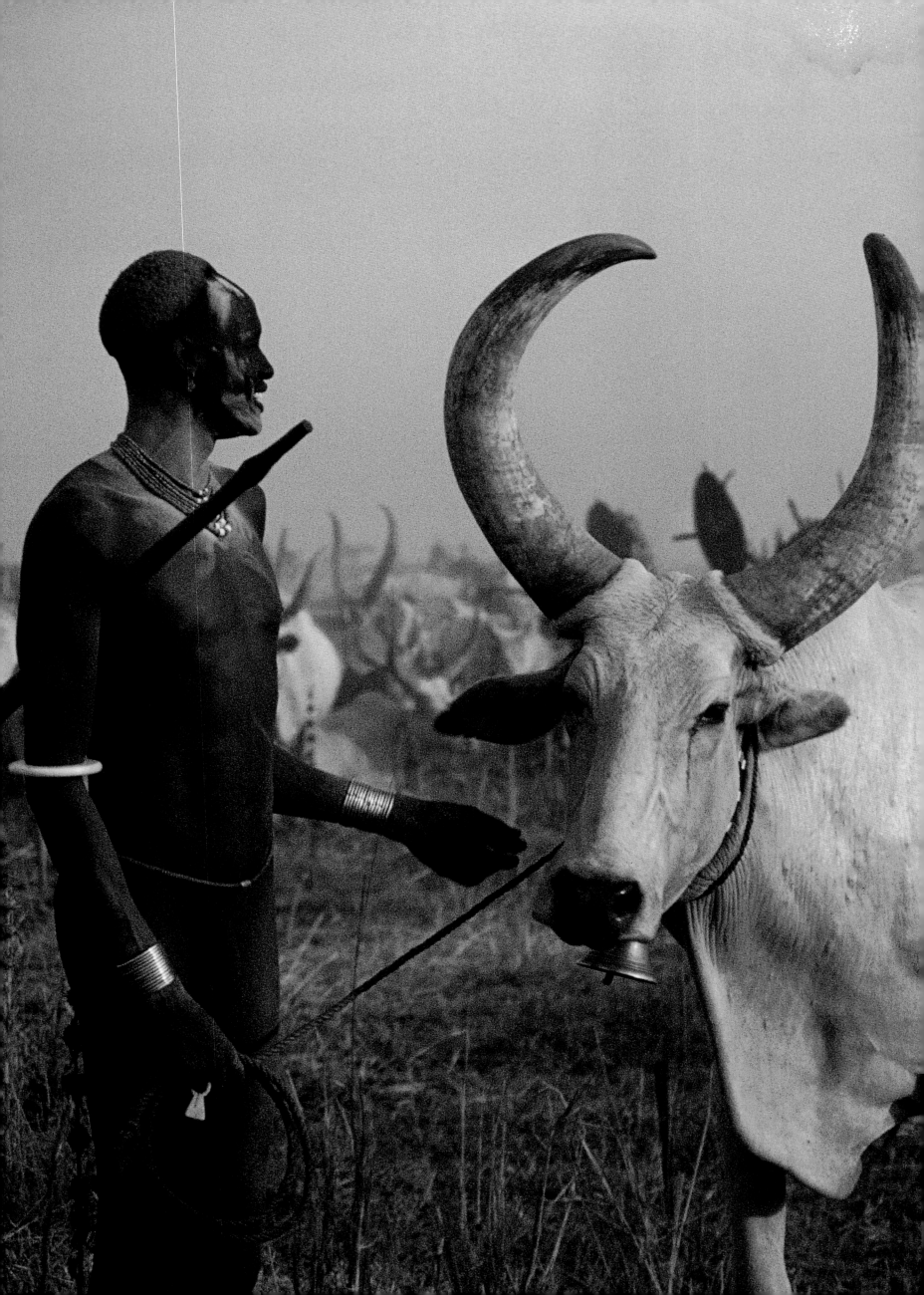

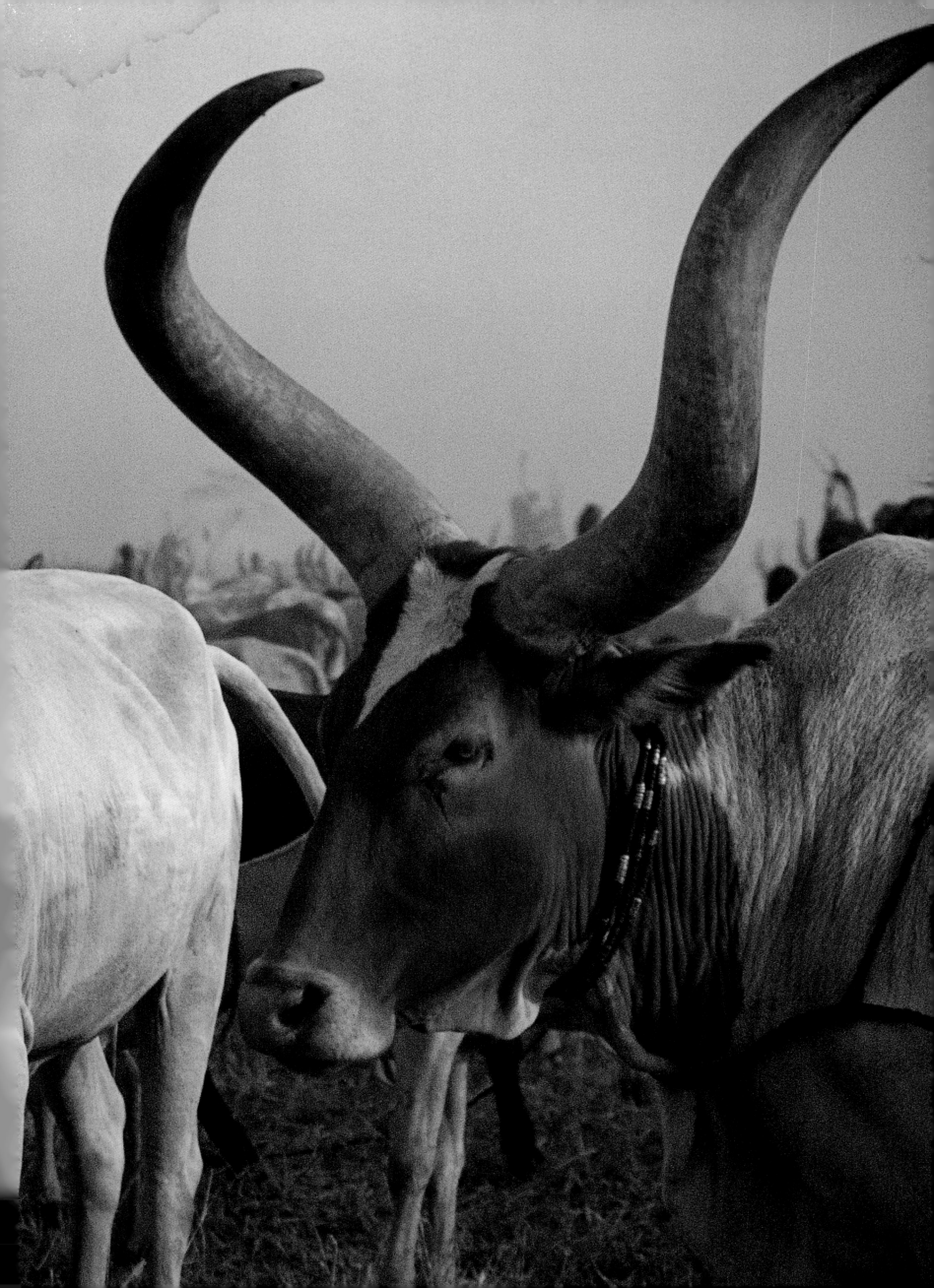

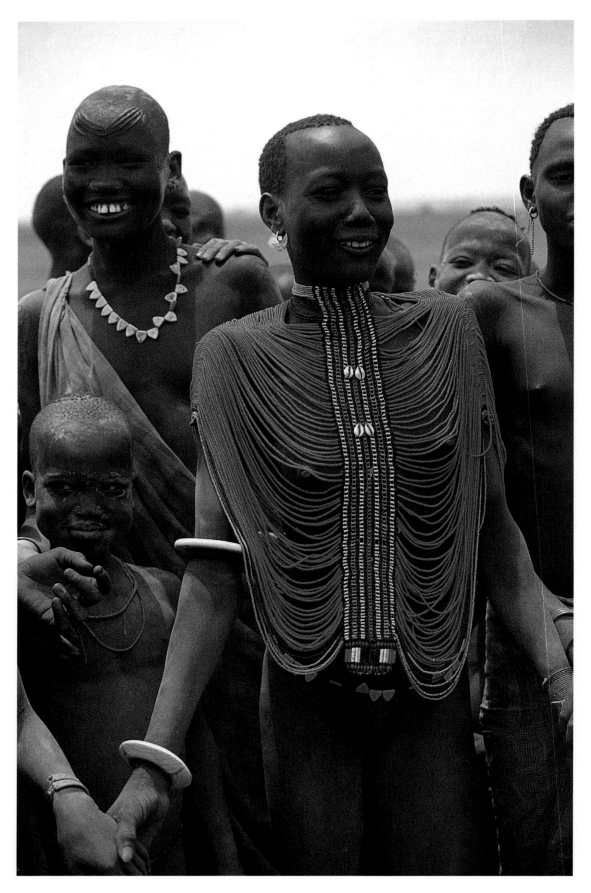

The Courting Season

At the Dinka cattle camps, young people seek their prospective partners. The young woman (*above*) wears a beaded bodice to signify her eligibility for marriage. The bead patterns on the front indicate that her family will demand many head of cattle for her hand. *Right*: Ready for marriage, this Dinka man has dusted his body with ash and adorned himself with seventeenth-century Venetian beads, each strand worth one cow. His seven-foot frame evokes the appearance of his ancestors, whom early European explorers referred to as "ghostly giants". *Following pages*: The beaded corsets worn by Dinka men indicate their age and wealth. Sewn on at puberty, they are changed when the wearer reachees a new age grade. Red and blue corsets indicate a man between fifteen and twenty-five years of age; yellow and blue mark a man over thirty and ready for marriage, after which the corset is removed altogether. The height of the beaded wire projections of the corsets worn by this couple indicate their families' wealth in cattle.

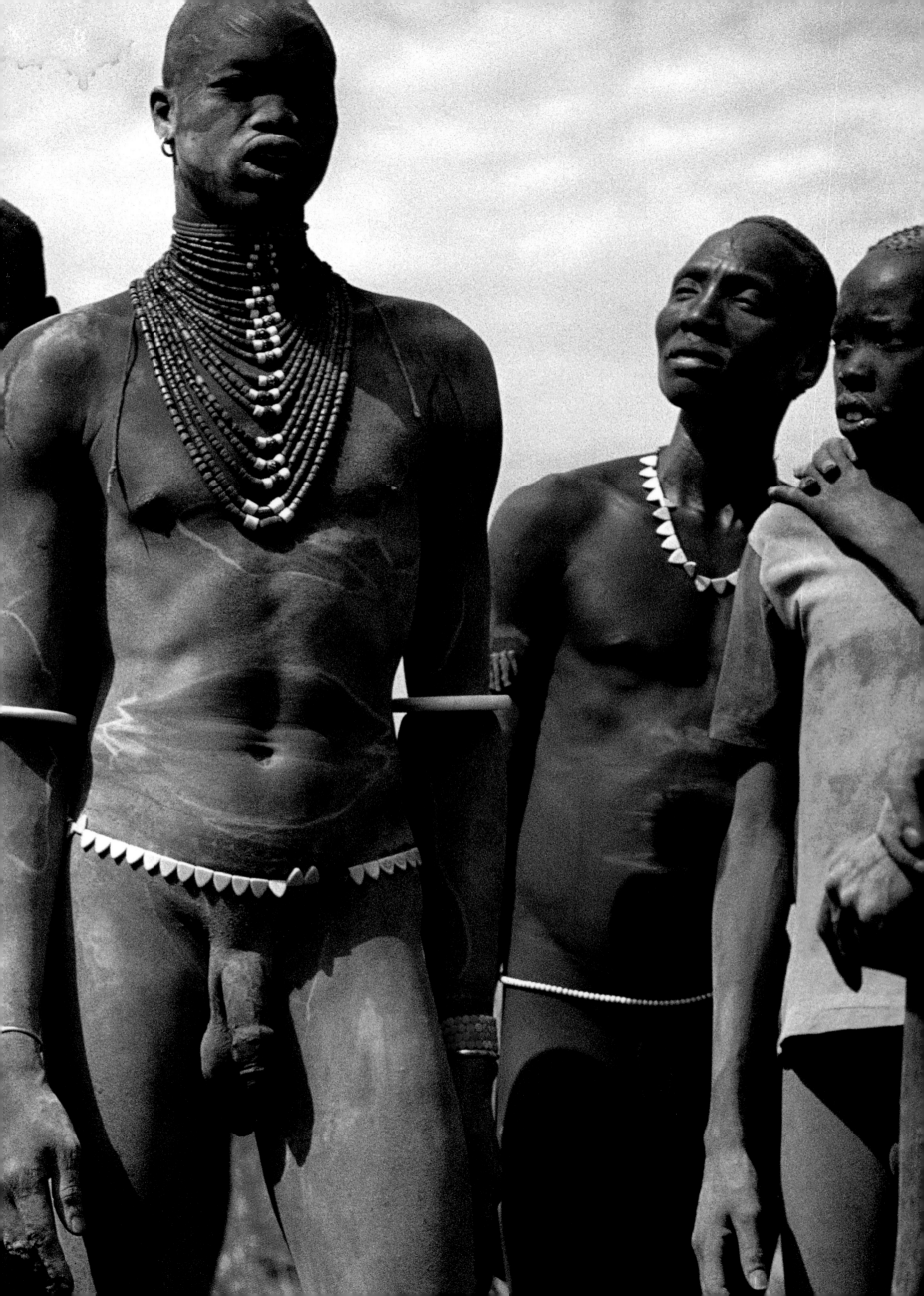

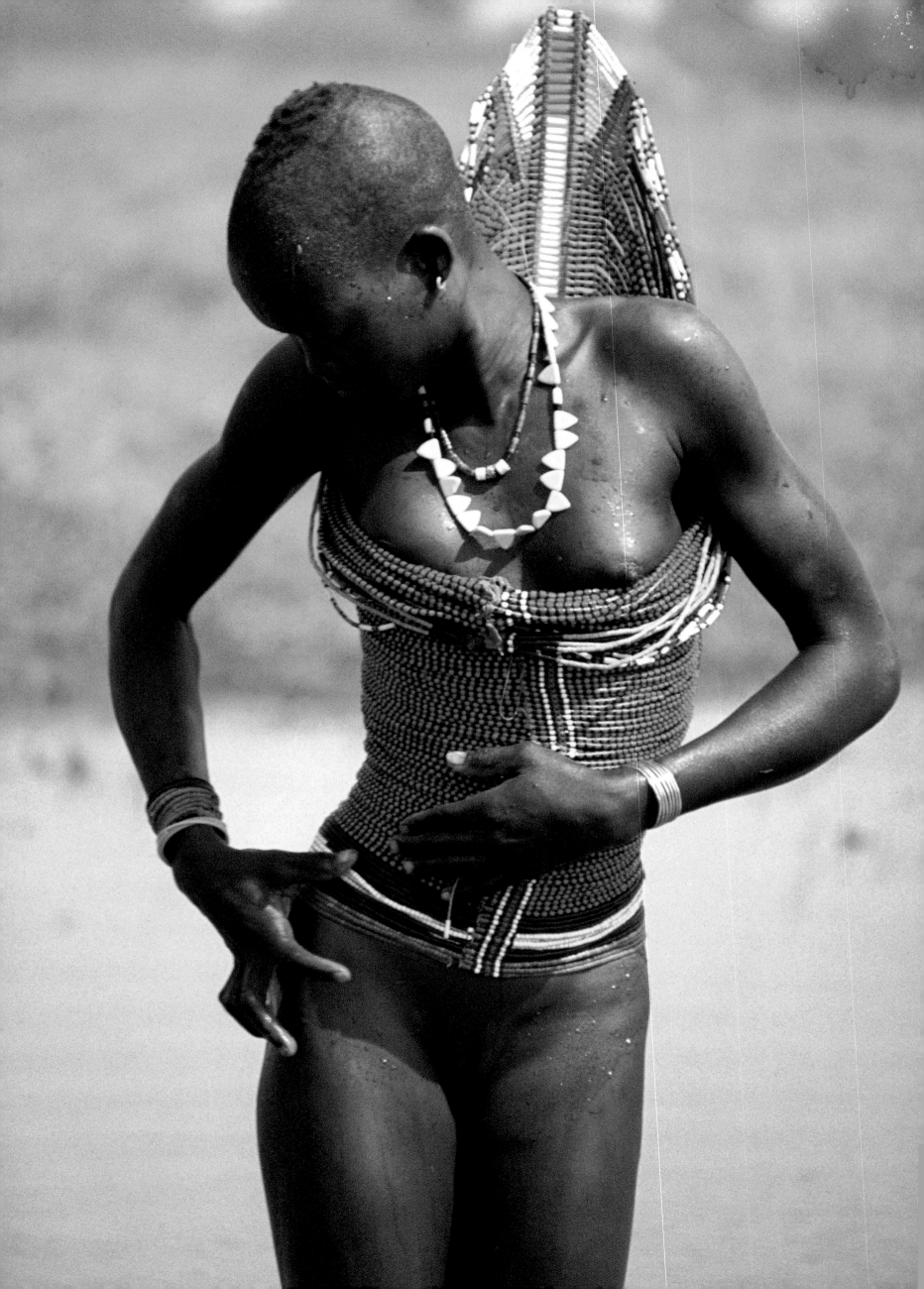

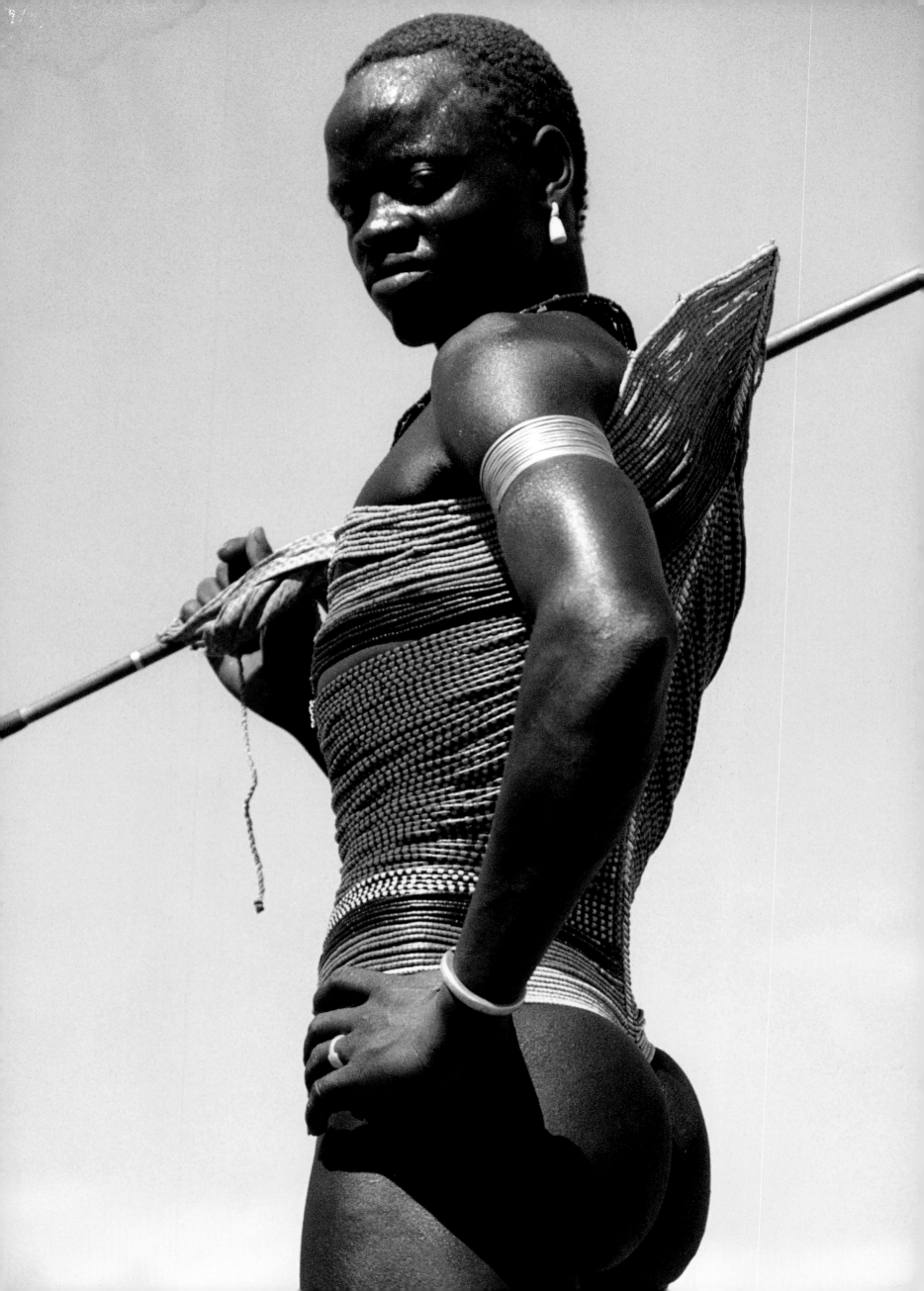

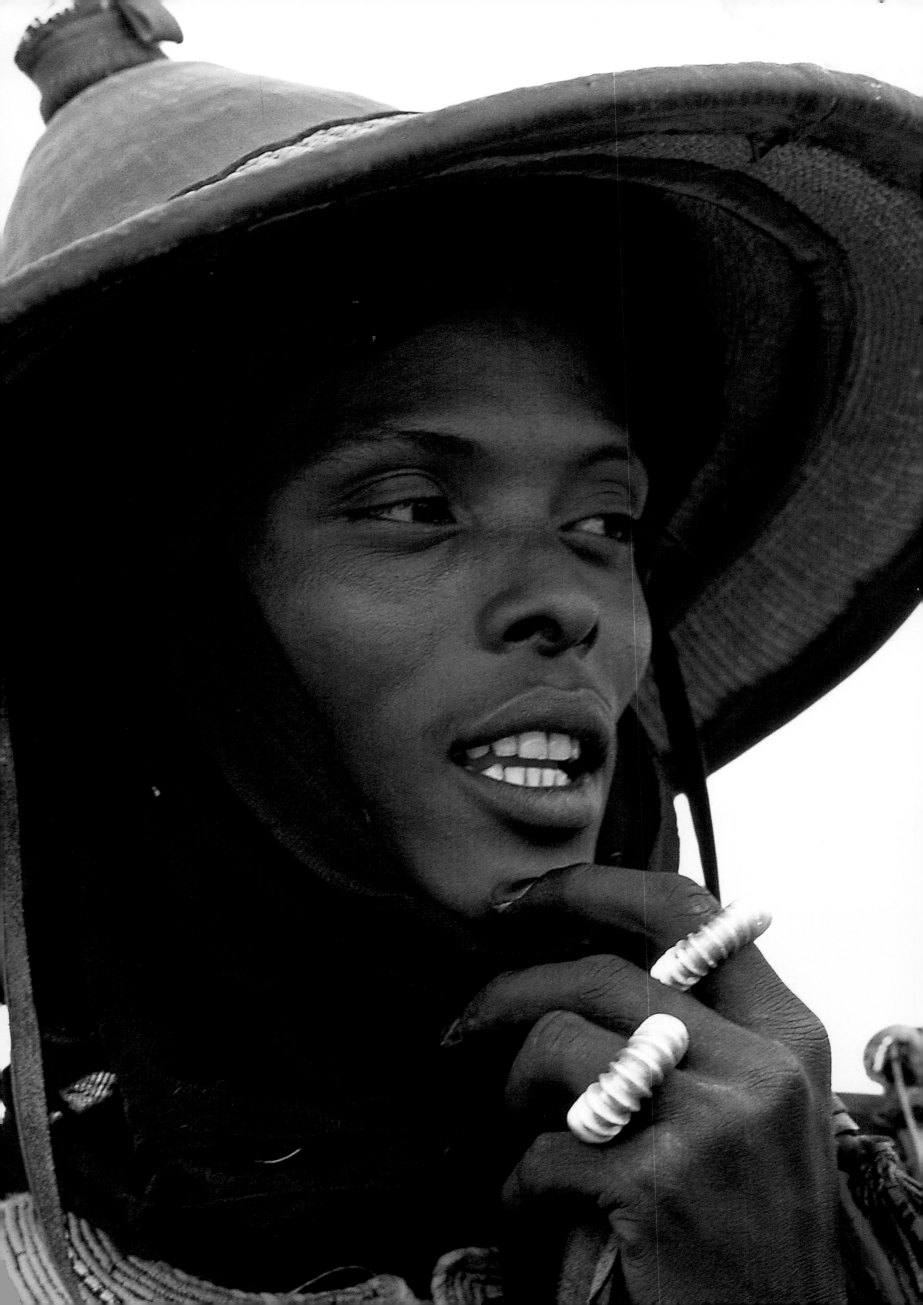

Fulani Cattle Crossing

The Fulani people, known variously as Peule, Fula, Fulbe, or Felaata, inhabit the savanna and Sahelian plains of West Africa. Nomadic herders until the fifteenth century, they gradually migrated from Senegal to Chad, spreading across the region in search of new pasturelands. On reaching Nigeria, they came under the influence of Islam, and adopted a semi-sedentary way of life, attempting to retain their cattle by supplementing their livelihood with agriculture.

The Fulani, living in Mali between Lake Debo and the town of Djenné, have retained their strong pastoral tradition despite the arid terrain that they inhabit. Every year between December and March, they hold a grand festival, celebrating the return of their herds after a six-month-long search for pasture in the inhospitable Sahelian steppe, northwest of the Niger River. The ceremony is highlighted by the dramatic crossing of the Niger and its tributaries by thousands of head of cattle, who are forced into the fast-flowing waters and made to swim. Their goal is the rich grasslands and vast, swampy plains of the river's interior delta. For the herders, who have been separated from their families and living in isolation, the river crossing marks a triumph over adversity. These young men have managed to return with the cattle alive and healthy, assuring the survival of their people. They receive gifts from their families and are courted by alluring Fulani girls, who adorn themselves with gold earrings and dress their hair with amber beads. The annual cattle crossing is one of the most impressive spectacles in West Africa, a huge feat of skill celebrated by villages throughout the delta region.

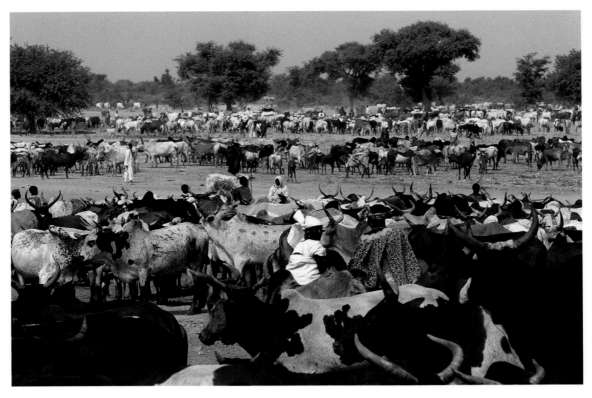

Left and above: Herders assemble their cattle along the banks of the Niger. *Following pages*: Villagers prepare for the return of their herds. The mud-brick buildings, with their turrets and minarets, date from Islamic empires of the Middle Ages and remain some of the best examples of Sudanese architecture in the Sahel.

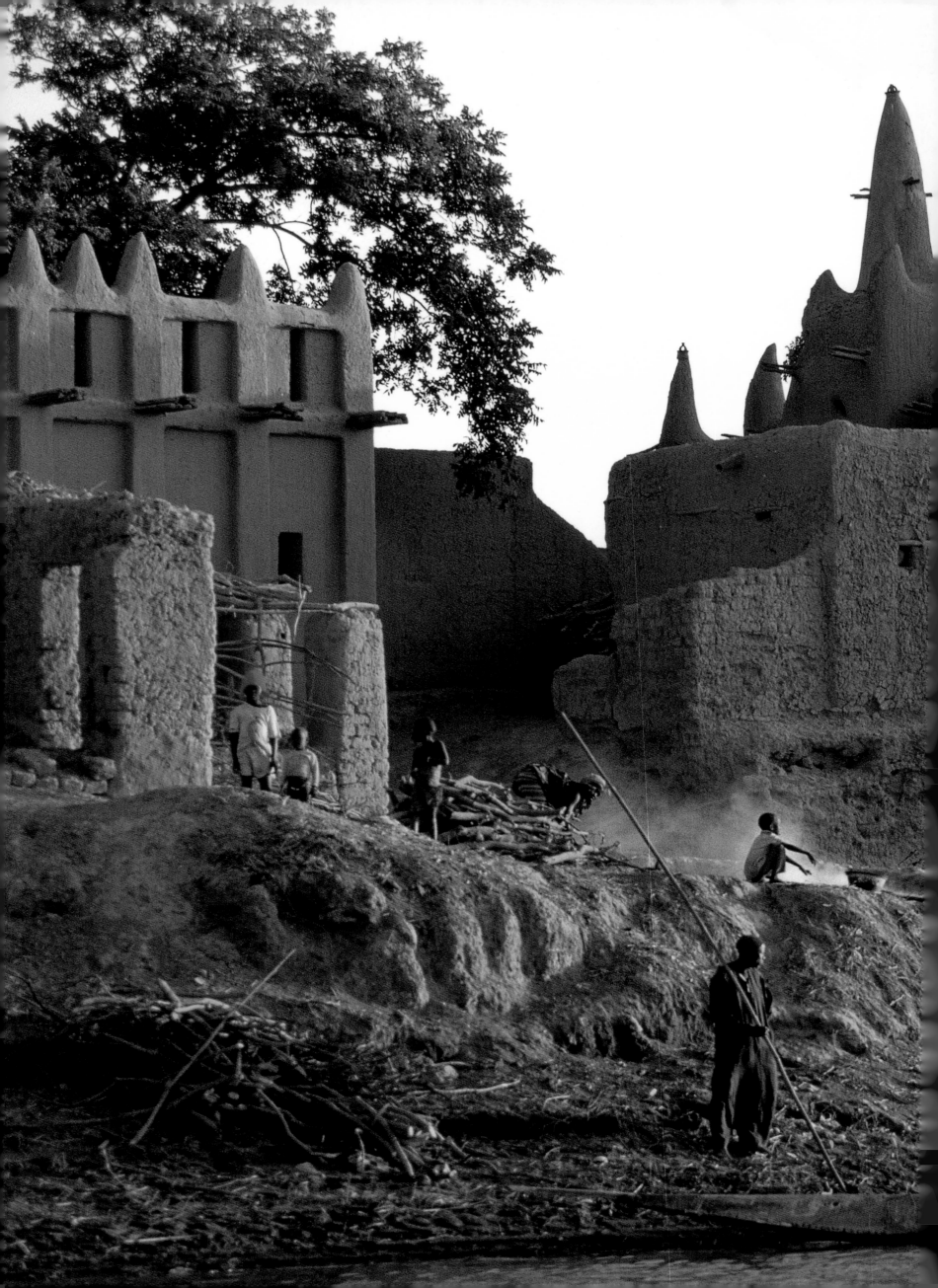

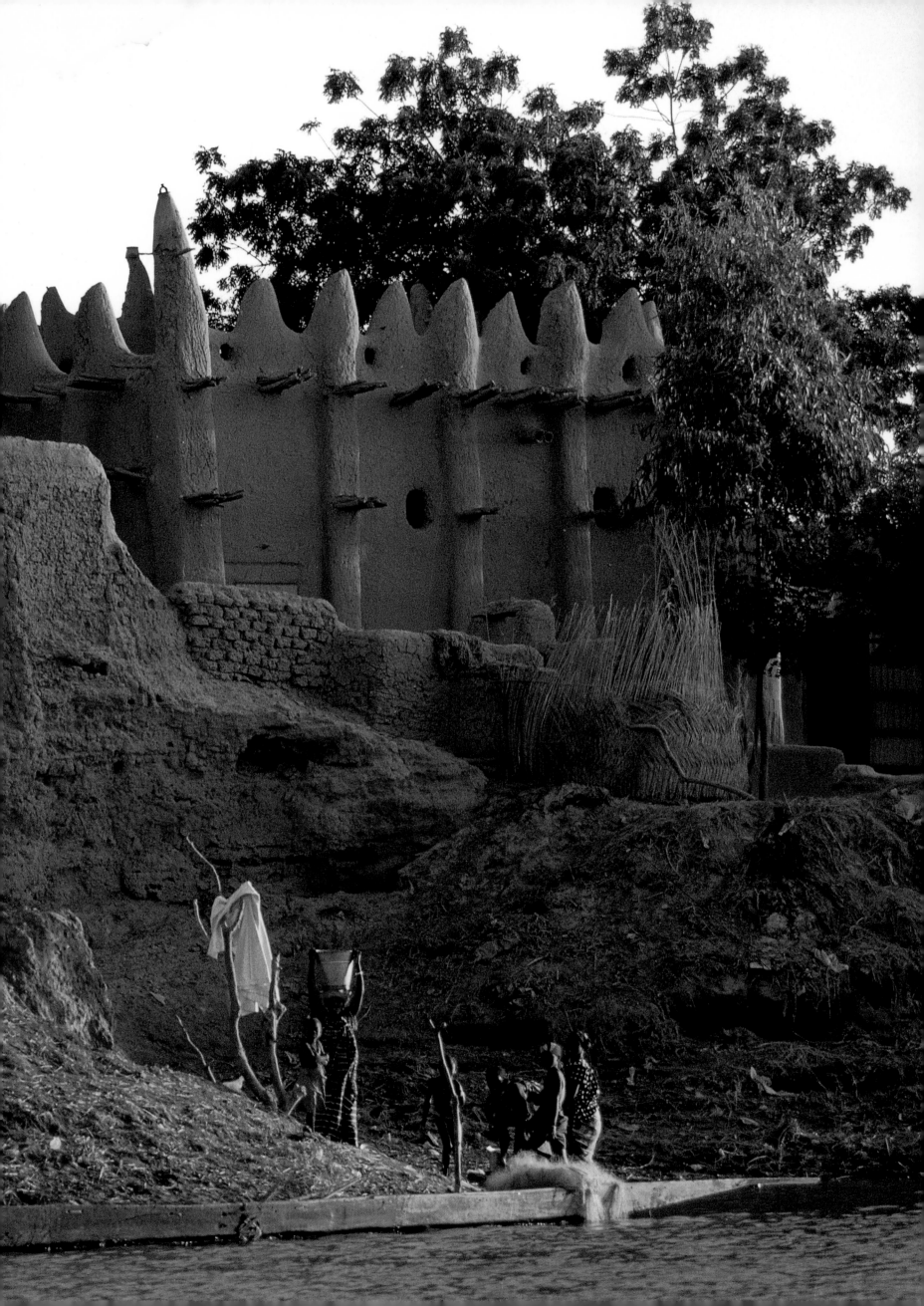

The Crossing

Women store their possessions in hollowed-out gourds called calabashes which are loaded aboard waiting pirogues for the river crossing. A Fulani woman's most treasured possessions are her calabashes. Strong and light in weight, they are carried stacked on her head, sometimes bound with a net for long journeys (*left*). These calabashes, decorated with paste made from milk, are working vessels for everyday use. Other highly prized calabashes, etched with carved patterns, represent a woman's wealth and are used only for ceremonial display. *Below*: Herders who have not driven cattle across the river are poled through the powerful currents in shallow-draft pirogues.

Following pages: At the great crossing, called Luumbal, a herdsman swims with his cattle, whipping the water with his stick to spur on animals who may struggle in the powerful current. On the far shore, other herdsmen wait in the water to drive the cattle up the slippery banks. After the crossing, prizes are awarded to cattle for beauty, weight, and the speed with which they made the crossing. Great lovers of beauty, the Fulani appreciate their cattle far more than the wealth they represent.

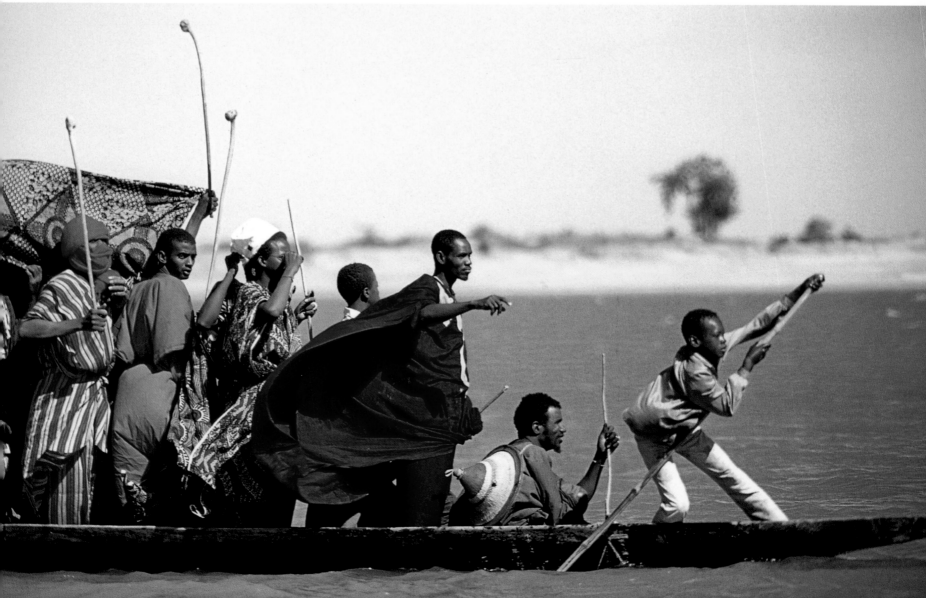

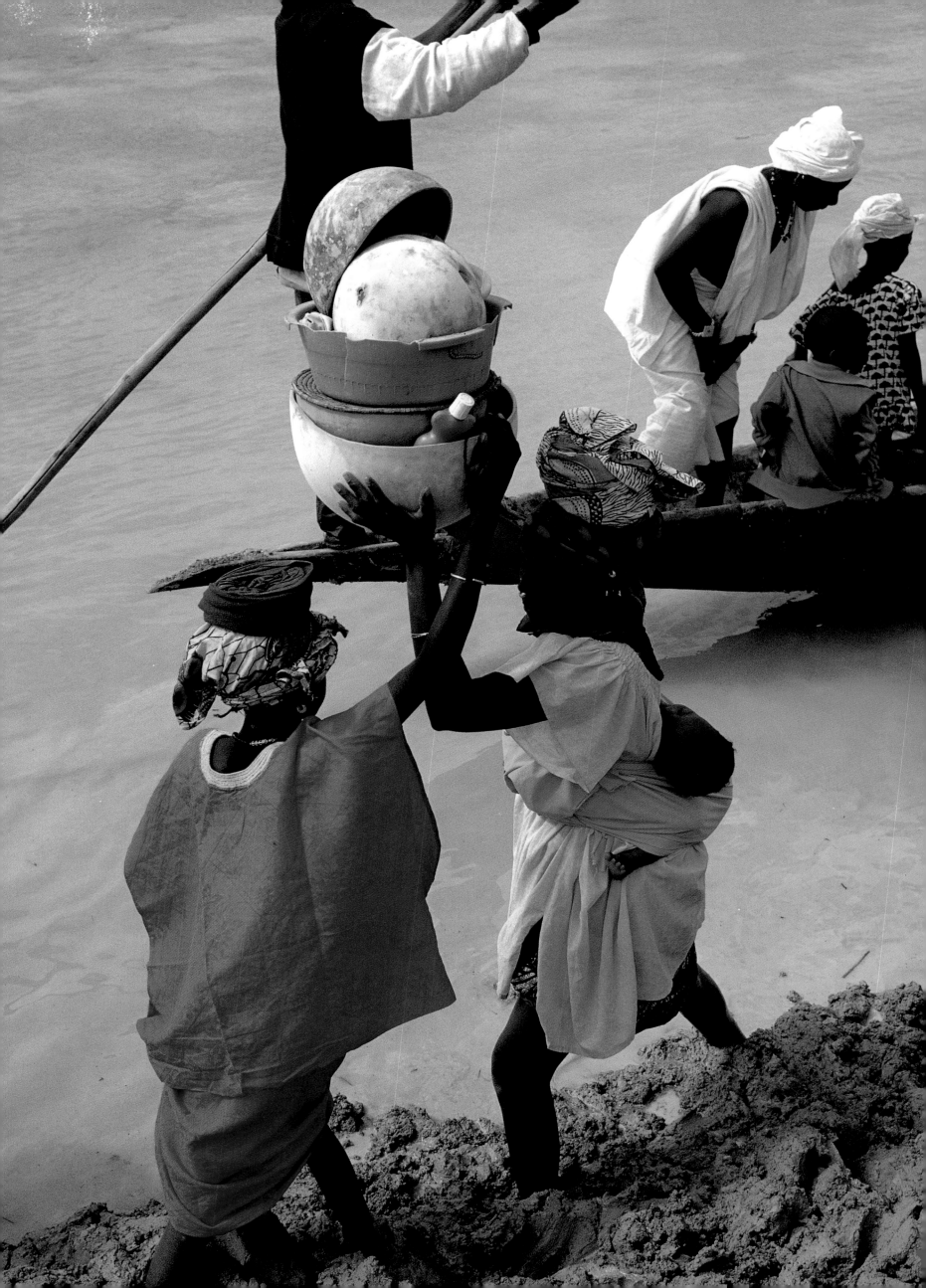

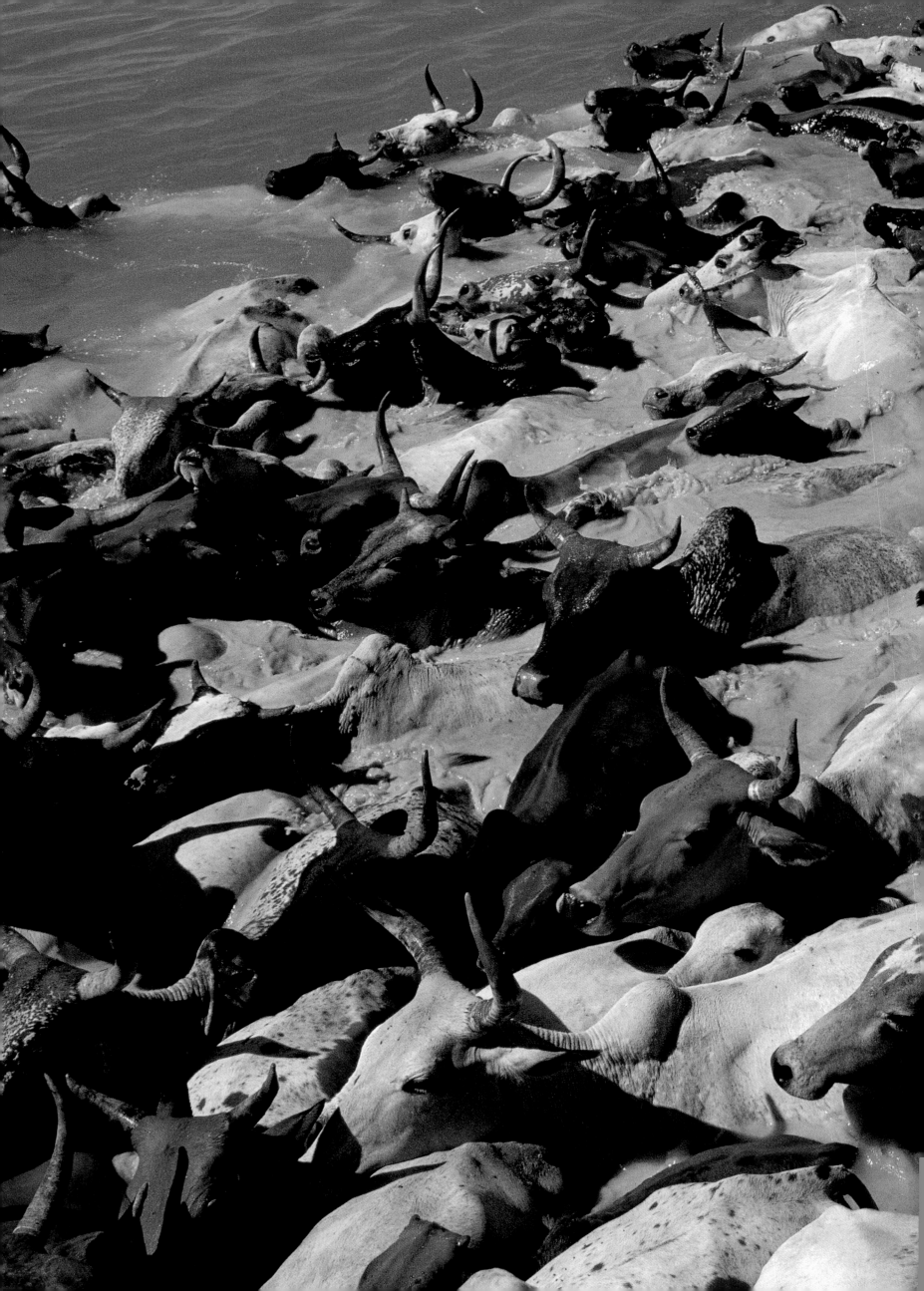

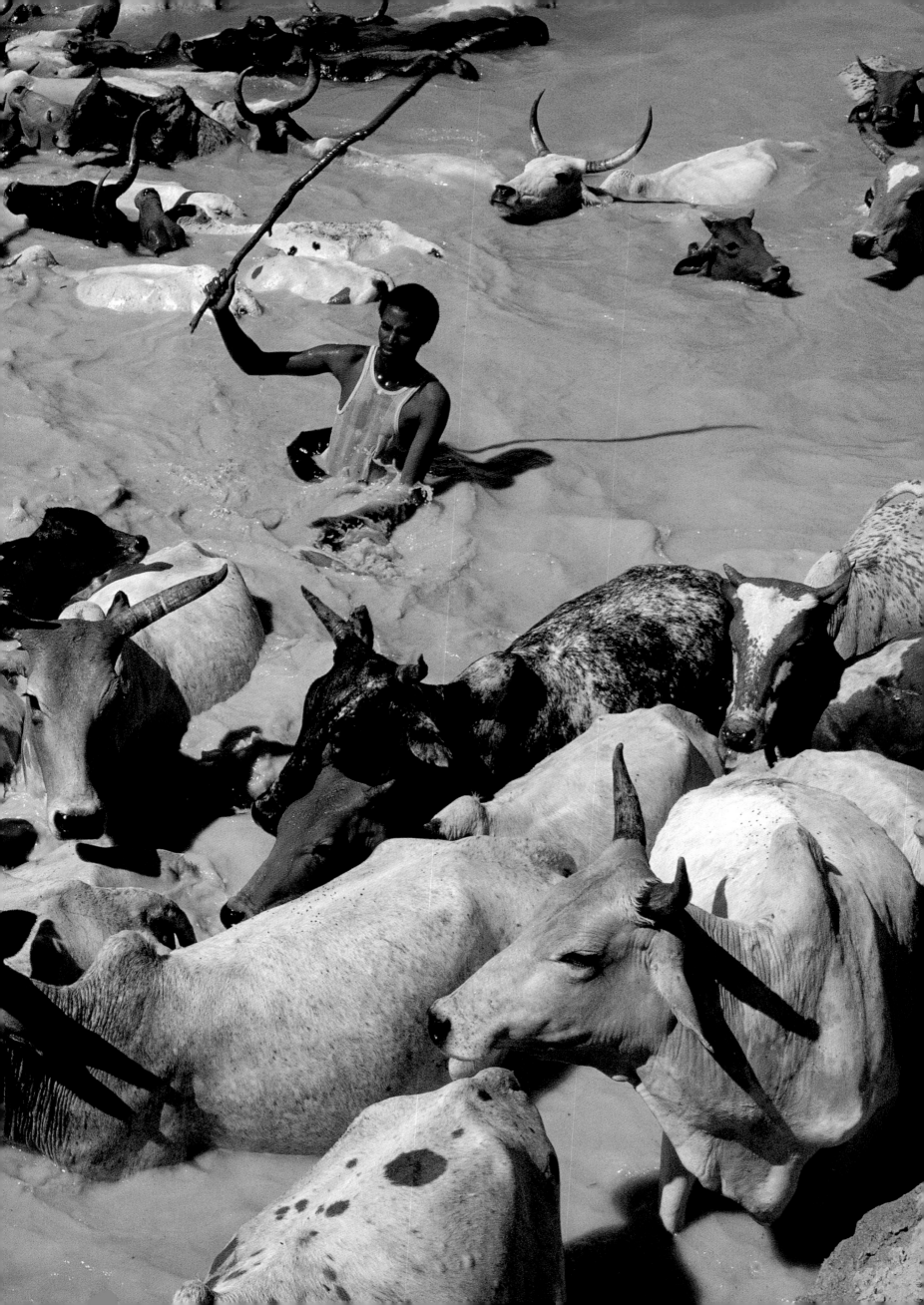

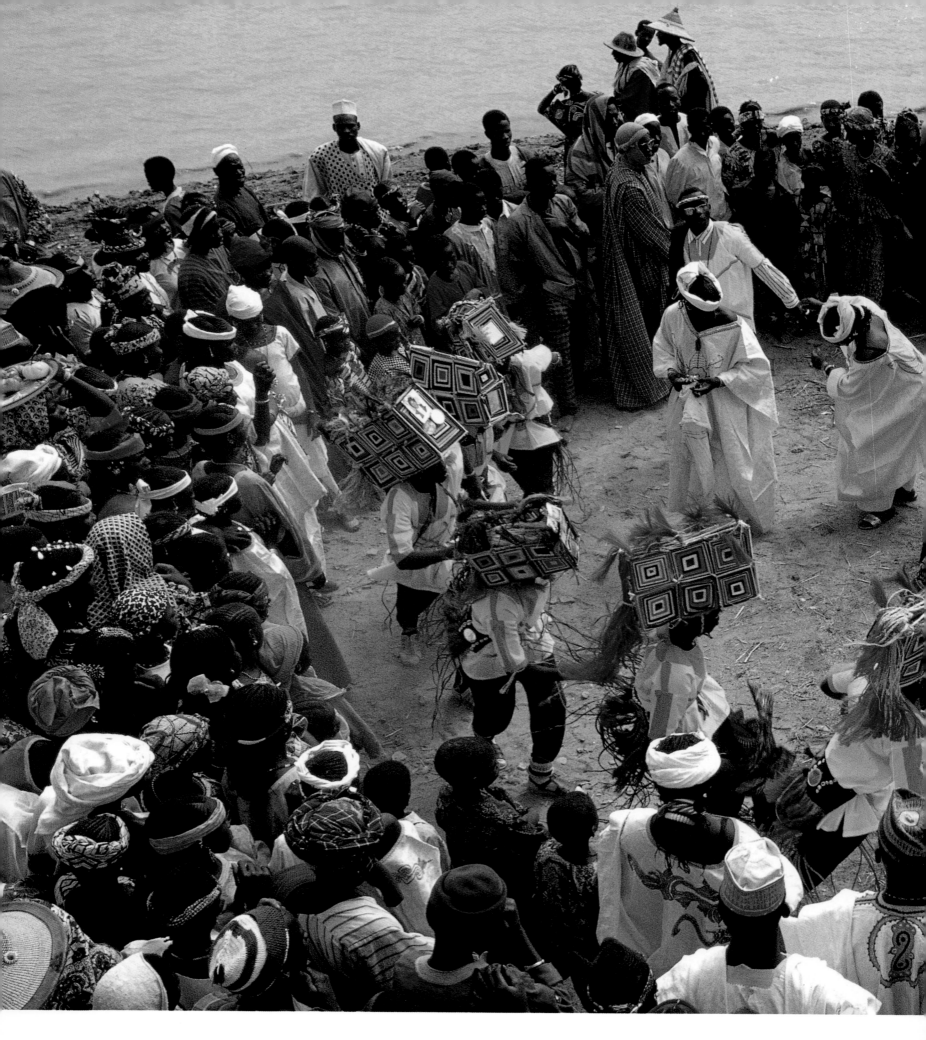

The Celebration

Villagers hold a celebration called Yaaral after a successful crossing. Performers, wearing large rectangular masks, conduct a ritual dance while a musician (*far right*) keeps the beat by rhythmically tapping his silver finger rings on a calabash as he bends his agile body backward. After their long absence, the return of the young herders stimulates an intense period of courtship. Young women (*right*)

stitch amber beads into their hair and wear magnificent gold earrings, called *kwottenai kanye*. The herders, wearing mirrored glasses purchased in market towns on their way home, radiate flirtatious charm. On top of their turbans they pile colorful cloths presented to them by admiring females who make sure that the patterns of the fabrics match those of the dresses they will wear themselves.

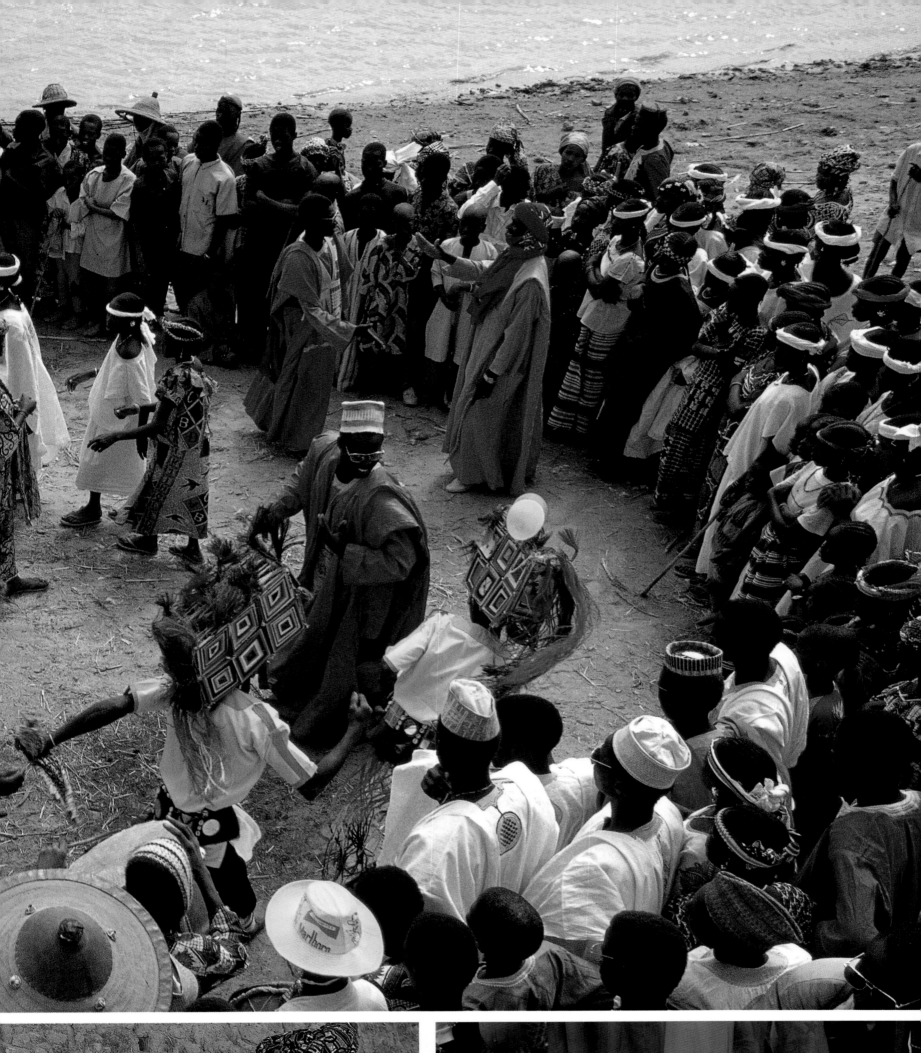

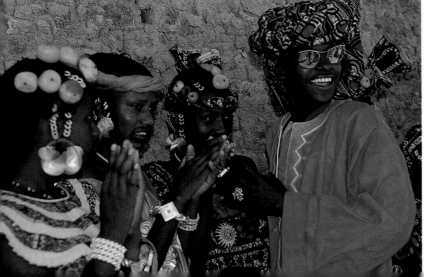

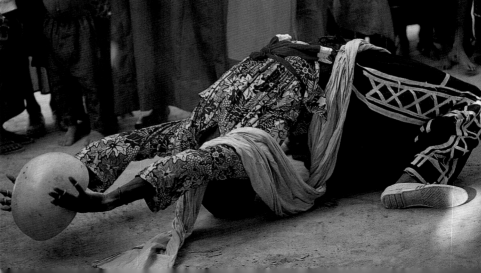

Kassena Harvest Rituals

The Kassena people of northern Ghana are traditional hunters and agriculturists. Like their neighbors, the Gurunsi, they perform ritual activities to insure the blessings of the earth and of ancestors before harvesting crops or going hunting.

The main Kassena festival, called Fao, occurs in December before the millet harvest. When the crop begins to flower, villagers are told not to make loud noises because God's wife is pregnant. As the flowers mature, the earth priest's son cuts a stem of millet and makes a flute from it. He then walks through the village, playing the flute to announce the start of Fao. To honor the event, villagers compose songs and dance to drumming, while guinea fowl, sheep, cows, and baskets of millet are brought to the chief's house to be blessed by the priests.

Soothsayers play a key role in Kassena hunting. Before the hunters go after antelope, buffalo, or other large game animals, they consult the soothsayers to determine the time and place of the hunt. To prepare for the dangerous task, the hunters put on special tunics covered with leather talismans to protect them. They then ritually enact the hunt before the village, thus capturing the spirit of the animal they seek and ensuring success. After the hunt, the hunters revisit the soothsayer to ask forgiveness for animals they have killed and to avoid having any misfortune befall the community. The Kassena honor the spirit of the earth for its role in human life, and at ceremonial times the villagers reconcile their differences so that their universe remains harmonious.

Kassena women sit in the doorways of their painted houses smoking a long pipe (*above*), and shelling shea nuts to make butter for cooking (*right*).

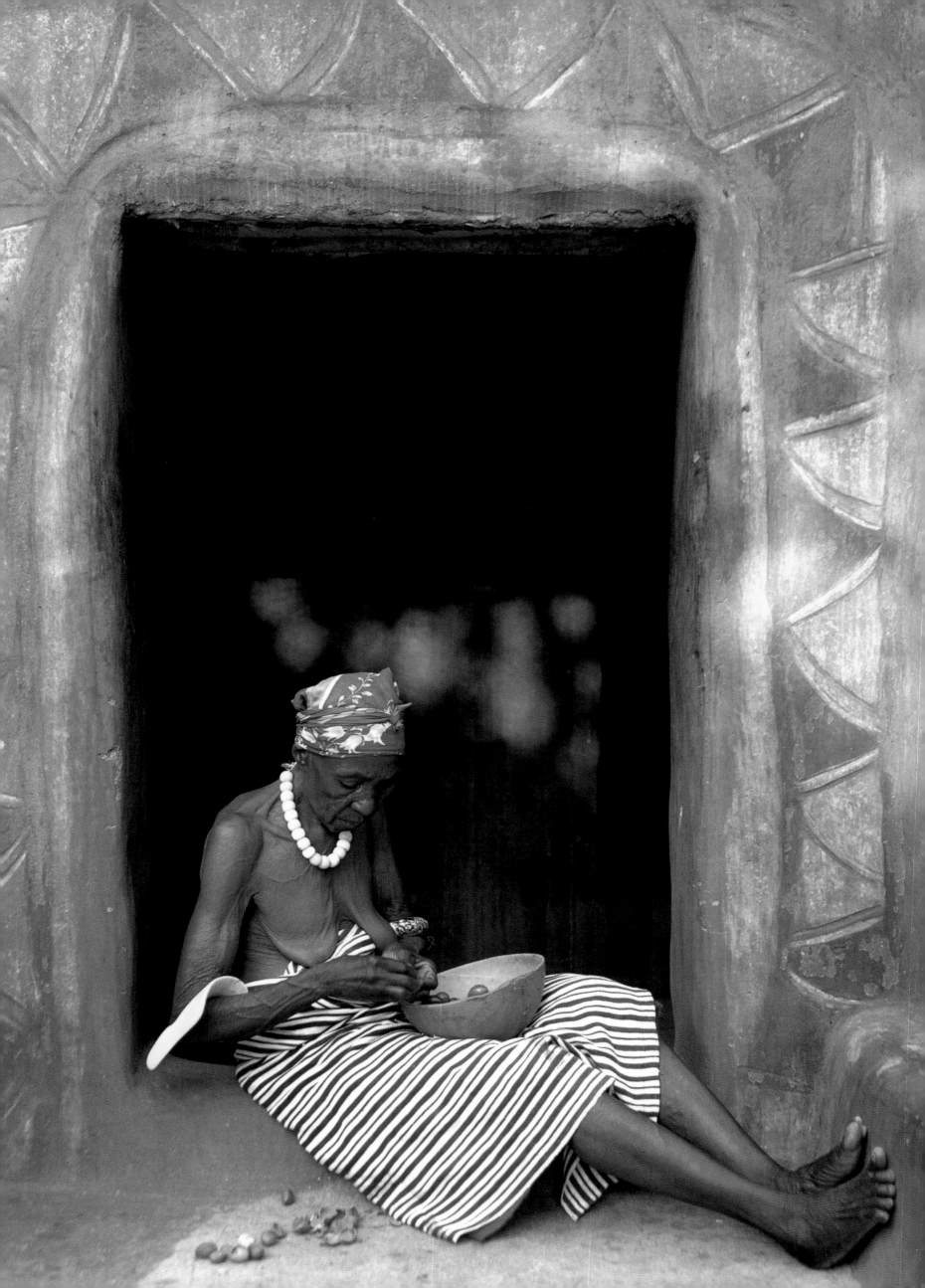

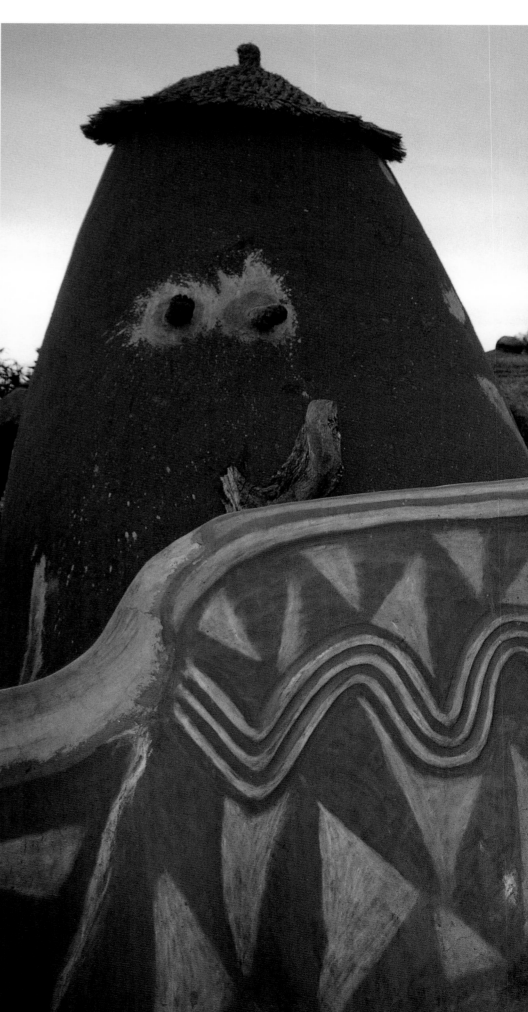

Harmony of the Home

Kassena domestic compounds combine practicality and beauty. Symbolically and literally protective in form, a perimeter wall encloses the dwellings. The flat roofs of the houses provide surfaces for drying millet, and the inner courtyards serve for grain storage, cooking, and socializing. Plastered with clay, the walls are repainted at the beginning of every dry season with bold decorative motifs inspired by daily life. The paintings depict the relationship between man and his environment as a harmonious whole, which is the Kassena ideal. The three motifs most widely used are Zanlenga, representing the fiber net that holds a woman's calabashes; Wanzagese, broken calabash pieces, alluding to the interlocking phases of family life; and Tana, which refers to men's clothing and suggests a state of well-being and prosperity. The hourglass design (*following pages*) represents the mortars used for crushing shea nuts.

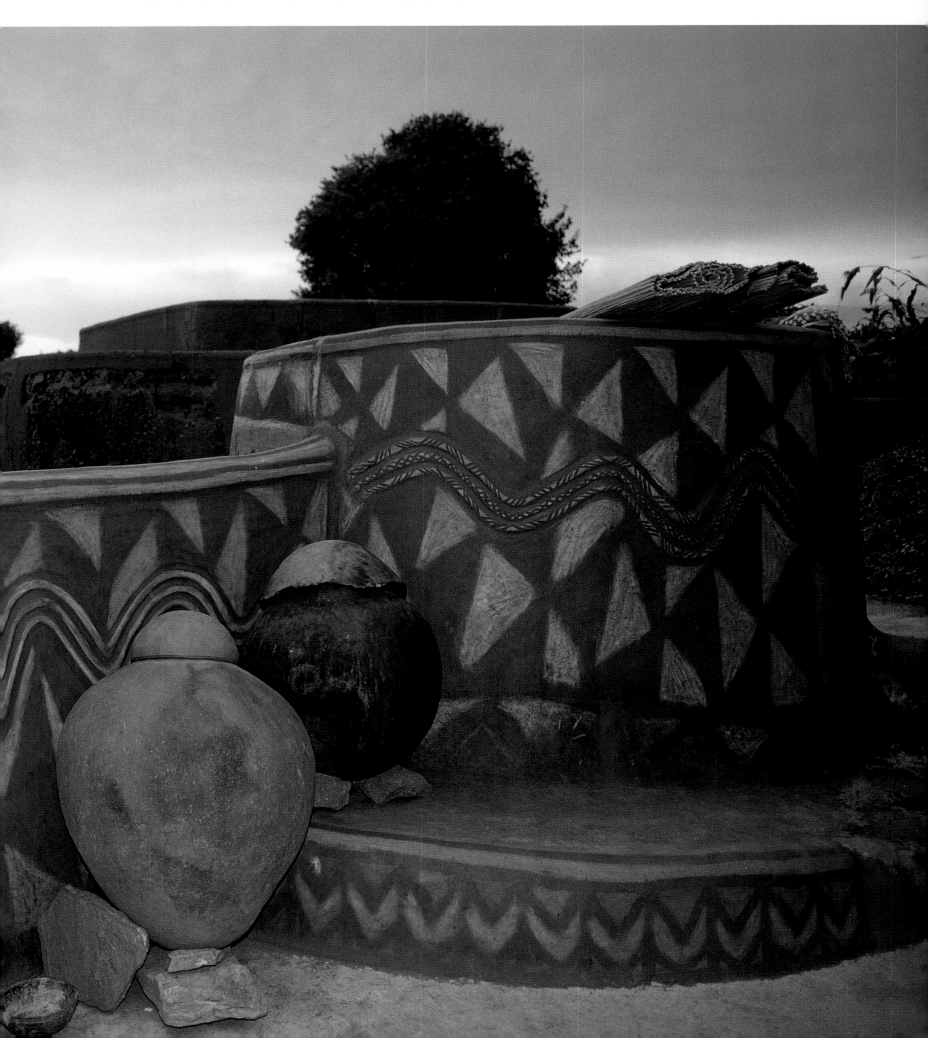

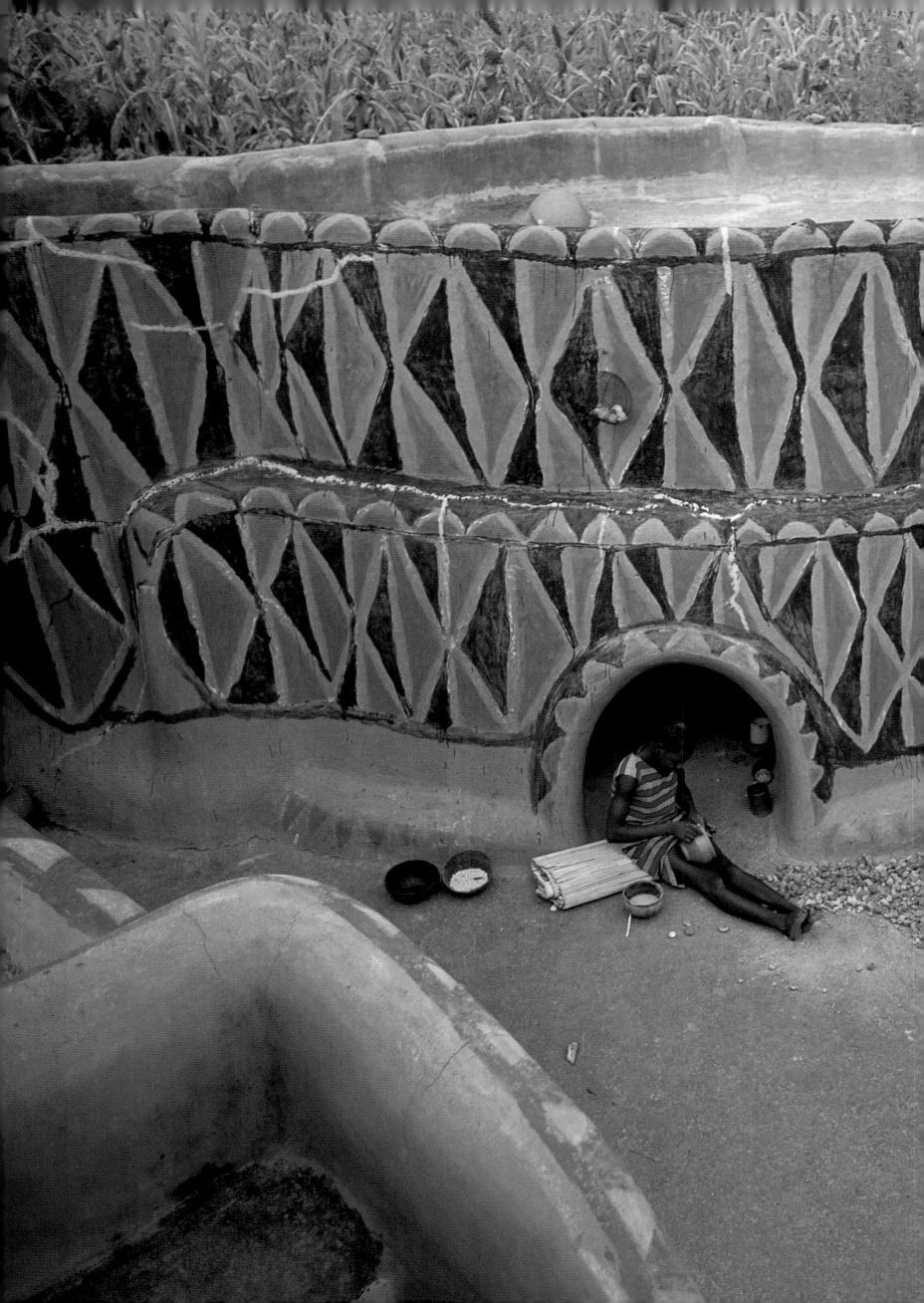

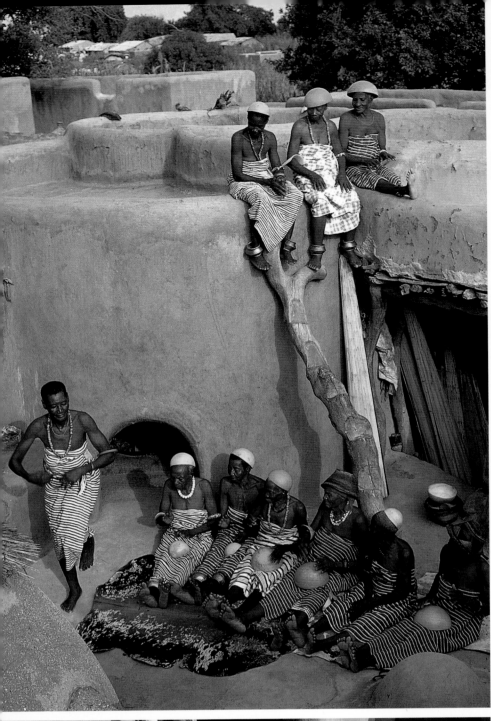

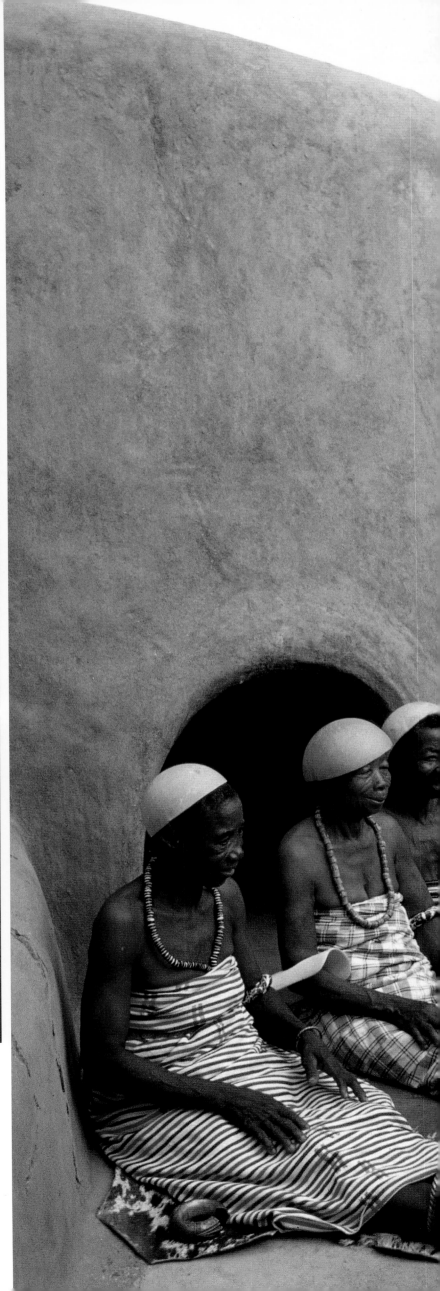

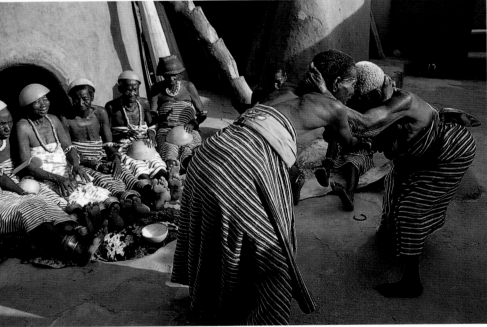

The Harvest and the Hunt

Kassena women celebrate the harvest with songs and dances accompanied by drumming on their calabashes, which also double as hats. They honor the earth deity by wearing their best cloth, ivory and marble arm bands, and brass anklets. *Following pages*: A hunter consults the village soothsayer to discover the most propitious day to begin the hunt and which animals to pursue. The answer depends on his interpretation of the random pattern created by dropping his sacred fork onto a stone divining board.

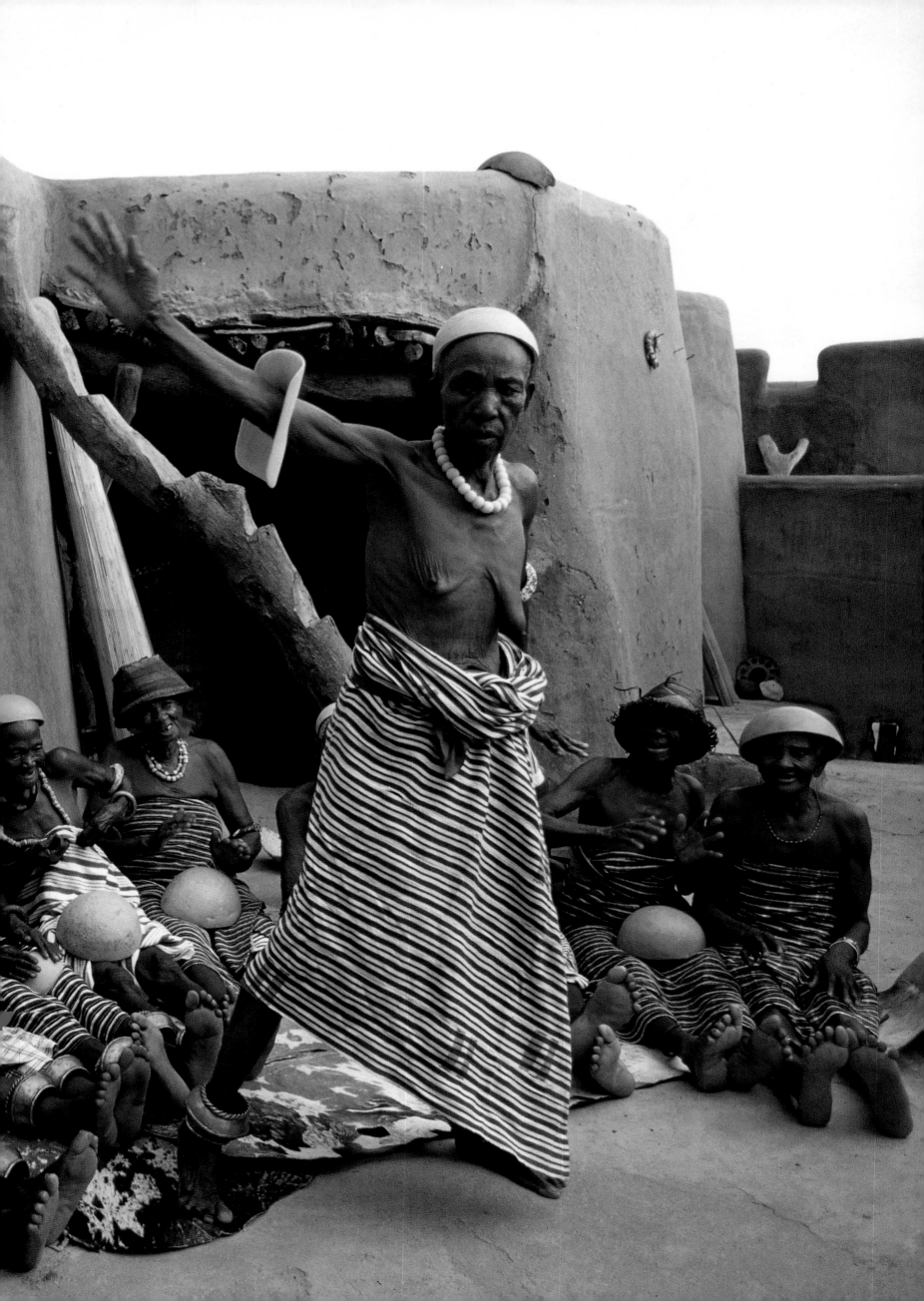

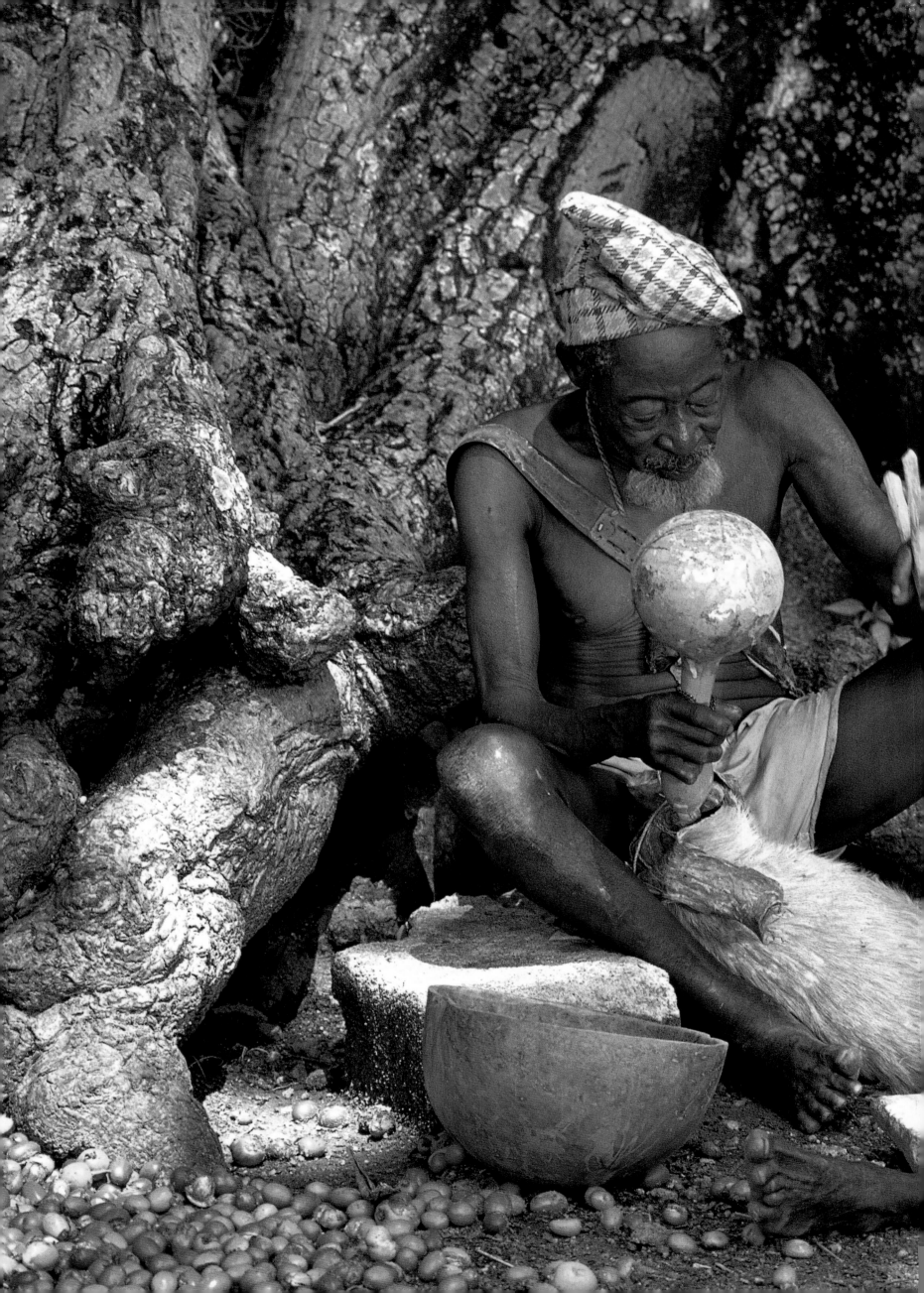

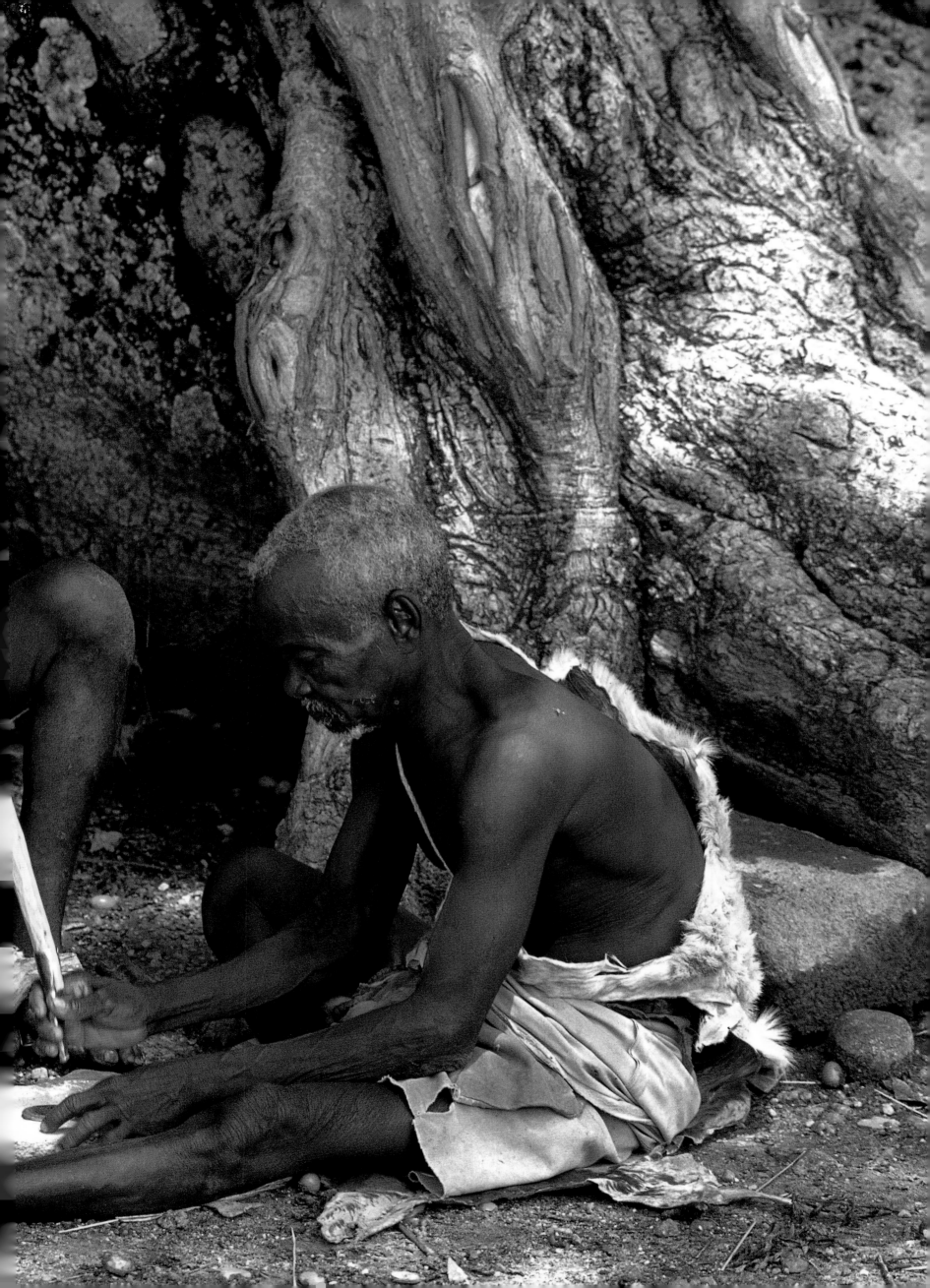

Bedik Planting Rites

The Bedik live hidden away in a mountainous area in southeast Senegal, near the border of Guinea. Relatively untouched by the outside world, they maintain a traditional agricultural lifestyle, performing rituals to ensure the fertility of their land. In May, the Bedik hold their annual Minymor festival, during which the community calls on the spirit world to appease the powers of nature, bless the planting of crops, and drive out evil forces. Communication with the spirits comes through the intercession of masked figures, who instruct the Bedik in sacred knowledge. The masks worn by these figures are among the most ancient in Africa. Made from the bark and leaves of special trees found in a sacred forest, each mask has a distinctive personality and plays a unique role in maintaining the balance of Bedik life.

Before the festival can begin, the Chief of Ritual, who is custodian of the mask society, must visit the masks in the sacred forest. Because he is the only person capable of translating their arcane language for the community, it is his responsibility to lead the masks into the village. The first to appear is the Kankouran, who teasingly chases and whips the uncircumcised young men of the village. The next mask to enter is the bushy Dokota. Calm and serious, it brings words of wisdom from the sacred forest and dances with the married women, who are responsible for the planting and cultivation of crops. The last mask to appear, Niathoma, leaps around the village wielding his sword and switch, chasing away evil, and cleansing the area of anything that might bring disharmony. As the festival comes to a close, the Dokota masks give a final blessing and return to the forest, leaving the villagers free to plant their crops.

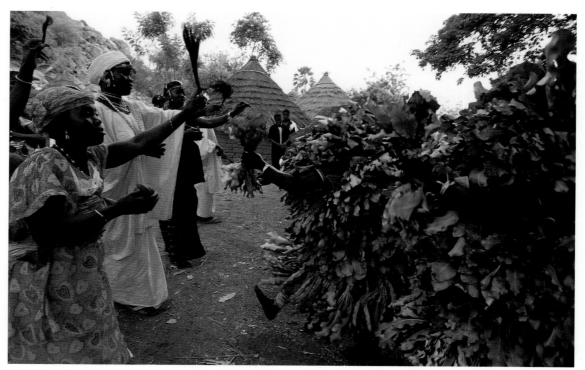

Above and right: The leaf-covered Dokota masks bring messages from the sacred forest. Entering the village, the masks join the women in a dance, known as Gamonde, which appeals to the forces of nature to bring ample rain and sunshine for the new crops. As the masks advance toward the women, they are chased back with the waving of fly whisks, symbolizing female reciprocity with the natural world.

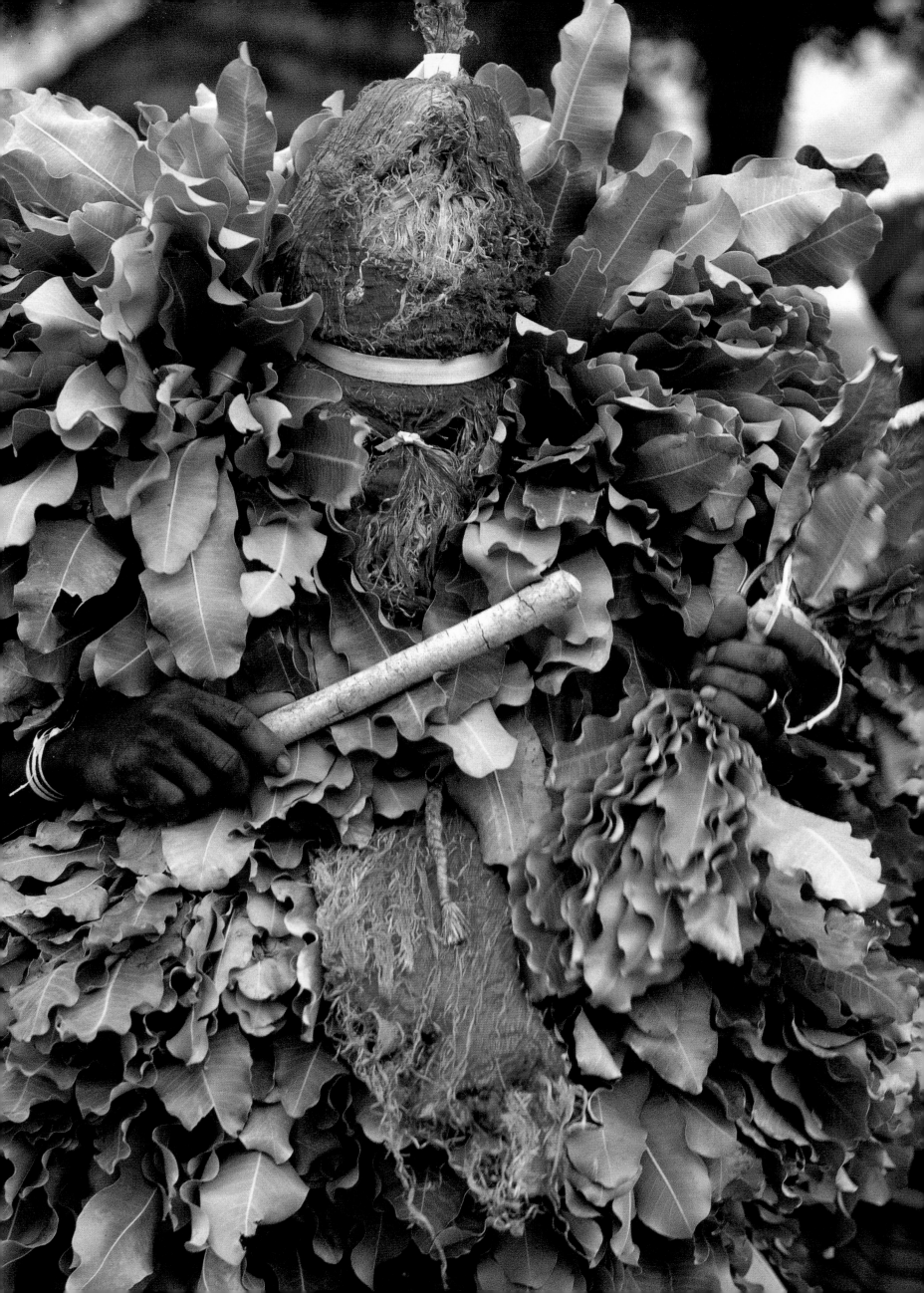

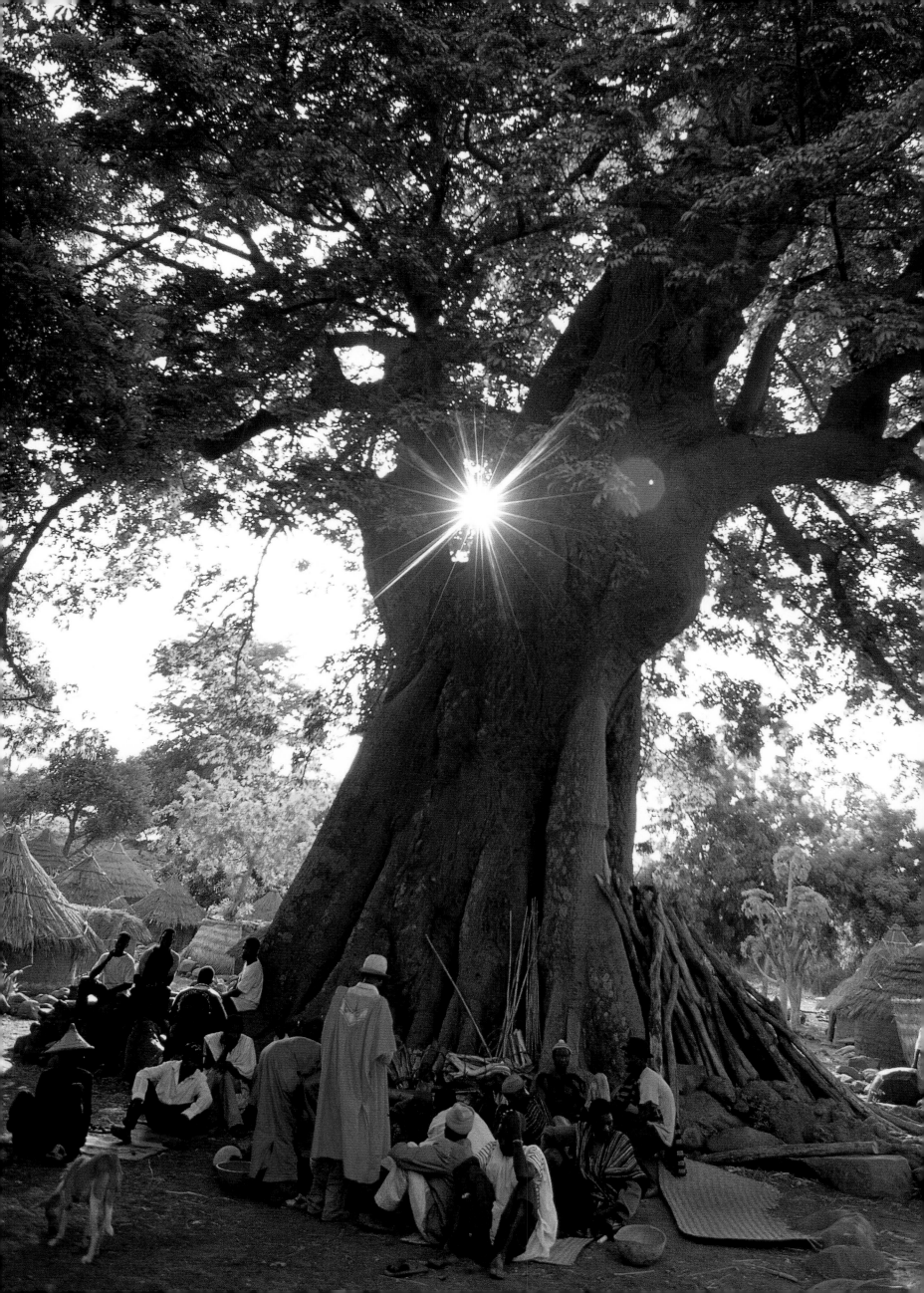

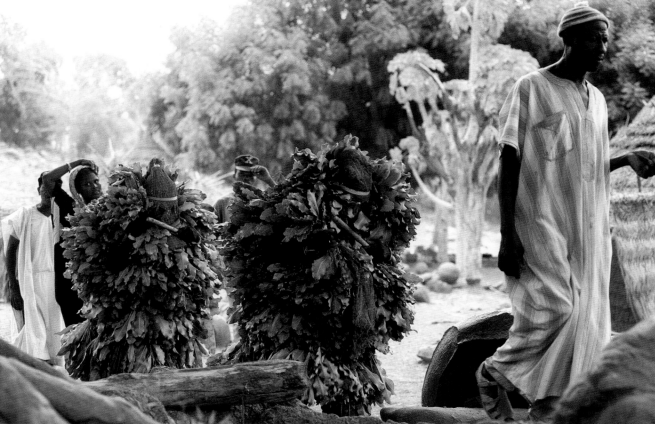

Visitors from the Sacred Forest

Sunlight streams through the branches of a sacred cottonwood tree at the heart of a Bedik village, surrounded by conical thatched homes. A group of elders gathers to discuss the ritual events that must take place before the cultivation of the new season's crops. As villagers wait for the celebration to begin, the Chief of Ritual enters a secret grove deep in the forest to commune with the bush spirits. Legend has it that he gives up one of his legs and an eye to appease the mask devils, who live in a hole in the earth. Lowering himself into this hole, the ritual chief begins a series of dialogues with the devils that disclose whether the ritual should proceed as planned. If he receives a negative answer from the underworld, the hole is covered over and the celebration is postponed. If the outcome is positive, the Chief of Ritual leaves the hole, retrieves his missing body parts, and makes his way back to the village with two Dokota masks, covered with bark and leaves. Respected for its stern wisdom, the Dokota mask symbolizes protection from evil forces. The Dokota decrees that if someone perpetrates evil, or if there is an enemy among the guests, the community must rid itself of that evil. To discover the perpetrator, the mask walks through the crowd rhythmically shaking a small leafy branch until the evildoer identifies himself.

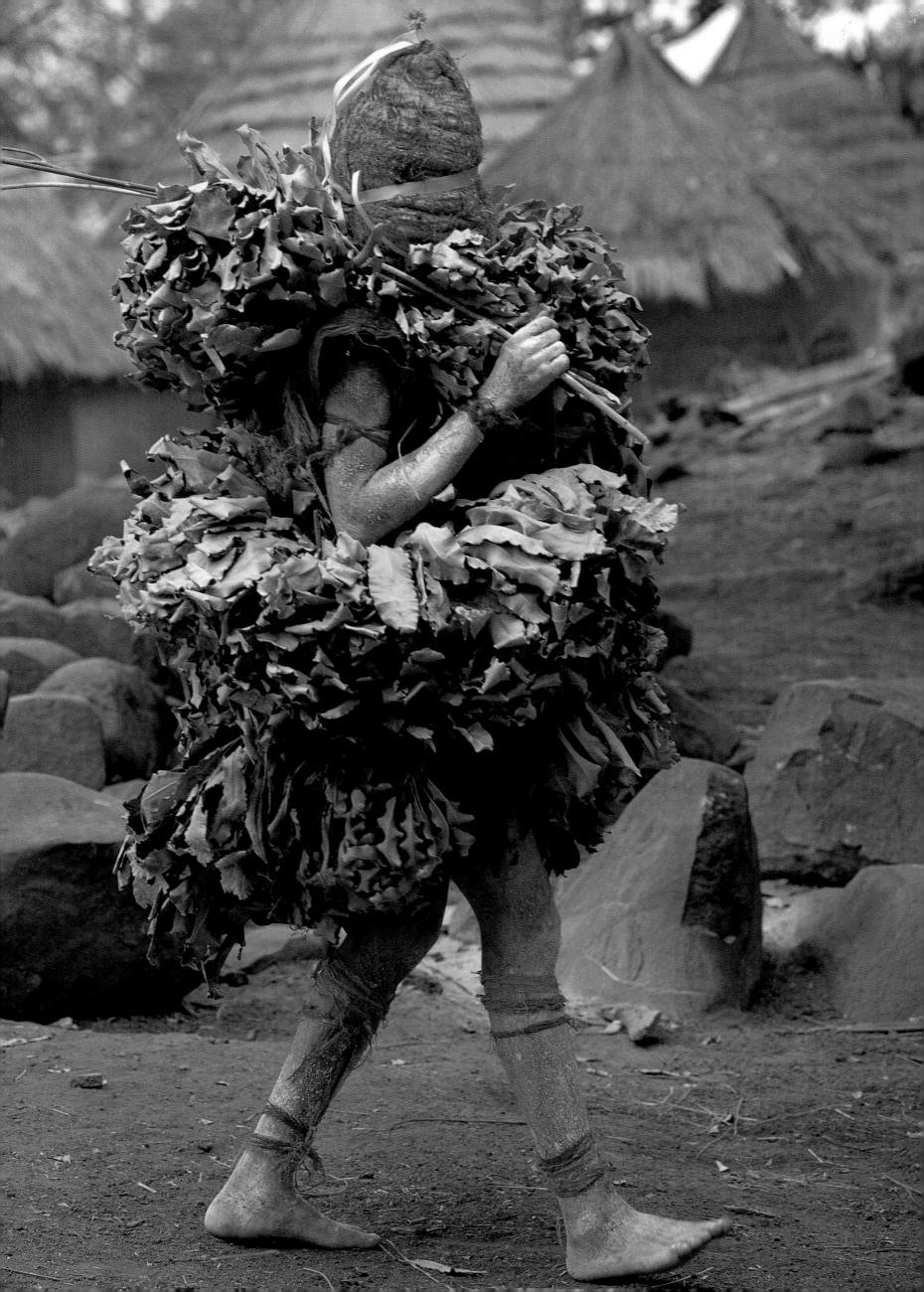

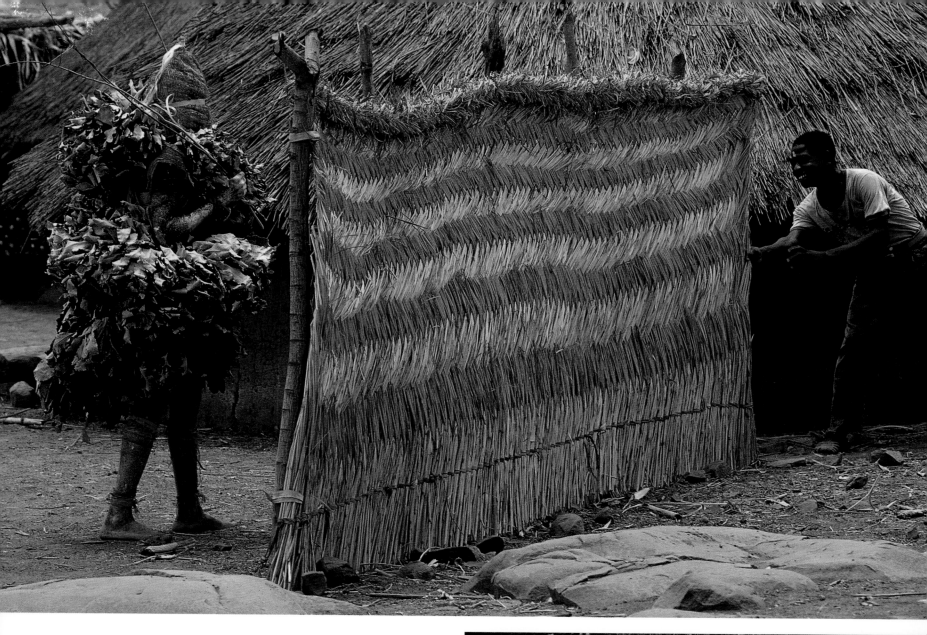

The Mask of Mischief

Coming from its home in the sacred forest to attend the Minymor ceremony, the first of the ritual masks to make its appearance is the Kankouran, a leafy ball of mischievous activity. Considered to be mildly malevolent, the Kankouran sneaks through the village seeking out young men to beat with a switch. He forces entry into the house of each boy who has been circumcised during the past year, leaves a protective charm, and demands that chickens be sacrificed in honor of the initiations. These chickens will later be cooked and distributed to the initiates, elders, and women. After the ritual meal, the community joins together in prayer for a season of rain and protection from harmful spirits. As the villagers return to their homes, the masks retreat to the sacred forest, having played their roles in maintaining the subtle balance between the Bedik people and the land that sustains them.

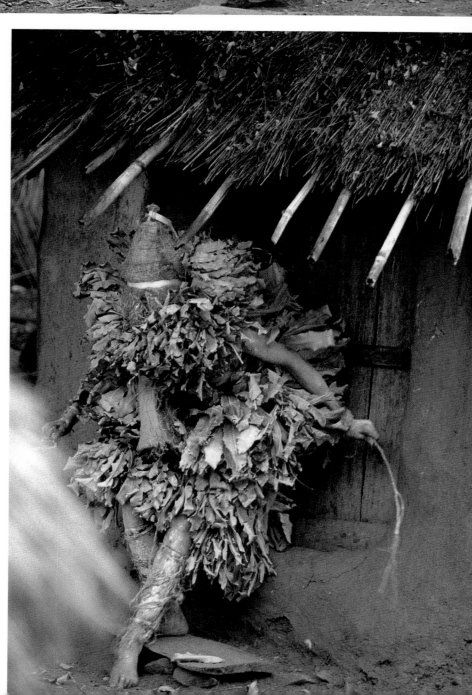

Bobo Bush Masks

The Bobo and Bobo Oule, also known as Bwa, live in the Upper Volta region of Burkina Faso. Agriculturists, they grow millet as a main crop, but also keep bees for honey, and dogs to eat on ritual occasions. Although the two groups regard themselves as separate, speaking different languages and living in small autonomous villages, they share the same lifestyle and similar cultural and spiritual beliefs.

The Bobo see nature as a benevolent entity, and for them it is the mistakes of humanity that upset the natural equilibrium established by the creator god, Wuro. They take great care to maintain the harmony between their god, man, and earth through a series of ritual masquerades, which purify the community and chase away evil. Carved and painted in the form of animals and bush spirits, Bobo masks represent the nature spirit, Do, who functions as a mediator between man and the creator god, offering atonement for human misbehavior. Blacksmiths are responsible for making the masks; some are constructed of plaited, dyed fibers, others are carved from wood in the form of multi-tiered planks. The

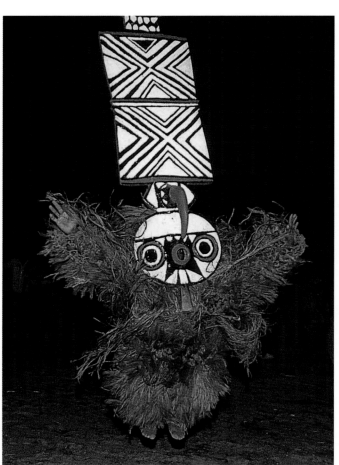

secrets of masking are kept hidden from women and children, and the identity of the maskers remains unknown to everyone except initiates of the secret society of Do, who have the sacred duty to organize all masking events.

The Bobo practice two types of purification rituals, both lasting for a period of three days. The first takes place in April, before the planting of the millet seed, and the second occurs in September, prior to the harvesting of crops. The masks also appear at initiations, at the funerals of chiefs, and at annual communal funerals, when the souls of all those who have died during the past year must be chased out of the villages and put to rest in the ancestral world.

Above and right: These carved wooden Bobo plank masks represent owls and a snake, creatures of the night.

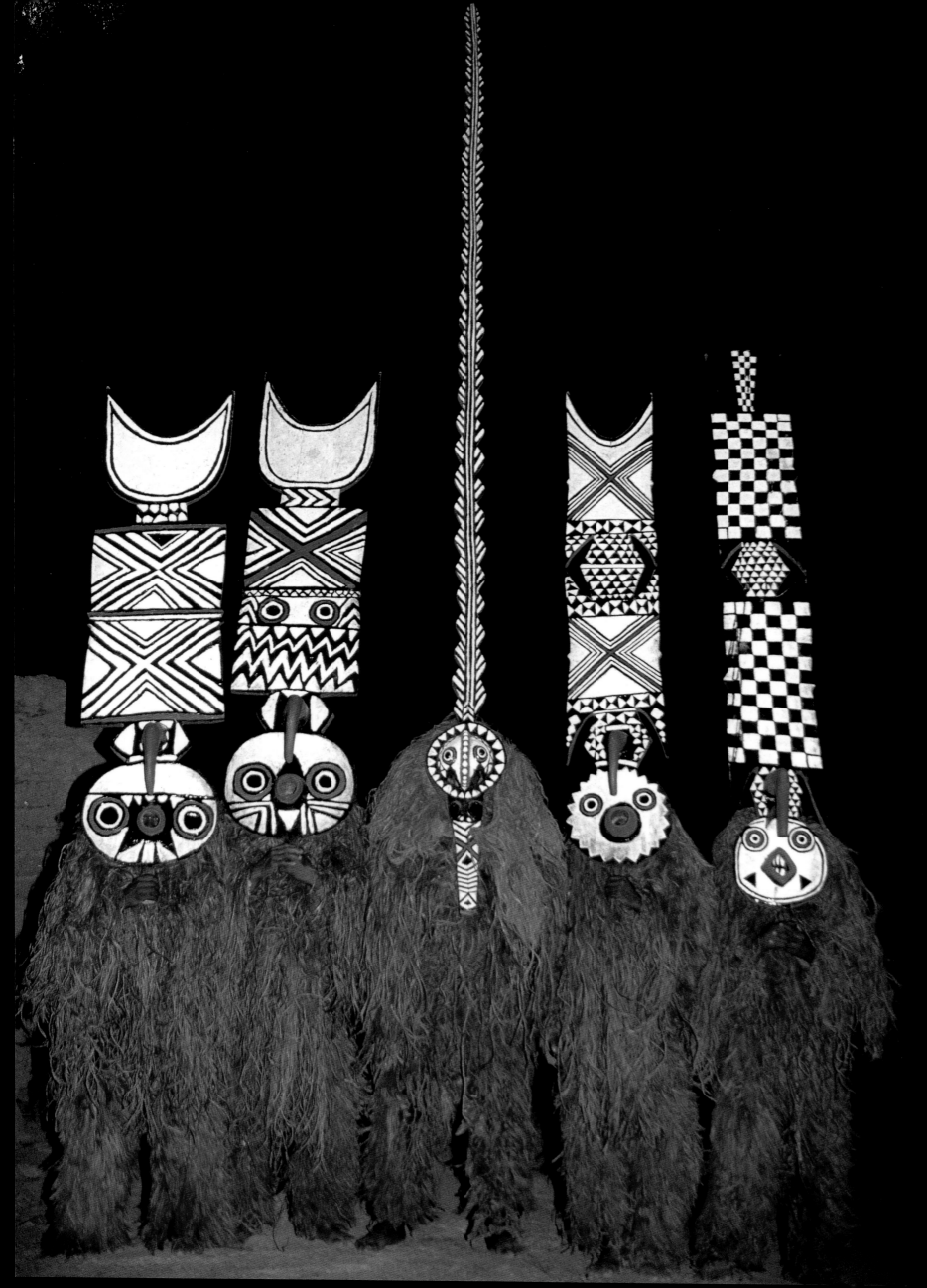

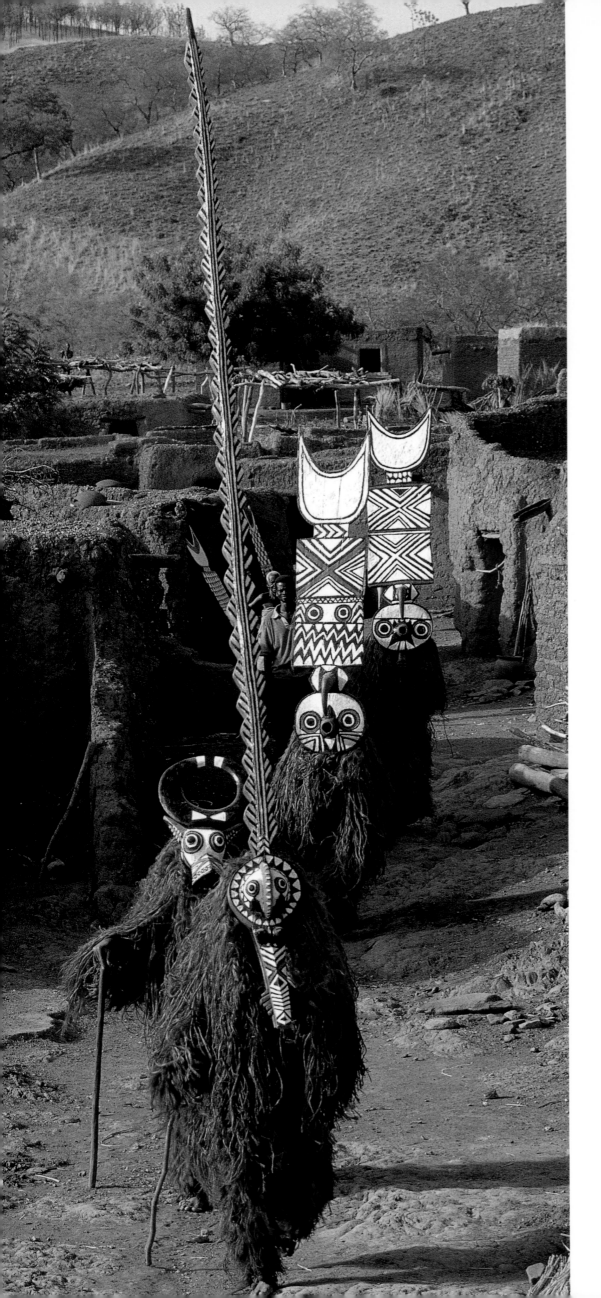

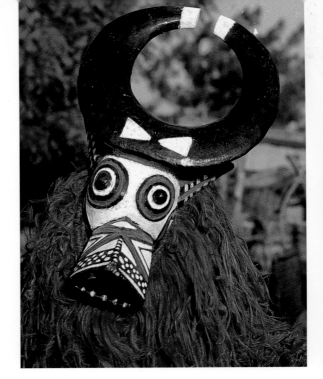

Messengers from the Spirit World

The sun has not yet fully risen and the village paths are still deserted when a line of masks proceeds to the ceremonial square. Led by the serpent mask and followed by the buffalo and two owl plank masks sent by the neighboring Bwa people, these Do-society maskers wear voluminous raffia costumes crafted by the highly respected blacksmith caste. Made of wood and plant fibers and decorated with geometric designs on the head crests, the masks act as human emissaries, while remaining entities of the bush. An artful synthesis of the two worlds, they are regarded as the perfect conciliators in all spiritual matters. The buffalo mask, known as N'Sinh (*above*), appears on the first day of the seasonal masking ceremony, chasing away evil that people have brought on themselves as a result of their transgressions against nature. N'Nan Gui, the chameleon mask (*right*), enacts a pantomime with slow reptilian grace. A powerful totemic creature, the chameleon is traditionally associated with change and the transformation of an individual from the mortal state to that of the spirit. Playing a major role in funereal rites, it serves as a messenger of the other world.

Following pages: Leaping with explosive energy, the antelope mask bounds through the village using a pair of long sticks to mimic the animal's stride.

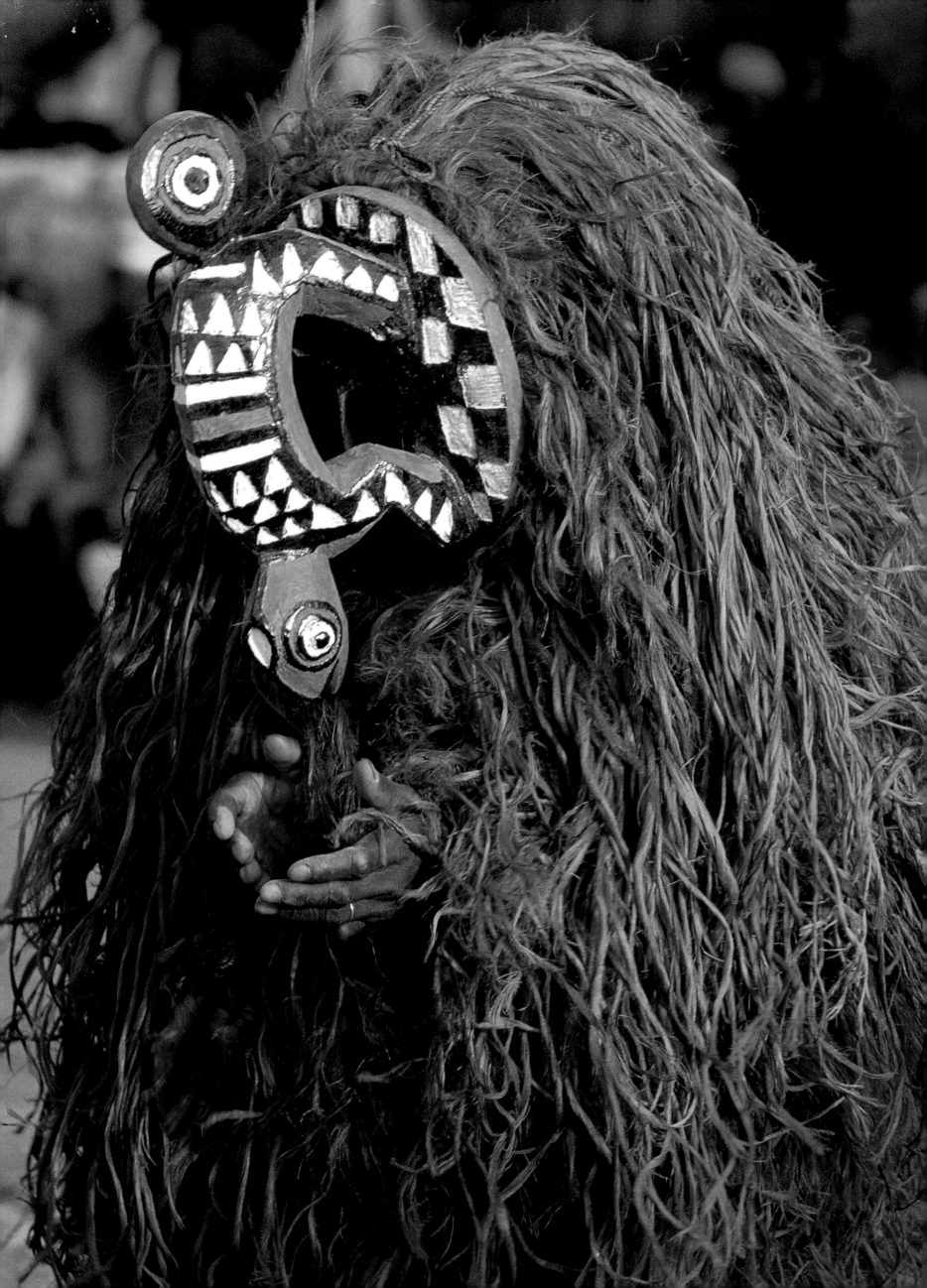

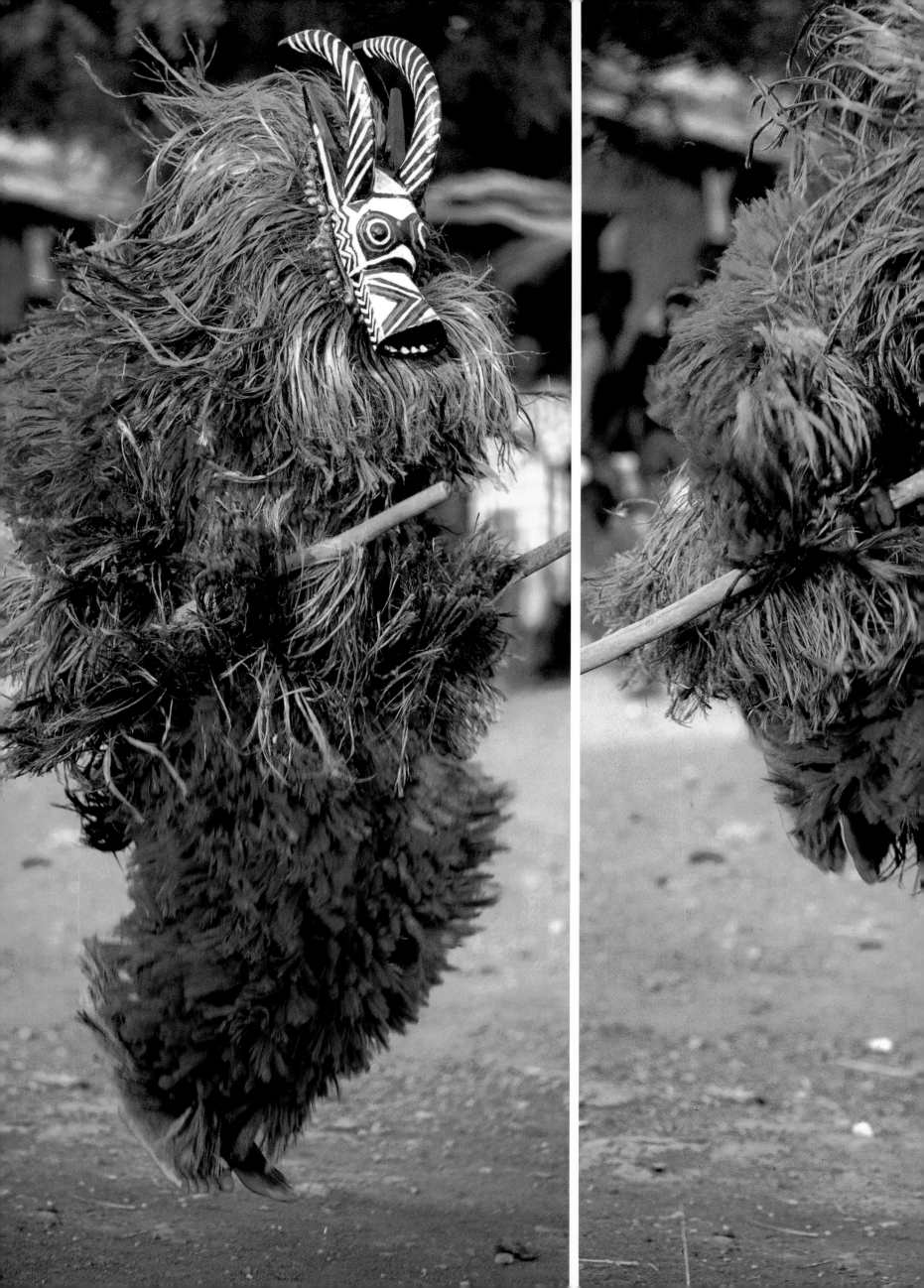

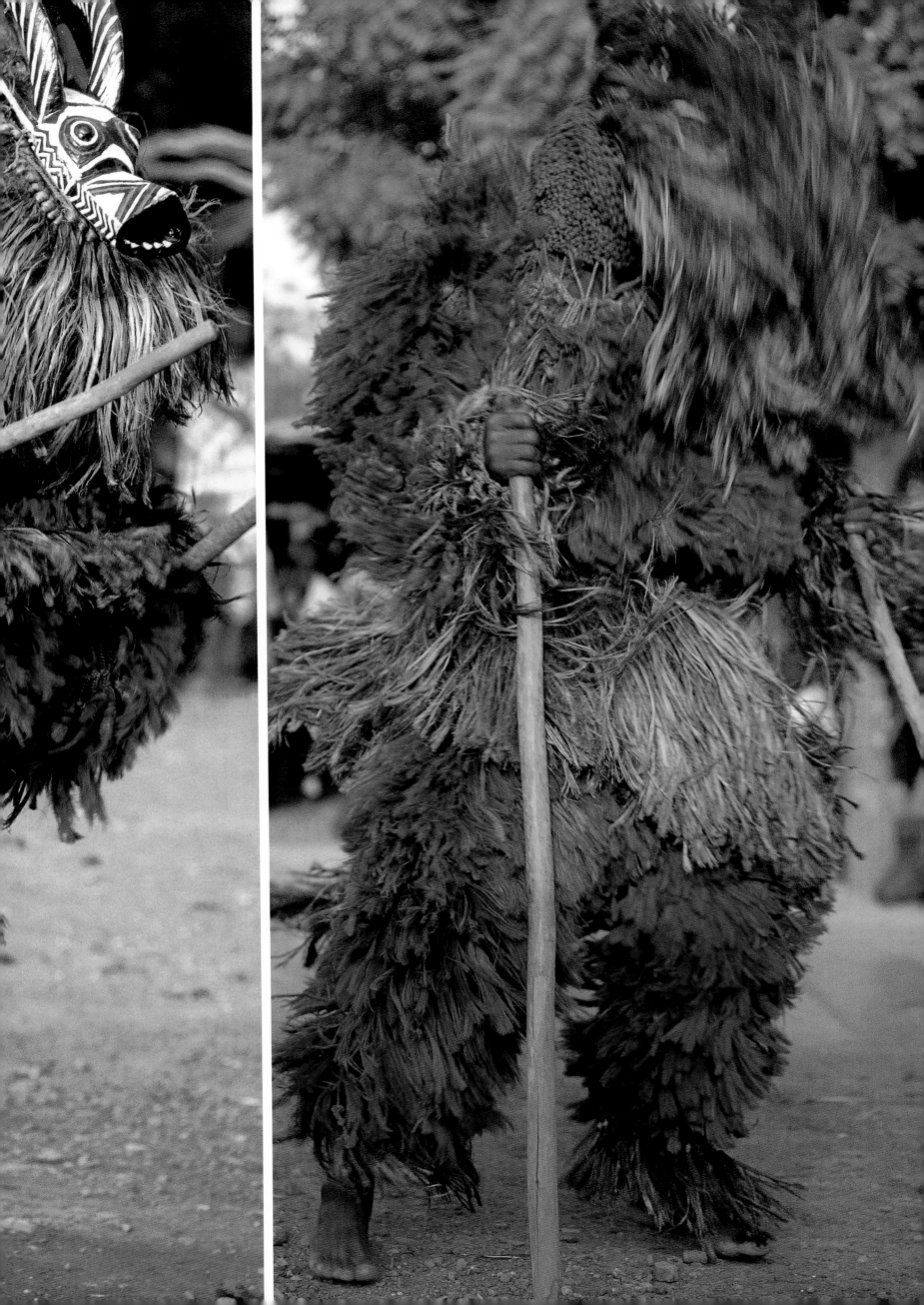

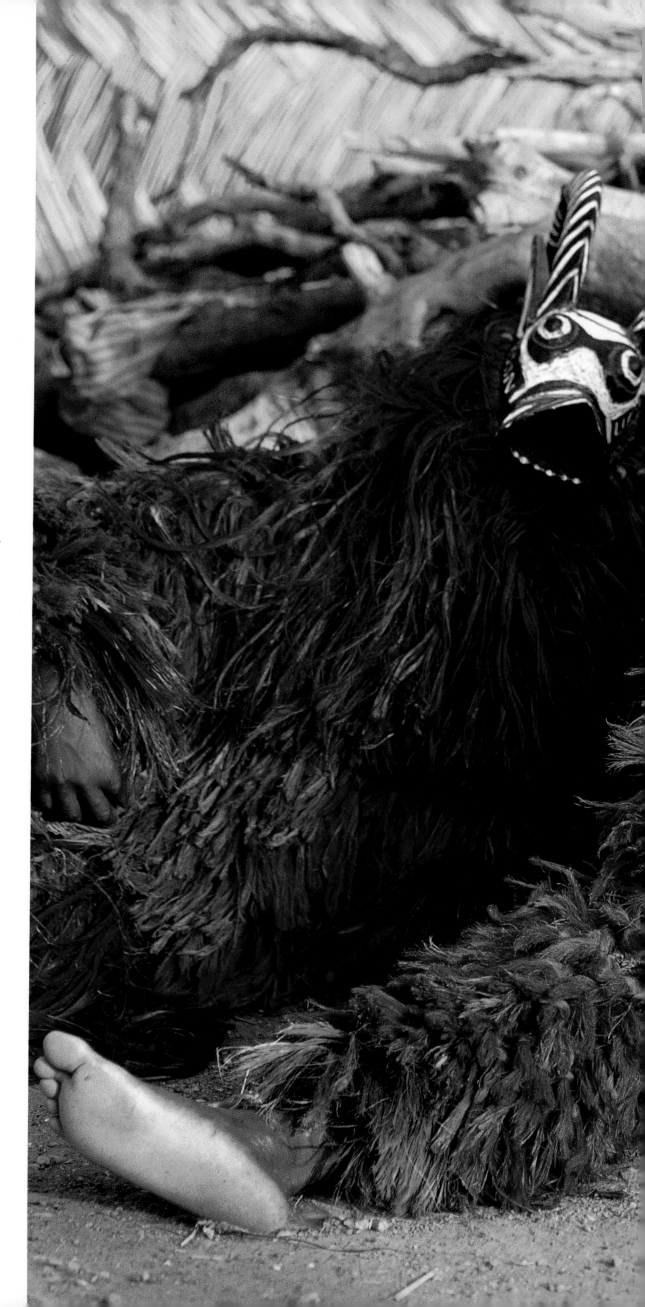

Dancing Away the Dead

Two antelope masks, called Kaan, rest
between dances. Exhausted by their
athletic exertions, they are cared for by
ritual guardians, who revive them with
millet beer. For the rest of the day, the
masks dance and parade among the
crowds removing negative energy accu-
mulated in the community since the last
harvest. Having been ritually cleansed
and absolved of misdeeds, the villagers
are now free to begin sowing and cultivat-
ing in preparation for the approaching
rains. The steps danced by the maskers,
performed over many generations, are
extremely complex. Danced correctly,
these movements are entreaties to the
creator god, Wuro, to bestow good crops,
health, and general prosperity on the
community. Any departure from the pre-
scribed steps would be considered highly
inauspicious, and disaster could follow.

Following pages: At Bobo funerals, the
masks confront the lost souls of the dead
in a series of ritual dances in order to
drive them into the afterworld. Funeral
maskers are a blur of explosive energy as
they spin, twirl, and jump their way
through a set of acrobatic dances. To the
loud accompaniment of horns and drums,
literally designed to wake the dead and
remind them that they have outstayed
their welcome in the material world, the
dancers contort their bodies, sometimes
disconnecting the heads of the masks
and spinning them independently.

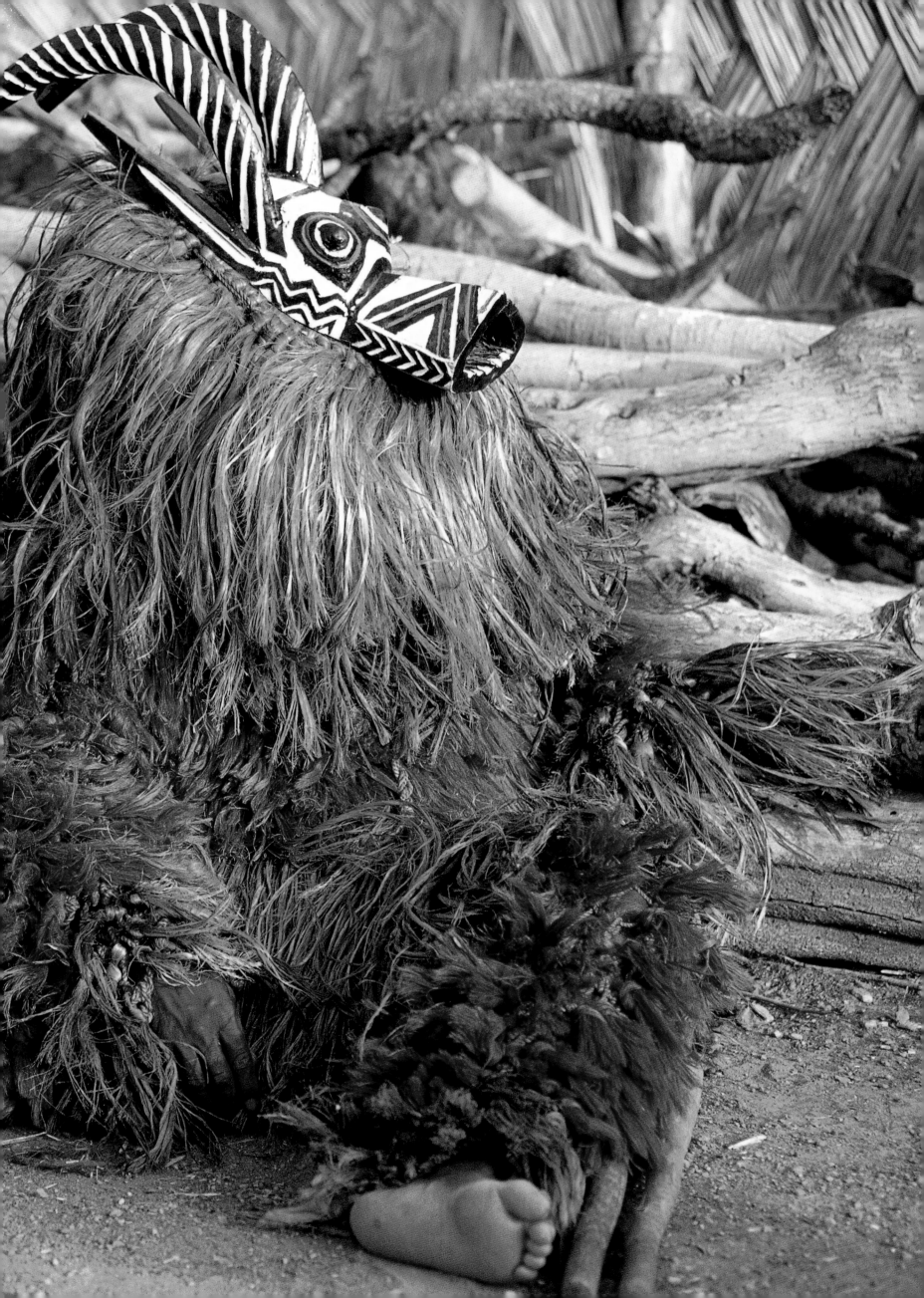

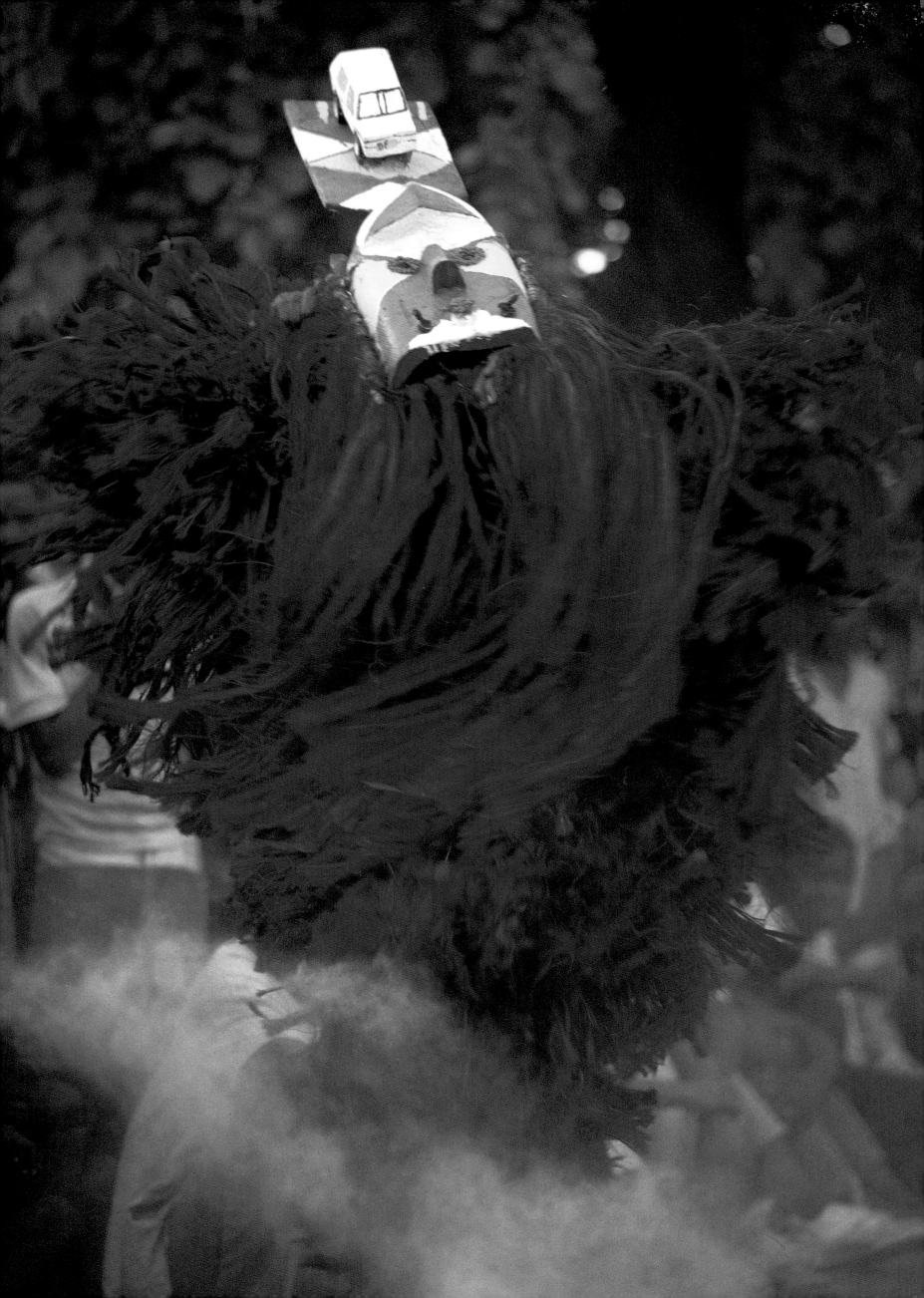

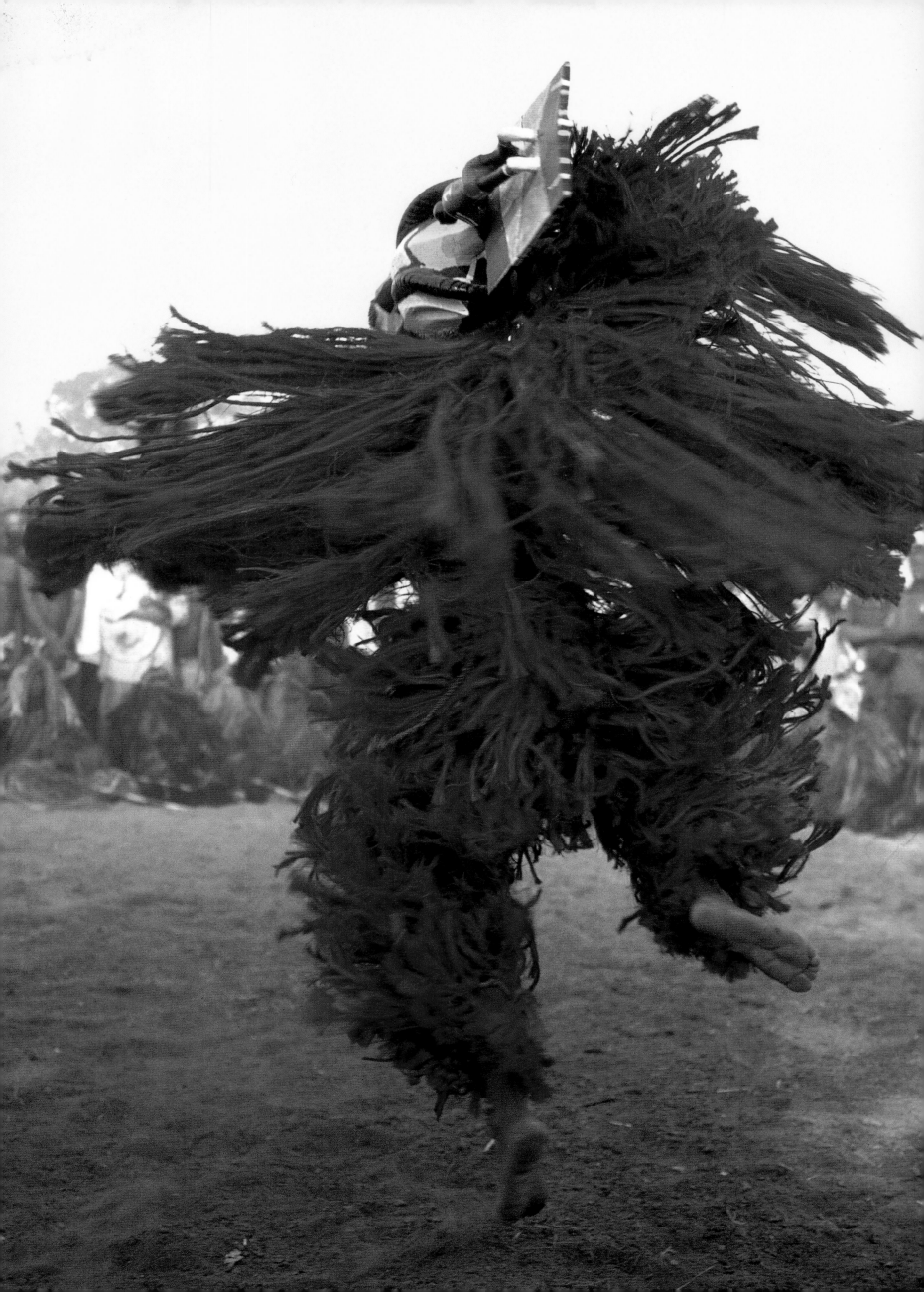

Yoruba Masquerade

Among the Yoruba people of southwest Nigeria and Benin, the Gelede society of masks plays an important role in a rich culture of drama, masquerade, and poetry. Every year, from March to May, the society performs a ritual masquerade in gratitude for the harvest and to invoke the arrival of the rains.

Danced exclusively by male members of a secret cult who have been trained in the art of masking from the age of five, Gelede offers a comedic, often farcical, spectacle that belies its more serious function of social and spiritual control. Gelede masks symbolize the omnipotent force of the ancestral mother, Iya Nla, who is believed both to nurture order and to threaten stability in Yoruba communities. The objective of Gelede ritual is to identify and eliminate the negative aspects of female power and replace them with the more benevolent themes of fecundity, maternity, and well-being. Elaborately dressed in vibrant costumes and crowned by masks representing characters from Yoruba folklore, the dance masters create a satirical world drawn from aspects of daily life. The masks worn include puppet masks that lightheartedly represent traditional proverbs, and intricately carved animal masks that remind the audience of the dangers of ignoring social position and natural order in the world.

Gelede masquerade opens with a performance of Efe prayer songs that honor the ancestral and living mothers in Yoruba society. The maskers dance to the insistent rhythm of drums that play linguistic phrases called *eka*. These are instantly recognizable to the Yoruba, and spell out cautionary tales that instruct the crowd on correct conduct in life. The crowd strains to catch the precise steps of the masks as they whirl majestically around the village square. Pairs of masks performing in quick succession demonstrate a mastery of increasingly complex drum phrases, sending out proverbial messages as they dance.

Eventually, the onlookers become so excited that they burst into the square and join the energetic pantomime. The masks' performances reach a climax, returning chaos to order, winning the benevolent blessing of the mother god.

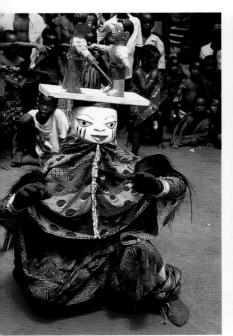
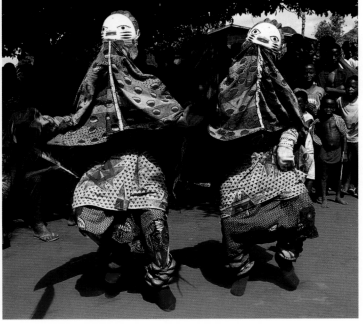

Above left: An Awo mask, portraying two brothers fighting, warns of the perils of family feuds. *Above right:* Two identical Lossi masks move in perfect synchronicity, illustrating the belief that twins share the same soul. *Right:* Profile of a Lossi mask.

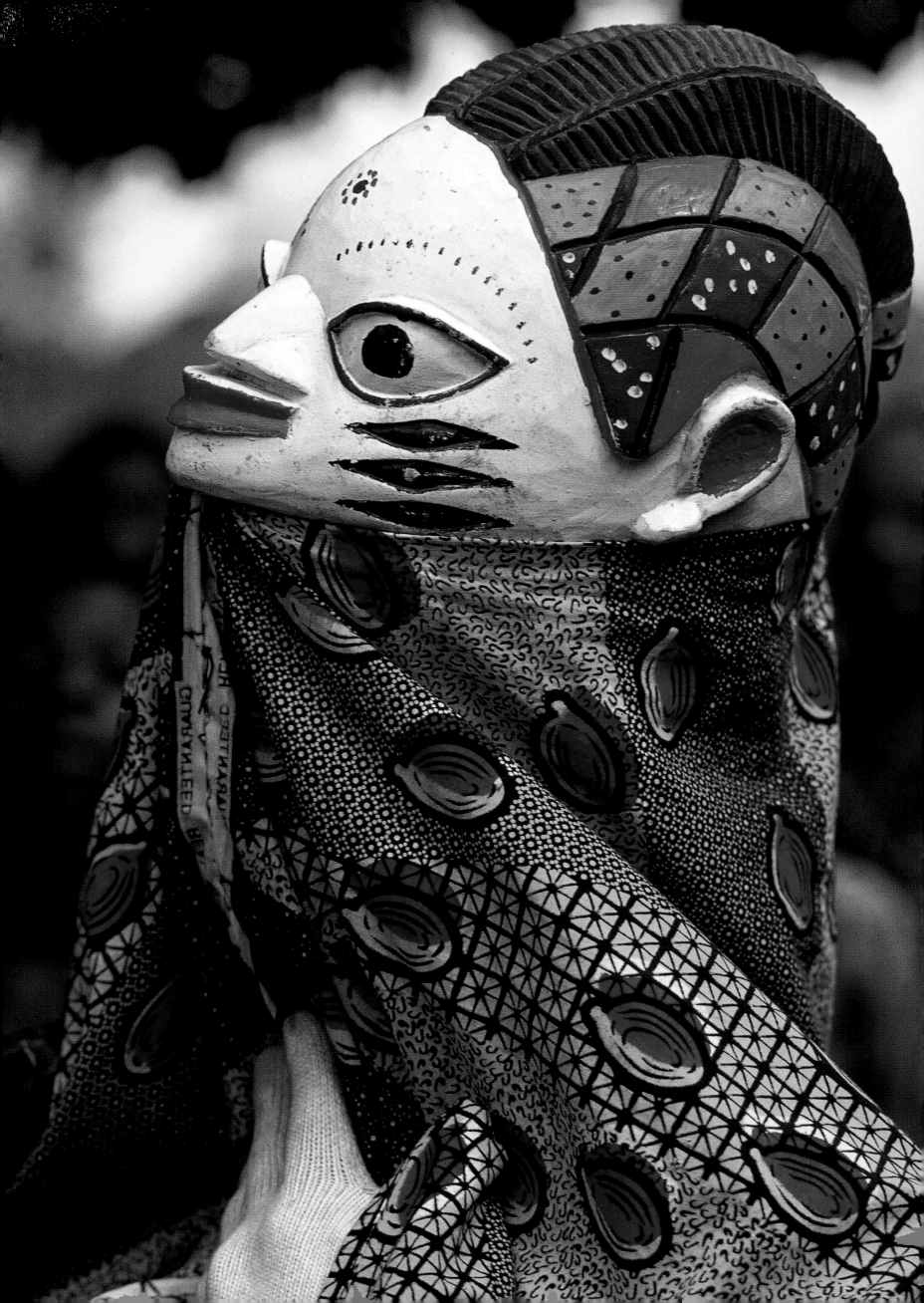

Masks of Morality

Gelede masks appear comic but possess a darker, more serious side that conveys powerful messages of moral and social instruction. *Left and below left:* The Daguno mask embodies female fertility in a ritual dance of maternity. This "pot-breasted" mask warns young women not to become pregnant before marriage. *Right:* The uncontrollable passion of romantic relationships is illustrated by two kissing Daguno masks. *Below centre:* Awo masks also illustrate well-known cautionary Yoruba proverbs. A chimpanzee urinates on an insensitive hunter (strings inside the mask release a stream of water). *Below right:* A barbaric ape mocks someone with no social skills.

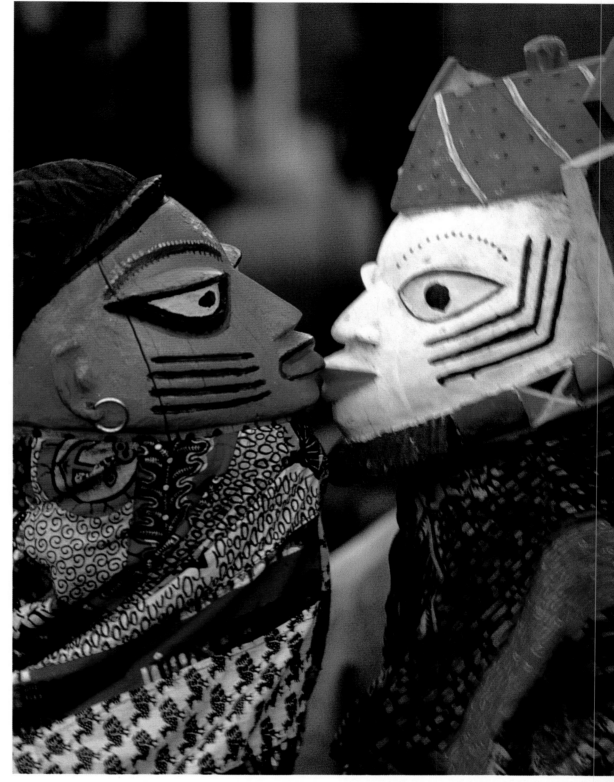

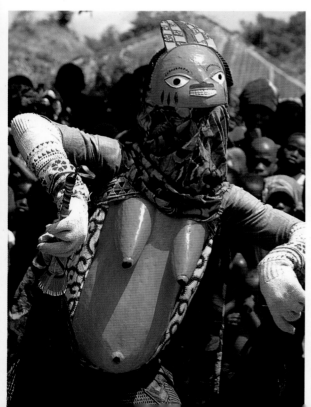

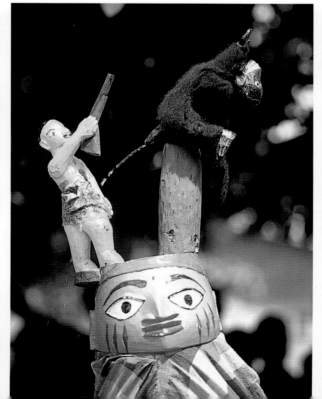

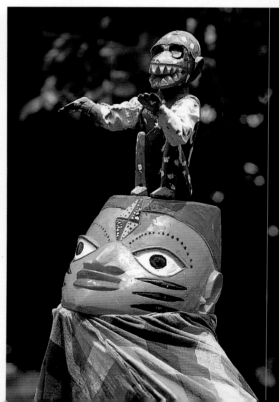

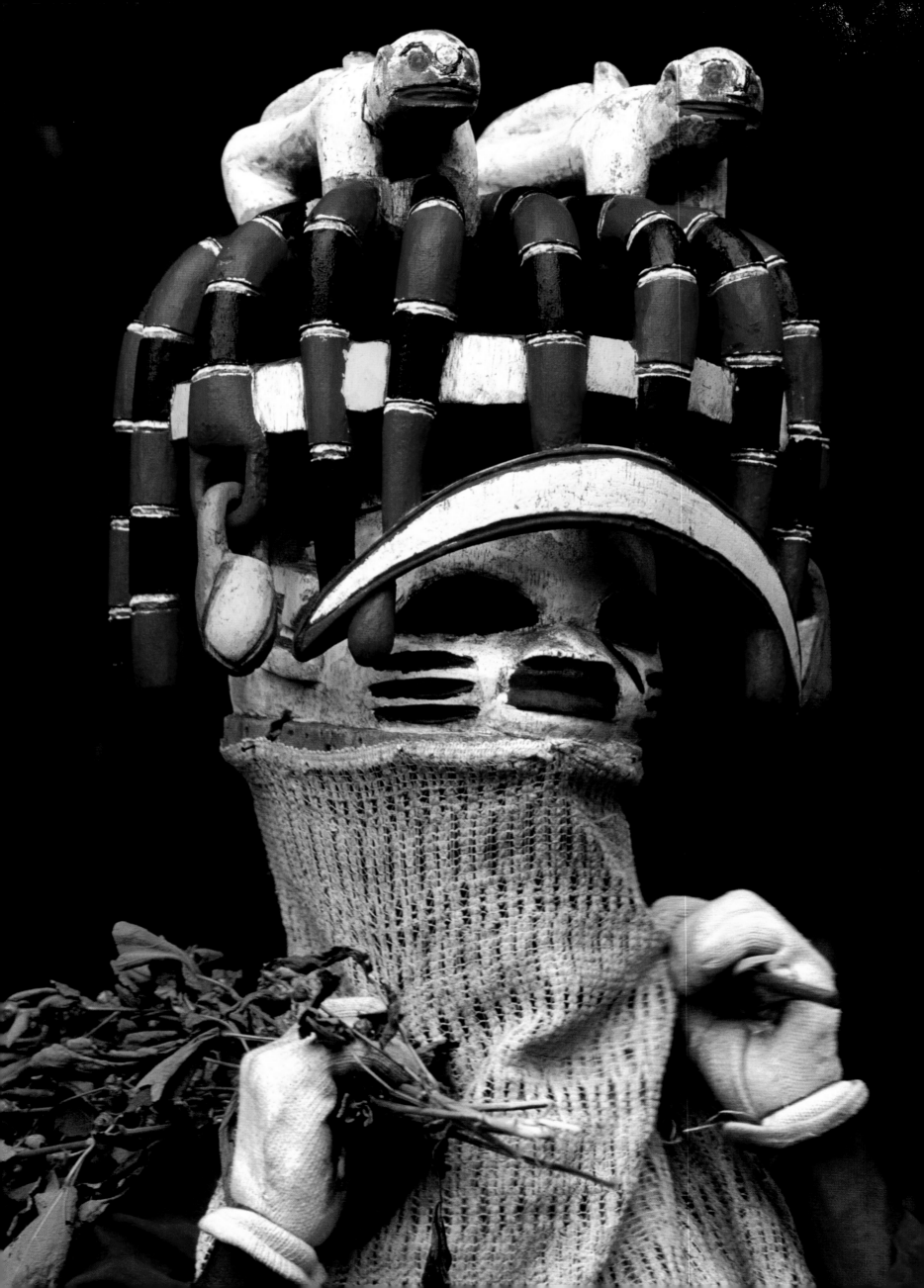

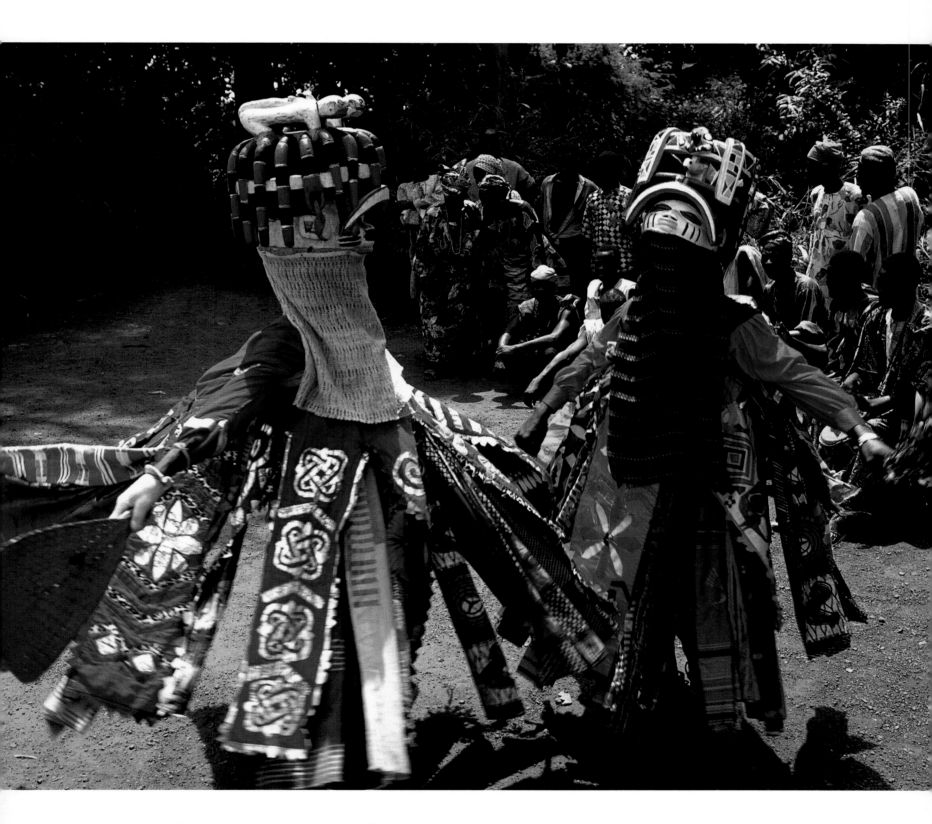

Honoring the Mother Deity

Oro Efe masks dance for the Yoruba to remind them to respect female elders and honor the mother deity. Carved by members of the secret Gelede society, their decorative facial scars and almond eyes are typical of Yoruba women, and their crescent brow symbolizes the moon. The masks feature large, carved headpieces depicting powerful creatures of the bush. The mongoose represents the power of natural law; the python symbolizes wisdom and tolerance; the boa stands for abundance and prosperity. Serpent masks are worn to bring rain or healing to the community. These and other creatures form part of an intricate natural hierarchy of power and social position. They remind people through allegory and riddle to respect those who are powerful, in particular, female elders.

Following pages: Oro Efe masks emerge from the sacred forest to sing traditional prayer songs, called Efe. These songs invoke divine blessings on the Gelede festival.

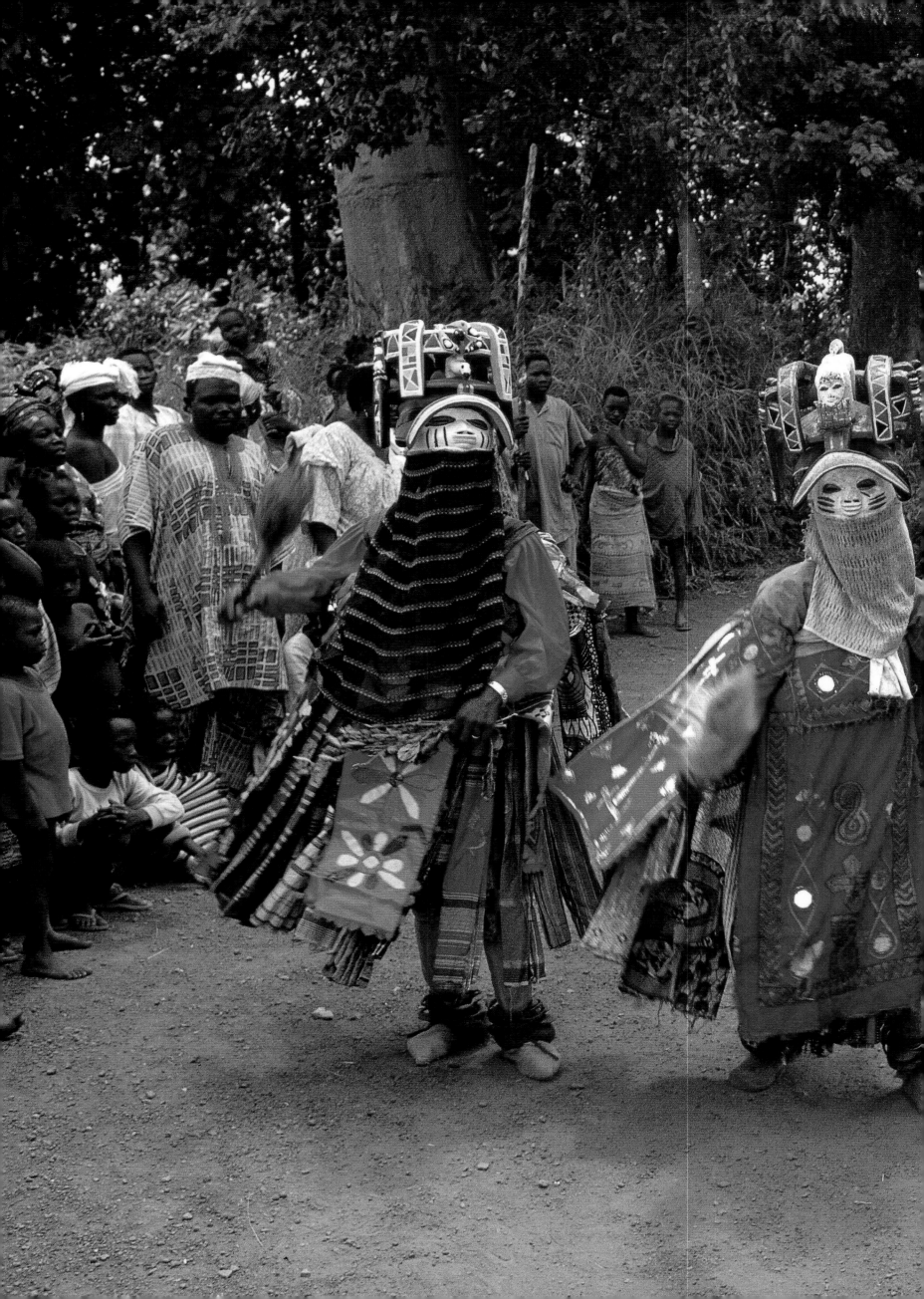

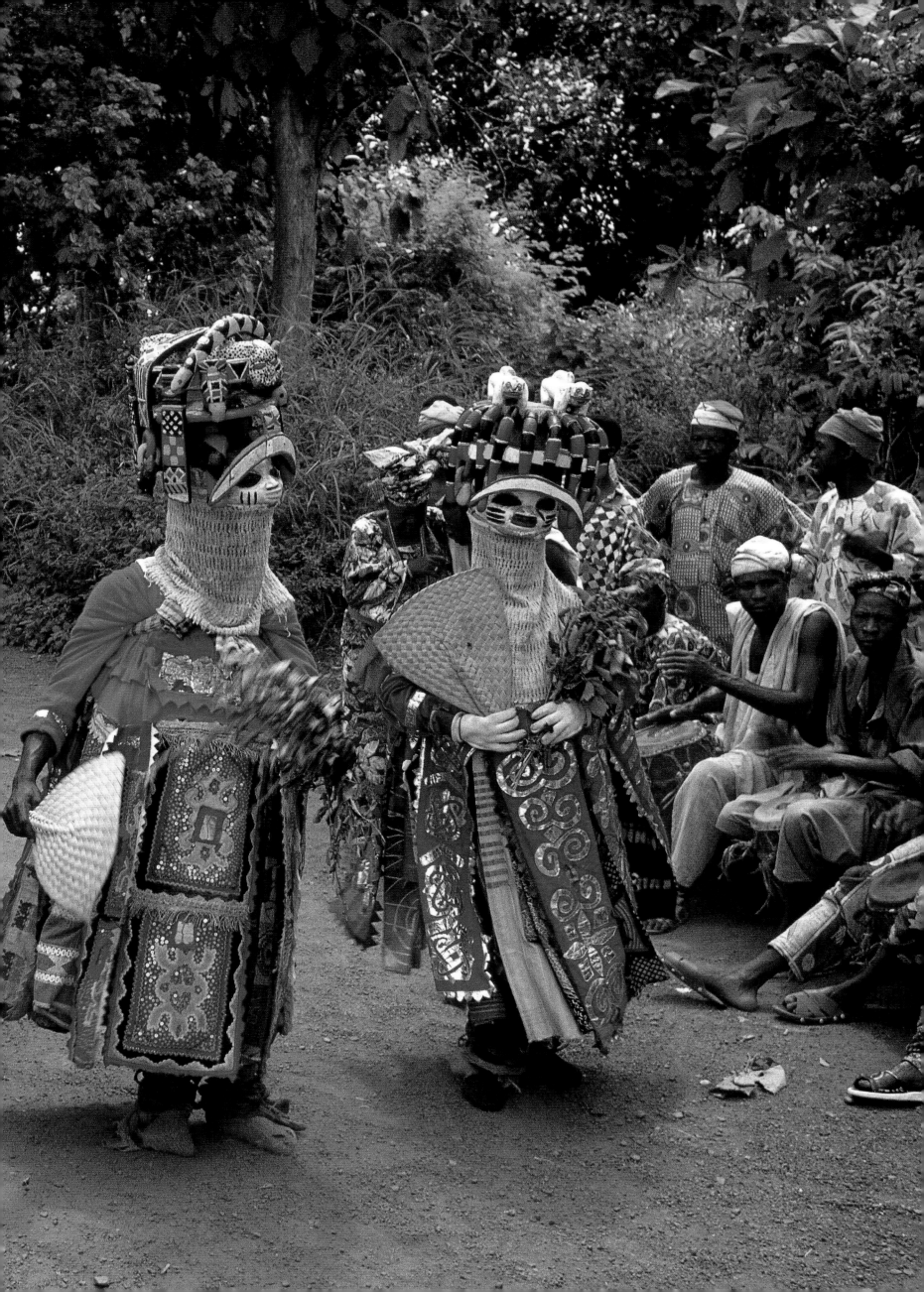

BELIEFS & WORSHIP

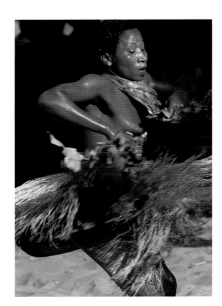

The distinguished Dagara shaman and modern scholar Malidoma Patrice Somé sat back on a couch in London, deep in thought. "What is their secret?" we asked him again. "How is it possible for people to dance on broken glass without cutting themselves? How can a man kill a chicken by pointing a knife at it, or a woman chew razor blades and swallow them without ill effect?" Only a few weeks before, we had witnessed these unbelievable feats performed on a beach in Ghana at a secretive gathering of voodoo devotees—followers of the powerful local deity, Koku. Now, back in London, we were searching for an explanation of the amazing events we had seen.

"You see," Malidoma finally answered, "you must be open to these transcendent experiences. Westerners, no matter how enlightened, may not have the ability to see these things clearly. Your secular lives have put up boundaries between the world of the spirits and the physical world. We don't see those boundaries. We can embrace things you may find inexplicable because we understand them. We are open to them. It is as if you haven't developed a sense of hearing yet. We Africans can hear it all—the music and din of the spirit world."

We listened to him carefully. Was it true? Have we in the modern world lost the ability to access the spiritual? What had happened to those devotees of Koku in that impassioned celebration on the beach?

INDIGENOUS BELIEFS

In many parts of Africa, the individual and the spirit worlds are inextricably bound together. Indeed, our Western forebears embraced this link: our word *religion* comes from the Latin, *religio*, which means an obligation or bond. The early Greeks quested for spiritual knowledge through membership in mystery cults, where they developed a personal relationship with the gods that was not taught but experienced.

Indigenous African religious beliefs often promote this direct link with the gods. Through the medium of ancestors, deities, or local spirits, these beliefs bring the practitioner into dialogue with the spirit world. This close connection can be liberating, but it is also dangerous: the powerful spirits must be respected in order to gain their protection.

Many religions in Africa are founded on a belief in a fundamental overarching creator god, sometimes a remote and distant deity, under whom there are lesser deities associated with various aspects of the world. For the Himba in Namibia, the creator god is Mkuru, the Supreme Being, who embodies all of the ancestors and is symbolized by fire. For centuries the Himba have carried this sacred fire in the form of a glowing ember whenever they moved the location of their camp. They believe that the ancestral power within the fire is the source of all physical and spiritual healing. On a daily basis, however, it is the lesser deities that intervene in the material world and influence the lives of devotees. Consequently, it is these deities toward whom much religious activity is directed.

THE ANCESTORS

For many Africans the ancestors provide an important continuity for the community. They mediate between the world of the living and the realm of the spirits and can intervene directly on behalf of a family or individual. Some believe that ancestors reincarnate as children within the family or lineage. But not everyone qualifies to be an ancestor—an individual must live a good life and a long one before joining the realm of ancestors in the spirit world. The ancestors hold power and wisdom and must be consulted through appropriate

channels before any important activity is attempted. This communication is usually carried out either by the head of the family or by a specialist such as a soothsayer, diviner, priest, or priestess. These intermediaries seek the advice of the ancestors on behalf of those with personal problems, such as infertility, children's sickness, or ways to appease the ancestors for killing an animal. They also receive ancestral assistance with communal concerns such as planting crops, timing a harvest, bringing rain in times of drought, and preventing the spread of epidemics. They even consult the ancestors regarding the most auspicious dates for holding ceremonies such as initiations and marriages.

Soothsayers and diviners use many different methods to address the physical and spiritual needs of the individual. In the Ivory Coast, a Senufo diviner interprets a collection of sacred items scattered on the ground in order to answer the questions asked of the spirits. After receiving the advice of the diviner, a client who has profaned an ancestor may be told to return home to make an animal sacrifice or have a talisman made to reconcile himself spiritually. In the Volta region of Ghana, when a crime has been committed, a soothsayer may request the family of the criminal to give one of their young daughters to the shrine. This act will absolve the wrongdoer and protect the family from the retaliation of the gods. The innocent girl must serve the priest and act as his "wife" for life.

CULT PRIESTS AND PRIESTESSES

The deities who act as messengers to the creator god may take the form of natural phenomena (earth, stones, and trees), carved sculptural figures, or even amorphous mounds of earth filled with sacred medicines. These objects of worship are often housed in shrines and cared for by cult priests and priestesses

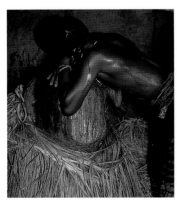

who go through a strenuous period of training, lasting from six months to three years. Concentrating on the arts of healing and religious practice, such training will allow them to speak in the tongues of the

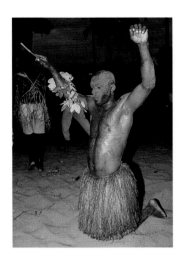

spirit world—the language of the gods. Dedicating their lives to the cult deities, the priests and priestesses make sacrifices and pour libations to elicit the power of the gods on behalf of their followers.

The knowledge of the spirit world held by cult priests and priestesses, and their techniques for intimate contact with that world, make them highly respected members of their communities. These powers can be inherited from family members or acquired through individuals' innate spiritual receptivity. Some priests and priestesses have been cured of illness by a shrine's deity and interpret this as a calling, subsequently dedicating their lives to the shrine.

One of the most powerful cult priestesses we met was the late Nana, a ninety-year-old woman who tended the Akonedi shrine in Lateh, Ghana. She was renowned for healing stomach pain and paralysis, as well as for curing infertility in women. We visited her early on a Tuesday morning, the time when she received people who needed help. Lying in bed, surrounded by her many shrine attendants, her body trembled as she began communicating with the spirits. Speaking in an unintelligible tongue, she was approached by a succession of devotees, including three infertile women. We learned later that in gratitude for Nana's services, each woman had offered to give her firstborn child to the shrine as a future priest or priestess dedicated to healing others. So great was her reputation that people came from all over the world to seek the restorative powers of Nana.

VOODOO

The cult of voodoo (variously known as vodou, vodun, and vodu) originated in West Africa. From the fifteenth century onward, it traveled with the transatlantic slave trade to Brazil, Cuba, and Haiti, and took myriad forms, among them Candomble and Santeria. Its origins and practices are still at the core of spiritual life for millions of people in Benin, Togo, Ghana, and Nigeria. Voodoo is a way of life, a religion that

incorporates hundreds of different deities who are physically embodied in a variety of natural and sculpted forms. Among the most popular deities are Mami Wata (goddess of water), who brings wealth and power to women, Hebioso (god of thunder, also known as Shango), who protects the innocent and punishes wrongdoers, and Sakpata (god of smallpox), who cures epidemics.

LIBATIONS

The gods of lineages and cults are active deities who need to be fed and looked after. Pouring a libation is a way of appeasing a deity and alerting it to the needs of the person trying to contact the spirit. Red palm oil, white kaolin powder, local gin, schnapps, and sacrificial blood may be offered or poured onto an altar to awaken the spirit and solicit its guidance. In their family compounds, the Somba of Benin construct phallus-shaped mounds to contain the spirits that protect their homes. When the Somba leave their homes, they drop a coin in front of a mound to insure protection on their journey, retrieving it upon their return. These thirsty Somba deities also need constant offerings of "spirit food"— millet beer and the blood of animals—to sustain their protective roles.

HEALING

Physical and emotional healing are important benefits for the adherents of many indigenous belief systems. At the Seko Voodoo Hospital in Togo, the chief priest, Sewavi Adjevi, claims a 90-percent success rate in treating afflictions as diverse as cirrhosis of the liver, lovesickness, and witchcraft. There are three shrines in

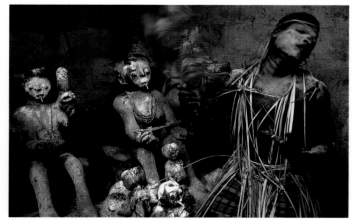

the hospital serving different types of illness. The first shrine houses a pair of deities—Gabara, who cures problems of lovesickness for women, and Agbengpan,

who, in the shape of a giant phallus, treats impotence in men. The second shrine is dedicated to Lansan, who cures major physical illnesses. The hospital's third shrine, considered highly dangerous, is dedicated to Hebioso, the famous deity of thunder, who has the power to curse, kill, punish, and make war. With appropriate libations, Hebioso's power can be channeled into a healing force.

In many African societies, individual healers have the unique ability to use the power of the ancestor spirits or creator god for the benefit of the community. The Himba of Namibia depend on these healers to access the spirit world to find the causes of illness. Once the source has been identified, the healer wrestles with the invading spirit to exorcise it from the afflicted person. Drawing on the power of three generations of ancestors, Katjambia, a renowned Himba female healer, rescued three women possessed by the spirit of a lion. We saw the women crawling around on all fours, growling, fighting one another, and risking injury. Exorcising the malevolent spirit, Katjambia was able to restore them to normalcy.

MIRACLES

Voodoo followers, possessed by their deities during worship at shrines or community gatherings, often perform amazing feats of superhuman power, which they refer to as miracles. We have seen men evince no pain when touching white-hot knife blades to their tongues. Other men seem suddenly able to lift huge weights, or appear impervious to the sting of cactus thorns piercing their skin.

Once every three years, on the border of Ghana and Togo, the spectacular Kokozahn celebrations take place, dedicated to the warrior deity, Flimani Koku. Over a period of seven days, hundreds of believers demonstrate supernatural powers. We saw the barefoot son of the Koku priest jump into a barrel of broken glass and perform a vigorous, shuffling dance to the rhythm of drums. After moving his feet across the shards of glass, he emerged unscathed. Another man single-handedly pulled down the ten-foot-high wall of the shrine, despite the efforts of half a dozen men to restrain him. These devotees were all protected by Koku and had been given protective potions by the cult priest. In order to gain these powers, the Koku

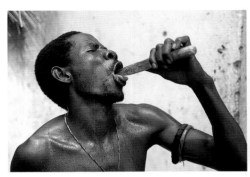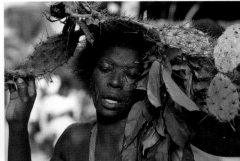

followers had to obey a series of dietary, sexual, and moral taboos before the ceremony. We were told that their transcendent experience gave the Koku followers the opportunity to "touch god"—to make a powerful contact with their deity.

TALISMANS

While most African devotees require the guidance of experts in spiritual matters, many also use amulets and talismans to ensure protection and good fortune. Talismans take a variety of forms and perform myriad functions. Voodoo initiates in Togo wear talismans woven into their hair. Around their necks Wodaabe men wear leather pouches containing special barks, seeds, and roots, to increase their virility and make their words so potent that no woman can refuse them. Talismans in the shape of a cross, representing the crossroads of life, protect them when they leave the desert and enter the dangerous city environment. The Lobi tie bells onto children's feet to attract the ancestors' spirits and to protect the innocent from harm. The Senufo of the Ivory Coast believe that if a woman treads on a chameleon, her child will die, and so the child wears a talismanic brass representation of a chameleon for protection against the vengeful nature of that animal spirit. Wodaabe men apply a powder of pulverised chameleon to their faces, which transforms them into paragons of beauty.

ISLAM AND CHRISTIANITY

Arriving in the eighth or ninth century A.D. through trans-Saharan trading networks, Islam has had a profound impact on Africa's indigenous cultures, touching nearly every corner of the continent. Today, some 20 percent of the world's Islamic population live in sub-Saharan Africa. The annual Bianou celebrations held by the nomadic Tuareg people in Agadez, Niger,

mark the Hegira, the Prophet Mohammed's migration from Mecca to Medina in the year 622 A.D. Over the course of three days, Tuareg warriors make a dramatic procession, reflecting the ancient Islamic holy wars. They join in communal prayers to Allah and visit the Islamic leaders in the ancient Sahelian town.

The Tuareg have adapted the Muslim religion to suit their nomadic lifestyle. While paying respect to Islamic tradition, they hold tightly onto their ancient beliefs about the spirit world. Around their necks, the Tuareg wear Tcherot boxes, made of copper and brass, which contain verses of the Koran as well as magical potions. Combining the elements of both belief systems makes for a shrewd double protection. The Tcherot have the power to heal injuries of men and their herds. In times of drought, we have seen Tuaregs write verses of the Koran on prayer boards and wash the ink into a calabash, drinking it to absorb the healing power of the blessings.

Although an early form of Christianity had reached East Africa, at Axum in Ethiopia, by the fourth century, the strong influence of missionary Christianity began in the fifteenth centuy, and continues to this day. Less widespread than Islam, the Christian doctrine has nevertheless had a profound impact on indigenous belief systems. Nana, the renowned late priestess of the Akonedi shrine, healed her patients through spirit possession on Tuesdays, but she attended the local Catholic church on Sundays. Voodoo followers in Benin place colorful posters of the Virgin Mary behind their cult altars to enhance the powers of their deities. Elements of imported religions are being successfully combined with indigenous belief systems. Africans see no contradiction in believing in the power of two religions simultaneously, as long as they both successfully serve the needs of the faithful.

Soothsayers & Diviners

Between the equatorial forests and the savanna grasslands of Africa live numerous isolated groups who survive in inhospitable terrains and rugged mountain retreats. Worshipping a pantheon of local deities, these people have largely resisted the introduction of outside faiths. Among them are the Senufo of Ivory Coast, the Lobi of Ghana and Burkina Faso, the Somba of Benin, the Luo of Kenya, and the Wodaabe of Niger.

For many of these people, one deity is often worshiped as the creator god, with other deities, ancestors, and spirits of the bush serving as intermediaries. Those in need can reach the spirit world through a soothsayer or diviner, who will intercede for them. Soothsayers deal with personal matters, such as how to heal a sick child or obtain forgiveness for killing an animal. They also advise communities on broader issues—the timing of initiation ceremonies or the locations for new millet fields. If the wrong times or sites are chosen, it is believed that epidemics may occur, or that rains will not fall.

Soothsayers often ask clients to perform sacrifices to appease the aggrieved spirits that are causing the problem. Home altars are set up for this purpose in many African houses. In Lobi homes, for example, clay altars often have figures built into them that represent the ancestors; Somba altars take the form of phallic mounds. Nomadic peoples like the Wodaabe do not construct permanent altars because they continually move about. Instead, they wear talismans to insure the cooperation of the spirit world. All of these indigenous peoples acknowledge the power of the spirit world and rely on it as a source of guidance in their daily lives.

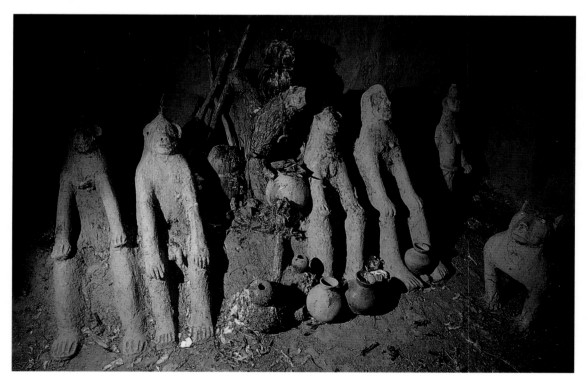

Above: A Lobi ancestral home altar in northern Ghana features clay figures representing deceased family members. *Right*: A Luo diviner from western Kenya wears a horn headdress, a cork necklace and a hippopotamus tooth which link him to the spirit world.

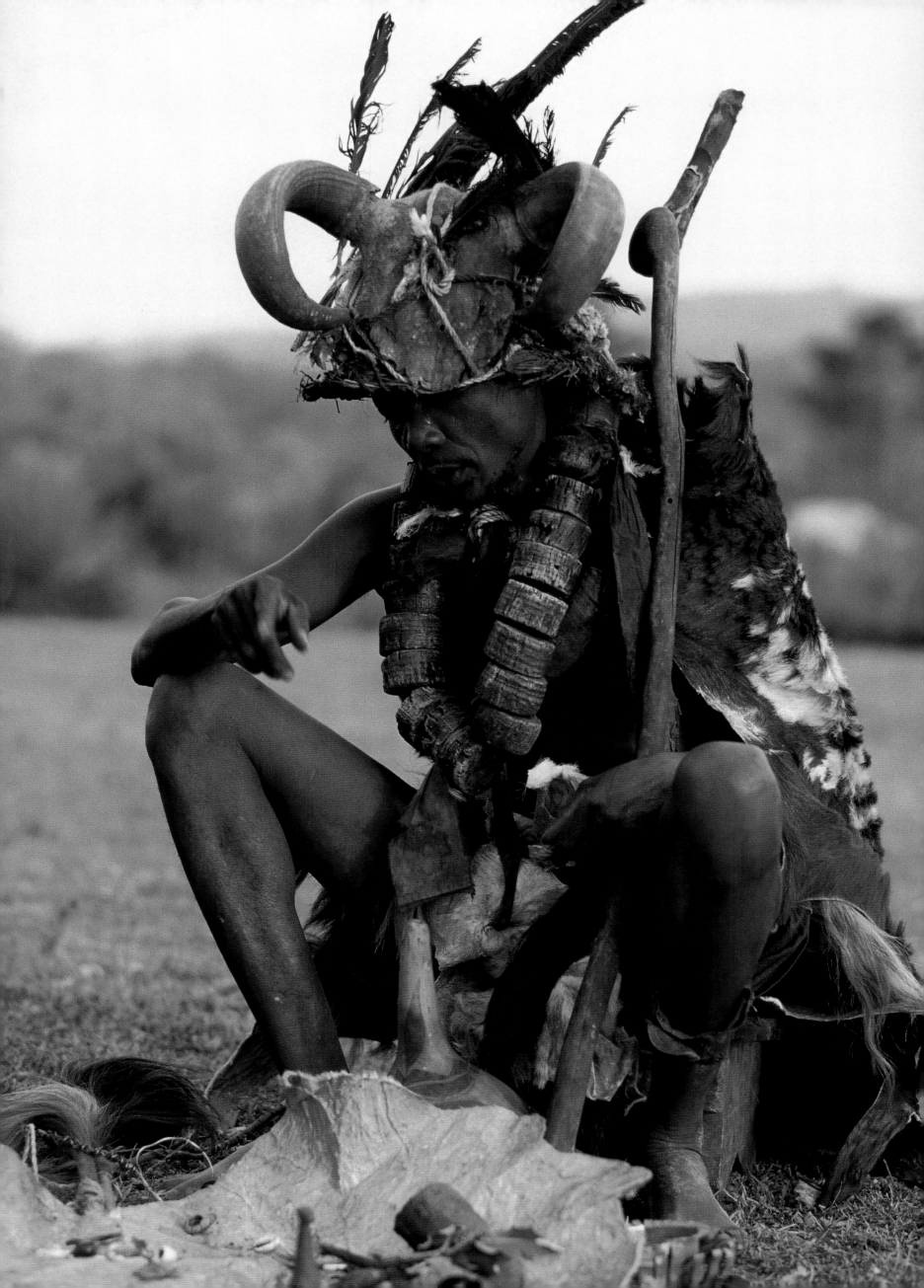

Invoking the Spirits

Preceding pages: The gourd at the feet of this Luo diviner enables him to 'hear' the voices of the spirits. When consulted on spiritual matters, he first ascertains the nature of the question by tossing sacred objects onto a cow-hide mat and interpreting the pattern as they fall. Then he consults the spirits via the gourd, which is said to "speak like a radio" to the diviner, who dispenses the advice needed. *Left*: Soothsayers from northern Ivory Coast receive petitioners in a *kargbee*, or spirit house. The outside of the house is decorated with spots like the feathers of a guinea fowl. Above: The guardian of the spirit house relaxes in the men's resting house. *Below center*: Inside the *kargbee*, wooden figures convey messages to the spirits, and clay pots filled with sap, water and medicinal leaves trap evil spirits. *Below left*: Clay reliefs depict powerful totemic creatures believed to be among the first beings created. *Below right*: Human figures with prominent genitalia covered in real hair represent ancestral power and fertility.

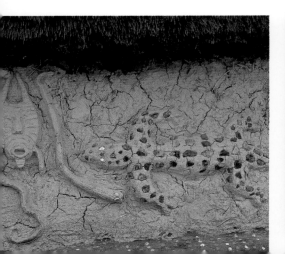
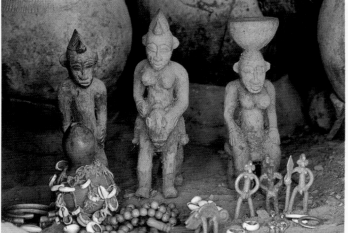
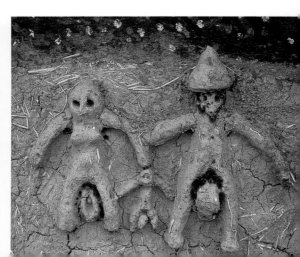

Talismans

For the Wodaabe nomads of Niger, leather pouches worn by men
are believed to possess great talismanic power. Filled with roots,
grasses, seeds, and barks, they protect the wearer from sorcery
and evil spirits as well increasing attractiveness and virility.
Right: Square leather talismans contain Koranic prayers; the
pendant decorated with cowrie shells contains a mirror to
enhance beauty; the small, round talisman is believed to make
a man invisible when he attempts to steal his lover from her
husband. *Left*: Items used in divining by a Senufo soothsayer,
include brass ornaments and cowrie shells.
Following pages: The phallic mounds outside the homesteads of
the Somba people in northern Benin, mark the graves of family
relatives. The Somba bury the dead nearby, so their disembodied
souls can continue to have a relationship with the living. To
appease the ancestors, the mounds are frequently doused with
millet beer and the blood of sacrificed animals.

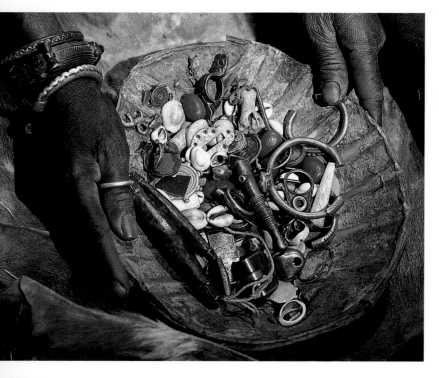

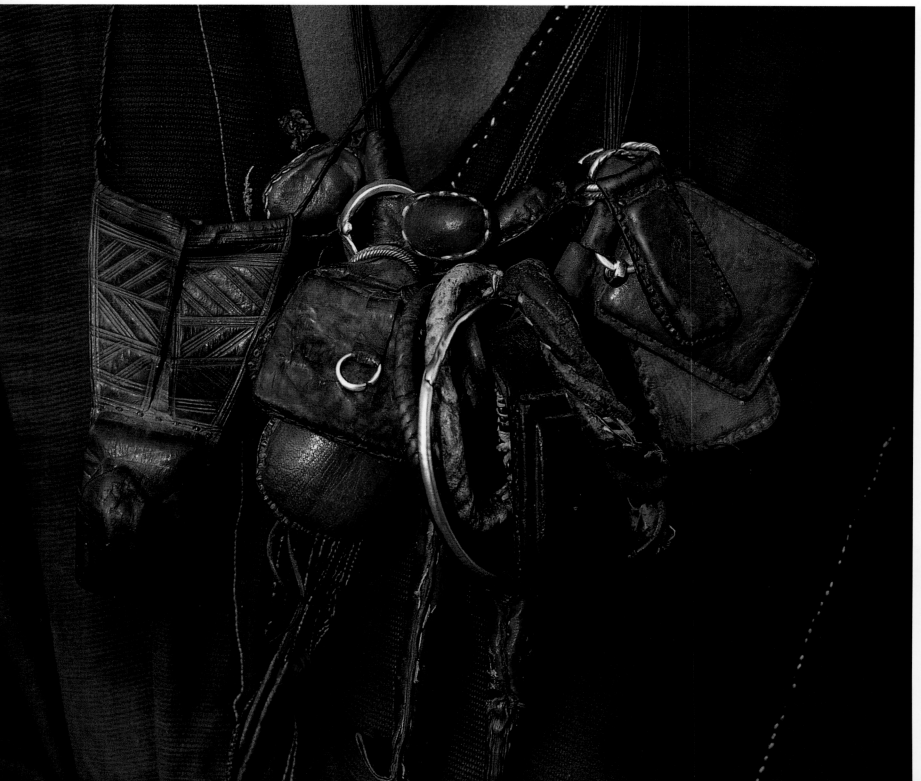

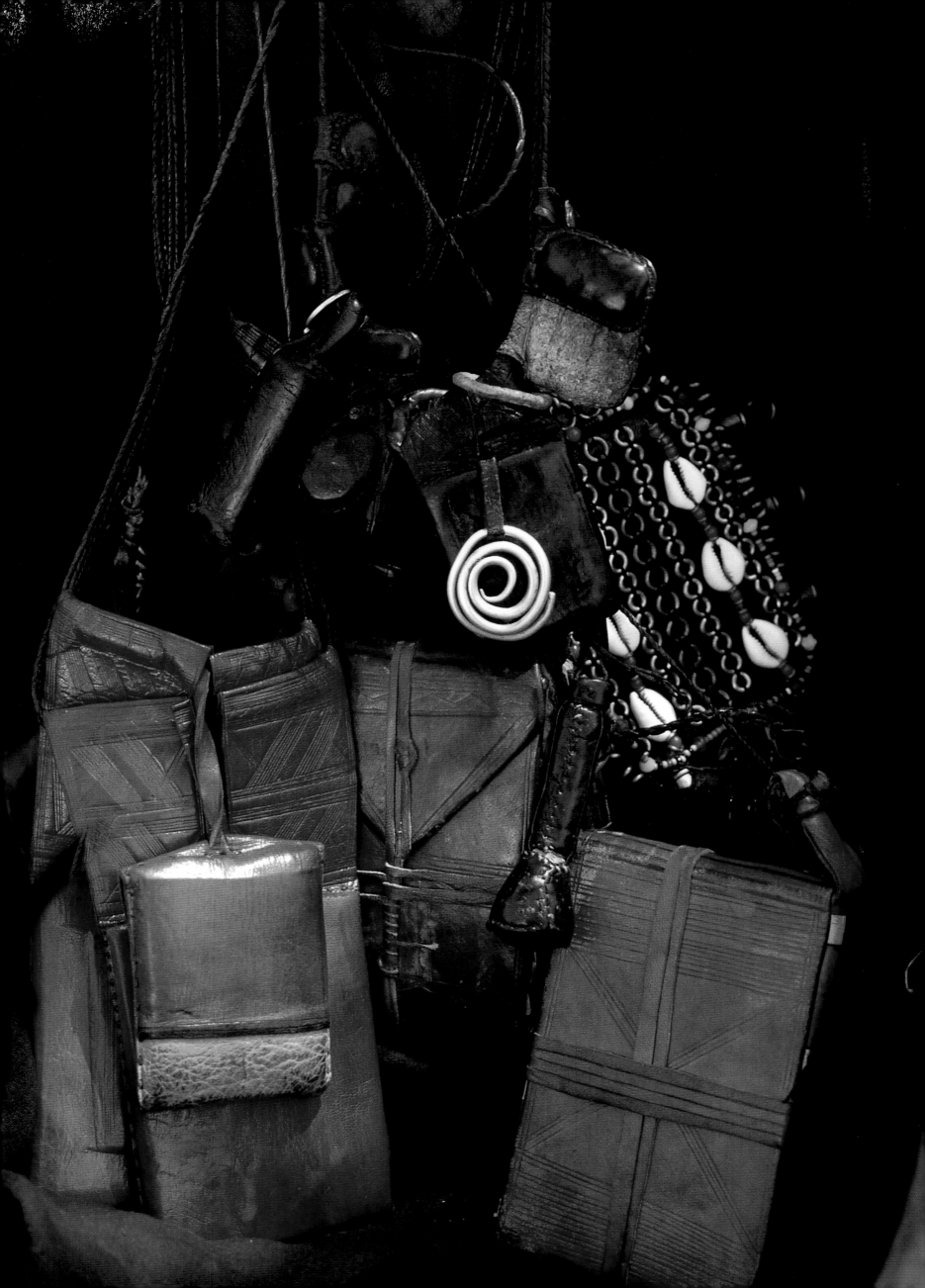

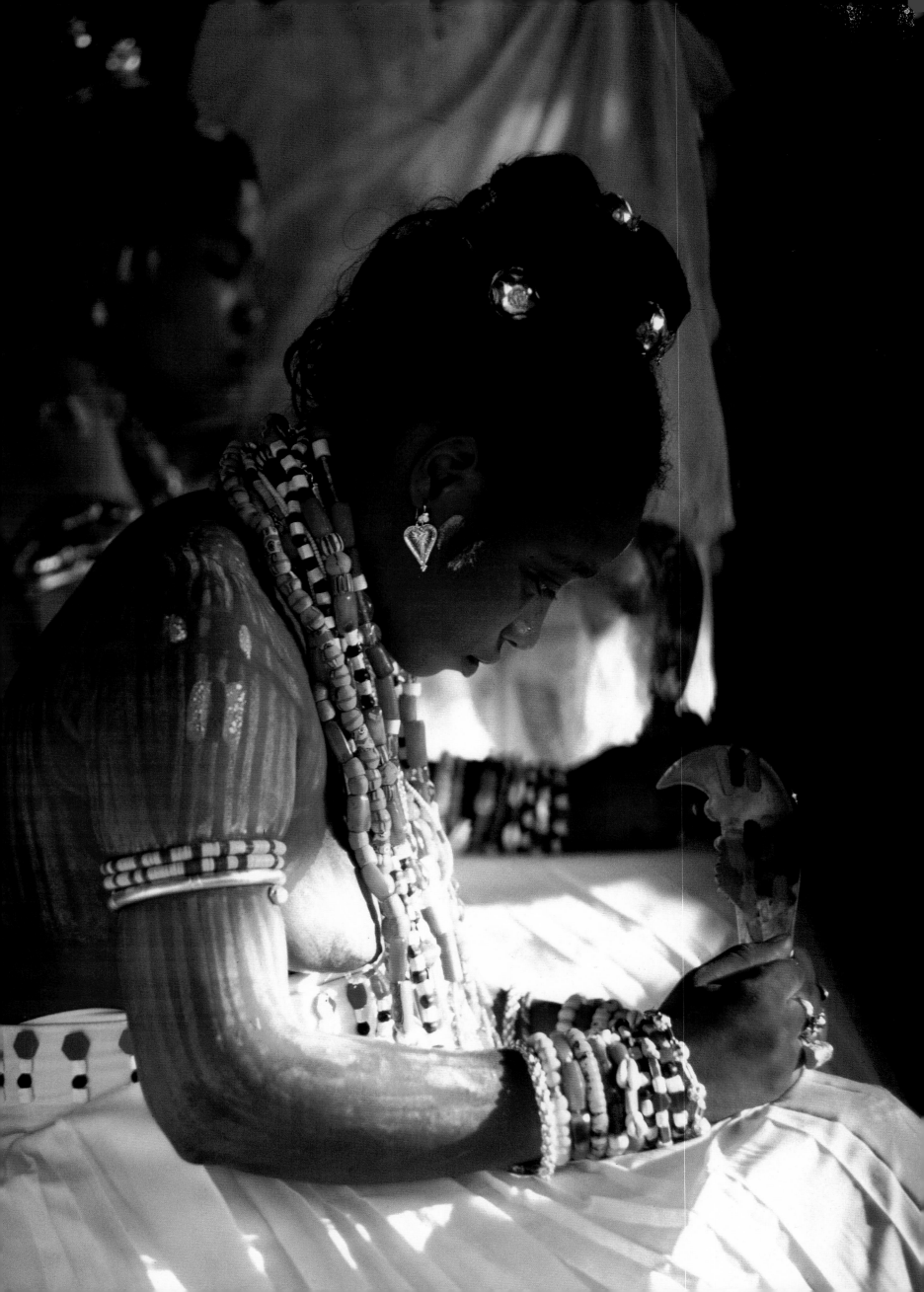

Priests and Priestesses

Men and women from the equatorial forests of West Africa, stretching from Nigeria in the east to the Ivory Coast in the west, serve their communities by dedicating themselves to a particular deity and becoming a priest or priestess. The training required to qualify for this calling takes anywhere from six months to three years, and higher qualification may take up to ten years. To enter this service, individuals are either chosen by the elders of a religious cult or they inherit the office from a parent. They can also be summoned into service by the deity itself during an ecstatic trance at a religious gathering. Other individuals dedicate themselves to a deity after being healed by it, and interpreting the event as a calling.

There are thousands of different deities in West Africa; each has its own form and character, which may range from carved wooden effigies to leather pouches containing powerful medicines. An initiate in priesthood is expected to perform many ritual duties, including the care of the shrines that house religious statuary and objects that are considered

to be the earthly representations of gods. At certain times special food and libations are prepared for the deity. Sacrificial blood and palm wine and other alcoholic beverages are offered to awaken its powers and solicit guidance, help, or protection.

Among the most important duties of a priest or priestess is the healing of ailments, from severe physical illness to emotional and spiritual disorders. By acting as mediators between the everyday world and the world of the gods, priests and priestesses not only provide healing and guidance for individuals but assist entire communities to maintain their religious and cultural heritage.

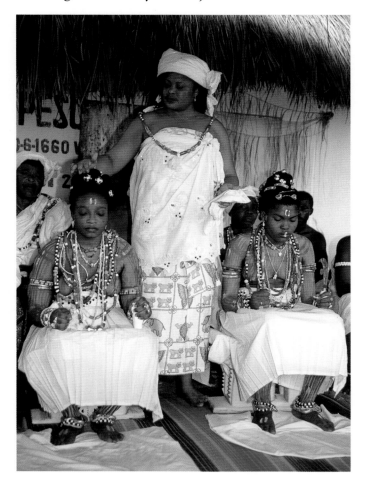

Left: A priestess is initiated at Glidji, Togo. She was called into the deities' service after being cured of an incurable disease. *Right*: Following six months of training in the arts of healing, two initiate priestesses, seated on ritual stools in a deep trance, are presented to the community at their graduation ceremony.

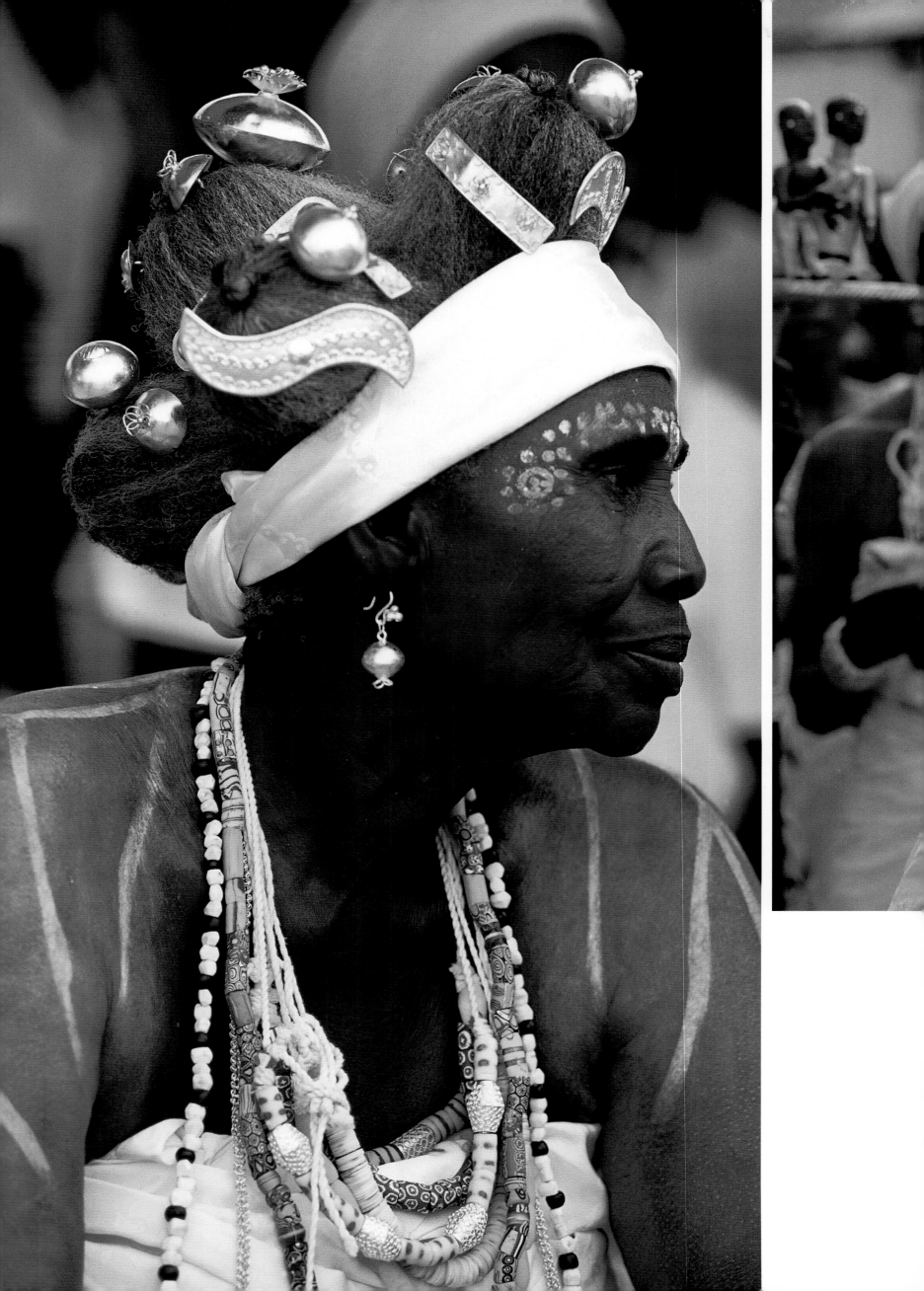

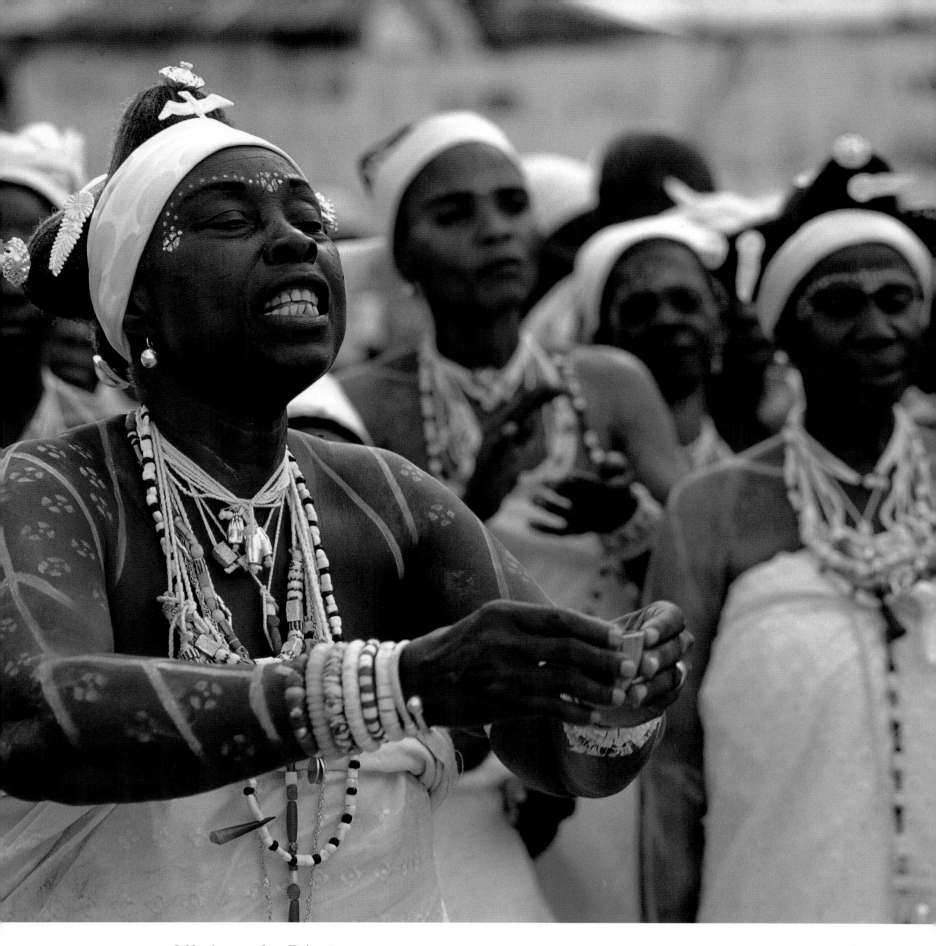

Offerings of a Priestess

Priestesses dress in white and paint their bodies with chalk and kaolin to signify purity. They adorn their hair with talismans and wear beads imbued with special powers. Certain strands cure headaches or skin troubles; others protect the wearer from harmful spirits. At the Fetu Afahye festival of the Fante people in Ghana, priestesses (*above*) elicit the blessings of the gods for the annual deer hunt. One priestess pours a libation while other elder priestesses, whose magnificent hairstyles indicate their status, look on. After the hunt, the blood of the deer will be fed to the war god, Apa Sekum, and his human intermediary. In the past, human sacrifice was required. Today, the Fante people believe that, as long as the war god is fed, they will be victorious in battle, immune from plague, and free from famine.

Following pages 308-309: The priestesses of the Akonedi shrine at Larteh, Ghana, present a ritual meal of mashed yam mixed with palm oil and eggs to the shrine deity. When Nana, the late head priestess, was possessed by this god, she was able to heal paralysis and deliver babies from barren women.

Following pages 310-311: The altar of a priestess displays many deities, including Mami Wata (*left*), the goddess of water, who traces her origins, and European-style hair, to a late nineteenth-century circus performer from Germany who advertised herself as an Indian snake charmer. Draped in cowrie shells and holding a serpent, Mami Wata summons health, prosperity, and fertility.

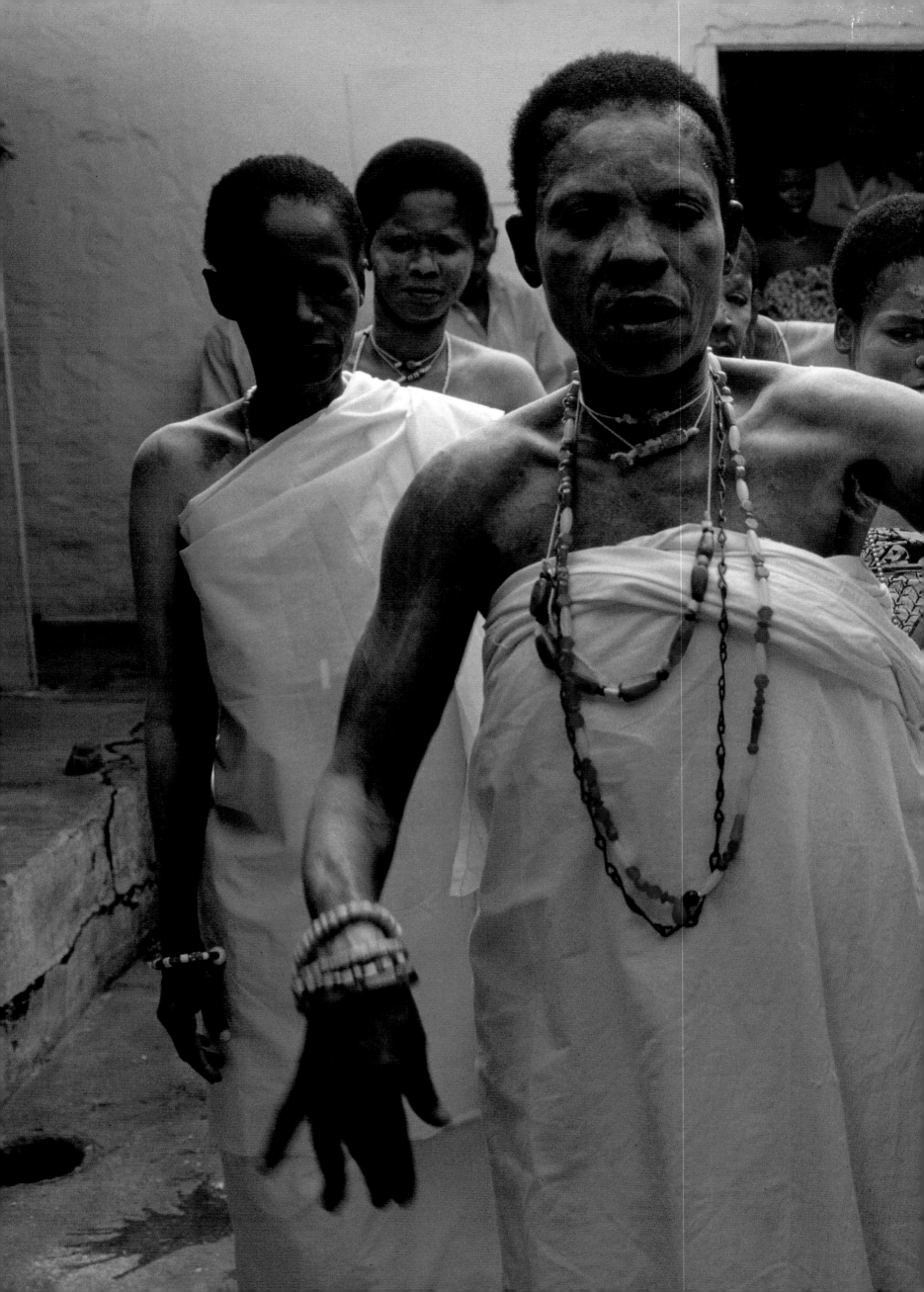

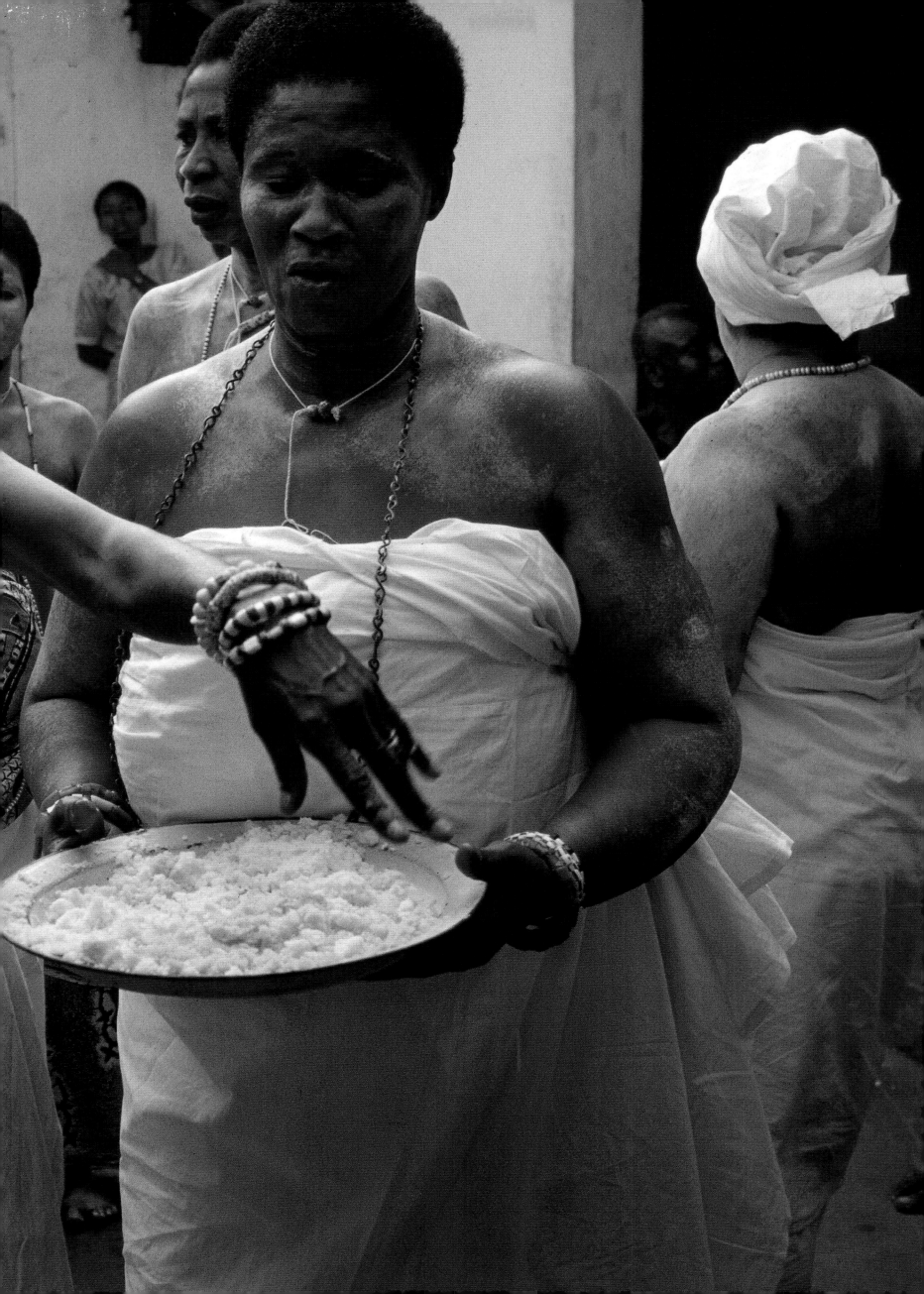

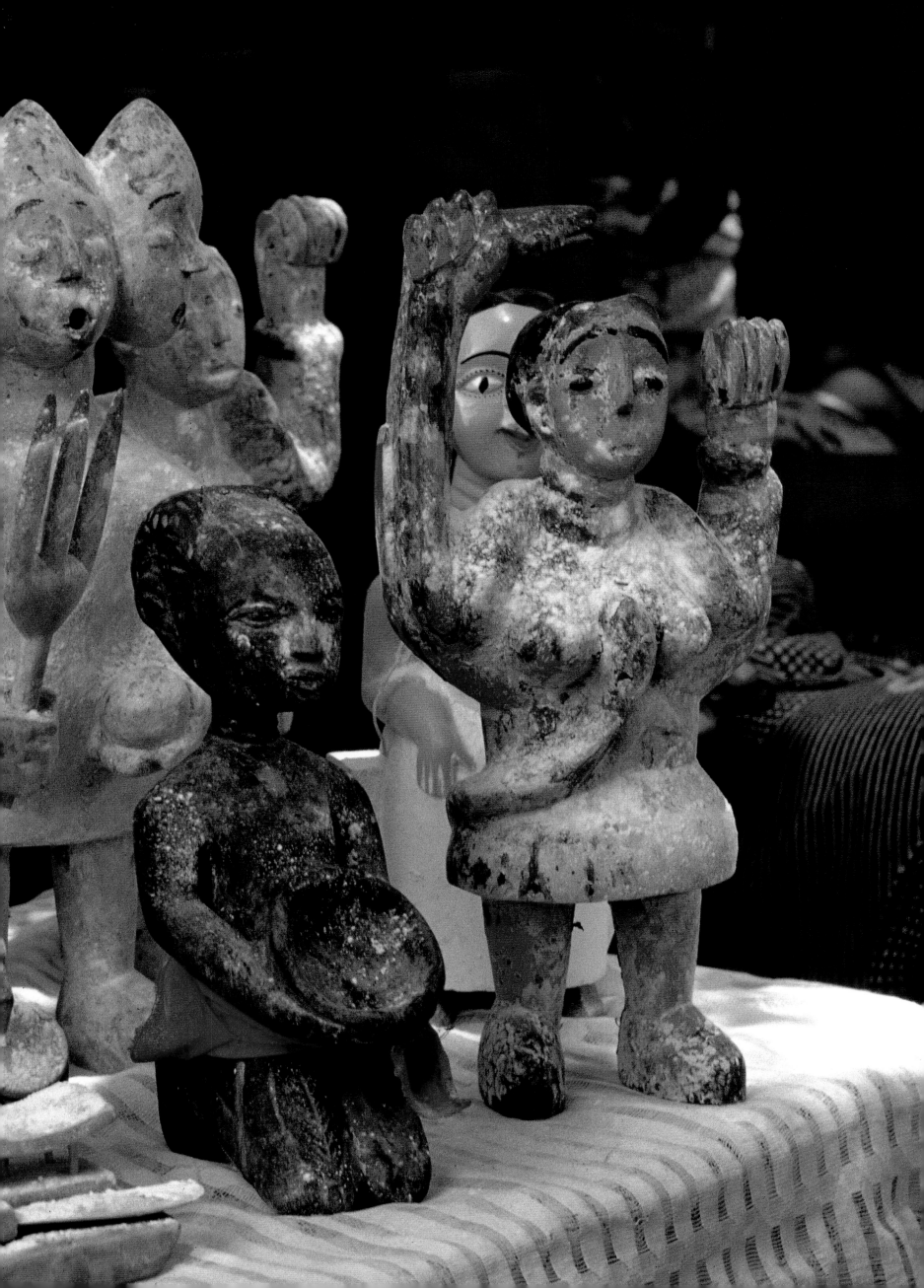

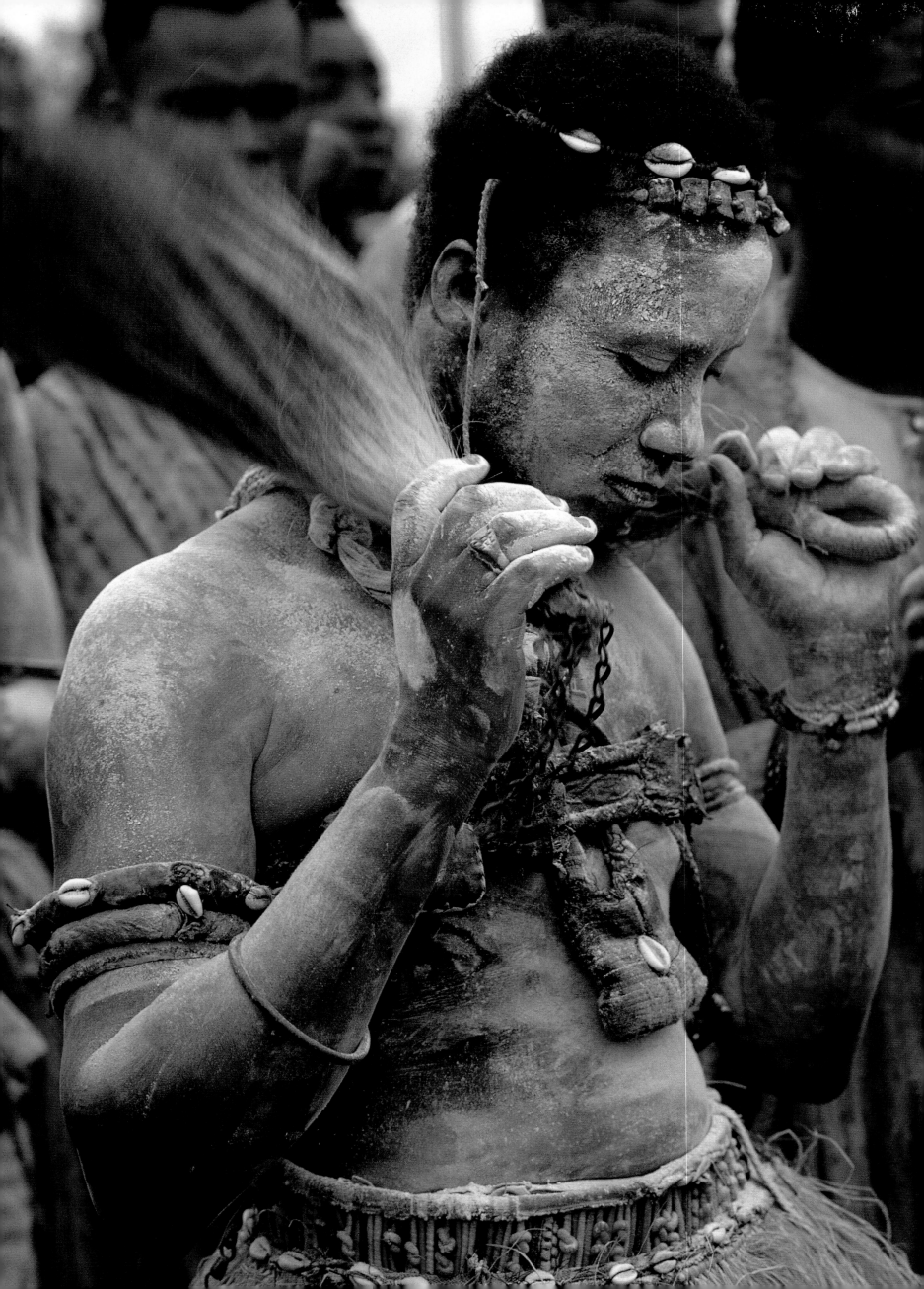

The Power of Priests

Prior to the public appearance of the Ashanti king at his Silver Jubilee celebration in 1995, priests from all over Ghana came together to call upon the power of the gods to insure the well-being of the kingdom. During the course of a day, the priests demonstrated their powers by entering into states of possession and performing amazing feats of endurance. Two groups of priests attended: the Atanofo, whose ancient deities are associated with rivers and nature, and the Sumanbrafo, whose medicinal charms are used to identify sources of evil. The Atanofo priests cover themselves with white chalk powder.

Left: A priest wears leather talismans across his back and chest and carries two fly whisks, which he uses to discharge his power once he is possessed by his deity. *Right*: Another priest demonstrates the protective power of his deity by crawling forward while three men pound pestles into a heavy mortar on his back.

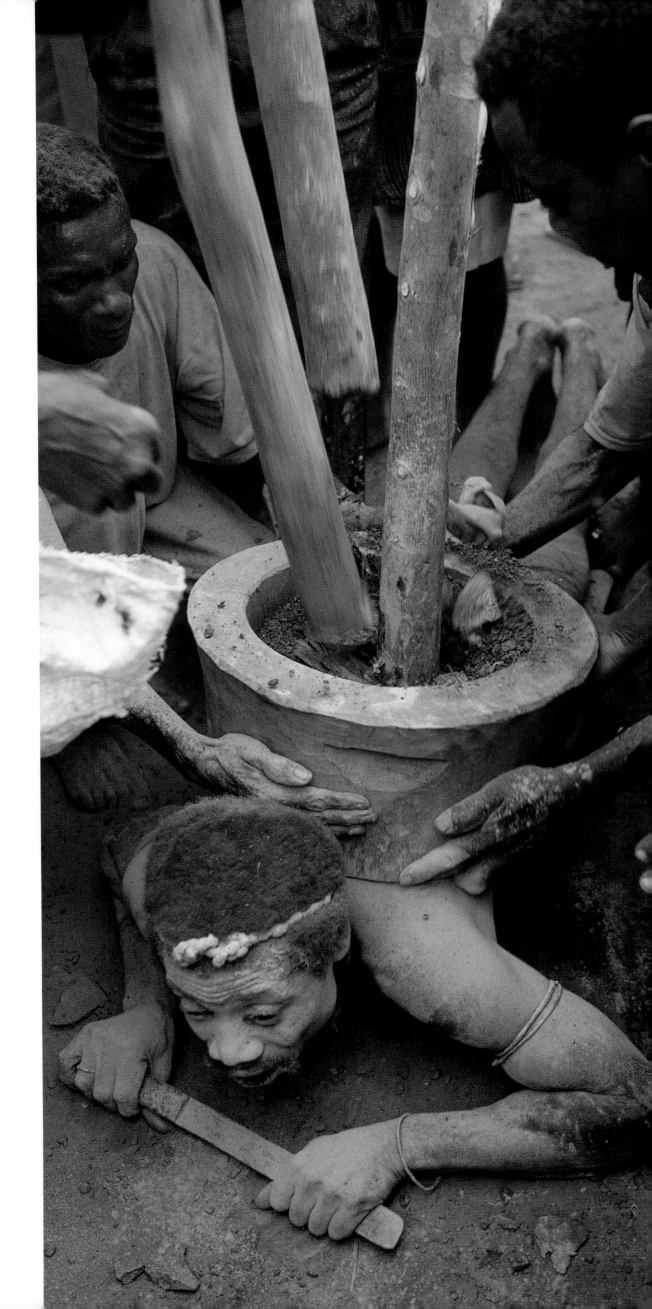

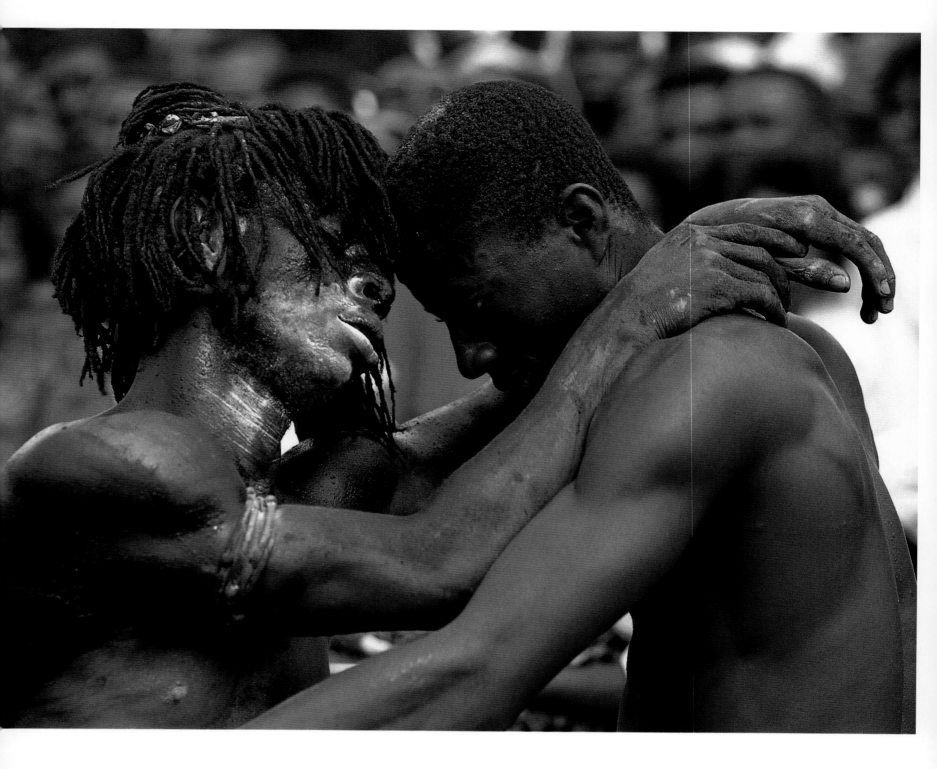

Possession

The states of possession entered by the priests render them immune to pain. Believed to be the most effective way to communicate with their gods, possessions come readily to the priests, whose commitment to a deity over many years gives them this facility. The Atanofo priest (*right*) has covered himself in kaolin powder, considered to be "food for the spirit," and used to elicit the deity's power. Worshippers may give kaolin powder as an offering to a god, or ingest it as medicine when prescribed by a priest. The Sumanbrafo priest (*above*), covered in black charcoal and red clay, has become exhausted by performing many feats, and is held by an attendant at the climax of his possession. The devotion to their gods shown by priests and priestesses at rituals compels powerful belief among the worshippers.

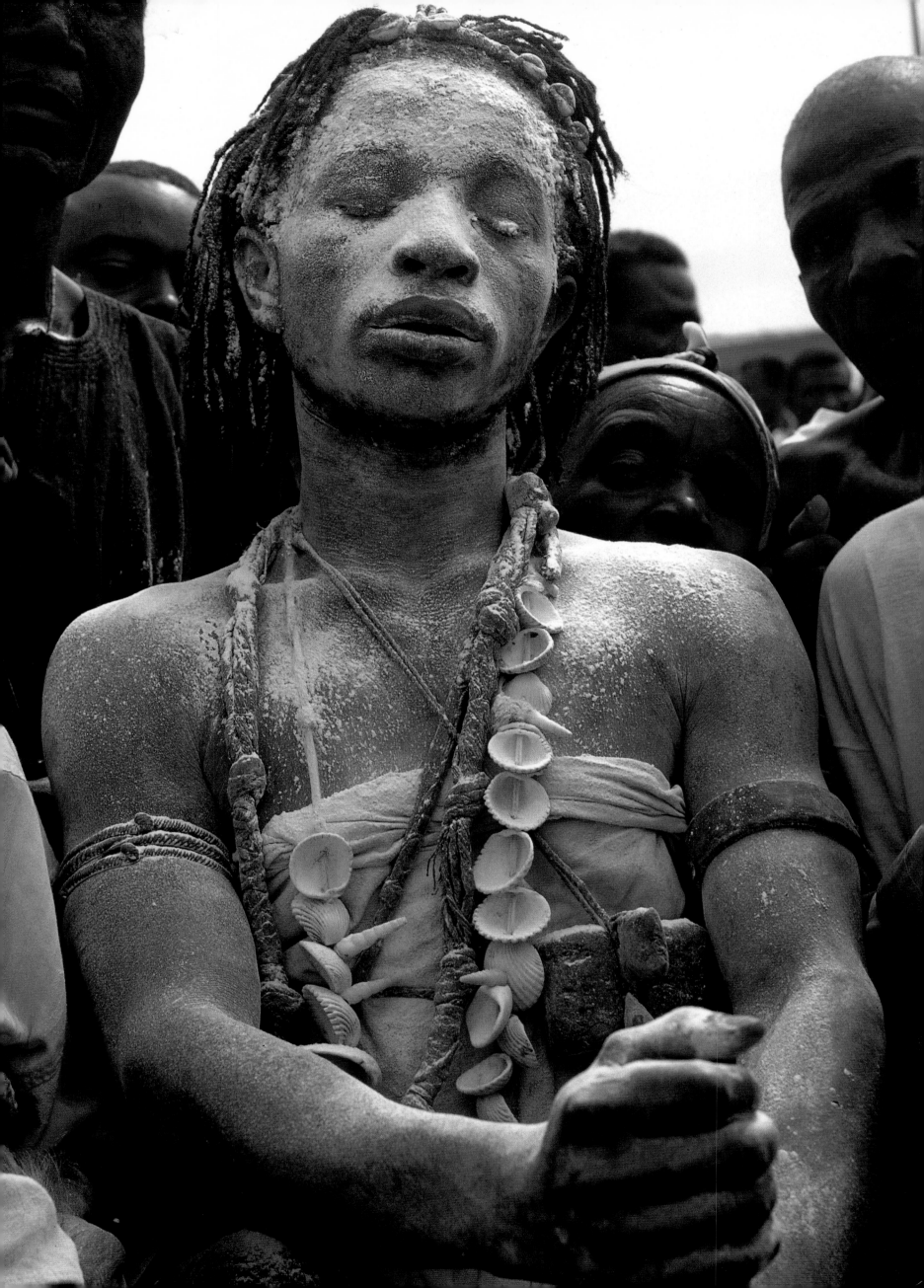

Voodoo

One of the oldest religions of West Africa, voodoo originated in the rain-forests and savannas of Benin, Togo, and eastern Ghana, and is practiced by the Fon, Ewe, and Ga peoples who inhabit these areas. Voodoo has more than fifty million believers in West Africa alone and is also practised today in Cuba, Haiti, and Brazil.

The word *voodoo*, variously known as vodou, vodun and vodoun, originated with the Fon people of Benin and means "spirit" or "god". In the world of voodoo there are thousands of deities who connect the everyday world to the realm of the supernatural. Voodoo deities inhabit nature—the earth, trees, and stones—and are also embodied by inanimate objects. These range in form from sculptural figures to amorphous mounds of earth containing medicines (mixtures of plants and other sacred substances), sometimes referred to as fetishes. This word, introduced by Portuguese traders in the sixteenth century, has acquired a negative connotation for many in the Western world.

The highest state of being for a voodoo believer involves complete abandonment to the spirit of a particular deity. When a worshipper enters this ecstatic state, his or her body is possessed by the deity, who then speaks and acts through that individual. In weekly village meetings, followers visit local shrines to worship collectively and reaffirm their faith. At these gatherings they are drawn into possessed states by dancing to unique drum rhythms associated with their particular deities. Voodoo has such deep roots that neither Christianity nor Islam have been able to eradicate it. On the contrary, voodoo has become stronger by incorporating aspects of other belief systems to enhance its power.

Right: At a voodoo hospital in Togo, a priest acts as an intermediary between a deity and a patient.
Above right: The lovesick bring offerings of cigarettes, gin, and perfume to the popular female deity, Gabara.
Above left: The male deity addresses the problems of men suffering from emotional distress, including impotence. *Following pages*: Devotees dance ecstatically into trance at the voodoo celebration of Kokuzahn.

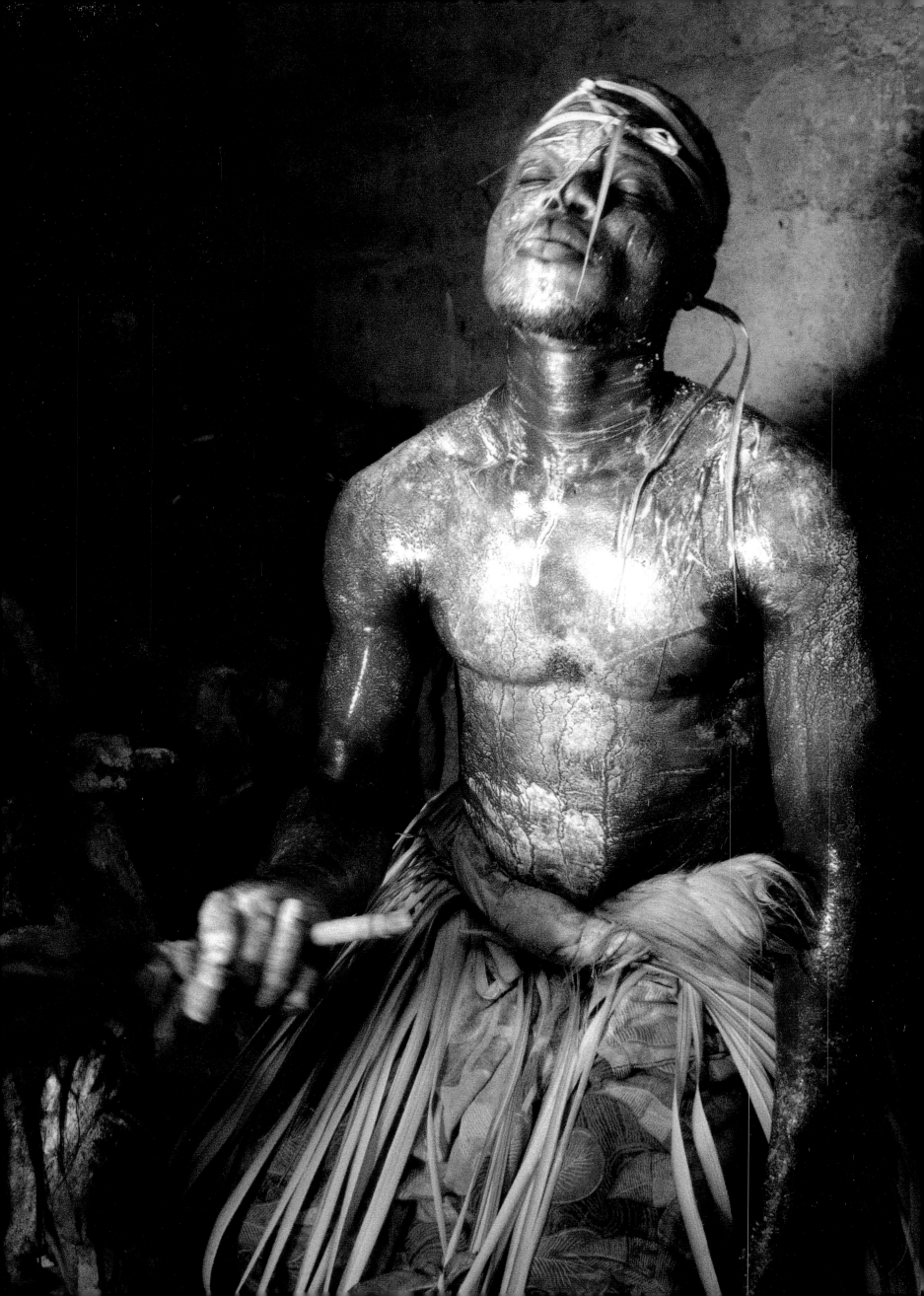

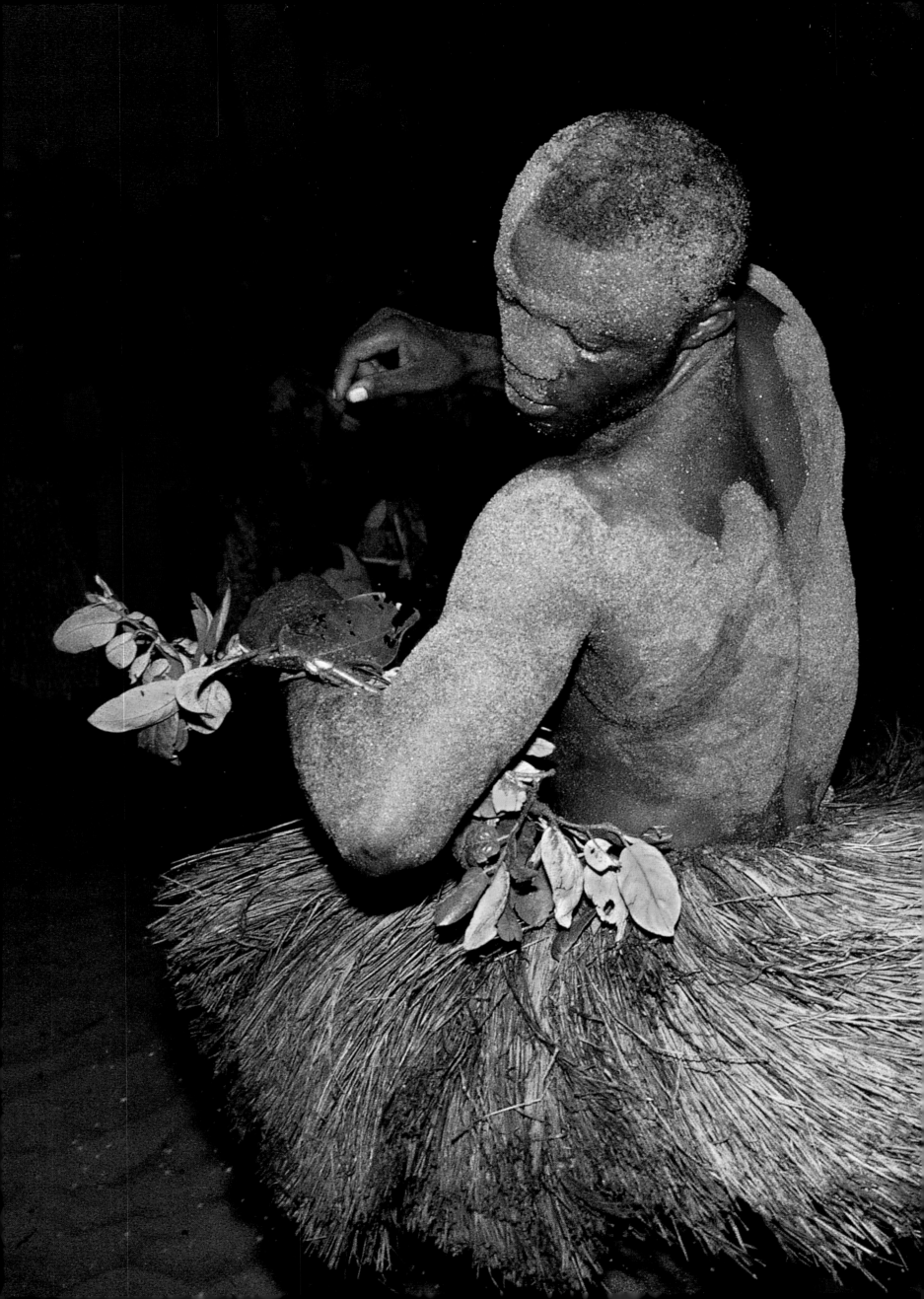

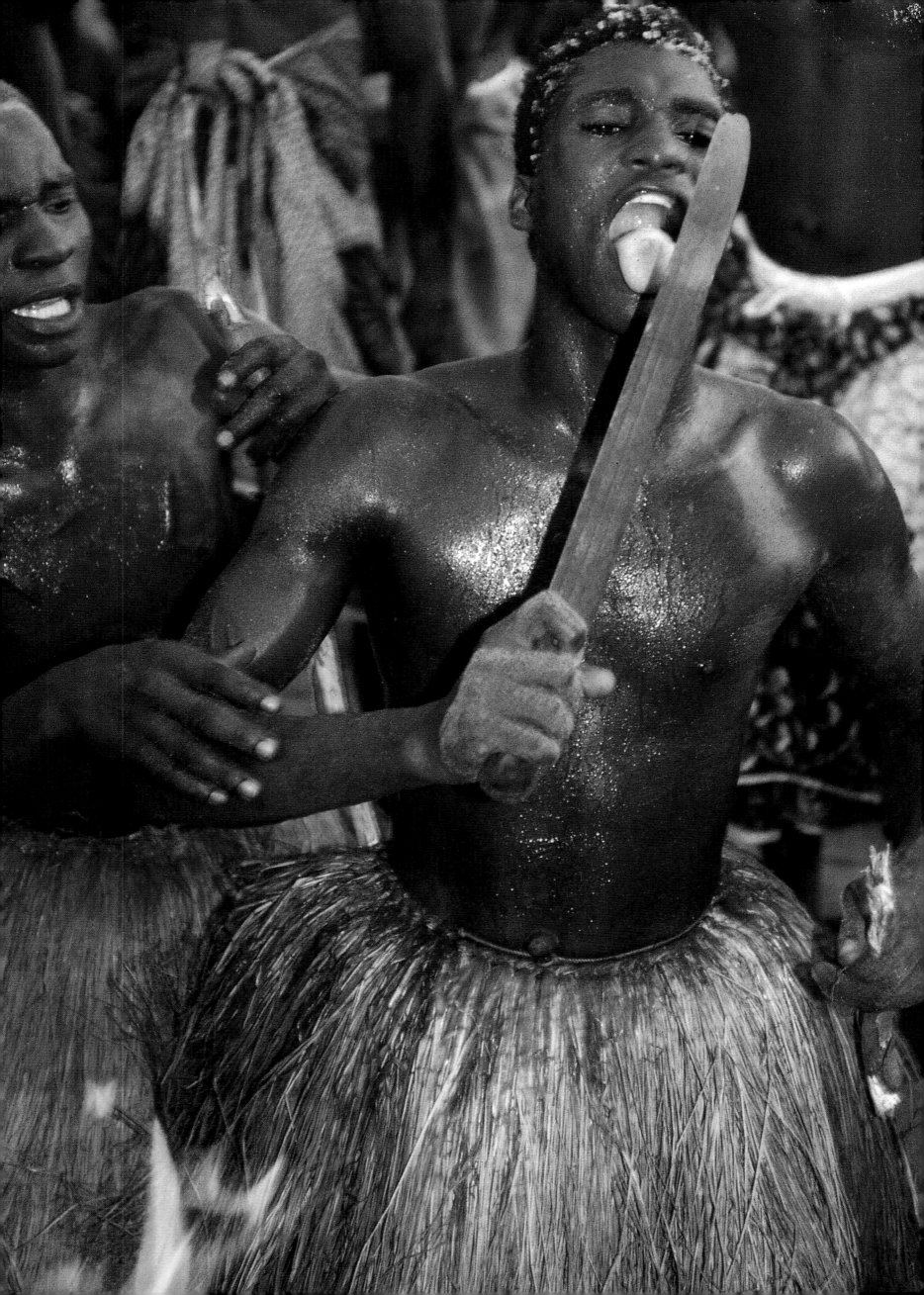

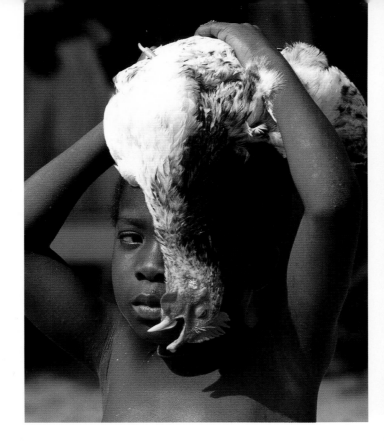
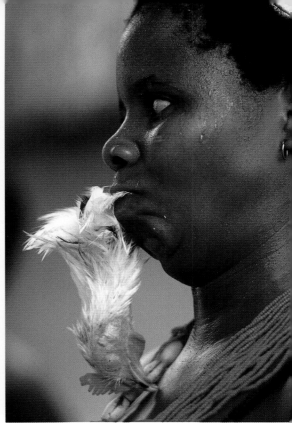

Spinning into Trance

Preceding pages: Once every three years, in a palm grove by the sea on the border of Ghana and Togo, thousands of voodoo followers gather for a spectacular seven-day celebration called Kokuzahn. They honor their deity, Flimani Koku, an ancient warrior god who protects them from witchcraft and evil. In return for his protection, the faithful must purify body and soul by abstaining from sex and meat for two weeks before the celebration. The festival begins with pulsating voodoo drum rhythms that send dancers spinning into intense states of possession.

Miracles of Faith

In altered states of trance and possession, oblivious to what they are doing or who they are, devotees are able to perform acts of superhuman strength and endurance. Known as miracles, these feats defy credibility and demonstrate the extraordinary power of the deity and the absolute faith of the worshipper.

Left: A voodoo dancer repeatedly touches his tongue with a white-hot knife he has just removed from a fire. His tongue neither burns nor blackens, and he feels no pain. Another dancer (*right*) throws his head back and thrusts a flaming branch down his throat. He expresses no discomfort. "The gods protect us," explains the chief priest, "They direct our actions and tell us which medicines to take so that no harm can come to us." One woman, lost in trance (*above right*), is driven by the deity to perform a wild dance with the head of a sacrificed chicken dangling from her mouth.

Above left: A chicken, balanced on a boy's head, is killed by a priest who points a sacred knife at it from five feet away. The miracle of killing the chicken without touching it reveals to onlookers the deity's power to control evil and to mete out punishment, even from a distance.

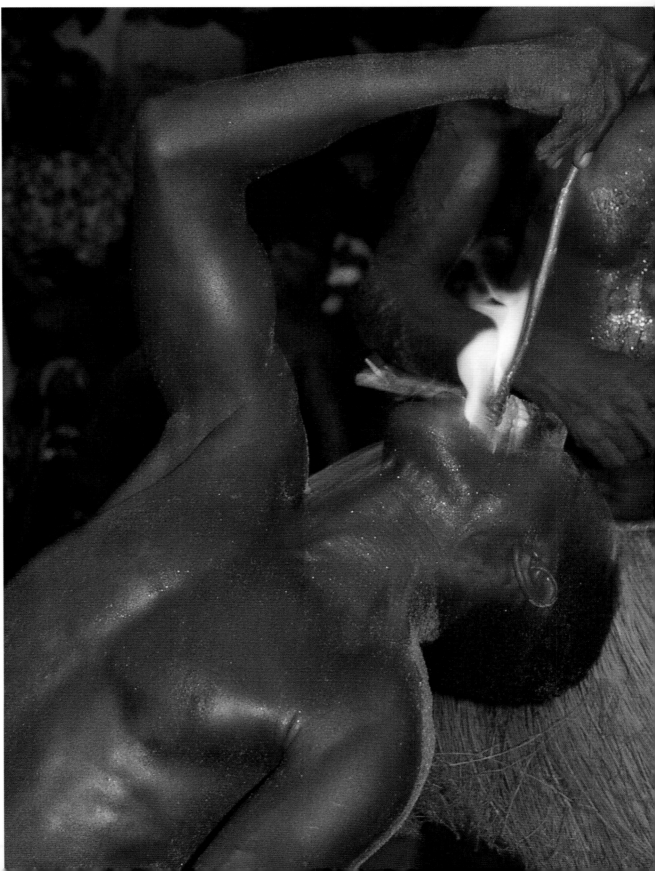

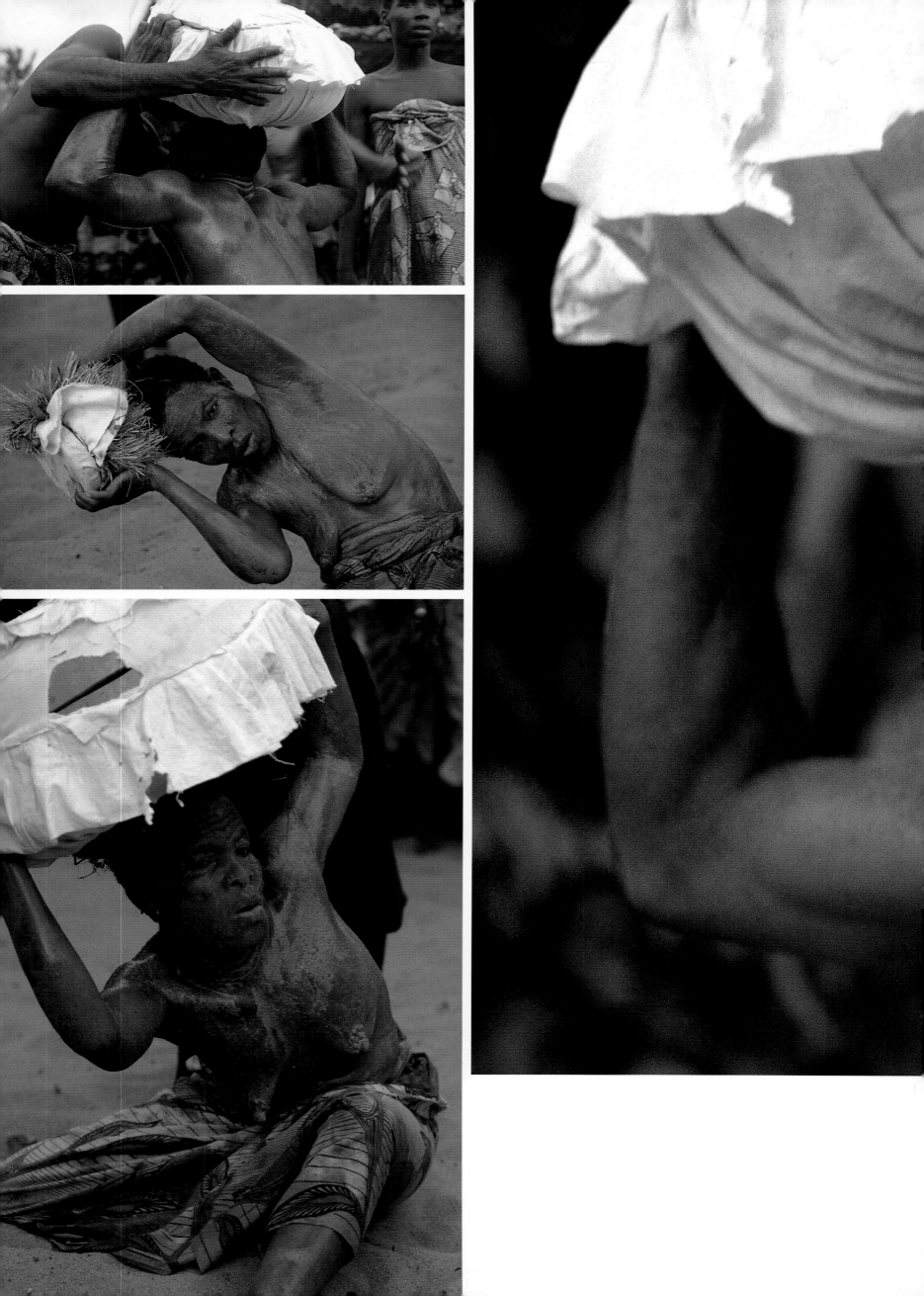

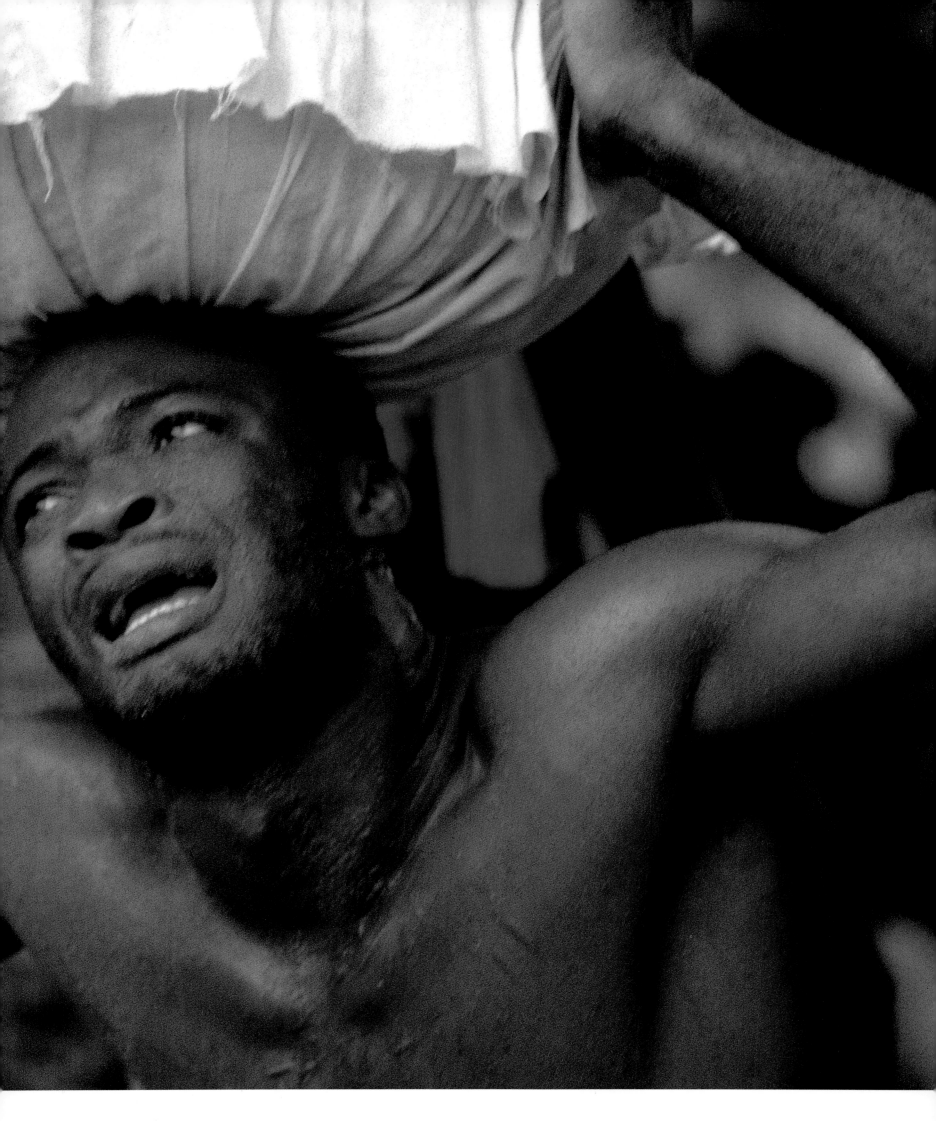

Weight of the Gods

The male deity Flimani Koku, contained in a calabash covered with a white cloth, is carried out of the shrine for all followers to see. Each devotee must carry the Koku deity once in his or her lifetime before becoming a Kokushi, or worshipper of Koku. The fetish representing the ancient warrior god contains fourteen sacred knives, each with a small gourd tied to its handle containing magical potions and covered with offerings of blood. The fetish was brought to Ghana from Benin by Ewe forebears at the beginning of the last century. Although the calabash and its powerful medicinal contents weigh very little, its psychological weight is immense.

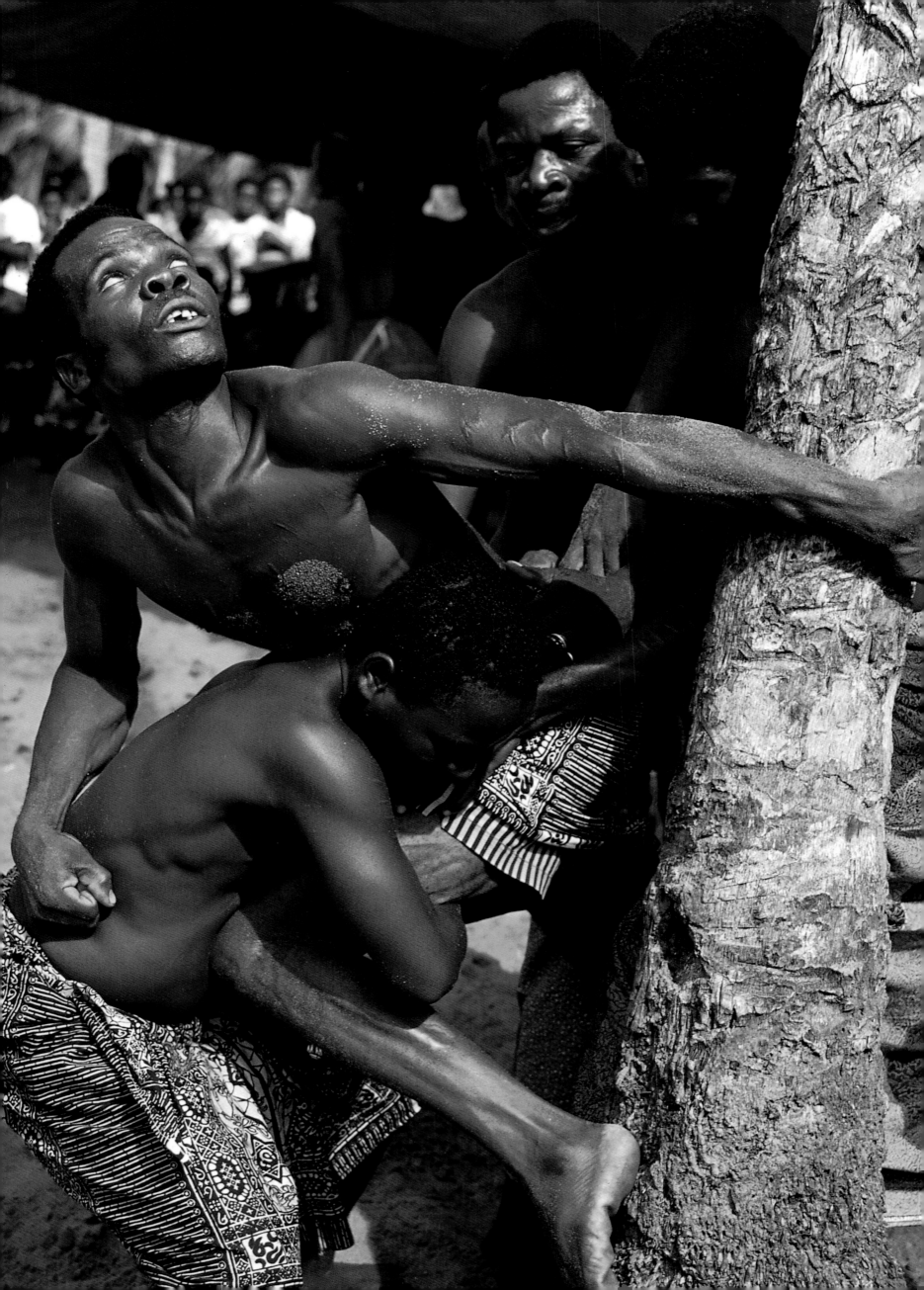

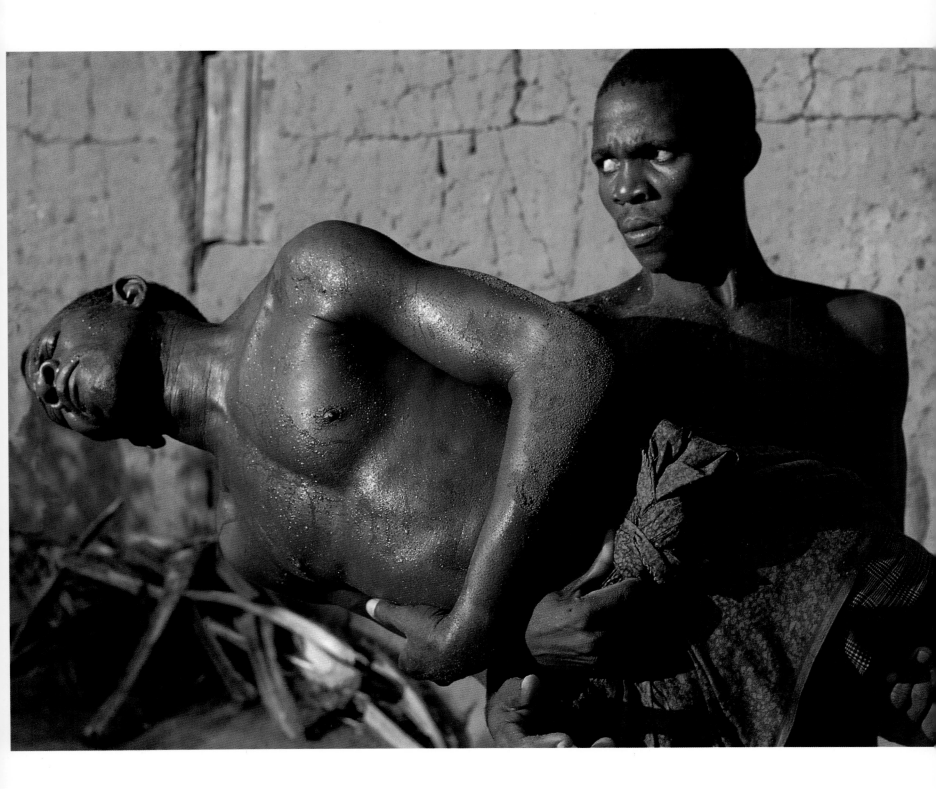

Possessed by Spirit

The opening of the calabash has a profound effect on followers of the deity. In its presence, one devotee after another becomes possessed. *Above*: A man becomes completely rigid and is carried, stiff-limbed, into the shrine, where the priest will revive him with a powerful potion. Left: Another man is prevented from repeating his extra-ordinary feat of climbing a tall coconut-palm tree and walking upright along the top branches, oblivious to danger. *Following pages 326-327*: As the festival reaches its frenzied climax, devotees spin faster and faster to the voodoo drums. They are protected from harm by wearing tree-fiber skirts and smearing their bodies with a medicinal paste. Finally, the dancers collapse on the ground, surrendering their bodies to the deity. Achieving oneness with their god, they say, affords one of the most acute sensations of happiness that human beings can experience. They do not need drugs to attain this state, only the power of faith. *Following pages 328-329*: In a state of possession, a man's eyes roll and the pupils disappear, leaving only the whites. Depending on which direction the eyes roll, the Ewe can tell which spirit possesses the individual. This man's eyes rolled upward, indicating possession by Hebioso, the thunder god.

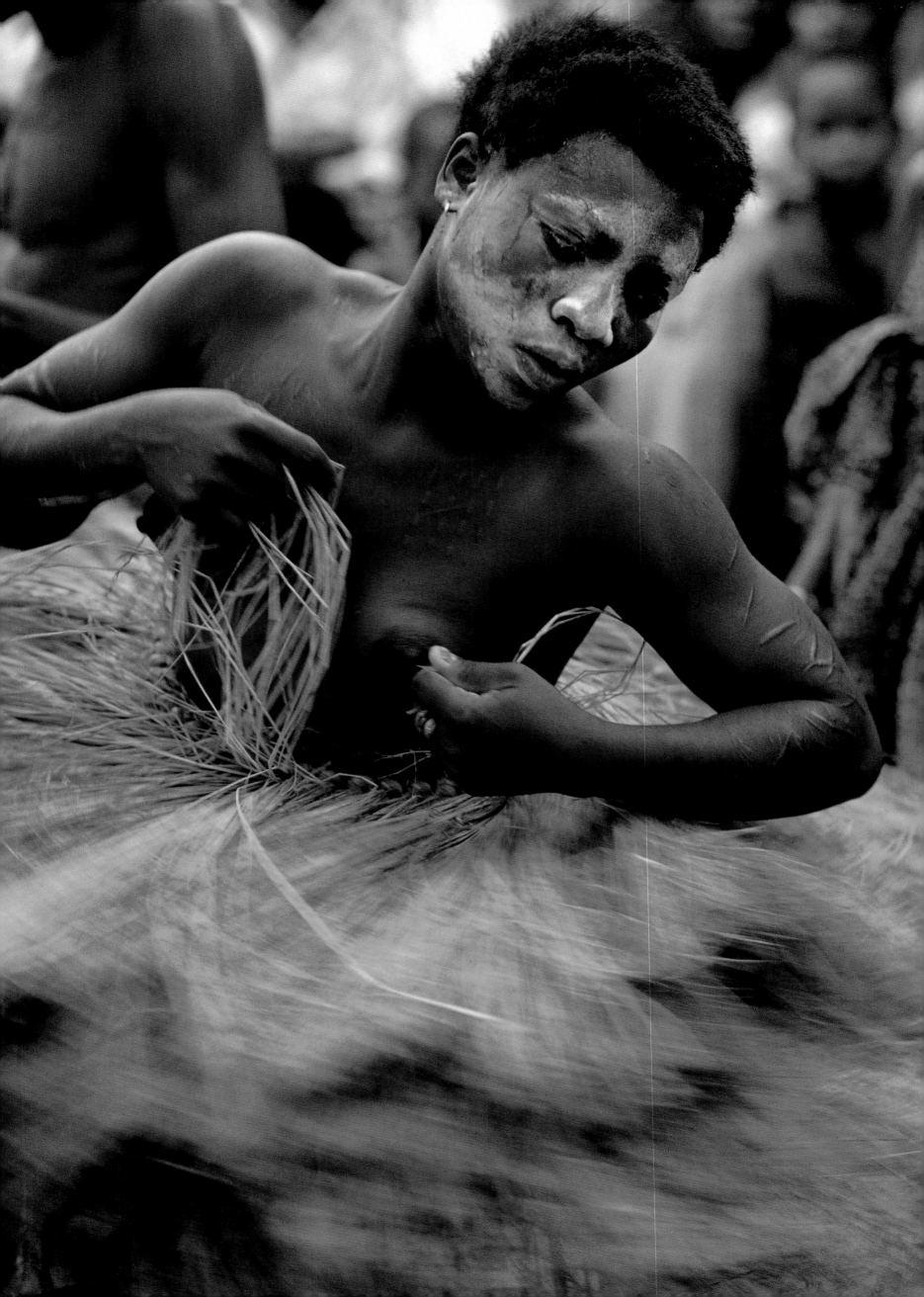

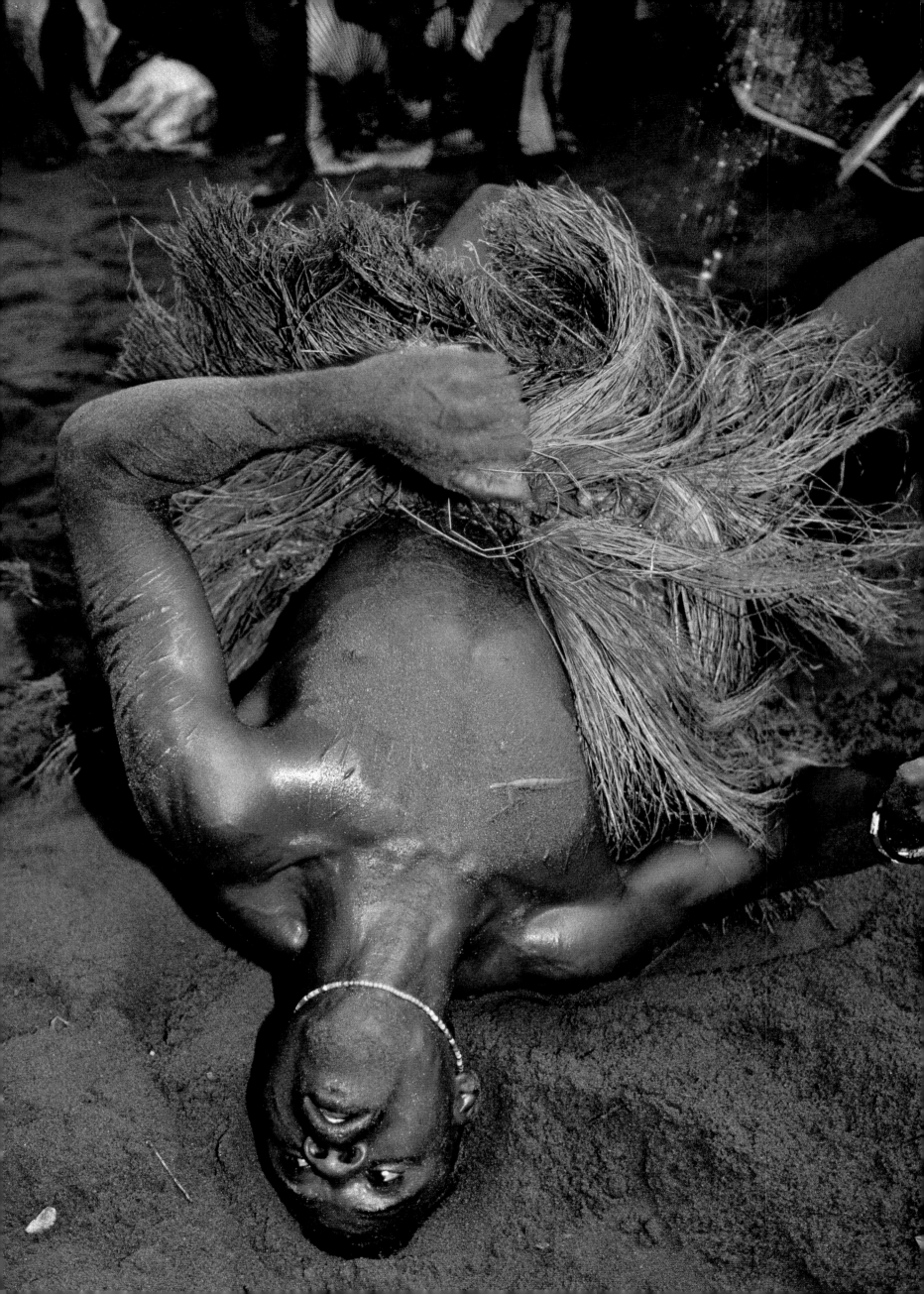

Himba Healing

The Himba people belong to a larger group of Herero pastoralists who migrated into Namibia from Angola in the sixteenth century. According to Himba belief, all sickness is brought on by either a curse or a premature call from the ancestors to join them in the afterworld. The curse is said to be carried by a black, dovelike bird that flies down from southern Angola. In the past, the exorcism of curses was carried out by male healers from Angola, but over the last thirty years, Himba women have also become known as powerful healers, and often practice communal trance healing.

Katjambia, the daughter of a renowned Himba headman who had fifteen wives and thousands of heads of cattle, is one of the most respected healers living today. A striking six-foot-two-inch-tall woman, she travels through the territory with a small team of assistants, providing healing wherever it is needed. Katjambia believes that it was her father and grandfather who gave her the power to heal, and also the ability to know who must live and who must die.

With the beating of a drum, the shaking of a calabash rattle, and the waving of long, forked healing sticks, Katjambia induces a trancelike state in her patients. As the patient's body moves deeper into trance, the possessive spirit becomes agitated, and Katjambia is able to identify the curse that is causing the illness. If it has been brought by the black bird, she will identify the sender and return it from whence it came. If the malevolent spirit comes from a dead person, she will ascertain who sent it and why, then return it to the ancestral world. The healing concludes with Katjambia absorbing the spirit into her own body, and ultimately exorcising it from herself.

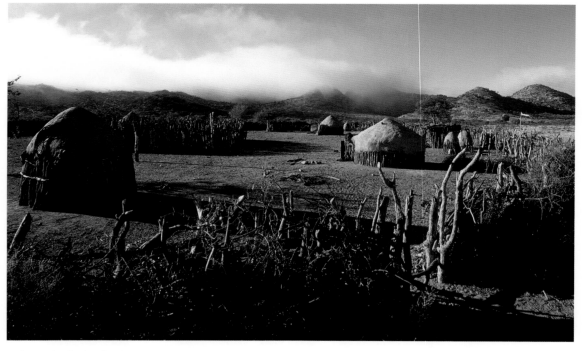

Above: A Himba family compound surrounded by a wall of thorny bushes. *Right*: Katjambia enters a trance, drawing an evil spirit out of a patient into her own body, before she calls on ancestral spirits to exorcise her. *Following pages*: Brandishing their healing sticks, Katjambia and her assistants travel from village to village treating the sick and exorcising the possessed.

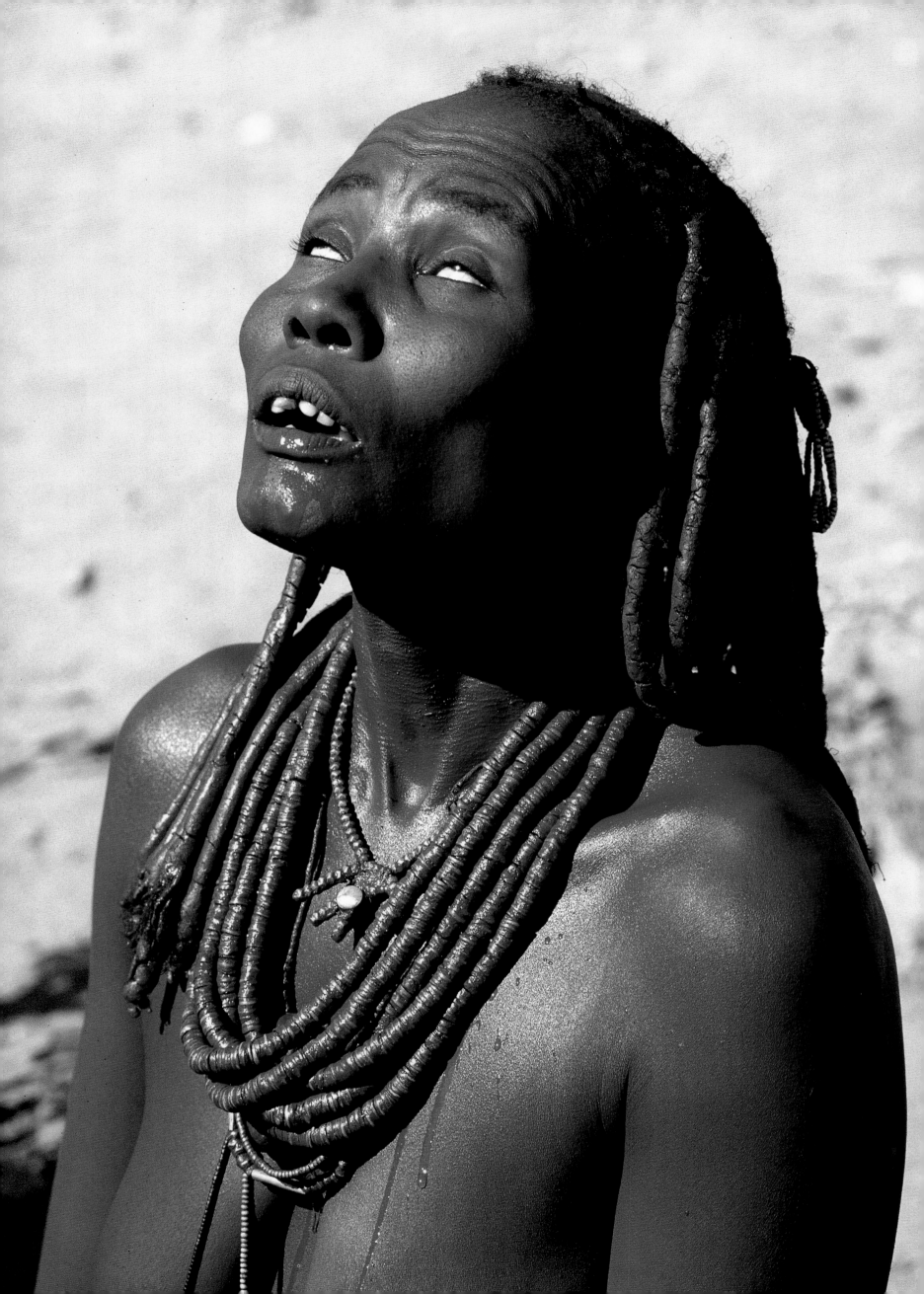

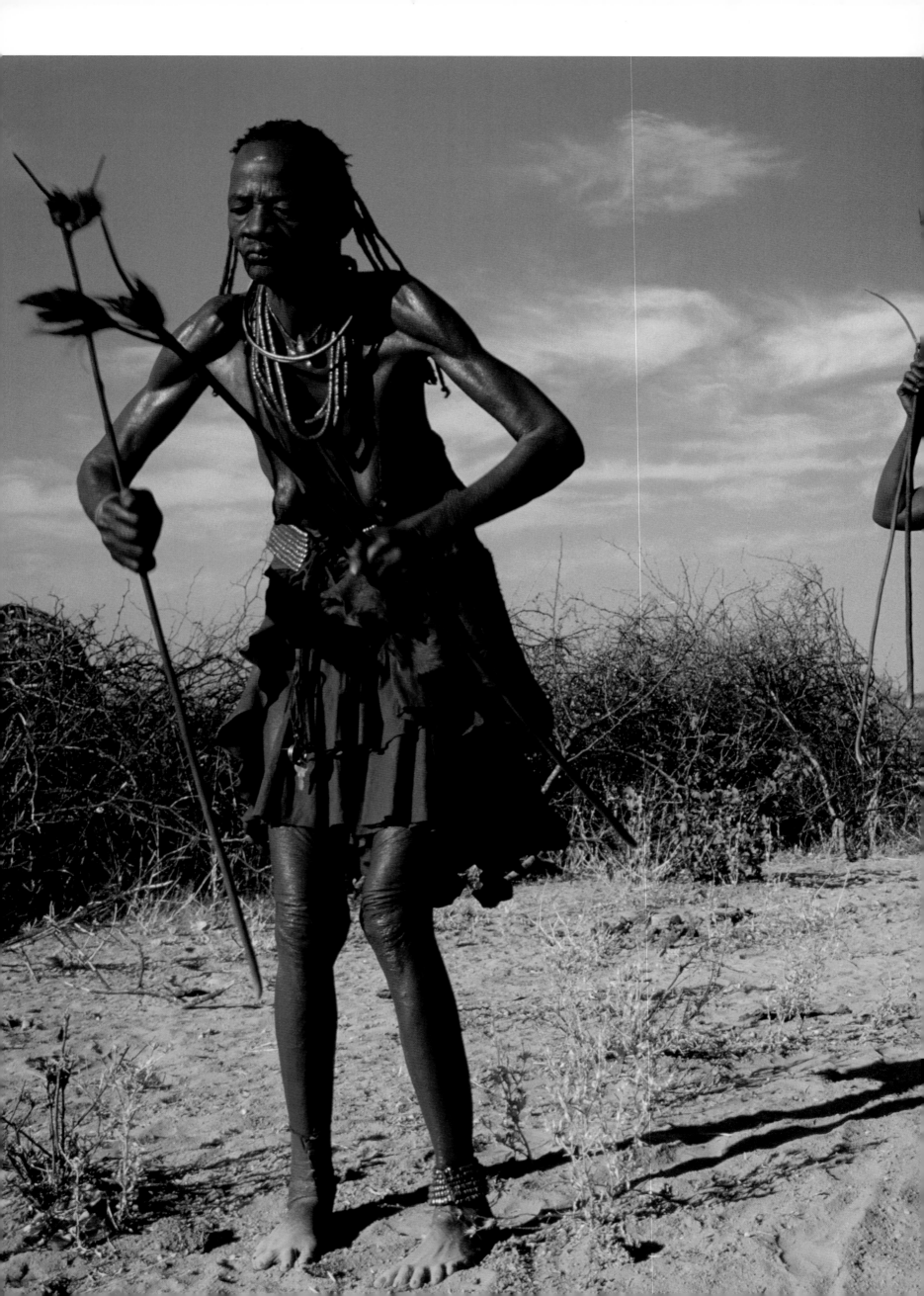

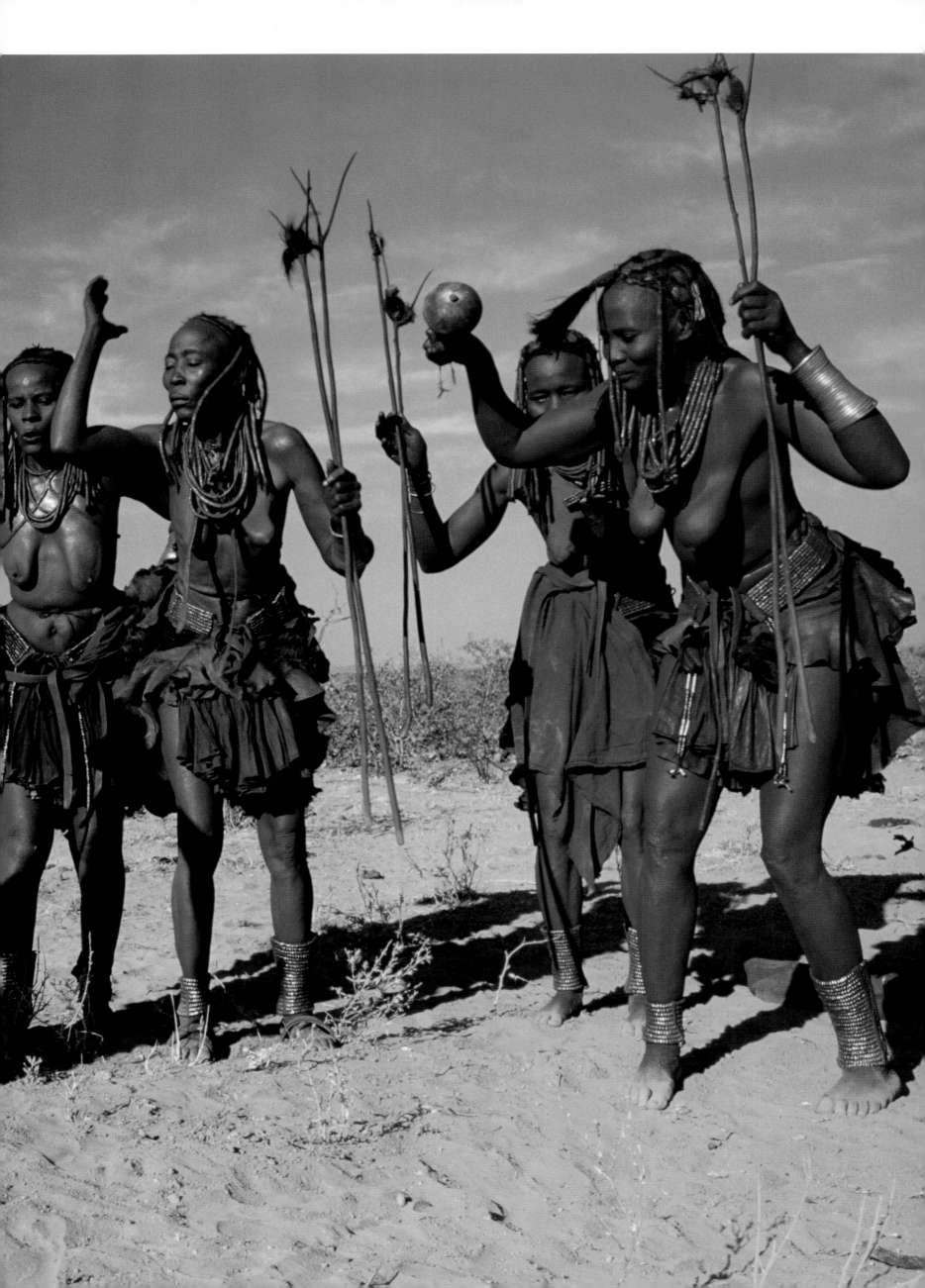

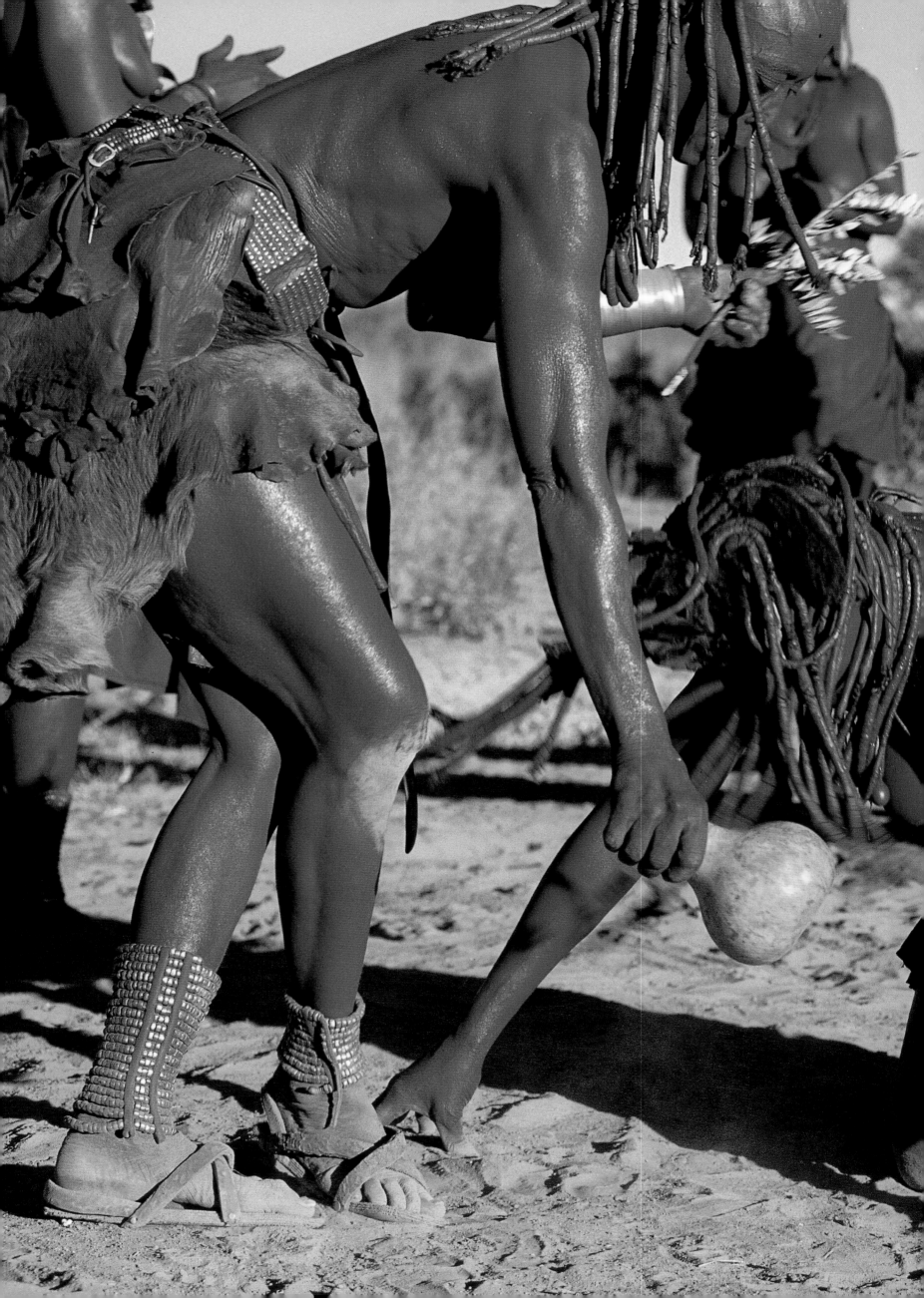

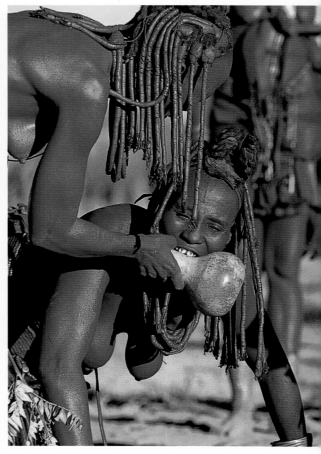

The Lion Spirit

Three women are possessed by the spirit of a lion sent to them by their deceased husband. Killed by a lion himself, he has dispatched the spirit to bring his wives to join him in the afterworld. Surrounded by chanting healers, the possessed women roar, growl, and lash out with their "claws". As Katjambia shakes her rattle to draw out the lion spirit, the women bite wildly at it in a frenzied state. *Following pages*: Totally possessed, the women are transformed into lions.

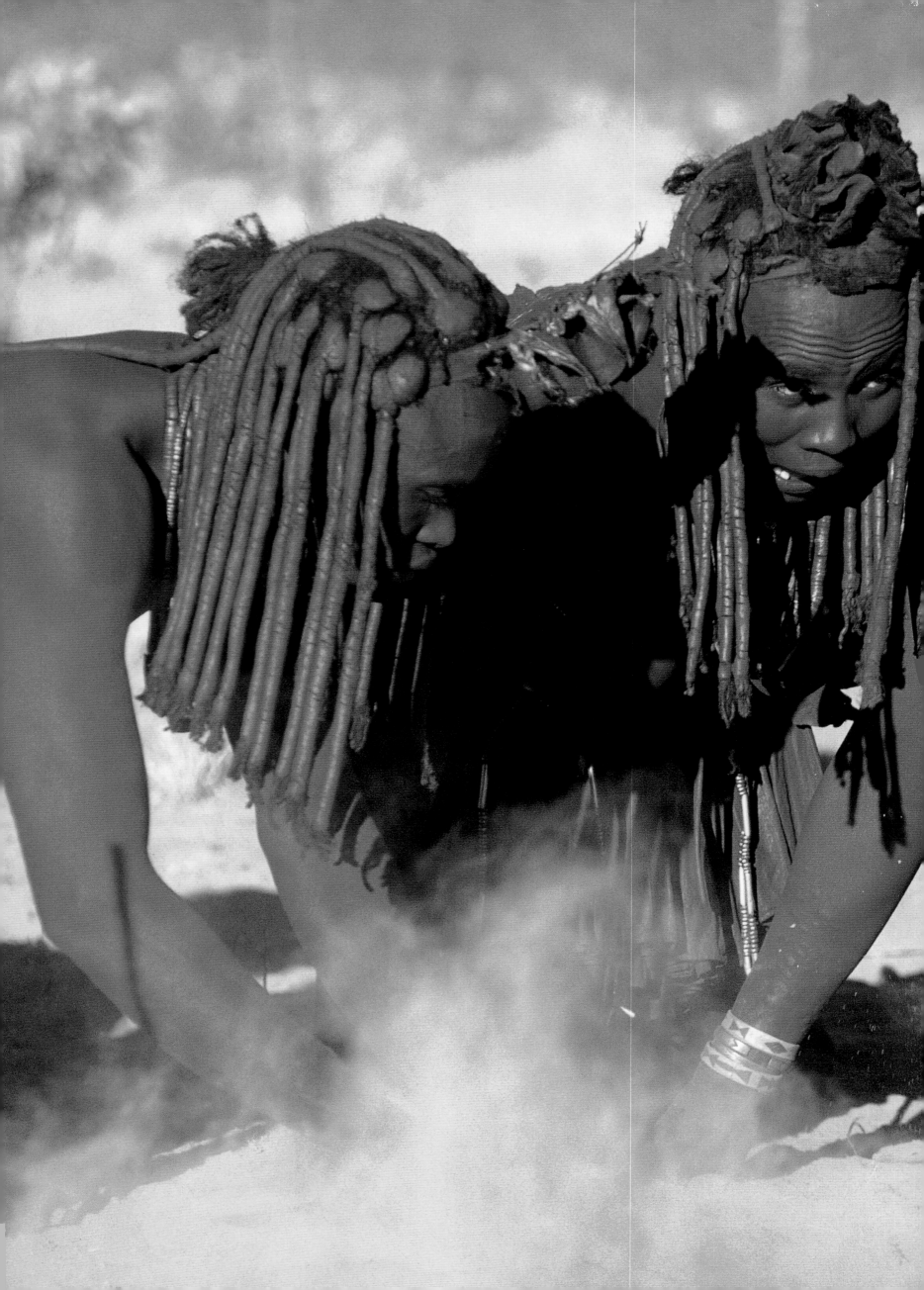

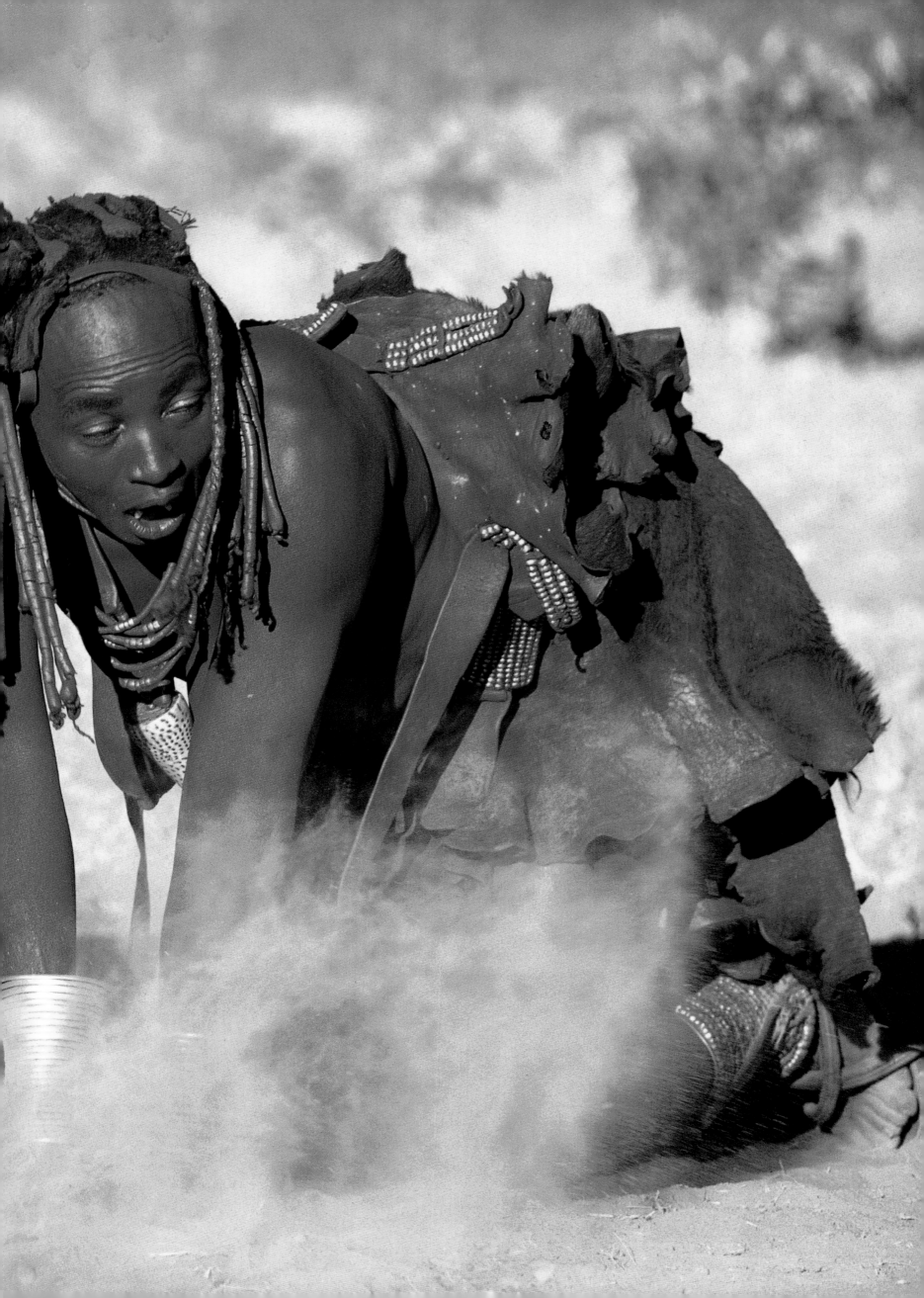

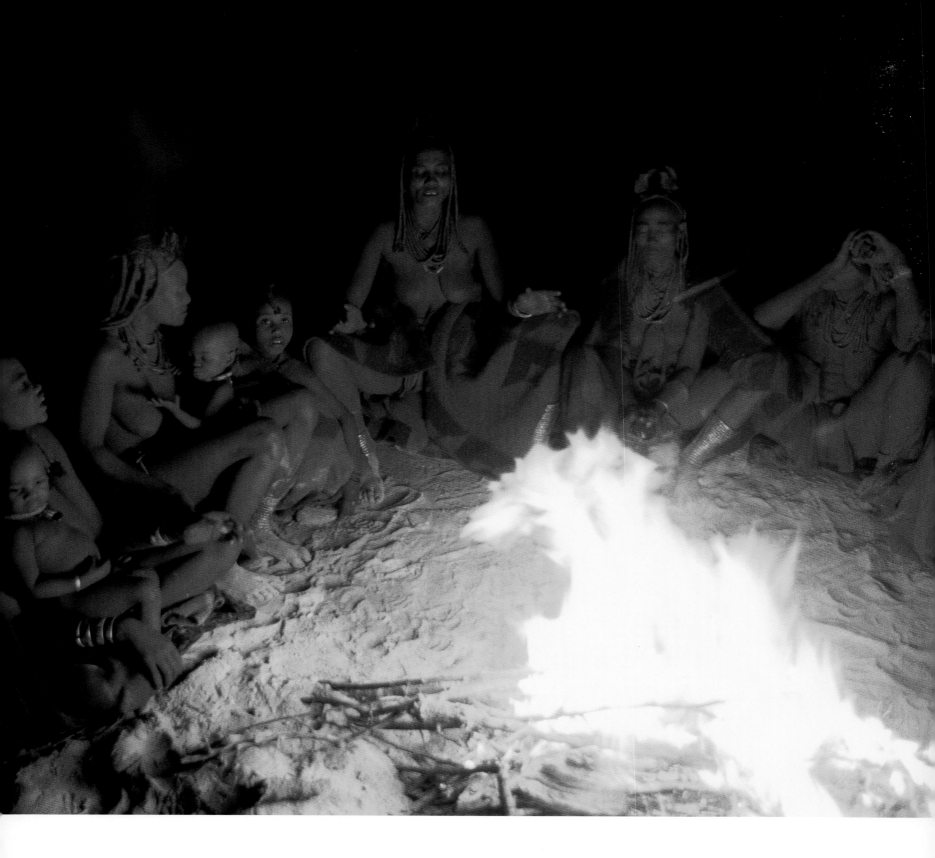

The Healing Fire

Preceding pages: Katjambia summons all of her powers to draw the lion spirit out of the women. Her eyes roll back and she enters a trance, absorbing the evil force into her own body. The wild behavior of the women gradually begins to subside, and after some time they are left totally exhausted but free from the dangerous spirit that possessed them. Forced into Katjambia's body, the lion spirit remains so powerful that she is unable to expel it no matter how she tries. Barely able to speak, she whispers that she must retreat to her family village to call on the help of ancestral spirits contained in the sacred fire.

Brought to the ancestral fire by her assistants (*above*), Katjambia summons the force of three generations of healers embodied within the flames. The fire has burned continuously since it was first lit many centuries ago, and its embers have been carried wherever the Himba moved. After six hours of chanting and praying to the ancestors for help, Katjambia reaches a state of total exhaustion. At two o'clock in the morning, a shaft of light miraculously flashes from her head and disappears into the darkness (*right*). Her body finally relaxes, and Katjambia, free of the lion spirit, silently lies down and sleeps.

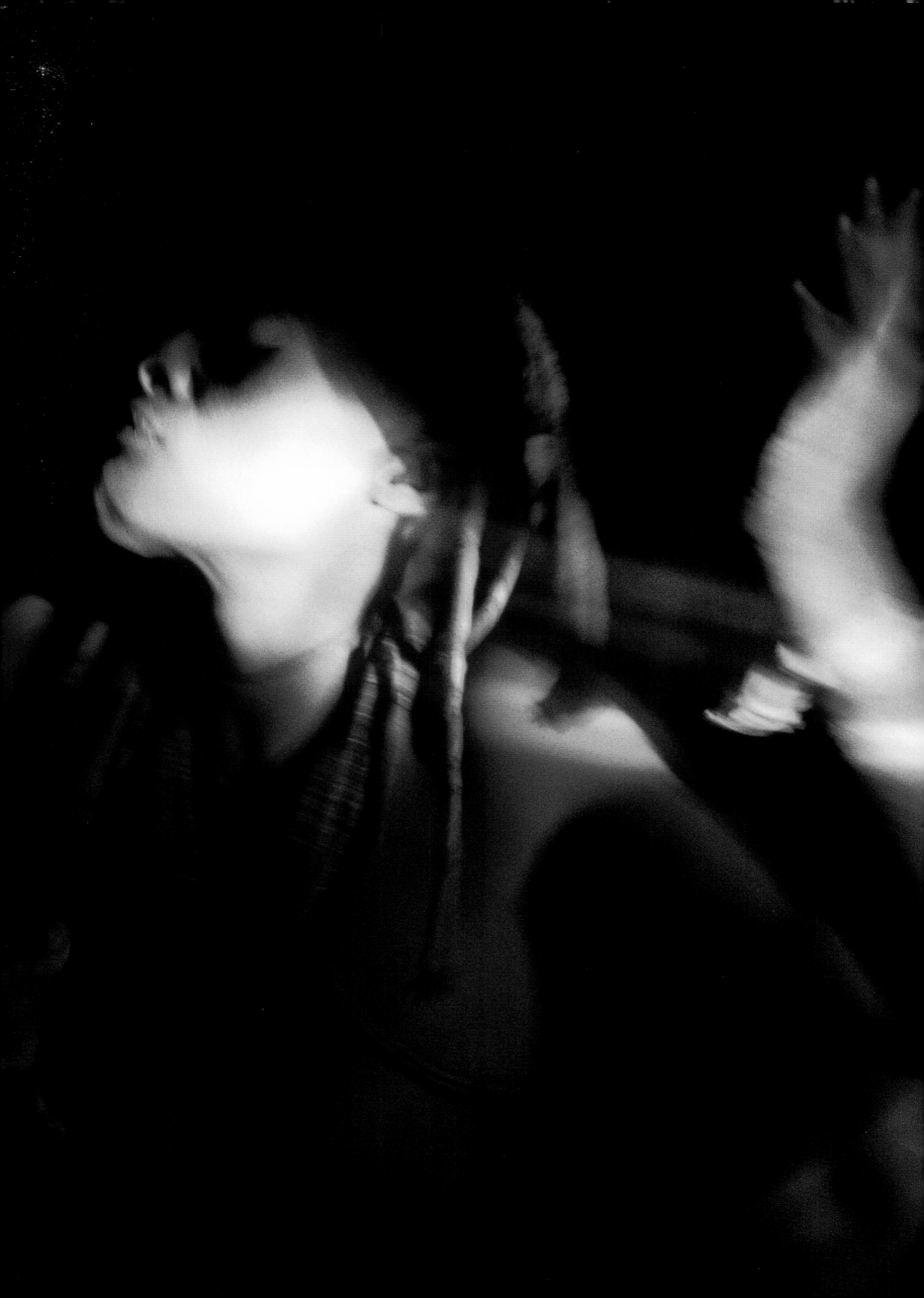

Tuareg Muslim Festival

Bianou, one of the most important festivals in Muslim Africa, is celebrated during May in the ancient Tuareg town of Agadez, on the southern edge of the Sahara Desert in Niger. It commemorates the Prophet Mohammed's historic flight from Mecca (where his teachings were not accepted) to Medina, which became the first Muslim community. This event, known as Hejira, occurred in 622 AD and marks the beginning of the Muslim calendar. Eight years later, the prophet returned to Mecca and established this city as the center of Islamic faith.

The festival of Bianou in Agadez commences with the slaughter of a sheep, symbolic of God's request of Abraham to sacrifice his son. The main event of the festival involves a parade of two groups of Tuareg celebrants, who march dressed as warriors to commemorate those who fought in the holy Islamic wars. One group comes from the west of the town, the other from the east: thousands of devotees, along with musicians and dancers, join them in the procession.

During Bianou, the celebrants visit the sultan's palace, the house of the kady—the traditional seat of justice in Agadez—and the Grand Mosque. Both groups then pay their respects to the town's most important holy man, the imam of Agadez, and to other traditional chiefs. The procession continues over three days, making its final call at the palace of the sultan, where the Bianou groups gather to pay homage to their leader, offering him good wishes for the new year. Drawing the festival to a close, the ceremonial drums that have been played throughout the celebration are placed one on top of another, and the festival is ritually closed until the following year.

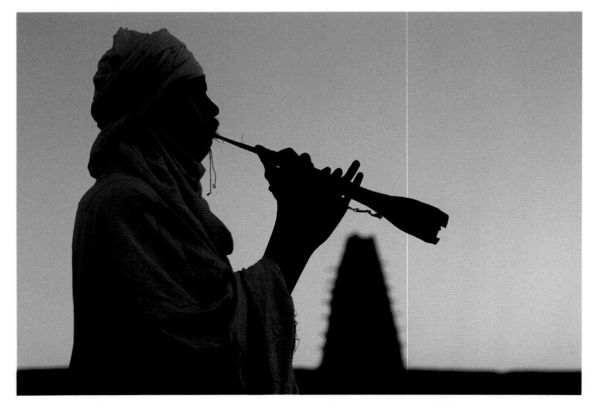

Above: Before the Grand Mosque of Agadez, a Tuareg musician heralds the arrival of the sultan. *Right*: A Bianou man displays a ceremonial headdress made from fabric dyed with crushed indigo. *Following pages*: Carrying regimental flags and dressed as warriors, Bianou men parade through Agadez.

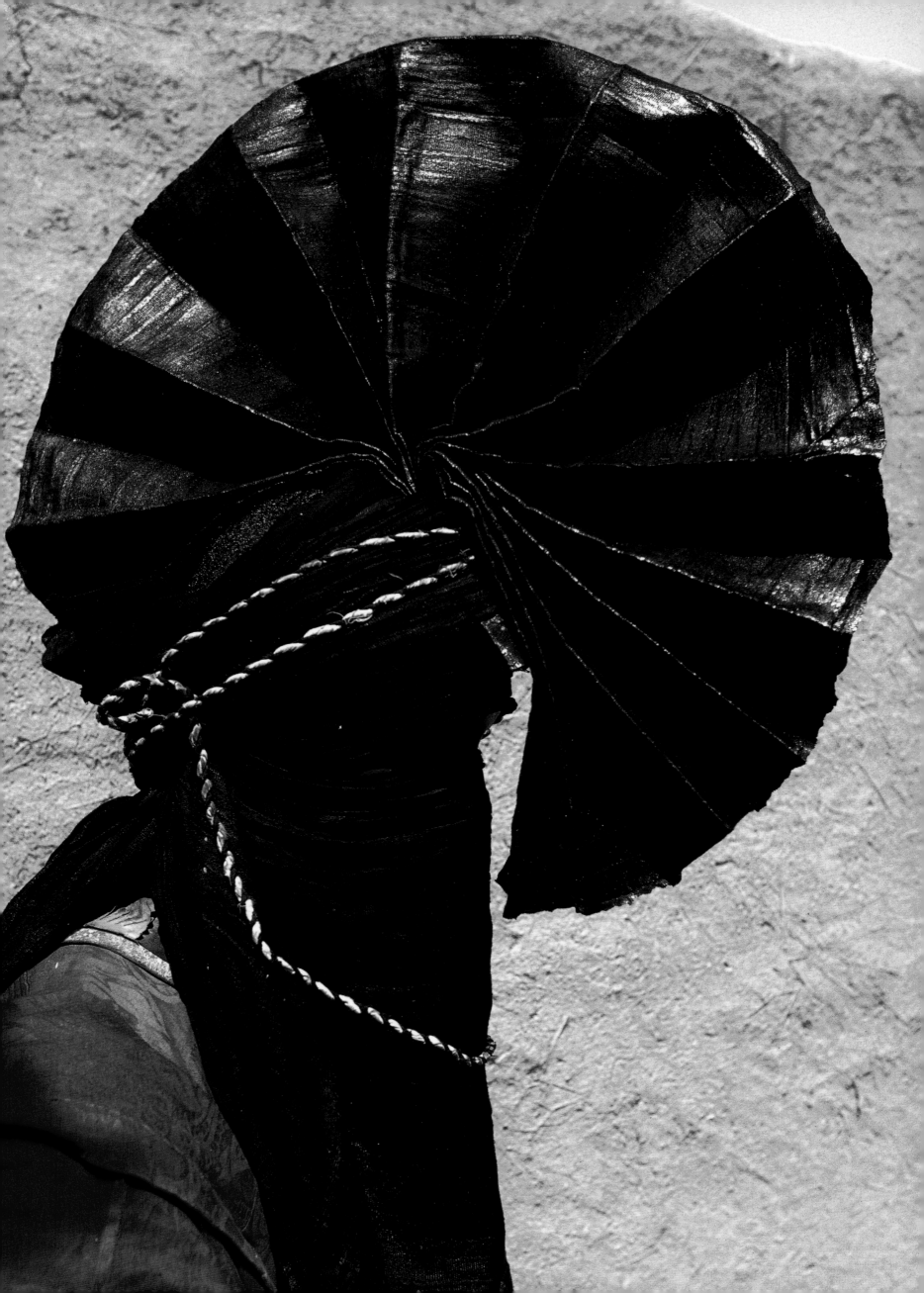

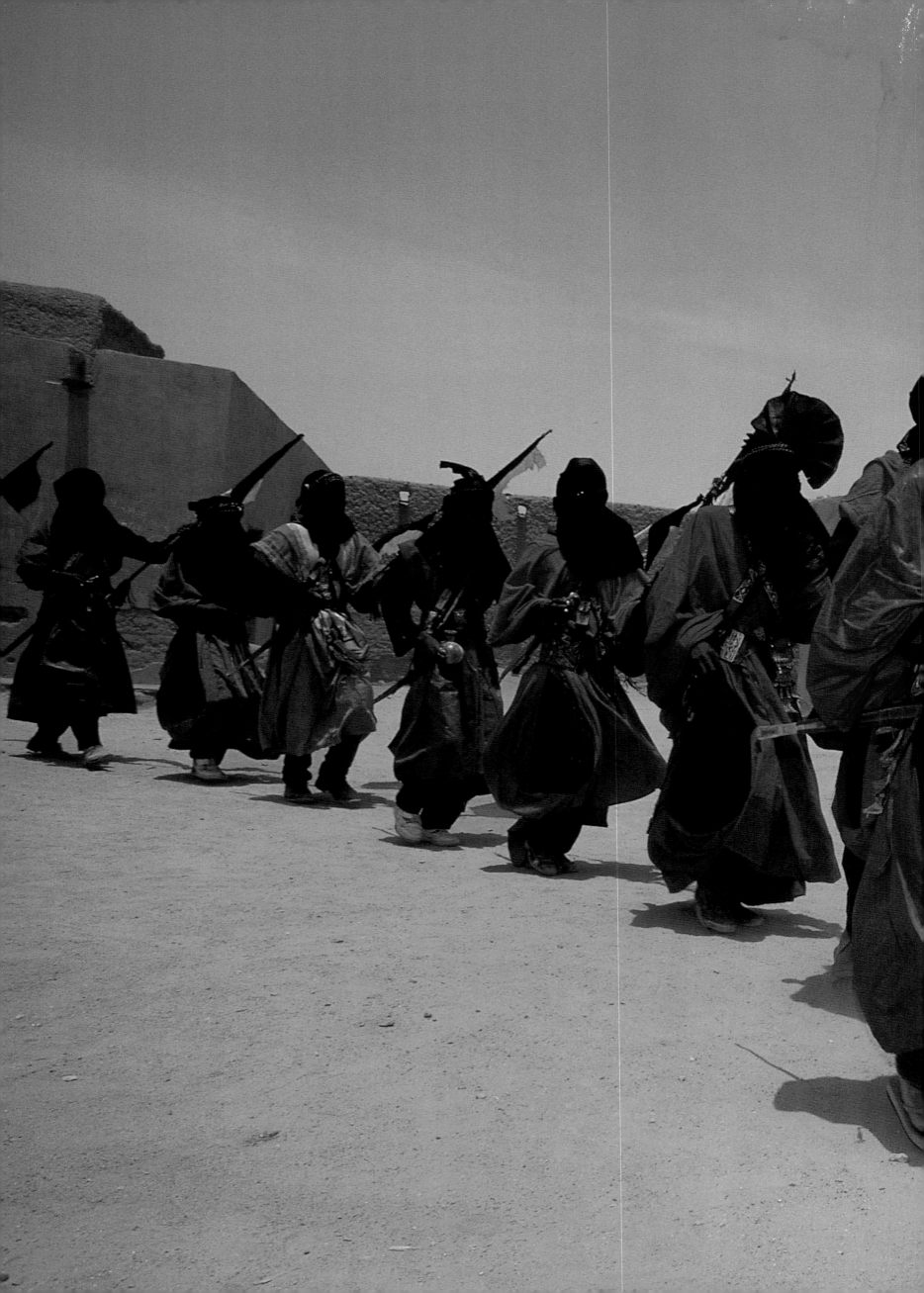

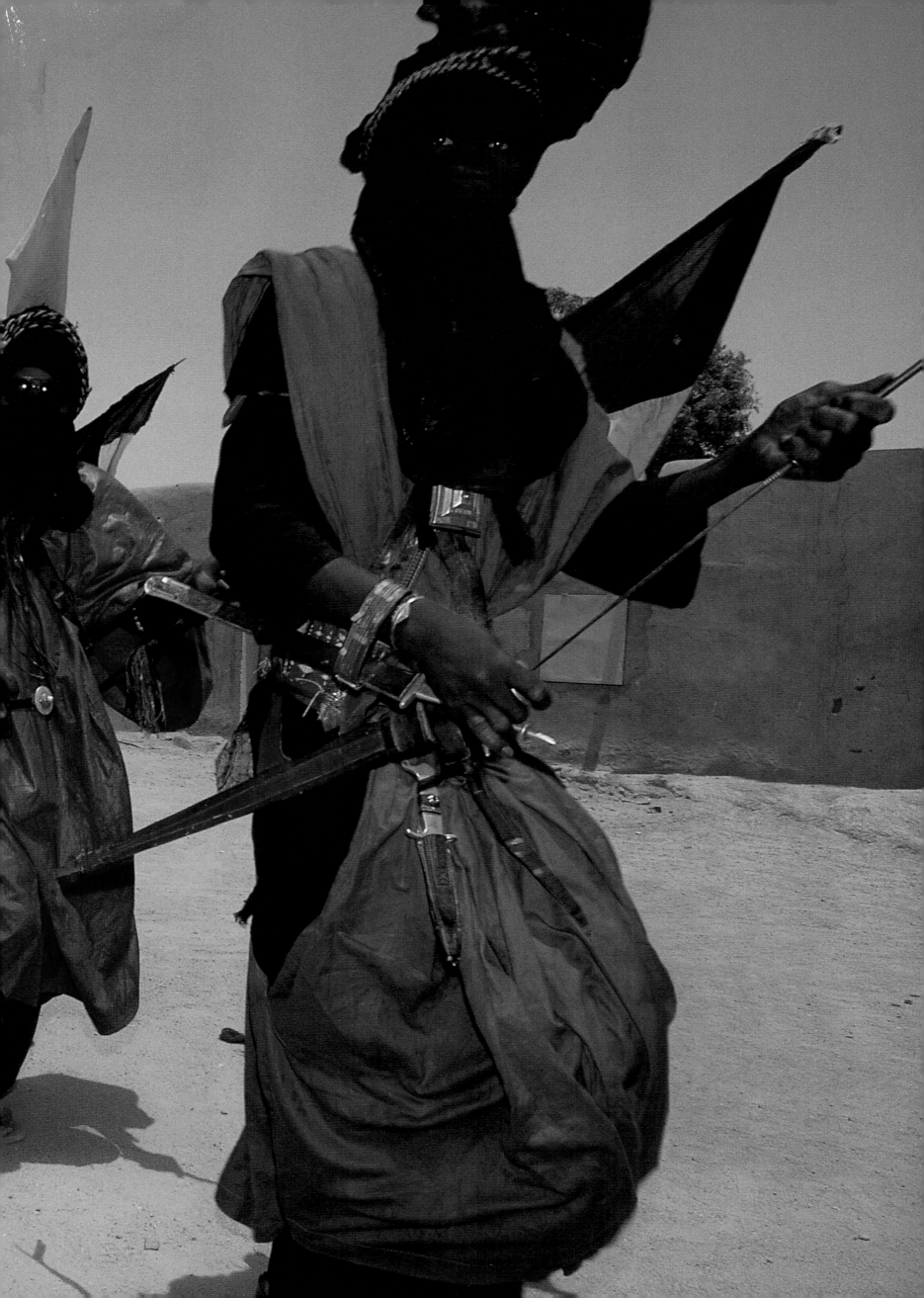

Holy Warriors

Right: After completing its tour of the town, the parade arrives in front of the royal palace to offer new year greetings to the sultan of Agadez. *Below*: Inside the palace a Tuareg follower pays respects to el Hadji Ibrahim Oumarou, Sultan of Aïr, the religious leader of Muslims in the region, who oversees the spiritual practices and well-being of 159 tribes.
Below right: Wearing a red turban and robes to denote his position in the royal household, a guardian looks after palace visitors.
Following pages 346-347: In front of the sixteenth-century mosque of Agadez, thousands of Tuaregs converge beating ritual tambourines. *Following pages 348-349*: The sultan's adviser is swathed in yards of costly indigo cloth. His turban-veil, known as *alacho*, signifies the attainment of manhood. The Tuareg believe that a man wearing *alacho* commands respect for himself and his forefathers: a proverb states that "A man with no veil is no man at all." The veil also preserves modesty, for a Tuareg man must always cover his nose and mouth in public, failure to do so being considered the height of disrespect. Sewn together from dozens of half-inch-wide strips of handwoven cotton, the *alacho* is colored with indigo-plant pulp beaten into the cloth, a method of dying devised because of water shortage. Everything that touches the cloth takes on a blue coloration, including the skin, which is why Tuaregs are called the "blue men of the desert". For protection, this nobleman attaches to his turban a silver Koran holder.

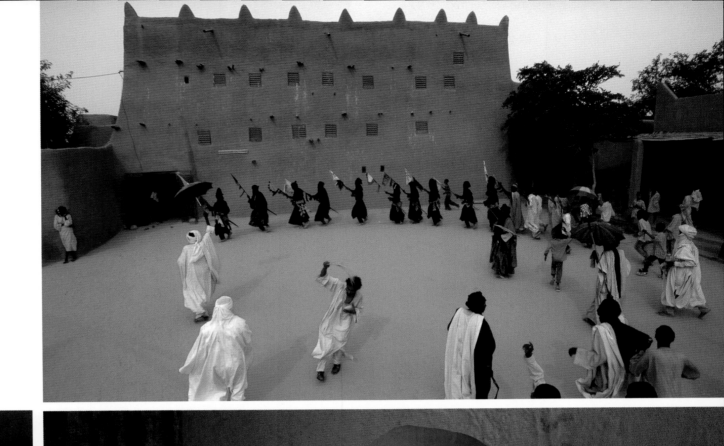

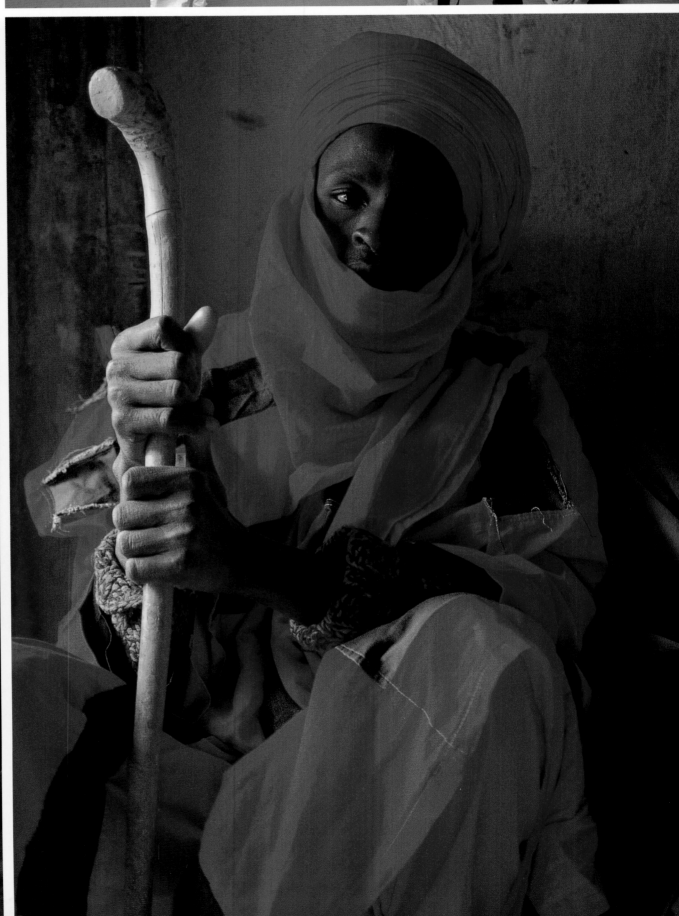

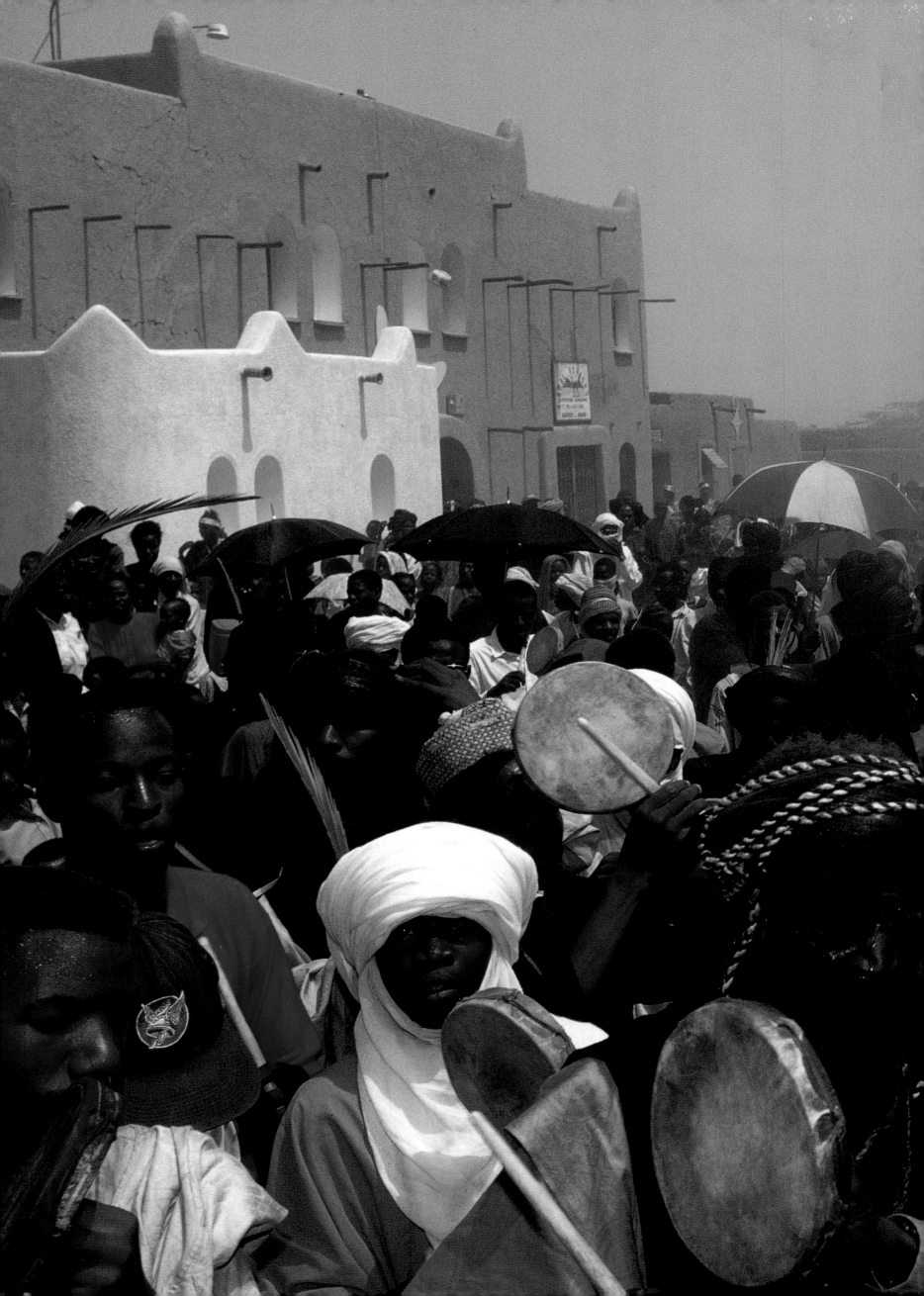

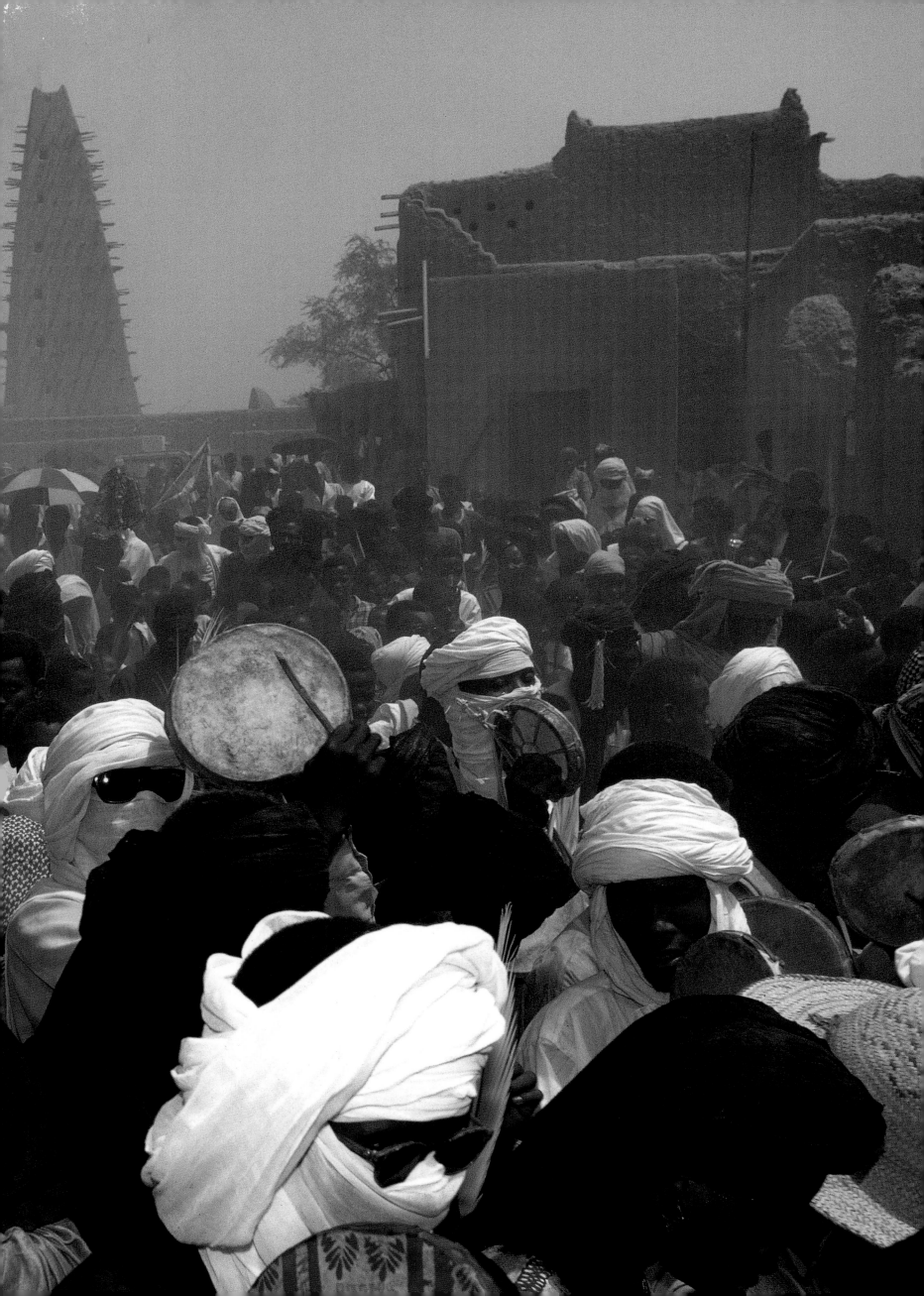

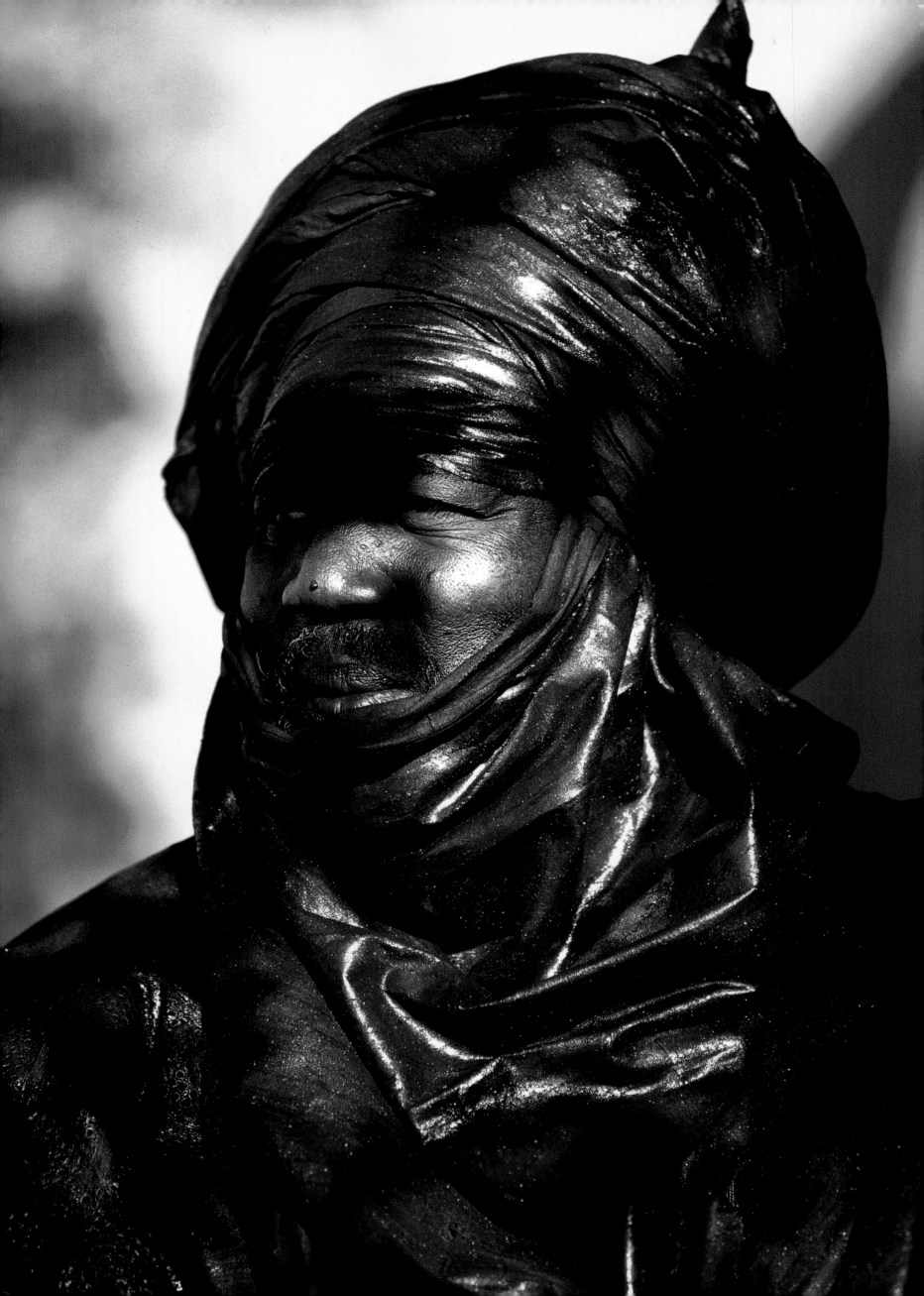

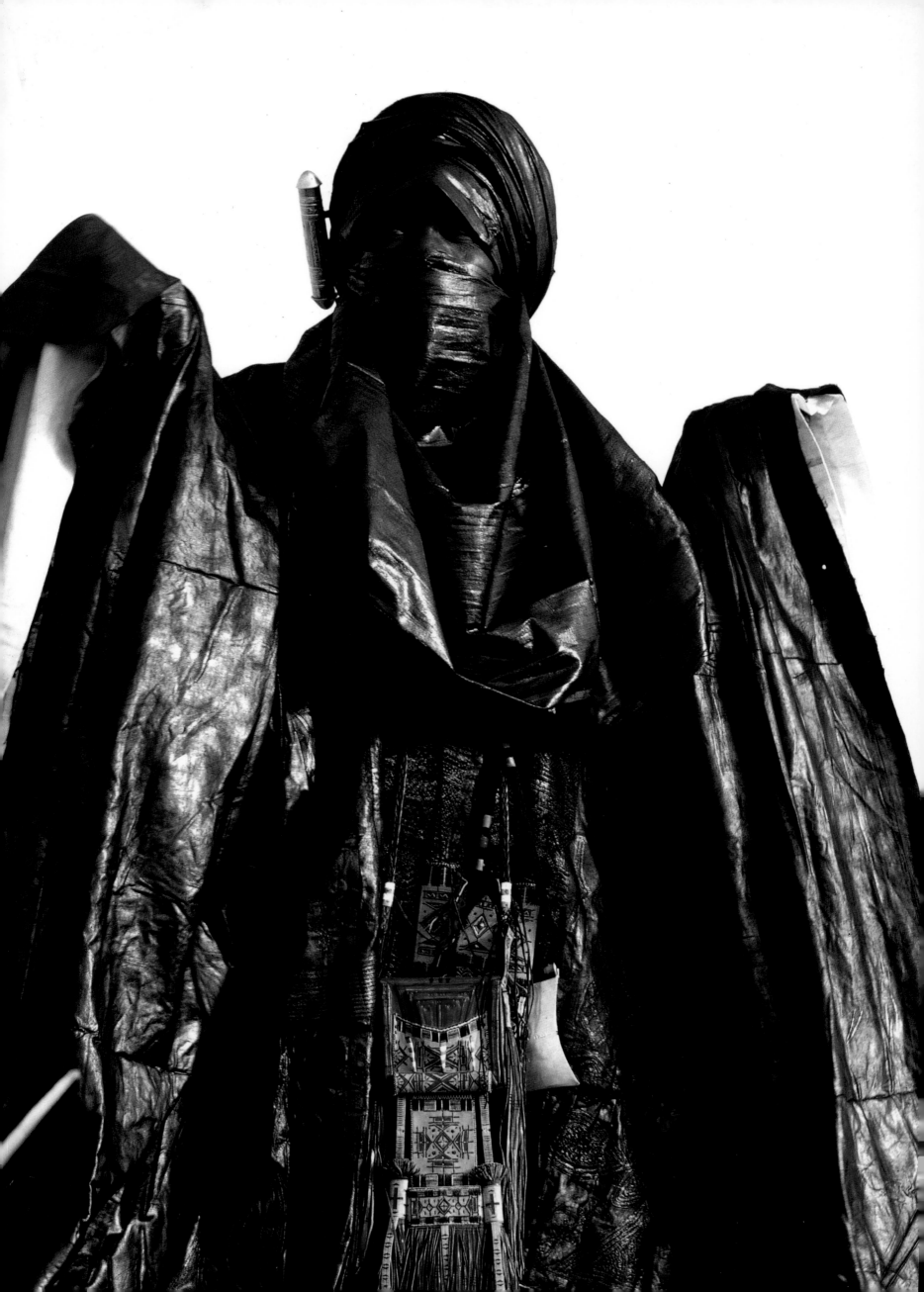

SPIRITS & ANCESTORS

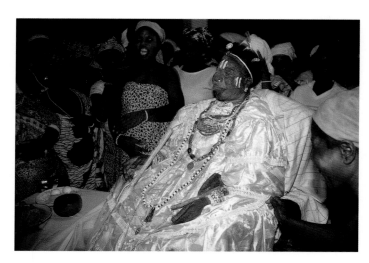

When the great fetish priestess Madame Amortsoe Quaye died suddenly at age seventy-nine, her death was believed to have been caused by a curse put on her by one of the priestesses she had trained. The notice of death posted on buildings in Accra, Ghana, caught our eye and aroused our curiosity.

On the night before her funeral, we visited Madame Quaye's village and observed a small pavilion draped in cloths at the center of her compound. Hundreds of devotees were gathering to pay their last respects to this renowned Ga healer. Just after midnight, the priestesses swept back the drapes of the funeral pavilion, and the crowd was awed into silence. In the eerie light, the dead body of Madame Amortsoe Quaye sat dressed in a shimmering white gown.

Her face was painted with symbolic white chalk designs and her hair coiffed in the traditional three-pronged Ga style. Her mouth was sealed with bright red wax, into which was stuck a red parrot feather, symbolizing her close association with the spirit world. One by one, priestesses approached her, crying out praises and wildly disclaiming any involvement with her death. Some then fell headlong into the crowd in a deep state of possession. Throughout the night, many hundreds of priestesses arrived to pay homage to their spiritual mentor. Finally, at daybreak, Madame Quaye began her journey to the afterworld. She was buried in a brightly painted replica of the thatched shrine in which she had long practiced her healing art—a

"fantasy coffin". This unforgettable event was our introduction to the powerful African rituals of death.

TWO WORLDS

As part of the human life cycle, funerals are considered the last transitional rite, a means of formally introducing an individual into the world of spirits. In most traditional African societies, the worlds of the living and the dead are equally real. They exist in a state of perpetual balance and rebalance; actions performed by the inhabitants of one world have a corresponding effect on the other—some beneficial, others detrimental. Although these worlds are essentially separate, they overlap, interact, and communicate with one another. Humans are seen as a combination of physical and spiritual elements, which, at the time of death, split into separate parts, the body returning to earth and the spirit or soul passing on to its role in the afterlife.

According to the Ashanti of Ghana, the basic elements in each person consist of a male-transmitted spirit called *ntoro*, through which cultural identity is received, and female-transmitted blood, known as *mogya*, from which an individual's lineage comes. In addition, *sunsum* embodies personality, and *okra*, or the soul, which is bestowed by God and is the only element not to die with the person, determines destiny. Across the continent, there are many variations on this theme, but all attest to the duality of humans and the universe in which they live.

In Africa, dying persons are shown great care, both to cater to their infirmity and to prepare them for their long journey to the afterworld. The Ashanti take pains to give a dying person a last drink of water, because they consider it unthinkable that a spirit should have to leave this world thirsty. When people are buried, coins are tied to a corner of the burial cloth so they will be able to buy drinking water on the other side.

Traditionally, much superstition surrounds death. As well as inciting fear of the unknown, death is seen to open a hazardous portal into the supernatural

world, through which spirit entities may pass back and forth unchecked. Thus, when a death occurs in a village, the balance between the two realms is considered profoundly upset. Until the spirit of the dead person has successfully completed its transition through this portal, that spirit is a disruptive force, which, if not contained and dealt with positively, has the potential to visit evil on the community it has left behind.

THE ANCESTORS

Africans say that when a spirit leaves the body, it is disoriented and clings to the places and people that it knew in life. Some spirits do not even realize that death has occurred, and they become angry and frustrated that no one recognizes them. This is especially true in the case of youthful or premature deaths, which are believed to be brought on by evil deeds. The earlier and more untimely the death, the greater the evil involved. Paradoxically, the death of a Senufo child from the Ivory Coast may be regarded as a "good death", because such an infant is considered to have been a dangerous python spirit in disguise.

How a person dies in Africa counts for a great deal,

because the victim of a so-called bad death can never become a proper ancestor in the eyes of the people. Ancestral spirits embody universal wisdom and are considered superior entities who live in close proximity to the creator god and can intercede on behalf of the families they have left behind. Custodians of tribal law and morality, these ancestors have the power to punish or reward and to maintain a society's equilibrium. They are the bearers of tradition and the strongest links to the historic origins of a clan and to the mythic foundations of its culture. To qualify as a benevolent ancestor spirit, the deceased must have lived an honest and long life and, perhaps most important, must have produced many children.

MOURNING ACTIVITIES

Because of the hot climate in most regions of Africa,

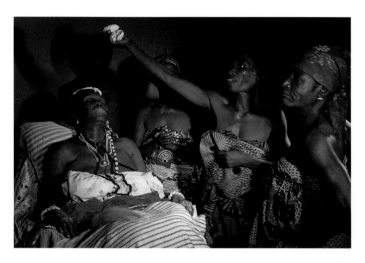

corpses are disposed of as soon as possible. Drumming, wailing, or the firing of guns typically announces a death to the community. Then the preparation of the body begins. In Ashanti rituals the body is bathed three times, a duty that is said to bring many blessings on those who do it. Maternal kinfolk wash the right side and paternal relations wash the left. As they wash, they talk to the deceased, saying such things as, "We are your relatives bathing you; take all our illness away; bring us health; send us children." They finish by washing their hands with rum, pouring a little down the throat of the corpse to "keep it happy" and to delay the process of decomposition. The body is then clad in its finest garments and jewelry and placed on its left side on a beautifully decorated bed, leaving the right hand free to receive the many mourners and to eat a last feast of favorite food.

On the first night of an East African Bantu funeral, the body of the deceased is laid in front of its hut. The several wives of a married man sleep beside his corpse in order of their seniority. The next morning, they sing dirges as community members visit the body. The Bantu believe that if the death was due to sorcery, the corpse will briefly open its eyes and stare at the responsible person. Afterward, all those who have come into contact with the body have their heads ritually shaved to make the evil come out, because they are believed to have death stuck in their hair.

The time and method of mourning vary widely. Hottentots from Namibia wail for many hours beside a dying person, reaching a climax as the individual takes a last breath. In contrast, the Ashanti refrain from loud wailing immediately after death, because they are fearful that the spirit will become deaf and be unable to hear their prayers when it reaches the after-

world. Among the Ga, families hire professional female mourners to attend funerals and make their sorrow more conspicuous. These women travel in groups from function to function, reciting traditional verses, crying on order, leaving no one—least of all the departing spirit—to doubt the family's inconsolable grief.

FUNERAL RITES

Funerary rituals reflect the rich variety of traditional belief systems evolved by African societies. Besides

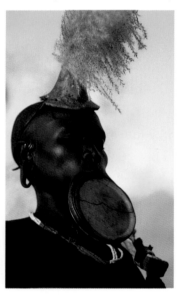

facilitating the disposal of the corpse, these ceremonies are often designed to raise the prestige of both the departed and the bereaved family. Wealth and position are often displayed through the choice of a coffin, refreshments served to guests, rich clothing, musicians to drum and sing, and gifts given to relatives. All these enhance the image of a lineage in the eyes of its community. Most importantly, however, as a result of the time and expense lavished on a funeral, it is hoped that the dead person's soul or spirit will be appeased, remain contented in the world beyond and not return as a dissatisfied ghost to plague its family.

The Senufo and the Dogon of West Africa practice protracted funeral rites in two phases to exorcise and banish spirits of the dead from their communities. The first stage focuses on the burial of the corpse and commemorates the life of the deceased. The second stage is a grand communal rite, designed to send to the afterworld the spirits of all those who have died during the preceding years, leaving the village and its community purged of unwanted supernatural influences. The Senufo ceremony called Kuumo takes place every five years; the Dogon Dama—one of the most elaborate and dramatic ritual performances in West Africa—occurs only once every twelve years.

A Surma funeral in Ethiopia takes the form of a relatively simple one-day burial, when the body is blessed with milk and interred vertically at the center of the family compound. The Hottentots, although intensely fearful of the ghosts of departed kinsmen, have a relative disregard for the land of the spirits. They bury a body flat on its back in a deep hole, with its head turned to the west, marking the head of the grave only with a small stone. After the interment, they become obsessed with getting as far away from the burial site as possible so the ghost will not follow them. The East African Bantu, seeking to please the deceased, dig a roomy underground chamber, where the body can move easily, should it wish to do so.

SACRIFICES AND LIBATIONS

Libations and ritual sacrifices play an important role in funeral ceremonies, appeasing the ancestors to make a funeral auspicious. Sacrifices aid in the journey of the dead to the afterlife and facilitate communication between the two worlds.

In preparation for the collective Dama funeral, Dogon high priests sacrifice certain culturally significant birds and animals each day for six weeks before the ceremony commences. The Ga pour libations of gin, schnapps, and the blood of a sheep over coffins as they move in procession, to keep evil spirits from contaminating the dead. At the funeral of a wealthy man, the pastoral Banyakole of Uganda slaughter all the full-grown bulls of the deceased, sprinkling their blood around the house and over the bereaved family as a gesture of purification. The Bantu of East Africa make an animal sacrifice on behalf of a dying person to ensure the welfare of the departing spirit and its kinsmen. Meat taken from the carcass provides both an opportunity for the dying to participate in a last communal meal and a means of detecting and punishing those who may be responsible for the fatal illness. The Bantu believe that whoever may be trying to kill the sick person will also die upon eating the sacrificial flesh.

MASQUERADES

African funerary masks are the physical manifestation of spirits from beyond the mundane world. They represent the forces of nature, myth, and the ancestors, emerging at ceremonial times to assist with the progress of the spirits of the dead from this world to

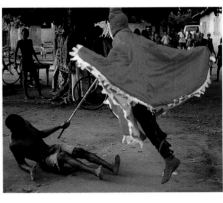

the next. An expression of order and reassurance at a time of great upheaval, masks depict deities or figures from legend, and they are used to enact events from the time of creation or a period in history when the world was in harmony. The masquerade also offers comfort to the onlookers by drawing their attention away from their sense of loss and the disturbing notion of their own mortality.

At the Dogon Dama funeral we witnessed, more than sixty-five types of masks came out both to entertain the villagers and to educate the spirits of the deceased by showing them the entire world for the last time in preparation for the next stage in their evolution. Spanning the entire Dogon cosmology, these masks represent both natural and supernatural forces.

The Yoruba Egungun masks of Nigeria and Benin evoke the ancestors who dwell in Kutome—the afterworld. These masks are brought into the community on an annual basis in order to rebalance the world. The cult of Egungun is the main way in which Yoruba "sons" continue to contact and honor their dead "fathers." To the Yoruba, neglect of the dead constitutes an unthinkably serious offense, and by regularly bringing the spirits back, the Egungun ensure that they are not forgotten.

The Senufo summon their masks out of the bush to preside over funerary rites, for they believe that the wisdom that man has lost resides in the bush. These "wild" bush dwellers return at funerals as the only beings capable of handling the spirits of the dead. The men wearing the masks during the rituals undergo a prolonged training, and for their sacred tuition they enter secret societies or ancestral cults: the Senufo Poro, the Dogon Awa, or the Yoruba Egungun and Oro. These powerful societies act on behalf of the ancestors, and their control over the community is absolute; their authority comes from the spirit world and, therefore, is beyond human questioning.

The masking societies also provide sacred music during a funeral. Senufo Poro musicians recount the life story of the deceased through the use of a special musical drum language. Drums are also played by Poro masks to release the dead person's spirit from the body and to send it out of the material world. The "talking drums" of the Yoruba receive messages from the afterworld that they pass to the audience.

FANTASY COFFINS

In the coastal region of Ghana, the Ga people bury their dead in elaborate fantasy coffins. During the last several decades, these coffins have been crafted by a group of artisans who take inspiration from the livelihoods of the deceased and make, for example, a Mercedes-Benz for a wealthy merchant; an eagle for a chief; a cow for a dairy farmer; or a lobster for a fisherman. Fantasy coffins are a modern way of expressing the

connection between the ancestral and living worlds. The deceased are sent into the hereafter literally contained within the trappings of everyday life. An inversion of the function of masks, which bring the ancestors into the mortal world, fantasy coffins allow the world of the living to cross into the land of the ancestors. Fantasy coffins also illustrate a humorous side to Ga beliefs. The dramatic and colorful coffins display a natural joy for life in the face of death and demonstrate the artful way in which indigenous Africans live their lives and overcome adversity. These peoples are not born into an easy relationship with the cosmos. From birth to death, they must tend it constantly.

Dogon Dama Funeral

The Dogon people live in one of the most spectacular geological areas of West Africa, the Bandiagara escarpment of Mali, south of the Niger River. They came to this region in the fifteenth century, driving out their predecessors, the Tellem, from their dwellings in the cliffs. Today, the Dogon build their villages at the foot of the cliffs, and lay their dead in the ancient burial caves of the Tellem, higher up on the cliff face.

The Dogon believe that all natural objects and living beings possess spirits. They hold that when a person dies, the spirit becomes detached from the body and has the power to disrupt the order of the world. To re-establish balance, Dogon funerals are performed in three stages. Immediately after death, the body is wrapped in cloth and hoisted up to a burial cave in the cliff face. The following year, a ceremony known as Nyu Yama commemorates the departure of the deceased with mock gun fights, song, dance, and animal sacrifice. The final and most dramatic stage of the funerary ritual occurs every twelve years and takes the form of a large collective funeral called the Dama. This ceremony honors all those who have died during the preceeding period and initiates them into the realm of the ancestors.

In preparation for the Dama, sacrificial offerings are made daily for six weeks by the Hogon, the chief village priest. During this time young men and blacksmiths carve masks that illustrate the many aspects of the Dogon universe. At the climax of the ceremony, hundreds of maskers arrive in the village to perform a series of ritual dances that appease the dead and show them the world of the living for the last time. In this way, the masks ease the spirits out of the villages and speed them on their journey to the ancestral world.

Above: A guardian surveys a burial cave high in the cliff face of the Bandiagara escarpment. *Right:* The Toguna house, decorated with relief images of masked dancers, is the meeting place for male elders.

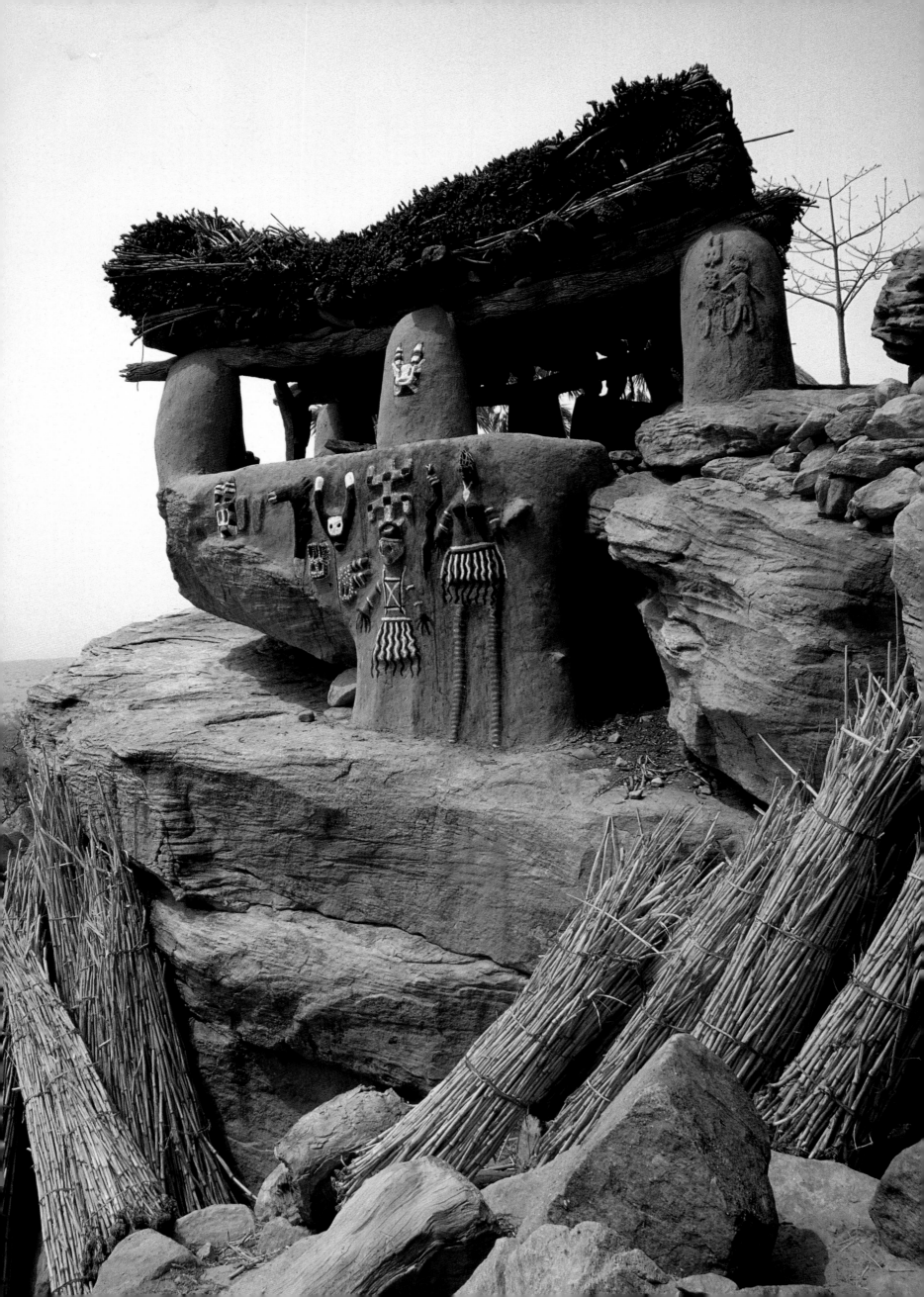

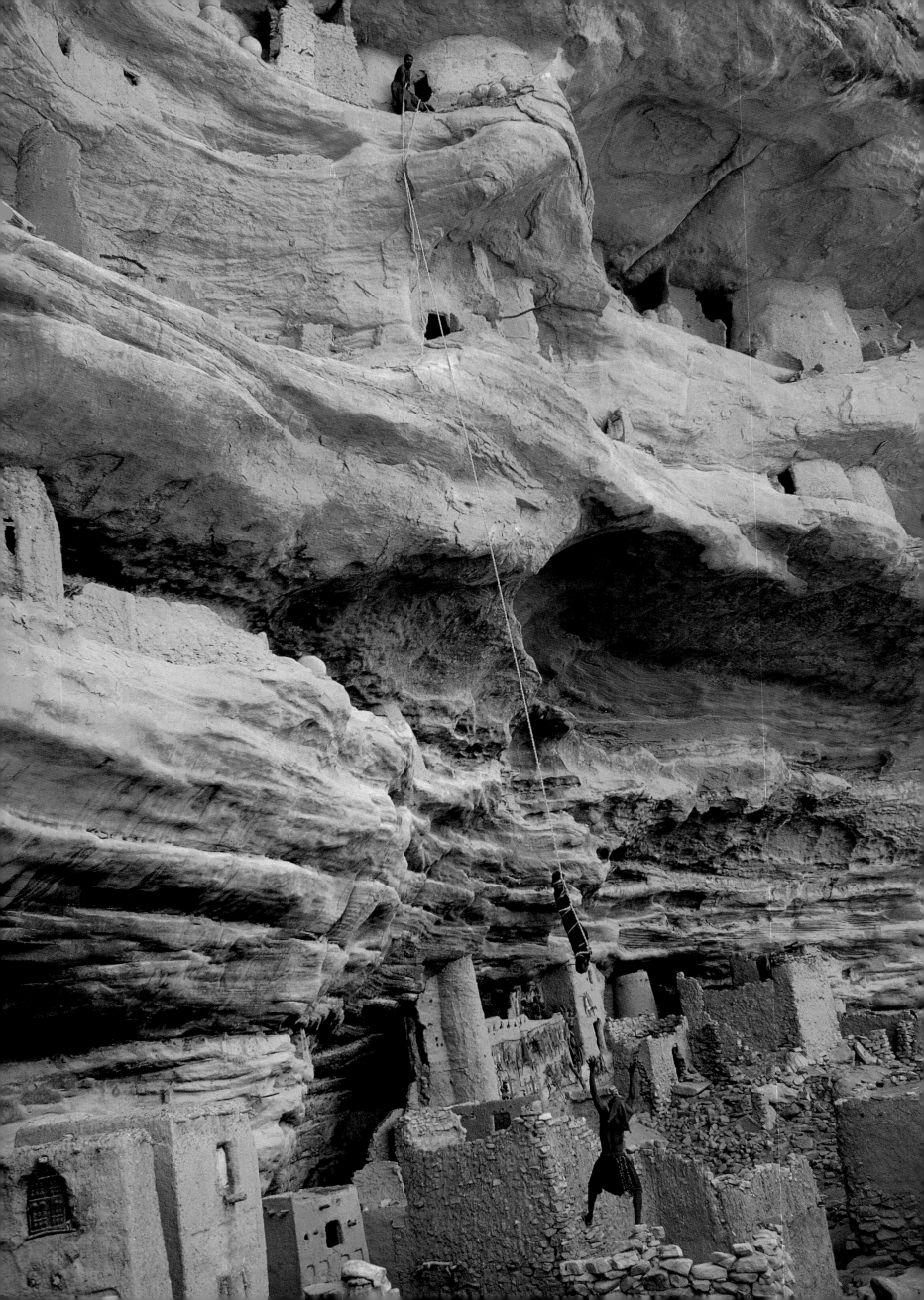

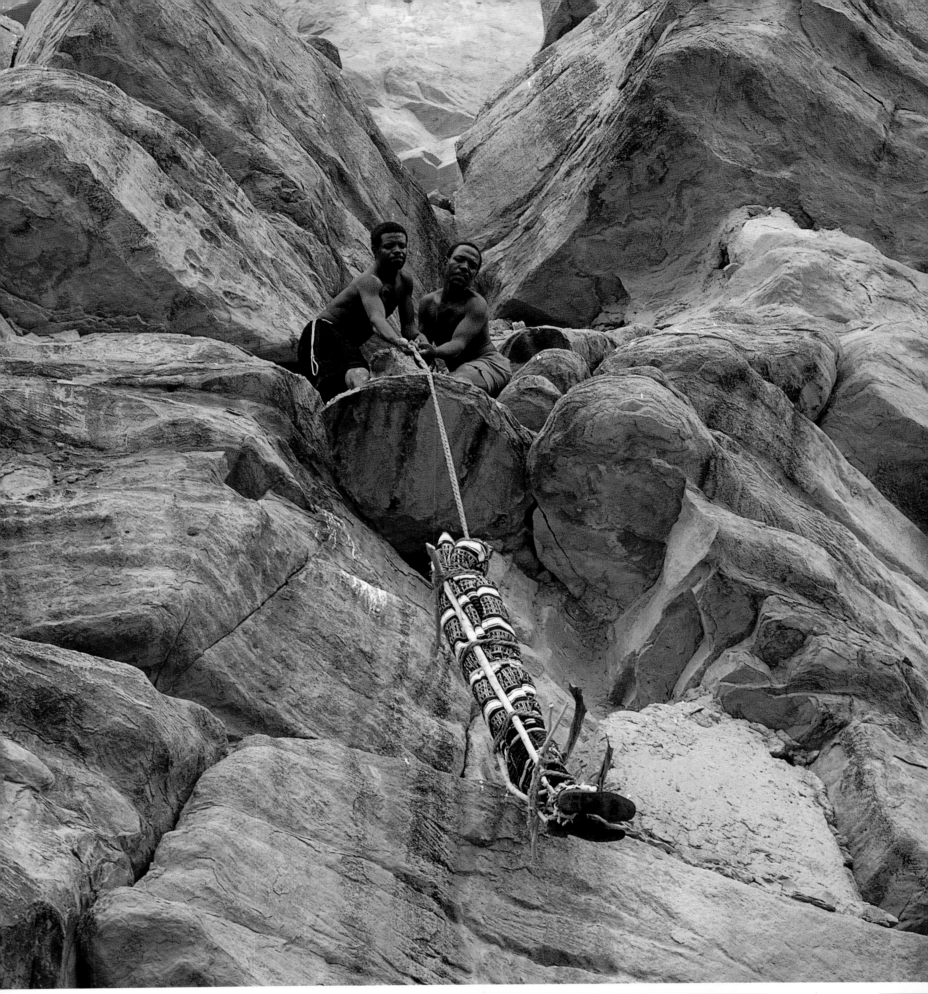

Burial of the Dead

The body of a village elder is taken to the foot of the escarpment wrapped in burial shrouds. The pallbearers tie the corpse to the end of a baobab-fiber rope lowered by attendants from the burial cave. The body is then hoisted to its final resting place amid the wind-eroded sandstone seams. When the corpse reaches the top, it is pushed through a small hole in the rock face into the cave to be laid out among the bones of its ancestors. A bowl of oil is left at the feet of the deceased to ease weariness from the journey to the afterworld. The cave floor (*right*) is strewn with bones of the dead that have accumulated over the centuries.

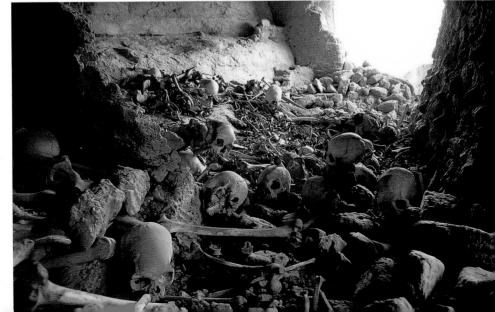

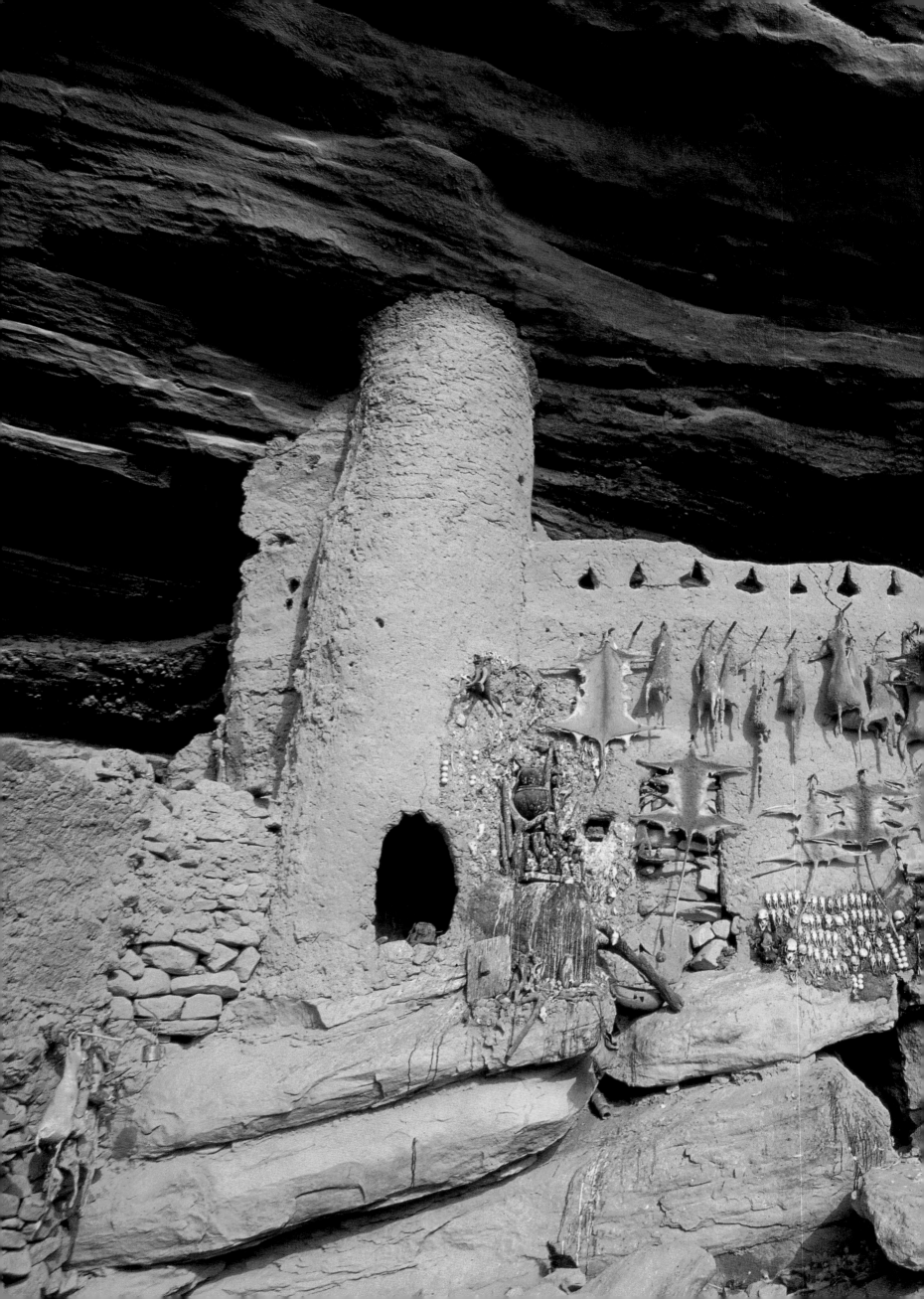

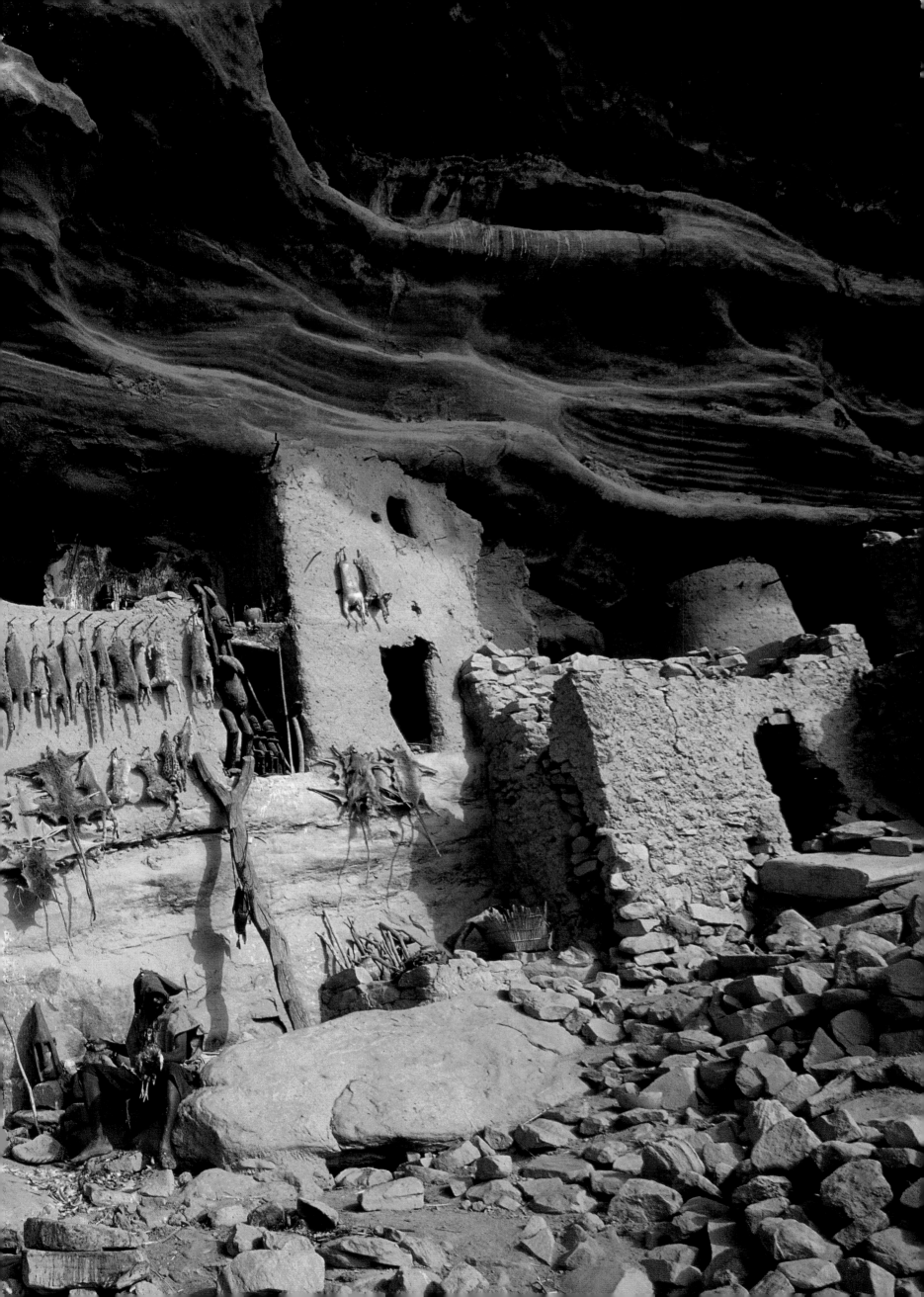

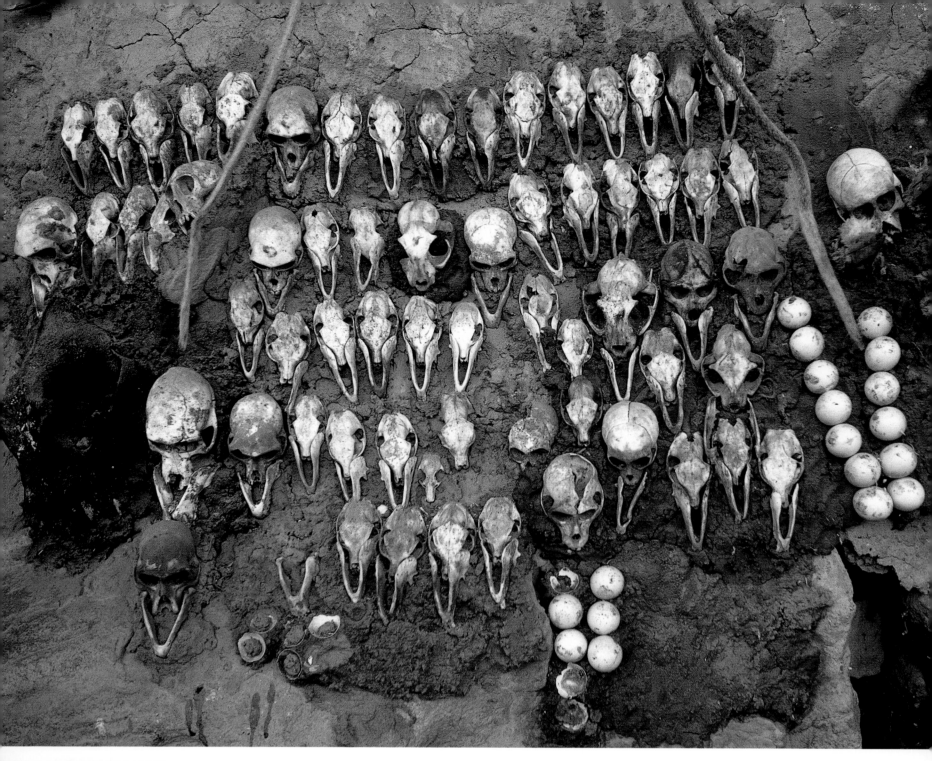

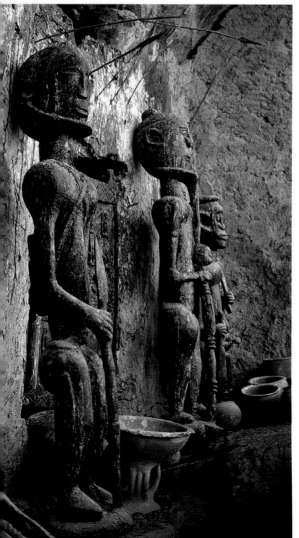

House of the Ancestors

Halfway up the escarpment, the Hogon's clan house (*preceding pages and above*) protects and guards the world of Dogon ancestors. It is the focal point of all ritual activity for the Dama funeral ceremony. Built into a large cave, the façade is covered with the skins and skulls of hunted game, and the countless animals sacrificed to invoke the power of the spirits during the six-week preparation for the Dama. The Hogon himself, both chief and high priest, is the most important member of Dogon society. He officiates at all religious ceremonies and acts on behalf of the ancestors during funerals.
Left: Within the house are statues carved in a stylized fashion to resemble the Hogon. They are commissioned by those in need to draw the attention of the ancestors to the problems or illnesses of the living. The Dogon believe that statues are the most effective way of petitioning the ancestral world, since "One cannot always pray and kneel at the altar, but the statue can."
Right: The Hogon offers a libation of chicken blood on the main altar, to appease the ancestors and purify the village for the Dama ceremony. The altar, a sacred earthen mound, supports a collection of carved wooden figurines representing ancestral spirits.

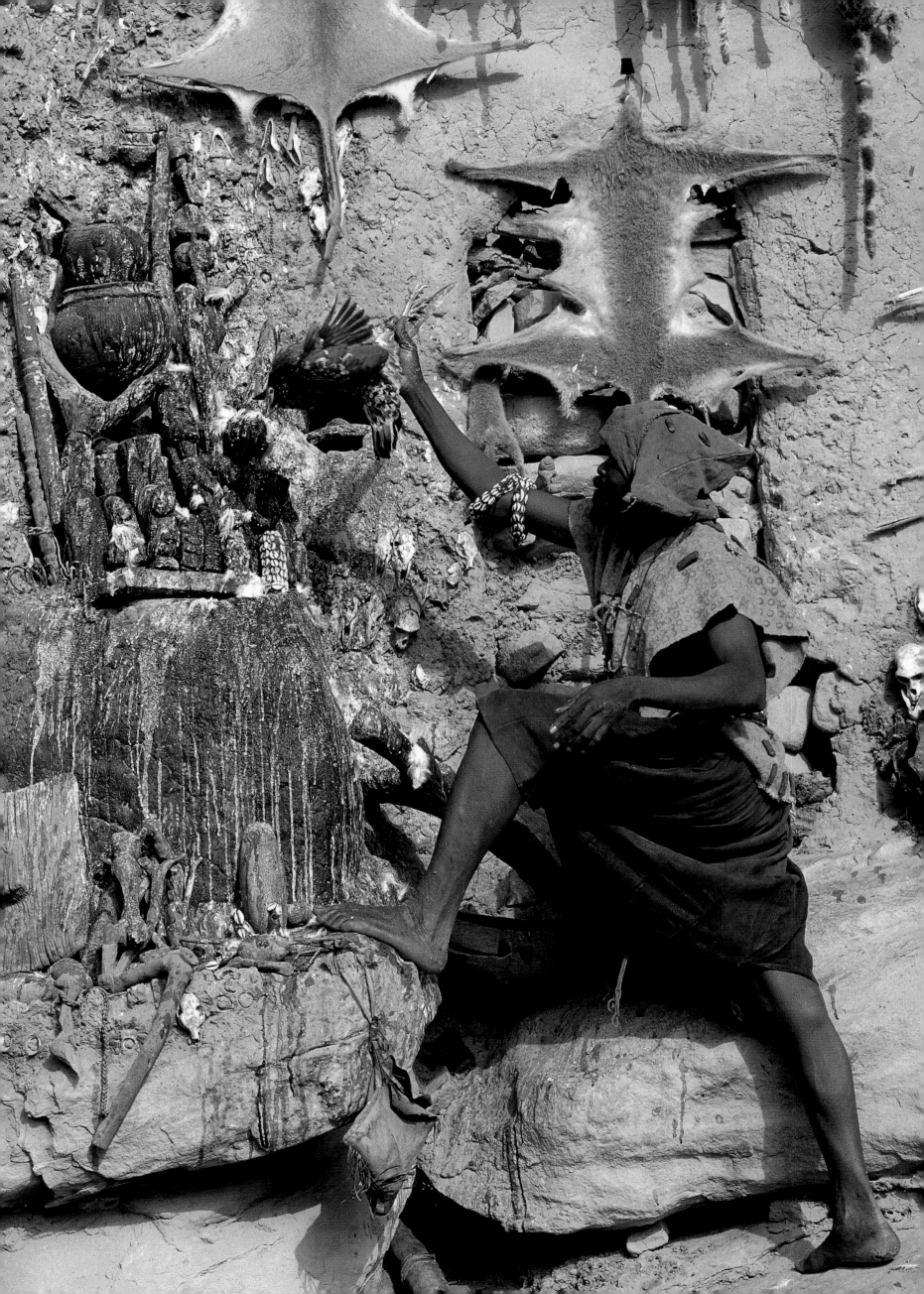

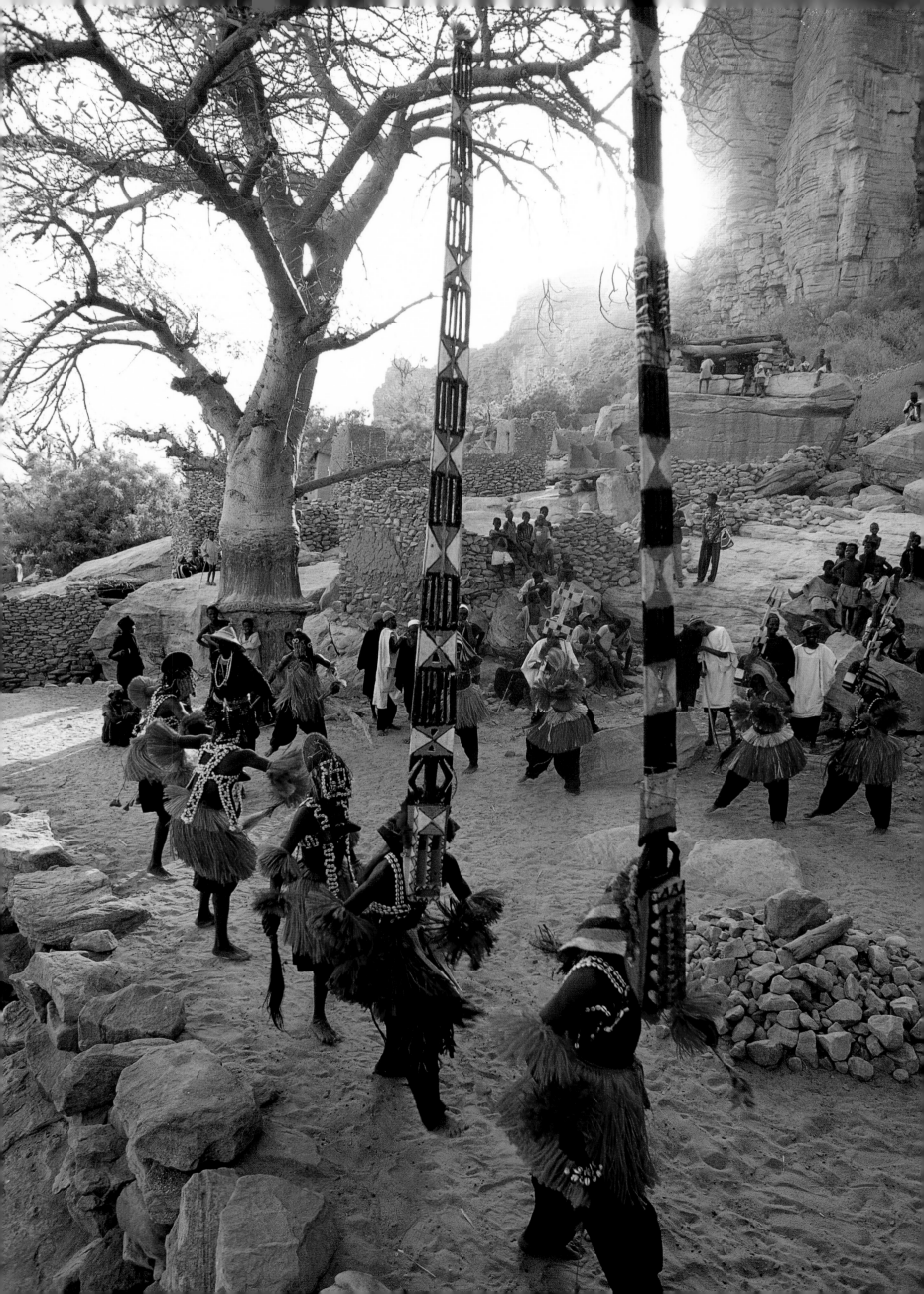

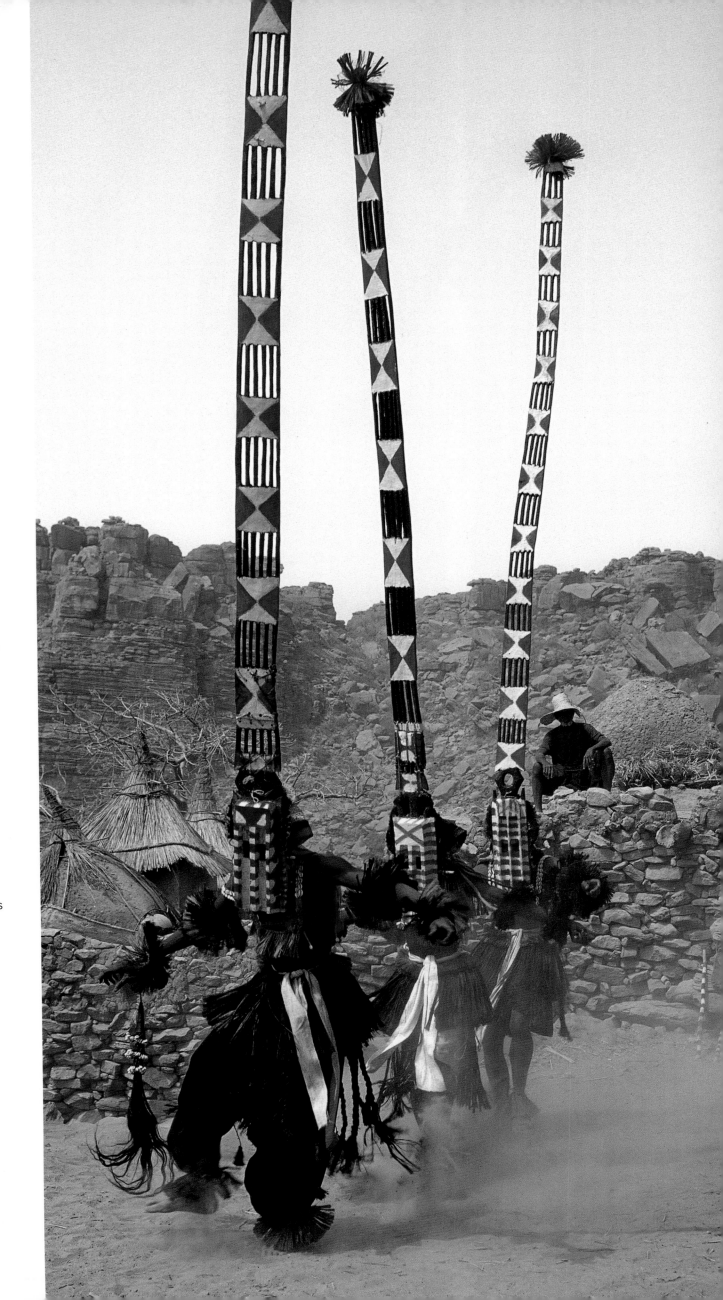

The Dama Masquerade

On the first day of the cere-
mony, the Dama masks make
their way down the narrow foot-
paths of the escarpment into
the village below, where they
burst into an explosive display
of dance and drama. For five
days, these and other masks
representing animal and human
forms perform ritual masqua-
rades that enable the earth-
bound souls of all those who
have died during the previous
twelve years to move into the
ancestral realms. The masks
are carved and freshly painted
by young Dogon men who work
in secluded caves, hidden from
the women and children who
may be punished if they see
the artisans at work. The
impressive Sirige mask, reach-
ing a height of fifteen feet,
serves as the symbolic link
between the mortal and
spiritual worlds. Some believe
that the mask refers to the
legendary journey of Ogo, the
first occupant of earth, who
traveled between his terrestrial
home and the heavens on a
long ladder. The Sirige requires
the most expert of dancers.
During its dipping and raising,
the towering mask is entirely
held in place by the dancer
gripping a wooden bar in his
teeth, the entire weight of the
mask being completely borne
by the jaw. The masker's face
is concealed in a distinctive
rectangular box, as the tall
wooden panel, painted with
geometric designs, teeters
majestically over the ritual
proceedings.

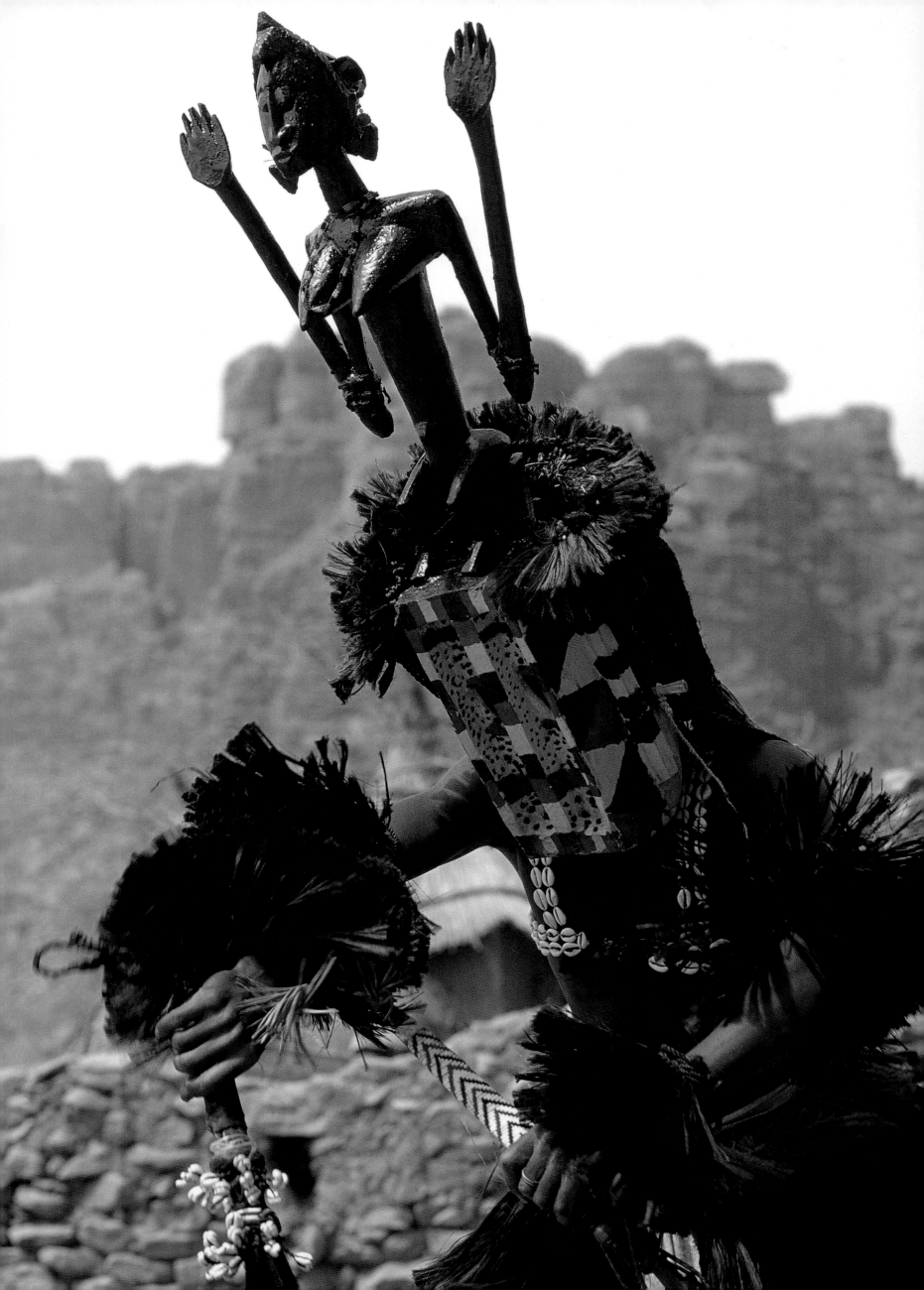

Dancing Away the Spirits of the Dead

The Satimbe mask *(left)* depicting a large-breasted female with bent arms lashed at the elbows honors the primordial woman. According to legend, she discovered the original masks, which were later taken from her by the men of her village. Since that time, Dogon masking has been an exclusively male activity.

Right: A Walu mask mimicking the gait of an antelope is closely trailed by an Adyagai mask that represents a stinging insect with large eyes. *Below*: A hyena mask uses two long sticks as support for his leaping dance. Able to tell the future, the hyena symbolizes wisdom and long life. *Following pages*: As evening falls and the Dama ceremony comes to a close, masked stilt dancers leave the village, their task complete. The spirits of the dead have been successfully initiated into their roles as ancestors. As spirit guardians of their clan, they will now watch over future generations, protecting their living descendants from harm and maintaining the natural balance within Dogon society.

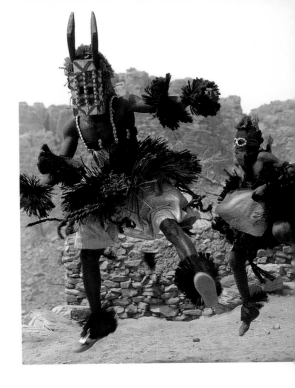

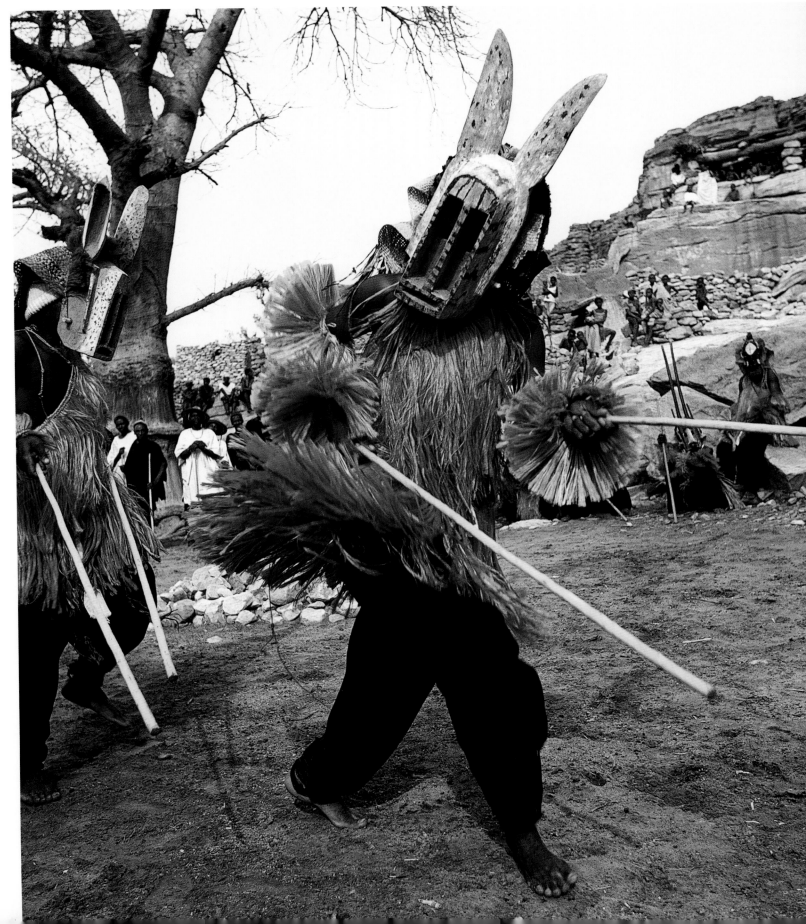

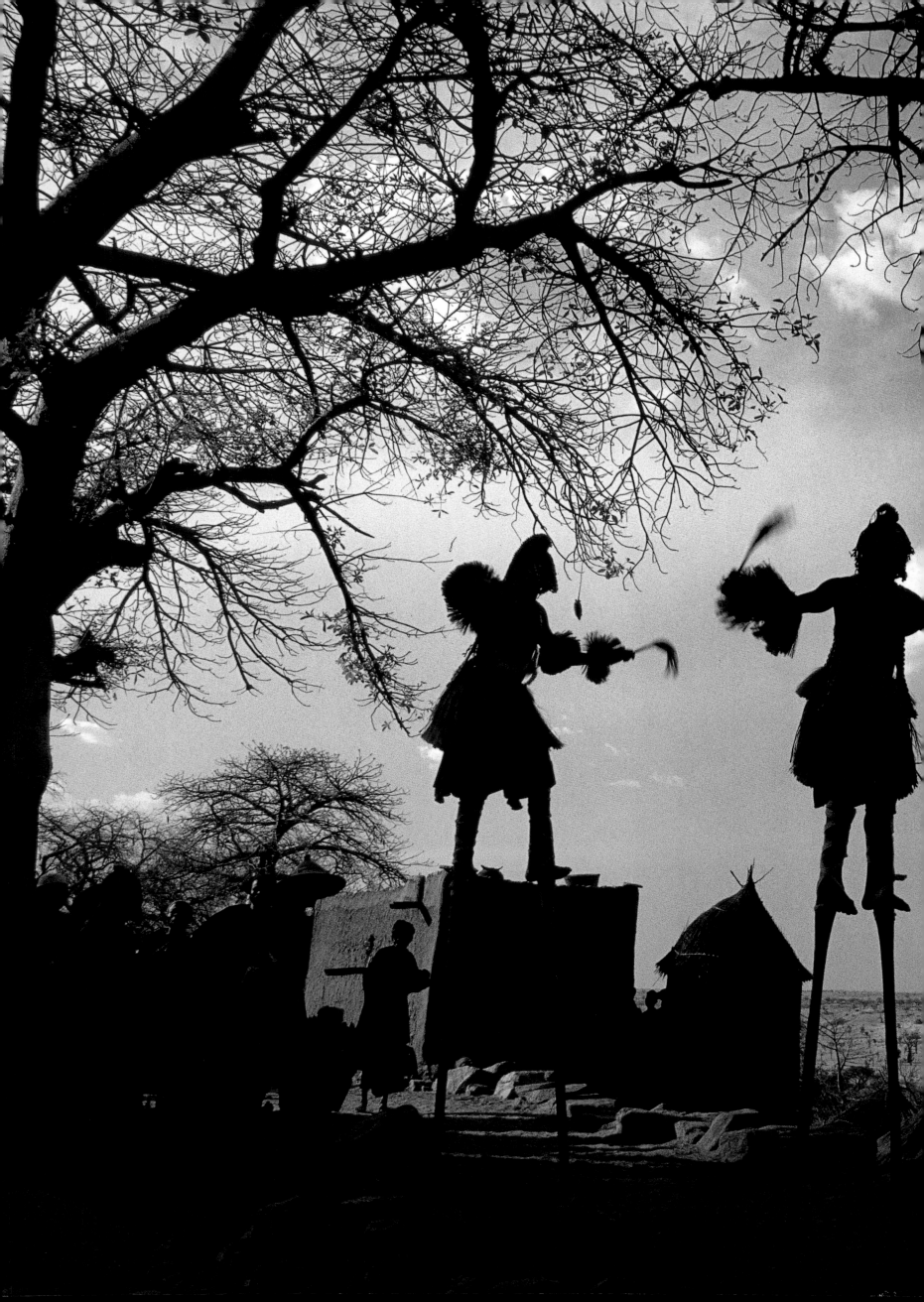

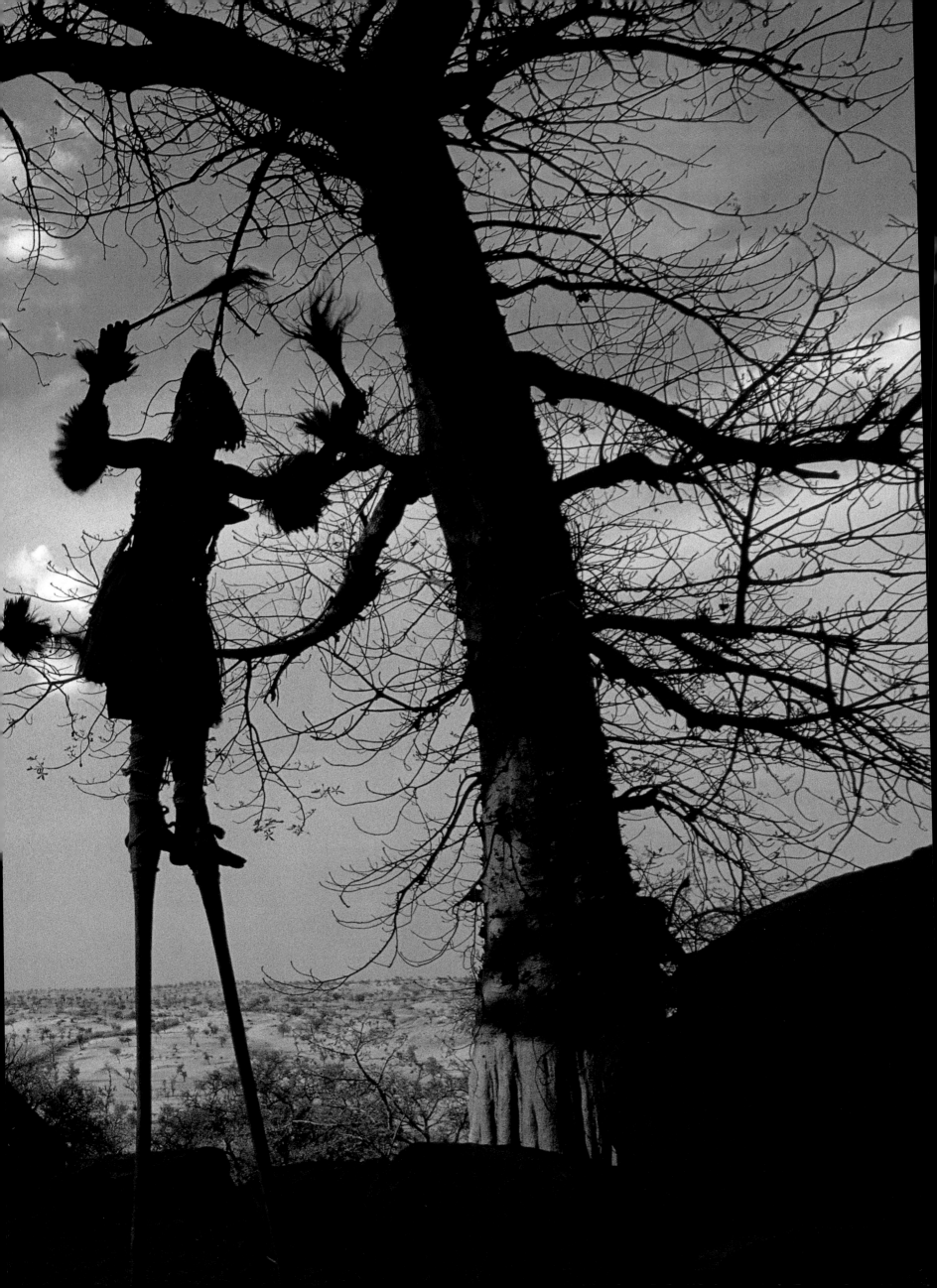

Senufo Spirit Masks

The Senufo people of Ivory Coast believe that after death, due to a strong attachment to the mortal world, the spirit of a deceased person may linger around the village in which he or she lived. Fearing that this will bring adversity to the community, villagers conduct a protracted funeral rite to exorcise the spirit from their midst, sending it to the afterworld. There, as a respected ancestor, the deceased will benefit both family and community.

The organization of all Senufo funerals is the responsibility of the highly secret male Poro society. Membership in the Poro society requires nearly twenty years of training, at the end of which initiates undertake ritual duties that help regulate Senufo society. These activities include organizing agricultural work and providing food for elders and less fortunate villagers. Senufo funerals are directed by a group of Poro elders from a sacred grove outside the village. The elders oversee a succession of Poro musicians and maskers, who, over the course of two days, preside over the burial of the body and the expulsion of the errant soul from the community. On the first day, a gift-giving is held in the courtyard of the dead person's home. The most coveted of all gifts are lengths of fine cotton cloth given to the relatives of the deceased to use as shrouds for the body. Additional cloths are

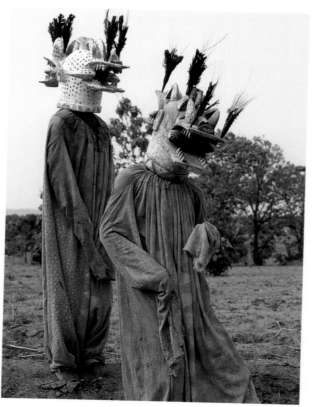

given to the family, forming a cache of collective wealth that is reserved for future ritual use.

The formal ritual is begun by Poro musicians, who tell the life story of the deceased through the use of a special musical language. As the ceremony progresses, Poro spirit masks are summoned from the forest. The two most notable members of this group are the Yarajo, who acts as master of ceremonies, and the Kporo, whose sacred duty is to sever the soul from the body and escort the deceased to its final resting place.

The photographs on the following pages include Senufo rituals from the Nafara, Djeli, and Fodonon groups.

Left and right: Janus-headed Wambele masks dance in pairs around ancestral burial grounds, chasing away lingering spirits of the deceased. Reminiscent of antelopes, the masks also feature wart hog tusks, crocodile teeth, and porcupine-quill plumes.

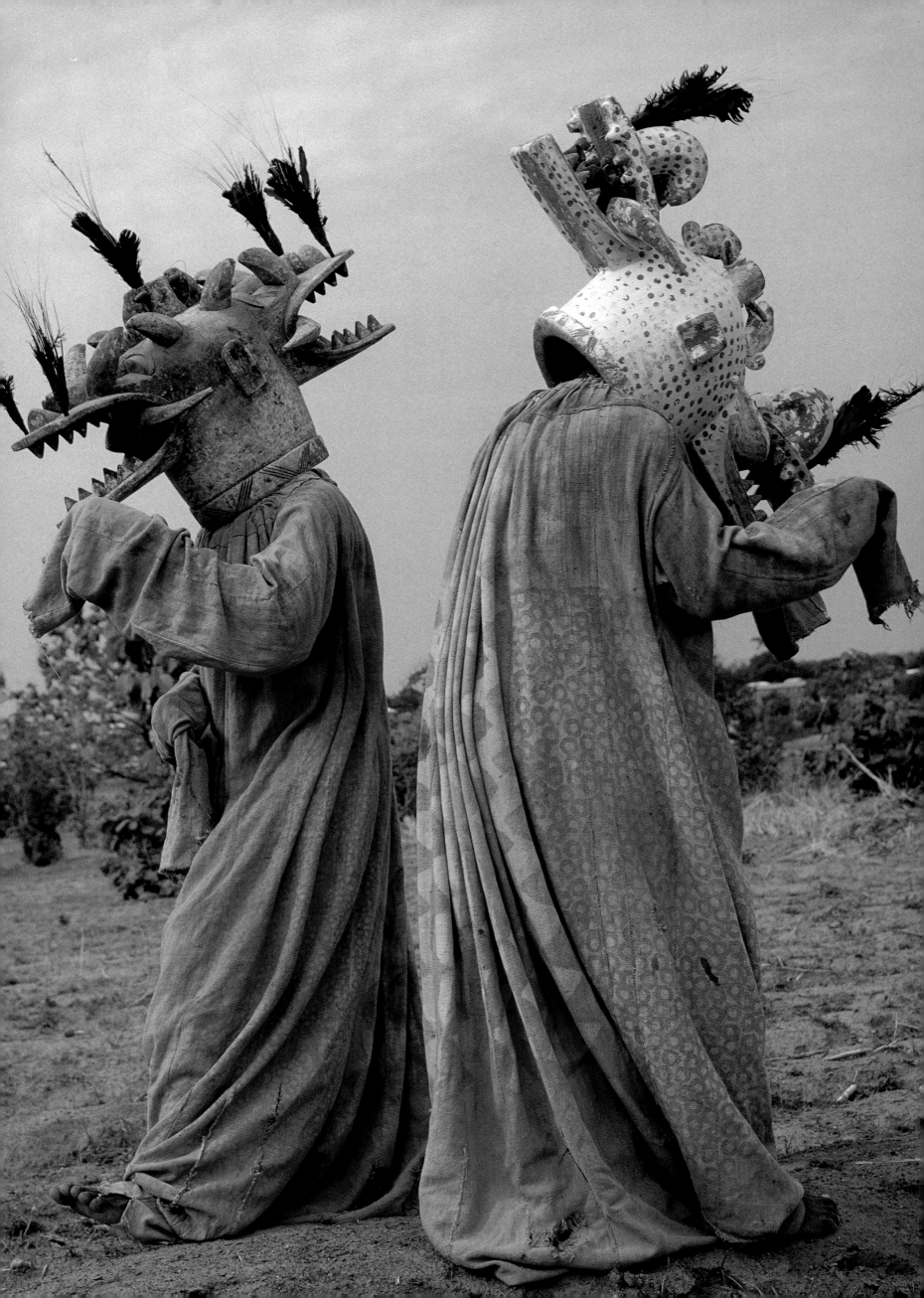

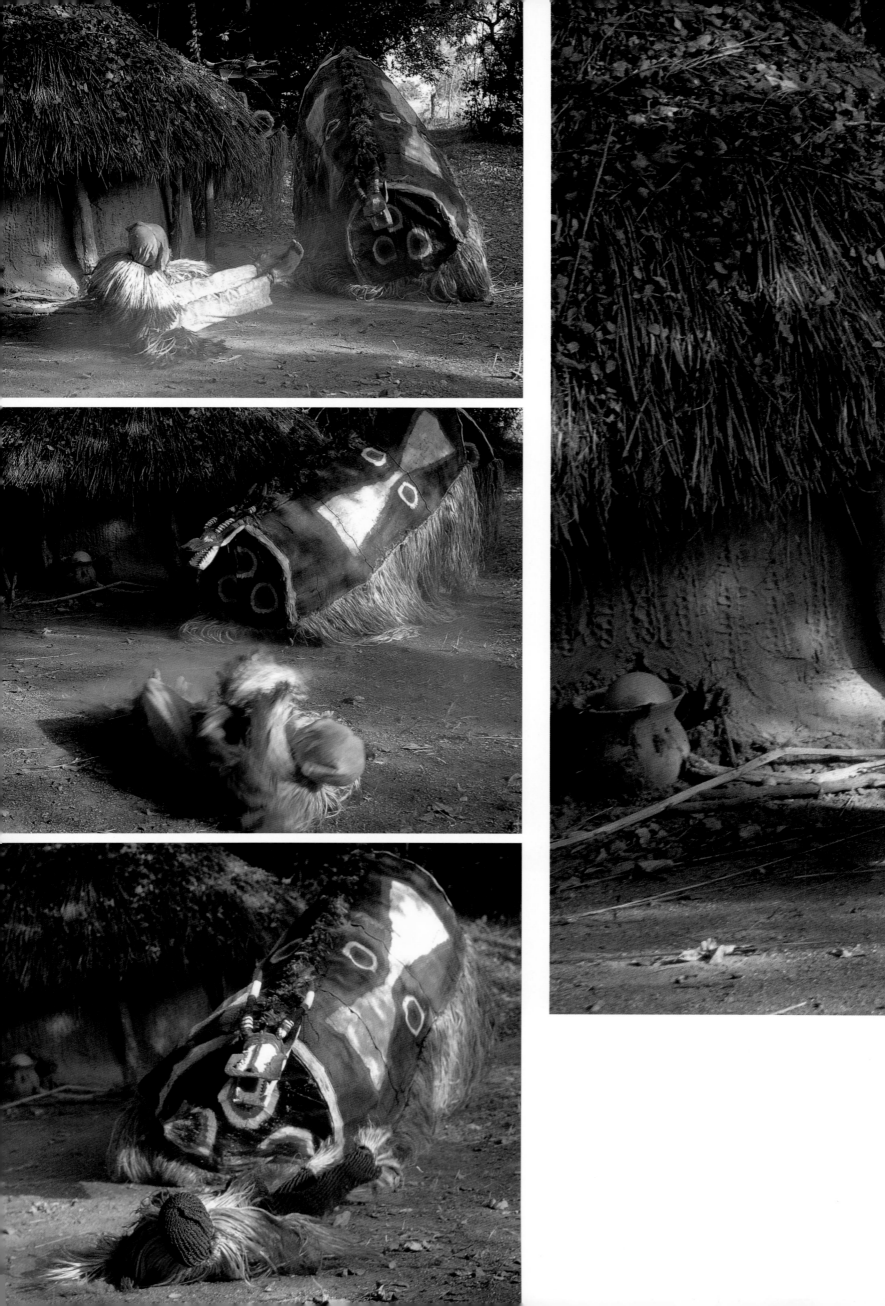

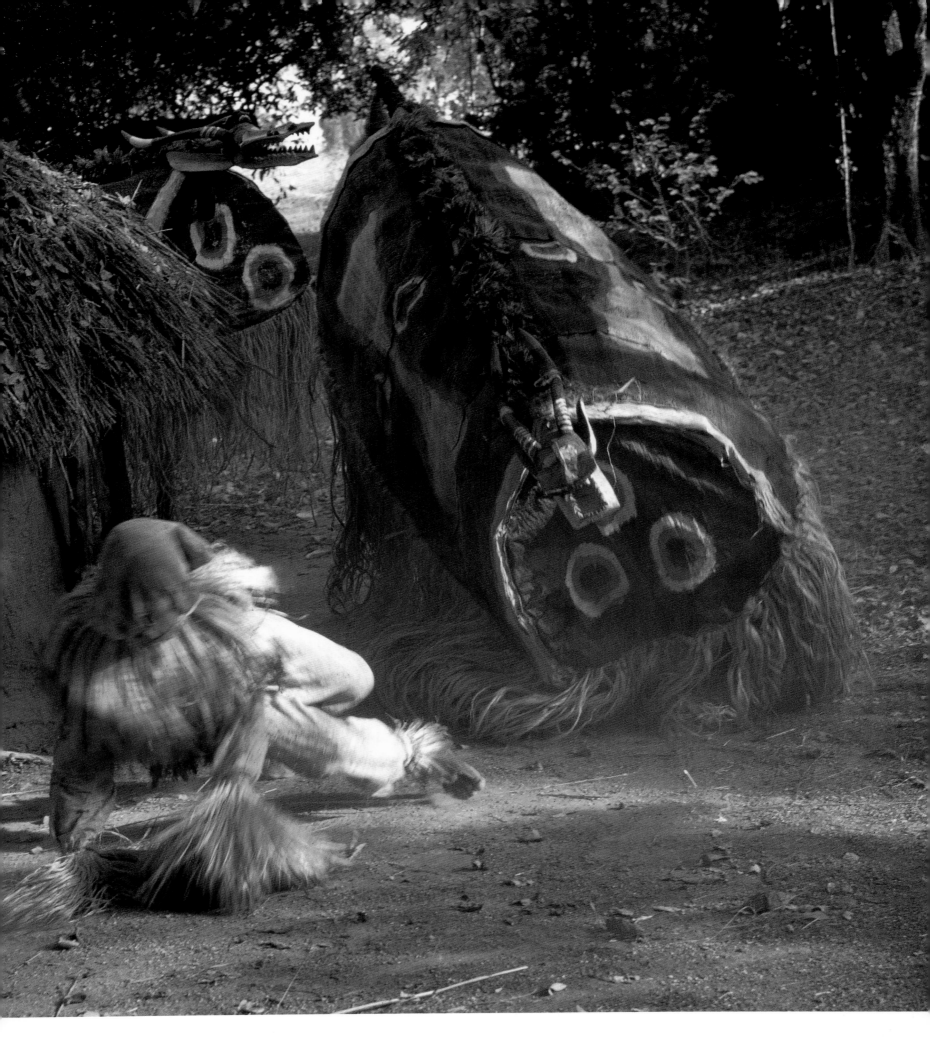

The Roaring Buffalo Mask

One of the largest masks to be seen at a Senufo funeral is the Nafiq, which charges at terrifying speed through the forest and into the village during funeral rites. Taking the form of a gigantic buffalo, with a head made up from elements of buffalo, wart hog, crocodile, and antelope, the Nafiq symbolizes intellectual and physical perfection. Its huge body is constructed on a wooden armature covered with geometrically patterned matting. When the horned head is fixed to the front, the mask measures more than six feet in height and can be up to fifteen feet in length. Concealed within the mask, two Poro society members articulate its enormous structure. One of them operates a resonating instrument that produces the creature's characteristic roar and acts as a warning for the uninitiated to keep out of its way. The Nafiq is guided by two acrobat-guardians dressed from head to toe in tightly woven mesh suits fringed with raffia. These ritual guardians dance agilely round the Nafiq, goading and taunting the enormous mask. They lie down in front of it, waiting until the last second before jumping up to escape its ravenous jaws.

371

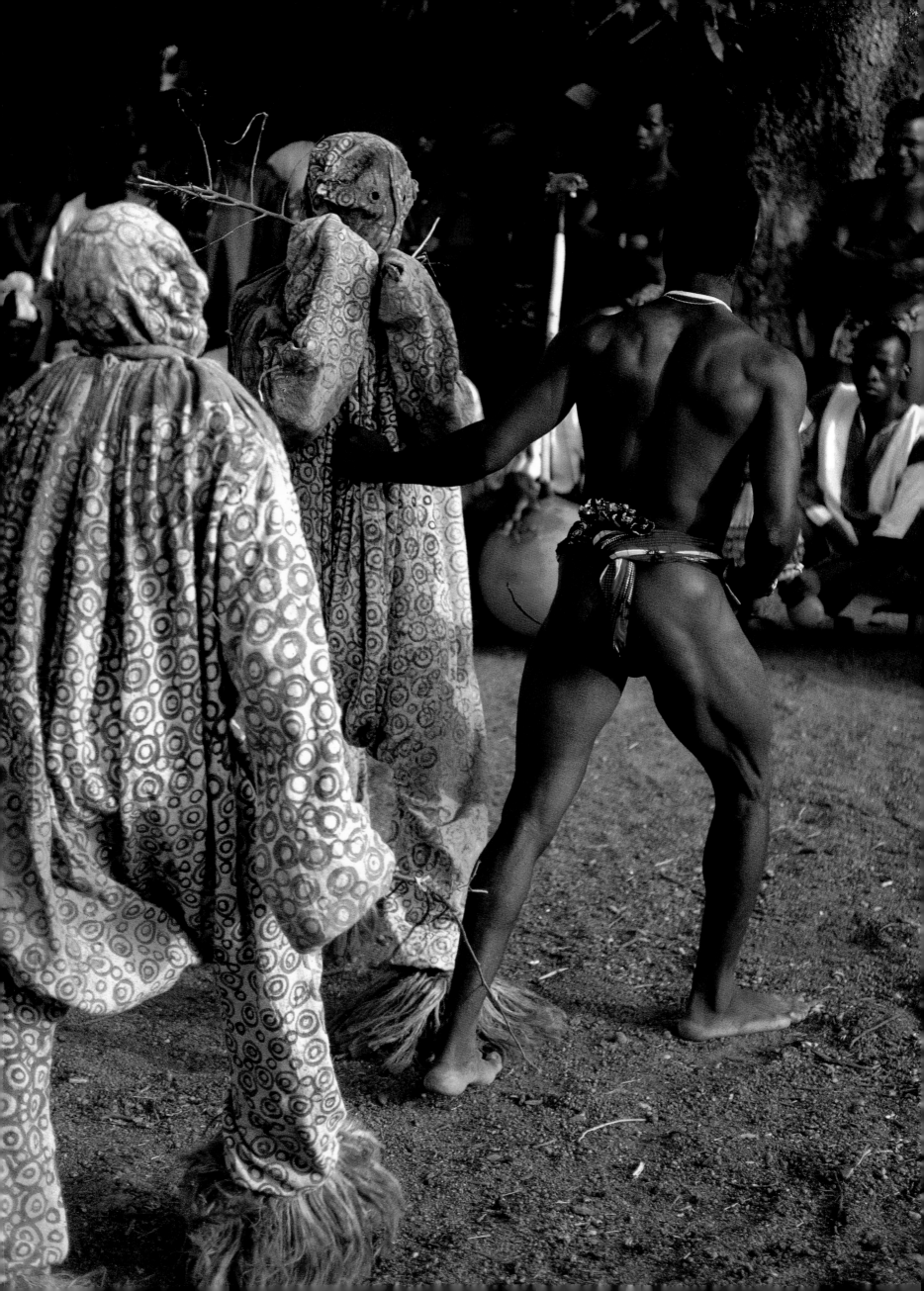

Panthers of the Poro

On the last day of the ceremony, a young Poro initiate leads two Nufori acrobat masks into the village square to perform the final rituals of the Senufo funeral. Known as Panthers of the Poro, the maskers wear brown, spotted costumes made from mud-dyed ritual cloth, designed to terrify the women and children in the audience, who are normally excluded from masked rituals. The masks are accompanied by a Boloye band playing unique one-stringed calabash harps called *bolongo*, plucking the strings and tapping the sides of the instruments with metal finger rings to establish rhythm.

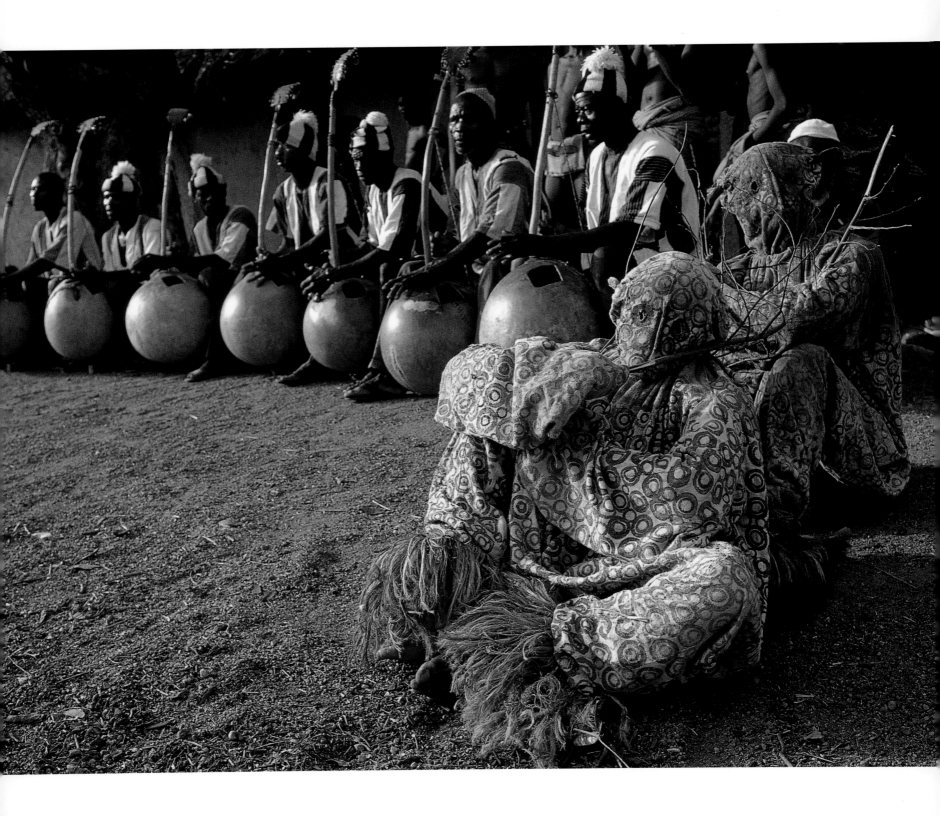

Following pages: As they leap, spin, somersault, and twirl with abandon, the Nuforis' acrobatics captivate the onlookers. Despite their often humorous antics, they are respected and even feared by villagers, whom they are entitled to hit with a switch. The maskers are selected for training at an early age, undergoing a rigorous course in the disciplines of comedy, acrobatics, dance, and, most important, the symbolism of their art.

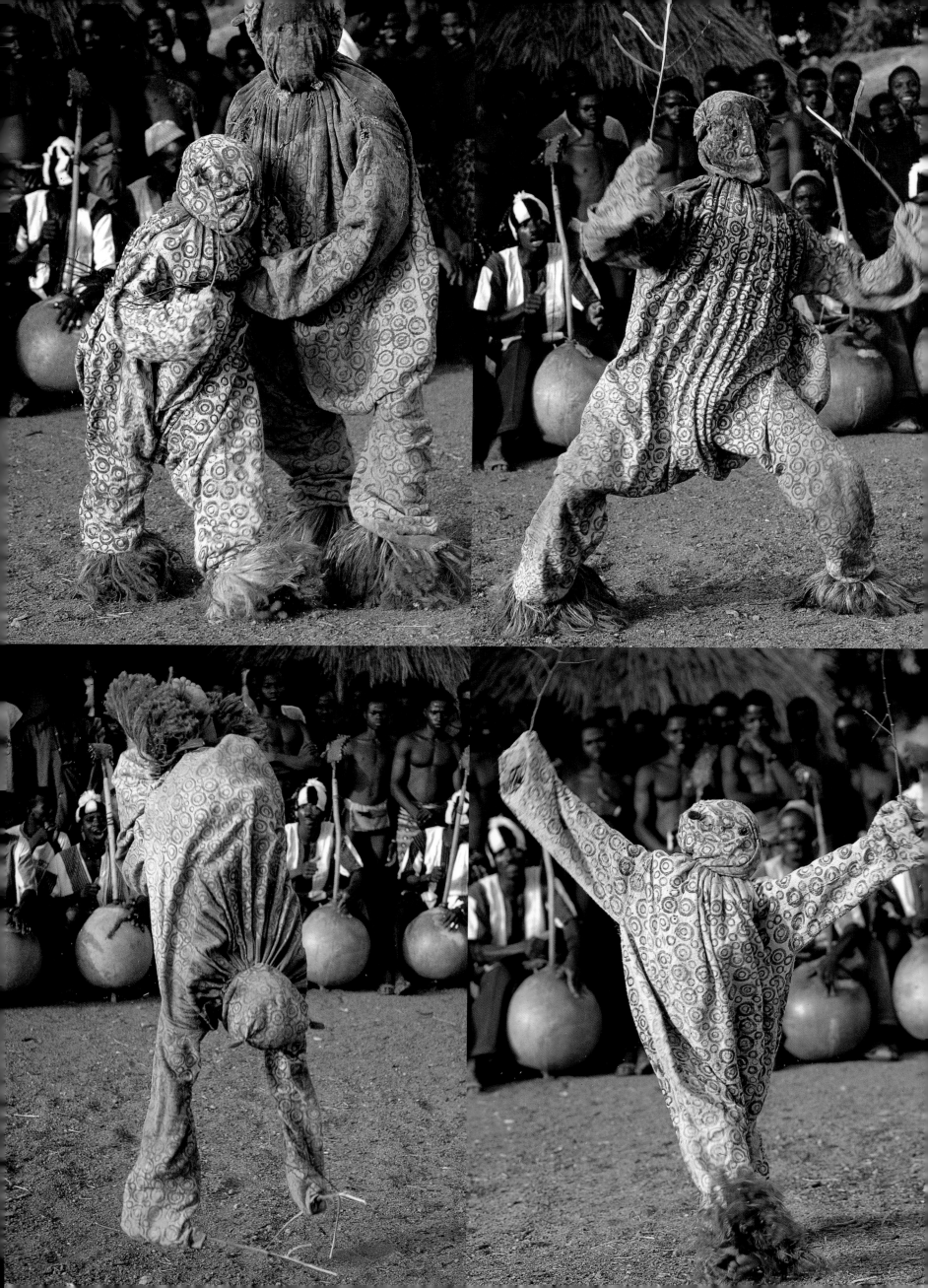

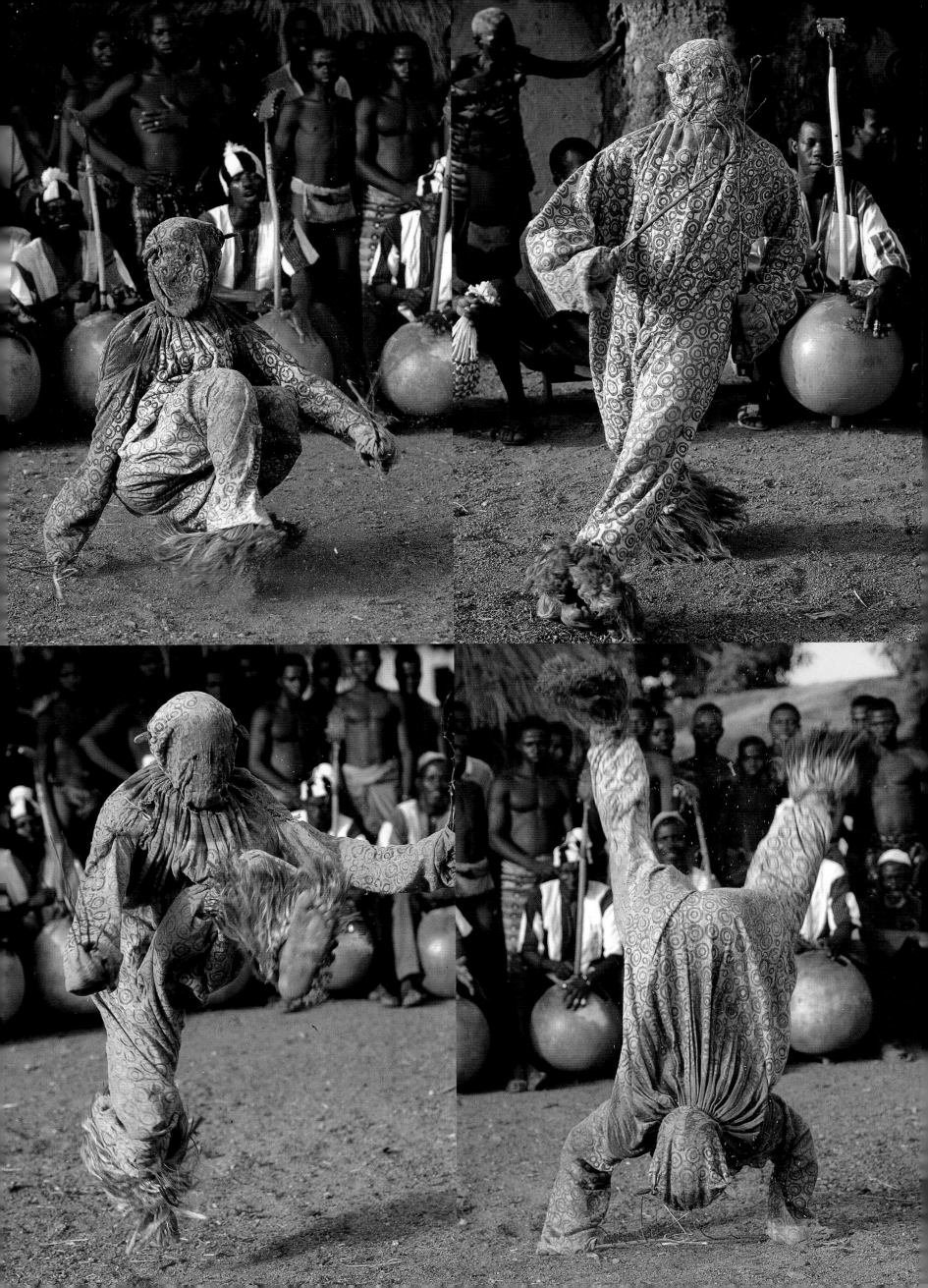

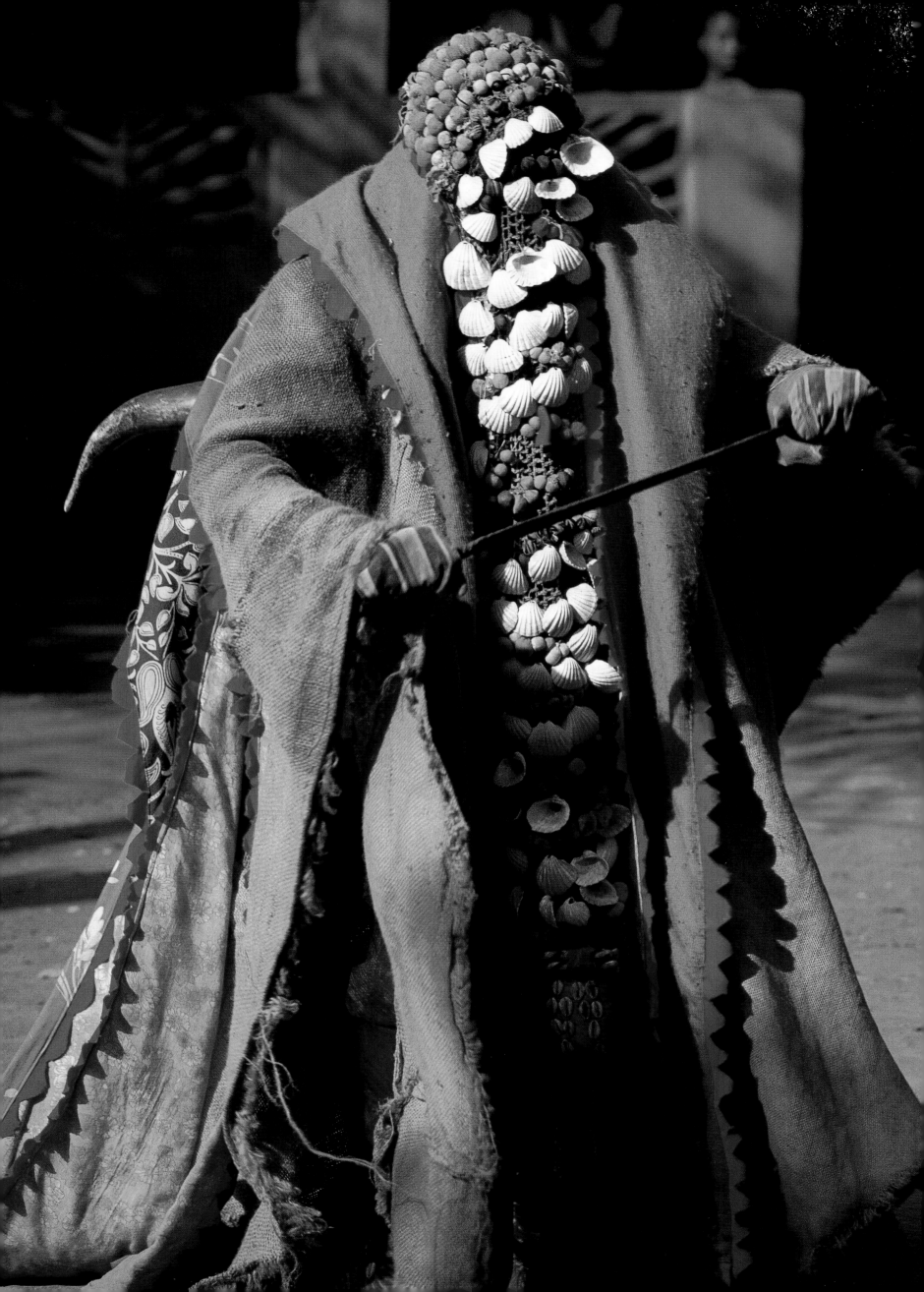

Egungun Masquerade

Literally meaning "bone" or "skeleton", the word *Egungun* is used by the Yoruba people of Benin and Nigeria to refer to their ancestors. The Yoruba believe that all spirits live in Kutome, the afterworld. These powerful spirits must be summoned back to earth regularly to rebalance a cosmic order upset by human transgressions. The ritual of return takes place every year between June and November at a month-long festival, when the Yoruba spirits, who possess immense knowledge and power, are invoked to help and advise the living. The dangerous visiting spirits enter the bodies of members of the secret Egungun masking society, who wear masked heads and vibrant costumes fashioned from many yards of magnificent fabric. This spectacle reflects the Yoruba preoccupation with cloth: the more sumptuous and expensive the fabric of a costume, the more powerful and influential the wearer.

At the start of the festival, following an all-night vigil in the Egungun grove outside the village, the masks are awakened by drums and assemble in the village square to perform whirling dances. When the masks communicate, they speak in guttural or high, reedy tones, mimicking the voices of the dead to counsel spectators on matters such as inheritance disputes and crop cultivation. Their advice is binding on all who receive it. On the last day of the festival, the masks gather in the chief's compound, where he prays for blessings for the coming year. When the spirits have returned to Kutome, farmers harvest their crops and make grateful offerings at Egungun shrines and in temples of the Yoruba gods.

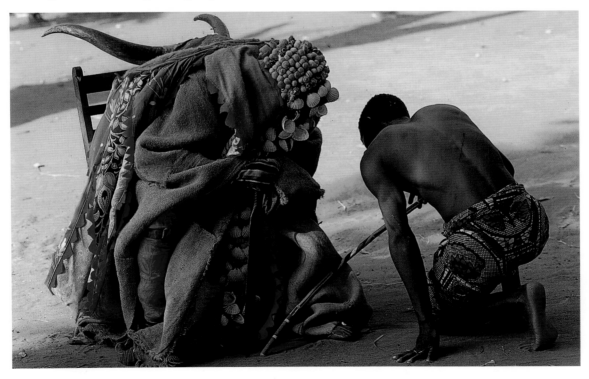

The shell-encrusted Oblameji mask (*left*), a noisy, evil troublemaker, conveys a message from the world of the spirits to his ceremonial guardian. *Following pages*: Egungun masks enter the village accompanied by ritual guardians who are mediators between the masks and the outside world.

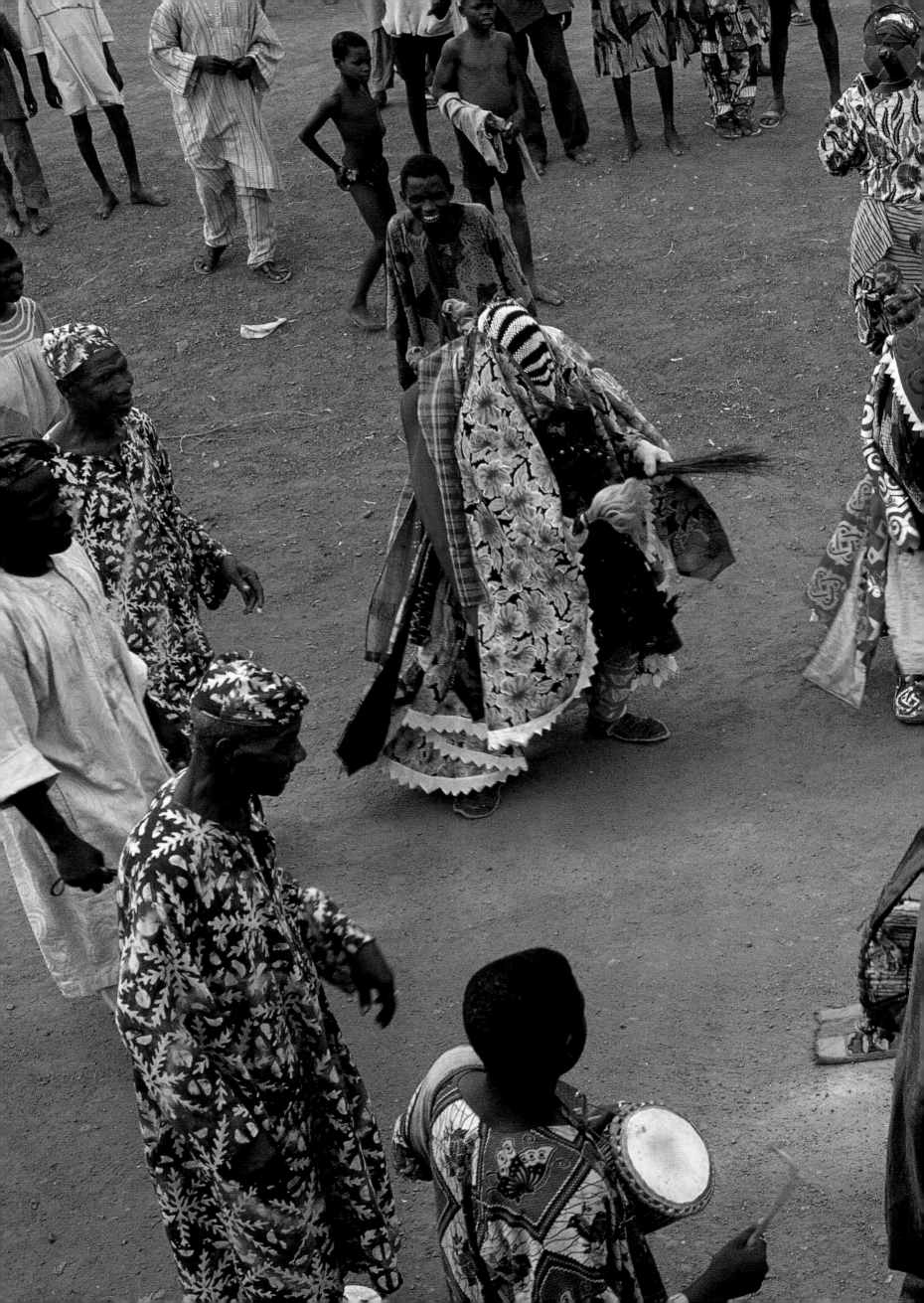

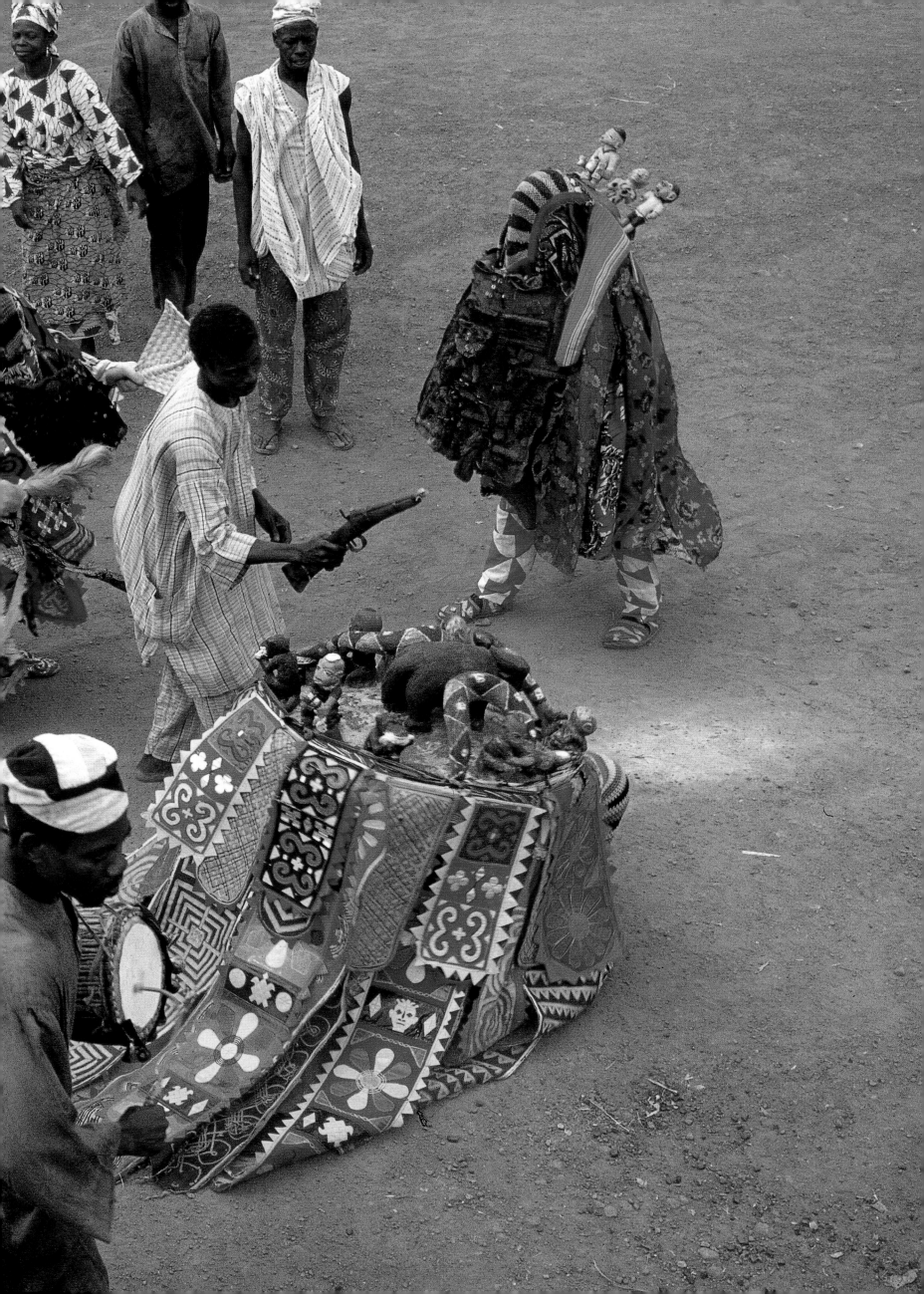

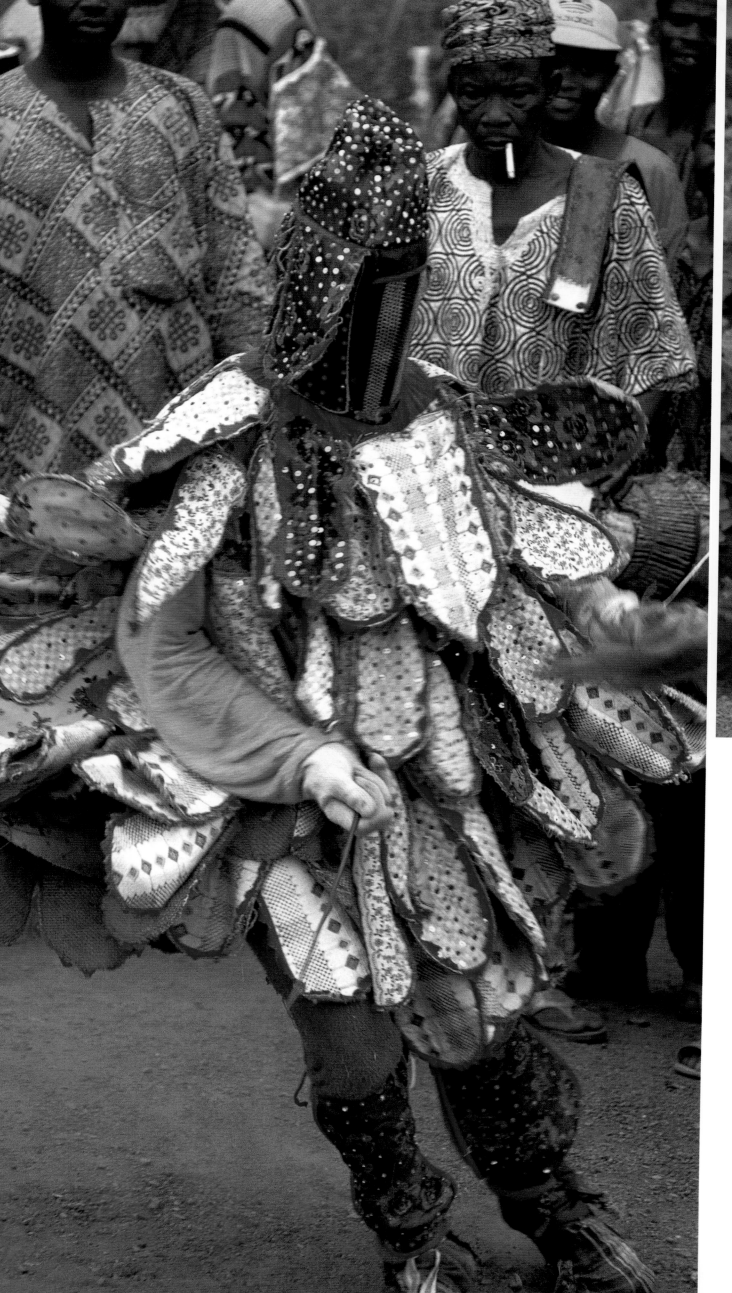

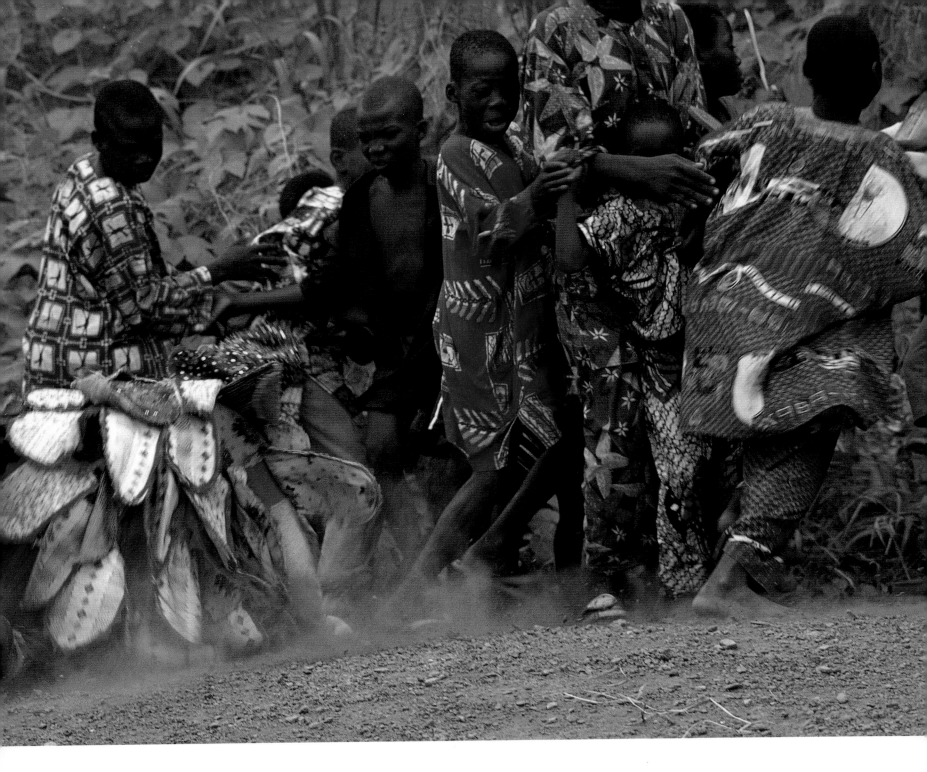

The Deadly Chase

Covered in leaf-shaped panels of cloth lavishly embroidered with mirrors and sequins, the Tahe mask (*left and above*) spins madly around the village. During his dance, he chases groups of terrified children, who scatter to avoid being touched. Believing that the touch of the mask spells death, the youngsters watch the spectacle with great trepidation. Should a mask actually touch a spectator, the emotion of the moment is so strong that the person will often collapse into a trance.

The Paka mask (*right*), with its flowing costume of appliquéed strips of cloth, twirls before the crowd with complete abandon. Though ritual guardians are normally able to inhibit the more dangerous movements of masks, a mask will occasionally charge out of control, knocking people down and injuring them.

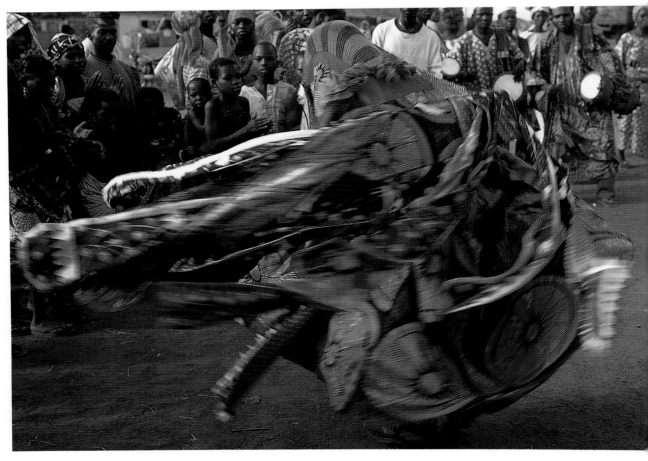

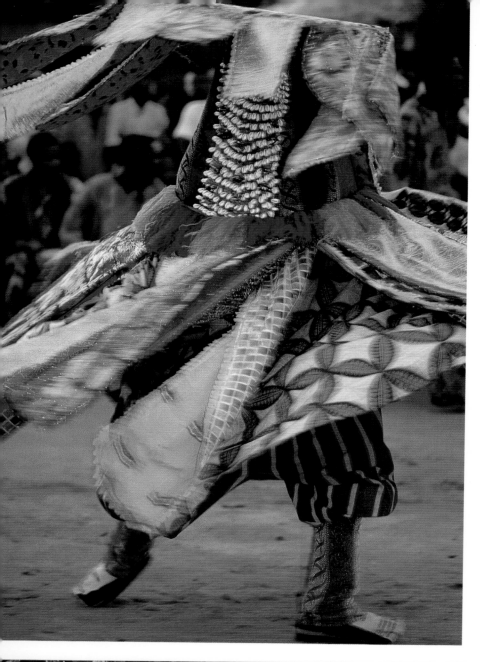

Masks of Ancestral Power

Iridescent with shimmering fabrics, Paka masks display the wealth and social standing of their owners. These masks are traditionally regarded as the physical manifestations of Yoruba ancestral power, so considerable sums are spent by Egungun society on sumptuous fabrics. As a visual metaphor, cloth plays an important role in Yoruba culture: the exotic weaves, patterns, and textures signify prestige. Nakedness, or a lack of cloth, is associated with infancy, insanity, or, worst of all, a failure of social responsibility. In ritual performances honoring the ancestors, exquisite fabrics are the major medium for the masker's transformation into a messanger of the spirit. By enclosing the *ara orun* — or "citizen of heaven" — in a cage of cloth, the power of the ancestor is simultaneously concealed and revealed within the world of the living.

Following pages: As the dance of the Paka mask becomes more ecstatic, the vibrant fabric panels of its costume begin to fly around, turning the mask into a blur of color. The Yoruba believe that the breeze stirred up by the whirling dance of an Egungun mask brings security and the promise of good fortune to those close enough to feel it.

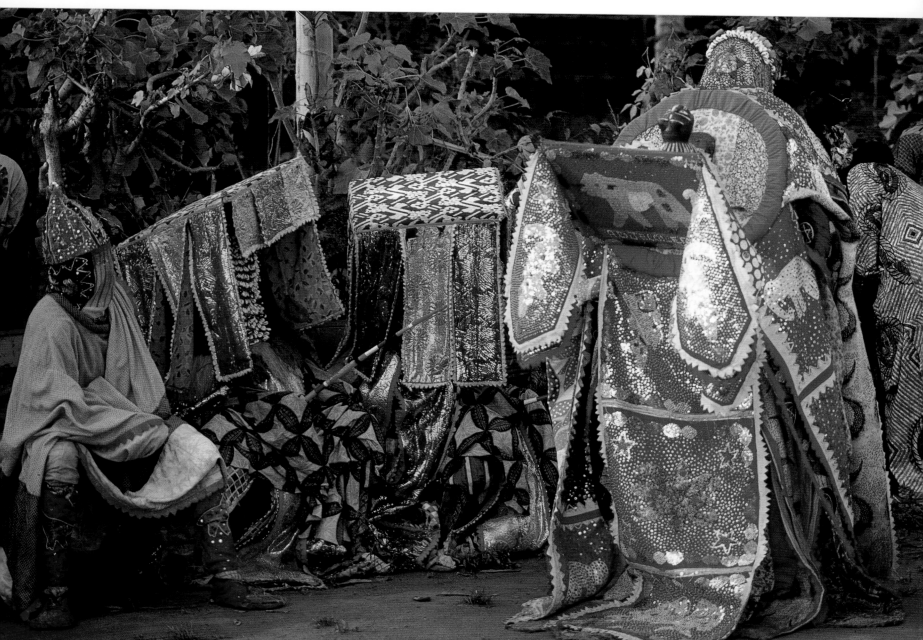

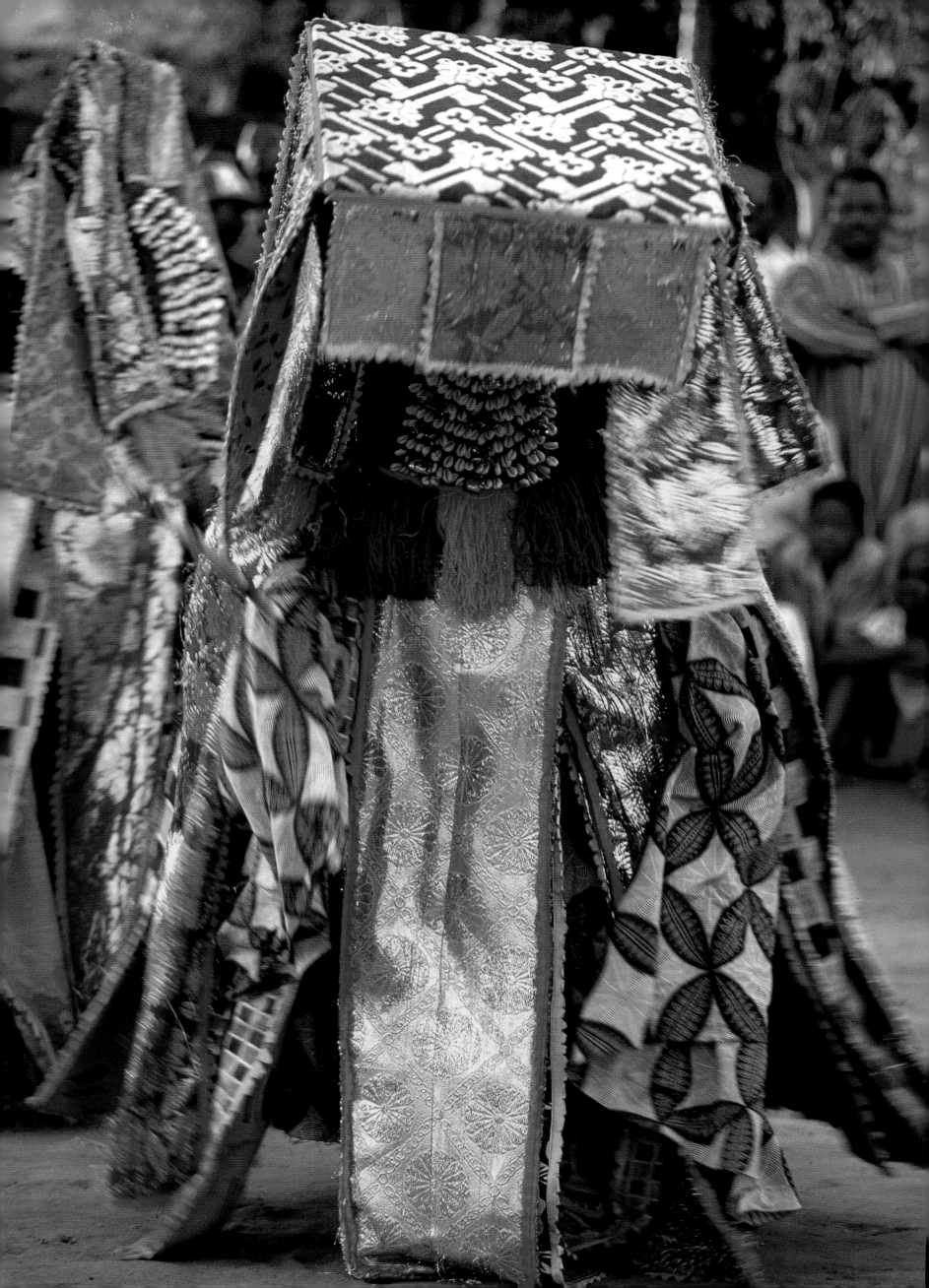

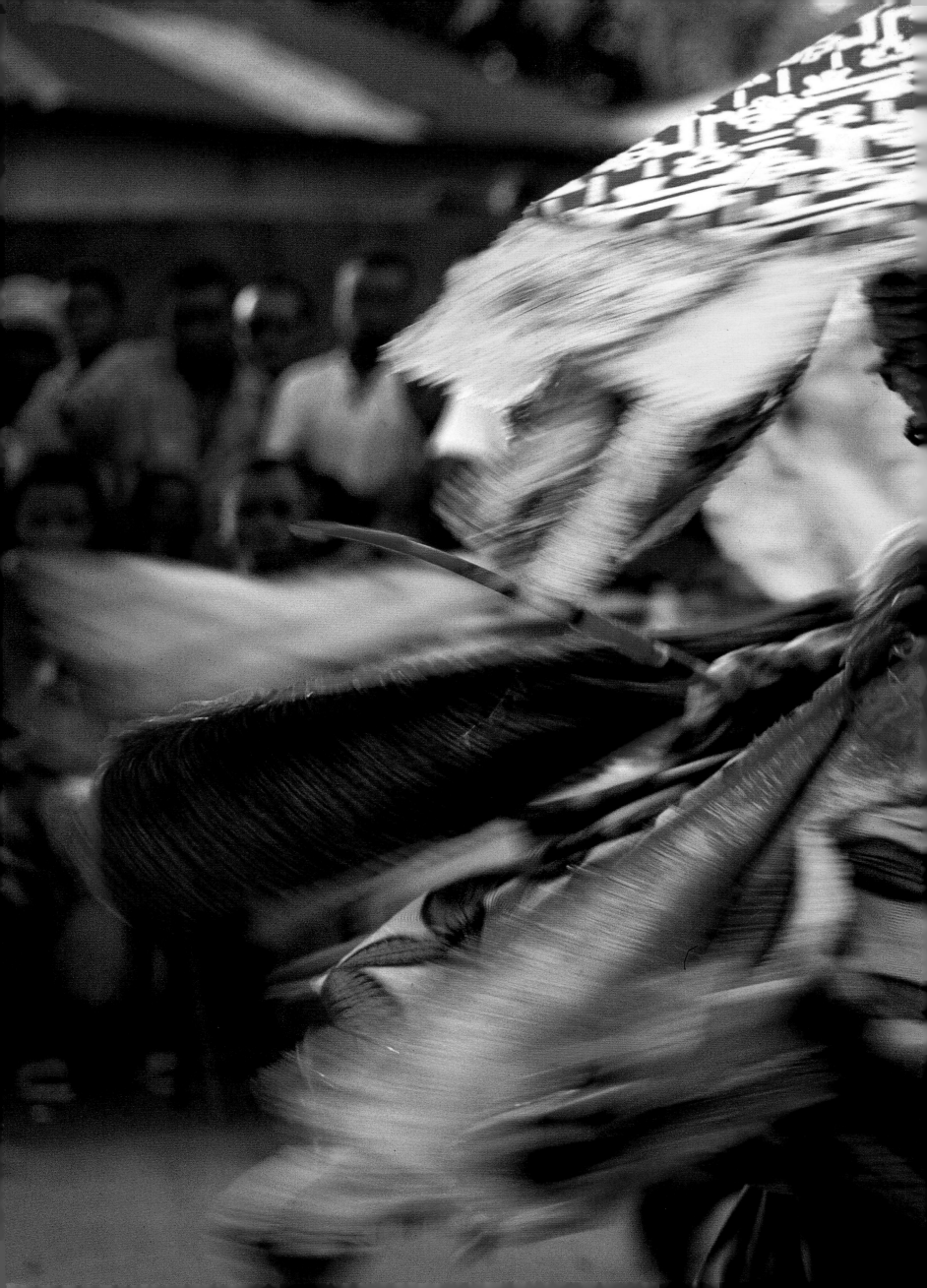

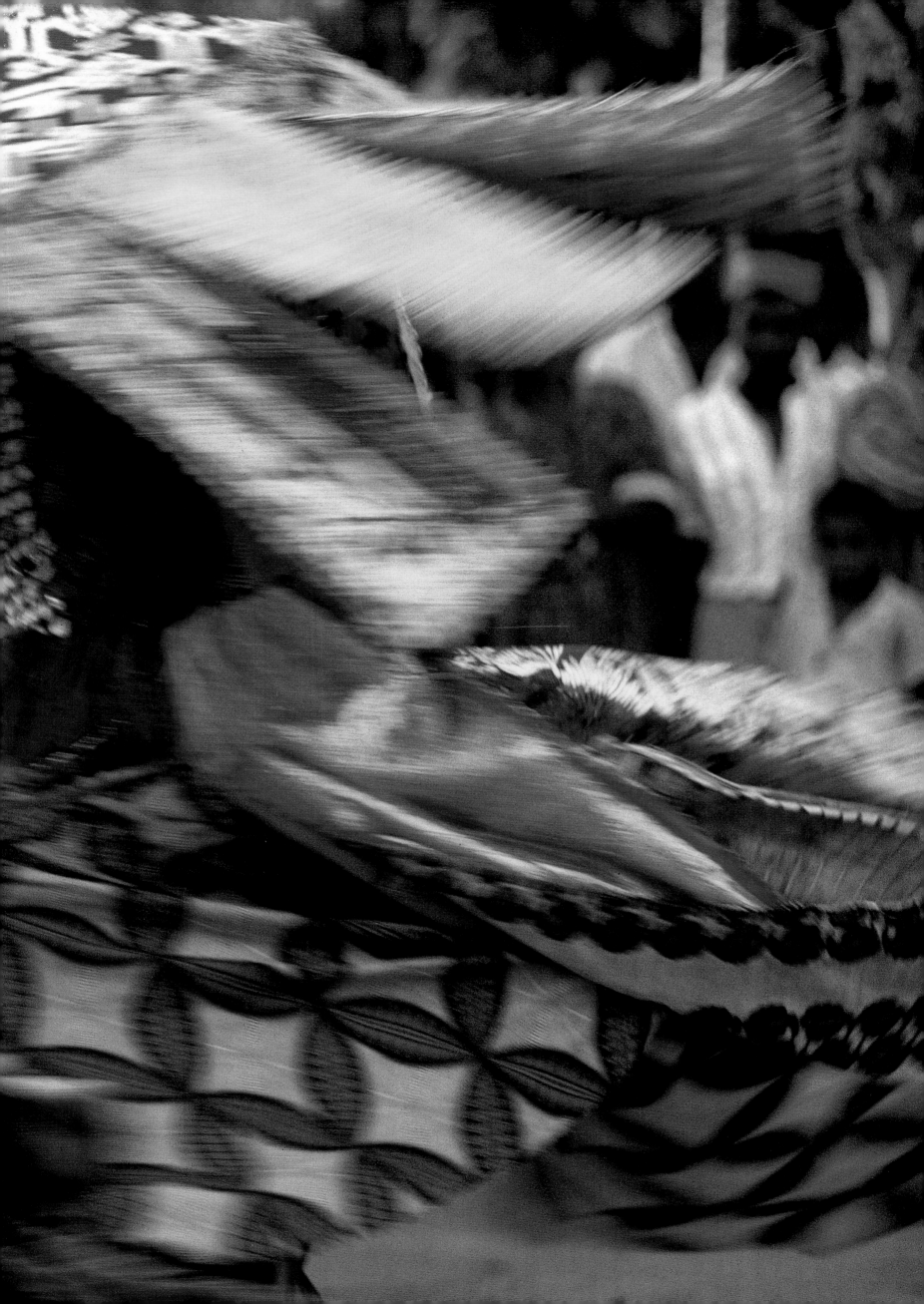

Ga Fantasy Coffins

The Ga people live along the coast of Ghana, where they engage in fishing, farming, and trading. In recent times, many have become involved in the city life and industry of Accra, Ghana's capital. For the Ga, funerals express a belief that family life extends to the realm of the dead, where ancestral spirits reside. During the last forty years, a new art form has been added to Ga funeral ceremonies—specially carved coffins that represent the lifetime professions of deceased persons. The originator of this innovative tradition was a carpenter, Kane Kwei, who created the first fantasy coffin to honor the death of his uncle. The old man had been a fisherman, and he wished to be buried in a coffin representing his trade so that he could arrive in the afterworld ready to continue his work. When Kane Kwei's mother died, to commemorate her fascination with the airplanes that flew over her house, he built an airplane coffin, so that she could fly wherever she wished in the next life.

These early fantasy coffins attracted much attention, and Kane Kwei was commissioned by others who wanted to be buried in his personalized creations. When Kane Kwei died in 1992, his skills and reputation were passed on to his son, Ben Kwei, and his nephew Paa Joe, who continue the tradition. To the outside world, fantasy coffins are witty and original works of art, but to the Ga they are vehicles designed to transport the dead to the afterworld in dignity and style. At a Ga funeral, when the coffin is lowered into the ground, it begins a journey to life in another world.

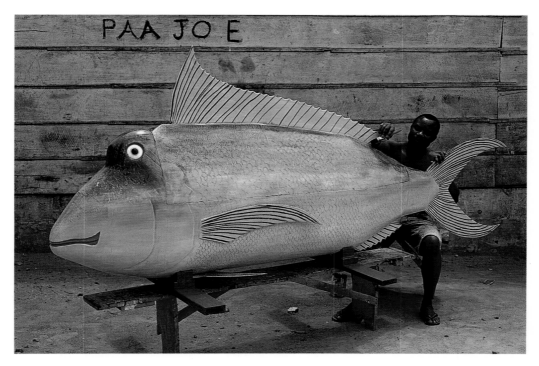

Above: Paa Joe puts finishing touches on a fish coffin for the Chief of Fishermen, De Tse Nunu.
Right: The coffin is later paraded through his village for all to pay their respects.

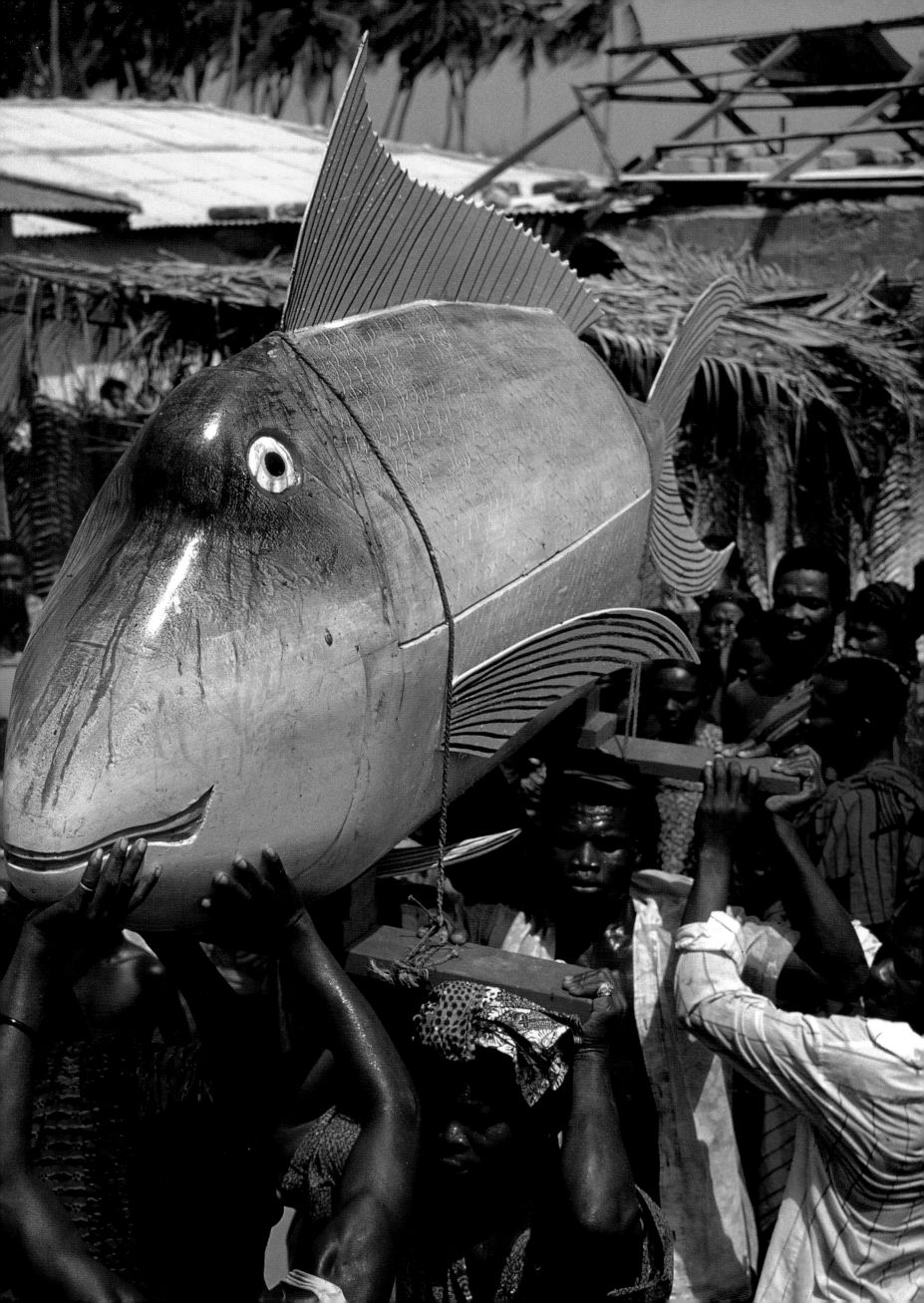

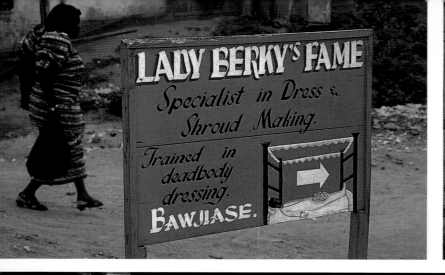

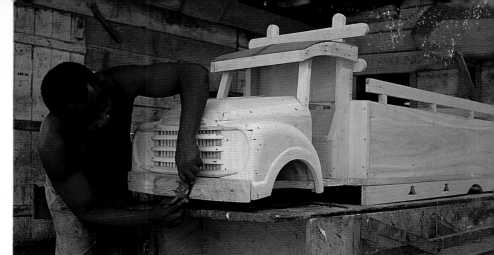

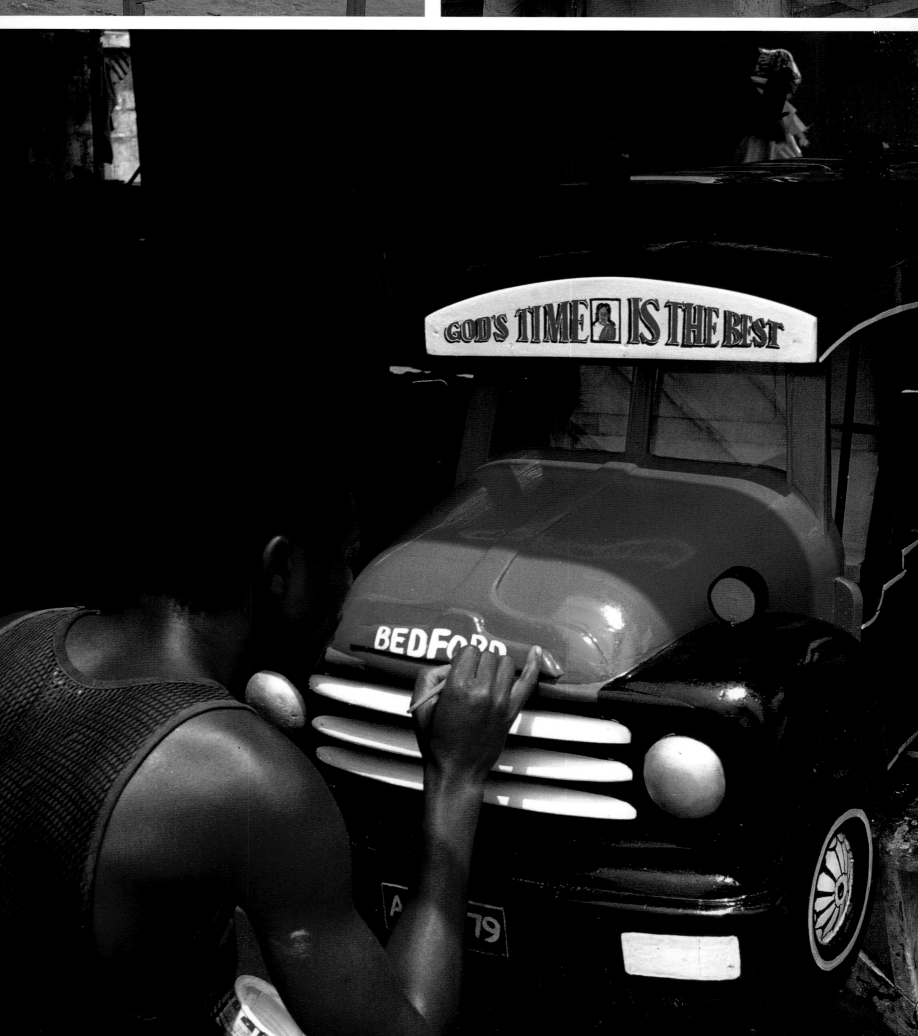

Buried in a Bedford Truck

At Paa Joe's workshop, a Bedford truck coffin is prepared for the body of a man who spent his life trading coal from inland Ghana to the coast. *Far left*: On the way to Paa Joe's workshop, customers pass the sign of Lady Berky, a dressmaker who stitches the elaborate shrouds essential for a proper Ga burial. *Left*: Working from photographs and sketches, Paa Joe builds the coffin. *Below*: Paa Joe's assistants paint the coffin to match the vehicle owned by the coal trader. The artists make sure that all of the details are faithfully represented, including the driver's favorite slogan on the front of the cab, "God's Time Is The Best." *Upper right*: The lid of the truck coffin has been carved and painted to resemble sacks of coal. The body will be placed in the back of the truck beneath the sacks. *Lower right*: The body lies in state inside the coffin during the wake at his home. Beside him, friends and family place numerous small gifts—a towel, sponge, lime deodorant, and soap—for his journey to the afterworld.

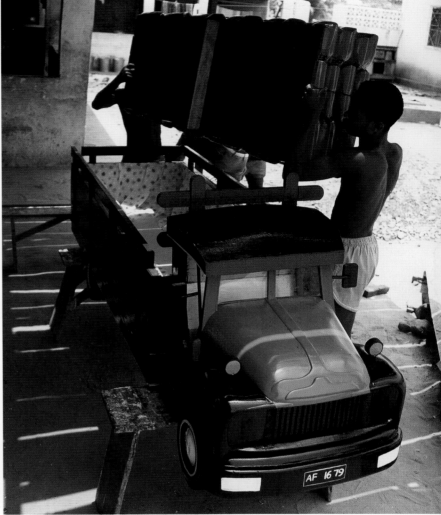

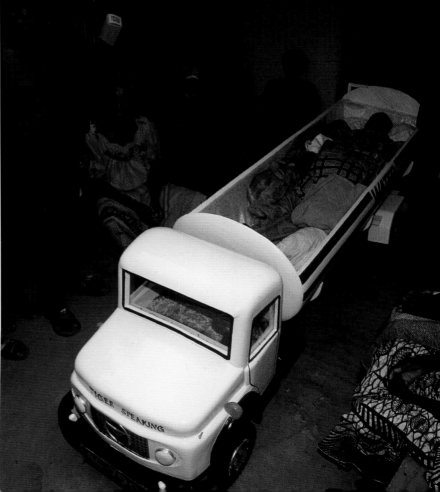

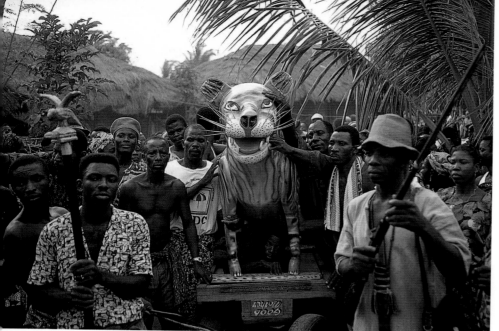

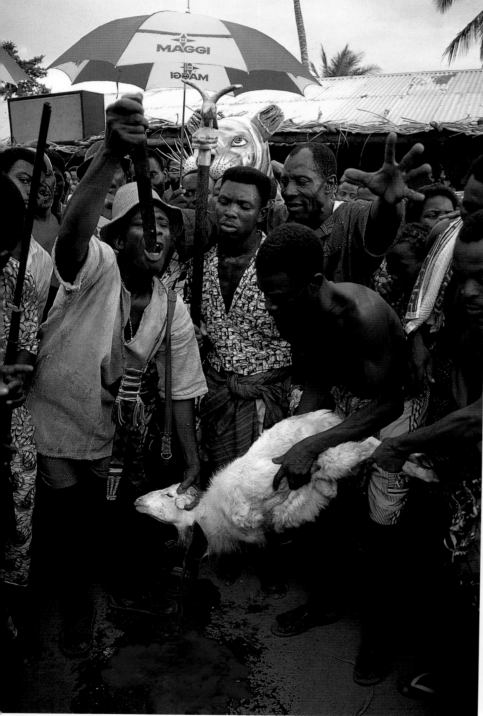

A Hunter's Funeral

At a village in Togo, near the Ghanaian border, mourners celebrate the funeral of Homawu Azanleko Latey, a chief of Ewe descent, who was also a renowned hunter. His coffin was designed by the late Kane Kwei's workshop in the form of a leopard, with bristling wooden whiskers and menacing teeth. As the coffin is carried out of the chief's house by a group of his fellow hunters, villagers dance around it to the sound of

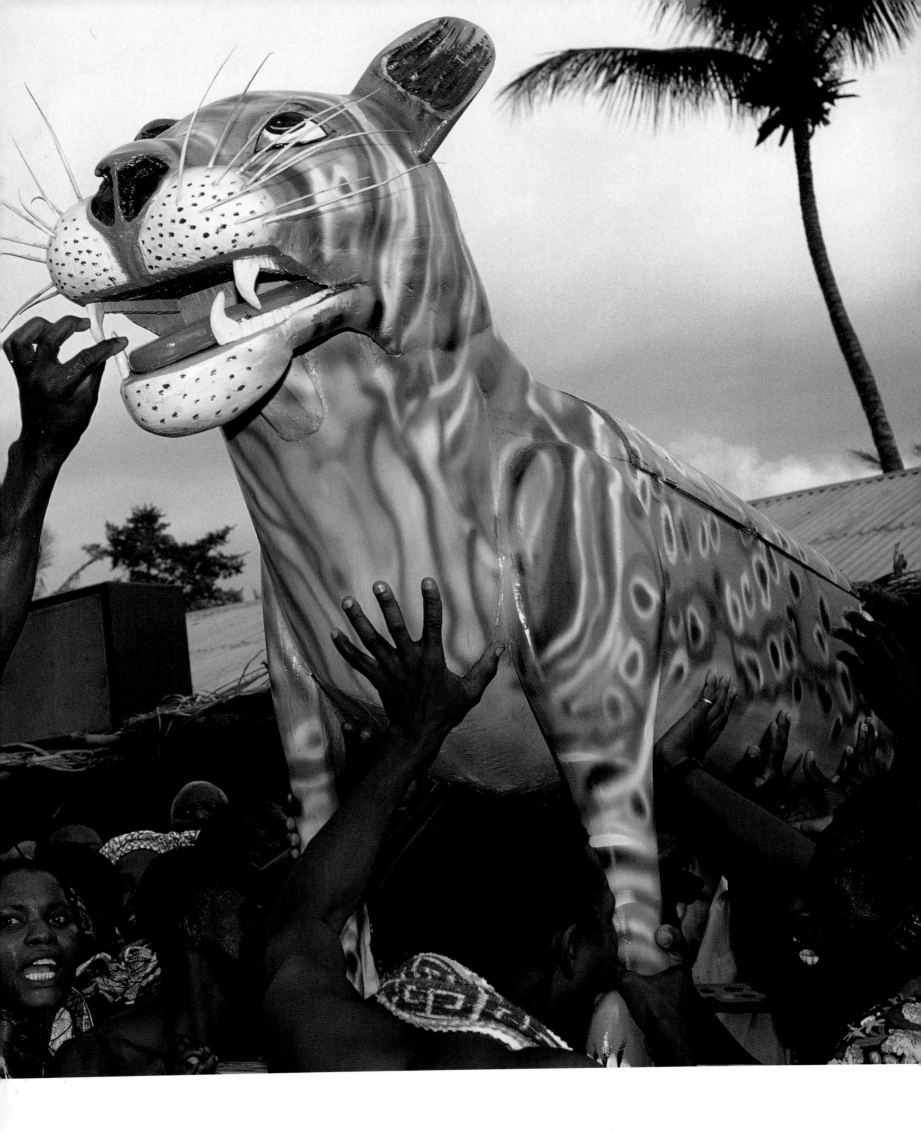

pulsating drums. A goat, whose meat will be cooked and eaten by mourners, is ritually slaughtered to insure safe passage of the dead man's spirit. The coffin is then wheeled around the village on a flatbed wagon, surrounded by hundreds of people forming a raucous procession. The hunter's gun is shot off at intervals, and will be buried beside its owner in the coffin.

A Royal Farewell

In the iconography of Ga coffins, powerful birds are specifically reserved for the burial of royalty, prominent chiefs, and leaders. Here, Paa Joe and an assistant apply gold paint to the eagle coffin of a paramount Ga chief, Nii Okansha. Attached to the back of the eagle is a small group of carved figures (*below*) depicting the chief and his two attendants, one of whom is carrying his golden stool, to accompany him to his new life in the afterworld.

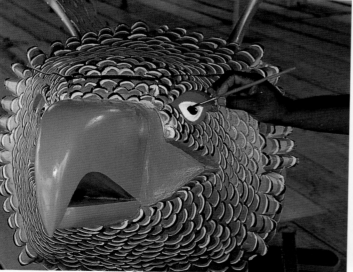

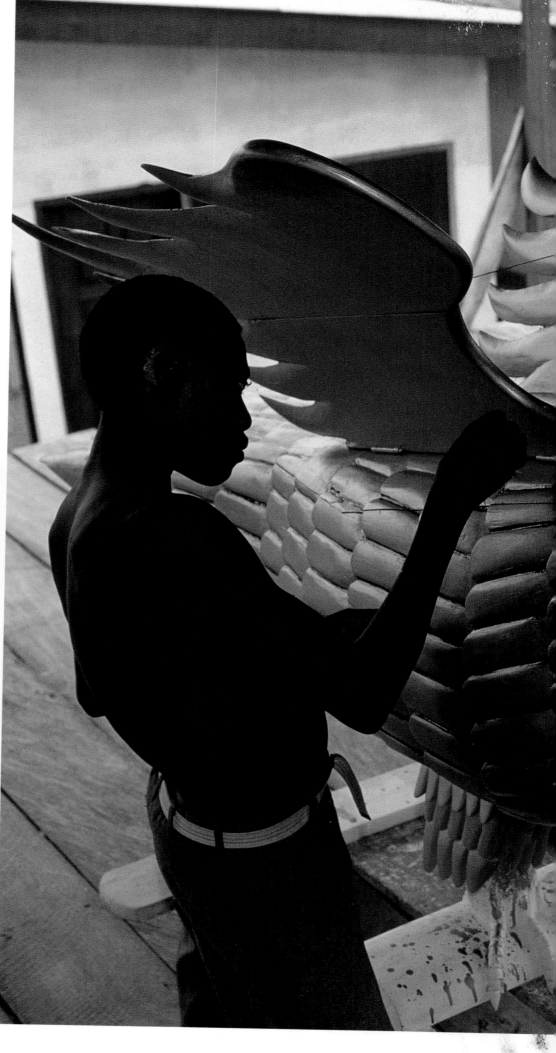

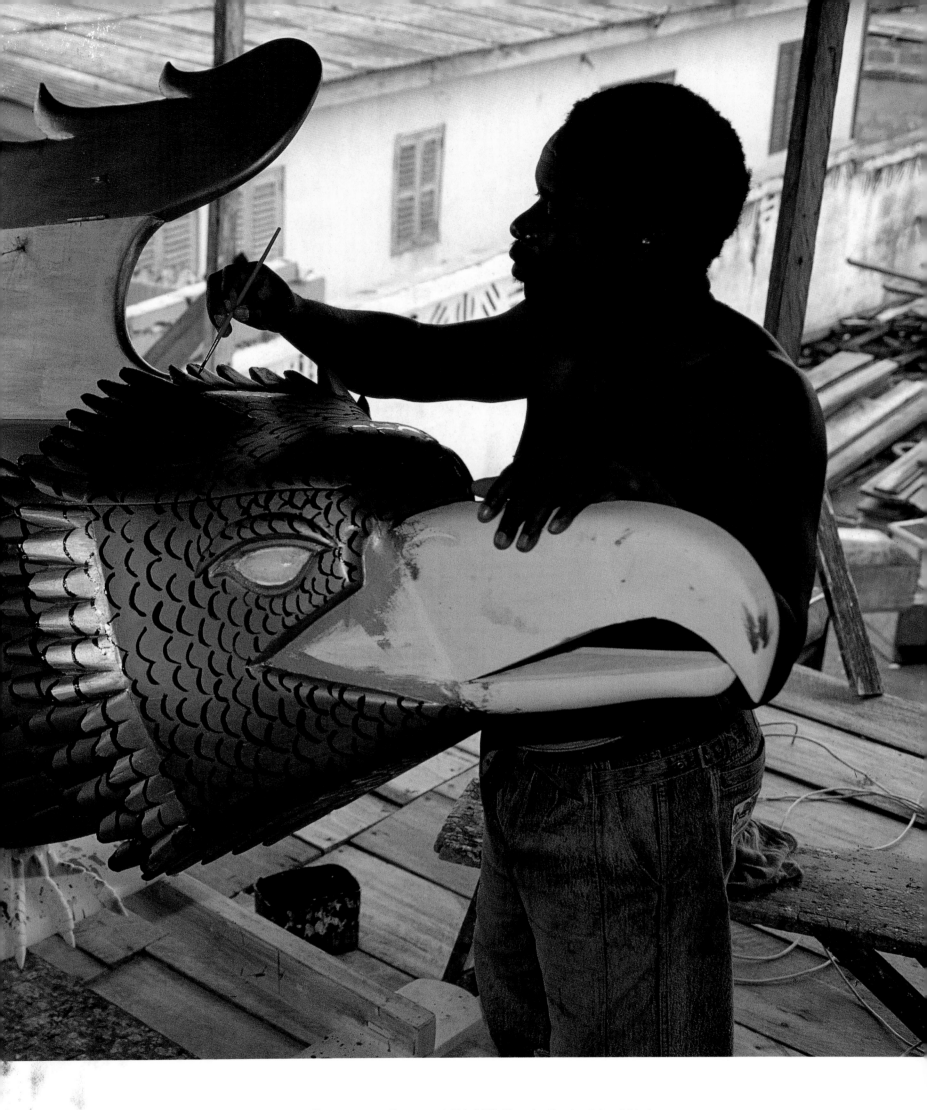

Following pages: Paramount Chief Nii Okansha lies in state at his home as mourners and family bid him farewell. The cortege is seen leaving the royal compound, as a libation is poured over the head of the eagle. The coffin is then hoisted to shoulder height and carried through the streets of Accra, where thousands of mourners pay their respects. Each time the eagle passes the home of an important family or chief, a libation is poured. The procession lasts for more than four hours before arriving at the burial site.

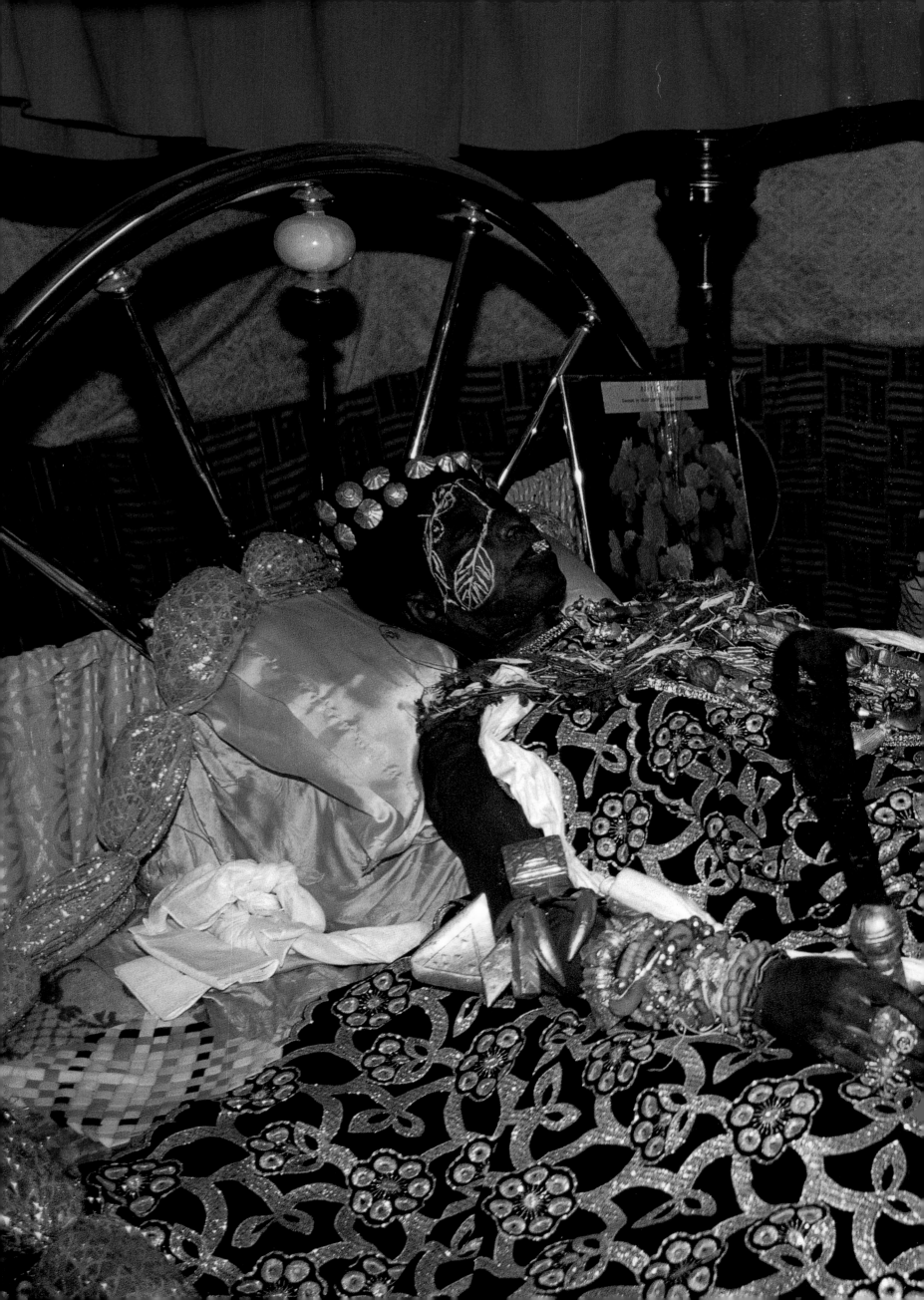

Bibliography

Adepegba, C.O. *Decorative Arts of the Fulani Nomads*. Ibadan University Press, Ibadan, 1986

Awolalu, Omosade. *Yoruba Beliefs and Sacrificial Rites*. Longman, London, 1979.

Adler, Peter and Nicholas Barnard. *African Majesty: The Textile Art of the Ashanti and Ewe*. Thames & Hudson, London, 1992.

Adler, Peter and Nicholas Barnard. *Asafo! – African Flags of the Fante*. Thames & Hudson, London, 1992.

Amadu, M. and A. Kirk-Green. *Pastoralists of the West African Savanah*. Manchester University Press, Manchester, 1986.

Anti, A. A. *The Ancient Asante King*. The Volta Bridge Publishing Co., Accra, 1974.

Beckwith, Carol and Angela Fisher. *African Ark*. Collins Harvill, London, 1990.

Beckwith, Carol and Tepilit Ole Saitoti. *Maasai*. Harry N. Abrams, New York, 1980.

Beckwith, Carol and Marion Van Offelen. *Nomads of Niger*. Harry N. Abrams, New York, 1983.

Bell, C. *Ritual Theory, Ritual Practice*. Oxford University Press, New York, 1992.

Beier, Ulli. *Yoruba Myths*. Cambridge University Press, London, 1980.

Blier, Suzanne. Preston. *African Vodun*. University of Chicago Press, Chicago, 1995.

Blier, Suzanne Preston. *The Royal Arts of Africa: The Majesty of Form*. Abrams, New York, 1998.

Cannadine, D. and S. Price (Eds). *Rituals of Royalty: Power and Ceremonial in Traditional Societies*. Cambridge University Press, Cambridge, 1986.

Capretz, Alain. *Etiquette of the Royal Court*. Emus Books, San Francisco, 1988.

Chalmers, B. *African Birth*. River Club, South Africa, 1990.

Cole, Herbert M. (Ed.). *I Am Not Myself: The Art of African Masquerade*. University of California, Los Angeles, 1985.

Cole, Herbert M. and Doran H. Ross. *The Arts of Ghana*. University of California, Los Angeles, 1977.

Cole, Herbert M. *Icons: Ideals and Power in the Art of Africa*. National Museum of African Art, Washington, 1989.

Coulson, David. *Namib*. Sidgewick and Jackson Ltd, London, 1991.

Dagan, Esther A. *The Spirit's Dance in Africa: Evolution, Transformation and Continuity*. Galerie Amrad African Arts Publications, Westmount, 1997.

De Mott, Barbara. *Dogon Masks: A Structural Study of Form and Meaning*. UMI Research Press, Ann Arbor, c1982.

De Villiers, Marq and Sheila Hirtle. *Into Africa: A Journey through the Ancient Empires*. Weidenfeld & Nicholson, London, 1997.

Delange, Jacqueline. *The Art and Peoples of Black Africa*. Dutton, New York, 1974.

Deng, Francis Mading. *The Dinka and Their Songs*. Oxford University Press, 1973.

Deng, Francis Mading. *The Dinka of Sudan*. Waveland Press. Prospect Height, 1984.

Dezentjé, Tatiana. *Africa: People & Beliefs*. Macgillavry Press, London, 1985.

Drewal, H. J. and M. T. Drewal. *Gelede: Art and Female Power among the Yoruba*. Indiana University Press, Bloomington, 1983.

Drewal, M. T. *Yoruba Ritual*. Indiana University Press, Bloomington, 1992.

Dzobo, N. K. *African Proverbs: Guide to Conduct (The Moral Value of Ewe Proverbs)*. Waterville Publishing House, Accra, 1973.

Eliade, Mircea. *Rites & Symbols of Initiation*. Harper & Row, New York, 1975.

Field, M. J. *Religion and Medicine of the Ga People*. Oxford University Press, London, 1937.

Fisher, Angela. *Africa Adorned*. Wm. Collins & Sons Co, London 1984.

Garrard, Timothy F. *Gold of Africa: Jewellery and Ornaments from Ghana, Cote d'Ivoire, Mali & Senegal*. Prestel-Verlag, Munich, 1989.

Gibbs, James L. Jr. (Ed.). *Peoples of Africa*. Holt, Rinehart & Winston Inc, New York, 1965.

Ginindza, Z. R. *King Mswati III: A Pictorial Biography of the New King of Swaziland*. Macmillan, Swaziland, 1988.

Girard, Jean. *Les Bassari du Senegal: Fils du Chameleon*. Editions l'Harmattan, Paris, 1984.

Glaser, B. and A. L. Strauss. *Status Passage*. Routledge & Kegan Paul, London, 1971.

Glaze, Anita J. *Art and Death in a Senoufo Village*. Indiana University Press, Bloomington, 1994.

Griaule, Marcel. *Conversations with Ogotemmeli: An Introduction to Dogon Religious Ideas*. Oxford University Press, London, 1975.

Griaule, Marcel. *Masques Dogons*. Institute d'Ethnologie, Paris, 1994.

Hallgren, Roland. *The Good Things in Life: A Study of the Traditional Religious Culture of the Yoruba People*. Plus Ultra, Loberod, 1988.

Heathcote, David. *The Arts of the Hausa*. World of Islam Festival Publishing Co, London, 1976.

Holas, B. *L'Art Sacre Senoufo*. Les Nouvelles Editions Africaines, Abidjan, 1985.

Huet, Michel and Claude Savary. *Africa Dances*. Thames and Hudson, London, 1995.

Ibitokun, Benedict M. *African Drama and the Yoruba World*. Ibadan University Press, Ibadan, 1995.

Ibitokun, Benedict M. *Dance as Ritual Drama and Entertainment in the Gelede of the Ketu Yoruba*. Obafemi Awolowo University Press, Lagos, 1993.

Imoagene, O. *The Hausa and Fulani of Northern Nigeria*. New Era, Ibadan, 1990.

Imperato, Pascal J. *Dogon Cliff Dwellers: The Art of Mali's Mountain People*. L. Kahan Gallery, New York, 1978.

Jacobson, Margaret. *Himba: Nomads of Namibia*. New Holland Publishers, London, 1990.

Karade, Ifa. *Handbook of Yoruba Religious Concepts*. Samuel Weiser, Maine, 1994.

Keenan, Jeremy. *The Tuareg: People of Ahaggar*. Allen Lane, London.

Kuper, Hilda. *The Swazi: A South African Kingdom*. Holt, Rinehart & Winston, New York, 1963.

La Fontaine, J. S. *Initiation*. Penguin Books, Harmondsworth, 1986.

Lalljee, Yousuf. *Ramazan: The Month of Glory*. Y. Lalljee, Bombay, 1982.

Laude, Jean. *The Arts of Black Africa*. University of California Press, Berkeley, 1971.

Lawal, Babatunde. *The Gelede Spectacle: Art, Gender and Social Harmony in African Culture*. University of Washington Press, Seattle, 1996.

Lawson, Thomas E. *Religions of Africa: Traditions in Transformation*. Harper & Row, San Francisco, 1984.

Le Guennec-Coppens, Françoise. *Wedding Customs in Lamu*. Lamu Society, Nairobi, 1980.

Mair, L. *African Kingdoms*. Oxford University Press, Oxford, 1977.

Marwick, Brian. *The Swazi: An Ethnographic Account of the Natives of Swaziland*. F. Cass, London, 1966.

Maybury-Lewis, David. *Millenium: Tribal Wisdom and the Modern World*. New York, 1992.

Mbiti, J. S. *Introduction to African Religion*. Heinemann, London, 1975.

McLeod, M. D. *The Asante*. British Museum Publications Ltd, London, 1981.

Morgan, K. *Legends from Yorubaland*. Spectrum Books, Ibadan, 1988.

Murdoch, George P. *Africa: Its People and Their Cultural History*. McGraw-Hill, New York, 1959.

Nelson-Adjakpey, Rev. Ted. *Penance and Expiatory Sacrifice among the Ghanaian-Ewe*. Rome, 1982.

Nicolaissen, Johannes. *Tuareg: Ecology and Culture of the Pastoral Tuareg*. Thames & Hudson, London, 1997.

Nooter, Mary H. *Secrecy: African Art that Conceals and Reveals*. The Museum for African Art, New York, 1993.

Obeng, Ernest E. *Ancient Ashanti Chieftaincy*. Ghana Publishing Corporation, Tema, 1986.

Oei, May-ling. *Concepts of God*. Van Bleiswijk, Den Haag, 1963.

Opoku, A. A. *Festivals of Ghana*. Ghana Publishing Corporation, Accra, 1970.

Owusu-Ansah, D. *Islamic Talismanic Tradition in Nineteenth Century Asante*. Edwin Mellen Press, New York, 1991.

Parrinder, Geoffrey. *African Mythology*. Hamlyn, London, 1967.

Parrinder, Geoffrey. *African Traditional Religion*. Hutchinsons University Library, London, 1954.

Peek, P. M. *African Divination Systems: Ways of Knowing*. Indiana University Press, Bloomington, 1991.

Pernet, H. *Ritual Masks: Deception and Revelation*. University of Carolina Press, Columbia.

Pern, Stephen. *Masked Dancers of West Africa: The Dogon*. Time Life Books, Amsterdam, 1982.

Philips, Tom (Ed.). *Africa: The Art of a Continent*. Royal Academy of Arts, London, 1995.

Picton, John and John Mack. *African Textiles*. British Museum Publications Ltd, London, 1979.

Radcliffe-Brown, A. R. and D. Forde. *African Systems of Kinship and Marriage*. Oxford University Press, London, 1950.

Rattray, Robert S. *Ashanti*. Clarendon Press, London, 1923.

Ray, B. C. *African Religions: Symbol, Ritual and Community*. Prentice Hall, Englewood Cliffs, 1976.

Ray, B. C. *Myth, Ritual and Kingship in Buganda*. Oxford University Press, New York, 1991.

Roy, Christopher D. *The Dogon of Mali and Upper Volta*. F. & J. Jahn, Munich, 1983.

Ryle, J. and S. Errington. *The Dinka: Warriors of the White Nile*. Time Life Books, Amsterdam, 1982.

Sarone O. S, and R. Hazel. *The Symbolic Implications of the Maasai Eunoto Graduation Ceremony*. University of Uppsala, Uppsala, 1984.

Sarpong, Peter. *Girls' Nubility Rites in Ashanti*. Ghana Publishing Corporation, Tema, 1977.

Sarpong, Peter. *The Sacred Stools of the Akan*. Ghana Publishing Corporation, Tema, 1971.

Secretan, Thierry. *Going Into Darkness: Fantastic Coffins from Africa*. Thames & Hudson, London, 1995.

Somé, Malidoma Patrice. *Of Water and the Spirit*. Tarcher Putnam, New York, 1998.

Somé, Malidoma Patrice. *The Healing Wisdom of Africa*. Tarcher Putnam, New York, 1998.

Trimmingham, J. Spencer. *History of Islam in West Africa*. Oxford University Press, London, 1962.

Trimmingham, J. Spencer. *The Influence of Islam upon Africa*. Longmans, Green & Co, London, 1968.

Turner, Victor. *The Ritual Process*. Routledge & Kegan Paul, London, 1969.

Van Gennep, Arnold. *The Rites of Passage*. Routledge & Kegan Paul, London, 1960.

Vizedom, Monica. *Rites and Relationships: Rites of Passage and Contemporary Anthropology*. Sage Publications, Beverly Hills, 1976.

Vogel, S. and N'Diaye, F. *African Masterpieces from the Musée de l'Homme*. Harry N. Abrams, New York, 1985.

Warren, Dennis M. *The Akan of Ghana*. Pointer Ltd, Accra, 1973.

Westermarck, Edward. *Marriage Ceremonies in Morocco*. Curzon Press, London, 1914.

Westermarck, Edward. *Ritual and Belief in Morocco*. Macmillan, London, 1926.

Wilks, Ivor. *A Portrait of Otumfuo Opoku Ware II as a Young Man*. Anansesem Publications, Accra, 1995.

The following articles are from *African Arts* magazine, University of California, Los Angeles:

Abiodun, Rowland, 'Understanding Yoruba Art and Aesthetics: The Concept of Ase,' Volume XXVII No.3

Appiah, Peggy, 'Akan Symbolism,' November 1979, Volume XIII No.1

Aronson, Lisa, 'The Language of West African Textiles,' July 1992, Volume XXV No.3

Bankole, Ayo / Bush, Judith / Samaan, Sadek H, 'The Yoruba Master Drummer,' Winter 1975, Volume VIII No.2

Bassing, Allen and A. Y. Y. Kyerematen. 'The Enthronement of an Asantehene,' Spring 1972, Volume V No.3

Bedaux, R. M. A, 'Tellem and Dogon Material Culture,' August 1988, Volume XXI No.4

Boyer, Ruth M. 'Yoruba Cloths with Regal Names,' February 1983, Volume XVI No.2

Burns, Vivian, 'Travel to Heaven: Fantasy Coffins,' Winter 1974, Volume VII No.2

Clark-Smith, Shea, 'Ashanti Kente Cloth Motifs,' October 1975, Volume IX No.1

Dieterlen, Germaine, 'Masks and Mythology Among the Dogon,' May 1989, Volume XXII, No.3

Drewal, Henry John, 'Efe: Voiced Power and Pageantry,' Summer 1974, Volume VII No.2

Drewal, Henry John, Gelede 'Masquerade: Imagery and Motif,' Winter 1974, Volume VII No.4

Drewal, Henry John, 'Mermaids, Mirrors, and Snake Charmers: Igbo Mami Wata Shrine,' February 1988, Volume XXI No.2

Drewal, Henry John, 'The Arts of Egungun Among Yoruba Peoples,' April 1978, Volume XI No.3

Drewal, Margaret Thompson and Henry John Drewal, 'Gelede Dance of the Western Yoruba,' Winter 1975, Volume VIII No.2

Ezra, Kate, 'The Art of the Dogon,' August 1988, Volume XXI No.4

Garrard, Timothy F. 'Akan Metal Arts,' November 1979, Volume XIII No.1

Garrard, Timothy F. 'Akan Silver,' February 1984, Volume XVII No.2

Gilbert, Michelle V, 'Mystical Protection Among the Anlo-Ewe,' August 1982, Volume XV No.4

Glaze, Anita J, 'Dialectics of Gender in Senufo Masquerades,' May 1986, Volume XIX No.3

Hale, Sjarief, 'Kente Cloth of Ghana,' Spring 1970, Volume III No.3

Heathcote, David, 'Hausa Embroidered Dress,' Winter 1972, Volume V No.2

Huet, Jean-Christophe, 'The Togu Na of Tenyu Irelli,' August 1988, Volume XXI No.4

Joseph, Marietta B. 'West African Indigo Cloth,' January 1978, Volume XI No.2

Kuper, Hilda, 'Celebration of Growth and Kingship: Incwala in Swaziland,' Spring 1968, Volume I No.3

Lamb, Alastair, 'Krobo Powder-Glass Beads,' April 1976, Volume IX No.3

Lawal, Babatunde, 'New Light on Gelede,' April 1978, Volume XI No.2

Mickelsen, Nancy R, 'Tuareg Jewelry,' January 1976, Volume IX No.2

Patton, Sharon F, 'The Asante Umbrella,' August 1984, Volume XVII No.4

Patton, Sharon F, 'The Stool and Asante Chieftaincy,' November 1979, Volume XIII No.1

Perani, Judith and Norma Wolff, 'Embroidered Gown and Equestrian Ensembles of the Kano Aristocracy,' July 1992, Volume XXV No.3

Priebatsch, Suzanne and Natalie Knight, 'Traditional Ndebele Beadwork,' January 1978, Volume XI No.2

Richardson, John Adkins, 'Speculations on Dogon Iconography,' October 1977, Volume XI No.1

Richter, Dolores, 'Senoufo Mask Classification,' May 1979, Volume XII No.3

Ross, Doran H. 'The Verbal Art of Akan Linguist Staffs,' November 1982, Volume XVI No.1

Ross, Doran H. 'The Iconography of Asante Sword Ornaments,' October 1977, Volume XI No.1

Salmons, Jill, 'Mammy Wata,' April 1977, Volume X No.3

Smith, Fred T. 'Death, Ritual and Art in Africa,' November 1987, Volume XXI No.1

Smith, Fred T, 'Earth, Vessels and Harmony Among the Gurensi,' February 1989, Volume XXII No.2

Smith, Fred T. 'Gurensi Wall Painting,' November 1978, Volume XII No.1

Van Beek, Walter, 'Functions of Sculpture in Dogon Religion,' August 1988, Volume XXI No.4

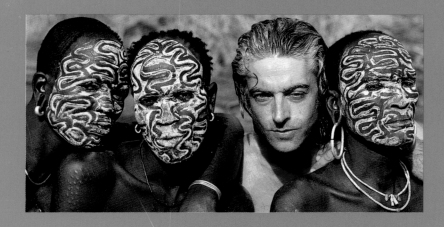

Award-winning composer and musician David Bradnum has teamed up once again with Angela Fisher and Carol Beckwith to produce this unique CD of traditional and ceremonial African music. Bradnum's musical journey with Beckwith and Fisher to record African ceremonies took him from the powerful Surma rituals in the last wilderness of Africa to the Wodaabe charm dances in the Sahel; from the sounds of the Bassari Sacred Forest to the haunting love songs of the Indian Ocean. Much of this music has not been recorded before and reveals the rich variety of African musical traditions. This CD adds a further dimension to the visual recordings of the ancient ceremonies in this book.

David Bradnum was born in England and educated at the Universities of Newcastle and Uppsala. As a guitarist, he lived in and toured the United States and has scored award-winning films and television. He is the creator of the acclaimed African Journey programs for the BBC. His musical recordings are published worldwide by EMI.

CHILDHOOD AND INITIATION

1. Bedik Dawn, Senegal
2. Adama and Basuna, Niger
3. Tamba Kora, Mali
4. Djamena Horns, Central Africa
5. Bassari Sacred Forest, Senegal
6. Taneka Initiation, Benin

COURTSHIP AND MARRIAGE

7. Asmira, Swahili Coast
8. Wodaabe Charm Dance, Niger
9. Kalimba Thumb Piano, Ethiopia
10. Joncounda, Mali

CHIEFS AND KINGS

11. Kamba Drums, Kenya
12. Kra Strings, Ethiopia

SEASONS

13. Muri Duet, Ethiopia
14. Ikitu Jagi-Hunting by Moonlight, Ethiopia
15. Bungo, Kenya
16. Senegalese Bass Box
17. Mabumbumbo, Indian Ocean

WORSHIP AND THE WORLD BEYOND

18. Sahara (composed from source flutes), North Africa
19. Tumu, Ethiopia
20. Oud, Morocco
21. Joncounda and Fatou, Senegal
22. Griot Praise Song, Sahel

Mastered at Floating Earth London 2002 www.dadadisk.com